ENGLISH ART
1870–1940

Dr. Dennis Farr is Director of the Courtauld Institute
Galleries, University of London, and author of *William Etty*
(1958), *British Sculpture since 1945* (1965), *New Painting in
Glasgow* (1968), and (with Mary Chamot and Martin Butlin)
Catalogue of the Modern British School Collection, Tate Gallery
(1964).

ENGLISH ART
1870–1940

———

DENNIS FARR

Oxford New York

OXFORD UNIVERSITY PRESS

1984

Oxford University Press, Walton Street, Oxford OX2 6DP

London New York Toronto
Delhi Bombay Calcutta Madras Karachi
Kuala Lumpur Singapore Hong Kong Tokyo
Nairobi Dar es Salaam Cape Town
Melbourne Auckland

and associated companies in
Beirut Berlin Ibadan Mexico City Nicosia

Oxford is a trade mark of Oxford University Press

First published 1978 as Volume XI in
the Oxford History of English Art
First published as an
Oxford University Press paperback 1984

British Library Cataloguing in Publication Data

Farr, Dennis
English art 1870–1940.—(Oxford paperbacks)
1. Art, English 2. Art, Modern—19th century—England
3. Art, Modern— 20th century—England
I. Title
709'.42 N6767
ISBN 0–19–281855–4

Library of Congress Cataloging in Publication Data

Farr, Dennis, 1929–
English art, 1870–1940.
(Oxford University Press paperback)
Bibliography: p.
Includes index.
1. Art, English. 2. Art, Modern—19th century—England
3. Art, Modern—20th century—England.
I. Title.
N6767.F36 1984 709'.42 84–9654
ISBN 0–19–281855–4

Printed in Great Britain
at the University Press, Oxford
by David Stanford
Printer to the University

To Diana
Benedict and Joanna

PREFACE TO THE PAPERBACK EDITION

THE publishers' decision to issue my book as an Oxford Paperback has given me a welcome opportunity to incorporate minor revisions to the original text, and to correct some factual errors. Wherever possible, I have tried to bring references contained in footnotes up to date, especially if new information has since come to light which alters my view of events discussed. There have been two recent important articles on the accessibility of Japanese prints in Western Europe (Martin Eidelberg, 'Bracquemond, Delâtre and the discovery of Japanese prints', *Burl. Mag.* CXXI (1981), 221–7, and Deborah Johnson, 'Japanese prints in Europe before 1840', *ibid.* CXXIV (1982), 343–8), and an unpublished paper by Toshio Watanabe, 'Early Whistler and Japonisme' (Association of Art Historians Conference 1981), which provide fresh evidence on this topic. In the field of nineteenth-century sculpture, Benedict Read's *Victorian Sculpture* (1982) and Susan Beattie's *The New Sculpture* (1983) are major additions to the literature and incorporate much new material.

I have revised my opinion of Mark Gertler's late work after seeing the exhibition at the Ben Uri Art Gallery in 1982; and further research in the Tate Gallery archives on the C. Frank Stoop Bequest has shown that I gave currency to an unfair assertion about J. B. Manson's role as Director of the Tate Gallery at that time. But the scope for such amendments is limited. Were I to have written this book now, my approach to certain aspects of the subject would inevitably have been rather different.

I have included a list of addenda to the Bibliography giving the more important publications that have appeared since 1978 and which are relevant to the period covered by this book.

D. L. A. F.

Bedford Park, London
January 1984

PREFACE TO THE FIRST EDITION

THIS is the final volume in the Oxford History of English Art and its title, *English Art 1870–1940*, is in some ways misleading. It should more accurately be called British Art, for no account of the seventy years under review would be complete without proper consideration of the important Scottish contribution to our art and architecture at the turn of the century. This I have attempted to do wherever it seemed to me appropriate to mention Scottish artists in a wider international context. For a more detailed account of this national school, readers must consult two recent works which deal exclusively with the subject. Although James McNeill Whistler, the American-born artist who dominates the opening chapter of this volume, was proud of his Scottish ancestry, nationality and the narrower claims of nationalism were for him beneath contempt: '. . . there is no such thing as English Art. You might as well talk of English Mathematics. Art is Art, and Mathematics is Mathematics' (*The Gentle Art of Making Enemies*, 171). Our geographical position as a large island-complex off the European mainland has proved a mixed blessing. Cultural isolationism earlier in the nineteenth century, linked no doubt with a sense of imperial self-sufficiency, had the effect of producing a distinctive provincialism. This, paradoxically, also enabled us to evolve a characteristically pragmatic approach to the decorative arts, to domestic architecture, and to social reform, the practical results of which were to win the appreciative emulation of our European neighbours by the early 1900s. It was not and could never be a complete and absolute isolation. In painting and sculpture our response to Impressionism and our contribution to Art Nouveau reflect this curious mixture of caution and innovation, just as our attempts at assimilation and adaptation of the great revolutionary movements in art and architecture from 1900 onwards were often erratic and almost always idiosyncratic.

The structure of this book reflects the different pace at which painting and sculpture develop in relation to architecture and

design. After a period of some thirty years during which English and Scottish architects explored new concepts and materials, and new methods of production, there was a retrogression to the grandeurs of neo-baroque and *beaux-arts* classicism which exerted their influence, with a few notable exceptions of those who worked in a 'free style', on almost a generation of architects. There was no contemporary architectural counterpart to Vorticist art, and in the decorative arts the solid virtues of the Arts and Crafts movement had become synonymous with traditionalism. The 1920s appear to have been a period of transition in all the arts in this country, a period in which the upheavals of the preceding decade were reassessed and new directions sought against a background of economic uncertainty culminating in the Depression of 1929 and its aftermath. Not until the final decade of the period covered by this survey do we find a concerted attempt, by a handful of artists, architects, and critics, to come to terms with what has now become known as the modern movement. That the adherents of this movement are, in their turn, now also regarded by some as dogmatic and in their own way productive of a new academicism should not blind us to their achievements in the face of hostility and incomprehension. It was only the dawn of a new era, which could not reach maturity until after the horrors of a second world war had been overcome.

English art can only be properly understood if seen in its European context, as the authors of previous volumes in this history have recognized. This survey is no exception and for that reason more attention has been paid to those artists who were independent of the Royal Academy of Arts, for it was they who, like some of their mid-nineteenth- and twentieth-century European contemporaries, had seized the initiative; it was they who, almost without exception, explored new ideas and broke with the ultra-conservatism of academies of art. Some prominent Academicians of the later nineteenth century have recently received well-merited attention from art historians, but the general thesis proposed here is not materially affected by this new research. Similarly, it is those patrons and collectors who were willing to support the independent artists who have been dealt with in greater detail, although

the sometimes immense financial rewards enjoyed by Royal Academicians is an economic indicator of taste that cannot be ignored. The breakdown of a sound academic tradition in the nineteenth century posed special problems to artists, who were impelled to question the principles on which their art was based. This was not a new process, but the conflict between neo-classicism and romanticism had already sharpened the debate. The quest for fundamentals led some artists to assert the primacy of the formal values of their art as distinct from the, to them, quite subordinate element of content. Even this assertion requires some qualification, for the symbolist artists evolved an elaborate pictorial language owing much to medieval romance and charged with meaning, whilst their spiritual heirs, the Surrealists, deliberately exploited the random association of ideas and images in an attempt to tap the hidden springs of the collective unconscious. Architects and designers, faced with more tangible problems, grappled with the conflict—some would say outright contradiction—between historicism (or revivalism) and the challenge presented by the machine age and new materials. Their restatement of fundamentals was largely determined by severely practical considerations and not the least of the benefits this brought was the breaking down of the old barriers between artists, designers, and architects which had been created in the nineteenth century.

When I began work on this book over fifteen years ago, the date at which the history would end was left open. As work progressed, it became clear to me that a natural watershed would be 1940 if I were to do anything like justice to the theme, and avoid too arbitrary a terminus. The enforced isolation and austerities of 1940–5 introduce a historical hiatus so far as the creative arts are concerned which also made 1940 more acceptable. Many artists and architects who had begun their careers in the 1930s could at least be discussed in their formative years, whereas a later date would have meant leaving them in mid-flight, so to speak; and I could not have dealt with the immediate post-1945 generation adequately enough had I chosen, say, either the Festival of Britain year (1951) or even 1960 as appropriate finishing-posts. There were also the practical considerations of length and historical

perspective. I have followed the example of the author of the immediately preceding volume in deciding to limit myself to a span of seventy years. I have grouped painting, sculpture, and the graphic arts together, but the decorative arts belong with architecture and are discussed in that context. Regretfully, I have had to decide to confine my remarks about photography to noting those occasions when artists took a particular interest in it, rather than embark on a more general discussion of its importance in the twentieth century. I am also conscious that, from necessity, my treatment of some minor arts has been perfunctory.

Inevitably, in so wide-ranging a work as this, my debt to others who have dealt with certain topics in greater detail is considerable, and this I gratefully acknowledge. Sir Nikolaus Pevsner and Henry-Russell Hitchcock are renowned authorities whose work has inspired a new generation of historians to study the art and architecture of Victoria's reign and of our own time. I am also much indebted to Sir Colin Anderson, Professor Bernard Ashmole, Lord Clark of Saltwood, Sir Roland Penrose, and Sir John Summerson for generously answering in some detail my inquiries about events in which they were actively involved during the 1930s. I am grateful to Miss Felicity Ashbee for allowing me to quote from her father's Memoirs. My interest in the fascinating but complex interrelationships between artistic theory, music, and literature in the nineteenth century was first stimulated many years ago by Ronald Alley. I should also like to thank Lord Moyne, Sir John Rothenstein, and Sir Norman Reid for their encouragement and help. At the Victoria and Albert Museum, Miss Elizabeth Aslin, Mrs. Shirley Bury, Dr. Michael Kauffmann, and Mrs. Barbara Morris have given me welcome advice about the collections in their care. To them, and to my colleague, Miss Glennys Wild, I express warmest thanks for their assistance willingly given.

The late Dr. T. S. R. Boase, the General Editor of the series, entrusted the writing of this volume to me. He read a substantial part of the manuscript in draft and I am deeply grateful to him for his patient encouragement over a long period. My other mentor has been the late Professor Andrew McLaren Young. He welcomed

me to Glasgow soon after I had begun work on this volume and shared with me the results of his research on Whistler, and later, as his colleague, I learnt from him much about Charles Rennie Mackintosh and the arts in Glasgow at the turn of the century. Just before his untimely death he had read all but the last chapter and made many helpful suggestions. I am much indebted to him.

I wish to thank the staff of the Victoria and Albert Museum Library, the University of Glasgow Library and Department of Fine Art, the City Reference Library, Birmingham, Professor Peter Lasko and his colleagues at the Courtauld Institute of Art, Miss Sue Kavanagh of the British Architectural Library, and Mr. John Harris and his colleagues at the R.I.B.A. Drawings Collection for their many kindnesses. I am also grateful to Mr. John Archer, Dr. Wendy Baron, Mr. Sherban Cantacuzino, Miss W. G. Constable of the *Architectural Review*, Miss Frances Abraham of the B.B.C. Photograph Library, Miss Sarah Hann of *Country Life*, Miss Charlotte Deane and Miss Anna Whitworth of Hamlyn Group Picture Library, Mr. A. J. Hucklesby, A.R.I.B.A., the staff of the British Library, National Monuments Record, the National Trust, and Mr. Bernard Carter, formerly of the National Maritime Museum, for their assistance in gathering illustrations. To all my colleagues in museums and art galleries in this country and abroad who have given similar help I express my thanks.

Her Majesty the Queen has graciously allowed me to reproduce the Alfred Gilbert Epergne from the Royal Collection. Other permissions which have been granted by owners of works of art reproduced in this book are also gratefully acknowledged. Their names are given in the list of illustrations. Some private owners were particularly helpful and made this part of my task a pleasure. I should like to make special mention of the late Edwin Smith, who photographed two London church interiors for me and supplied photographs of other churches used in this book.

I must also thank members of my own staff for their help, particularly Mr. William Belsher and Mr. David Bailey for photography; and Miss Sheila Jones, whose secretarial skills ensured that the typescript reached the publishers in fair state.

I am most grateful to Mr. John Bell and his colleagues at the Oxford University Press for their professional guidance and support, but I owe a special debt to my wife and children who have borne with me patiently during the long gestation of this book, and to whom I dedicate it with affection.

D. L. A. F.

Longborough, Glos.
April 1977

CONTENTS

LIST OF ILLUSTRATIONS

ABBREVIATIONS

Arch. Rev.	*Architectural Review*
B.E.	The Buildings of England, ed. Sir Nikolaus Pevsner, 1951–74
Burl. Mag.	*Burlington Magazine*
D.N.B.	*Dictionary of National Biography*
Ferriday (1963)	Peter Ferriday (ed.), *Victorian Architecture* (1963)
G. des B.A.	*Gazette des Beaux-Arts*
H.M.S.O.	Her Majesty's Stationery Office
I.W.M.	Imperial War Museum, London
L.C.C.	London County Council
N.G.	National Gallery
N.P.G.	National Portrait Gallery
O.H.E.A.	Oxford History of English Art
R.A.	Royal Academy of Arts
R.I.B.A. Jnl.	*Journal of the Royal Institute of British Architects*
Service (1975)	Alastair Service (ed.), *Edwardian Architecture and its Origins* (1975)
T.G.	Tate Gallery
V. & A.	Victoria and Albert Museum

PART ONE

PAINTING AND SCULPTURE
1870–1900

I

WHISTLER AND ART FOR
ART'S SAKE

'MORE than any other painter, Mr. Whistler's influence has made itself felt on English art. More than any other man, Mr. Whistler has helped to purge art of the vice of subject and belief that the mission of the artist is to copy nature.' So wrote George Moore in *Modern Painting*, 1893. Inaccurate as George Moore was in so many ways, this time he had struck home. The break with tradition to which he referred was the crux of Whistler's conflict with John Ruskin, and, paradoxically, Whistler's aesthetic code owed most to the advanced trends in French litera ture of the mid-1850s. These trends were soon to be reflected in England. Literature, which had provided artists of the preceding neo-classical and romantic periods with a rich source of subject-matter, was now to be instrumental in destroying the cult of the subject. This apparent contradiction is resolved after a closer examination of the literary aesthetic of the Art for Art's sake movement led by Théophile Gautier and Charles Baudelaire, and of the development of this aesthetic by the Symbolists, with whose leading spirit, Stéphane Mallarmé, Whistler was on terms of intimate friendship. The English Art for Art's sake movement cannot be fully understood without first studying its French antecedents.

The advanced French writers of the period 1835–95 became increasingly aware of the importance of the formal elements of their craft, of the self-sufficiency of a poem or a novel in which, though they might draw on their experience of the world around them, they saw no reason to use their art to preach a moral or to serve a useful purpose. Gautier affirmed this principle as early as 1835, when he wrote in his preface to *Mademoiselle de Maupin* that 'Objects are beautiful in inverse proportion to their utility. There can be nothing of real beauty save that which serves no purpose.

Everything that is useful is ugly.' He reiterates this idea in an editorial to *L'Artiste* of 1856: 'Art is not a means but an end in itself', and nearly forty years later Oscar Wilde ends his preface to *The Picture of Dorian Gray* (1891) with the provocative assertion, 'All art is useless.'[1]

If art was deemed self-sufficient, its canons were all-embracing. Thus Gautier, in his *Salon* of 1845, had drawn a parallel between poetry and sculpture as sister arts: 'Marble and verse are two media equally hard to work, but they are the only ones to retain for ever the shape given them.' This idea that the artist's chief concern is with the perfection of form, which transcends time and death, appears again in Gautier's poem *L'Art* of 1852. It is the antithesis of romantic individualism, for now the artist hides his personality in 'objective' descriptions. *L'Art* was one of the key poems from the collection published as *Émaux et camées*, each of which is a little picture in words on a cameo or enamel, like those of a Renaissance craftsman.

Both Baudelaire and Gustave Flaubert turned to Gautier for inspiration, and Baudelaire's *Salons* of 1845 and 1846 elaborate Gautier's original thesis. In 1845 Baudelaire pleads that artists should abandon the medieval world of the romantics and take their subjects from everyday life. In 1846, discussing colour in his essay *De la couleur*, he quoted a section from E. T. A. Hoffmann's *Kreisleriana* (published 1814), which has now become an important cornerstone in the documentation of the concept of *correspondances*, of the links between music, colours, sounds, and perfumes. A poem entitled *Correspondances* actually appeared in Baudelaire's *Fleurs du mal* of 1857. The theories in which music and painting are linked, the technicalities of *audition colorée* and synaesthesia, are a study in themselves and we can only touch on those aspects immediately relevant to Whistler's art.[2] Baudelaire considered that beauty re-

[1] Nikolaus Pevsner, *Pioneers of the Modern Movement* (2nd edn., 1949, as *Pioneers of Modern Design*), 8, recalls John Keats's lines 'Oh sweet Fancy! let her loose; Every thing is spoilt by use'.

[2] Lionel Johnson, 'A Note upon the Practice and Theory of Verse at the Present Time Obtaining in France', *Century Guild Hobby Horse*, VI (1891), 61–6, is one of the first accounts in English of the bases of Symbolism and the relationship between sound and music. Johnson quotes M. Anthoni Lange and René Ghil's *Le Traité du verbe*. See

sides not in the object itself, but in what the artist brings to it. He searched for earthly symbols for spiritual truth expressed in terms of painting, sculpture, music, and poetry. Often one art would be expressed in terms of another, but, as has been pointed out, Baudelaire realized that 'music, above all the other arts, had the power of rendering, of conveying, a transcendental experience, and his effects thus tended towards making poetry approximate to music in powers of expression and suggestion'.[1] Walter Pater was later to echo this idea in a slightly different form: 'All art constantly aspires towards the condition of music.'[2] Eight years after Pater and nearly forty years after Baudelaire's *Salon* of 1846, Whistler restated this aesthetic doctrine in his famous 'Ten o'Clock' lecture. This lecture, delivered in the Prince's Hall, London, at the fashionable hour of ten in the evening on 20 February 1885, received great publicity and was repeated at the Universities of Oxford and Cambridge, at the Grosvenor Gallery, at Dieppe, and elsewhere. It was also published, translated into French by Mallarmé in 1888, into German by Theodor Knoor in 1904, and there was a Danish edition in 1907.

Baudelaire's *Fleurs du mal* was first published in 1857. Whistler had been living in Paris since November 1855 and, thanks to his cosmopolitan upbringing, could speak fluent, idiomatic French. He had arrived in Paris at the age of twenty-one, having failed his examinations at the United States Military Academy, West Point, and idled briefly in the U.S. Coast Geodetic Survey, although here, at least, he had learnt to etch plates of maps and topographical plans. He had received his first drawing-lessons when a child at St. Petersburg and, deciding at last to become an artist, he studied first at the École Impériale et Spéciale de Dessin in November 1855, and in June the following year entered the Académie Gleyre. It was here that he met George Du Maurier, Edward Poynter (a

also Dennis Farr, 'James McNeill Whistler—His Links with Poetry, Music and Symbolism', *Journal of the Royal Society of Arts*, CXXII (Apr. 1974), 267–84.

[1] Enid Starkie, *From Gautier to Eliot, The Influence of France on English Literature 1851–1939* (1960), 36.

[2] Walter Pater, 'The Renaissance—The School of Giorgione', *Fortnightly Review* (Oct. 1877), republished in *The Renaissance* (3rd edn., 1888).

future President of the Royal Academy), Thomas Armstrong, and the Scotsman Thomas Lamont, as well as the Frenchmen Henri Martin, Henri Oulevey, the musician Becquet, Drouet a sculptor, and Ernest Delannoy. He lived a carefree bohemian life on an annual allowance of $350. His attitude towards his hearty, athletic, and rather insular English art-student friends is neatly drawn by his remark, on seeing them at their gymnastics in the studio, 'Can't you get the concierge to do that sort of thing for you?'[1] Although he remained on good terms with Du Maurier, Poynter, and the English group in Paris, his first important contact was with the French painter Henri Fantin-Latour, whom he met while copying in the Louvre in 1858. Fantin introduced him to Alphonse Legros, Carolus-Duran, Zacharie Astruc, and, most significantly, to Gustave Courbet. Among the living masters Courbet was most to influence Whistler's early style, and it was Courbet, leader of the new realist school, who admired Whistler's first important oil, *Au piano* or *At the Piano*, when in 1859, following its rejection by the Salon jury, it was shown at the 'atelier flamand' held in François Bonvin's studio in the rue St.-Jacques.

Whistler was indebted to Courbet in his choice of a subject from everyday life, and to Fantin in his simple treatment of the theme, the sombre palette, and carefully disposed areas of light and dark colour. The flattening of the picture space, and the emphasis on the horizontal lines of the composition also foreshadows the use Whistler was later to make of the conventions of the Japanese print. He knew Bracquemond, the possessor of the precious volume of the *Manga* of Hokusai, but there is no evidence that he was already familiar with these prints. It seems more likely Whistler was following the Dutch genre tradition of the seventeenth century. The artist who most consistently inspired him was Velázquez, whose work he first saw at the Manchester Art Treasures Exhibition in 1857, and whose style underlies many of Whistler's full-length portraits of the 1880s and 1890s.[2] One of the few copies he made in the Louvre was of Juan de Mazo's *Cavaliers* (then thought to be by Velázquez), although his one attempt to see the Velázquez

[1] E. R. and J. Pennell, *Life of James McNeill Whistler*, I (1908), 52.
[2] Ibid. I. 67.

collection in the Prado fizzled out at Biarritz in October 1862.[1] Courbet's influence gradually waned so that by the summer of 1865, although working side by side with Courbet from the same motif at Trouville, Whistler had established a much more distinctive style. Where Courbet emphasized the rugged strength of the sea, even in moments of tranquillity, Whistler evokes a more tender mood; the paint is laid on in thin, fluid washes which suggest rather than describe the forms of the rocks and waves. Two years later, in August 1867, after seeing Courbet's one-man show at the Paris World's Fair, Whistler wrote to Fantin-Latour and hotly disclaimed the value of Courbet's teaching and guidance in particular, and generally denounced 'ce damné Réalisme'.[2]

Whistler's first *succès de scandale* came when he sent his *The White Girl* (National Gallery of Art, Washington D.C.), painted 1861–2, to the famous Salon des Refusés of 1863, after it had been rejected first by the Royal Academy of Arts in 1862 and by the official Salon the following year. English critics had supposed that this red-haired model (Joanna Heffernan), clothed in white and standing on a white bearskin rug, was an unsuccessful attempt to illustrate Wilkie Collins's popular novel *The Woman in White*.[3] French critical reactions to it were equally baffled, and the interpretations no less ridiculous. The painting was considered ugly. Castagnary, the realist, after two hours' perusal of the work concluded that it represented a young girl after her first night of marriage. But Fernand Desnoyers, Baudelaire, and Courbet agreed in their verdict that Whistler had achieved a work of haunting, ethereal beauty.[4] One may also observe that this idealization

[1] Léonce Bénédite, *G. des B.A.*, XXXIII (1905), 406. Another of Whistler's copies was of the figure of Angelica from Ingres's *Roger and Angelica*, now in the University Art Collections, Glasgow.

[2] Bénédite, *G. des B.A.*, XXXIV (1905), 232–6; and John Rewald, *The History of Impressionism* (2nd edn. 1961), 162, who sees in Whistler's renunciation of Courbet a fatal weakness which led him 'to put taste above creative power'.

[3] E. R. and J. Pennell, op. cit. (5th edn., 1911), 69, quote *in extenso* Whistler's letter to the *Athenaeum*, 5 July 1862, on the occasion of the Berners Street Gallery exhibition of *The White Girl*: 'My painting simply represents a girl dressed in white, standing in front of a white curtain.'

[4] Bénédite, op. cit., 509, for an account of the general critical reception of the picture. F. Desnoyers, 'Salon des Refusés', quoted by J. K. Huysmans, *Certains* (1925

of virginal womanhood was a recurrent theme in the work of Rossetti, who shared the cult of the 'stunner' with other mid-Victorian artists.[1] The *White Girl* is the first step towards a personal style and prepares us for the innovations of the 1870s. The title of the painting was later expanded to *Symphony in White, No. 1: The White Girl*, and was exhibited under this new title at the International Exhibition of 1872. This change is significant and provides a clue in answer to the question why Whistler should have attempted this exercise in white. *Symphony in White, No. 3*, signed and dated 1867 (Barber Institute of Fine Arts, Birmingham), was the first painting to be exhibited with a musical title, and two earlier 'Symphonies' were later renamed to conform with this system of nomenclature.[2] In the 'Programme of Reception' printed for the 1872 International Exhibition, Whistler explained his choice of such titles as 'Harmonies', 'Symphonies', 'Variations' as suitable for works which were 'the complete results of harmonies obtained by employing the infinite tones and variations of a limited number of colours'.[3] There can be little doubt that Whistler had a literary prototype in mind when he painted his *White Girl*. This was Gautier's poem *Symphonie en blanc majeur*, published in *Émaux et camées* in 1852. Just as the poet carefully collects all the objects capable of suggesting an impression of whiteness and orchestrates them into a verbal tone poem, so Whistler harmonizes in this painting all the subtle nuances of white upon white—or near-white. The critic, Paul Mantz, quickly perceived the allusion and in 1863 described the picture as a 'symphonie du blanc'.[4]

Although Whistler had decided to settle in London early in 1863, he still maintained full contact with Parisian literary and artistic life. In March that year he accompanied Swinburne to

edn.), 64, called Whistler 'le plus spirite de tous les peintres'; the *White Girl* was 'le portrait d'une spirite, d'un médium'. Courbet spoke of the painting as 'une apparition du spiritisme' (letter to Whistler from Fantin-Latour, written immediately after his return from the opening of the Salon des Refusés. Letter in Birnie Philip Collection, University of Glasgow).

[1] Denys Sutton, *James McNeill Whistler* (1966), 10–11.
[2] E. R. and J. Pennell, op. cit. I. 144–6. [3] Ibid. I. 157.
[4] *G. des B.A.* II (1863), 61; James Laver, *Whistler* (1930), 77.

Paris and introduced him to Édouard Manet, and in the following year figured prominently in Fantin-Latour's *Hommage à Delacroix*, where he is in the company of Champfleury, Baudelaire, Legros, Bracquemond, Manet, and Duranty. An important non-literary influence also began to make itself felt in his work at this time, and, in common with his French artist friends, he began to patronize M. and Mme de Soye's shop, 'La Porte chinoise', established in the rue de Rivoli in 1862 as a clearing-house for orientalia of all kinds. Between 1863 and 1866 Whistler amassed a valuable collection of Japanese and Chinese porcelain, fans, silks, and costumes, all of which began to feature as studio properties in his paintings. Japan had taken part for the first time in a World Exhibition in London in 1862, and in the same year the architect Edward William Godwin furnished his house at 21 Portland Square, Bristol, in a simple Japanese style with plain colours and Japanese prints on the walls.[1] The credit for introducing 'blue and white' porcelain from Paris to London in 1863, belongs, however, to Whistler.[2]

Japanese elements, which had been obtrusive in earlier paintings, take on a more subtle aspect in the delicately painted *Symphony in White, No. 2: The Little White Girl* [Tate Gallery; plate IB], exhibited at the Royal Academy in 1865. Whistler has understood the simplicity of design, the delicacy of outline, and exquisite compositional harmonies which are the essentials of Far Eastern art. This was the picture which inspired Swinburne to write his poem *Before the Mirror*, the first two verses of which were actually printed in the Academy catalogue. The poem is strongly reminiscent of Gautier's *Symphonie en blanc majeur* in its evocation of a 'white' mood. Swinburne uses the similes of a white rose, snowdrops, 'the hard East' wind which brings snow, and in the lines

My hand, a fallen rose,
 Lies snow-white on white snows, and takes no care

the poet transposes Whistler's visual image into a verbal picture.

[1] Stephan Tschudi Madsen, *Sources of Art Nouveau* (1956), 188.

[2] W. M. Rossetti, *Some Reminiscences*, I (1906), 276. John Sandberg, 'Japonisme and Whistler', *Burl. Mag.* CVI (1964), 500–7, carefully examines the question of Japanese influence on Whistler's work; see also my comments in the Preface to the Paperback Edition.

Seven years later, in 1872, Swinburne was to pay tribute to Gautier with ten commemorative poems in French for *Le Tombeau de Gautier*, later republished in the second series of *Poems and Ballads* (1878). *Symphony in White No. 3*, of 1867, shows yet another development. The Japanese elements—magnolias, fans—are discreetly tucked away, and the figures draped in semi-classical dress. Whistler now emulates Albert Moore, whose work he had come to admire and with whom he remained friendly for the rest of his life. Moore took the place of Legros in Whistler's Society of Three, the remaining member being, of course, Fantin-Latour.

The 1870s were among the most fruitful years of Whistler's whole career. To this period belong the series of Nocturnes and famous portraits, the painted decorations for the Peacock Room of 1876–7 in Oriental style which replaced the original scheme by Thomas Jeckyll, and the first big one-man show at the newly-opened Grosvenor Gallery in 1877. He was an established artist and a social success, but the decade ended disastrously with the Ruskin libel action and bankruptcy.

The *Nocturne in Blue and Green: Chelsea*, 1871 (Tate Gallery) and *Nocturne in Blue and Silver: Cremorne Lights*, 1872 (Tate Gallery) are exquisite refinements of earlier themes such as *Brown and Silver, Old Battersea Bridge*, 1863–5 (Addison Gallery of American Art) and *Crepuscule in Flesh Colour and Green: Valparaiso*, 1866 (Tate Gallery).[1] In the first of the Thames views, *Wapping*, 1860–4 (John Hay Whitney), Whistler used a comparatively wide range of colours and worked from direct observation of the subject, but his methods underwent considerable change. He had always been interested in the methods of memory training taught by Fantin's master, Lecoq de Boisbaudran, and increasingly worked up his paintings from memory, helped only by notes in black and white chalk on brown paper made on the spot the night before. Late evening or night-time is preferred, the colour harmonies become more restricted, until in the Nocturnes of the 1870s, the forms of the

[1] The chronology for Whistler's paintings used here and throughout is based on Andrew McLaren Young's research first published in his exhibition catalogue, *James McNeill Whistler*, written for the Arts Council of Great Britain and the English-Speaking Union of the United States in 1960.

buildings are extremely simplified bands of darker blue-green on a lighter ground. The flowing river is suggested by the broad brush-strokes which sweep almost uninterruptedly across the length of the panel. A few carefully-placed spots of yellow and orange indicate lights and their reflections in the water, and these form a framework within which the spectator's eye travels from the butterfly signature (now an integral part of the composition and a stylized rendering of the artist's initials), to the barge, thence to the distant shore. Foreground figures and water-reeds, where they occur, suggest borrowings from Japanese woodcuts. Yet the Thames-side paintings originate from the series of etchings, *The Thames Set*, begun in 1859, and by choosing the sordid warehouses of the Lower Thames dockside and of Chelsea Reach for his graver and brush, Whistler surely fulfils the Baudelairean doctrine that the artist should look to the world around him for inspiration, and that it is the artist alone who can find beauty in what has hitherto been considered squalid and ugly. Indeed, Baudelaire had seen and warmly praised the *Thames Set* etchings, shown in Paris at Martinet's Gallery in 1862, describing them as 'poésie profonde et compliquée d'une vaste capitale'.[1]

The title 'Nocturne' with its musical connotation and links with Frédéric Chopin would seem to be a logical continuation of the series of 'Symphonies' and 'Harmonies', but Whistler originally called his Thames night-pieces 'Moonlights', for example, *Harmony in Blue-Green—Moonlight* which appears in the 1871 Dudley Gallery exhibition catalogue, refers to the *Nocturne in Blue and Green: Chelsea* mentioned above. It was F. R. Leyland who first suggested to Whistler the word 'Nocturne', but it admirably suited the artist's purpose and he later defended its use in this novel context.[2] Two portraits of this period, the *Carlyle*, 1872–3 [Glasgow Art Gallery; plate 2B] and the much smaller, less highly finished *Self-Portrait*, c. 1871–3 [Detroit Institute of Arts; plate 2A] were given titles which stressed the nature of the painting rather than the importance of the sitter; they were 'arrangements'. The

[1] E. R. and J. Pennell, op. cit. I. 98.
[2] Val Prinsep, 'A Collector's Correspondence', *Art Journal* (1892), 249 et seq., provides the evidence of this acknowledgement to Leyland.

first was *Arrangement in Grey and Black, No. 2: Thomas Carlyle*, the second, *Arrangement in Grey: Self-Portrait*. Whistler explains the purpose of this emphasis in *The Gentle Art of Making Enemies*, where what he writes of the *Portrait of his Mother—Arrangement in Grey and Black, No. 1* (Louvre), applies equally to his *Carlyle*:

Art should be independent of all clap-trap—should stand alone, and appeal to the artistic sense of eye or ear, without confounding this with emotions entirely foreign to it, as devotion, love, patriotism, and the like. All these have no kind of concern with it and that is why I insist on calling my works 'arrangements' and 'harmonies'. Take the picture of my mother, exhibited at the Royal Academy as an 'Arrangement in Grey and Black'. Now that is what it is. To me it is interesting as a picture of my mother; but what can or ought the public to care about the identity of the portrait?[1]

The artist has pared away the trappings of conventional portraiture and has relied on his unerring instinct for a balanced composition, the disposition of the elements of which have an air of inevitable rightness. It is a portrait of a tired old man, who happens to be a philosopher, and whose *Sartor Resartus* was soon to be a source of inspiration to the Symbolists.[2]

In May 1877 the wealthy dilettante painter Sir Coutts Lindsay, aided by his wife and the artist Charles E. Hallé (son of the famous pianist and conductor, Sir Charles Hallé), opened the Grosvenor Gallery with an exhibition of portraits and Nocturnes by Whistler, and works by Edward Burne-Jones, including his masterpieces *The Seven Days of Creation* flanked on the centre south wall by *The Mirror of Venus* and *The Beguiling of Merlin*.[3] Other artists represented were Rossetti, Holman Hunt, Walter Crane, Legros, Gustave Moreau, and Albert Moore, with an admixture of more conservative paintings by Frederic Leighton and Poynter, G. F. Watts's *Love and Death*, and Lawrence Alma-Tadema's *The Bath*. Despite

[1] This apologia first appeared in *The World*, 22 May 1878, and was reprinted in *The Gentle Art of Making Enemies* (1890), 126–8.

[2] *Les Sources du xxᵉ siècle*, Council of Europe (Paris, 1960–1), 248, under the biography of the Danish artist, Jens Ferdinand Willumsen.

[3] W. Graham Robertson, *Time Was* (1931), 47–9; C. E. Hallé, *Notes from a Painter's Life, including the founding of two galleries* (1909), gives a full account of his part in the establishment of the Grosvenor and New Galleries.

the academic element, the policy of the early years of the Grosvenor Gallery favoured the more *avant-garde* artists, so much so that it became identified with the new aesthetic movement and in 1882 was satirized by W. S. Gilbert in the well-known couplet from *Patience*:

> A greenery-yallery, Grosvenor Gallery,
> Foot-in-the-grave young man!

—a hit at the deathly pallor possessed by many of the heroes in the paintings of Burne-Jones, Watts, and Rossetti. Nevertheless, the seeds of academic reaction had been sown in the first exhibition, and by the time that the New Gallery took over the Grosvenor Gallery in 1888, its exhibitions had become little more than an overflow from the Royal Academy.

Whistler contributed eight portraits and Nocturnes to the Grosvenor Gallery's first exhibition. These included the *Carlyle* and, among the Nocturnes, *Nocturne in Black and Gold: The Falling Rocket*, c. 1874 [Detroit Institute of Arts; plate IA], first shown at the Dudley Gallery in 1875 and the only picture for sale. The *Falling Rocket* was pounced on by Ruskin and made the chief target of his now famous wrathful denunciation of the artist in *Fors Clavigera* of 2 July 1877: 'For Mr Whistler's own sake, no less than for the protection of the purchaser, Sir Coutts Lindsay ought not to have admitted works into the gallery in which the ill-educated conceit of the artist so nearly approached the aspect of wilful imposture. I have seen, and heard, much of cockney impudence before now, but never expected to hear a coxcomb ask two hundred guineas for flinging a pot of paint in the public's face.' We know that the powerful champion of Turner's late works now had a morbid sensitivity to light and may also have had an obsession concerning fireflies and fireworks.[1] The *Falling Rocket* gave Ruskin a feeling of menace. Whistler brought an action for libel, the outcome of which was a pyrrhic victory for the painter and a demonstration of the public's contempt for, and ignorance of, the artistic principles upheld by the plaintiff. In a sense, the public took their revenge for the justifiable disdain in

[1] Joan Evans, *John Ruskin* (1954), 372.

which Whistler held their views on art, but it was a semi-farcical trial which began on 25 November 1878, in the Court of Exchequer Division before John Walter Huddleston, last baron of the Exchequer.[1]

Ruskin was unfit to appear, and the long-awaited personal confrontation was thus frustrated, but such was his influence that Whistler, disliked also by many conservative artists both within the Academy and outside, had great difficulty in finding anyone of sufficient standing who would be a witness for him. After considerable heart-searchings, Burne-Jones, one of his strongest hopes, defected to the defence; Charles Keene, whose graphic work Whistler warmly admired, preferred to stand aside from this 'lark' (as he called it); Leighton, strongly opposed to Ruskin, withdrew at the last minute, as he was to be knighted on the day the trial opened. Dante Gabriel Rossetti was too ill, but his brother William Michael, although friendly with Ruskin, supported Whistler 'willy-nilly', along with Albert Moore and William Gorman Wills, a minor playwright and portrait painter. Ruskin's strange array of witnesses included Burne-Jones, Frith, and Tom Taylor, the assertive sixty-one-year-old art critic of *The Times*, and former denigrator of the Pre-Raphaelites. Whistler, supremely witty and self-assured under cross-examination, was awarded the token sum of one farthing in damages, each party to pay his own costs. Throughout the trial, the jury had been hopelessly confused, and mistook as a work by Whistler a portrait of *Doge Andrea Gritti*, then considered an authentic Titian, which belonged to Ruskin, and rather surprisingly was brought forth as evidence of that 'finish' he found so wanting in Whistler's art.[2] At no time during the trial did the

[1] Whistler's *The Gentle Art of Making Enemies* contains an 'improved' version of the trial with characteristic marginal comment; E. R. and J. Pennell, op. cit. I, ch. XIX, give a full, if partisan, account of the trial; William Gaunt, *The Aesthetic Adventure* (1945), 83–96, discusses the wider significance of it. In 1882–4 Baron Huddleston heard another libel case between the sculptors Belt and Lawes over the authorship of the *Byron* statue in Hyde Park. Lawes accused Belt of using 'ghosts', but after two appeals lost the case and went bankrupt despite the support he had been given by Leighton and other Academicians when Belt sued him (see Peter Ferriday, 'Free standing and civic', *Studio International*, CLXXXIV (July 1972), 42–3).

[2] The *Doge Andrea Gritti* now hangs in the National Gallery, London, and has been identified as a work by Catena. It is in some ways a fairly highly finished picture.

plaintiff's counsel challenge the propriety of Ruskin's action in questioning the price asked for the *Falling Rocket* (which by Victorian standards was by no means high), but the verdict shattered Ruskin's status as a national *arbiter artium*, and shortly afterwards he resigned his Slade Professorship at Oxford. As for Whistler, he was shunned by society and found it impossible to sell his pictures. In May 1879 he was declared bankrupt and on 18 September that same year, the elegant White House in Tite Street, Chelsea, built for him by E. W. Godwin the year before, was sold for £2,700 to Harry Quilter, who briefly succeeded Tom Taylor as art critic of *The Times* in 1880, and remained the butt of Whistler's sarcasm for years to come.

During the trial Whistler made some important statements about his work. Of the Nocturnes he said: 'I have perhaps meant to indicate an artistic interest alone in my work, . . . it is an arrangement of line, form and colours first, and I make use of any incident of it which shall bring about a symmetrical [harmonious] result. Among my work are some night pieces; and I have chosen the word Nocturne because it generalises and simplifies the whole set of them.'[1] Just as Swinburne wrote verses for *The Little White Girl*, so, in 1881, another young poet, Oscar Wilde, published a volume of poems containing two pieces, *Impression du matin* and *Symphony in Yellow*, which are largely inspired by such works as *Nocturne in Blue and Gold: Old Battersea Bridge*, c. 1872–5 [Tate Gallery; plate 3A] shown at the Grosvenor Gallery. Wilde describes the fog-bound Thames thus:

> An omnibus across the bridge
> Crawls like a yellow butterfly,
> And, here and there, a passer-by
> Shows like a restless midge.
>
> Big barges full of yellow hay
> Are moved against the shadowy wharf,
> And, like a yellow silken scarf,
> The thick fog hangs along the quay.[2]

[1] E. R. and J. Pennell, op. cit. I. 234. McLaren Young suggested to the author that by 'symmetrical' Whistler probably meant harmonious.

[2] From *Symphony in Yellow*. These poems owe their literary inspiration to Gautier,

If further proof were needed, we have Wilde's essay 'The Decay of Lying', first published in the *Nineteenth Century Review* in 1889: 'At present people see fogs, not because there are fogs, but because poets and painters have taught them the mysterious loveliness of such effects. There may have been fogs for centuries in London. But no one saw them. They did not exist until Art invented them.'[1] Other poets were also inspired by Whistler's Nocturnes, notably W. E. Henley, who dedicated one of his evocative London poems to the artist. Whistler returned the compliment by offering one of his Nocturnes for use as an illustration when the poem was published in *The London Garland* in 1895.

French Impressionism received somewhat limited acclaim even from the more adventurous English artists of the 1880s and 1890s, and the movement had hardly begun to be more generally understood here before being engulfed by the strong tide of Post-Impressionism and the more complex cross-currents of the modern artistic movements which eddied and swirled across the European continent in an upsurge of creative activity and inventiveness comparable only to the High Renaissance and the Baroque. The strong literary tradition in English art, manifest in the work of artists as diverse as Rossetti, Millais, Burne-Jones, Watts, Frith, and Leighton, weighed against an art based almost exclusively on direct observation and analysis of natural appearances. Ruskin's approval of the Pre-Raphaelites' fidelity to natural detail, of their emphasis on the particular at the expense of more general aesthetic considerations, coupled with a sense of high moral rather than scientific purpose, provided a very different soil in which to nurture the Impressionism of Degas, Monet, and Camille Pissarro. It might be thought that the francophile Whistler, friendly with Monet and Degas, would have been an all-important link, an active supporter and disseminator of Impressionist principles, but he proved to be a doubtful ally in so far as his own taste and per-

and another poem in the same volume, *In the Gold Room: A Harmony*, recalls Verlaine's *Le Piano que baise une main frêle*. Wilde met Whistler for the first time in 1881, three years after leaving Oxford, where he had begun collecting blue and white china, and decorated his rooms with peacock feathers in emulation of *The Peacock Room*.

[1] Republished in O. Wilde, *Intentions*, 1891 (4th edn. 1909, p. 39).

sonality were antipathetic to those of many of his British colleagues, and for many years his public image wavered between that of a bankrupt *farceur* and an alien dandy. The 'Islanders' either resented his often well-deserved criticisms or laughed at him. Above all, it cannot be too strongly emphasized that Whistler, in his opposition to Realism, was opposed to a fundamental principle of Impressionism. Technically, he became far removed from the leading French Impressionists of the 1870s, for he did not adhere to their method of placing strokes of pure colours side by side on the canvas with the intention of allowing these to become fused optically when viewed at a certain distance to produce the desired composite colours and tonalities. It may be argued that Whistler's preoccupation, in his Thames Nocturnes for example, with the evanescent atmospheric effects of twilight and London fog was his interpretation of Impressionism. Against this must be set the fact, already noted, that he re-created in the studio remembered effects aided by notes made on the spot, rather than by working direct on the canvas outdoors before the motif. Nor, unlike Degas, was he interested in capturing the fleeting movement of a ballet dancer, or a racehorse in action. We must also remember Degas's interest in the photographic 'snapshot' effect in planning his compositions, and the importance of Eadweard Muybridge's experiments in accurately recording for the first time the movements of animals in his series of instantaneous photographs. These photographs first appeared in France in 1881, and Degas immediately modified his rendering of galloping horses from the old convention, which showed them with fore and hind legs extended and all four hoofs in mid-air simultaneously, to accord with the new photographically recorded information.[1]

There was also a basic philosophical difference in approach in that the Impressionists attempted to subordinate personal taste to objective analysis, whereas Whistler in his 'Ten o'Clock' lecture of 1885 implicitly repudiated this by asserting that Nature was but the raw material of art: 'Nature contains all the elements, in colour and form, of all pictures, as the keyboard contains the notes of all

[1] Rudolf Arnheim, *Art and Visual Perception* (1956), 354–6. Arnheim also notes that the action of the horse was better understood in antiquity.

music. But the artist is born to pick, and choose, and group with science, the elements, that the result may be beautiful—as the musician gathers his notes, and forms his chords, until he bring forth from chaos glorious harmony.' And more pointedly, 'The holiday maker rejoices in the glorious day, and the painter turns aside to shut his eyes. How little this is understood, and how dutifully the casual in Nature is accepted as sublime, may be gathered from the admiration daily produced by a very foolish sunset.'[1]

Whistler began to find himself in closer spiritual rapport with the Symbolists or, more precisely, with their leading poet, Mallarmé. On a Sunday early in January 1888, just before Whistler formally relinquished the presidency of the Royal Society of British Artists, he was taken by Monet to lunch with Mallarmé at the Café de la Paix, and as a result of this meeting Mallarmé agreed to translate Whistler's *Ten o'Clock* into French. The two men had much in common; both had endured ridicule and neglect and were only now beginning to achieve a reputation among a devoted following. Still more important was the mutual regard they had for each other's work, for not only did Whistler attend many of Mallarmé's famous Tuesday salons (*les Mardis*), but they carried on a prolific correspondence which covers the last ten years of the poet's life.[2] It was due to pressure from Mallarmé and his influential friends that the French Government was persuaded to purchase Whistler's *Portrait of his Mother* for the nation. When Mallarmé published his first collected edition of *Vers et prose* in 1893 he asked Whistler to provide a lithograph portrait as frontispiece and dedicated a copy to the artist with the lines:

> Whistler
> Selon qui je défie
> Les siècles en lithographie.[3]

This *dédicace* is signed with a monogram which in form closely resembles Whistler's own butterfly signature, and it appears on

[1] *Ten o'Clock* (1885), 14–15.

[2] The correspondence has been edited by Carl Paul Barbier, *Correspondance Mallarmé–Whistler* (Paris, 1964), who suggests, pp. 5–7, that Mallarmé and Whistler were probably acquainted with each other by either 1886 or 1887.

[3] First published by A. McLaren Young, *James McNeill Whistler* (1960), cat. no. 158.

other Mallarmé *dédicaces* of the time. The fondness for these simple rhythmical designs which are both decorative and functional was shared by many others outside the Whistler circle, such as Millais, Rossetti, and Arthur Mackmurdo. Whistler's style changed in the 1890s, and the figures in his late portraits become enveloped in a soft, atmospheric twilight, their forms less precise, less robust; almost as if Whistler were obeying Verlaine's 'Car nous voulons la Nuance encor, Pas la Couleur, rien que la nuance!' (*Art poétique*). It seems likely that Eugène Carrière's own penumbral style was influenced by Whistler, especially in view of the high regard in which his art was held by some French artists and writers. J. K. Huysmans warmly praised Whistler in his essay in *Certains* of 1889, for the Symbolists preferred a mood of weary sadness: they chose to describe the hour of twilight with its vague melancholy, and their favourite season was autumn, which with its rotting leaves symbolized a state of passionless decay, of *morne ennui*. Such an autumnal mood seems to pervade Whistler's late self-portrait, *Gold and Brown: Self-Portrait* of 1898 [Glasgow University; plate 4B], which shows him saddened and embittered. The cocky assurance of the *Arrangement in Grey: Self-Portrait* [Detroit Institute of Arts; plate 2A] painted over twenty-five years before has now been superseded by a very different feeling. Yet it would be wrong to dismiss Whistler's later work as relatively unimportant and perpetually shrouded in a *fin de siècle* mist. Nor should we make the mistake of labelling it symbolist. Whistler's art defies attempts at neat categorization.[1] He did not share the Symbolists' delight in medieval romance and chivalry, nor do his paintings sustain elaborate symbolical interpretations. He had some admiration for Burne-Jones, whose work was greatly to influence the continental Symbolists, but their point of contact, and this an important one, could only have been a common belief in the need for a work of art to be a self-sufficient creation within its own terms. The formal integrity of a painting remained for Whistler of

[1] A. McLaren Young, 'Der Einzelgänger Whistler', in *James McNeill Whistler*, Nationalgalerie, Berlin (1969), 10–20; and 'Whistler Unattached', in *James McNeill Whistler*, Nottingham University Art Gallery (1970), 4–8, for an English version of the text.

paramount importance, as we see from an examination of his later work.

An impressive group of full-length portraits belong to the 1880s and 1890s, such as the *Arrangement in Black: Lady in the Yellow Buskin, Lady Archibald Campbell, c.* 1883 [Philadelphia Museum of Art; plate 4A], as well as some exquisite small-scale seascapes and landscapes. The Venice set of etchings and pastels, and a wide range of graphic work, including lithographs, show him still pre-eminently capable of producing work of great beauty and significance. The abstract elements in his Nocturnes reappear in the Venice pastels of 1879–80, the brilliant atmospheric tonalities of which remind us of Turner's treatment of these same Venetian scenes almost fifty years earlier. Rich textural and tonal subtleties characterize Whistler's etchings of these two decades, in comparison with which the early Thames etchings appear to be linear and relatively lacking in chiaroscuro. The medium had always attracted Whistler and, like Rembrandt, certain aspects of whose work he emulated in this later period, his fascination with, and mastery of tonal complexities increased with the years [plate 3B]. Plates and stones were frequently reworked, and up to four or five, even six, states of some etchings and lithographs have been identified.[1] Whistler's highly developed aesthetic sensibilities and his rigorous quest for artistic perfection found ample scope here. In both his oils and graphics, the treatment of certain themes, such as the series of shop-fronts, show a continuing preoccupation with the formal, one might almost say the geometrical aspect, that anticipates the two-dimensional abstraction of much twentieth-century art.

[1] E. G. Kennedy, *The Etched Work of Whistler*, New York (1910); T. R. Way, *Mr. Whistler's Lithographs* (2nd edn. London and New York, 1905); and E. G. Kennedy, *The Lithographs by Whistler: Arranged according to the Catalogue by Thomas R. Way*, New York (1914).

IMPRESSIONISM, THE NEW ENGLISH ART CLUB SICKERT AND STEER

OFFICIAL taste as represented by the Royal Academy had reached its nadir in the 1870s and 1880s, and if French artists were invited to exhibit, they were invariably the less than inspiring Salon figures such as Bougucreau, Meissonier, Gérôme, and Decamps. The decline in artistic standards was matched by a feeble system of art training at both national and provincial levels. The student was taught a slavish imitation of the antique, in the form of plaster casts, with the emphasis on correct drawing and modelling to the detriment of colour. Working from the life was not permitted until the student had mastered the antique, when he would be considered fit to produce faithful inter-pretations of the frigid, pseudo-classical never-never land beloved by Leighton and Alma-Tadema, both of whom, however, had been trained abroad and whose best work has a technical excellence far above the general standard which prevailed at the Academy Schools. The French system of drawing and painting from the living model at an early stage in a student's career, linked with the practical experience of working in the studio of an established artist, which had been enjoyed by Whistler and Poynter at Gleyre's studio in the 1850s, was not introduced into England until 1871, when Poynter became the first Slade Professor at University College, London. In his inaugural address at the opening of the Slade School, 2 October 1871, he praised the French method and went one step further by suggesting that students should study the Old Masters, particularly the Italians, since a study of English masters alone could only lead to poor craftsmanship.[1] This advice

[1] Sir Edward Poynter, *Lectures on Art* (4th edn., 1897), Lectures III, IV, and V: 'Systems of Art Education' (1871), 'Hints on the Formation of a Style' (1872), and 'The Training of Art Students' (1873).

had been given to students by Reynolds a century before, but seems to have been quite lost sight of by his successors at the Royal Academy Schools. Writing within the context of a lengthy correspondence in the columns of *The Times* in August and September 1886 concerning the reform of the Academy, an 'R.A. Gold Medallist' (as he signed himself) considered the teaching at the R.A. Schools to be '. . . lamentably inefficient. . . . I never met an Academy student who does not say that he stops in the Academy Schools because he cannot leave them for Paris. I have never met an Academy student who, having left the Academy Schools for the French, did not strenuously advise others to do the same.'[1] Some indication of how lackadaisical the Academy had become in its administration of the Schools is given by the fact that the post of Professor of Painting had been left vacant from 1852 to 1867. When Poynter became Director of the South Kensington Schools in 1874 and, by virtue of his office, supervisor of the chief provincial art schools, he revived a stagnant curriculum by the introduction of French methods.

But Poynter, who became an R.A. in 1876, had a limited comprehension of contemporary French painting, and in the preface to the fourth edition of his *Lectures on Art*, which appeared a year after he was elected President of the Academy in 1896, his attitude towards the Impressionists was inflexibly hostile and contemptuous, for he writes: 'I believe . . . on . . . impressing on young students the importance of studying the works of the great masters of the past, . . . in spite of, or rather should I say, because of the strange tendency of the day among a certain class of painters to neglect the study of form, in favour of so-called impressions, hastily, and more or less dextrously, thrown on canvas. How much of this is due to the belief that the technique of the brush or palette knife is the sole end of art, and how much to the convenience of shirking the labour and difficulties of the study of form would be thought, no doubt, invidious to enquire; . . . nevertheless, . . . there is a very present danger for young students.' And he goes on to castigate the 'clique of self-styled "Impres-

[1] *The Times*, 23 Aug. 1886, 12. Letter dated 20 Aug. 1886.

sionists" and their apologists in the Press' for 'their incompetency in drawing and slovenliness in execution'.

Obviously Poynter, and many like him, had no real understanding of what the Impressionists were trying to do; in his eyes they were either simply incompetent or downright dishonest. On the other hand, it is clear that by 1897 there was a body of more or less informed critical opinion willing to defend the Impressionists, including men like R. A. M. Stevenson, Richard Muther (whose scholarly three-volume *History of Modern Painting* had been published in translation in 1895 and contained the first account in English of the Impressionist movement), D. S. MacColl, George Moore, Frank Rutter, and a little later, Roger Fry. Their attitudes were neither entirely homogeneous nor free from prejudice.

Alphonse Legros, who had been in England since 1863, succeeded Poynter as Slade Professor and remained Principal of the School for sixteen years, from 1876 to 1892. His appointment had been supported by Poynter in the face of strong opposition, for it was thought that only an Englishman of suitable qualifications should fill so important a post. Legros, the friend of Manet, Fantin-Latour, Courbet, and Degas during the 1860s, does not seem to have been able to interest dealers and wealthy collectors in the Impressionists beyond persuading Constantine Alexander Ionides to buy one of the versions of Degas's *Ballet de Robert le diable* (Victoria and Albert Museum) in June 1881.[1] However, he probably encouraged his students to go to Paris, where many of them would have seen Impressionist exhibitions and met French artists. He had himself exhibited at the Second Impressionist Exhibition of 1876, but by the early 1880s seems to have lost touch with the Impressionists and was even regarded by them as a harmful influence. Camille Pissarro in June and July 1883 repeatedly cautions his son Lucien, a prospective Slade School student, against following Legros's teaching: 'I want you to be protected against Legros,

1 Ronald Pickvance, 'Degas's Dancers: 1872–6', *Burl. Mag.* CV (1963), 266. Pickvance has established that the first British collector to purchase a Degas was Louis Huth, who in December 1872, acquired *La Leçon de danse* (Lemoisne 298, Louvre) from Paul Durand-Ruel. The only other noteworthy collector of works by Degas during the 1870s was Captain Henry Hill of Brighton, who owned six which were sold seven years after his death in 1889.

he has lost sight of so much that he once did here, or so I am told'—
and again: '. . . I fear Legros has a *preconceived method.*'[1] The some-
what austere linear style of Legros's later work, with its hard,
cool tonalities, would certainly have been antipathetic to Pissarro,
who would also have disapproved of Legros's practice of painting
in the studio. As late as November 1890, in reply to one of his
son's letters, Camille remarks, 'I am happy to hear that you have
found friends worthy of you, but it is strange that the young Eng-
lish artists are so ignorant of the Impressionists.'[2] Strange indeed
when one considers that, from Manet's visit to London in 1868
up to the comprehensive Impressionist exhibition of 315 paintings
organized by the Parisian dealer Paul Durand-Ruel at the Grafton
Gallery in January 1905, the British public had been given many
opportunities of studying the work of the Impressionists either in
group shows or individually. Twenty works by Monet had been
shown at the Goupil Gallery in 1889, and Durand-Ruel had earlier
unsuccessfully tried to run a London branch of his gallery at
168 New Bond Street for five years from December 1870 to 1875,
where he showed ten 'annual' exhibitions of the Society of French
Artists, as he styled it, the Committee of Honour of which con-
sisted of many of the most gifted French artists of the day, includ-
ing, after 1872, the name of Legros.[3] An almost total lack of
support forced Durand-Ruel to abandon his London project, and
not until 1882 did he again attempt to promote the Impressionists
with a small exhibition at a gallery in King Street, St. James's,
followed by a much larger exhibition held at Dowdeswell's Gal-
leries from April to July 1883 consisting of sixty-five works by

[1] John Rewald (ed.), *Camille Pissarro: Letters to his son Lucien* (1943), 35, 39,
French edn. (1950), 49, 58. These adverse opinions seem to have been shared by both
Degas and Monet.

[2] Ibid. 140; French edn. (1950), 192.

[3] Douglas Cooper, *The Courtauld Collection* (1954), 21-8, for details of these and
subsequent exhibitions and English critical reactions to them. I am also indebted to
this author in a more general way for his pioneer work in charting the fortunes of the
Impressionists in England. Pickvance, loc. cit., notes that Charles W. Deschamps,
Durand-Ruel's secretary at the London branch, continued the series of annual ex-
hibitions until April 1876, having become director of the tenth and eleventh exhibi-
tions in 1875. In 1876 he renamed the gallery after himself. The twelfth exhibition he
called 'Pictures of Modern French Artists'.

Degas, Manet, Monet, Pissarro, Renoir, Sisley, Boudin, Mary Cassatt, Berthe Morisot, and John Lewis Brown. It achieved a *succès de scandale* and was reviewed in most of the leading newspapers and magazines. *The Times*, the *Morning Post*, *Punch*, and *Illustrated London News* were predictably antagonistic and derisive, but a substantial number of critics were genuinely anxious to understand Impressionism, if not to welcome its artists wholeheartedly, and some were perceptive enough to recognize that Monet was the strongest of the landscapists. But Victorian England was wedded to the subject picture, the figure piece—hence the artists whom the critics most admired were Manet, Renoir, and above all Degas. This should not surprise us when we recall the derision with which the public greeted the work of Constable and the more daring atmospheric paintings by Turner. Furthermore, the figure pieces and portraits by Whistler had accustomed, if not reconciled the public to a more austere style of painting, and directed their attention to the more formal elements of composition, line, colour, and tone. Even so, Monet, the most consistent exponent of Impressionism and the artist destined to carry the process of analytical observation of light and colour further than any of his contemporaries, presented the greatest challenge both to French and English public opinion.

Monet also had an unsuccessful one-man exhibition at Durand-Ruel's new gallery in the Boulevard de la Madeleine in March 1883, echoes of which reached the London *Art Journal* through the anonymous writer of their Paris letter in the April number, when he wrote: 'we much prefer . . . the curious assemblage of canvases, painted with plenty of spirit and energy, by Claude Monet. This collection may not please every one, and certain people accuse them of *impressionisme*—as if that were something of which to be ashamed. Yet nevertheless they are excellent in treatment, with much feeling, and combine fresh and original talents with an artistic temperament of the first order. There are fifty-six pictures, . . .' The same reviewer in the May issue spoke warmly and perceptively of Renoir's exhibition, saying 'M. Renoir is in portrait-painting what M. Monet is in landscape. Both exert themselves to the utmost to catch the most fugitive aspects of nature, and to

fix on canvas the varieties of light and shade in foliage, in dress, or in the painting of flesh. To obtain these effects, M. Renoir brings . . . a great richness of colour, and a free yet precise touch in painting.'[1] The writer seems only to have been misled as to the financial success of these exhibitions, well-attended though they were.

Two English painters, Philip Wilson Steer and Walter Richard Sickert, both born in 1860, responded to French Impressionism in very different ways but were undoubted leaders of the new genera- tion of lively-minded artists who looked to France for inspiration. Both men were artist's sons but in almost all other respects were quite dissimilar characters. Steer had a conventional English back- ground and upbringing, first in Birkenhead, then in Herefordshire, whereas Sickert came of mixed Danish and Anglo-Irish descent, was born in Munich, and settled with his family in London in 1868, having stayed at Dieppe for several months *en route*. Thus the seeds of Sickert's cosmopolitan outlook were sown early in childhood, and after his school and university education (at King's College, London) were completed, he decided to try his luck on the stage and toured with Henry Irving and Mrs. Kendal. He never got beyond minor parts and abandoned the theatre in 1881 to enter the Slade School. He also worked for a time under the Frankfurt- born painter, Otto Scholderer, a friend of Fantin-Latour and of Sickert's father, Oswald Adalbert Sickert.[2] Scholderer, who ap- pears in Fantin-Latour's group portrait *Un Atelier aux Batignolles* of 1870, along with Manet, Renoir, Astruc, Zola, Maître, Bazille, and Monet, had come to London at the age of thirty-seven in 1871.

However, his roots were in the tradition of Courbet, whose work had so deeply impressed German artists of Scholderer's generation—particularly Wilhelm Leibl and Hans Thoma—and the sombre tonalities and objective approach of these men may

[1] *Art Journal* (Apr. 1883), 131; ibid. (May 1883), 167.
[2] Scholderer was then living at Putney; his son, the late Dr. Victor Scholderer, confirmed that the two men were great friends during the 1880s, and Scholderer's head-and-shoulders portrait of Oswald Sickert was presented to the Kunsthalle, Hamburg (No. 1445), by Walter Sickert in 1926 (letter from Dr. Scholderer to the author, 7 July 1963).

well have found a sympathetic echo in Sickert's style of the late 1880s. It has often been remarked that Sickert never lost his love of acting a part, of adopting disguises at whim, of walking into art societies and abruptly walking out again after a few weeks' or months' membership. Steer, by contrast, after exhibiting at the R.A. from 1883 to 1885, became a loyal, lifelong member of the New English Art Club in 1886. Steer also made a false start, and had tried for a post in the Department of Coins and Medals at the British Museum, but found the academic requirements for the Civil Service beyond him, and in 1878 began studying under John Kemp at the Gloucester School of Art, where he obtained a second-class certificate in perspective drawing from the South Kensington Schools. Having failed to gain admission to the R.A. Schools, he went to Paris and entered the Académie Julian in October 1882, working under Bouguereau, where he progressed sufficiently to be admitted to the École des Beaux-Arts in the following year and trained under Cabanel. At both the Académie Julian and the École he mixed exclusively with English and Scottish fellow students, but in 1884 his Paris training was cut short when he failed a newly-introduced French-language examination in history and other subjects. It is an indication of the popularity of this institution with foreign students, predominantly British and American, that the authorities felt it necessary to sift them out in this way. Sickert, it should be noted, was a fluent linguist. Steer returned to London, but between 1887 and 1891 visited France on no fewer than four occasions; after this, with the exception of a visit to Montreuil-sur-Mer and Paris in 1907, he confined his summer painting expeditions to Welsh and English resorts.[1] After 1895, his work became progressively less audacious.

Steer does not seem to have come into contact with any of the Impressionist painters while in Paris, but it is known that he saw the Manet memorial exhibition held at the École des Beaux-Arts in 1884, and confessed to being 'partly puzzled',[2] perhaps because

[1] Bruce Laughton, *Philip Wilson Steer* (1971), 58–60, has suggested that Steer may have visited Paris again in April–May 1894 when he might have seen the Manet exhibition at Durand-Ruel.

[2] D. S. MacColl, *The Work and Setting of P. Wilson Steer* (1945), 24–5.

the artist's work was unfamiliar to him—though its impact may consequently have been all the greater—or perhaps because he had for the first time seen the full range of Manet's development. Other British artists in Paris at about the same time as Steer were Fred Brown, in 1883, later to succeed Legros at the Slade School; John Lavery, who studied under Bouguereau in 1881, and in 1882 exhibited a small canvas at the Salon which was hung on the line next to Manet's *Un Bar aux Folies-Bergère*;[1] W. J. Laidlay, later the guarantor of the New English Art Club, who had arrived in about 1880 with James Christie and Edward Stott; and Sickert.

Sickert had become the pupil and studio assistant to Whistler, who in the spring of 1883 sent Sickert on his first visit to Paris as guard for Whistler's *Portrait of his Mother*. He provided Sickert with letters of introduction to Manet, who was too ill to receive him, and to Degas. This meeting with Degas began a lifelong friendship, profoundly influenced Sickert's own work, and helped to mould English artistic taste over the next twenty-five years or so. Sickert became a passionate and persistent advocate of Degas, and his purchases of at least four examples of the Frenchman's work between 1889 and 1895 were, with those of Louis Huth and Captain Henry Hill over a decade earlier, among the first to be made by Englishmen.[2] These included such important items as *Répétition d'un ballet sur la scène* (1873, Metropolitan Museum, New York) and *Femme à la fenêtre* (Courtauld Collection). The next meeting with Degas took place at Dieppe in the summer of 1885, when Sickert was the guest of Jacques-Émile Blanche. A pastel by Degas shows Sickert in company with Daniel and Ludovic Halévy, Gervex, Boulanger-Cavé, and Degas, and this visit marks the beginning of the popularity of Dieppe as an Anglo-French artistic centre which continued until the First World War and after.

Sickert's early work is unequivocally Whistlerian, both in technique and subject matter. One of his earliest works, a small

[1] John Lavery, *The Life of a Painter* (1940), 51. Lavery appears not to have been particularly enthusiastic about this or any of the other Impressionist paintings he saw.
[2] Douglas Cooper, op. cit. 31, 61, also discusses other Impressionist works in English collections at this time.

panel, *On the Sands, St. Ives* (Hon. Christopher McLaren), painted in the winter of 1883 while he was staying with Whistler in Cornwall, is a composition schematically divided into three horizontal bands, with a high skyline and clear, though restrained colour, still a little awkwardly manipulated. *The Laundry Shop, Dieppe*, 1885 (Leeds), is a narrow, more complex composition showing greater fluency of brushwork, but still predominantly *à la* Whistler. In 1887, at the invitation of Willie Finch, Sickert exhibited with the recently established *Société des Vingt (Les XX)* at Brussels, a group of twenty young artists either Belgian or resident in Belgium, whose programme was to promote yearly exhibitions of independent, new, and unconventional art to which the twenty members with an equal number of guests from abroad could contribute. At their first exhibition in 1884, the Society had invited Rodin, Whistler, William Stott, William M. Chase, and Sargent; in 1886 Monet, Renoir, Redon, and Monticelli sent works; and a year later Seurat was asked to exhibit among other things his by then notorious *Île de la Grande Jatte*.[1] To this enterprising society Steer sent five works in 1889 and nine in 1891; probably the only occasions on which he supported a foreign exhibiting body.[2]

Steer's solidly constructed and conscientious early work such as *What of the War?*, 1882 (Tate Gallery), gives little hint of the adventurous palette and exciting technique of the late 1880s. *Fisher Children, Étaples* (Fitzwilliam Museum) and *The Bridge* [Tate Gallery; plate 5A], both of 1887, show the liberating effect of his Paris training, yet above all reflect the pervasive influence of Whistler, whose work Steer greatly admired at this time, until Whistler ceased to exhibit with the New English in 1889. In these Étaples paintings Steer is already beginning to analyse the colours of shadows, and he uses mauve for those cast by the figures and the boat on the sandy beach in the *Fisher Children*, while in *The Bridge* he attempts a contre-jour effect. *The Bridge*, incidentally,

[1] John Rewald, *Post-Impressionism : From Van Gogh to Gauguin* (New York, 1956), 101 ff.

[2] Bruce Laughton, 'The British and American Contribution to Les XX, 1884–93', *Apollo*, LXXXVI (Nov. 1967), 372–9.

was stigmatized by the critic of the *Daily Telegraph* as 'Either a deliberate daub or so much mere midsummer madness'.[1]

After a difficult first two years, the New English Art Club had settled down as a serious rival to the Royal Academy. It was to become the liveliest exhibiting society in England during the 1890s, and its members were regarded as the modern wing of British painting. Laidlay, the wealthy barrister turned painter who guaranteed the rent of the Club for the first two years, recalled that it 'was the outcome of a movement or feeling expressed at divers little meetings held in Paris and London between the years 1880 and 1886, with a view to protesting against the narrowness of the Royal Academy and to obtaining fuller recognition for the work of English artists who had studied in France'.[2] An alternative title, The Society of Anglo-French Painters, had also been proposed at the first committee meeting held 4 January 1886, and many of the leading members, including Sargent, Brown, Laidlay, Christie, T. B. Kennington, George Clausen, Herbert La Thangue, Henry Scott Tuke, and Stanhope Forbes, had been trained in Paris, and their styles bore traces of French ideas. To emphasize the French connection would also defiantly challenge the English tradition associated with the Royal Academy. But the New English was not launched without some dissensions and counter-plots. By the summer of 1886, with one exhibition to its credit but still financially weak, the Club was nearly wrecked by an over-ambitious scheme which made its first appearance in the form of a letter to *The Times* on 7 August where the foundation of a National Exhibition of Art was advocated. The signatories were a curiously assorted band: George Clausen, Walter Crane, and Holman Hunt, of whom only Clausen had exhibited at the New English's first exhibition in the previous April. After a long and acrimonious exchange in which some harsh blows were dealt to the Academy, the original three men produced a programme for their National Exhibition on 15 September, naming the sculptor

[1] *Daily Telegraph*, 30 Apr. 1888, quoted by MacColl, op. cit. 26. Laughton, *Steer*, 12–13, considers the Tate painting to have been painted at Walberswick, not Étaples.

[2] W. J. Laidlay, *The Origin and First Two Years of the New English Art Club* (1907), 3; Alfred Thornton, *Fifty Years of the New English Art Club 1886–1935* (privately printed, 1935), 3.

James Havard Thomas as temporary Honorary Secretary. The scheme was quite impracticable and fell through, but it emphasizes that the mood was primarily one of revolt against the Academy rather than a wholesale conversion of the younger artists to Impressionism; and once again French artists had already taken the lead against the tyranny of Salon juries by forming their Société des Artistes Indépendants in 1884.

The Club's formal inauguration took place on 22 April 1886 and the constitution and rules, drafted by Brown with the aid of Thomas Cooper Gotch and Kennington, were approved. The chief innovation was the adoption of a system which permitted the exhibitors as well as members annually to elect the selection jury, before whom both members' and outsiders' work would be submitted. The mildly couched statement of intention in the preface to the catalogue of the Club's first exhibition markedly differs from the inflammatory style of manifestos put out by Wyndham Lewis and his associates over twenty-five years later. We are politely informed that 'This Club consists of some 50 Members, who are all more or less united in their art sympathies. They have associated themselves together with the view of holding an Annual Exhibition, hoping that a collective display of their works, which has hitherto been impossible, will prove not only of interest to the public, but will better explain the aim and method of their art.' There is hardly a hint of the deeply-rooted antagonism which was beginning to harden against the Royal Academy among younger artists, and the absence of polemic may well have been a sop to the more moderate voices in the Club. It is surely significant that, of the forty-three painters and one sculptor who contributed to this first exhibition, fourteen later became Royal Academicians or Associates, and of the fifty-three newcomers in 1887, six became R.A.s and one, William Llewellyn, President of the Royal Academy. The exhibits at the first New English were headed by Steer's *Andante*, a girl with a violin and two other figures, a picture which he afterwards destroyed, but as we look down the list now only a few names evoke an immediate response. Maurice Greiffenhagen sent in an illustration to *Hamlet, Laertes and Ophelia*; Sargent contributed *A Study* and a *Portrait of Mrs Barnard* (Tate

Gallery), Edward Stott a pastoral, Arthur Hacker *The Cradle Song*; from the Newlyn School group were Stanhope Forbes's two Cornish subjects, two works by Henry Scott Tuke, one of which was apparently priced at 200 guineas, and Frank Bramley showed *A Fisherman's Head*.[1] There were fifty-eight pictures and two sculptures (by Havard Thomas) in this first exhibition, which received quite favourable notices. One of the outstanding works was Fred Brown's *Hard Times* [plate 5B], bought for £60 by the Walker Art Gallery, Liverpool, when it was shown at the Liverpool Autumn Exhibition.[2] This, and Brown's '*Waiting*', were in a sober realist vein probably influenced by such works as Legros's *Le Repas des pauvres*, 1877 (Tate Gallery) and the social comment of Frank Holl and Luke Fildes. In style, they owed much to the tonal painting of Whistler and the French school. Clausen sent one work, *A Shepherdess*. One must remember that Clausen (born 1852) and Sargent (born 1856) were slightly older than most of the members of the New English, and that the Club had been formed around the dominant group of Newlyn School painters; by 1889, however, two newer and more powerful groups, the Glasgow School, including George Henry, Joseph Crawhall, John Lavery, and James Guthrie, and the London Impressionists under Sickert's leadership, began to take control. These factions each had rather different ideas about modern French painting, and in the crucial years between 1886 and 1895 we can see how the younger generation of British painters, although willing to break with tradition, were side-tracked to a considerable degree from the more progressive developments of French art. Yet there was at least one Scottish painter, William McTaggart, who developed his own impressionistic style independently of either the London-based painters or the Glasgow School, for he was trained in Edin-

[1] Annotated catalogue of the first N.E.A.C. exhibition in the V. & A. Library. The highest recorded price is 300 guineas for W. H. Bartlett's *Venturesome*.

[2] Thornton, op. cit. 4, says that eighty-one pictures were exhibited, whereas only fifty-eight are actually listed in the catalogue. He also states that Brown's picture was bought direct from the N.E.A.C., but letter books in the Walker Art Gallery record that the Curator, Charles Dyall, wrote to Brown on 23 November 1886 asking him to accept an offer of £60, £20 less than the catalogue price (from information conveyed to the author by Mr. John Jacob).

burgh where he worked primarily as a portrait painter until
he moved to the country in 1888. There he concentrated on land-
scapes and seascapes, often painting out of doors, and his work of
the late 1880s and 1890s has an extremely free, painterly style, of
which *Dawn at Sea—Homewards*, 1891 (Glasgow Art Gallery), is
a fine example.[1] Very different in style, but no less striking, are
the early paintings by the Glasgow-trained George Henry, whose
Galloway Landscape, 1889 (Glasgow Art Gallery), with its broadly
painted forms and almost Gauguin-like rhythmical composition,
created a stir when shown first at the Glasgow Institute in 1890 and
shortly afterwards at the Munich International Exhibition.

George Clausen was typical of the conservative wing of the New
English. He had sent regularly to the Academy since 1876, and
relinquished his connection with the Club after 1895, the year in
which he was elected an A.R.A. He soon won official acclaim and
was Professor of Painting from 1903 to 1906, an R.A. in 1908,
and knighted in 1927, dying in 1944 at the age of ninety-two.
Clausen was less faithful to the Impressionist style than the more
gifted American-born William Mark Fisher, who became a mem-
ber of the New English in 1887 and was eleven years his senior,
but many people came to regard Clausen as the doyen of the
plein air tradition in British art, producing an agreeably anglicized
version of 'Impressionism'. Just what this meant in 1889 is clear
from Clausen's *Girl at the Gate* [Tate Gallery; plate 6B], and we
need only compare this picture with Jules Bastien-Lepage's *The
Potato Gatherers* of 1879 to see how closely Clausen followed in the
steps of this 'Bouguereau of naturalism', as he was once called by
Degas. In both works there is the same even, grey-green tonality,
the same attention to detail, and, unfortunately, the same sap-
ping sentimentality. Admittedly, in a letter to J. B. Manson of
23 February 1935, Clausen wrote of his picture that 'it is not one
which I should choose to represent my work now', and he refused

[1] McTaggart's son-in-law and biographer, James Caw, in 1917 does not mention
the French Impressionists as an influence on his work and there is no direct evidence
that McTaggart knew of them. Caw does record that McTaggart was in Paris in 1860,
and again in April 1876 and 1882. It was at least feasible for him to have seen the
second, if not the seventh Impressionist Exhibition, and had he gone to the 1882
Salon he would have seen Manet's *Un Bar aux Folies-Bergère*.

to allow any work earlier than 1904 to be reproduced in a mono-graph published in 1923.[1] It is only fair to add that his style had changed considerably during the early 1900s, when detailed realism gave place to a more monumental, less particularized type of composition similar in many ways to the grand peasant themes of J. F. Millet in the 1850s. Clausen's early work takes on a new significance in this context, as do his remarks about Bastien-Lepage at this time and at the turn of the century. His *Royal Academy Lectures on Painting* of 1904, especially those 'On Landscape and Open-Air Painting' and 'On Realism and Impressionism', display a curious sense of values. He is full of praise for the great inventive-ness of Millet yet can still write: 'If we compare his work with that of Bastien-Lepage, the greatest of those who have been in-spired by him [i.e. Millet], we find Millet still the master, though Bastien, as a painter, was incomparably more able and skilful. Bastien painted the same kind of subjects . . . Not, like Millet, letting everything go for the sake of the expression, but painting for the sake of giving the true effect of people in the open air, with the light and actual colour of nature; . . . this became the dominant motive, and he has done this more beautifully than any other.'[2]

In an earlier essay on Bastien-Lepage, published in the memorial volume of 1892 edited by André Theuriet, Clausen discusses the new awareness on the part of artists 'that a picture should be the record of something seen, of some impression felt, rather than be formally constructed. And men have awakened at length to see that all nature is beautiful, that all light is beautiful, and that there is colour everywhere . . .'[3] The men whom he considers to have brought about this revolution were, significantly, the Pre-Raphael-ites, J. F. Millet, Corot, Rousseau, Courbet, Manet, and Whistler; there is no mention of Monet, Degas, or Pissarro. When defining the limitations of Bastien-Lepage's art, Clausen rightly observes that 'He did not care for the strong oppositions of light and shadow,

[1] Letter in the T.G. archives.

[2] George Clausen, *Royal Academy Lectures on Painting* (collected edn. 1913), ch. V, 106–7.

[3] André Theuriet, *Jules Bastien-Lepage and his Art. A Memoir* (1892), 112.

and seems almost to have avoided those aspects of nature which depend for their beauty on the changes and contrasts of atmosphere and light. All that side of nature which depends on memory for its realization was left untouched by him, . . .'[1] And he endorses an observation in Sickert's much more critical essay on 'Modern Realism in Painting' in the same volume, to the effect that 'To begin with, it was thought meritorious, and conducive of truth, and in every way manly and estimable, for the painter to take a large canvas out into the fields and to execute his final picture in hourly *tête à tête* with nature. This practice at once restricts the limits of your possible choice of subject. The sun moves too quickly. You find that grey weather is more possible, and end by never working in any other. Grouping with any approach to naturalness is found to be impossible. You find that you had better confine your compositions to a single figure. And with a little experience the photo-realist finds, if he be wise, that that single figure had better be in repose.'[2] Earlier in the same essay Sickert had quoted with approval Millet's dictum: 'La nature ne pose pas', and he considered Degas to be the true heir to Millet, choosing the theatre instead of the fields for his subjects. In his view, Bastien-Lepage was a meritorious workman rather than an inspired executant, and he ends his essay with the challenge: 'if, in league with the modern gigantic conspiracy of toleration, we are to speak of Bastien-Lepage as a master, what terms are left us for Keene and Millet, for Whistler and Degas?'[3]

The London Impressionists, already mentioned as a powerful element within the New English Art Club, took their name from an exhibition organized by Sickert at the Goupil Gallery in December 1889, to the catalogue of which he contributed a foreword defining Impressionism. MacColl recalled how, when Sickert was interviewed before the exhibition opened and asked what an Impressionist was, he replied, 'I don't know, it is a name they will give us in the papers.'[4] Certainly Sickert's definition of Impressionism, or rather of what it was not, comes closest to Whistlerian teaching. 'Essentially and firstly,' wrote Sickert, 'it is not realism.

[1] Ibid. 124.　　　　　　　[2] Ibid. 139.　　　　　　　[3] Ibid. 143.
[4] MacColl, *The Work . . . of P. Wilson Steer*, 31.

It has no wish to record anything merely because it exists. It is not occupied in a struggle to make intensely real and solid the sordid or superficial details of the subject it selects. It accepts, as the aim of the picture, what Edgar Allan Poe asserts to be the sole legitimate province of the·poem, beauty.' Among the artists whom he named with approval were Corot, Millet, Turner, Degas, and Whistler. The omissions are again revealing; no reference to Manet, Monet, or Pissarro, and yet Monet had shown twenty of his paintings at the Goupil Gallery in the spring of 1889. A patronizing reviewer in the *Magazine of Art* concluded from Sickert's preface that 'It is, in fact, no paradox to say that Impressionism is not to be distinguished in essentials from Pre-Raphaelitism'.[1] Monet was invited to send four works to the R.B.A. winter exhibition of 1887 and included one of his recent Brittany seascapes painted at Belle-Île. Paintings from this series of often stormy coast scenes are remarkable for their superb solidity of construction, and shimmering, translucent atmosphere. R. A. M. Stevenson singled out Monet's *Coast of Belle-Île*, *Bretagne* for special praise in his review of the R.B.A. exhibition: 'When the truths he conveys become more familiar to us in art perhaps they will be perceived more readily in nature, and accepted as an important part of vision.'[2] But Sickert, the most authoritative of the younger painters, deliberately ignored Monet and turned his compatriots' eyes to Whistler and Degas, for whose work he undoubtedly felt greater sympathy. Seventy paintings by the following ten artists were shown at this first and only London Impressionists' exhibition: Sidney Starr, Francis James, George Thomson, Bernhard Sickert (Walter's younger brother), Wilson Steer, Fred Brown, Paul Maitland, the French *émigré* Théodore Roussel, Francis Bate, and Sickert. Of these, Starr, the two Sickerts, Maitland, and Roussel were Whistler followers.

Sickert and Steer were by now on very friendly terms, and a year later painted each other's portraits, both of which are now appropriately in the National Portrait Gallery. Sickert also engraved

[1] *Magazine of Art* (Jan. 1890), xv.
[2] *Pall Mall Gazette* (3 Dec. 1887), quoted by Denys Sutton in a foreword to his edition of Stevenson's *Velasquez* (1962), 15.

Steer's *Knucklebones, Walberswick* [Ipswich; plate 7A], painted in the summers of 1888 and 1889 and one of eight pictures which he sent to the London Impressionists. This oil is most remarkable for its shimmering, atmospheric quality, brilliant colour, and bold informality of composition. Already in this picture can be seen the small broken touches of colour and analysis of tonalities which bring Steer, of all the New English painters, closest to true Impressionism. It may be argued that the shingle beach lent itself to a semi-pointillist technique, and there is a noticeable difference between the fragmented treatment of the pebbles and the broader areas of paint on the children's clothes and limbs. But in later works a more complete homogeneity of treatment soon becomes apparent. During the late 1880s and early 1890s critics consistently compared Steer with Monet, and far less frequently in a pejorative sense than might be thought.[1] Support for this view also comes from Lucien Pissarro, who wrote to his father in May 1891 that Steer 'separates the tones as we do and is very intelligent—in a word, an artist'.[2] Lucien Pissarro had just given a short paper on Impressionism to members of the New English, a club, he noted, 'composed in part of more or less official artists; there are even R.A.s'. The younger men were to be considered English impressionists, though 'they talked of the subject as Englishmen who knew not the first thing about Impressionism, young men who paint smoothly and have black on their palette'. Steer confided to Pissarro that he was hesitant because the other painters mocked him and did not understand him.[3] He also remarked that he preferred Camille Pissarro's paintings to those of Monet, but this may have been politeness on Steer's part, although MacColl rightly saw some pointillist influence in his work of 1893. Pissarro had been experimenting with Seurat's technique for several years past and may have been briefly instrumental through his paintings in forming Steer's style. MacColl, needless to say, abhorred

[1] A comprehensive set of press cuttings relating to N.E.A.C. exhibitions from 1886 onwards is in the T.G. archives.

[2] John Rewald, 'Lucien Pissarro Letters from London 1883–1891', *Burl. Mag.* XCI (1949), 192, for this and the two following quotations.

[3] Steer's fellow artists rated him only moderately—in the N.E.A.C. committee elections of 1888 he was placed fourteenth out of twenty (MacColl, op. cit. 27).

pointillism and regarded it as an artistic aberration of the first mag-
nitude.

Lucien Pissarro also met Sickert at the same time as Steer in
1891, but was quite appalled by Sickert's work, for which he could
only find the adjective 'déplorable!' Sickert's contribution to the
London Impressionists' exhibition probably included the picture
now known as *Joe Haynes and Little Dot Hetherington at the Old
Bedford Music Hall* [plate 7B], *c.* 1888–9 (formerly Robert Em-
mons).[1] His earliest theatre and music-hall interiors date from
three years before, and by his choice of subject no less than by
his treatment of them he shows his allegiance to Degas. He has
adopted the low viewpoint and seat-in-the-stalls position found in
so many Degas oils and pastels, such as *Le Café-Concert, 'Les Am-
bassadeurs'* of *c.* 1877. We see the performers over the heads of the
spectators in front of us, although in this particular composition
Sickert has introduced the complicating factor of a glass screen
or mirror. Like Degas, Sickert leaves details on the periphery of
the composition deliberately unelaborated in order to focus atten-
tion on the chief figure of Dot Hetherington. The general greenish-
brown tonality characteristic of so many of Sickert's compositions
of the early 1890s also appears in this painting.

John Singer Sargent's role in the history of English impres-
sionism is a relatively minor one. He had come to London in
1885, disillusioned by the cool reception accorded his portrait
of Mme Gautreau, which had greatly offended the sitter by its
frankness, and, as a result, blighted Sargent's hopes of a flourishing
society portrait-painting practice in France. Trained in the studio
of Carolus-Duran to construct a picture more by broad masses
than by outline and, probably through Manet's example, attracted
by the bravura techniques of Hals and Velázquez, Sargent was
technically far more accomplished than most of his English con-
temporaries. He first met Monet in Paris some time between 1878
and 1882, but was never a close friend of the Impressionists.[2] One

[1] Wendy Baron, *Sickert* (1973), 304, gives the original, shorter title. She also notes
The Circus, c. 1885, as the first known theatrical work.

[2] Charles M. Mount wrote to the author, 15 May 1963, to correct the usual date of
April 1876 given for this first meeting. Monet's letter to the Hon. Sir Evan Charteris

of the first of his major English pictures was *Carnation, Lily, Lily, Rose* [Tate Gallery; plate 6A] painted in the late summer and autumn of 1885 and completed in October the following year. Struck by the combined effect of Chinese paper lanterns and beds of lilies seen through the trees one summer's evening on the Thames near Pangbourne, Sargent wanted to capture that peculiar mauvish glow he had observed, and with Dorothy and Polly Barnard for models began painting this composition *en plein air* in the garden of Mr. and Mrs. Frank Millet's house at Broadway, Worcestershire. He often scraped off an evening's work and began afresh, but such was the fugitive nature of the twilight effect he wanted, and so ill-adapted was Sargent's technique to the task, that the blossoms faded and were replaced by artificial flowers long before the picture was finished. The situation resembled that of Cézanne rather than Monet before their motifs, although Sargent was attempting a type of subject favoured by the Impressionists and used in this work a fairly typical high-keyed Impressionist palette. Much more successful was his painting of Monet and his future second wife Mme Hoschedé painted at Giverny in the spring of 1888. Done out of doors, it shows Monet at his easel and is entitled *Claude Monet painting at the Edge of a Wood* [Tate Gallery; plate 8A]. Sargent also painted a profile portrait of Monet (National Academy of Design) at this time. Not long previously he had purchased Monet's *Rock at Tréport* and had written to Monet to express warm admiration for his work. The years 1888–90 are the peak period of Impressionist influence on Sargent's work, but in some later landscapes, notably those of 1905–14, traces reappear in modified form. The Impressionists quite liked Sargent as a person, but had little respect for his art; no doubt they felt success as a society portraitist on both sides of the Atlantic had corrupted his finer qualities as an artist.

Plein air painting in the tradition of Bastien-Lepage had first become established in England with the growth of a small colony of artists at the remote Cornish village of Newlyn in the early

(quoted Charteris, *John Singer Sargent* (1927), 130–1) of 1926 in which he recollects his meeting with Sargent cannot be relied on, for Monet was then 85, a sick man and his memory failing.

1880s. The little-known painter Henry Martin had worked in the area since 1873 (a local guide-book records him as having been there as early as 1854), but he seems to have left with the advent of the new group. T. C. Gotch had visited the village for the first time in 1879 and Walter Langley came the following year, but Gotch, whose marriage to Caroline Yates took place at Newlyn in 1881, was still a student, and the first artists actually to settle were Langley in 1882, and Edwin Harris and H. S. Tuke in 1883.[1] These were joined by Stanhope Forbes in 1884, Frank Bramley about a year later, then Norman Garstin, and finally Gotch in 1887. Almost without exception the leading members of the Newlyn School had received part of their training abroad, either under Léon Bonnat, Carolus-Duran, or Jean-Paul Laurens in Paris, or under Verlat at Antwerp—four teachers who had taught a large number of English art students at this period. Harris, Langley, Forbes, and Bramley had visited Pont Aven and other Brittany resorts, and many of the members had known each other from student days. There was never any formal proclamation of aims, and the group received newcomers on personal recommendations alone. It is characteristic of the times that a group of English artists should want to escape from a somewhat artificial metropolitan existence, but in this they were only emulating the artists of the Barbizon School. Cornwall in the 1880s must have been still quite primitive, unspoilt, and akin to Brittany in both its terrain and peasant life; it also had the advantage of being a cheap place in which to live. Two of the better-known works of the Newlyn School are Frank Bramley's *A Hopeless Dawn* [plate 9A] of 1888 and Stanhope Forbes's *The Health of the Bride* [plate 9B] of 1889. The first was purchased by the Chantrey Bequest Trustees, the second by Henry Tate and given to the Tate Gallery. Both are characterized by an honesty of purpose and searching observation; the element of pathos and domestic sentiment com-

[1] Michael Canney, *Introduction to Paintings by the Newlyn School* (exhibition catalogue, Newlyn Society of Artists, Passmore Edwards Art Gallery, Newlyn, 1958), with biographies, outlines the history of the School and its members, and has provided the author with more recent information. See also Michael Braby, 'The Newlyn School: a fresh breeze from Cornwall', *Art & Antiques* (5 May 1973), 21–7.

mon to these and other Newlyn works should not blind us to the passages of extremely fine painting, especially the still life on the wedding-breakfast table in the Forbes, which is plainly reminiscent of the work of Legros and Fantin-Latour. Bramley's sad subject, the mother and daughter waiting in vain for the return of their menfolk after the night's terrible storm at sea, was an all too frequent occurrence in the life of the fishing communities in Cornwall and elsewhere. Forbes also took his theme from real life. The sitters are the artist's own friends whom he painted in his studio, and not professional models, and the setting is the local inn. Soon after completing the picture Forbes celebrated his own marriage to the Canadian painter Elizabeth Armstrong, to whom he had been engaged for three years. But the early ideals of the Newlyn School gradually became corrupted: the picturesque and the sentimental, as well as the fancy-dress medievalism of some of the members' work (Gotch's *Alleluia* (c. 1896, Tate Gallery) painted after his visit to Italy in 1891 is a typical example of this) clogged the springs of originality, so that by the late 1890s Newlyn had become vulgarized by an influx of inferior talents. Forbes and his wife began an art school about 1900, but by then most of the pioneers had left Newlyn. Other art colonies were to spring up in Cornwall, such as those at Falmouth, Lamorna Cove (inseparable from S. J. Lamorna Birch, R.A., who settled there in 1902), St. Ives, and Zennor, of which the two last-named were greatly to exceed Newlyn in importance. The colony at St. Ives does not seem to have come into being before 1885 and was a rather less tightly-knit group than the Newlyn School.

Two interiors by Wilson Steer of 1891 are stylistically far in advance of any Newlyn School work: *Girl on a Sofa* (formerly Mrs. Anne J. Burrell) and *Mrs. Cyprian Williams and her two little Girls* [Tate Gallery; plate 8B], the latter commissioned by the artist Francis James. The model for *Girl on a Sofa* was Rose Pettigrew, who features in several of Steer's paintings of this date, and we have here a most refreshing close-up study of her. The informal pose—she is shown as if asleep—has all the spontaneity of an Impressionist painting, and her cheeks are brushed in with the delicacy of a good Renoir. A similar handling appears also in the

modelling of the faces of the two girls in *Mrs Cyprian Williams*, the composition of which, with its high viewpoint, is quite unusual in British portraiture up to that time. Not even Whistler had used so striking a formal device, although there are prototypes in portraits by Degas, for example the *Carlo Pellegrini*. The elegant, sinuous pose of Mrs. Williams may also betray an undercurrent of Art Nouveau style, just as the cover Steer designed for the catalogue to his first one-man exhibition at the Goupil Gallery in 1894 is more obviously so influenced. Steer's draughtsmanly gifts are well demonstrated by the beautifully fluent outline and firm modelling of Mrs. Williams's right arm and hand, though the hands of the little girls are much more perfunctorily treated, and the vase of flowers in the foreground strikes us as an awkward device to suggest spatial recession.

Steer read a paper on 'Impressionism in Art' to the Art Workers' Guild in 1891. It is not particularly informative, and Steer seems more anxious to stress that Impressionism in art is no new thing and is of no particular nationality, than to attempt the much more difficult task of giving a succinct definition of it. His remark that 'Art is the expression of an impression seen through a personality' smacks more of Émile Zola, whose *L'Œuvre* of 1886 had shown him ignorant of Impressionist aims. On the other hand, Steer rejects the idea that Impressionism is merely a fashion: 'Is there any fashion . . . in painting grass green instead of brown; in making a sky recede and hold its right place in the picture . . . ? Is it a craze that we should recognise the fact that nature is bathed in atmosphere? Is it a fashion to treat a picture so that unity of vision may be achieved by insisting on certain parts more than others? No! it is not fashion, it is *law*.'[1] Theorizing was no part of Steer's temperament, and his intellectual laziness in this respect left him vulnerable to the arguments of his more articulate friends MacColl and Henry Tonks. The myth of the 'holy fool of art' was fostered in later years about the acquiescent, ample shape of Steer, to the detriment of his brilliant artistic intuition.[2]

Among the fruits of this intuitive approach to painting were the

[1] MacColl, *The Work . . . of P. Wilson Steer*, 177.
[2] Andrew Forge, *Wilson Steer*, Arts Council (1962), 11.

remarkable series of beach scenes at Boulogne and Walberswick, and of yachting subjects at Cowes painted between 1891 and 1894. There is complete uniformity of treatment in these works, where the individual strokes of colour tend to have an existence independent of the forms. Common also to many of these outdoor scenes is a quality of drenching sunlight which together with the other stylistic characteristics make Steer one of the most daring English landscape painters of his day. One of the key works is a beach scene at Walberswick, *Children Paddling* [Fitzwilliam Museum, Cambridge; plate 10A], shown at Goupil's in 1894.[1] A comparison with Monet is instructive. Steer applies a kind of shorthand notation for the features and dresses of the two children on the right of the picture, their forms are flat, decorative areas of insubstantial paint. The flecks of white foam make an elegant arabesque on the water, but do not define the space in which the children and the near-by boat are set. Compared with a Brittany coast scene by Monet, where the cliffs and sea, though glittering with light, have such architectural solidity, Steer's painting seems to be less a matter of detailed observation than painterly improvisation. R. A. M. Stevenson sensed this contradictory element when he wrote of Steer in the *Pall Mall Gazette*, 14 April 1895: 'His impressionism has not always appeared natural enough: here the method of suppressing things has seemed more obtrusive than the thing itself; here drawing and modelling of essentials have been queer or inefficient . . . In fact, the style of Mr. Steer's work has often been inconsistent, and has resulted in a mere suggestion of the way he saw things somewhat deformed by obtrusive splashy handling, or by exaggerated hints of expressiveness.' One must always remember that a generation separates Monet and Steer, that Stevenson, in his enthusiasm for the Impressionists, may not have been sufficiently tolerant of any local variation from the canon, and that Steer, coming to maturity in England of the 1890s, could not possibly have had the same outlook as the Impressionists. He took from them what he wanted and was in some respects

[1] The site of *Children Paddling* is usually given as Swanage, but Dr. Bruce Laughton has suggested that the conformation of headland and bay most closely resembles Walberswick.

a pioneer in his own right. His beach scenes have an idyllic air about them, they exude a *fin de siècle* nostalgia which is completely alien to the older French artists' paintings and which, incidentally, does not appear in Steer's 'realist' *Self-Portrait with Model* (Earl of Drogheda), also of 1894 and reproduced in the *Yellow Book*. Here he links momentarily with the tradition of Degas and Sickert, but his style was soon to undergo a fundamental, some might say retrogressive, change, the reasons for which may in part be sought in the wider historical context of the late 1890s in England.

The year 1895 is a crucial one in British art. The Aesthetic Movement lost one of its chief ornaments with the prosecution and imprisonment of Oscar Wilde. Aubrey Beardsley died three years later, a convert to Roman Catholicism, and from his deathbed implored Leonard Smithers to destroy '*all* copies of Lysistrata & bad drawings . . . By all that is holy *all* obscene drawings.'[1] The *Yellow Book* died of respectability and feeble circulation in 1897. George Moore, in a characteristic mood of chauvinism, wrote in 1895 that 'Art has fallen in France, and the New English seems to me like a seed blown over-sea from a ruined garden. It has caught English root, and already English colour and fragrance are in the flower.'[2] The dirge was taken up by MacColl, who condemned neo-impressionism (i.e. Post-Impressionism) in the last section of his survey of *Nineteenth Century Art* published in 1902, and never changed his opinion thereafter. In the same book he had spoken of Turner as one of the two decisive influences on the career of Monet, and although duly respectful of Monet's single-minded genius, ranked him less highly than Degas, a preference endorsed as late as 1932 by Roger Fry in *Characteristics of French Art*. This national-istic interpretation of the Impressionists' overwhelming debt to Turner, Constable, and Bonington was developed at greater length by Wynford Dewhurst in *Impressionist Painting* (1904), and roundly denied by Camille Pissarro in one of his last letters to Lucien of 8 May 1903.[3] However misguided in his historical assessment,

[1] R. A. Walker (ed.), *Letters from Aubrey Beardsley to Leonard Smithers* (1937), Letter CLXXXV. [2] *Modern Painting* (2nd edn. 1898), 211.
[3] John Rewald (ed.), *Camille Pissarro: Letters to his son Lucien* (1943), 355–6; French edn. (1950), 500–1. See also Alan Bowness, *The Impressionists in London* (1973), Introduction.

Dewhurst deserves credit as the first Englishman to attempt a genuinely sympathetic full-length survey of the subject.

There were perhaps other reasons for a recrudescence of nationalism. Wilde symbolized for many Englishmen the moral depravity that they liked to associate with France. John Davidson, in his burlesque novel of the decadence, *Earl Lavender*, published in 1895, makes the point through the words of one of his Cockney characters, Mrs. Scamler: 'It's *fang-de-seeaycle* that does it, my dear, and education, and reading French . . .' By a delicious piece of irony it was a fat yellow bound French paperback novel seen under Wilde's arm at the time of his arrest that was mistakenly identified by the crowd as a copy of the *Yellow Book*. John Lane, publisher of the *Yellow Book*, was abroad at the time but heard ominous reports connecting Wilde with his quarterly and, fearing for his reputation and yielding to pressure from other contributors, sacked Beardsley whose drawings had earned the magazine uncomfortable notoriety.[1] There was no room for decadence in the upsurge of fierce imperialist sentiment best expressed by Rudyard Kipling's *Barrack-room Ballads*: the British were a Chosen People whose duty it was to rule 'the lesser breeds without the law' (Kipling here refers to the Germans)—a concept soon to be shaken by the disasters of the Boer War. It is not surprising that artists should be affected by this, and by 1895 Lucien Pissarro was telling his father that the New English Art Club was showing signs of retrogression: 'Here the old pupils of Julian's, who set themselves up as champions of Impressionism, are without talent and losing ground rapidly, breached by the Vale group, a kind of Neo-PreRaphaelitism . . . You will protest that the sub-Julians have nothing to do with the rest of you. This is a mistake: they are your so-called heirs. Is not Bastien-Lepage the true Impressionist? It is always possible to recognise a movement by its vulgarisers.'[2]

Steer, who was thirty-five in 1895, reached a crisis in his own career and for the next five years groped uncertainly towards a new

[1] Katherine Lyon Mix, *A Study in Yellow* (1960), 141–6, for a full account of the affair.

[2] John Rewald, 'Lucien Pissarro Letters from London, 1883–91', *Burl. Mag.* XCI (1949), 192.

style, making pastiches of Monticelli, of Gainsborough's elegant rococo fancy pieces, of Fragonard and Corot, until by 1900 his landscapes became luminous, grandiose compositions inspired by Constable and Turner, culminating in the *Chepstow Castle* of 1905 [Tate Gallery; plate 10B]. Steer visited many of the sites recorded in Turner's *Liber Studiorum*, a copy of which he is said to have carried round on his travels.[1] Echoes of Turner and Constable abound in this painting, but Steer imposes his personal style, the nervous impasto, the long curling brush-strokes and golden tonality. Trees, river, and castle are bathed in light, but are we not conscious of a certain lack of solidity in basic construction such as we rarely experience before one of the most evanescent of Monet's canvases? At about this period Steer turned increasingly to water-colour painting, itself a traditional English medium, and produced some brilliant work until forced by failing eyesight to cease exhibiting in 1935.

Sickert left for Venice in 1895, and after his divorce in 1899 lived abroad, mainly in Dieppe. He faded from the London art world until his return in 1905. He was more consistent in his development, far less in-bred and much more susceptible to new ideas than Steer, taking from them what suited him and intelligently adapting them. His *St. Mark's, Venice: Pax tibi Marce Evangelista Meus* of 1896–7 [Tate Gallery; plate 11A] is a remarkable exercise within a narrow range of tonalities, but how very different from Monet's high-keyed Venetian paintings. Sickert was much more concerned with the all-over pattern of areas of colour, and in the *Piazza San Marco* [plate 11B] of *c.* 1906 (Laing Art Gallery, Newcastle upon Tyne) with La Giuseppina in the foreground, he rigorously subordinates the modelling of individual forms to this general pattern. Pictorial space is suggested almost exclusively by colour. Sickert's advice to students was to paint *across* forms, not into them.[2] To this extent he followed Degas, but unlike him, Sickert was rarely interested in suggesting movement. French Impressionism was never fully understood by more

[1] Laughton, *Steer* (1971), 89–90, qualifies this assertion by MacColl.
[2] John Rothenstein, *Modern English Painters: Sickert to Smith* (1952), 79, quotes this advice as recalled by Ethel Walker.

than a handful of English artists, critics, and collectors, and even these few preferred Degas to Monet. In 1900 a rich, middle-class English collector of taste was regarded by his equals as *avant-garde* if he collected the work of the Barbizon School, of Anton Mauve and the Maris Brothers. Such a man was epitomized by John Galsworthy in his *Man of Property* (1906), Soames Forsyte. As an envoi to this phase of English art, here is Sickert's sardonic observation: 'The pictures at the New English Art Club are often described as Impressionist, and their painters called Impressionists. This always surprises and amuses French visitors to England. A painter is guided and pushed by his surroundings very much as an actor is, and the atmosphere of English society acting on a gifted group of painters, who had learned what they knew either in Paris or from Paris, has provided a school with aims and qualities altogether different from those of the Impressionists. . . . the Impressionists put themselves out more than we do in England. We all live like gentlemen, and keep gentlemen's hours.'[1] Sickert, by his increasing preoccupation with low-life subject-matter which occasionally carried sordid undertones, was the visual counterpart to his friend George Moore, who in his novel *Esther Waters* (1894) shocked public opinion by frankly treating the life and hardships of an unmarried mother. A new realism in art and literature coexisted with more exotic manifestations.

[1] Walter Sickert, 'The New English and After', *New Age* (2 June 1910), 109–10. But Soames Forsyte's taste undergoes a remarkable transformation in the later *Forsyte Saga* novels; see Léonée Ormond, 'The Soames Forsyte Collection: a study in fictional taste', in *Burl. Mag.* CXIX (Nov. 1977), 752–6.

III

WILLIAM MORRIS
BURNE-JONES, AND SYMBOLISM
THE ROYAL ACADEMY, GENRE
AND PORTRAITURE

WE step into an entirely different world when entering the company of William Morris and his associates. Inspired largely by Ruskin, these men led the most powerful and historically significant counter-movement against the doctrines of Art for Art's sake. Burne-Jones, although he admired certain aspects of Whistler's painting, notably its qualities of fine colour and atmosphere, deplored the lack of finish and detail, of craftsmanship in fact, and this concern with craftsmanship combined with a nostalgia for the illusory glories of medieval chivalry and legend made Burne-Jones an ideal workmate for Morris. The contrast in temperament between dreamy Burne-Jones and the superabundantly energetic, politically conscious Morris could hardly be greater than that between Morris and Whistler. Morris, it is true, began his artistic career in the circle of adherents to Art for Art's sake, but gradually moved to an independent position, unequivocally maintaining that art should be related to use. In his first public lecture on 'The Decorative Arts', given before the Trades' Guild of Learning on 4 December 1877, he said: 'I beg you to remember . . . that nothing can be a work of art which is not useful; that is to say, which does not minister to the body when well under the command of the mind, or which does not amuse, soothe, or elevate the mind in a healthy state.'[1] He emphasized honesty of craftsmanship—hand craftsmanship, that is, for Morris passionately hated the machine civilization which in his eyes was

[1] William Morris, 'The Lesser Arts', lecture reprinted in *Hopes and Fears for Art* (4th edn. 1896), 31.

enslaving the lives of every man, woman, and child in England. It is now axiomatic that his solution to the evils of industrialization, its vulgar designs and sham, synthetic materials, was hopelessly impracticable. Even Morris himself realized that the medieval guild structure was no match for the increasingly centralized machine manufacture, but he could never come to terms with the age in which he lived. His products were far too expensive for the working man and he found himself, as he ruefully admitted, 'serving the swinish luxury of the rich'. Politically, however, he seems to have had a much clearer vision of what socialism should aim at than most of his colleagues, and was prepared to face the consequences of Marxist doctrine, of revolution even, if needs be in his own lifetime.[1] George Bernard Shaw, in a personal reminiscence written nearly forty years after Morris's death, recalled that 'Morris, when he had to define himself politically, called himself a Communist. Very often . . . he had to speak of himself as a Socialist; but he jibbed at it internally and flatly rebelled against such faction labels as Social-democrat and the like.'[2]

In 1870 Morris's firm of Morris, Marshall, Faulkner & Company, 26 Queen's Square, had been producing designs for tapestries, stained glass, wallpapers, glassware, tiles, and furniture for nine years. The partnership of the old firm was dissolved in 1875 and restarted under the name Morris & Company, with Morris in sole control. At this moment, too, he began his experiments in dyeing, under the guidance of Thomas Wardle of Leek, whose brother-in-law, George Wardle, was manager of Morris & Co. It was typical of Morris that he should want to learn for himself as much as possible about all aspects of textile manufacture and to return to the traditional vegetable dyestuffs. In his quest for alternatives to

[1] In addition to books and articles on Morris listed in Boase, O.H.E.A. X, *English Art 1800–1870* (1959), 295, see also Philip Henderson, *The Letters of William Morris to his Family and Friends* (1950), especially the letters to C. E. Maurice (173, 175–8), Andreas Scheu (183–8), Mrs. Burne-Jones (196–200), and the Rev. George Bainton (282–91); also *Morris and Company*, Arts Council (1961).

[2] George Bernard Shaw, 'Morris as I knew him', from May Morris, *William Morris, Artist, Writer, Socialist*, II (1934), ix. Shaw is careful to add that Morris had no 'prevision of Soviet technique or any other developed method of Communist organisation'.

the crudities of aniline dyes in current commercial use he consulted sixteenth and seventeenth-century French herbals, and began to use a limited but pure range of such brilliant permanent colours as indigo blue (notoriously difficult to produce correctly), madder red, kermes red, walnut-root brown, and weld yellow. The bold, simple patterns of some of his Hammersmith carpets, of the *Little Tree* design, for example, are very similar to Oriental prototypes, although he was emphatic that they should be obviously 'the outcome of modern and Western ideas'.[1] His researches were well rewarded, for even today the colours of many of his fabrics retain their original lustre, such as the Kennet pattern printed chintz of 1883 [plate 13B], and some have actually improved with washing and the passage of time.[2] In 1881 he moved his works from Queen's Square to the more salubrious Merton Abbey, once a silk-weaving factory begun by Huguenot refugees, where the clear water of the near-by river Wandle was ideally suited to madder-dyeing. The stained glass produced by Morris & Company was also much superior to the typical Victorian glass, with its realistic painted designs applied to the surface. Morris returned to the purer medieval practice of simple, flat shapes in pure, glowing colours, with leading sensitively placed between individual 'quarries'.

Another aspect of Morris's genius, the literary and poetic, is intimately related to his romantic artist-craftsman's temperament. His keen interest in the myths of Ancient Greece, in Nordic and Celtic folklore (the story of Tristan and Iseult strongly appealed to his imagination), and in English medieval poetry sprang from and supported his belief that nobler and purer civilizations were mirrored in these ancient epics and sagas. Characteristically, Morris went to the primary source whenever possible, and in 1868

[1] J. W. Mackail, *Life of William Morris* (1899), II. 5; May Morris (ed.), *The Collected Works of William Morris* (1915), xxii, 47, etc.; also Pevsner, *Pioneers* (3rd edn. 1960), 49. Mackail, op. cit. I. 294, recalls that the archaeologist and architect, Dr. John Henry Middleton, whom Morris met on his second Icelandic voyage in 1873, advised Morris on oriental art. Middleton became Director of the Fitzwilliam Museum in 1889, and later of the V. & A., from 1892 to 1896.

[2] A sample of this chintz and the preliminary design for it are in the Birmingham Museums and Art Gallery (404 '41 and 405 '41).

began studying Icelandic under the tutorship of Eiríkr Magnússon. The early fruits of these studies were his translations of *The Saga of Gunnlaug Worm-tongue* and *The Story of Grettir the Strong* in 1869, and in 1870 the publication of *The Story of the Volsungs and the Nibelungs*, followed a year later by his first visit to Iceland. Morris's early poem *The Defence of Guenevere* of 1858, dedicated to Rossetti, is a tremendously powerful vision of life in the Middle Ages, inspired to some extent by his avid reading of Chaucer, Malory, and Froissart. Not surprisingly, Morris scorned Tennyson's Arthurian legend poems as pale, academic reconstructions: 'I suppose', he wrote to Mrs. Coronio in October 1872, 'you see that Tennyson is publishing another little lot of Arthurian legend [Gareth and Lynette]. We all know pretty well what it will be; and I confess I don't look forward to it.'[1] Morris's preoccupation with medieval literature is only part of a more general awakening to the qualities of northern mythology. The Brothers Grimm, for example, published their anthology *Kinder- und Hausmärchen* between 1812 and 1815 and the famous *Deutsche Mythologie* in 1835. The *Fairy Tales* of Hans Andersen, the first instalment of which appeared in 1837, influenced, in his choice of subject matter, Richard Wagner, whose great operatic cycle *Der Ring des Nibelungen* took shape between 1852 and 1876, the year in which the complete cycle was first performed at Bayreuth. Wagner's theories on art and music spread far beyond the operatic stage. As the propounder of the ideal of a 'total' work of art, in which music, poetry, and the visual arts of theatrical presentation become inextricably fused into a homogeneous whole, with complete identity of purpose and effect, he was a powerful inspiration to late nineteenth-century painters and poets, and was, with Morris, a formative influence on the whole Art Nouveau movement.[2]

Morris, however, vehemently disliked Wagner, and thanking H. Buxton Forman for a copy of his brother's translation of *Die*

[1] Henderson, op. cit. 49. As an undergraduate, Morris had admired Tennyson's *Maud* (1855).

[2] The *Gesamtkunstwerk* concept has a long history, and the German romantics, particularly Philipp Otto Runge, were deeply interested in its philosophical and practical aspects.

Walküre in November 1873, wrote that 'his [Wagner's] theories on musical matters seem to me as an artist and non-musical man perfectly abhominable [*sic*]: besides I look upon it as nothing short of desecration to bring such a tremendous and world-wide subject [as the 'unspeakable woes of Sigurd'] under the gaslights of an opera: the most rococo and degraded of all forms of art— ... Excuse my heat, but I wish to see Wagner uprooted, however clever he may be, and I don't doubt he is.'[1] Wagner visited London in 1877 to conduct at a three-day festival of his music, organized by Hans Richter, at the Albert Hall (a building recently completed in 1871). This was the earliest introduction to England of Wagner's mature work (the *Ring* was not performed in London until 1882), and although the Burne-Joneses attended these concerts and became acquainted with Cosima Wagner, it is most unlikely that Morris accompanied them.

The romantic medievalism of Morris and Burne-Jones is epitomized in the series of four large canvases illustrating the *Legend of the Briar Rose*, or *Roman de la Rose*, which Burne-Jones painted between 1871 and 1890, and which were exhibited at Agnew's in April–May 1890. Each episode was inspired by lines written by Morris which read in sequence from left to right: 'The fateful slumber floats and flows ...', 'The threat of war, the hope of peace ...' [plate 12], 'The maiden pleasance of the land ...', and 'Here lies the hoarded love. This sleeping world awake.' Morris afterwards wrote another four-line verse which, with the first, was published in his volume of *Poems by the Way*.[2] At the close of the exhibition, the paintings were bought by Alexander Henderson (later the first Lord Faringdon) and installed in the drawing-room at Buscot Park, not far from Kelmscott Manor, with additional decorative panels painted *in situ* to fill the spaces between each canvas. Morris's verse is carved into the lower part of the gilt frame, which is in an Italian Renaissance style and thus blends the medieval story of knight errantry with the late eighteenth-century

[1] Henderson, op. cit. 60-1.

[2] Georgiana Burne-Jones, *Memorials of Edward Burne-Jones*, II (1904), 29, 141, 145, 204–6, for a history of the murals and the verse. According to the Agnew exhibition catalogue, the paintings were commissioned by William Graham, but Lady Burne-Jones states that Graham arranged for Agnew's to purchase the set.

architecture of the house. These paintings exude an air of wistful nostalgia, of yearning for an unattainable state of perfection which seems symbolic of the aspirations of both men. If this should seem too fanciful, we have Burne-Jones's own words written to a friend: 'I mean by a picture a beautiful romantic dream of something that never was, never will be in a light better than any light that ever shone—in a land no one can define or remember, only desire . . .'[1] It is characteristic too, that Burne-Jones should invent his own designs for the armour of the Lover, which in its exotic style looks forward to the Art Nouveau extravagances of Alfred Gilbert's *St. George* panel for the Duke of Clarence memorial, Albert Memorial Chapel, Windsor, of 1892–6. Burne-Jones met Gilbert for the first time in 1884, during the summer and autumn of which year he was working hard on the *Briar Rose*.[2] There are echoes of Mantegna's severe classicism and of Piero di Cosimo's strange mythological world in these and many other paintings by Burne-Jones, but the muted, silver-grey tonalities and unearthly pallor of the typical Burne-Jones idealized female are personal glosses on an earlier tradition. The *Briar Rose* is one of the few surviving decorative schemes of the period. Burne-Jones executed many designs for Morris & Company, including eighty-seven woodcut illustrations to the magnificent folio edition of *The Works of Geoffrey Chaucer* begun in 1892 and published by the Kelmscott Press in June 1896 [plate 14]. The illustrations, incidentally, were cut into the wooden blocks by W. H. Hooper to designs by Burne-Jones, whilst Morris designed all the initial letters and decorative borders surrounding the text.[3] It was bound by Douglas

1 Julia Cartwright, 'The Garden of Hesperides' [by B.-J.], *Art Journal*, New Series (1900), 94.

2 Lady Burne-Jones, op. cit. 145–6, recalls that 'endless studies of armour' were made from the collection of Sir Coutts Lindsay in 1884, but Burne-Jones also designed, with the help of W. A. S. Benson, many pieces 'expressly in order to lift them out of association with any historical time'. Benson designed and made the king's crown in Burne-Jones's *King Cophetua and the Beggar Maid* (T. G.; pl. 13A).

3 Cosmo Monkhouse, *Exhibition of Drawings and Studies by Sir Edward Burne-Jones, Bart.* (1899), 54–5, gives a check-list of Kelmscott Press publications illustrated by Burne-Jones; see also Mackail, *Life*, II, 274, 306, 321, 325–6 for particulars of the Kelmscott *Chaucer*. Burne-Jones's original pencil drawings were redrawn in ink, under his strict supervision, by Robert Catterson-Smith and, in a few cases, by Charles

Cockerell in white pigskin with silver clasps at T. J. Cobden-Sanderson's bindery. The actual printing had taken twenty-one months, and the roughened hand-made paper was of the highest quality obtainable. The Chaucer was the last and the most ambitious of all Morris's publishing ventures, carried out in the face of failing health, so much so, that any small delay during the last few months of printing occasioned him the greatest anxiety, almost as if he feared he might die before its completion. The fount was a specially-cut smaller version of the 'Troy' gothic which, with the original roman 'Golden' fount of 1890, based on a design by the fifteenth-century Venetian printer, Nicolas Jenson, made up the trio of founts designed and used by Morris in his efforts to raise the standard of typography and demonstrate that the designer must be concerned with every aspect of book production and layout. Each two-page spread in the Chaucer, as in all Kelmscott Press books, is treated as a single unit and the book thus becomes a series of related units which combine into a total work of art. It may be objected that the lavish ornament almost overpowers the text and that Morris leans too heavily on fifteenth-century models, but his fine work led to a revival of printing throughout the western world.

Among the unfulfilled plans for the Kelmscott Press were an edition of Froissart, a companion to the Chaucer; a reprint of the English Bible of 1611 and a folio edition of Malory's Morte d'Arthur, which was to have had at least a hundred illustrations by Burne-Jones, rivalling the Chaucer in splendour. However, a small volume of Latin poems, Laudes Beatae Mariae Virginis, from a thirteenth-century English Psalter belonging to Morris, was published in August 1896, just two months before his death, and, in it, Morris for the first time successfully experimented with printing in three colours. Another joint venture by Morris and Burne-Jones which must be mentioned is the tapestry of The Adoration of the Kings for the chapel of Exeter College, Oxford—Morris and Burne-Jones's old college—which was woven at Merton Abbey and completed in February 1890.

Fairfax-Murray. These were then revised by Burne-Jones before being transferred to the wood by photography.

The language of Symbolism, certainly in France, where the movement's aims were first explained by Jean Moréas in an article in *Le Figaro* of 18 September 1886, was deliberately esoteric, rarefied, and in every sense artificial. In its search for the highest and noblest reality, the impossibility of expressing this vision directly was acknowledged, and it could be suggested only through its earthly *correspondances*, through analogies or *symboles*, imperfect though these might be. The French Symbolists felt that Baudelaire's literary example could be followed without descending into vice and depravity. In England, the central figure of the Art for Art's sake movement had been Rossetti, poet and painter, whose life had followed a pattern of Dantesque tragedy and anguish. A man of great imaginative gifts, he was incapable of fully expressing his ideas in pictorial media, for which his aptitude lagged behind aspiration, yet he was the foundation stone on which English Symbolism was built. Rossetti's pupil, Burne-Jones, if less diversely gifted, was better equipped artistically, and able to marry art with experience. Burne-Jones, Rossetti, and Morris were all to enjoy a brief but important interlude of acclaim and success in France, Morris more particularly for his work in the decorative arts. Rossetti had died in 1882, and his work was less well known to French critics, for so much of it was inaccessible in English private collections. Ernest Chesneau, in his *La Peinture anglaise* (1882), translated into English by Lucy N. Etherington and with a preface by Ruskin, remarked on the insularity of English artists at this time and their ignorance of European art. This is fair comment, but in a paradoxical way, the distinctive flavour of Pre-Raphaelitism and its later development was to arouse great interest among certain French artists and critics from the mid-1880s until 1895.[1] Even as early as 1869, Philippe Burty, recently returned from a visit to London, had written an article on Rossetti in the *Gazette des Beaux-Arts* and had made a comparison between *Les Fleurs du mal* and Burne-Jones, whose work he had so admired that he had visited the artist's studio. It was Burne-Jones who above all other

[1] Jacques Lethève, 'La connaissance des peintres préraphaélites anglais en France 1855–1900', *G. des B.A.*, Period 6, LIII (May–June 1959), 315–28, is the most thorough examination so far of the links between England and France in this context.

English artists aroused the greatest interest, beginning with the 1878 *Paris Exposition Universelle*, where he had shown *Love among the Ruins* and *The Beguiling of Merlin*, acclaimed even by the traditionalist Charles Blanc.

Exhibitions of work by Millais and Watts at the Galerie Georges Petit, Paris, in 1882 and 1883, were visited by J. K. Huysmans and Robert de Montesquiou, and Huysmans makes his hero Des Esseintes (a character whom he had based on his friend de Montesquiou) admire the two artists in *À rebours*. The tide of French critical opinion began to swing in favour of the Pre-Raphaelites by 1884, and a certain number of articles began to appear in French literary and art journals. It must again be emphasized that in continental eyes Pre-Raphaelite had become a generic term to describe the proto-symbolism of the second-generation artists like Morris and Burne-Jones. The climax of popularity was reached at the 1889 *Exposition Universelle*, for although Burne-Jones was represented by only one painting, *King Cophetua and the Beggar Maid*, 1884 [Tate Gallery; plate 13A], it was a major work and far outshone the eight paintings by Watts in the same exhibition. The French aesthetes praised Burne-Jones for his artifice and the creation of a type of female beauty *à la* Botticelli. Puvis de Chavannes and Gustave Moreau were enchanted by it, and although Moreau tried unsuccessfully to obtain a medal of honour for Burne-Jones, he was awarded the Cross of the Légion d'Honneur. Thereafter, Burne-Jones made regular appearances at the official Salon in 1890, and at the rival Société Nationale des Artistes Français in 1892, 1893, 1895, and 1896.[1] The actress, Georgette Leblanc, even dressed in the Burne-Jones mode, and Burne-Jones designed the costumes for a production of *La Belle au bois dormant* at the Théâtre de l'Œuvre in 1894. Sar Péladan's Salon de la Rose ✠ Croix was based on Pre-Raphaelite ideals. But a reaction against the sickly preciosity of the aesthetic movement generally set in, and by 1900 interest in Burne-Jones had subsided in France. In Germany, where he had also been honoured in 1893 and 1897 (Munich), and 1895 (Dresden), Otto von Schleinitz published his

[1] Alan Bowness, 'An Alternative Tradition', in *French Symbolist Painters* (Arts Council, 1972), 15 and n. 3.

monograph on Burne-Jones in Knackfuss's Künstler-Monographien series in 1901. The Jugendstil artists of Germany and Austria regarded him as a spiritual leader, and Kandinsky refers to Rossetti and Burne-Jones (along with Arnold Böcklin and Giovanni Segantini) in *Über das Geistige in der Kunst* as examples of painters searching for the abstract or non-corporeal values in art. Even the young Picasso had admired Burne-Jones and other English artists of the period in distant Barcelona.[1]

Much nearer home, a group of artists in Birmingham were also greatly influenced by Burne-Jones, Morris, and the early Italian Renaissance painters. Burne-Jones had been born and spent his boyhood in Birmingham, and both he and Morris had lectured and taught in the city on several occasions. The work of Joseph Edward Southall and his younger followers such as Kate Bunce, Sidney Meteyard, Henry Payne, and Charles Gere, who were soon to become known as the Birmingham Group, is deliberately archaic and highly stylized. It was, in effect, a late provincial renaissance of Pre-Raphaelite and Symbolist art, which flourished from the 1890s to at least 1914. Cayley Robinson, although not a member of the Birmingham Group, shared much of their artistic outlook, except that he was primarily influenced by Puvis de Chavannes. Southall is also of interest for his revival of egg-tempera and fresco painting. Although Spencer Stanhope and Walter Crane had painted pictures in egg-tempera in the early 1880s, Southall, inspired by Ruskin's enthusiasm and his own first-hand study of Carpaccio in 1883, was to spend eight years developing a modern method of tempera painting.[2] By the end of 1901, following an exhibition of tempera paintings at Leighton House in April and May of that year, a Society of Painters in Tempera had been formed which included Southall, Holman Hunt, Watts, Crane, Mary Sargant-Florence, and J. D. Batten. Rules were laid down defining the media which could be described as tempera painting, and recourse

[1] Anthony Blunt and Phoebe Pool, *Picasso: The Formative Years. A Study of his Sources* (1962), 8, 19–20; Martin Harrison and Bill Waters, *Burne-Jones* (1973), 177, refer to an exhibition of Burne-Jones drawings at Barcelona in 1904.

[2] Charlotte Gere, *The Earthly Paradise: F. Cayley Robinson and the Painters of the Birmingham Group* (Fine Art Society Ltd., 1975), usefully summarizes events in her Introduction.

to Christina J. Herringham's translation of *The Book of the Art of Cennino Cennini*, published 1899, provided members with essential technical information as to the ingredients to be used and the best types of gesso grounds. One of the few surviving frescoes by Southall is his charming period-piece, *Corporation Street Birmingham in March 1914*, painted 1915–16, which adorns the head of the main staircase in the Birmingham Museum and Art Gallery.

Morris attempted only one piece of art criticism. In January 1883, the year of Karl Marx's death, he had joined the Social Democratic Federation and a year later started a weekly paper, *Justice: the Organ of Social Democracy*, to which he contributed extensively both in money and articles. The issue for 24 May 1884 contained his review of that year's Royal Academy Summer Exhibition.[1] He searched vainly for 'traditional workmanlike skill' and found instead much that was 'dashing, clever, and—useless' among close on two thousand exhibits. The flavour of the exhibition may quickly be gained by a glance at the principal exhibits in Gallery III, traditionally the place of honour. Sir Frederic Leighton, P.R.A., held the centre of the north wall with a learned interpretation of Boccaccio's *Cymon and Iphigenia* (165 × 350 cm), described in Henry Blackburn's *Academy Notes* as the most important feature of the exhibition, with nearly life-size figures, 'an elaborate study of colour and line'. The picture was bought by Sir W. E. Cuthbert Quilter, Bart., for an unspecified sum, but when the Quilter collection was sold at Christie's in July 1909 this painting fetched 2,250 guineas, a good sum but by no means exceptional for the period. Facing *Cymon and Iphigenia* was Millais's slightly smaller *An Idyll, 1745* [Lady Lever Art Gallery; plate 15A], a suavely executed painting calculated to win popular acclaim by its appeal to the romantic, sentimental conception of a soldier lad fifing away before an enraptured young audience in a woodland glade during a lull after the battle of Culloden. Morris wrote of this picture that it was 'the record of a ruined reputation, of a wasted life, of a genius bought and sold and thrown away'. It was a 'crime against

[1] 'Individualism at the Royal Academy', later published in expanded form in *To-day*, July 1884, as 'By a Rare Visitor'. The texts appear in May Morris, op. cit. I. 225–41, II. 140–2.

art'. It was also an example of the artist's increasing use of photo-graphy as an *aide-mémoire*, for there still exists the photograph of the drummer boy in the pose which Millais faithfully reproduces in his painting.[1] On the east wall hung Frith's Cromwellian history piece, *Cruel Necessity*, and in the opposite corner, Frederick Goodall's *A New Light in the Hareem*. Also on the west wall was Alma-Tadema's *Hadrian in Britain : visiting a Romano-British pottery*, a large upright composition, seven by five-and-a-half feet, suitably embellished with correct Romano-British detail from Alma-Tadema's considerable stock of archaeological knowledge.[2] Morris approved of the skilful still-life and flesh painting, although he thought that the composition as a whole failed to cohere. Flanking Millais's *Idyll* was another 'crime': William Quiller Orchardson's *Mariage de convenance* [City Art Gallery, Glasgow; plate 15B], a typical example of this artist's running commentary on the mis-demeanours, miseries, and occasional joys of members of the rich, middle, and upper classes of Victorian society. Orchardson had by now evolved a low-toned palette and delicate brushwork which seem particularly suited to his brand of drab anecdotal realism, and in his choice of subject he was the painters' counterpart to the dramatist Arthur Wing Pinero, whose brilliantly-constructed comedies of manners were just beginning to make their way on the London stage. It should come as no surprise that Orchardson's skilful tonal painting was not only greatly admired by Whistler—an esteem warmly reciprocated by Orchardson—but also by Degas and Sickert.

John Pettie, like Orchardson a native of Edinburgh, had studied at the Trustees Academy under Scott Lauder and came south in 1866 to join John MacWhirter and Orchardson, forming a Scottish group at the Academy. Pettie's *The Vigil* (Tate Gallery) also hung alongside Millais, and had been purchased for £1,000 by the

[1] Jeremy Maas, *Victorian Painters* (1969), 190–212, for a general discussion of the impact of photography.

[2] Percy Cross Standing, *Sir Lawrence Alma-Tadema, O.M., R.A.* (1905), reproduces this work (facing p. 76) and quotes a review by Miss Helen Zimmern in which she observes that Alma-Tadema had tackled the Romano-British period for the first time in the *Hadrian*. The painting was subsequently cut up into three sections.

Trustees of the Chantrey Bequest. The administration of this Bequest was to become a source of fierce controversy for over half a century and is bound up with the fortunes of the Tate Gallery which are discussed in Chapter XII. The other Chantrey purchases of the year were John Seymour Lucas's *After Culloden: rebel-hunting* (Tate Gallery) for £700—a grimmer aspect of the theme than that chosen by Millais, twenty years his senior—and David Murray's *My Love has gone a-sailing* (Tate Gallery) for £300. It is worth recalling that one of the highest prices paid, £2,000, had been in 1880 for Orchardson's *grande machine*, *Napoleon on board H.M.S. 'Bellerophon'* (Tate Gallery). Sepia reproductions of this work graced many a working-class wall into the mid-1930s. The Chantrey purchases of 1884 made Morris bubble with angry indignation: 'This is the sort of thing which gets the Academy the bad name it has got, and makes it perhaps the most contemptible public body in England—which is saying much.'

We have seen what kind of paintings were honoured at the 1884 Academy; the accomplished 'Olympians', Leighton, Poynter, and Alma-Tadema, were enjoying their heyday and the 'vice of subject' remarked upon by George Moore was rampant. Older Academicians, such as John Rogers Herbert and John Calcott Horsley rubbed shoulders with the later Victorians. Briton Rivière, continuing the anthropomorphic tradition of Edwin Landseer, had sent *The King and His Satellites*—a lion with almost human features surrounded by lower mammals—and Marcus Stone contributed two banal sentimental 'keepsake' companion pieces with the revealing titles *Fallen Out* and *Reconciled*. Yet there were more serious things to set against such trivia. These were the paintings of social protest by Luke Fildes, Frank Holl, and Hubert von Herkomer. One of the earliest of this new group, Fildes's *Applicants for Admission to a Casual Ward* [Royal Holloway College; plate 16A], shown at the 1874 Academy, proved a great personal success for the artist. The composition had been developed from a drawing published in *The Graphic* of 4 December 1869. Technically most accomplished, the group of little children in the centre of the painting is reminiscent of Murillo in its delicacy of brushwork and glazes. This painting was later acquired by Thomas Holloway, who also

bought Holl's *Newgate: Committed for Trial* (Royal Holloway College) from the 1878 Academy, which was based, it seems, on a real incident the artist had witnessed at Newgate. Sombre in theme and colour, its low tonalities probably derive from Millet or Legros. The Bavarian-born Herkomer submitted for his Diploma Work *On Strike* [Royal Academy of Arts; plate 16B], a large upright painting shown at the 1891 Summer Exhibition. Predominantly brown in tone, there are touches of rawer colour, and this starkness of colour and composition are entirely appropriate to the grim theme. At the 1884 Academy he had shown *Pressing to the West*, which dealt with the topical subject of the miseries endured by European immigrants to America.

In the pastoral vein, strongly influenced by the Barbizon School tradition of Millet, were George Clausen, H. H. LaThangue, and Stanhope Forbes, who, as we have seen, were soon to become a nucleus of the new English school of *plein air* painting. From Paris came a portrait of *Mrs. H. White* by a promising young American, Sargent, who, after the disastrous reception of his *Mme Gautreau* at the 1884 Paris Salon, settled for good in the more congenial social world of London. Another, somewhat unexpected contribution from France was Auguste Rodin's bronze, *L'Âge d'airain*, first shown at the Paris Salon in 1877, though not without protests from some members of the French jury that Rodin had made a cast from a live model, so perfect was the anatomical detail. Among the young English sculptors destined for public acclaim were Alfred Gilbert and Hamo Thornycroft. Gilbert's beautifully carved marble, *The Kiss of Victory* [R.A. 1882, The Minneapolis Institute of Arts; plate 26B] was his first contribution to the Academy and if its Michelangelesque conception gives little hint of his mature style, there can be no doubt as to its technical excellence. The financial success of the 116th Royal Academy Summer Exhibition is recorded in the *Art Journal*. Out of a total of 1,664 paintings, 203 were sold during the exhibition for £11,813. 8s.; and of the 191 pieces of sculpture, five were bought for £139. 13s. 'The prices for the pictures ranged from £1,000 to a guinea, there being one sold for £1,000 (T. Faed's "Of what is the wee Lassie thinking?"), 1 for over £500, 1 over £400, 4 over £300,

10 over £200, and 16 over £100.'¹ These figures do not take into account the many pre-exhibition sales, especially those enjoyed by the well-established Academicians, and their financial successes are also discussed in Chapter Twelve.

In 1886, as we know, the Academy received a blow to its pride with the founding of the New English Art Club by a group of painters in revolt against the stifling complacency of the established artistic oligarchy. Another ominous portent was the election of Whistler to the presidential chair of the Society of British Artists, which he had been asked to join in 1884, and which he set about reforming with characteristic autocracy when he took office in December 1886.² The election was regarded by some as an act of desperation on the part of a society whose fortunes were at low ebb, by others as a well-deserved compliment to an artist of international renown. On the occasion of Queen Victoria's Jubilee the year following Whistler's inauguration, he sent her an illuminated address on behalf of the Society, and as a personal tribute, an etching of Windsor Castle and a series of twelve, done in one day, of the Naval Review. In recognition, the Queen granted the Society a Royal Charter, thus bringing it still closer in status to the Academy.³ In the autumn, Whistler had the R.B.A. galleries in Suffolk Street redecorated in a delicate shade of primrose yellow, introduced a velarium designed by himself to diffuse the light more evenly, and insisted on a more spacious hanging of the exhibition, innovations which were favourably received, even by the rather conservative critic of the *Art Journal*. But the quality was improved and representation liberalized at the expense of some members' pictures, and opposition intensified when Whistler invited Claude Monet to send four pictures to the winter exhibition.⁴ By May

¹ 'Art Notes', *Art Journal* (1884), 287.

² E. R. and J. Pennell, op. cit. II. 47–74, devote two chapters to this episode of Whistler's career.

³ The Society was founded in 1823 and was incorporated under Royal Charter in 1847 (*The Year's Art* (1902), 103–4).

⁴ Accounts usually credit Monet with only two exhibits, but the R.B.A. catalogue lists four paintings: '212 Coast of Belle-Isle, Bretagne; 375 Meadow of Limetz; 384 Village of Bennecourt; 391 Cliff near Dieppe'—all were priced £160 each. The Belgian, Alfred Stevens, sent five pictures.

1888 Whistler was compelled to resign the presidency in favour of a safe nonentity, Wyke Bayliss, soon afterwards knighted. The young Walter Sickert, Whistler's protégé, and two dozen of the more adventurous artists who had banded together to secure his election originally, such as Charles Keene, Alfred Stevens, Roussel, Starr, and Mortimer Menpes, left with him— as Whistler quipped, 'The Artists have come out and the British remain.' The loss to the Royal Society of British Artists was indeed greater than they realized, and the Society never regained the impetus it enjoyed during Whistler's brief reign.

By the turn of the century almost all the great Victorian painters were dead and with the passing in 1904 of one of the last of them, G. F. Watts, an era was virtually ended. Whistler had died in 1903, but was more honoured in France than in England. In 1902 Watts had become one of the twelve original members of Edward VII's Order of Merit, and remained actively painting until three weeks before his death; Holman Hunt succeeded Watts in the Order and survived him by six years. For the last twenty years or so, Watts had laboured on large canvases of such symbolical cosmic themes as *The Sower of the Systems*, *The Slumber of the Ages*, *Sic Transit*, and the ambivalent *Hope*. The tenor of these grandiose works is generally pessimistic, their colours appropriately sombre, and their technique broad and diffuse like the late Titians that Watts so much admired. Towards the end of his life he gave thirty-six portraits to the National Portrait Gallery, and twenty-five of his paintings to the Tate Gallery, eighteen of which he presented in 1897 to mark its opening to the public. He had opened a private gallery at his country house, Limnerslease, near Compton in Surrey, in April 1904. The merits of his allegorical works may still be in dispute, but no such reservations are held over his portraits of famous contemporaries, the majority of which are justly regarded as among the most penetrating psychological studies we have of such eminent Victorians as Tennyson (1873), Cardinal Manning (1882), and William Morris [1880; plate 17A]. A bronze cast of Watts's giant equestrian statue, *Physical Energy*, developed from a projected memorial to Hugh Lupus on which he had worked for more than thirty years, was placed in Lancaster

Walk, Kensington Gardens, after the artist's death. Decidedly less earnest than those of Watts are the fashionable portraits by John Singer Sargent, who had enjoyed so much successful patronage by the rich during the fifteen years he had spent in London up to 1900 that he became satiated and sickened by it, and voluntarily renounced almost all portraiture after 1910 in favour of landscape painting. His bravura technique has a superficial allure which is admirably suited to the glittering society he was called upon to portray, but it would be greatly underrating his powers to over-look the irony and acute observation of human character that distinguish his best work. What greater contrast in male character-ization could there be between say, the patrician *Lord Ribblesdale* (Tate Gallery, 1902) shown in hunting costume, and the astute, fifty-four-year-old art dealer, *Asher Wertheimer* [Tate Gallery, 1898; plate 17B]? Wertheimer was probably instrumental in ob-taining portrait commissions for Sargent, in part-return for which he painted the rest of the numerous Wertheimer family. Of his portrait groups, none better combines this mixture of respectful irony and aristocratic aura than the *Sitwell Family* (Trustees of the Sitwell Settled Estates) of 1900 [plate 18A]. Sargent's exact con-temporary, John Lavery, was an early member of the Glasgow School and had trained in Glasgow, London, and Paris, but his work was most influenced first by Bastien-Lepage and then by Whistler. He helped Whistler found the independent International Society of Sculptors, Painters, and Engravers in 1898, of which he was vice-president until 1908. Under Whistler's presidency, the International Society became an important bridge between British and French artists, inviting to its exhibitions work from Bonnard, Rodin, Monet, Sisley, and Toulouse-Lautrec. Lavery was a flam-boyant Ulsterman and began his career as an official portraitist as early as 1888, with the commission for the commemoration picture of Queen Victoria's State Visit to the Glasgow Exhibition (Glasgow Art Gallery, 1890). One of his most attractive paintings, *La Mort du cygne: Anna Pavlova* (Tate Gallery), commemorates the world-renowed ballerina of the Imperial Russian and Diaghilev Ballets in her most famous role [plate 18B]. Painted in 1911, it is one of several portraits of her by the artist, but neither the pose

nor the setting are, in fact, taken from Fokine's choreography of 1905. Sir Osbert Sitwell has recalled how Pavlova made her first appearance in England at a private performance before the King and Queen at the Marquess of Hertford's house in 1909.[1] Lavery's portrait is more coarsely painted than any Degas, with whose work it incvitably invites comparison, even to the extent of imitating the characteristic tilted perspective. A flickering, nervous brush-stroke and a high-keyed palette are his somewhat perfunctory acknowledgements to Impressionism. Lavery's later work, especially his outdoor scenes of tennis and bathing parties, has a certain period charm at its best.

[1] Osbert Sitwell, *Great Morning* (1948), 137.

IV

ART NOUVEAU, GRAPHIC ART
AND SCULPTURE

ART Nouveau was an international style of the late nineteenth century, complex in origin and of far-reaching effect. It was a continuation of the revolt against the historicist, realist, and rational approaches to form and subject-matter. Although its practitioners often used motifs taken from nature, they wilfully exaggerated natural forms for purely artistic effects. Elongated proportions and an elaborately-wrought sinuous pattern were the hallmarks of the style at its apogee, but there were distinctive national variations of Art Nouveau. French and Belgian Art Nouveau is, generally speaking, more voluptuous in form than the German and Austrian versions. Those British artists who had provided a vital stimulus to Art Nouveau must also be differentiated, since the Scots in Glasgow were more radical than their English colleagues (with the important exception of Beardsley), who preferred a gentler, more lyrical mood. Art Nouveau can be seen either as a last exotic flowering, some would say a poisonous growth, at the end of the century or, and this is the more positive historical view taken here, as a cathartic process leading to a new and purer artistic order, a more acute understanding of the fundamentals of art and design. Difficulties arise when an attempt is made to chart where Art Nouveau begins and ends; so far as individual artists are concerned there are usually no hard and fast demarcations. The work of Charles Rennie Mackintosh after about 1900, for example, evolves directly from his work of the previous six years or so, and yet has undergone just that process of refinement and purification which puts its creator in the advance guard of the modern movement.

Some of the basic elements of Art Nouveau have been traced to English and Scottish sources.[1] There are two extraordinarily

[1] Robert Schmutzler, 'English Sources of Art Nouveau', *Arch. Rev.* CXVII (Feb.

prophetic designs by Arthur Mackmurdo, a pair of chairs with proto-Art Nouveau serpentine flower patterns pierced in the backs, of 1881 [William Morris Gallery, Walthamstow; plate 19A], which anticipate the motif he used for the cover of his *Wren's City Churches* [plate 19B] published in 1883, ten years before the movement came to fruition.[1] Mackmurdo was strongly impressed by the teaching of Ruskin, whom he twice accompanied to Italy in 1874 and 1875, and by Italian Renaissance architecture. It is significant that his first book should be in defence of architecture which derives from this source rather than medieval work, of which his friend Morris was the champion. The curving, flame-like, asymmetrical design of Mackmurdo's cover, with the phoenix's wings which blend into sunflowers, is inspired by details from late Pre-Raphaelite paintings and drawings by Burne-Jones and Rossetti. William Blake, for whose paintings and poems Rossetti had great admiration, must also be considered a formative influence on English Art Nouveau. The swirling S-patterns of many of Blake's compositions, as well as the manner in which text is juxtaposed with illuminated margins in the illustrated books, do indeed foreshadow much that was to become characteristic of Art Nouveau designs and book illustration. The elegant linearity of much Art Nouveau design carries on, too, the refinement inherent in Japanese art that had inspired Godwin and Whistler in their own work. Whistler's *Peacock Room*—or *Harmony in Blue and Gold* as he called it—of 1876–7, now in the Freer Art Gallery, Washington, D.C., especially its upright panels of blue and gold peacocks whose magnificent tail plumes sweep upwards in graceful curves [plate 19C], provides a motif that was to recur again and again in Art Nouveau, not least in the work of Aubrey Beardsley, who was an ardent admirer of the *Peacock Room*.[2]

1955), 108–16; also Stephan Tschudi Madsen, op. cit., and Pevsner, *Pioneers of Modern Design* (1960); R. Schmutzler, *Art Nouveau* (1964), contains recent research and a comprehensive bibliography; while for architecture and design the essays by various authors in J. M. Richards and Nikolaus Pevsner (eds.), *The Anti-Rationalists* (1973), shed new light on important aspects of Art Nouveau and its progeny.

[1] The chairs were first published by Aymer Vallance, 'Mr. Arthur Mackmurdo and the Century Guild', *Studio*, XVI (1899), 186.

[2] Brian Reade, *Beardsley* (1967), 16; Henry Maas, J. L. Duncan, and W. G. Good,

Mackmurdo founded the Century Guild in emulation of the artistic ideals of Morris (he was much less convinced by Morris's political views), and to some extent anticipated Morris's interest in printing by the production of the Guild's journal the *Hobby Horse*, the first issue of which appeared in April 1884 [plate 20A]. The editors, Herbert P. Horne and Selwyn Image, designed a new typeface for the magazine and printed it on handmade paper, and for the cover used a design by Selwyn Image in which the wealth of ornithological and animal motifs set the style for much later British Art Nouveau design. The January 1886 number of the *Hobby Horse* carried an enthusiastic article on Blake by Herbert H. Gilchrist, son of Blake's biographer, Alexander Gilchrist, and a reproduction of Blake's illustrated broadsheet poem, *Little Tom the sailor*, the typography of which earned Gilchrist's special praise. No fewer than three articles on Blake appeared in the fifth issue of the *Hobby Horse* in 1887. The examples of Mackmurdo and Morris prompted two younger artists, Charles Ricketts and Charles Shannon, to establish the Vale Press in Chelsea in 1888, but this press did not become completely self-sufficient until 1896 when, with L. Hacon, Ricketts opened a print shop at 52 Warwick Street, just behind Regent Street. Ricketts was undoubtedly the driving force behind the Vale Press, for which he designed the 'Vale' typeface in 1894, and, where previously books had been issued under his supervision, he was now able, two years later, to take charge of the whole production. A very clear picture of the group's tastes and affiliations emerges from the five issues of *The Dial. An Occasional Publication* edited jointly by Ricketts and Shannon from 1889 to 1897, the fourth and fifth numbers of which were published by Hacon and Ricketts. The cover of the first issue, designed by Ricketts and engraved in wood by Shannon, shows a sundial set in a walled garden richly strewn with spring flowers and ornamented with classical satyr Terms. Above the title is a Sun God motif. The flavour in this and the second cover design, entirely the work of Ricketts, which replaced it for the remaining

The *Letters of Aubrey Beardsley* (1971), 19, 21; and Malcolm Easton, *Aubrey and the Dying Lady: A Beardsley Riddle* (1972), 8–10. Mr. Easton also explores the sexual ambiguities in Beardsley's life and work.

numbers, is a mixture of strong, florid neo-medievalism, partly derived from Dürer woodcuts, with Renaissance trimmings [plate 20B]. Ricketts was a man of catholic outlook and the *Dial* contained essays and poems by T. Sturge Moore, John Gray, Charles Sturt, and Herbert Horne, as well as illustrations by Lucien Pissarro, Ricketts, and Shannon. Sturge Moore published poems, 'To the Memory of Arthur Rimbaud' and 'On a Picture by Puvis de Chavannes', in the second number; in the third Sturt contributed 'A Note on Gustave Moreau'; while the fifth contained Émile Verhaeren's 'La Vie élargie' and Laurence Housman's 'Open the Door, Posy', with a review by Sturt of Edmond de Goncourt's monographs on the Japanese artists Utamaro and Hokusai. Shannon's rather fluffy, formless lithographic illustrations in a Symbolist idiom are markedly different from the tougher, more spare style of Lucien Pissarro's decorative Symbolism, which, in its turn, avoided the Germanic exuberance of Ricketts's work and retained something of its earlier expressive realism.

Lucien Pissarro had been introduced to Ricketts and Shannon by John Gray, an official in the Foreign Office and a Symbolist poet, who later became a Roman Catholic priest. The meeting took place at the end of 1890, when Pissarro had decided to leave France and settle at Epping, and their friendship thrived for some fifteen years on a common interest in the revival of the graphic arts and printing. Pissarro founded the Eragny Press in 1894, naming it after the Normandy village where his father lived. Lucien's *First Portfolio of Twelve Woodcuts* was published at the Vale Press in 1891, to be followed in 1893 by a second portfolio, *Les Travaux des champs*, consisting of six woodcuts after Camille's drawings. His first book in the new Vale type was *The Book of Ruth and Esther* (1896), and is strongly influenced by those English and Pre-Raphaelite elements against which his father had repeatedly warned him. The process was not all in one direction, however, and Ricketts's *Pan Hailing Psyche across a River*, published in the last issue of the *Dial*, owes much of its simple, direct style to Pissarro. The Eragny Press flourished until 1914, and in 1902 Pissarro designed his own typeface, 'The Brook', so called after his new Hammersmith home. His wife Esther often made the woodcuts from his

own designs and these are a characteristic feature of their books, as also are the richly coloured frontispieces and decorative initials that recall medieval illumination.

The heady, medieval fantasies of Rossetti and Burne-Jones became fused with the alembicated world of Swinburne, Wilde, and Arthur Symons to find their most dazzling and bizarre expression in the drawings of Aubrey Vincent Beardsley, one of the most important and influential graphic artists of the Art Nouveau movement. Largely self-taught, Beardsley, who was also a talented musician, had made illustrations and caricatures in boyhood, and at the age of nineteen was so much encouraged by Burne-Jones, to whom he had shown a series of drawings, that in August 1892 he decided to abandon his job as an insurance clerk and devote himself to art. His formal training does not seem to have extended beyond twelve months spent at Fred Brown's evening classes at the Westminster School of Art from the autumn of 1891 to the autumn of the following year, for Burne-Jones had advised him that 'he had learnt too much from the old masters and would benefit by the training of an art school'.[1] A group of Beardsley caricatures of well-known actors and artists appeared in issues of the *Pall Mall Budget*, 6 and 9 February 1893 (the original drawings for which are now part of the Harrod Bequest, Victoria and Albert Museum), but his first major achievement was 350 illustrations for Sir Thomas Malory's *Morte d'Arthur*, commissioned by J. M. Dent in the autumn of 1892, published in monthly parts from June 1893, and complete in two volumes in 1894. These were still close enough to the manner of Burne-Jones and Morris, whom Beardsley had visited at the Kelmscott Press, to arouse Morris's indignation at this frivolous imitation of the Press's work, but already sufficiently distinctive for us to recognize clear intimations of Beardsley's maturer style. At John Lane's request he began to illustrate Wilde's *Salomé* with drawings that are not so much related to specific themes in the play as a commentary on it, and in four of them there are caricatures of Wilde, whom Beardsley rather disliked [plate 21A].[2] The drawings are in black and white

[1] Robert Ross, *Aubrey Beardsley* (1909), 17.
[2] When Beardsley's drawing of *J'ai baisé ta bouche Iokanaan—j'ai baisé ta bouche*

and were published in 1894. They are remarkably assured, and in retrospect it seems almost as if Beardsley matured with an extraordinary rapidity to compensate in part for a grievously short working life of some six years. His draughtsmanship is now incisive, cold, and wilful, the forms are no longer realistic but grotesque, and often contain erotic overtones. One of the most striking innovations is the importance given to the juxtaposition of large areas of black and white, of negative and positive voids and shapes, to produce an abstract compositional pattern of flat, decorative shapes. The illustrations he made for the *Yellow Book*, of which he became art editor at its inception in 1894, and for the *Savoy* (published by Leonard Smithers) after his break with John Lane in 1895, show a paring away of inessential detail in favour of voluptuous elongated curves and highly simplified composition. Typical examples are *The Wagnerites* (Victoria and Albert Museum) first published in volume three of the *Yellow Book*, 1894, and a caricature of Mrs. Whistler, *The Fat Woman* [Tate Gallery; plate 21B], also of 1894, which exude an atmosphere of evil, of corruption and decay made intellectually attractive by the sheer technical brilliance of line and form to the exclusion of emotion. The female figure which in Rossetti's and Burne-Jones's work had become either a languid, voluptuous creature with dark heavy-lidded eyes and sensuous mouth, or an ethereal etiolated wraith, was transformed by Beardsley into a sinuous sorceress. The original pure Pre-Raphaelite image had been triumphantly corrupted. Such were Beardsley's gifts that he could suggest colour by the subtle tonal gradations that he introduced into his black-and-white medium.

In his later drawings Beardsley turned for inspiration to Greek and Pompeian vase paintings and, like Charles Conder, to eighteenth-century French *galanteries* so that the full Art Nouveau savour became diluted by arcadian nostalgia. Gone are the bold, black, sardonic lines—instead, an effete over-complexity of design. Beardsley, by temperament inward-looking and hypersensitive,

(Princeton University Library, Princeton, N.J.) was shown to John Lane in 1893, he commissioned the artist to do the *Salomé* illustrations. This particular drawing was published in *Studio*, I (Apr. 1893), 19.

dogged by ill-health and dissipation to an early grave, epitomizes the exotic bloom of the Decadence. His work is the product of the cloistered, doomed world of Des Esseintes, the hero and literary archetype of the Decadence portrayed in Huysmans's *À rebours*, a work much admired by Wilde, George Moore, and Arthur Symons, who called it 'the breviary of the decadence'. In an article in *Harper's*, Symons defined Decadence in this way: 'After a fashion it is no doubt a decadence; it has all the qualities that mark the end of great periods, the qualities that we find in the Greek, the Latin, decadence: an intense self-consciousness, a restless curiosity in research, an over-subtilizing refinement upon refinement, a spiritual and moral perversity. If what we call the classic is indeed the supreme art—those qualities of perfect simplicity, perfect sanity, perfect proportion, the supreme qualities—then this representative literature of to-day, interesting, beautiful, novel, as it is, is really a new and beautiful and interesting disease.'[1]

Although Symons spoke only of literature, his remarks are equally relevant to the fine and decorative arts. Much Art Nouveau design, whether in typography, illustration, furniture, fabrics, architecture, or painting, displays an exaggerated exoticism, a hot-house fragility, which mark it out as an unstable hybrid doomed to swift extinction. On the positive side, the impact of Art Nouveau came as a refreshing breeze through the stuffy atmosphere of the gloomy Victorian drawing-room, cluttered with knick-knacks, antimacassars, and shrouded table legs. The striking colour scheme of Beardsley's studio at 114 Cambridge Street, Pimlico, would no doubt have sent a shudder down the spine of Queen Victoria, who preferred white and gold painted furniture and plum-coloured walls. It was the work of a follower of Morris, Aymer Vallance, who decreed black floors and black furniture upholstered in blue and white, green rugs, and walls hung with brilliant orange. Many of the chief architects of Art Nouveau were young men who later became leading interpreters of the crisp, functional style which was evolved in the early twentieth century. Art Nouveau was attacked and so was Beardsley; his style was caricatured by

[1] *Harper's New Monthly Magazine* (Nov. 1893), 858–67; quoted by both Holbrook Jackson, *The Eighteen Nineties* (1950 edn.), 55, and Katherine Lyon Mix, op. cit. 11.

Linley Sambourne in *Punch*, which referred to him as 'Aubrey Weirdsley', and by James Hearn in his poster for *Pygmalion and Galatea* at the New Theatre, Oxford, 7–9 June 1895, where he used the pseudonym 'Weirdsley Daubery'.[1] On a wider front, the decadent art and literature of the 1890s were fiercely denounced by Max Nordau in his jeremiad, *Entartung* (1892–3), which was published in English under the title *Degeneration* in 1895. The century was dying, and with it, civilization; *fin de siècle* was an apt despairing cry in Nordau's opinion: it was the fulfilment of a cultural *Völkerdämmerung*. Others saw the period as one of great liveliness, of inventiveness and wit. If one era was dying, the seeds of another were breaking through the mulch of the old. The *Yellow Book*, which made publishing history in that for the first time a quarterly was given the status of a book, is a convenient symbol of the period. Indeed, the phrase, the 'Yellow Nineties', soon caught on, and the colour, first made fashionable by Whistler, was applied as an epithet to lady novelists writing for the *Yellow Book*, and more scornfully to the new cheap mass-circulation daily newspapers, the first of which was the *Daily Mail*, founded in 1896 and part of the so-called 'Yellow Press'. The tone of the *Yellow Book* was set by Max Beerbohm's essay, *A Defence of Cosmetics*, which appeared in the first number. The author was just twenty-two and still at Merton College, Oxford. This was his first publication of note, and in it he sustains the case for artifice and artificiality: 'For behold! The Victorian era comes to its end and the day of sancta simplicitas is quite ended. The old signs are here and the portents to warn the seer of life that we are ripe for a new epoch of artifice.' The theme recalls Baudelaire's *Éloge du maquillage*, but Beerbohm treats it in an urbane, witty manner spiced with the polished erudition of a man precociously well-read. Beerbohm was a regular contributor to the *Yellow Book* and other periodicals of the time, and these essays were collected together in a slim volume, *The Works of Max Beerbohm*, and published with a bibliography in 1896 by John Lane at the Bodley Head. In this publication Beerbohm whimsically announced his retirement from the literary scene—he was outmoded, he belonged 'to the Beardsley

[1] Charles Hiatt, *Picture Posters* (1895), 224, repr. 225.

Period', and at the age of almost twenty-five he resolved to make way for youth! It was a pose worthy of a period in which it was fashionable to strike an attitude. Beerbohm's early caricatures appeared in the *Yellow Book*, the *Sketch*, *Pick-me-up*, and the *Pall Mall Budget*, but his best work belongs to a later generation.

A no less characteristic magazine of the time, which preceded the *Yellow Book*, was the *Studio*, an art periodical founded and edited by Charles Holme, the first number of which was on sale in April 1893 with a cover designed by Beardsley. This cover and the enthusiastic article on Beardsley by Joseph Pennell also in the first number earned Beardsley immediate attention and prepared the way for his *Morte d'Arthur* illustrations. The *Studio* was devoted largely to arts and crafts, although it gave ample space to painting, sculpture, and architecture. The editor was alert to new talent, and his magazine was the first in Europe to publicize the new trends. The *Studio* gradually superseded the more conservative *Art Journal* (1839–1912) and outlived its near-contemporaries such as the *Poster and Art Collector* (1898–1901), the *Magazine of Art* (1878–1904), and the *Hobby Horse* (1883–93). The *Studio* soon achieved an international circulation, and disseminated British variants of Art Nouveau to such an extent that for a short time in Germany the term 'Studio-Stil' gained currency. Beardsley's drawings were influential on artists as diverse as Gustav Klimt in Vienna, Victor Horta in Brussels, Jan Toorop in Antwerp, Félix Vallotton in Paris, Léon Bakst in St. Petersburg, William H. Bradley in Chicago, and 'The Four' in Glasgow led by Charles Rennie Mackintosh.[1]

The nineties were the golden age of the periodical and many were founded during the decade, a few of which survive today. The adjective 'new' featured in the titles of several, such as the radical weekly, the *New Age*, and the *New Review* edited by W. E. Henley. In other contexts, Wilde's *The Picture of Dorian Gray* was attacked as 'The New Voluptuousness', while Wilde wrote on 'The New Remorse'. Other writers referred constantly to the 'New Spirit', the 'New Humour', the 'New Realism', and the 'New

[1] Peter Selz, in *Art Nouveau: Art and Design at the Turn of the Century* (New York, 1959), 66.

Woman'.[1] There was a remarkable proliferation of literary ventures which catered for a wide variety of tastes: the *Parade*, the *Pageant*, the *Evergreen*, the *Chameleon*, the *Rose Leaf*, the *Quarto*, the *Venture*, the *Dome*, the *Chord* (musical counterpart to the *Dome*), the *Butterfly*, *To-Morrow*, the *Idler*, and *Pick-me-up*.[2] These magazines often required posters and black-and-white illustrations, thus providing employment for a host of graphic artists, including some of the most distinguished men of the day, such as A. S. Hartrick, Phil May, Leonard Raven-Hill (the chief editor of *Pick-me-up*), Edwin Abbey, S. H. Sime, Edgar Wilson, and, of the older generation, George Du Maurier, author of the famous novel *Trilby* (1894), in which he describes through English eyes the *vie de bohème* of Paris in the 1850s. Du Maurier chiefly satirized the middle classes, and in his work for *Punch* he continued the tradition of excellent draughtsmanship begun in 1841 by John Leech, whom he succeeded as a regular contributor in 1864. Artists' drawings were reproduced with much greater fidelity to the original as printing processes were gradually improved, including the development of photolithography by the three-colour process during the 1880s.[3]

The minor art of the poster was radically transformed in the 1890s, partly under French influence and partly by the emergence of three highly-gifted British artists, Beardsley and the two 'Beggarstaff Brothers'. Until at least the 1870s, public notices and playbills consisted almost entirely of letterpress and die-stamp, while colour lithography seems never to have been used in this context. The modern poster had its origins in the vogue for print collecting which began in France during the mid-nineteenth century, and the posters themselves were monochrome lithographs issued to advertise the publication of new books.[4] Distinguished

[1] Holbrook Jackson, op. cit. 20, gives many other examples of the fashion.

[2] Ibid. 34–5.

[3] Ruari McLean, *Victorian Book Design* (1963), 161.

[4] E. Maindron, 'Les affiches illustrées', *G. des B.A.* XXX (1884) and *Les Affiches illustrées*, 3 vols. (1896); Octave Uzanne et al., 'L'affiche internationale illustrée', *La Plume* (1 Oct. 1895); Charles Hiatt, *Picture Posters* (1895); Robert Koch, 'The Poster Movement and Art Nouveau', *G. des B.A.*, Period 6, L (Nov. 1957); and Bevis Hillier, *Posters* (1969), for good up-to-date general survey and bibliography.

graphic artists such as Gustave Doré, Honoré Daumier, and Paul
Gavarni were contributors, but Jules Chéret (who had spent eight
years in London from 1859) and Eugène Grasset are usually
regarded as the true innovators of the modern commercial poster.
For the connoisseur, the movement reached its peak in France
during the 1890s with the posters of Théophile Steinlen, Henri de
Toulouse-Lautrec, Alphonse Mucha, and Pierre Bonnard. There
were also many other talented designers, but Bonnard and
Toulouse-Lautrec revolutionized the art of the poster with two
designs in 1891, *France—Champagne* and *Le Moulin rouge: La
Goulue*. In England the pioneers were Walter Crane, who de-
signed his first poster for a firm of pencil manufacturers in 1869,
Fred Walker, and Hubert von Herkomer. Crane's second poster
was for a Promenade Concert at Covent Garden, and did not
appear until 1880; designed in blue and yellow, it showed Orpheus
charming the animals with the sounds of his lyre. Meanwhile
Walker produced his striking woodcut design for the stage version
of Wilkie Collins's *The Woman in White* in 1871, the full-size
cartoon for which is in the Tate Gallery [plate 22B]. Here were the
essential qualities of poster art: bold shapes, simple design, and an
arresting motif. This was Walker's only poster design, but how
favourably it compares with Poynter's overloaded classical design
of the statue of Pallas Athene in her temple, which he produced in
1886 for the Guardian Fire and Life Assurance Company, or with
Herkomer's pretentious Raphaelesque figure composition for the
Magazine of Art of 1881: 'Art bestowing her honours to Painters,
Sculptors and Engravers'. This reliance on elaborate classical
or Renaissance subject-matter weakened the impact of many of
Crane's designs, such as that for the Great Paris Hippodrome at
Olympia in 1888 (152·5×200·5 cm) with its two medallion-insets
of a chariot race, or the overcrowded text and Pegasus symbol of
his Scottish Widows' Fund Life Assurance design of 1888 (both
Victoria and Albert Museum). He made a much simpler, more
effective four-colour lithograph poster for Champagne Haü of
Rheims, published by Champenois in 1894, though the motif of
the classically-draped female figure bearing an amphora on her
left shoulder and, somewhat incongruously, a champagne-glass

in her outstretched right hand, discreetly recalls ancient Roman bacchanalia [plate 24A].[1] Crane's greatest contribution was to the art of book illustration and design. His illustrations for children are delightful and have made his reputation secure.

In one sense, poetic justice was done when Messrs. A. & F. Pears bought Millais's oil-painting *Bubbles* (1885) from the *Illustrated London News* and used it, somewhat to the artist's mortification, as an advertisement for their soap.[2] This episode highlights how little understanding of good poster art there was in England at the time. The successful recipe was to take one oil-painting or illustration more or less relevant to the thing to be advertised and marry it to some text, or so it seemed. Although artistically deplorable, if one compares it to a poster by Toulouse-Lautrec, the *Bubbles* advertisement was a huge success with the public, justified the company's astuteness, and set the tone for rival soap manufacturers. Lifebuoy soap was advertised by Burton Barber's picture of a dog and child asleep done in the manner of Sir Edwin Landseer; Sunlight soap, not to be outshone, commissioned John White to adapt G. D. Leslie's *The Scottish Gathering* for their billboards.[3] A gradual improvement in taste began to show itself in the late 1880s, when posters by Chéret appeared on London hoardings. Chéret's posters with their pert gay girls and slightly brittle style undoubtedly influenced Lautrec and a host of younger French and English artists, notably the *Gaiety Girl* series of 1893 by Dudley Hardy, one of our most prolific poster artists of the period. But the watershed was reached with the founding of the *Studio* in 1893, the first number of which contained an article on posters by Charles Hiatt, and two major international exhibitions of posters held at the Royal Aquarium, London, in November 1894 and in 1896. That posters should be deemed worthy of an exhibition is some indication of the collectors' awakened interest in this art form. A similar international exhibition was held at the Salon des Cent,

[1] Isobel Spencer, *Walter Crane* (1975), 140 (and reprod.) where it is dated *c.* 1910, although the poster appears in E. Bella's first Royal Aquarium poster exhibition of 1894 (cat. no. 70) and is described in Bella's article in *La Plume* (1 Oct. 1895), 415.

[2] J. G. Millais, *The Life and Letters of Sir John Everett Millais* (3rd edn. 1905), 305–8, for an account of the episode.

[3] Octave Uzanne, op. cit. 416, and C. Hiatt, op. cit. 195–6.

Galeries de la Plume, Paris, in 1895 and the printseller Edward Bella, a prime mover of the London exhibitions, contributed a lively survey of English poster art to a special number of *La Plume*, in which he blamed the stifling influence of the School of Design at South Kensington for so much that was bad in industrial art.[1] The first of the London exhibitions was dominated by Chéret (forty-nine exhibits out of a total of 193 posters and eleven designs for posters), Grasset (fifteen), A. Willette (thirteen), and Toulouse-Lautrec twelve, including such famous designs as *Aristide Bruant dans son cabaret*, *La Divan japonaise*, and *Jane Avril*. Other outstanding contributions included two posters by Bonnard (*France—Champagne* and *La Revue blanche*), and works by Beardsley, 'J. & W. Beggarstaff', Frank Brangwyn, Crane, Greiffenhagen (whose four-colour lithograph of 1894 for the *Pall Mall Budget* is a lively essay in the style of Toulouse-Lautrec), Hardy, Menpes, Raven-Hill, Wilson Steer (the Art Nouveau poster advertising his exhibition at the Goupil Gallery, 1894), Steinlen, and designs by Sickert and Fred Walker [*The Woman in White*; plate 22B]. Many of the posters were lent by Bella, whose premises in the Charing Cross Road were a clearing-house for British, Continental, and American posters. Of the British artists represented, Beardsley and the 'Beggarstaff Brothers' made the greatest impression, and one of the most enchanting Beardsley posters was for a double bill at the Avenue Theatre, 29 March 1894: J. Todhunter's *A Comedy of Sighs* and W. B. Yeats's *The Land of Heart's Desire* [Victoria and Albert Museum; plate 22A]. The text is carried on a wide vertical band on the right of the composition, the left is filled by a Junoesque figure who appears in a gap between two semi-transparent lace curtains. The poster is in green, white, and blue, and the artist has defined the relationship of figure to curtain by the simplest of hatchings, at once bold yet delicate.

'J. & W. Beggarstaff' was the pseudonym adopted by James Pryde and his brother-in-law William Nicholson when they joined forces in 1894, and for the next five years they produced a series of posters which by their bold simplicity and clarity of design revolutionized certain aspects of poster art throughout

[1] E. Bella, 'L'affiche anglaise', *La Plume* (1 Oct. 1895), 428.

Europe. Usually signing themselves 'Beggarstaffs', they presented the image in its starkest form: the background is stripped bare of unnecessary detail and the fullest use is made of the silhouette, often, as in the *Don Quixote*, designed but never used for the Lyceum Theatre, 1895, superimposing a paler silhouette against a darker, with sufficient outline details to make the poster legible and telling [plate 23A]. When composing their large posters, they used sheets of coloured paper to form a collage of the required design, and in this respect anticipated modern commercial studio practice. Other designs, such as that for Gordon Craig's *Hamlet*, were stencilled, and the Beggarstaffs usually drew the lettering for their posters. Despite the brilliant originality of their work, or perhaps because of it, they received relatively few commissions and several of their designs never reached the hoardings. The chocolate firm Rowntree patronized them, as did Sir Henry Irving and *Harper's Magazine*. After the partnership broke up in 1899 (an unpublished poster for Irving's production of Sardou's *Robespierre* at the Lyceum in April 1899 seems to have been one of their last joint designs), Nicholson continued graphic work and, in 1899, produced for Heinemann the series 'London Types' illustrating verses by W. E. Henley, of which the *Queen Victoria* is perhaps the best known. For the production of Thomas Hardy's *The Dynasts* at the Kingsway Theatre, 25 November 1914, he made three striking posters of Nelson, Wellington, and Napoleon.

The second poster exhibition contained 283 exhibits and was notable for the strong American contingent making its first appearance in London. Edwin Abbey, Will Bradley, William Carqueville, Edward Penfield, and the English-born Louis Rhead made distinguished contributions and, of these, Bradley chiefly interests us as an intelligent follower of Beardsley who avoided the more extreme idiosyncrasies of his style. Writing in a foreword to the catalogue, A. S. Hartrick referred to 'the Triumph of the Silhouette . . . so infectious has the new doctrine of the Silhouette proved that it is almost open to question, if it has not already reached towards the point of decadence. Certainly there is a tendency in some of these later posters to incoherency and a sacrifice of everything to freedom of line, particularly in the case

of certain extreme examples coming from America and Glasgow, in all of which the influence of Mr. Beardsley's work (without any of his judgement), is now more or less present.'[1] The criticism now seems misplaced, but perhaps understandable when one examines the startlingly original design by Charles Rennie Mackintosh for the Glasgow Institute of the Fine Arts, a narrow upright poster (223·75×89 cm) in three colours, published in 1895 and included in the exhibition—or the even more *outré* design advertising the *Scottish Musical Review*, 1896, printed in black, blue, purple, and emerald green [plate 23B]. The long flowing lines and narrow format are close to Beardsley, but there the similarity ends, although Celtic art and *The Three Brides* of Jan Toorop must also be counted as formative influences. Formalized plant and bird shapes and the hieratic symmetry of the dehumanized central female figure in the *Review* poster are features peculiar to Mackintosh. How unusual these posters must have seemed in comparison with Robert Anning Bell's *City of Liverpool School of Architecture and Applied Art*, which was reproduced on the cover of *La Plume*, 1 October 1895 [plate 24B]. Bell, a pupil of Crane, incorporated two Rossetti-type females symbolizing, one presumes, Art laureating Industry, set in a heavy foliated border with panels of illuminated text top and bottom to form an ensemble strongly reminiscent of a page from the Kelmscott Chaucer.

Julius Meier-Graefe sweepingly dismissed English sculpture with the judgement: 'There is no plastic art in England. The nineteenth century produced but one solitary sculptor, Alfred Stevens, and he has left almost nothing behind him.'[2] Meier-Graefe was far too harsh, but it is true that sculpture produced in England between 1870 and 1914, unlike the architecture of the same period, is distinguished less for its originality than for its technical virtuosity.[3]

[1] A. S. Hartrick, *A Collection of Posters. The Illustrated Catalogue of the Second Exhibition* (1896), 5–6.

[2] A. Julius Meier-Graefe, *Modern Art*, II (1908), 194. Somewhat surprisingly, Meier-Graefe completely ignored Alfred Gilbert.

[3] M. H. Spielmann, *British Sculpture and Sculptors of To-day* (1901), and Eric G. Underwood, *A Short History of English Sculpture* (1933), are still two of the best general surveys of the sculpture of this period; the exhibition, *British Sculpture 1850–1914,*

Monumental sculpture flourished, and the Royal Academician sculptors, like their successful painter colleagues, were in great demand for portrait busts, allegorical groups, tombs, and statues. The resurgence of the Palladian Imperial style for public buildings created opportunities for appropriate sculptural enrichments, and private patronage was sufficient to support a largish number of sculptors. It is noticeable that sculptors would frequently first exhibit a plaster at, say, the Royal Academy, which, if it found an admirer or prospective purchaser, would then be cast in bronze or carved in marble and re-exhibited a year or so later in its new medium. Then, as now, the expense of casting limited the scope of all but the most successful or financially independent sculptor. There was a fair diversity of talent and temperament even within the academic fold. What greater contrast in style and attainment than that exemplified by the careers of Alfred Gilbert and Hamo Thornycroft? Gilbert was recognized as one of the most original sculptors of his day, and his beneficial influence on the younger generation was regarded as being as great as, if not greater than, that of Jules Dalou, who had taught in several important London art schools during his exile from France between 1871 and 1880. As in painting, French influence—this time in the persons of Dalou and his younger compatriot and successor at the Royal College of Art, Edouard Lantéri—was strong in the training of British sculptors, many of whom were encouraged by their French instructors in London to go to Paris to complete their studies. The native neo-classical and mid-Victorian historical narrative traditions were in this way tempered by the more naturalistic styles evolved by J.-B. Carpeaux, A.-L. Barye, and Dalou. Among the more prominent men who received part of their training in France were W. Robert Colton, Alfred Drury, who worked with Dalou in Paris as his assistant, 1881-5, George Frampton, Frederick Pomeroy, and John Tweed, who in 1893 went to see Auguste Rodin in Paris and afterwards studied under Alexandre Falguière at the École des Beaux-Arts. The pre-eminence of France was acknowledged by a still younger generation, and, as a young man, Jacob Epstein left

Fine Art Society (1968), with a catalogue introduction by Lavinia Handley-Read, revived interest in a rather neglected aspect of the period.

New York in 1902 to visit Paris and see works by Rodin and the antique Greek sculpture in the Louvre. He spent six months at the École des Beaux-Arts and then went on to study at the Académie Julian. He was destined to become—and to remain for over two decades—the most controversial figure in the art world of his adopted country (he became a British citizen in 1907).

Alfred Stevens's Wellington Monument, incomplete at his death in 1875, was to remain unfinished and hidden from public view until 1912, when John Tweed, after nine years' work, completed the casting of the equestrian figure, and the Monument was placed in the position originally intended for it in the nave of St. Paul's Cathedral.[1] This was the last great High Victorian monument, complete with allegorical figures of Valour and Cowardice, Truth and Falsehood, but done by an artist who had an extremely intelligent and sympathetic understanding of Italian High Renaissance art. The classical tradition, in fact, no matter how much sentimentalized or perverted, persisted throughout the latter part of the nineteenth century but, as in architecture, the period of inspiration fluctuated from the Late Hellenistic of the Laocoön back to the Periclean ideal. Two life-size bronze sculptures by Leighton in the Tate Gallery, *An Athlete Struggling with a Python* [1877; plate 25 B] and *The Sluggard* (1885), are Laocoönian; but James Havard Thomas, on the other hand, was a pioneer in the revival of ancient Greek methods, especially the use of black wax in large-scale works, and in his bronze, *Lycidas* [1902–8, Tate Gallery; plate 25A], he adopts the static, self-contained composition of an earlier period. Havard Thomas first made a wax model for this statue (1905) which was rejected by the Royal Academy, perhaps because it seemed too 'primitive' for the jury's taste. The bronze was finished in the ancient Greek mode, that is by working on the surface with files and by inlaying where there were imperfections, until a close, polished texture was obtained. It was a slow process and in this instance took three months to complete. Hamo Thornycroft, R.A., son of the sculptors Thomas and Mary Thornycroft, was also a student of Greek sculpture in his youth and, stylistically, stands somewhere between Leighton and Havard Thomas. He

[1] Discussed by Boase, O.H.E.A. X (1959), 305–7, reprod. pl. 91.

specialized in monumental figure groups and realistic genre, and of his public monuments in London among the best-known are the life-size *Oliver Cromwell* (1899) in Old Palace Yard, Westminster [plate 26A], the *Dean Colet with Two Scholars*, old St. Paul's School (1902), and the W. E. Gladstone memorial in East Aldwych (1905). Outside London the most important works are the *King Alfred* monument at Winchester (1901) and a memorial to Edward VII at Karachi (1915). All are strongly realistic works, competent, but a trifle dull. His first success in life was an early Grecian subject, *Artemis*, a large marble group of 1882 commissioned by the Duke of Westminster for the Marble Hall at Eaton Hall, Cheshire (where it was until recently), on the recommendation of the Duke's architect, Alfred Waterhouse, who had first seen a plaster version of it at the Royal Academy exhibition of 1880. Thornycroft followed this success with *Teucer* (1881, Tate Gallery), an accomplished over-life-size bronze of the famous Greek archer of antiquity, finely modelled and tautly composed. Rather different in spirit is his late marble, *The Kiss* (1916, Tate Gallery), a naturalistic mother-and-child group in which a faint echo of Rodin may be detected. It was a work he particularly enjoyed carving, and was reluctant to let it leave his studio.[1] Thornycroft, in common with some other sculptors, produced many small-scale versions of successful works, such as *Teucer*, *Artemis*, and *The Mower* (1882 4), which he either sold or lent to provincial and foreign exhibitions. Mention ought to be made here of Thomas Brock, a pupil of John Henry Foley, R.A., and a prolific portraitist. His most famous work is the huge *Queen Victoria* memorial in front of Buckingham Palace, designed in conjunction with Aston Webb and unveiled in 1911. It is typical of many life-like statues of the old Queen by lesser men which are scattered throughout the realm, but distinguished by a technical mastery which only becomes apparent to us now if we are willing to look beyond the subject-matter and its overtones of imperial sentiment.

Alfred Gilbert was the outstanding English sculptor of his generation and of international renown, yet his career underwent

[1] M. Chamot, D. Farr, and M. Butlin, *The Modern British Paintings, Drawings and Sculpture*, Tate Gallery, II (1964), 722.

changes of fortune that remind one of Benvenuto Cellini, with whom Gilbert was, in a moment of pardonable exaggeration, compared by Rodin to Cellini's disadvantage.[1] The parallel is not entirely apt—for Gilbert possessed a truer artistic sensibility than the Florentine goldsmith, and was less prone to pursue technical virtuosity for its own sake—but there are undeniable similarities between the late mannerist style of Cellini and Gilbert's love of complex, labyrinthine ornament. Gilbert's parents were both talented musicians and passed a love of music to their son, who otherwise received a fairly conventional public-school education, but showed some independence of mind by refusing to go on to University, preferring to study to be a surgeon. Failing to pass the necessary preliminary examinations, at the age of eighteen he entered Heatherley's art school and also studied for a year at the Royal Academy Schools under Edgar Boehm. Boehm, an immensely industrious craftsman of Austro-Hungarian extraction, was much patronized by the Government and fashionable society. He became Sculptor-in-Ordinary to Queen Victoria in 1881 and produced numerous images of that monarch. The seated *Thomas Carlyle* memorial executed by him in 1881 for Chelsea Embankment rises above the general pedestrian level of his work. Well aware of his own limitations, he at least had the wit to realize the genius of his pupil and encouraged Gilbert to go to the École des Beaux-Arts in Paris, where he studied under P.-J. Cavalier from 1875 to 1878 and improved his technique. From Paris he moved to Rome, where he worked until 1884, and it is significant that, like Stevens before him, he should have been most attracted by fifteenth-century Florentine work, particularly Donatello and Verrocchio. An early half-life-size terracotta group, *Mother and Child* (1876, formerly Miss I. Cruttwell Abbatt), which was modelled on his wife, Alice, and eldest son, George, has a tender naturalism closely akin to Dalou. A later variant of the theme, the marble group,

[1] Isabel McAllister, *Alfred Gilbert* (1929), 144. In addition to the bibliography published in the biographical note for Gilbert in the *Tate Gallery Modern British School Catalogue*, I (1964), 221, there are four articles by Lavinia Handley-Read: 'Alfred Gilbert and Art Nouveau', *Apollo*, LXXXV (Jan. 1967), 17–24; 'Alfred Gilbert: a new assessment. Part 1: the small sculptures. Part 2: the Clarence tomb. Part 3: the later statuettes', *Connoisseur*, CLXIX (Sept.–Dec. 1968), 22–7, 85–91, 144–51.

Mother teaching Child (1881, Tate Gallery), like *The Kiss of Victory* [plate 26B], is much more Michelangelesque in conception. Italian quattrocento art does not make itself strongly felt in his work until the bronze *Perseus Arming* (Leeds City Art Gallery), exhibited at the Paris Salon in 1883, and the *Icarus*, shown at the Academy the following year. In skilfully modelled bronzes such as these, Gilbert exploits the dramatic possibilities of a single figure caught in *contraposto* movement, and in the exuberant shape of Perseus' helmet we have an intimation of those flamboyant formal intricacies that characterize Gilbert's mature designs.

The bronze statue of *Queen Victoria* at Winchester was commissioned to celebrate her Golden Jubilee in 1887, when it was unveiled in an unfinished state. Gilbert did not complete it in all its details until 1912. This was his first important public monument and it is a remarkable achievement, not least in that the sculptor obtained a good likeness of the Queen without the advantages of a sitting from life—although it may be remarked that Gilbert's numerous portrait busts are far and away the most lively and distinguished of their period. What to modern eyes seems so original in the *Queen Victoria* is its elaborate architectural setting and symbolical trappings. Ostensibly Renaissance, or rather neo-baroque, in character though these are, there is already an intricate sinuosity in the design of the large crown and its decorative appendages that must be considered proto-Art Nouveau. Where would he have found inspiration for this? Although himself an indifferent painter, he greatly admired Burne-Jones (whom he first met in 1884), and like him was greatly moved by the Italian quattrocento. If we compare details of armour, of plant forms, and even the treatment of the human figure, in the work of both artists, many close analogies will be found which cannot be dismissed as coincidental. Gilbert's biographers have noted the quattrocento affinities and have even called his work 'Gothic', but not one of them has considered him an exponent of Art Nouveau despite all the incontrovertible evidence of obvious stylistic affinities. Gilbert's unfavourable opinion of Art Nouveau in no way invalidates the connection. Whether consciously or otherwise, he was an exotic romantic at a time when romanticism blossomed into Art

Nouveau. This term has lost its pejorative connotations for us, and the movement has now become art-historically respectable.[1]

Gilbert's *chef d'œuvre* and his most famous work is the Shaftesbury Memorial Fountain in Piccadilly Circus, now usually known simply as *Eros* after the crowning figure, erected to commemorate the famous philanthropist, Anthony Ashley-Cooper, Seventh Earl of Shaftesbury [plate 28]. It has brought Gilbert undying fame, but in his own day it cost him much criticism and anxiety, and led indirectly to the severe financial embarrassments which culminated in bankruptcy in 1901 and a self-imposed exile in Bruges which lasted until 1926. Gilbert was a visionary, impractical artist, hopelessly out of his depth in business matters and too independent to delegate them to a manager. Intensely self-critical and a perfectionist, he took on far more work than he had time for, often on terms that left him greatly out of pocket, and to make matters worse, he was incapable of employing assistants. Although an extremely hard worker and possessed of exceptionally strong physique, he could not meet all the demands made of him and consequently disappointed many clients with whom he had unwisely entered into contracts. This, coupled with his own unrelenting high standards, drove him into an impossible position, and one infuriated patron went so far as to accuse him publicly of fraud—a doubly cruel charge for one so unworldly and, at that time (1906), on the verge of poverty.[2]

The *Eros* commission had originally been offered to Boehm who, too busy to undertake it, recommended his old pupil. Gilbert accepted the work in 1887 on condition that he would be able to realize it in his own way. After making a small working model, he was ready to begin the full-size fountain, modelled in clay, and this was ready for casting after a year's work. The contract permitted a total cost of £3,000, a limit within which Gilbert claimed he could have kept had the Committee not delayed matters by insisting on the addition of a parapet and canopy to

[1] Gilbert's comments are quoted below, chap. VI, p. 139.

[2] One must observe, however, that Gilbert's propriety in disposing of the full-size figures of St. Elizabeth of Hungary and the Virgin Mary (both Kippen Parish Church, Stirlingshire), described as variant replicas of the Clarence Tomb figures, has been discussed by Lavinia Handley-Read, *Connoisseur* (Dec. 1968), 145–6.

hold a portrait bust of Shaftesbury. Gilbert temporized, but it soon became clear that such an addition was incongruous and spoilt the underlying allegorical concept. Other complications arose and Gilbert's idea of a larger octagonal basin at the base of the fountain (now occupied by a flight of steps), into which sprays of water were to fall from the upper part, had to be abandoned. The authorities considered that too great a flow of water would not only cause spray to be blown across the Circus but would cost too much to pump. The Government failed to provide the old guns they promised Gilbert for melting down for metal, and the sculptor, caught in a sudden rise in the cost of copper, had therefore to buy it at a much inflated price. Altogether, he expended far more on the Memorial than he received, and although it was admired by the more discerning at the time of its unveiling in June 1893, many years were to pass before *Eros* became the most popular landmark in London. The delicately-poised figure was cast in the new light weight metal aluminium, which allowed Gilbert to provide a much more elegant design than if he had been restricted to bronze. Aluminium also had a certain 'snob' value for Gilbert, as it remained a very expensive metal until new methods of extracting it were found at the end of the century.

The poetical interpretation of the Memorial was much confused by members of the public who sought some prosaic pun on the name 'Shaftesbury', but Gilbert himself explained it in simple enough terms: 'As to the figure surmounting the whole . . . I confess to have been actuated in its design by a desire to symbolise the work of Lord Shaftesbury; the blindfolded Love sending forth indiscriminately, yet with purpose, his missile of kindness, always with the swiftness the bird has from its wings, never ceasing to breathe or reflect critically, but ever soaring onwards, regardless of its own peril and dangers.'[1] The fountain, with its wealth of sinuously curving shapes both in its profiles and surface decoration, is a highly personal marriage of baroque formulas with Art Nouveau, and anticipates by some ten years the elaborate elongated shapes of Hector Guimard's Métro stations in Paris. Still more obviously Art Nouveau forms appear in the base and pedestal

[1] Joseph Hatton, 'Alfred Gilbert, R.A.', *Easter Art Annual, Art Journal* (1903), 16.

of Gilbert's *John Howard Centenary Statue*, unveiled at Bedford in March 1894. This finely conceived monument is much to be preferred to Boehm's statue of *John Bunyan* not far distant in the same town. Two small works, the Epergne [plate 29A] presented to Queen Victoria on her Jubilee by Officers of the Army (1887, completed 1890) and the Mayoral Chain for Preston Corporation, completed in 1892, show Gilbert's exquisite skill as a jeweller. He excelled at intricate detail and lavished great pains on these as on everything else he set himself. Unlike Cellini, he relished the minutiae of the goldsmith's art.

Gilbert's last great monument and possibly his finest work is the Clarence Tomb, Windsor, which commemorates Edward VII's son, the Duke of Clarence and Avondale, who had died in 1892 at the age of twenty-eight. He began work on it in 1892 and had almost completed the tomb by 1898 when the crisis in his private affairs halted progress for nearly thirty years, and not until 1926 did he return to England at the invitation of George V to complete his *magnum opus* [plate 27A]. Five of the small figures of saints, those of SS. Hubert, Nicholas of Myra, Catherine of Siena, Ethelreda, and Catherine of Egypt were finished and placed in position by 1928. The monument is of the traditional High Renaissance type with recumbent effigy in bronze supported on a Mexican onyx sarcophagus (of which the fine base is unfortunately almost concealed by an open-work bronze grille), as used by Torrigiano for the tomb of Henry VII and his Consort at Westminster. At the head of the effigy kneels an angel holding aloft a crown symbolizing eternal life, with a smaller winged mourning figure at the foot. The grille is divided into four panels on each side with two panels at either end, and in each of these panels stand two angels whose outspread wings form an elaborate screen evolved from the Tree of Jesse theme, a heraldic allusion to the Prince's ancestry. Figures of the Virgin Mary and eleven patron saints of the European royal houses to which the Prince's family was kin, as well as representations of his pursuits in life, surmount the centre of each panel. The tomb harmonizes well with its Gothic setting and has been described as Gothic in spirit. But the mysticism, elaborate symbolism, and actual sculptural details, particularly the figures of the

Virgin, St. George, St. Michael [plate 27B], and St. Elizabeth of Hungary, are pure Art Nouveau, though of a very personal kind. The sculptor said that the armour of St. George was based on a shell motif, and the serpentine forms of the base on which he stands was an allusion to the slain dragon. By comparison with the tender introspection of Gilbert's St. George, the *St. George and the Rescued Maiden* (1898, Clifton College) by a much lesser talent, Henry Charles Fehr, appears coarse and banal, if not comic. Elements of Art Nouveau and of the Arts and Crafts Movement may be detected in the earlier work of George Frampton, notably in his polychrome plaster bas-relief, *Mysteriarch* (1892, R.A. 1893, Walker Art Gallery, Liverpool) which, perhaps because of its Gustave Moreau-like Symbolist overtones, won a *médaille d'honneur* at the Paris International Exhibition of 1900 [plate 29B]. The allegory in his bronze memorial to the ship-builder Charles Mitchell of Newcastle upon Tyne (1898) is more explicit with its formalized orange trees and decorative frieze along the base. Frampton contributed several articles to the *Studio* on goldsmiths' work, enamelling, wood-carving, and polychrome sculpture: an outstanding example of the last technique is the *Dame Alice Owen* (1897) for Owen's School, Islington. The imaginative, but slightly precious, *Peter Pan* monument in Kensington Gardens (1912) and the *Edith Cavell Memorial* (1920), St. Martin's Place, London, are two of his best-known public works, although the Cavell now seems to us a clumsy attempt to combine a 'modernistic' base with a figure in more traditional portrait style.

PART TWO

ARCHITECTURE
AND THE
DECORATIVE ARTS
1870–1920

V

NORMAN SHAW, VOYSEY,
AND ENGLISH
TRADITIONALISM

ENGLISH church and domestic architecture of the last quarter of the nineteenth century, in the hands of a few distinguished practitioners, became the envy of continental countries. The so-called 'Battle of the Styles', which had raged over the previous twenty-five years, was practically spent by the time George Edmund Street's Law Courts were completed in 1882. The worry and physical effort involved in these buildings literally killed the architect, and as the German architect and historian, Hermann Muthesius, acutely remarked, the controversy they aroused finally convinced the public of the unsuitability of the Gothic revival style for public buildings other than ecclesiastical.[1] Yet a number of important public buildings in medieval style had either been finished or were nearing completion by about 1875: Alfred Waterhouse's Town Hall at Manchester (1868–77), the same architect's Romanesque Natural History Museum, London (1873–81), and Gothic St. Paul's School (1884–5), William Butterfield's Keble College and Chapel, Oxford (1870–5), and his work at Rugby School (1875). Aston Webb and Edward Ingress Bell's Victoria Law Courts at Birmingham (1886–91), on the other hand [plate 31A], were executed in a style owing much to French early sixteenth-century Renaissance château architecture, principally Blois, and W. H. Crossland looked more to Chambord when designing his magnificent Royal Holloway College, Egham, Surrey (1879–86). Cathedrals, churches, and universities continued to be designed in Gothic, but the medieval period and country of origin chosen by the revivalist architect as his inspiration now tended to

[1] Hermann Muthesius, *Die neuere kirchliche Baukunst in England* (Berlin 1901), 30.

be wider and less rigidly confined than during the heroic 'Early English' years of George Gilbert Scott, John Loughborough Pearson, Street, and G. F. Bodley. The Great Hall of Bristol University, designed by George Oatley and Lawrence in 1912, has a hammer-beam roof and Decorated Gothic detailing with a fan-vaulted entrance-hall modelled on Henry VII's Chapel. An exception to this prevailing fashion was Richard Norman Shaw's St. Michael and All Angels, Bedford Park, built in 1878 and deriving mostly from Dutch seventeenth-century church architecture [plate 31B]. Church authorities were essentially conservative, however, and Gothic was considered an appropriate setting for Anglican worship until well into the twentieth century. Thus a number of Anglican cathedrals were all designed in this style, including George Gilbert Scott's St. Mary's Cathedral, Edinburgh (1873–9), Pearson's noble design for Truro (1879–87), Giles Gilbert Scott's Liverpool Cathedral (begun 1903, and completed 1978), and Edward Maufe's Guildford Cathedral (1936–66). It was not until 1951 that a modern design by Basil Spence was accepted in the competition for Coventry Cathedral. The Roman Catholic communion frequently looked to Italy for guidance in more things than the purely spiritual, and although William Burges won the competition for Cork Cathedral with a Gothic design (1865–76), in 1878 the Oratorian Fathers selected Herbert Gribble to build their Oratory in Brompton Road (1880–4, dome by G. Sherrin 1897) in a skilful pastiche of the Gesù, Rome. The Hierarchy instructed John Francis Bentley to use the Early Christian Byzantine style for their Cathedral at Westminster begun in 1895, partly, no doubt to distinguish it from near-by Westminster Abbey, and partly because it was both less costly and quicker to erect than Gothic [plate 30]. Westminster Cathedral is a superb historicist monument, and a brilliant personal reinterpretation of an earlier style. The fugal treatment of the west front, for example, with its banded brickwork and asymmetrically sited campanile is a lasting memorial to Bentley's genius. Sadly, he never lived to see the external fabric of his masterpiece completed. As late as 1929 the Roman Catholic authorities sought a design in Renaissance style, when Edwin Lutyens

was commissioned to do the metropolitan cathedral for them at Liverpool.[1]

Immense wealth had been produced by the Industrial Revolution and this is reflected in the tremendous building activity of all kinds which continued unabated until the First World War. Cities and towns grew rapidly as the national population increased and migrated to the conurbations; new suburbs sprang up, and villages on the periphery of major cities were swallowed up as the boundaries of the latter expanded. The problems of overcrowding and over-extended communications caused by this unprecedented and uncoordinated urban sprawl are still with us today in even more acute form, and the expedients of garden suburbs and new dormitory towns which were first pioneered at Bedford Park as early as 1875, and developed at Bournville, Port Sunlight, and Letchworth and Welwyn Garden Cities during the next three decades or so, have proved to be but temporary palliatives. The problems of large-scale town-planning in the modern sense were not recognized by architects and civic authorities as being their joint concern until spurred to action by the social reformers and a few philanthropic industrialists. The Town and Country Planning Association, founded in 1899, supported the garden-city movement, but the word town-planning did not enter the English language until about 1904, and the first book in English on the subject, Raymond Unwin's *Town-planning in Practice*, appeared in 1909. In the same year, the first Town-Planning Act was passed, the first School of Town-Planning was established at Liverpool University, and in 1914 the Town-Planning Institute was founded.[2]

Artistically, the outstanding development of the last thirty years of the nineteenth century was the transition from Gothic Revival to 'Queen Anne' and neo-Georgian as the prevailing building styles. As a very broad generalization one may describe it as a

[1] Only the crypt of Lutyens's design was completed when work was stopped in 1941. In 1955 his monumental scheme was abandoned in favour of a simpler and uncompromisingly modern one by Frederick Gibberd, chosen after an open competition, and the new Cathedral was built between 1962 and 1967.

[2] M. S. Briggs, *Town and Country Planning* (1948), see also the bibliography under 'Town-Planning' in Briggs's *Concise Encyclopaedia of Architecture*, Everyman edition (1959).

movement away from romantic medievalism in favour of a more disciplined classical idea. The strongly anti-historicist Art Nouveau movement contained the seeds of a revolutionary new style which flowered briefly in England around 1900, but failed to develop into a healthy growth until regrafted and revitalized by continental influences in the late 1920s, by which time it had become so transformed that its original debt in part to British inventiveness had been obscured. In England, the promise of a new, modern architecture had been thwarted by a pompous Edwardian Imperial baroque style in official building, and in domestic architecture by a generally timid, if tastefully proportioned, neo-Georgian. With the wisdom of hindsight, all the basic ingredients for the subsequent historical development of English architecture up to 1925 can be found in the work of one extremely brilliant man, Richard Norman Shaw.

Articled first to William Burn in or before 1849, Shaw then studied under Charles Cockerell at the Royal Academy Schools, where he distinguished himself by winning the Silver and Gold medals and a travelling studentship to Europe. His prize-winning design was an essay in Vanbrugh-like baroque of a full-bloodedness never to be equalled again by him even in his later career, although the Gaiety Theatre (1902–3) in the Strand and the Piccadilly Hotel (1905) were perhaps his nearest approach to it. While abroad, he sketched details exclusively from Gothic architecture, a selection of which he later published as *Architectural Sketches from the Continent* (1858). These brought him favourable notice, and possibly paved the way to Street's office which he entered early in the following year to become principal assistant (or chief draughtsman) in succession to Philip Webb, whose term of office actually overlapped with Shaw's for a few weeks. Shaw worked with Street for four years before setting up in the same office with William Eden Nesfield, whom he had known as a fellow pupil at Burn's office. The Nesfield and Shaw formal partnership lasted for only three years from 1866, but they usually designed independently of each other despite the fact that some drawings are inscribed 'Nesfield & Shaw'. Nevertheless, they were well aware of each other's work and supervised each other's

jobs, and although the partnership was dissolved in 1869, they continued to share offices until 1876. This link is important in the history of the revival of the 'Queen Anne' style, as we shall see. Nesfield's first important work, Cloverley Hall, Shropshire (1864–8, now demolished), was a vast mansion in a slightly Frenchified, Tudor domestic style with Gothic dormers set in a steep pitched roof with stone ridges and gables. The revival of interest in Elizabethan and Jacobean domestic architecture owes much to the example of George Devey, whose sensitive recasting of Betteshanger House was begun in 1856.[1] Devey's maturest work is well represented by Goldings in Hertfordshire of *c.* 1870, and it is hard to believe that Nesfield was ignorant of him, although both architects shunned any form of publicity—unlike Shaw. Leyswood, Sussex (1868), certainly Shaw's own work in entirety, was the last to be done during the partnership, and contains features such as the very tall clustered chimneys, elaborate barge-boarded gables, non-structural half-timbering, weathervane, and turret which were to become the hallmark of Shaw's early mature style, for which the term 'Shavian Manorial' has been proposed.[2] The house is also important for its plan in which the main rooms are grouped loosely around a central hall of modest size. Webb was one of the first to adopt this arrangement in his house at Arisaig (1863), but it was Shaw's version that set the pattern. There is, however, strong evidence that Nesfield was the real originator of the Queen Anne, or more accurately, William and Mary revival, first in his Lodge Gate for Kew Gardens (1867), a small commission obtained through his father, and, on a much grander scale, at the remotely situated Kinmel Park, Abergele, *c.* 1866–8.[3] A more sophisticated essay in

[1] For George Devey, an underrated architect, see Walter H. Godfrey, 'The Work of George Devey', *Arch. Rev.* XXI (1907), 22–30, 83–8, 293–306; and 'George Devey, F.R.I.B.A., a Biographical Essay', *R.I.B.A. Jnl.*, 3rd Ser. XIII (1906), 501–25.

[2] H.-R. Hitchcock, *Architecture Nineteenth and Twentieth Centuries* (1958), 209.

[3] Hermann Muthesius, *Das englische Haus*, Berlin, I (1904) 110–11, was one of the first to assert Nesfield's primacy in this respect. The problem is also touched on, a little inconclusively, in the obituary notices for Nesfield in *The Builder*, LIV (1888), 225, 244, 269; by J. M. Brydon, 'William Eden Nesfield 1835–1888', *Arch. Rev.* I (Apr. 1897), 235–47, 283–95, and Bulkeley Cresswell, ibid. II (June 1897), 23–32. More recently: N. Pevsner, 'Richard Norman Shaw, 1831–1912', *Arch. Rev.* LXXXIX

this manner is his Plas Dinam, Montgomeryshire (1872). Shaw was undoubtedly the more gifted and inventive—one might also add, the more ambitious—of the two, but the inspiration is clearly Nesfield's. After the dissolution of the partnership, Shaw continued to design large country houses in a Tudor manner enlivened by his flair for imaginative planning and picturesque grouping of the various elements. The lavishly half-timbered (and completely sham) tile, brick, and stone Grims Dyke, Harrow Weald (1870–2), which he built for Frederick Goodall in a hundred-acre estate, is the second of several houses commissioned from Shaw by wealthy Royal Academicians and is an instructive comment on their taste and prosperity [plate 32A]. The house was purchased in 1890 by W. S. Gilbert, who added a swimming pool. Other town houses for artists were at fashionable Melbury Road, Kensington: No. 8 for Marcus Stone in 1875–6, and No. 11 for Luke Fildes in 1875–7, next came George Boughton's at Camden Hill (1877–8), followed by those for Edwin Long (1878–90), Frank Holl (1881–2), and Kate Greenaway at 39 Frognal, in 1884–5. Rich industrialists soon followed where Academicians led, and Sir William (later Lord) Armstrong, the armaments king, commissioned Cragside, Northumberland, as early as 1870. This is perhaps one of the most dramatically composed of all Shaw's country houses and lies in a particularly rugged hill setting. Shaw's own house, 6 Ellerdale Road, Hampstead, which he built in 1875–6, is notable for its ingenious ground-plan and, like the houses he built for all his clients, is tailor-made to suit individual requirements. Shaw's imaginative use of interior space often involved expensive constructional devices to support loads at first and second-floor levels, but since cost was rarely a critical factor in these private houses, he could indulge his fancy. The Ellderdale Road house,[1]

(Mar. 1941), 41–6, a review of Sir Reginald Blomfield's tendentious *Richard Norman Shaw, R.A.: Architect, 1831–1912* (1940); H. S. Goodhart-Rendel, 'The Country House of the Nineteenth Century', and N. Pevsner, 'Richard Norman Shaw', in Ferriday (1963), 53–70 and 237–46 respectively. This chapter was written before the publication of Andrew Saint's comprehensive monograph, *Richard Norman Shaw* (1976), and Mark Girouard's detailed account, *Sweetness and Light. The 'Queen Anne' Movement 1860–1900* (1977).

[1] Blomfield, op. cit. 41–2, draws attention to Shaw's innovations of ventilated out-

with its sequence of three round-headed bay windows separated by ornamental plaster strap-work panels, repeats a motif first used by him in the New Zealand Chambers, Leadenhall Street, of 1872–4 [plate 32B].[1] This motif, which was to be repeated many times with slight variations by Shaw, is derived from the seventeenth-century prototype of Sparrowe's House, Ipswich, and is one of the signs of that widening of the period of reproduction which Shaw did so much to popularize.[2] The introduction of a building in red brick and plasterwork into an area predominantly built of stone and stucco is symptomatic of a change from the yellow London stock brick to a raw red brick which radically altered the appearance of large areas of the city.

Shaw's earliest important building in London was Lowther Lodge, Kensington Gore (1873–5), now the headquarters of the Royal Geographical Society [plate 33A]. Built of red brick on a once open site, its tall, rather closely set, narrow windows and ornamented Dutch gables set the pattern for the near-by seven-storey Albert Hall Mansions (1879–81), of historical significance as the first massive block of service flats in London of any distinction [plate 33B].[3] Lowther Lodge undoubtedly influenced the design of another class of buildings destined, with the passing of the 1870 Elementary Education Act, to become an important feature of public architecture. John James Stevenson in partnership with Edward Robert Robson, who was architect to the newly established London School Board from 1871 until his retirement from it in 1889, did much to popularize the William and Mary style for schools, not only in London but almost throughout England. An interesting exception to this is the fifty or so excellent Birmingham Board Schools built from 1871 to 1902 by the local

side soil pipes and intercepting traps between house drains and sewer, first used at 6 Ellerdale Road, which foreshadowed the modern system of sanitation.

[1] E. S. Prior in the *D.N.B.* states that they were begun in 1871; they were destroyed in the Second World War.

[2] C. R. Ashbee, *Memoirs*, I (1938, typescript MS. in V. & A.), 46, recalled that G. F. Bodley had said 'that Shaw "based his style" on the "Ancient House" in the Butter Market' at Ipswich. (Entry for 20 Dec. 1887.)

[3] The first block of flats in London was that by Thomas Cundy the Younger in Grosvenor Gardens of 1868.

architects Martin and Chamberlain in their characteristic geo-
metric and very robust Gothic style, for which they used industrial
materials such as red brick, terracotta glazed tiles, and cast iron,
all to a very high standard. Naturalistic Ruskinian decoration
softened the austere lines of these schools, and the Birmingham
School Board probably spent more on its schools than its London
counterpart.[1] Limited budgets and often restricted sites necessitated
a plain but practical standardized design, especially in London with
its very large school population to house. By October 1876, such
was Robson's energetic efficiency that he had built no fewer than
134 of his tall new schools, with forty more in preliminary stages
of construction.[2] One of his best surviving works is Berger Road
School, Hackney (1878). Basil Champneys must also take some
credit for shaping the new L.S.B. style in his prototype Harwood
Road School, Eel Brook Common, Fulham (1873), built for the
Board before Robson assumed full charge of all school planning.
Similarly, Stevenson has a valid claim to be considered one of the
pioneers of 'Queen Anne' in London, where he first used the style
for his Red House, 140 Bayswater Road, in 1871. He asserted his
claim in a paper, 'On the Recent Reaction of Taste in English
Architecture', read at the Architects' Conference of 1874, but, as
we have seen, it was Stevenson's fellow-Scot, Shaw, who became
its most distinguished and influential exponent.[3] The increasing
subtlety and courage with which Shaw manipulated the new
idiom may be seen in the four town houses he built in Queen's
Gate between 1874 and 1890, where the crowded composition and
elaborate early Renaissance detail of the earliest, No. 196, built
for the art collector J. P. Heseltine, gradually gives way to the
spacious, symmetrical elegance of No. 170 (1888), with its heavy
crowning stone modillion cornice, quoins, tall green-shuttered

[1] I am indebted to Mr. James Thompson for this information about the Birming-
ham Board Schools.

[2] Philip A. Robson, 'Edward Robert Robson, FSA. A Memoir by His Son',
R.I.B.A. Jnl., 3rd Ser. XXIV (1917), 92–6; David Gregory-Jones, 'Towers of Learn-
ing', *Arch. Rev.* CXXIII (June 1958), 393–8. See also E. R. Robson, *School Architec-
ture. Being Practical Remarks on the Planning, Designing . . . of School Houses* (1874), for
examples and much technical information on the subject.

[3] Stevenson's paper was reported in the *Architect*, XII (1874), 1.

white-painted wooden sash windows, and imposing Renaissance
doorway surmounted by a broken pediment [plate 34A]. The
epitome, in fact, of Shaw's orthodox Queen Anne style, and it
prepares us for the more ambitious essay in this grand manner at
Bryanston, Dorset, the country house he designed for Lord Port-
man in 1889–90 and which now forms part of Bryanston School.
Here, his model seems to have been Sir Roger Pratt's Coleshill.
No. 185 Queen's Gate (1890, now demolished), was more idio-
syncratic, and combined Tudor-style oriels going up through two
storeys and a stepped Dutch gable on one façade, with a mixture
of Wren-like classical and Tudor motifs on the other [plate 35B].
Shaw's ability to vary designs to please particular clients is also well
demonstrated by the contrasting treatment of Swan House [plate
35A] and Cheyne House (both 1875–7), which adjoin each other
on Chelsea Embankment. In these, as in later houses, his expressive
use of windows as a vital compositional element gave each building
a particular character and was a new trend in nineteenth-century
architecture. The cantilevering forward of the whole façade at
first and second-floor level is a particularly bold constructional
feature of Swan House [figure 1].

 Although Shaw evolved at least three separate styles, they did
not replace each other, for he continued to use the earlier con-
temporaneously with the later ones. His designs for New Scotland
Yard, made in 1886, were for a noble free-standing seven-storey
block faced with Dartmoor granite to the top of the second floor,
and in red brick with Portland-stone dressings and string-courses
thereafter [plate 34B]. Four circular turrets corbelled out from
the corners of the main building enhance the fortress-like air
entirely appropriate to the headquarters of the Metropolitan
Police. It is typical of Shaw that he used here a mixture of classi-
cal motifs in an eccentric, free-thinking manner. His original
monumental conception was spoilt by the addition, from his de-
signs, of an annexe on the south side of 1901–7, seventeen years
after the completion of the first building. He had used alternating
bands of brick and stone, corbelled corner turrets, and elaborate
stepped Dutch gables in his first design for the Alliance Assurance
Building in Pall Mall (1881–3). This was a deliberately ostentatious

work to project a desired image of corporate prosperity. The four large ground-floor windows set in arches of brick-and-stone voussoirs are a florid development of the large windows in the New Zealand Chambers, and the motif is taken yet a stage further in the

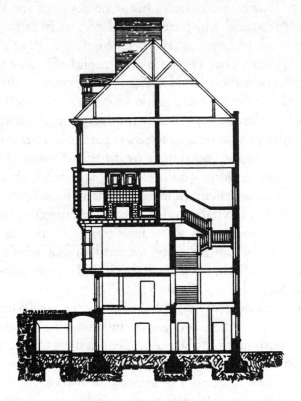

FIG. 1. Richard Norman Shaw: Swan House, 17 Chelsea Embankment, London. 1875. Cross-section showing cantilevering forward of front elevation

second Alliance Assurance Building, which Shaw designed in collaboration with Ernest Newton in 1901–3. Here, heavily rusticated Portland stone arcades replace brick-and-stone arches in a heavy, neo-Palladian baroque stone façade which anticipates the Piccadilly Hotel arcades on Piccadilly and Regent Street, begun two years later and completed in 1908.

The history of the Piccadilly Hotel [plate 36] is bound up with the redevelopment of the Quadrant and is one of the most de-

pressing sagas in English town-planning. The old Quadrant build-
ings by Nash were considered decayed beyond reasonable repair,
and as the leases were falling in, the moment was ripe for change.
A Crown Committee consisting of John Taylor, architect to the
Office of Works, Aston Webb, and John Belcher, unanimously
recommended that Shaw, who had retired from practice in 1900,
be entrusted with the rebuilding of the area of Regent Street
stretching from Piccadilly Circus to Vigo Street, with the excep-
tion of the south-east corner site between the Piccadilly Hotel on
the Piccadilly side and the Circus, for which a building had already
been approved. Shaw's original design can be visualized by extend-
ing the Regent Street façade of the Piccadilly Hotel as a repeated
unit along both sides of the Quadrant. Despite the acclaim it re-
ceived when shown at the Royal Academy in 1906, it was a massive,
unimaginative, and unpractical scheme which angered the shop-
keepers because the huge stone arcades would have severely
diminished the available shop frontages. A more serious criticism
is Shaw's wilful disregard of the original scale of Nash's Quadrant
in favour of much higher units which dictated the size of all
future development.[1] Bowing to the tradesmen's protests, the
Government tried unsuccessfully to persuade Shaw to modify his
plans and the project was held in abeyance until Reginald Blom-
field, one of Shaw's disciples, took up the task of redesigning and
completing the Quadrant after Shaw's death in November 1912.
Work was further delayed while committees deliberated, and then
nothing could be done until after the 1914–18 War.

 Blomfield's solution was 'to treat the [Piccadilly] Hotel in the
Quadrant as the centre of a composition extending from the
Circus to Vigo Street with plainer buildings on either side of
the centre-piece, and pavilions at the two ends, recalling like a coda
the columns in the centre, less the square blocks'.[2] He omitted the
blocks from the columns, which he regarded as an 'unhappy aberra-
tion' of the eighteenth-century Palladians, and substituted Doric

[1] Even now, opinions are divided over the merits of Shaw's Quadrant design.
Hitchcock, op. cit. 220, rates it bold and spectacular, while others, notably Pevsner,
deplore it. Blomfield admired it, but thought it impracticable.
[2] Blomfield, *Shaw* (1940), 65–6.

for Ionic order over the great arches spanning the side streets, interpolating a pedestal course above the arch to avoid an effect of 'crushing the haunches of the arches'. He justified this mixture of the orders in the interests of a convincing appearance of stability. He continued Shaw's main horizontal lines but otherwise felt free to pursue his own design; construction work began again in April 1923 and included new buildings for the County Fire Office (by Ernest Newton) and Swan and Edgar's, all completed by 1930. Blomfield's regret that Shaw was not asked to replan the whole of Regent Street, from Piccadilly to Oxford Circus, is a valid criticism of the Government's haphazard approach to metropolitan planning.[1]

Shaw's conversion to neo-Palladian baroque is a curious development, although one might explain it as a logical progression from his interest in English seventeenth-century architecture. The fact remains that his design for the Quadrant set the style for official British architecture for the next forty-odd years, and paved the way to such monuments to Edwardian and early Georgian Imperial taste as Aston Webb's Admiralty Arch (1906–11), a subtly-oriented triumphal arch on an awkward, twisting site linking Trafalgar Square and the Mall [plate 37B], his remodelling of Edward Blore's eastern façade of Buckingham Palace (1913), and the architectural surround to Thomas Brock's memorial to Queen Victoria (1911) in front of the Palace. Other landmarks on the road to the 'Classical Re-Revival' are John Belcher's picturesque neo-baroque Institute of Chartered Accountants, Great Swan Alley, off Moorgate [1888–93, but largely designed by Belcher's assistant, Beresford Pite, with sculptured figure-reliefs by Hamo Thornycroft and J. A. Stevenson; plate 37A], and a formidable group of buildings in South Kensington. These include Thomas Edward Collcutt's Imperial Institute (1887–93),[1] and three by Aston Webb,

[1] Piccadilly Circus is again the centre of controversy. The late William Holford's scheme, first submitted in 1969, has once again been referred back for modification to accommodate a revised estimate of increased 'traffic flow'. The rape of our cities by the motor-car continues.

[2] Now demolished, with the exception of Collcutt's magnificent central tower, to make way for the new and rather unimaginative Imperial College of Science buildings by Norman and Dawbarn (begun 1959).

the earliest of which is much the most attractive: the main block
of the Victoria and Albert Museum, designed in 1891 and built
1899–1909,[1] the Imperial College of Science and Technology
(1900–6), and the Royal School of Mines (1911–13). In Whitehall,
J. M. Brydon's Ministry of Health, Housing, and Treasury building
on the corner site of Great George Street and Parliament Street
(1898–1900, completed by Henry Tanner), and William Young's
War Office (1898–1907), are competent essays in the Grand
Manner, but Edward W. Mountford's Cornish granite and Port-
land stone Central Criminal Court, Old Bailey (1900–7, sculpture
by F. W. Pomeroy) has been described as one of the best examples
in London of the English neo-baroque, with its echoes of Green-
wich Hospital in the design of the central dome.[2] The most extra-
ordinary blossoming of the style appears in an epic design for the
Oxford Street department store built by H. Gordon Selfridge,
begun in 1908 by R. Frank Atkinson with Daniel Burnham of
Chicago as consultant.[3] This is a five-storey block girt for three of
its storeys by a colossal Ionic order, the columns of which frame
all-glass expanses, except that the floors between each storey are
concealed by metal panels. There is an enriched attic and top
balustrade, and at ground-floor level are large shop windows with
short pillars between, from which rise the enriched shafts of the
giant Ionic columns. The building is a triumphant monument to
trade, well fulfilling Selfridge's declared aim 'that it was the duty
of the great business house to unite beauty with its effort'—and no
effort appears to have been too great to accomplish this. Compared
with the assertive vulgarity of Selfridge's, Stevens and Munt's buff
terracotta façade for Harrods (1901–5), for all its busy small-scale

[1] Webb used elements of the V. & A. design, notably the general grouping and
fenestration of the main façade, in his buildings for the University of Birmingham
(1906–9). Eccentric features are the medieval keep-like central pavilion and turreted
side pavilions reminiscent of the Tower of London, while the campanile ('Chamber-
lain's Folly') is pure thirteenth-century Tuscan.

[2] Pevsner, B. E., *London*, I (2nd edn., 1962), 172; 'The New Sessions House, London',
Arch. Rev. XXI (Mar. 1907), 136–52. For a survey of period revival styles in the
nineteenth century see Pevsner, 'Victorian Prolegomena', in Ferriday (1963), 21–36.

[3] Pevsner, B. E., *London*, I (2nd edn., 1962), 555. The R.I.B.A. possesses a drawing
by Philip Tilden (Ref: X7/25) showing a monstrous tower design for Selfridge's in
Babylonian style.

baroque detailing, has an air of respectable gentility entirely appropriate to Knightsbridge.

Scholarly reappraisals of Renaissance architecture provided invaluable comparative material and propaganda for the neo-classicists, notably Blomfield's two-volume *A History of Renaissance Architecture in England 1500–1800*, published 1897, of which a shortened version was printed in 1900 with a table of correct classical orders. John Belcher and Mervyn Macartney's illustrated survey, *Later Renaissance Architecture in England*, which appeared between 1897 and 1901, was an important formative influence on contemporary building. Finally, Banister Fletcher's *History of Architecture on the Comparative Method*, first published in 1896 and frequently revised ever since, provided an invaluable vade-mecum for the student and a treasure-house for the eclectic. In passing, it is only fair to mention that one of the best books on Gothic architecture, E. S. Prior's *A History of Gothic Art in England*, appeared in 1900. While it is important that domestic architecture was hardly influenced by this classicizing trend until about 1905, some explanation in wider terms of the reaction in official taste is required. There was undoubtedly a resurgence of nationalist sentiment among the major European nations, which in Britain found tangible public expression in the celebration of the Diamond Jubilee of Queen Victoria's accession in 1897—a monarch who had grown in the public's affection and esteem ever since her Jubilee of 1887. A sense of national identity was strongly felt, and the founding of an Imperial Institute in 1887 was intended to focus attention on the great and still growing family of nations under the British crown; an Empire on which 'the sun never set'.[1]

The parallel between Imperial Rome and Imperial England would not have seemed immodest, and what could have been more suitable than an official architecture which borrowed freely from the classical tradition? Nowhere is this imperial grandeur more clearly shown than in Edwin Lutyens and Herbert Baker's Vice-

[1] For the growth of imperialism in the late nineteenth century, see vol. XI of *The New Cambridge Modern History: Material Progress and World-Wide Problems 1870–1898* (1962), particularly ch. XIV, 'Great Britain and the British Empire', by Paul Knaplund.

regal Government Buildings at Delhi (1920–31), plans for which had been begun in 1911 and, as it happened, were destined to be a brilliant imperial swan-song. There were other points of similarity. Material prosperity, a love of lavish display and palmy exuberance characterized court and social life during Edward VII's reign, which often bordered on gross vulgarity and provoked the savage satire of Max Beerbohm in his *Edwardyssey* of 1903 [plate 72A]. The way this nationalism worked adversely in the pictorial arts has already been mentioned, and its baneful influence undoubtedly stifled any adventurousness in architecture after 1900. There is also the English character to be reckoned with, and foreign-born observers of the phenomenon have remarked on the essential conservatism and distrust of the unconventional that has shaped our political and social institutions, at least since the eighteenth century.[1] A gift for understatement has also been detected, though this may be of comparatively recent date, and it might at first seem difficult to reconcile this characteristic with a taste for the neo-baroque Imperial style, until one remembers that English interpretations of it are remarkably controlled by comparison with dramatic continental examples such as Joseph Poelaert's Law Courts in Brussels (1866–83). There is another factor which, taken with the cultural climate of the day, enabled the forces of reaction to triumph: there simply was no young British architect of overriding imaginative genius and courage to lead his colleagues forward. Gifted men there certainly were, and a few pioneer works in a recognizably twentieth-century style exist, but traditionalism exerted the greater influence for the first thirty years of this century.

If the English temperament was predisposed to conservative traditionalism, how was it that this country's pre-eminence in domestic architecture was such that the German government sent the architect, Hermann Muthesius, as a special attaché to its Embassy in London in 1896, expressly charged to study the new

[1] N. Pevsner, *The Englishness of English Art* (1956, 1964 edn.), 193–206. But Professor Pevsner is careful not to push his interpretation of national character too far, pointing out the contradictions and complexities which would invalidate too simplistic an approach.

developments in this field?[1] The answer lies in the comparatively slow and unspectacular nature of the evolution of the new style, which was itself rooted in a sensitive reinterpretation of English traditional domestic architecture of the sixteenth and seventeenth centuries. A significant landmark was Philip Webb's Red House, Upton, Bexley Heath, built for William Morris in 1859 in a style refreshingly devoid of conscious period revivalism, though influenced by the country parsonages built by his master, Street, and by Butterfield. An exact contemporary of Shaw, Webb, who refused to undertake work he could not personally superintend in every detail, was a much less prolific builder, and his importance lies chiefly in his work for Morris & Company, and for the great improvement in quality of design and craftsmanship in the applied arts that he helped to bring about by his own teaching and practice.[2] Webb had a profound knowledge of building techniques and the proper use of materials, particularly in relation to local traditions, which also enabled him to make additions to older houses in a sympathetic manner. He, as much as anyone following the spirit of Pugin's *True Principles*, can be regarded as the first exponent of what has come to be thought of as a modern concept —'fitness for purpose'. His wisdom and integrity made him an invaluable professional adviser to the Society for the Protection of Ancient Buildings, of which he was a founder member, and he was the guiding force in matters of practical building procedure. In 1890 he pioneered a remarkable piece of patient conservation work on the tower of St. Mary's, East Knoyle, Wilts., which involved the complete reconstruction of the inner core of the tower, section by section, in such a way as to leave the outer skin intact. The technique has frequently been repeated in more recent times. Webb's most famous country house, Clouds, East Knoyle, some twenty miles east of Salisbury, epitomizes the austere, highly per-

[1] The first of Muthesius's major publications on English architecture, *Die englische Baukunst der Gegenwart. Beispiele neuer englischer Profanbauten*, 2 vols., Leipzig and Berlin (1900), provides a detailed and well-illustrated survey of the period hardly superseded today.

[2] George Jack, 'An Appreciation of Philip Webb', *Arch. Rev.* XXXVIII (July 1915), 1–6; W. R. Lethaby, *Philip Webb and his Work* (1935); John Brandon-Jones, 'Philip Webb', in Ferriday (1963), 249–65.

sonal handling of disparate elements of which he was capable. Commissioned by the Hon. Percy Wyndham, M.P., late in 1876, Webb abandoned his first design [plate 39A], and the plans and contract were not approved until 1881, after which construction work took four years, 1883–6, to complete. A disastrous fire in January 1889 destroyed much of the interior and Webb repaired the damage in 1890–1.[1] A complete set of working drawings for the house which survive at the Victoria and Albert Museum are beautiful objects for their own sake—delicate, lucid, and brilliantly practical. The same qualities appear in his drawings of plants, birds, and animals.

Clouds is a monumental, sandstone house with a brick attic storey and dormers in a tiled roof. The south-west front [plate 38], with its spacious ground-floor balcony, originally had a typical Webb feature of three gables with black weather-boarding above the sash windows, which were themselves set in alternate bands of brick and stone. Ornament has been kept severely simple, and a subtle rhythm of repeated motifs in modified form, such as the segmental arched window recesses and line of arched corbels supporting the cornice at first-floor level, are felicitous inventions which unify the whole façade. The turrets on the east and west fronts are alternately square and hexagonal in plan with pointed-arch window recesses in the bays to provide variety in a predominantly round-arch arcading. The white-painted wooden-paling garden fence on the south-west front was deliberately introduced by Webb for its 'cottagy' look, since it would enhance the scale and dignity of the house far more effectively than a stone balustrade and was much cheaper to build. The interior of Clouds is centred around a main hall with a first-floor gallery set over the recessed bays, divided by pillars on the ground floor, the whole area lit by a teak-framed lantern in the centre. The dining-room was simply panelled for two-thirds of its height with a carved frieze of foliage-patterned panels echoed in the ornamental plasterwork of the coved ceiling. The room is divided by an open screen

[1] In 1938 the house was considerably altered and mutilated—on the SW. front, the service wing was demolished and the interior of the great hall spoilt by green pantiling (see Pevsner, B. E., *Wiltshire* (1963), 206).

formed by two arches, and a square pillar set back a few feet from the windows. Standen House, East Grinstead, which he designed for J. S. Beale in 1891–2 and completed in 1894, is a more informal type of house developed from Red House and Joldwynds, near Dorking (1873), and its square water tower and weathervane (the latter essential to any. country house in Webb's view) at the east end were as much practical as decorative features [plate 39B]. A solid, honest workmanlike air distinguishes Webb's houses from the more exuberant, often playful style of Norman Shaw.

Ernest George is now chiefly remembered for his extensive development of town houses on the Cadogan estates between Knightsbridge and Sloane Square during the 1880s. Shaw's Dutch Renaissance style was his starting-point, although he had seen the traditional continental examples first-hand on his regular annual sketching trips abroad, and used these numerous volumes of sketches as cribs for his own work. His best-known partner was an able, well-connected building contractor, Harold A. Peto, who worked with him from 1871 until his retirement in 1893. Together they built large and expensive country houses in the West Country and Home Counties using traditional Tudor or Jacobean revival styles, but treated in an unusually romantic, imaginative way. George and Peto enjoyed tremendous popularity among the very rich, fashionable society of the day, commissions flowed in, and their office became a much-sought-after training-ground. Among their more distinguished pupils and assistants were Edwin Lutyens, Herbert Baker, J. J. Joass, and E. Guy Dawber. Examples of George and Peto's commodious town mansions in red brick, often rich in pink and brown terracotta or rubbed brick early Renaissance ornamentation and elaborate Dutch or Flemish gables, can be seen in Collingham Gardens, Harrington Gardens, Cadogan Square, and Mount Street.[1] Two of the best-known are the adjoining houses they built for W. S. Gilbert at 39 Harrington

[1] In Collingham Gardens are the following houses by them: Nos. 1–5, 6, 7, 8, 12 & 13, 14, 15, 16, 17, 18 & 19 (1881–7); in Harrington Gardens: Nos. 35, 37, 39, 41, 43 & 45 (1882–3); two in Cadogan Square, Nos. 52 and 50 (1886); and the following in Mount Street: 5 (1889), 110–13 (1885–90), and 105–106 (1889). An early work in South Audley Street is the shop for J. Goode (1875–90).

Gardens (1882) and Ernest Cassell, the banker, at 41 [1883, plate 40]; the Gilbert House is in elaborate, light-hearted Nuremberg medieval or Meistersinger style, appropriate to the composer of the Savoy Operas. George and Peto had many lesser imitators and the area bounded by Sloane Street, Brompton Road, Cromwell Road, and the King's Road has large outcrops of tall red-brick mansions in 'Pont Street Dutch', to use Osbert Lancaster's apt phrase. An important consequence of this development of highly individualistic house façades was the end of the traditional unified terrace block.

One of Shaw's most influential followers in domestic architecture was Ernest Newton, who entered Shaw's office as a pupil in 1873 and remained there six years, for the last three of which he was Shaw's senior assistant. While with Shaw he met a diverse but gifted group of fellow students which included Edward S. Prior, Mervyn E. Macartney, and Gerald C. Horsley. He later came into contact with William Richard Lethaby, who entered Shaw's office in 1879 and had become chief draughtsman by the time he left to set up independently in 1889.[1] From the discussions of this group, known at first as the St. George's Art Society after the Bloomsbury church, was born the Art Workers' Guild. Newton afterwards succeeded Macartney as Chief Editor of the *Architectural Review* from 1920 to 1922, and was himself followed in that post by his son, Lieut.-Col. W. G. Newton. It was Shaw who taught Newton and his contemporaries to regard architecture as an art and mode of personal expression rather than a dry professional exercise. Nor was this distinction merely academic, for during the 1880s and 1890s strong opposition was aroused by the attempts of the R.I.B.A. to obtain Parliamentary sanction to enforce the examination and registration of architects. The R.I.B.A. had first proposed that architects be registered as early as 1854, but without success, and in March 1891 a new Bill was presented to Parliament which, if passed, would have had the effect of making architecture a closed profession accessible only to those who, by passing suitable examinations, could show a generally

[1] Godfrey Rubens, 'William Lethaby's Buildings', in Service (1975), 130-41, is the most recent study of the architect.

acceptable level of professional training and competence. The 'Registrationists' looked to the organized professions of Divinity, Law, and Medicine in support of their argument that only good could come of their attempts to raise the standards of professional practice. The Anti-Registrationists, led by Shaw, took the view that architecture was above all an art and as such could not therefore be taught and assessed by a system based entirely on examinations. They feared also that architectural standards would suffer from too rigid a distinction between it and the sister arts of painting and sculpture, and that the valuable cross-fertilizing process between architect and artist would be irretrievably lost. It was an argument directed more to the emotions than to the intellect and doomed to ultimate failure because it ignored the increasing complexity of modern building at all levels: social, legal, commercial, as well as technical.[1] The dichotomy between architecture and the sister arts was already beginning to show itself at this time (the split between architect and engineer had already occurred much earlier in the century), and has become even more acute in our own day, despite many brave attempts to bridge the gulf. Some of the arguments against registration appear in a letter to *The Times*, 3 March 1891, signed by Arthur Blomfield, John Sedding, T. G. Jackson, Norman Shaw, Alma-Tadema, and Burne-Jones, to which was added a memorandum addressed to the President and Council of the R.I.B.A. signed by twenty-three members of the Institute, twenty-two non-members, and twenty-four artists (including twelve R.A.s and A.R.A.s). Newton, Prior, Macartney, E. J. May, Horsley, and F. M. Simpson resigned their membership immediately. Shaw, who twice refused the Gold Medal of the R.I.B.A., was supported in his campaign by some of the most distinguished architects of his day, such as Bodley, Webb, Butterfield, Champneys, and Lethaby. The Bill failed to obtain a second reading and the profession had to wait until the passing of the Architects (Registration) Acts of 1931 to 1938, administered jointly by the Architects Registration Council of the United

[1] R. Norman Shaw, R. A., and T. G. Jackson, A.R.A. (eds.), *Architecture: A Profession or an Art. Thirteen Short Essays on the Qualifications and Training of Architects* (1892), presents the Anti-Registrationists' views held by Shaw and his associates.

Kingdom and the R.I.B.A., before gaining its legitimate status—but in practical terms the battle had been won by the turn of the century. The concept of the architect as pre-eminently 'a man of affairs' was triumphant.[1]

Throughout Newton's work runs a vein of quiet sanity and simplicity, with an intelligent appreciation of the potentialities of the site of each of his buildings. He is responsible for introducing neo-Georgian into domestic architecture and it appears fully developed in his *A Book of Houses* of 1890, consisting mainly of small suburban houses, followed by *A Book of Country Houses* in 1903.[2] He represents an undramatic, but no less revolutionary, aspect of the movement towards a modern style. That his manner has subsequently been imitated countless times by lesser men all over the country is a tribute to its freshness, although the very proliferation of the style now makes it harder for us to appreciate the achievements of its originator—for all too often it has become in less inspired hands the refuge of official and civic timidity in architectural taste. Newton's early designs are either simplified Norman Shavian half-timbered country houses, or closely follow his Queen Anne style[4]—but he strikes an individual note in his Chapel for the House of Retreat, Lloyd Square, Clerkenwell, built in 1891 (bombed in 1941), and in St. Swithun, Hither Green, designed in collaboration with Lethaby in 1892. In both churches a much simplified form of Decorated Gothic is used, and a high standard of wood-carving appears in the discreetly yet richly ornamented

[1] For a general survey see Frank Jenkins, 'The Victorian Architectural Profession', in Ferriday (1963), 39–49. In connection with this dispute, it is interesting to see that issues of the *Architectural Review*, founded 1896, were originally sub-titled '. . . a magazine for the artist, archaeologist, designer and craftsman'. By 1908 this had become '. . . for the Artist & Craftsman', and from 1913 onwards '. . . a magazine of architecture and decoration'. This last sub-title was dropped in January 1950.

[2] See also Ernest Newton, 'Die Architektur und das englische House', in *Kunst und Kunsthandwerk*, Ier Jahrg., Vienna (1898), 164–76, an early statement of the architect's credo, in which he advocates adaptation of traditional skills to the machine age while remaining true to the basic principles underlying all good architecture, i.e. a natural fitness for individual function, as displayed in the English home—'Simplicity is for us necessity'.

[3] Ernest Newton, *Sketches for Country Residences: designed to be constructed in the Patent Cement Slab System of W. H. Lascelles* (1882), includes fifteen original designs and one house by Norman Shaw.

screens for the beechwood gallery and side chapel in the House of Retreat added in 1899.[1] Certain characteristic features begin to appear frequently in Newton's designs by about 1890, such as the curved or pentagonal bay window running up two storeys and punctuated by bands of decorative, beaten metal panels, or, if confined to ground-floor level, domed over in lead. Semicircular porticoes with Tuscan or Ionic columns, sometimes with a balcony over, give a satisfying gentle undulating rhythm to his façades. Steep Hill, Jersey, of 1899–1900 [plate 41B], with its white rough-cast walls, green shutters, and balcony, is designed for a particularly sunny location; it nicely blends a neo-Georgian symmetrical garden front with a more flexibly planned entrance-front. Six years later, Newton built Ardenrun Place, Surrey, which is the mature, archetypal neo-Georgian house in Sussex stocks with Portland-stone dressings, complete with cupola, 'Palladian' dormers, and formal gardens. The entrance-hall and staircase are lavishly embellished with carved walnut and limewood panelling, and fluted Ionic pilasters of almost Kentian gravity grace the vestibule and first-floor landing.

Lethaby, a year younger than Newton, is undoubtedly chiefly remembered as a theorist and teacher, for his work in the Arts and Crafts Movement, and for his scholarly books on medieval architecture, of which the most important was *Medieval Art from the Peace of the Church to the Eve of the Renaissance, 312–1350*, first published in 1904. In this book, Lethaby was the first English scholar to give proper emphasis to the formative role of Byzantium and the Middle East on western art of the Romanesque and Gothic styles.[2] It was a prophetic reappraisal fully justified by the researches of later scholars. In 1894 Lethaby became the first Principal of the L.C.C. Central School of Arts and Crafts, where he introduced a programme of workshop training with all the latest equipment to make it one of the most progressive European art schools of its

[1] Illustrated in Sir R. Blomfield and W. G. Newton, *The Work of Ernest Newton, R.A.* (1925), 23–5.

[2] See Editor's Preface by David Talbot Rice to the revised third edition of Lethaby's *Medieval Art* (1949), xii–xiv. In 1894 Lethaby published, in collaboration with H. Swainson, *The Church of Sancta Sophia, Constantinople: a Study of Byzantine Building*, which also was a pioneer work of great importance.

day, and in 1900 he was the first Professor of Design to be appointed at the Royal College of Art. He succeeded J. T. Mickelthwaite as Surveyor of Westminster Abbey in 1906, and in his
twenty-two years of office he halted the tide of nineteenth-century-
style 'restoration', and substituted an intelligent, sensitive programme of conservation, as befitted a loyal member of the Society
for the Protection of Ancient Buildings. His aim was to preserve
the Abbey by constant daily care, and so avoid the massive
periodical restorations that he believed were so harmful to the
homogeneity of ancient buildings, and he initiated the skilful
cleaning that revealed much of the original colour of monuments
and fabric, for so long hidden under centuries-old grime. His
two books on the Abbey, published in 1906 and 1925, remain
standard works to this day. One of his most interesting country
houses is that built in 1891 for Lord Manners at Avon Tyrell,
near Christchurch, Hants [plate 41A], where he uses different
coloured bricks for a decorative chequerboard effect on the
garden-front exterior, a motif that was later used by Lutyens on
a much larger scale in his council estate flats (the Grosvenor
Housing Scheme) between Page and Vincent Streets, Westminster
(1928–30). In 1900, Lethaby, in collaboration with J. L. Ball,
completed the Eagle Insurance Buildings in Colmore Row,
Birmingham [plate 42A], which has been regarded as a highly
original and sensitive solution for its date. The large ground-floor
windows echo Shaw's Tudor tradition; the chamfered piers and
alternating round and pointed top arcading come from Webb.
But to this Lethaby adds the extremely simple fenestration of the
first and second floors, and the plain discs ornamenting the top
parapet. He has eliminated all irrelevant ornamentation, yet even
so, the general effect is curiously reminiscent of a fifteenth-century
Venetian palazzo façade.[1]

Lethaby was surprisingly modern not only in his writings on

[1] N. Pevsner, 'Nine Swallows—No Summer', *Arch. Rev.* XCI (May 1942), 109.
The façade is now marred by a modern signboard which covers the original
carved inscription. J. L. Ball later became the first Director of the newly-established
Birmingham School of Architecture in 1909 until the First World War (see
obituary, *R.I.B.A. Jnl.*, 24 February 1934).

medieval art but also on contemporary artistic and social problems —or, to put it another way, some of the solutions he advocated between 1910 and 1920 remain as valid for us today.[1] His essays, *Form in Civilisation: Collected Papers on Art and Labour* (1922), contain much practical common sense expressed in an enviably crisp, rigorous manner. He had a much clearer grasp of the possibilities of modern design than Voysey, and did not share Voysey's obsessive insularism. He could recognize that the Germans, in forming the Deutscher Werkbund in 1907, had profited from the English Arts and Crafts Movement in their characteristically efficient way. While admiring Ruskin and Morris, he realized that the machine age had to be accepted and come to terms with: 'A motor-car is built with thought for 'style', that is, finish and elegance, but it is not built to look like a sedan chair or a stage coach.'[2] Again, from the same essay: '"House-like" should express as much as "ship-shape". Our airplanes and motors and even bicycles are in their way perfect. We need to bring this ambition for perfect solutions into housing of all sorts and scales.' And this antedates Le Corbusier's *Vers une architecture* by nearly two years. In other essays he urges the need for everyone to be visually alert and aware of their urban surroundings as a necessary first step towards ameliorating the horrors and ugliness there, and he specifically attacks the unseemliness of advertising hoardings, the grime of railway and underground stations, and the mindless festooning of buildings and streets with telephone and electricity cables—or, in modern parlance, 'wirescape'.

Charles Francis Annesley Voysey, Lethaby's contemporary, was a brilliant yet paradoxical man, and certainly one of the most inventive designers of his day. All his mature work has an unmistakably unique character and it seems entirely appropriate that Voysey should have written his artistic credo under the title *Individuality*

[1] Even Lethaby had his blind spots; see Reyner Banham, *Theory and Design in the First Machine Age* (1960), ch. 4: 'England: Lethaby and Scott', 44–67. The 'Scott' is Geoffrey Scott, author of *The Architecture of Humanism* (1914).

[2] Ch. IV, 'Housing and Furnishing', in *Form in Civilisation* (1922), 36; the essay was first published in *Athenaeum*, 21 May 1920. For a detailed examination of Lethaby's theoretical writings see Robert Macleod, *Style and Society. Architectural ideology in Britain 1835–1914* (1971), 55–67.

(1915). His father was an Anglican clergyman whose unorthodox but strongly-held views earned him the deprivation of his living, and he imparted to his son much of his own pronounced individualism. Annesley Voysey, Charles's grandfather, was a noted engineer–architect, bridge-builder, and lighthouse designer. After five years articled to J. P. Seddon, Voysey briefly assisted Saxon Snell before joining George Devey's staff in 1880, where he widened his practical experience, and absorbed much of Devey's interest in late Gothic and Tudor domestic architecture. Two years later, he set up independently and, in default of more substantial commissions than the alteration and decoration of existing buildings, he followed Arthur Mackmurdo's example and technical advice and began designing fabrics and wallpapers. He sold his first design to Jeffrey & Co. in 1883, and it was immediately successful; by 1893 he had obtained a regular contract from Essex & Co. for twenty designs a year, all to be paid for by the company without the option of refusing designs they could not use.[1] Voysey's outlook was Ruskinian: 'Simplicity, sincerity, repose, directness and frankness are moral qualities as essential to good architecture as to good men'; and in *Individuality* he quotes Ruskin's precept, 'Good taste is a moral quality'.[2] For one so insular— he once suggested that no man should travel abroad for study until he was forty five years old[3]—it is ironic that his designs should have been among the most widely disseminated and best known on the Continent, particularly in Germany and Austria. From 1893, such periodicals as the *Studio*, *Pan* (founded 1895), *Dekorative Kunst*, *Art et décoration* (both founded 1897), *L'Art décoratif* (founded 1898), *L'Art moderne* (Brussels, begun 1881), and *Moderne Bauformen* (Stuttgart, 1902) all contained a number of articles either entirely devoted to Voysey or mentioning him

[1] John Brandon-Jones, 'C. F. A. Voysey 1857–1941', *Architectural Association Journal*, LXXII (May 1957), 239–62; and the same author's essay on Voysey in Ferriday (1963), 269–87; Judith Bock, 'The Wallpaper Designs of C. F. A. Voysey' (1966), unpublished M.A. thesis submitted to New York University, N.Y.

[2] Brandon-Jones, op. cit. 239, and *Individuality*, 22.

[3] C. F. A. Voysey, 'Patriotism in Architecture', *Architectural Association Journal* (June 1912), 21.

as an important member of the new movement in English architecture and design. Voysey, in pleading that it would be sufficient for a student to have a thorough knowledge of his native architectural tradition rather than ape foreign styles of which he could have but superficial knowledge, had to overstate his case, and ignore the beneficial formative influence of foreign ideas on earlier periods of English architectural history. None the less, in 1912 he had good cause to view with dismay the prevalence of Edwardian baroque, and later considered that the desertion to neo-Palladianism of Lutyens, whom he greatly admired, was a serious obstacle to the establishment of a genuine English architecture.

Voysey's early style owed much to Devey and, at one remove, to Norman Shaw, whom he came to know through the Art Workers' Guild. The first house he designed for himself in 1885, although not built, was a two-storey, half-timbered house, incorporating a top-lit gallery on the ground floor. The walls were buttressed, with Tudor-style mullion windows and depressed arch doorway. (Voysey greatly admired Pugin for his inventiveness and wide knowledge of Tudor details.) It was not until 1891 that the characteristics of what was later to become Voysey's mature style first appear in a house built for J. Wilson Forster at 14 South Parade, Bedford Park [plate 42B]. The first design, made in 1888 and fairly conventional, was never carried out, and a note on the drawing for the second design, published in the *British Architect* in September 1891, shows that actual building had not then begun.[1] It is a remarkable three-storey house: its plain white-painted roughcast walls and blue doors and wrought-iron window frames stand out among the prevailing red brick and white-painted woodwork of Bedford Park. The subtly battered walls, wide overhanging eaves with gutters supported on delicate wrought-iron brackets, and low-pitched hipped roof set off by a high chimney-stack, the wide horizontal bands of casement windows, and extremely simple

[1] Brandon-Jones, op. cit. 250. The contract price was £494. 10s. Such was the revolutionary nature of its simplicity that the architect had to prepare no fewer than eighteen sheets of contract drawings for the house to prevent the contractor from putting in all the usual ovolo mouldings and stop chamfers.

mouldings all make the house took taller and more imposing than
it actually is. Once established, Voysey's style underwent no great
change in essentials but developed in subtlety and complexity of
detail, though never to a point where his basic conception of
simplicity and fitness ('a Divine Law') would be violated. Certain
practical innovations, some recently rediscovered by present-day
architects, are common to all his houses: cellars are eliminated to
prevent cold, damp air spaces below the ground floor; fireplaces
are fed with draughts from the outside of the house to avoid floor
draughts in a room; air flues are placed alongside smoke flues to
provide a compact, efficient system of ventilation (this feature
may be seen in many of his working drawings); low-ceilinged
rooms, properly ventilated, cost less to heat and are more intimate
in character; wrought-iron casements set in stone have the advan-
tage of greater durability over wooden frames, are almost rustless,
and less likely to rattle.[1] Voysey said that he learned from the work
of Bodley, Burges, Godwin, and Mackmurdo that no detail of
a building was too small to merit an architect's closest attention.
The ground-plan of the Forster house has the simple practicality
of a Regency town house, and it is significant that at about this time
Voysey moved to 11 Melina Place, St. John's Wood, the plan of
which suggested to him the solution of a side entrance with a wide
hall for a house built, as was Forster's, on a long narrow site.
Although Voysey insisted on using only the finest materials, he
co-ordinated ground and first-floor plans so that the partition
walls could be taken up through both storeys and also support the
roof timbers in order to simplify construction and reduce building
costs. It was his practice to supervise all the details himself, to draw
all the plans and elevations and only allow his pupils to copy his
drawings, although he gave them full opportunity to learn all the
routine of an architect's office.

Radical though the Forster house was, its design owed some-
thing to two important prototypes, namely Shaw's second house
for Edwin Long, R.A., at 42 Netherhall Gardens, designed and
built in 1887–8 (now destroyed), and Mackmurdo's design, 'House
for an Artist', published in volume three of *Hobby Horse*, October

[1] Brandon-Jones, op. cit. 249–51.

1888.[1] The elegant use of simplified classical motifs in Mack-murdo's house, its beautiful proportions, and compact plan un-doubtedly impressed Voysey, and Shaw's subtle playing-off of windows against large areas of plain wall also finds an intelligent echo in the Forster house. Mackmurdo had specified cement roughcast over brick, a favourite rendering used extensively by Voysey. Annesley Lodge, Platts Lane, Hampstead, which Voysey built for his father in 1895, with its clean lines, buttressed walls, and unbroken roof line (the gutter brackets have been dispensed with), looks back a little to The Cottage, Bishop's Itchington, c. 1888-9, and forward to the houses of the 1900s, one of the most important of these being the architect's own house, The Orchard, at Chorley Wood, Herts., of 1899 [plate 43A]. In these later houses the roofs are pitched more steeply, usually at fifty to fifty-five degrees, often with two cross gables and a stepped gable extending down to first-floor level over the kitchen and offices. Sometimes the roof seems almost to dwarf the house, an effect accentuated by the battered walls which soften the junction between wall and roof. Voysey's houses always appear to nestle firmly into the sur-rounding countryside, and one of the most successful of his country houses, Broadleys on Lake Windermere (1898), is a triumphant blend of artefact and nature. Their interiors are simple, white-painted rooms, with tapered door-frames and newel-posts; fire-places, hinges, and furniture are frequently decorated with varia-tions on Voysey's favourite heart-shaped motif.[2] Only a few of the rooms are papered, and these usually to a very low frieze about one-third of the height from ceiling level. Apart from the factory for the wallpaper firm of Sanderson's at Chiswick (1902) and the shop for Atkinson's in Old Bond Street (1911, now demolished), Voysey was almost exclusively preoccupied with private house building and the redesigning and decorating of a few City offices; none of the competition designs he entered was successful,

[1] Pevsner, 'Richard Norman Shaw, 1831-1912', *Arch. Rev.* LXXXIX (Mar. 1941), 46; and Pevsner, 'A Pioneer Architect—A. H. Mackmurdo', *Arch. Rev.* LXXXIII (Mar. 1938), 141-3.
[2] For Voysey's remarks on furniture see 'Furniture: Domestic and Ecclesiastical', *R.I.B.A. Jnl.*, 3rd Ser. I (Apr. 1894), 415-18.

although those for the new Government Buildings, Ottawa (1913–14), are an interesting exercise in Tudor Gothic. By the First World War, Voysey had begun to be out of fashion; his strongly-held views and his refusal to work for clients whom he felt were in less than complete sympathy with his ideas contributed to his declining popularity. As he grew older, he vehemently repudiated any suggestion that he was a pioneer of modern architecture: '. . . I make no claim to anything new. Like many others, I followed some old traditions and avoided some others. I made the most of my roofs, seldom, if ever, making them of a less pitch than 55 degrees. Steel construction and reinforced concrete are the real culprits responsible for the ultra-modern architecture of today.'[1] He saw himself as a reformer not an innovator.

Mackay Hugh Baillie Scott is an interesting link between the English modern movement represented by Voysey and Lutyens, and the Scottish advance guard led by Charles Rennie Mackintosh. Himself of mixed Scottish and Huguenot descent, he was educated in England, and after completing his articles with Colonel C. E. Davis, the City Architect of Bath, settled at Douglas, Isle of Man, by about 1889.[2] His early work is in the local stone tradition of the island, although he did collaborate with J. L. Pearson on St. Matthew's Church, Douglas, and in the later 1890s exhibited at the Royal Academy designs for houses at Bexley, Windermere, and Wantage. In 1902 he moved to Fenlake Manor, Bedford. His first published design was for 'an ideal suburban house', which appeared in the *Studio*, January 1895, and was subsequently built at Bexton Croft. Neither exterior nor interior are particularly remarkable, but the plan, on the other hand, shows the three main ground-floor rooms, Drawing Room, Hall, and Dining Room, linked *en suite* by wide screen doors which can be opened to provide

[1] C. F. A. Voysey, 'Ultra-modern Architecture', letter to the Editor in *Architects' Journal*, LXXXI (14 Mar. 1935), 408.

[2] John Betjeman, 'M. H. Baillie Scott, F.R.I.B.A.: An Appreciation', *Studio*, CXXX (July 1945), 17; Nicholas Taylor, 'Baillie Scott's Waldbühl', *Arch. Rev.* CXXXVIII (Dec. 1965), 456–8. See also Raymond Unwin and M. H. Baillie Scott, *Town Planning and Modern Architecture at the Hampstead Garden Suburb* (1909), and James D. Kornwolf, *M. H. Baillie Scott and the Arts and Crafts Movement: Pioneers of Modern Design* (1972).

one long room [figure 2].¹ This feature anticipates the 'open plan' solution now widely used in modern houses, and reappears in many of Baillie Scott's early designs, notably in his work for

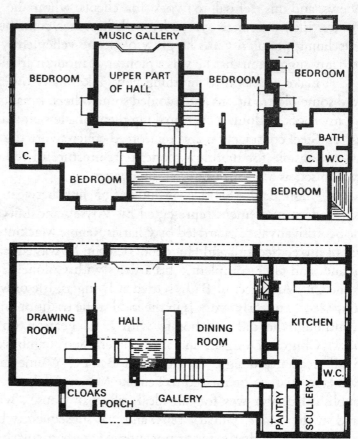

FIG. 2. M. H. Baillie Scott: 'An Ideal Suburban House' (Bexton Croft)
Ground and First Floor Plans

Hampstead Garden Suburb. The most distinguished example is The White House, Helensburgh, near Glasgow [1900; plate 43B]. Externally, The White House is a development of Blackwell House, Lake Windermere, but simplified and with cleaner lines. The battered chimney-stacks recall Voysey, as do the long, narrow bands of stone-framed casement windows. The rooms were fur-

¹ Kornwolf, op. cit. 39–42, 44–7, 104–9, also discusses the possibility of American vernacular architecture as a formative influence on Scott in relation to Bexton Croft.

nished by George Walton of Glasgow, and, while still a little ob-
sessed with peasant cottage beams in the dining room, elsewhere
Baillie Scott worked with a lighter, more elegant touch. His re-
discovery of the hall as the central multipurpose circulating space
of the modern house is an adaptation of the continental plan, and
would have been known to the Adolf Loos Peter Behrens circle
of architects at least by 1904, if not from Scott's *House for an Art
Lover* of 1901. In America, Frank Lloyd Wright was evolving the
'open plan' house between 1897 and 1900, but his work was not
published in Europe until 1910.

Baillie Scott's excellent furniture designs will be discussed later,
but his commission from the Grand Duke of Hesse to redesign
and redecorate the Palace at Darmstadt in 1898 must be mentioned
here as evidence of his growing international reputation. The
climax to his career came in 1901 with his prizewinning design
for a *House for an Art Lover* [plate 44A] in a competition promoted
by the German periodical, *Zeitschrift für Innendekoration*, which
was afterwards published as a separate folio volume by the *Zeit-
schrift* editor, Alexander Koch of Darmstadt, in 1901. Mackintosh's
much more distinguished and controversial *House for an Art Lover*
[plate 44B], was in fact preferred by the panel of judges, but
because Mackintosh had failed to comply with the competition
conditions, he could only be awarded second prize—although his
entry was also published by Koch in 1902.[1] In comparison with
the Mackintosh entry one can already see an unfortunate penchant
on the part of Baillie Scott for whimsical decoration in bright
purples, greens, and orange, in a brasher version of the William
Morris style. While this is not entirely absent from Scott's first
book of designs, *Houses and Gardens* (1906), they are much

[1] H. Muthesius, *Meister der Innenkunst I : Baillie Scott, London, Haus eines Kunst-
freundes* (1901); and Muthesius, *Meister der Innenkunst II : Charles Rennie Mackintosh,
Glasgow, Haus eines Kunstfreundes* (1902), both published Verlag Alex: Koch, Darm-
stadt. Robert Judson Clark, 'J. M. Olbrich 1867–1908', *Architectural Design*, XXXVII
(Dec. 1967), 568, refers to the official report of the competition for evidence of the
judges' preferences, but Kornwolf, op. cit. 216–38, discusses the matter in greater
detail and quotes from the judges' reports. Baillie Scott houses were built in Germany,
Switzerland, Italy, Poland, Russia, Austria, Rumania, and America. He was extremely
prolific, and for several years up to 1914 often had as many as thirty houses on hand
at a time.

superior to those in a later volume which he published in collaboration with his partner, A. Edgar Beresford, *Houses and Gardens* (1933). Here there is a lamentable decline into 'Anne Hathaway Tudor', and many of the cottages seem to anticipate, no doubt fortuitously, the architectural fantasies of Walt Disney's popular *Snow White and the Seven Dwarfs* (1938). Baillie Scott had developed his gift for intelligent interior planning at the expense of the external coherence of his houses, without any compensating originality.

If one seeks an heir to Norman Shaw who was his equal in every way, then the choice must fall on Edwin Landseer Lutyens, some of whose most original houses were designed before 1914.[1] A delicate child, he received little formal education, but early showed an artistic talent, and in 1885 entered the Royal College of Art (as it later became). After two years there he became a pupil of Ernest George, in whose office he remained a little under two years before setting up for himself at 6 Gray's Inn Square. His new office was not far from Philip Webb's, with whose buildings he became acquainted at about this time. While his greatest enthusiasm was reserved for Norman Shaw, Webb's integrity and freshness must also have appealed to him. His first important house was Munstead Wood, near Godalming, built in 1896 for his cousin, Miss Gertrude Jekyll, well known as a landscape gardener in her own right and an exponent of the herbaceous-cum-formal type of garden. She was instrumental in securing several commissions for Lutyens in Surrey, and collaborated with him over the gardens of various of his major houses elsewhere. Already, in Munstead Wood, Lutyens's highly personal style had attained great technical assurance, and was the harbinger of a wonderful group of romantic country houses, including six begun in 1899, four of them in

[1] (Sir) Lawrence Weaver, *Houses and Gardens by E. L. Lutyens* (1913); Robert Lutyens, *Sir Edwin Lutyens : An Appreciation in Perspective* (1942); N. Pevsner, 'Building with Wit. The Architecture of Sir Edwin Lutyens', *Arch. Rev.* CIX (Apr. 1951), 217–25; Christopher Hussey, *The Life of Sir Edwin Lutyens*, and A. S. G. Butler, *The Architecture of Sir Edwin Lutyens*, composing in four volumes *The Lutyens Memorial Volumes* (1950). In the correspondence columns of the *Times Literary Supplement* (22 Apr. 1977 and 6 May 1977), 490, 560, Mr. Roderick Gradidge and Mr. Andrew Saint have also discussed Lutyens's early training and association with Norman Shaw.

Surrey: Orchards, Godalming; Goddards, Abinger Common; Tigbourne Court, Witley; and Littlecroft, Guildford; the remaining two, Overstrand Hall, and The Pleasaunce, Overstrand, were in Norfolk. Orchards and Tigbourne Court are developments of Munstead Wood, but each of these houses has a separate identity although certain characteristics are shared by all of them. Great importance is given to the massing of the steeply pitched roofs, gables, and tall clustered chimneys, in true Shavian Manorial tradition, and, coming upon a Lutyens house for the first time, one is struck by the near-perfect harmony between house and setting no matter from which elevation it is viewed. In Orchards [1899–1901; plate 45A] particularly, the house seems to grow up organically from its site, an effect heightened (as in Voysey's houses) by the use of battered buttresses and hipped gables extended to ground-floor level on the north-west block containing the entrance to the courtyard. Once inside the square courtyard around which the house is built, a full arched cloister to the west acts as a foil to the square porch and rectangular lines of casement windows. This playing-off of curve against angle is a favourite Lutyens device, and appears again in the entrance front to Tigbourne Court [plate 46]. The garden front of Orchards is asymmetrical and picturesque, reflecting an organic rather than a rigidly geometric ground-plan of great spaciousness. Since it was built, over seventy years ago, the local greenish-yellow rubble-stone and red tiles of which the house is constructed have beautifully mellowed. Lutyens's puckish sense of humour already shows itself in features such as the empty dormer 'windows' set in the roof over the entrance way, which play an aesthetic rather than a functional role. The interior of the house, like the outside, is quite simple and deftly proportioned, with occasional recourse to beams and wooden archways in the passages for compositional as much as structural necessity. One of the most spectacular exercises in massively constructed roof-beams, complete with brackets and queen-posts, occurs in the upstairs corridor of Munstead Wood. The key to Lutyens's mastery of architectural design lies in his instinctive grasp of the niceties of balance and proportion, for these are the qualities that shine out in all his work, whatever its scale.

Abbotswood, Gloucestershire (1901–2), marks a change of direction in Lutyens's work, for here he introduces Palladian motifs into his picturesque manner, and dispenses with rustic beams in favour of Doric pilasters and columns, cornices, and dados. Heathcote, Ilkley [1906; plate 45B] is his first consistently Palladian mansion, although preceded by the London office building of *Country Life* (1904–5) in Wrenaissance mode. The red pantile roof of Heathcote is, however, an Italianate gloss on a Yorkshire stone house, and the massive rusticated square coupled chimney-stacks are a Vanbrugh-like feature of this rather curious house. Lutyens did not abandon his former style completely, but, like Shaw, he came to regard classical architecture as the most appropriate not only for civic design but also for the English country house. He realized, too, that his own success in the competition for commissions depended on an ability to produce Palladian baroque, and being ambitious, he could not afford to ignore this prejudice in official circles. But above all, it represented for him a stern discipline which he felt he needed after the idiosyncrasies of his picturesque phase. He wrote to his friend and former fellow-student, Herbert Baker, in 1903: 'In architecture Palladio is the game. It is so big. Few appreciate it now and it requires considerable training to value and realize it. The way Wren handled it was marvellous. Shaw has the gift. To the average man it is dry bones, but under the mind of Wren it glows and the stiff material becomes as plastic as clay . . . It is a game that never deceives. Dodges never disguise. It means hard thought all through. If it is laboured, it fails.'[1] And again, after the completion of Heathcote: 'You cannot play originality with the Orders. They have been so well digested that there is nothing but essence left. When right they are curiously lovely and unalterable like a plant form.' Thus, supremely gifted though he was, he turned his back on any attempt at originality in the wider context of the modern movement, and English architecture is greatly the poorer for it.

[1] A. S. G. Butler, *The Architecture of Sir Edwin Lutyens*, I (1950), 34, for this and the following quotation.

One of the most important developments in domestic building of the latter part of the nineteenth century was the growing interest in mass social housing estates for a broad cross-section of the community (excluding the very rich, the aristocrats, and upper middle class). The aim was to bring about an improvement in the quality of housing both for the poorest workers—many of whom still lived in incredible squalor—and for the better-off professional classes. At first the initiative was left to private individuals or companies. It was only slowly recognized that where housing for the very poor was concerned, the absence of the usual commercial factors which motivated the building companies, such as a dividend of six per cent on invested capital as an essential minimum, made it an uneconomic proposition and they were left uncatered for. The remedy was for the municipality to allocate public funds for low-cost housing projects and subsidize rents. The first municipal working-class flats to be erected were Corporation Buildings, Farringdon Street, built in 1865 on freehold land acquired by the Common Council of the City of London, largely at the instigation of Alderman (later Sir) Sydney Waterlow, head of the printing works of that name and first Chairman of the Improved Industrial Dwellings Company.[1] Other landmarks were the slum clearance programme which the Metropolitan Board of Works began in 1875, and the foundation of the London County Council (now Greater London Council) in 1889, followed by the passing of the Housing of the Working Class Act in 1890. The slum areas cleared by the M.B.W. were handed over to the Peabody Trust (founded 1862), the Artizans', Labourers' and General Dwelling Company (founded 1867), and similar companies for development, but the new L.C.C., aided by legislation, brought fresh social ideas and an entirely changed outlook to the problem. Housing became a public duty, not an area for private profit, and improved standards of architectural design, hygiene, and domestic comfort were adopted. The austerity of the old Peabody

[1] N. Pevsner, 'Model Houses for the Labouring Classes', *Arch. Rev.* XCIII (May 1943), 119–28, covers the period 1818–70 and gives much useful historical and statistical information on the subject. R. C. K. Ensor, *England 1870–1914* (1936), 301, quotes Charles Booth's estimate that, in 1889, 30·7 per cent of the inhabitants of London lived in poverty.

Trust tenements, with their bleak, charmless, standardized eleva-
tions, was replaced by a more cheerful neo-Georgian style based
on Norman Shaw's example. Two such L.C.C. estates may be
quoted: Boundary Estate, Bethnal Green (once one of the worst
London slums) of 1897–1900, designed by the L.C.C. architect,
Thomas Blasehill; and the Millbank Estate, Westminster, of 1897–
1902, an extensive scheme of working-class flats housing some
4,500 people—humane in scale and pleasant to the eye, even if the
courtyards now strike us as rather chill places. Appropriately
named after famous British painters, the blocks are planned axially
to the Tate Gallery (completed in its first stage by 1897) in tree-
lined streets; the layout was by R. Minton Taylor under the L.C.C.
architect, W. E. Riley.[1] Despite the considerable improvement in
working-class housing which took place from the late 1890s
onward, the image of tenements as 'grim and grimy barracks of
the poor'—which indeed they were between the 1860s and 1880s,
although still an advance on the fearful conditions of slum ac-
commodation elsewhere—dies hard with the working class. Their
continuing prejudice against flats was noted by George Orwell in
The Road to Wigan Pier in 1937. It still remains a considerable
factor in shaping modern housing policies in this country—and
not without good reason, for dwellers in multi-storey flats have
been found to suffer from psychological stress.

Ironically, the open-planned estate still so dear to the speculative
builder and town council alike, both between the two World Wars
and since, owes its origins to a scheme labelled in its day as a place
'Where men may lead a chaste, correct, Aesthetical existence'.[2]
This was Bedford Park, near Turnham Green, the earliest planned
garden suburb initiated in 1875 by Jonathan T. Carr, brother of
Comyns Carr.[3] It was intended to be a harmonious, self-contained

[1] In the early 1960s the blocks were renovated internally to meet higher L.C.C.
standards.

[2] 'The Ballad of Bedford Park', *St. James's Gazette*, 17 Dec. 1881, 11.

[3] The earlier planned picturesque villages of Edensor, Derbyshire, or Blaise Hamlet,
near Bristol, were not garden suburbs as we understand them. G. K. Chesterton
parodied Bedford Park as 'Saffron Park' in *The Man Who Was Thursday* (1908):
'It was built of a bright brick throughout; its skyline was fantastic, and even its ground
plan was wild . . . the outburst of a speculative builder, faintly tinged with art, who

assembly of modest-sized terrace, detached, and semi-detached
houses in red brick with sparingly applied, sober Renaissance or
Queen Anne detail; each house had its own garden, old trees were
preserved, and the twisting roads gave variety of vista. The chief
architect was Norman Shaw, who built the church [plate 31B], the
bank, and the Tabard tavern between 1877 and 1880, and supplied
designs for a number of houses. Other architects employed were
Edward Godwin's assistant, Maurice B. Adams, editor of *Building
News*, who built the Parish Hall and Clubhouse, and E. J. May.
Godwin also designed some of the best of the houses, which are
simpler in style than Shaw's. The Tabard Inn and adjoining bank
are interesting examples of Shaw's use of large expanses of win-
dows—one might almost call them window-walls—on the ground
and first floors, which he pioneered in his New Zealand Chambers.
Bedford Park was aimed at members of the professional lower
middle class with artistic tastes, and was a reaction against the
speculative builders' 'villa' or cottage in debased taste, run up by
the score on congested sites during the previous forty years or so.
Other social housing schemes which catered for the working man
came later and continued the Bedford Park garden suburb experi-
ment, the most notable being Port Sunlight, near Birkenhead,
started by Lever Brothers for their employees in 1888, and George
Cadbury's model workers' settlement at Bournville, Worcester-
shire (then just outside Birmingham), founded in 1895.[1] The two
schemes differ in certain details, but both provided well-planned
and carefully sited houses varying in size between two and four
bedrooms, living-room, kitchen and bathroom (even the smallest
of them had a bathroom). At Port Sunlight several architects
collaborated, among them William Owen, C. Clarke, John
Douglas and Fordham, Grayson and Ould, and Maxwell and
Luke. The earlier houses were in traditional Cheshire 'black and
white' half-timbered style, of which some of 1892 are typical,

called its architecture sometimes Elizabethan and sometimes Queen Anne, apparently
under the impression that the two sovereigns were identical.'

[1] The pioneer workers' housing estate was Sir Titus Salt's Saltaire, near Bradford,
begun in 1851. See J. M. Richards, 'Sir Titus Salt', *Arch. Rev.* LXXX (Nov. 1936),
213–18.

and later ones were in the simpler modern idiom popularized by Ernest Newton. Only one architect, William Alexander Harvey of Birmingham, was employed at Bournville from 1895 to 1904, with a corresponding gain in homogeneity of layout and design; although Harvey was obviously much influenced by Voysey and Newton, as may be seen from the examples of Bournville houses he published in his *The Model Village and its Cottages : Bournville* (1906). Both estates suffer from a discrepancy in scale between the unnecessarily wide roads, due to local by-laws since repealed, and the low elevations of most of the buildings, which negates any attempt at the intimacy of effect so conspicuously successful at Bedford Park. Whereas W. H. Lever financed the building of Port Sunlight and used the rents entirely for the upkeep of the houses, George Cadbury set off rents against the initial building costs of the houses, and once these were met, the houses became the property of the former tenants, who were then granted a 999-year lease. Any surplus from the low interest on loans was immediately ploughed back into further house-building. Thus was set a pattern of home-loan finance which could later be adopted by local authorities as a viable alternative to direct subsidy of rents.[1]

Still more far-reaching, however, were the Garden Cities of Letchworth and Welwyn, and the Garden Suburb of Hampstead. Arthur Mackmurdo was one of the first in England to think about regional planning and garden cities. In 1881 he discussed with Patrick Geddes an idea to establish 'regional communities' with a Civic Hall and a Spiritual Hall as their centres, while on the outskirts would be factories, workers' houses, and well-sited schools and hospitals. Nothing came of the scheme. The theoretical basis

[1] H. Muthesius, *Das englische Haus*, I (1904), 199–200, where he incorrectly attributes the Bournville designs to Ralph Heaton; J. H. Whitehouse, 'Bournville. A Study in Housing Reform', *Studio*, XXIV (1901–2), 162–72; Bournville Village Trust, *Sixty Years of Planning : The Bournville Experiment* (1942). The Bournville Village Trust was formed in 1900 to continue Cadbury's work. The Deed of Trust (dated 14 Dec. 1900) specified, among other things, that 'no ... factory shall occupy in area more than one fifteenth part of the estate on which it may be built' and '. . . dwellings may occupy about one fourth part of the sites on which they are built . . . the remaining portions to be used as gardens or open spaces . . .'. An obituary notice for W. A. Harvey appeared in *R.I.B.A. Jnl.*, 3rd Ser. LVIII (1951), 247–8.

for the garden city lay in Ebenezer Howard's *To-Morrow : A Peace-ful Path to Real Reform* (1898), better known as *Garden Cities of Tomorrow*, the title used for the second edition of 1902.[1] Briefly, Howard evolved a plan to relieve the intolerable congestion of our big cities by attracting people back to the countryside to a specially created open planned environment which would combine the advantages of town and country without any of the disadvantages of either. Industry and commerce would be permitted side by side with agriculture, to form an interdependent, balanced community offering opportunities to all sorts and conditions of men. Growth would be limited to about 32,000 inhabitants, and once this figure was reached the overspill would be absorbed by a new satellite town or garden city. This is the blueprint for the New Towns of the post-1945 era. The financing of these 'Social Cities', as envisaged by Howard, involved a characteristically British com-promise between free enterprise and socialist planning. Howard's book gave a new term to many European languages, but his pre-cise definition of a garden city has been as much misunderstood as it was widely used. Far too frequently during the past fifty years, open-planned garden suburbs have been created as appen-dages to existing cities and have only worsened the urban sprawl, wastefully utilizing the land without bringing about the balanced communities vital to civilized life. The land for the future Letch-worth Garden City was acquired by the Garden City Association in 1903 and a limited company was formed the same year. The actual construction of it to the plans of Raymond Unwin and his partner, Richard Barry Parker, took place after their work for Hampstead Garden Suburb.[2] Unwin, it may be noted, had formed his ideas on German town-planning, of which he had made an intensive study. Dame Henrietta Barnett was the guiding force behind the Hampstead project, land for which was acquired near Golders Green in 1907, and the suburb was planned as a whole by Parker and Unwin, with other architects contributing individual

[1] A third edition, edited and prefaced by F. J. Osborn with an Introductory Essay by Lewis Mumford, appeared in 1946 (with good select bibliography).

[2] Parker and Unwin had already laid out a model village at New Earswick, near York, for the Joseph Rowntree Village Trust in 1904.

groups of houses and flats.[1] The group of public buildings in the centre, two churches, an Institute, and the contiguous terrace-framed North and South Squares are by Lutyens and generally accounted among his best work (1908–10). They have a coherence and distinction that was lost at Welwyn Garden City, begun in 1919 and predominantly neo-Georgian in character, which followed the rather diffuse plan of Letchworth. Welwyn Garden City did, however, have an industrial area as an integral part of it and thus fulfilled one of the most important of Howard's criteria. Another of his principles, that there should be a wide diversity of class, was also Dame Henrietta Barnett's wish for Hampstead Garden Suburb, but as it developed this mixed character was lost. Other disadvantages, such as no convenient shops, no direct public transport, and the deliberate exclusion of public houses, cinemas, and cafés, have militated against the Suburb's becoming a real social centre, and are a dreadful warning to present-day town-planners.

The two churches in the Suburb are Lutyens's only major ecclesiastical work to be completed, and although in general plan they are similar, the Anglican St. Jude's [1910–33; plate 47] is more elaborate and 'High Church', with, instead of a dome, a magnificent tall spire that dominates the central hill around which the Suburb is grouped. The church is a wilful mixture of medieval and baroque features, the discord between which has been wittily exploited to give the building its emphatic originality. The huge pitched roof of the nave starts surprisingly low off the ground and is broken by tall dormer windows of aedicule form; inside, the central tunnel- and dome-vaults conflict with the open timber lean-to roofs of the aisles. The brickwork, as always in Lutyens, is beautifully laid and detailed.

There are good reasons why the Garden City concept should have originated in England, where a centuries-old love of gardens and the countryside has been encouraged in part by a favourable climate. Foreign observers have remarked on this national trait,

[1] Raymond Unwin and M. H. Baillie Scott, *Town Planning and Modern Architecture at the Hampstead Garden Suburb* (1909), illustrate their own and other architects' work for the Suburb.

but at the turn of the century increased and more widespread leisure stimulated a remarkable proliferation of magazines devoted to country and garden pursuits, of which the following selection may be quoted: *Amateur Gardening* (1884), *Country Life* (1897), *Gamekeeper and Countryside* (1897), *Country Gentlemen's Estate Magazine* (1902), *Country-Side* (1905, organ of the British Naturalists' Association), *Home Gardener* (1910), and *Homes and Gardens* (1919). It is also relevant to recall that the need to preserve the countryside from the ever-increasing depredations of industrial and urban exploitation began to exercise men's minds at this time. Thus in 1895, Miss Octavia Hill, inspired by the teachings of Ruskin and aided by Sir Robert Hunter and Canon H. D. Rawnsley, founded the National Trust with the object of preserving 'lands and buildings of historic interest or natural beauty for public access and benefit'. There were also a number of books on landscape gardening, some written by architects, such as John D. Sedding's *Garden Craft, Old and New* (1891), Reginald Blomfield and F. Inigo Thomas's *The Formal Garden in England* (2nd edn. 1901); others by landscape gardeners, like Thomas H. Mawson's *The Art and Craft of Garden Making* (1900, 3rd edn. 1907), H. Inigo Triggs's *Formal Gardens in England and Scotland* (1902), and Gertrude Jekyll's *Some English Gardens* (1904) and *Gardens for Small Country Houses* (1912). A perusal of Mawson's book suggests that in his day the emphasis was on an agreeable mixture of the formal garden and Reptonian picturesque. On medium- to large-sized estates, the formal part would be set near the house with such natural features as rock outcrops and streams utilized for terraces and small lakes, beyond which 'natural' gardens and landscape would provide an admirable foil. For the small suburban garden he recommended an unpretentious informal layout. The generation of Webb, Shaw, and Nesfield inclined towards the formal garden wherever suitable; Voysey, Lutyens, Baillie Scott, and their contemporaries were generally disposed to a blend of the two traditions, with the balance just weighted in favour of the picturesque.

A new approach to the conservation of ancient buildings and monuments was formulated in the late 1870s which still has great

relevance for us today. Once again, William Morris was its in-spiration and prime mover. In April 1877 he became the energetic founder and honorary secretary of the Society for the Protection of Ancient Buildings. Throughout the nineteenth century the controversy concerning the restoration of English cathedrals and medieval buildings had raged at frequent intervals. In the 1830s and 1840s it was York Minster and the cathedrals of Durham, Southwark, and St. Albans which were among the victims of the restorer's uncertain art. The immediate causes of Morris's disquiet were the projected restorations at Lichfield Cathedral, visited in the autumn of 1876, and, nearer home, at Burford parish church. Finally, George Gilbert Scott's plans for restoring Tewkesbury Abbey prompted Morris to write, on 5 March 1877, to the *Athenaeum*. In this letter, published five days later, he deplored 'those acts of barbarism which the modern architect, parson, and squire call "restoration" . . .' and yet considered, despite 'interest, habit and ignorance' that 'still there must be many people whose ignorance is accidental rather than inveterate, whose good sense could surely be touched if it were clearly put to them that they were destroying what they, or, more surely still, their sons and sons' sons, would one day fervently long for, and which no wealth or energy could ever buy again for them'. Morris then pleaded that 'an association . . . be set on foot to keep a watch on old monu-ments, to protest against all "restoration" that means more than keeping out wind and weather'. The S.P.A.B. or 'Anti-Scrape Society' was the result, and Morris's attitude to restoration is re-vealed in the foregoing quotation from his *Athenaeum* letter, which was expanded into a fuller statement of principles issued by him on the foundation of the Society.[1]

Morris, as might be expected, took a purist view and con-demned the wholesale destruction and replacement of weakened

[1] Mackail, *Life*, I. 342–4; May Morris, op. cit. I. 106–12, reprints the letter and Manifesto of the S.P.A.B.; she also reprints all Morris's letters to the press, addresses, reports, etc., in connection with 'Anti-Scrape' (112–92). The first A.G.M. of the Society was held 21 June 1878, and among the Committee were Carlyle, Ruskin, James Bryce, Sir John Lubbock, Lord Houghton, Leslie Stephen, Mark Pattison, Coventry Pat-more, Ingram Bywater, Charles Keene, Holman Hunt, F. A. White, J. P. Heseltine, Burne-Jones, Webb, and Faulkner.

fabric and detailing by masonry carved in imitation of the style of
the original, a process he considered nothing less than 'feeble and
lifeless forgery'. The aim of the responsible cathedral chapters
should be one of conservation: 'to put Protection in place of
Restoration, to stave off decay by daily care ... and show no
pretence of other art, and otherwise to resist all tampering with
either the fabric or ornament of the building as it stands; if it has
become inconvenient for its present use, to raise another building
rather than alter or enlarge the old one; ... to treat our ancient
buildings as monuments of a bygone art, created by bygone
manners, that modern art cannot meddle with without destroy-
ing'. This idealistic view could not be expected always to prevail,
but Morris intervened many times during the next two decades
to sound a note of caution—first in 1878 during the re-roofing
of the nave of St. Albans Cathedral, and again in 1879 when his
Society persuaded Disraeli to sign a protest against the restoration
of St. Mark's, Venice. The Gothic Revival architect, Pearson, who
succeeded George Gilbert Scott as the leading architectural adviser
to the ecclesiastical authorities up and down the land, came under
heavy fire in 1885 for his restoration of the north transept of West-
minster Abbey, and in 1892 Morris thundered against the proposed
complete restoration of the interior of the Abbey. The following
year, he fought and lost his battle with the Convocation of Oxford
University over the crumbling medieval statuary on the spire
of St. Mary's, which he preferred to see encased in iron cages
rather than replaced by copies. The year before he died, Morris
and the S.P.A.B. again crossed swords with Pearson and the Dean
and Chapter of Peterborough Cathedral. One of his last surviving
letters, written on behalf of the Society in December 1895 to
The Times, challenges the wisdom of rebuilding the north-west
tower of Chichester Cathedral.

VI

THE INNOVATORS
ART NOUVEAU
ART AND CRAFTS

THROUGHOUT his career as a designer and craftsman, Morris consistently maintained the principles that nothing should be done in his workshops which he did not know how to do himself, and that all forms of decorative art should bear an intimate relation to the supreme art of architecture, if they were to be at all meaningful and vital. Giving evidence before the Royal Commission on Technical Instruction in March 1882, Morris insisted that the designer himself should be able to weave, and should not simply farm out designs for a technician to execute as best he could. He affirmed a principle, now become commonplace, that the designer should be fully aware from practical experience of the possibilities and limitations of the materials for which he designed.[1] This basic training of potential designers was most fully implemented for the first time by Walter Gropius and his colleagues at the Weimar Bauhaus in the 1920s and has since become part of the curricula of design schools all over the world. But Morris wanted his workmen to be alive to the principles of design, and to some extent, modern mass-production methods have worked against the fulfilment of this craftsmanly ideal. However, in his own day, Morris's teaching began to break down the false division between the fine and applied arts. Ruskin had believed that art and life should be regarded as an integrated whole, and Morris constantly stressed this idea that true art was the expression of man's pleasure in his work and that consequently the arts, when honest, were simultaneously beautiful and useful. The aim of the Arts and Crafts Movement, as defined by Walter Crane in 1888, was to turn

[1] May Morris, op. cit. I. 205–25, quotes the whole of Morris's evidence.

'our artists into craftsmen and our craftsmen into artists'.[1] Due to Morris's example, a group of young artists, architects, and amateurs decided to devote themselves to the crafts, and between 1880 and 1890 no fewer than five societies for the promotion of handicrafts came into being.[2] These included Arthur Mackmurdo's Century Guild, founded in 1882 when Mackmurdo was thirty and significantly called a 'Guild' in emulation of medieval fore-runners, followed in March 1884 by the Art Workers' Guild, established by Walter Crane and Lewis Day; in the same year came the Home Arts and Industries Association interested in rural crafts, which, with other Village Industries and Home Arts and Cot-tage Arts Societies, was the inspiration of the state-subsidized ad-visory Rural Industries Bureau, established in 1921 by the Minister of Agriculture. Finally, in 1888, Charles Robert Ashbee started his Guild and School of Handicraft, and in the same year the Arts and Crafts Exhibition Society was formed. Cobden-Sanderson, co-founder with Emery Walker of the Doves Press, is credited with inventing the name of the new exhibiting society and with the innovation of including the executant's name, wherever possible, alongside the designer's in the catalogue.[3]

The astonishing resurgence in English industrial design during the last two vital decades of the nineteenth century is now acknow-ledged. The appalling trash that made up so much of the 1851 Great Exhibition is indeed a far cry from the work of the potter, William De Morgan, of the glass designer, Harry J. Powell, of the metal worker, W. A. S. Benson, and the designs of Christopher Dresser for domestic hollow-ware and cutlery. Dresser is of great interest to us not only for his knowledge of Japanese art, but as a botanist, and a precursor of functionalism in industrial design: 'Silver objects, like those formed of clay or glass, should perfectly serve the end for which they have been formed...' (*Principles of Design*, 1873). Moreover, his designs were carried out by two Birmingham firms, J. W. Hukin & J. T. Heath (from 1878) and

[1] Walter Crane, *Transactions of the National Association for the Advancement of Art and its Application to Industry* (1888), 216; see also Peter Selz and Mildred Constantine (eds.), *Art Nouveau, Art and Design at the Turn of the Century* (New York, 1959), 7.

[2] Pevsner, *Pioneers* (1960 edn.), 54 ff., discusses the proliferation of arts and crafts societies. [3] Mackail, *Life*, II. 200.

Elkington's (from 1885), the second of which had earned during the previous twenty years or so an international reputation for elaborate High Victorian exhibition pieces designed to exploit to the full the firm's patent silver electro-deposition process. These intricate essays were anathema to Morris and his colleagues, and nothing could be in greater contrast to them than Dresser's rigorously severe, almost unadorned, and often remarkably angular designs [plate 48A].[1] The work of Dresser, De Morgan, Benson, and their peers was influential far beyond England and out of all proportion to their numerical strength. Their work is characterized by a keen insight into the basic forms suitable for the objects they are designing, and, in the sphere of applied ornamentation, by a sensitive appraisal of the two-dimensional function of the design in relation to the plate, tile, or fabric. The full significance of the work of these innovators will be seen when the second generation of architects and designers, those born about 1850–60, are discussed below.

Art Nouveau made little lasting impact on English architecture, and, with a few notable exceptions, where it does exist it is usually in the form of decorative ornament applied to a building rather than as a complete expression. Primarily associated, as we have seen, with the graphic and applied arts, Art Nouveau is not essentially an architectural style. The exceptions are important, for there are English equivalents of Victor Horta's Maison Tassel, Brussels (1892–3), of August Endell's Atelier Elvira, Munich (1897–8), and of Josef Olbrich's Secession building in Vienna (1898–9).[2] By far the most outstanding and influential of the

[1] Harry J. Powell (died c. 1922–3) was the son of James Powell, and during the 1880s the chief designer at James Powell & Co., known as the Whitefriars Glass Works and the firm used by Morris and his associates. On Christopher Dresser, see Pevsner, 'Minor Masters of the XIXth Century: Christopher Dresser, Industrial Designer', *Arch. Rev.* LXXXI (Apr. 1937), 183–6; Shirley Bury, 'The Silver Designs of Dr. Christopher Dresser', *Apollo*, LXXVI (Dec. 1962), 766–70. Two exhibition catalogues are also useful: *Christopher Dresser 1834–1904*, Fine Art Society (1972), and *Birmingham Gold and Silver 1773–1973*, Birmingham Museum and Art Gallery (1973), Section E, 'Functionalism', n.p., where a revised dating for the Dresser/Elkington link is given.

[2] Art Nouveau has undergone a fashionable revival since the 1960s, and the Italian section of the XII Esposizione Internazionale Triennale, Milan, 1960, was dominated by this revivalism.

British exponents of Art Nouveau was the Scotsman, Mackintosh, for not only was he from the mid-1890s much more closely linked with continental Art Nouveau than any other Briton, but he also, by his example, suggested craftsmanly alternatives to some of the wilder extravagances and superficialities of the style. Indeed, by about 1900, Mackintosh can no longer be called an Art Nouveau architect. His buildings, already so distinct from continental, especially French and Belgian, examples, had begun to evolve towards a new purity of design that found a sympathetic response among those of his German and Austrian colleagues who were also seeking a more rational, functional style.[1] Of the major English architects, Voysey came closest to the spirit of Art Nouveau in certain sinuous wallpaper designs such as *The Snake* [plate 48B], first published in the *Studio*, VII, of 1896 and described there as 'from an earlier period',[2] and in the elongated forms of the Forster house of 1891. Although later hailed as a prophet of the movement,[3] Voysey hated it and while he conceded that the condition which made Art Nouveau possible was 'a distinctly healthy development . . . the manifestation of it is distinctly unhealthy and revolting. . . . What we need now is more religious earnestness and conscientiousness, and a real style will in the end result from it.'[4] Voysey was by no means alone in his detestation of Art Nouveau, but it is amusing to see Alfred Gilbert, the most Art Nouveau of all the English sculptors, indignantly join in the general condemnation: '*L'Art Nouveau*, forsooth! Absolute nonsense! It belongs to the young lady's seminary and the "duffer's paradise".'

[1] H. R. Hitchcock, 'Architecture' in *Art Nouveau: Art and Design at the Turn of the Century* (1959), 141, rightly draws attention to those developments in Mackintosh's work which went 'all against the continuance of Art Nouveau in architecture'.

[2] R.I.B.A. Drawings Collection. Margaret Richardson, 'Wallpapers by C. F. A. Voysey (1857–1941)', *R.I.B.A. Jnl.*, 3rd Ser. LXXII (1965), 399–403, repr. in colour, 399. This is now dated *c.* 1889 by E. Aslin in *C. F. A. Voysey architect and designer 1857–1941*, Brighton (1978), 96–100, fig. D.48.

[3] '"Notes" on the Paris Exhibition'—British Section of Essex & Co. wallpapers, etc., *Journal of Decorative Art*, XX (1900), 366.

[4] 'L'Art Nouveau: What it is and what is thought of it—A Symposium', *Magazine of Art*, New Ser. II (1904), 211–12, for Voysey's and Gilbert's opinions, as well as those, almost all hostile, of several other leading artists of the day.

Other voices joined in the condemnation of Art Nouveau, notably T. G. Jackson, who in his Royal Academy lectures called the movement 'a mere bubble of vanity and eccentricity'; for those who sought to avoid 'the Scylla of conventionalism and imitation of the past' it was 'the Charybdis of a forced originality that one does not really feel . . . pure affectation, and surely as base a motive as ever entered into the heart of any one pretending to be an artist'.[1] The *Architectural Review*, once the mouthpiece of Lethaby and his friends, became increasingly reactionary after Macartney took over the editorship in 1905. In the Editorial Notes for July 1907 the work of Mackintosh and 'The Four' is attacked as 'entirely foreign and repugnant to English tastes. L'Art Nouveau has never made great headway in England, and we hope it never will.'[2] This failure to accept the Glasgow Art Nouveau as part of the 'English Free Architecture' as Lethaby called it, is another cause contributing to its decline after 1900. Even the *Architectural Review* became aware that England's reputation for domestic architecture was endangered, after an American writer's critical reception of Macartney's special number, *Recent English Domestic Architecture*, of 1908.[3] It was indeed a very dull survey, even when compared with the *Studio*'s rather smaller special summer number, *Modern British Domestic Architecture and Decoration*, of 1901, and makes a sad contrast with a fiery statement of faith from an anonymous contributor to the *Architectural Review*, of which this extract gives something of the uncompromising flavour: 'Why should we architects live in such rebellion with the present? We talk about picking up the thread of architectural tradition where it was broken. Is it not really an excuse to go back a couple of hundred years or so, that we may get away from the needs and conditions and stern realities of life? . . . The scientists have been truer to their generation. The impressive dignity, the beauty, the perfect fitness, and the style of a modern express locomotive is incomparably finer than the best work of the best architect today. If we could

[1] *Reason in Architecture* (1906), 157, 183.
[2] *Arch. Rev.* XXII (July 1907), 8.
[3] *Arch. Rev.* XXV (May 1909), 233, quoted by Banham, *Theory and Design in the First Machine Age* (1960), 44.

only build with the same fitness, the same science, the same *un-challenged acceptance of modern material and modern conditions*, and the same sincerity; if we could only think of our buildings as an entirely modern problem without precedent (and it is . . . without precedent), just as the modern railway engine is; then, without doubt, the same beauty, the same serene dignity would inevitably accompany our efforts, and the ruins of the past might crumble to dust, but the architectural tradition would remain with us still. . . . We must put aboriginal constructive force into our work, and leave it to speak for itself: no mere ingenuity will suffice; tricky combinations of style and smart inventions are fool's play. . . . The grave yawns for "Architects' Architecture" . . .'[1]

The origins of Art Nouveau in the graphic arts have already been discussed—not least important was a renewed interest in Japanese art, which in England may be conveniently dated from the exhibits of Japanese lacquer, bronze, and porcelain in the International Exhibition of 1862.[2] Several architects and artists began collecting Japanese prints and porcelain, including William Burges and Whistler, Nesfield, who incorporated Japanese motifs in the decorative enrichments to the interior of Cloverley Hall (1868), and Godwin, who began to design furniture in Anglo-Japanese style. Godwin moved to London with the actress Ellen Terry in 1875, and in their rooms in Taviton Street continued the Japanese-inspired décor of his Bristol house of ten years earlier. He arranged his friend Whistler's first one-man exhibition at 48 Pall Mall in July 1874 on Japanese principles, and four years later the two men contributed a joint Anglo-Japanese exhibition piece, which they described as a 'Harmony in Yellow and Gold', to the Paris International Exhibition.[3] This consisted of an elaborate

[1] 'Thoughts for the Strong', *Arch. Rev.* XVIII (July 1905), 27; also quoted in part by Banham, op. cit. 46–7, who thinks that it is perhaps by someone even more radical than Lethaby.

[2] Elizabeth Aslin, 'E. W. Godwin and the Japanese Taste', *Apollo*, LXXVI (1962), 779–84, points out that Japanese objects of applied art were exhibited in London as early as 1854, and in 1858 Daniel Lee of Manchester produced roller-printed cottons with designs derived directly from Japanese prints.

[3] Dudley Harbron, *The Conscious Stone. The Life of Edward William Godwin* (1949), 101, 125. A description of this 'Primrose Room' is given by a correspondent in the

fire-place and overmantel with a chair and table in front of it. The whole chimney-piece was later made up into a cabinet and in 1973 was bought at Christie's for the University Art Collections, Glasgow. Also in September 1877 and March 1878 came Godwin's two intriguingly linear designs for the White House, Whistler's new studio at 35 Tite Street, Chelsea (now demolished), the first of several by him in that street, and almost proto-Art Nouveau in its wilful asymmetry [plate 48c].[1] For by now Godwin had abandoned the Italianate Gothic style which in the 1860s had won him commissions for Town Halls (at Congleton and Northampton) and an Assize Court. In 1884, he devised the refreshingly unconventional scheme of interior decoration for the newly-wed Oscar and Constance Wilde's house in Tite Street (16, now 33), details of which have been published by H. Montgomery Hyde.[2] Godwin was a man of many accomplishments: as well as designing furniture, he produced stage décor and costumes, to which he brought a new respect for historical accuracy. His antiquarian instincts well fitted him to become the Secretary of the Costume Society in 1883. He also advocated a more hygienic and rational approach to modern women's dresses, drawing on the best examples from earlier periods, and modifying them for contemporary use. Some of these ideas were put into practice in dresses designed by Liberty's on Godwin's advice from 1884 until his death two years later. One must also mention other orientalists such as Thomas Jeckyll, the designer of the room and fittings for what was later to be transformed (against Jeckyll's intentions) by Whistler into the *Peacock Room*; Christopher Dresser, who, after a visit to Japan in 1877, published *Japan, its Architecture, Art and Art Manufactures* (1882);

American Architect and Building News, 27 July 1878, quoted by Pennell, *Life of Whistler*, I (1908), 219–20, and discussed by D. Sutton, *Nocturne: The Art of James McNeill Whistler* (1963), 86 and fig. 36. See also D. Harbron, 'Queen Anne Taste and Aestheticism', *Arch. Rev.* XCIV (July 1943), 15–18. The greater part of Godwin's notebooks and drawings are now in the V. & A., although there is a sizeable collection of plans and drawings in the R.I.B.A.

[1] Mark Girouard, 'Chelsea's Bohemian Studio Houses. The Victorian Artist at Home—II', *Country Life* (23 Nov. 1972), 1370–4.
[2] H. Montgomery Hyde, 'Oscar Wilde and his Architect, Edward Godwin' (reprinted from *Arch. Rev.*, Mar. 1951, 175–6) in Service (1975), 69–76.

and E. S. Morse, whose *Japanese Houses and their Surroundings* (1886) dealt with the construction and decoration of the ordinary Japanese house.

Charles Harrison Townsend, although never closely associated with the continental practitioners of Art Nouveau, was one of the few English architects to produce designs that belong unequivocally to that style. The forerunner of these is his Bishopsgate Institute, Bishopsgate, London (1892–4), a narrow-fronted building with a broad arched entrance and a frieze above of flatly stylized leafy trees in a characteristic Arts and Crafts manner. Although he owed much to Webb in the bold massing of verticals, for example the twin octagonal towers, his inclusion of a large-scale frieze is a startling innovation, as is the big arch, both of which suggest a knowledge of the work of the American architect, H. H. Richardson.[1] Townsend's next work, the Whitechapel Art Gallery (1896–1901), first designed in 1895 on a more ambitious scale than the finished building (it was to have had a large mosaic by Walter Crane above the main entrance), is a radical development of the Bishopsgate design [plate 49A]. An off-centre, massive arched doorway and lunette dominates the lower half of the stone façade, above runs a narrow line of windows surmounted by two angle turrets ornamented with bands of low-relief Art Nouveau foliage. The Horniman Museum, Forest Hill, Lewisham (1896–1901, addition 1910), is the most remarkable of all his buildings, with a highly original rounded and pinnacled clock tower set to one side of the main façade, the strong horizontals of which frame a long mosaic by R. Anning Bell [plate 49B]. After this, Townsend produced little else of note, unless one recalls his church of St. Mary the Virgin, Great Warley, Essex, of 1904, a simple Voysey-like work with buttressed walls and roughcast exterior. Inside, however, are some astonishing Art Nouveau decorations by William Reynolds-Stephens. Some of the most interesting Arts and Crafts work may be found in churches built between the mid-1880s and

[1] A full-length monograph on Richardson was published in Boston and New York, 1888, and his design for a lodge which appeared in *The Builder*, 5 Jan. 1889, incorporates a distinctive arch feature. Alastair Service, 'Charles Harrison Townsend', in Service (1975), 162–82, publishes new information about this architect.

1914, and a few representative examples will be discussed later in the chapter.

One other English Art Nouveau public building deserves mention here, the Mary Ward Settlement, Tavistock Place, Holborn, built by A. Dunbar Smith and Cecil Brewer in 1897–8 [plate 50B].[1] It is an interesting fusion of styles: the tripartite windows are Norman Shaw, the wide overhanging cornices and shallow roof are from Voysey, and the massive entrance is inspired by Townsend. But the architects successfully combine these elements into a gracefully balanced composition, intimate in scale but with a judicious formal symmetry. Brewer's country house, The Fives Court, Pinner (c. 1900) is clearly modelled on Voysey,[2] and the treatment of the chimney-stack, with its battered sides, smoke-vents, and flat coping-stone, first appears in Voysey's Perrycroft, Colwall, near Malvern (1893). Smith and Brewer were perhaps too imitative to be pioneers and followed the prevailing neo-baroque fashion in their major work, the National Museum of Wales, Cardiff (1910, completed 1927). On the other hand, they maintained their reputation for graceful formality and modernity in the façade to Messrs. Heal's store, 196 Tottenham Court Road, an exemplary model for its time (1916). Three adjoining private houses by C. R. Ashbee in Cheyne Walk, Chelsea, are almost a miniature history of the town house at the turn of the century [plate 50A]. The earliest, No. 37, the Magpie and Stump of 1894 (now demolished), with its three-storey oriel window, is a free adaptation of a Norman Shaw feature, but Nos. 38 and 39 of 1904, are uncompromisingly Art Nouveau with elegant ironwork in the Mackintosh idiom, made, in all probability, by Ashbee's Guild of Handicraft. Ashbee contributed a perceptive foreword to Wasmuth's second publication of Frank Lloyd Wright's work in 1911, and was the first of his European admirers. He first met Wright in Chicago on his second lecture tour in America in 1900, when he was campaigning on behalf of the National Trust, and recorded his impressions of him in his 'Memoirs':

[1] W. R. Lethaby, 'Cecil Claude Brewer', *R.I.B.A. Jnl.*, 3rd Ser. XXV (1918), 246–7.
[2] Reproduced in *Studio Special Summer Number* (1901), 54, but not located by Pevsner when preparing his guide to Middlesex in 1952.

Wright is far and away the ablest man, in our line of work that I
have come across in Chicago. He not only has ideas, but the power of
expressing them, and his Husser House [1899] over which he took me,
showing me every detail with the keenest delight, is one of the most
beautiful and individual creations I have seen in America. He threw
down the glove to me in characteristic Chicagoan manner when we
discussed the arts and crafts. 'My God' he said 'is machinery; and the
art of the future will be the expression of the individual artist through
the thousand powers of the machine, the machine doing all those things
that the individual workman cannot do. The creative artist is the man
who controls all this and understands it.' He was surprised to find
how much I concurred, but I added the rider that the individuality
of the average [worker] had to be considered in addition to that of
the 'artistic creator' himself.[1]

The rider is significant of Ashbee's own equivocal attitude to
the machine and of his reluctance to admit that machine produc-
tion would inevitably eliminate the individualistic quirks of hand
craftsmanship. Frank Lloyd Wright's surprise was not misplaced.

The architectural scene in Glasgow during the 1880s and 1890s
is beginning to receive much more attention from historians. The
city's thriving mercantile and industrial activities had created
great wealth, which in turn stimulated a tremendous upsurge in
public and commercial building. Many of these new buildings
were in current revivalist styles, often garnished with distinct
Scottish vernacular ingredients. A few buildings incorporated
constructional innovations that antedate anything produced in
England, and at least one Glasgow architect, John James Burnet,
subsequently brought to London some of this pioneering zeal.
It is as well to remember the ferment of ideas in art and architecture
in this, the largest of Scotland's cities, when considering the career
of its greatest architect, Charles Rennie Mackintosh. Mackintosh
began his architectural studies in the office of the Glasgow archi-
tect John Hutchinson, and at the same time enrolled as an
evening student at the Glasgow School of Art under the head-
mastership of the remarkable Francis ('Fra.') H. Newbery in

[1] C. R. Ashbee, 'Memoirs', I, 'The Guild Idea' (1938), 242, entry for 7 Dec. 1900
(from typewritten MS. in the V. & A. Library).

1884.[1] Five years later, his articles completed, Mackintosh joined the Glasgow firm of John Honeyman and John Keppie, of which he was a partner from 1904 until his resignation in 1913. His work as an apprentice architect brought him the coveted Alexander (Greek) Thomson Travelling Scholarship, which he was awarded by the Glasgow Institute of Architects in 1890 for his design of a Public Hall in Early Classic Style. He was thus enabled to visit Italy, France, and Belgium from April to August of the following year. While abroad, he kept a diary for much of his Italian tour and made a vast number of sketches in a variety of media and with a wide range of subject-matter. From about 1893 he began to experiment with interior decoration and furniture, but although his first private commission may have been for a suburban house in 1890, commissions for decoration and craftwork did not come his way until 1894. Some furniture he designed for Guthrie & Wells at about this time has fairly commonplace Art Nouveau detailing that he could have picked out from current numbers of the *Studio*. Yet, by 1896, when the work of 'The Four' (i.e. Mackintosh and Herbert MacNair, Frances and Margaret Macdonald, afterwards Mrs. MacNair and Mrs. Mackintosh respectively) was first shown in London at The Arts and Crafts Exhibition, the grotesque conventionalization of the human form and extraordinary linear patterns which were its hallmarks caused such an uproar that the Society refused to invite the Glasgow artists to exhibit with them again. It was about this time that the sobriquet, 'The Spook School', was applied by the English and, indeed, by many of their fellow Scots, to Mackintosh and his associates. Gleeson White, contributor to the *Studio*, was more receptive than most of his compatriots, and between July 1897 and January 1898

[1] Thomas Howarth, *Charles Rennie Mackintosh and the Modern Movement* (1952), 4 ff., the first standard work on the architect, needs to be supplemented by more recent research contained in A. McLaren Young, *Charles Rennie Mackintosh* (1968), catalogue to the Edinburgh Festival Exhibition, and Robert Macleod, *Charles Rennie Mackintosh* (1968), who draws attention to Mackintosh's debt to W. R. Lethaby's *Architecture, Mysticism and Myth* (1892) for many of his ideas about architectural theory. The second edition of Howarth's monograph appeared in 1977 with a new preface and updated bibliography, but with the text otherwise largely unchanged.

published three discerning and well-illustrated articles on the Glas-
gow designers. His untimely death from typhoid a year later de-
prived Mackintosh and his friends of a warm advocate. Alexander
Koch, editor of *Dekorative Kunst*, gave 'The Four' their first con-
tinental review in November 1898. The first major architectural
work with which Mackintosh's name may be connected is the
Glasgow Herald building (1893–4), built by Honeyman and Keppie,
but in fact entirely designed by Mackintosh.[1] The proportions and
fenestration of the Mitchell Street façade and the upper part of
the tower, in particular, bear his personal stamp. His hand is even
more clearly observable in the Martyrs' Public School, Glasgow
(*c.* 1895), especially in the unusual detailing of the internal roof
trusses of the main hall. The turning-point of Mackintosh's career
came in 1896, with the competition for the new Glasgow School
of Art building and his meeting with Miss Catherine Cranston, the
Glasgow restaurateur.

 The competition for the School of Art was officially won by
Honeyman and Keppie, but this uncompromising design was
obviously by Mackintosh and, when publicly exhibited early in
1897, aroused fierce controversy.[2] Newbery, however, was de-
lighted and must have been one of Mackintosh's most sympathetic
clients. He had specified very large studio-classrooms and because
of limited finances, it was decided to build the eastern half of the
School first, although foundations were to be laid for the whole
scheme. The Memorial Stone was laid on 25 May 1898, and an
account of the ceremony in the *Glasgow Herald* next day referred
to the designs as being by John Keppie! The 'plain' two-storey
building asked for by the Governors slowly took shape, until in
December 1899 the first section was publicly opened [plate 53].
The second, western section was designed in 1907 and completed
in 1910. The earlier part is an extraordinarily advanced design, yet
Mackintosh was to incorporate even more radical features in the
later wing, which contains the Library, Lecture Hall, and an addi-
tional attic storey running across the top of the north façade, barely

 [1] McLaren Young, op. cit. (1968), cat. no. 109.
 [2] Douglas Percy Bliss's *Charles Rennie Mackintosh and the Glasgow School of Art*
(1961) contains new photographs and measured drawings of this remarkable building.

visible from street level. Three façades are built of local grey 'Whitespot' and Giffnock stone; the south is of roughcast brick-work. The north façade, with its huge studio windows asymmetri-cally arranged around the main entrance and set in bare, functional reveals, the glazed areas divided by broad, unmoulded, wooden frames, certainly met requirements of light and plainness. No fussy cornices or frieze break the clean rectilinearity of the façade, the strong verticals of which are logically capped by a broad projecting flat roof, the rafters of which are exposed in playful counterpoint to the austerity of the walls and windows.

The solid masonry of the main entrance, set off-centre, provides another contrast, and this, coupled with the heavy arch over the French windows that light the Director's room on the first floor, reminds one of Townsend's contemporary work. If any source be sought for this most untraditional building, it must be in the Scottish Baronial style with which Mackintosh was enthusiasti-cally familiar from boyhood.[1] As an elegant foil to the massive masonry, Mackintosh has introduced delicate wrought-iron rail-ings along the street wall and balcony, and—a master-stroke—curved wrought-iron window braces that are both functional and decorative. The main studio windows are each twenty-two feet high, and the braces, set on large iron angle brackets that were meant to take window-cleaners' planks, gently curve back to the window-frame and end in a web of metal shaped like the basket hilt of a sword. In these, as in the fantastic openwork metal emblems on the railings and at the top of the building, one can see echoes of Celtic and Viking art, interest in which had begun to spread beyond the confines of contemporary scholarship to in-fluence artists of the Art Nouveau [plate 52A]. The few curved forms admitted in the ornamentation of this part of the building were rigorously excluded from the dramatic west façade, where the difficult, steeply sloping site has been exploited to the full.

Mackintosh's first design for the Library wing was a timid

[1] In a lecture on *Scotch Baronial Architecture*, given to the Glasgow Architectural Association in February 1891, Mackintosh notes a revival of the style, but expresses the hope that modern exponents will adapt it to modern requirements (pp. 33–4 of the MS. notes, Glasgow University).

affair and impracticable [figure 3]; he later rethought the whole
scheme and conceived the three rows of oriel windows which are

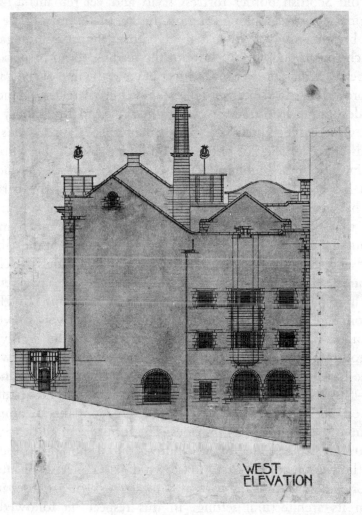

FIG. 3. Charles Rennie Mackintosh: Original Design for Library Wing, Glasgow
School of Art, West Elevation. 1897

carried up three storeys to make a striking vertical feature of the
façade [plate 53].[1] The bold silhouette of the gable end which

[1] Macleod, op. cit. 133–40, refers to the similarity between this feature and Charles
Holden's design for the Central Reference Library, Bristol, of 1905, especially the

caps the façade is a fitting climax to a design that ingeniously blends the multi-storey tenement tradition of the city with the old Scottish border fortress style, and yet remains a highly original, forward-looking solution. Inside, the Library [plate 52B] is a breathtakingly bold spatial adventure: the first-floor gallery which runs round all four sides of the reading room is supported on beams which project several feet beyond the line of the gallery before striking load-bearing pillars; these pillars are also connected by decorative balustrades set at right-angles to the gallery rail, a device that heightens the play of interpenetrating voids and solids characteristic not only of the Library, but of the whole of the interior of the building. In this sculptural use of space, Mackintosh has been compared with the great masters of the baroque and hailed as a forerunner of Wright and Le Corbusier. One might add that this open organization of space is very much in the Japanese tradition. The dominant rectilinear pattern of the Library is offset by the introduction of decorative pendent panels of delicate elliptical section, and pierced ovoids which fortuitously remind one in miniature of the sculptural forms later developed by Henry Moore and Barbara Hepworth. Mackintosh's creatively irreverent attitude to tradition is delightfully illustrated in the highly un-orthodox patterned infilling of the flutes extending for two or three feet below the capitals of the Ionic pilasters in the panelled neo-classic Board Room—a tongue-in-cheek symbolic gesture to the establishment. The Board Room also contains an amusing group of beaten metal lampshades. The furniture in all the princi-pal rooms was designed by Mackintosh, and it should be observed that he was one of the first in his own day to conceive of interior décor and furnishing as part of a total work of art inseparable from its architectural setting. In this respect he followed the example of his eighteenth-century compatriots, the Adam Brothers,

elevation facing The Deanery (repr. *The Builder*, LXXXIX (2 Sept. 1905), 255, as the work of Holden's firm, H. Percy Adams), and endorses John Summerson's ob-servation of a Michelangelesque 'drama and distortion' in Mackintosh's handling of architectural forms. Summerson makes the point again in *The Turn of the Century: Architecture in Britain around 1900* (W. A. Cargill Memorial Lecture, University of Glasgow, 1976), 24, where he also reminds us that this Tudor feature was first reintro-duced by Norman Shaw.

but went far beyond Morris and was even more thoroughgoing
than Voysey, his closest English counterpart. Burges, it is true,
designed everything in his own house and in those of his wealthy
patrons, but he did not have to work within strict financial limits.
Mackintosh's fertile inventiveness sometimes overrode practical
considerations and involved him in constructional difficulties.
The School of Art originally had only one main wooden staircase
and, in order to meet fire precaution standards, the two stone
staircases had later to be included at either end of the building—
the one in the east wing was tacked on to the old external wall.
None the less, the School of Art is superlatively well designed and
functional, a lasting monument to its creator's genius.

Before discussing Mackintosh's other major work, the series of
Tea Rooms designed for Miss Cranston, it must be recalled that
he designed or altered six country houses during his Glasgow
period. Hill House, Helensburgh, is the largest and most dis-
tinguished, also, fortunately, the best preserved of them all [plate
51A]. It was built for the publisher Walter W. Blackie, in 1902–4,
and in its design Mackintosh develops ideas explored in an earlier
house, Windyhill, Kilmacolm, Renfrewshire, built for William
Davidson (1899–1901), as well as the more exotic *Haus eines
Kunstfreundes* scheme of 1901–2. Both Blackie and Davidson were
congenial clients, and this sympathetic relationship was particu-
larly fruitful in Hill House, where the architect took great pains
to study the needs and wishes of the Blackies, even making it
a condition of the brief that he spent some time with the family
to get the feel of their pattern of domestic life. The house is on
a gently sloping site overlooking the Firth of Clyde and facing
south. Like Voysey, by whom he was influenced in domestic
architecture, Mackintosh massed the house in such a way as to
make it seem an organic part of the landscape, and blended the
traditional elements—in this case, Scottish Baronial architecture—
with functional modern design. The external elevations are com-
plex but firmly resolved, and the internal disposition of space is
even more subtly treated, particularly in the two principal rooms,
the sitting-room and main bedroom [plate 51B]. In both, space is
defined both by physical structure and the most judicious use of

light and colour, so as to create, in the sitting-room, for example, a 'summer' area around the deep window alcove and a 'winter' retreat by the fire-place.[1] All the fixed and moveable furniture for the main rooms was designed by Mackintosh, so that there is an organic homogeneity here as in all his work, but his skill in handling every detail throughout Hill House is such, too, that we are never oppressed by any sense of rigid uniformity. The house has a rare serenity that reflects the joyous creative mood of architect and client.

Unlike Hill House, the Tea Rooms have now almost all perished as the various premises changed hands or were demolished. By the turn of the century, Glasgow, once notorious as a hard-drinking city, had become famous for its tea-shops, a welcome alternative to the gloomy public houses, and a source of good, cheap meals for Glasgow's rapidly increasing working population. Miss Cranston, after her marriage to Major John Cochrane in 1892, was able to expand her business, and under her guidance restaurants became more like community centres, with separate billiard-rooms, ladies' tea-rooms, smoking-rooms, and so on; and, not least important, she immeasurably improved the general standards of service. Mackintosh first worked for Miss Cranston in collaboration with the architect and decorator, George Walton, on the decorations for the tea-room at 91 Buchanan Street in 1896–7.[2] Walton did most of the decorative work and designed the sturdy but pleasantly-proportioned restaurant furniture; Mackintosh decorated only three of the eight main rooms: the general tea-room, the dinner gallery, and the smoking-gallery. Of these, the murals in the general tea-room are the most important, and are a large-scale application of stylistic conventions first evolved in the posters of 1895–6, with their elongated, etherealized human forms inspired in part by the art of Beardsley and the Dutchman,

[1] Macleod, op. cit. 80–90, discusses Hill House in some detail.

[2] N. Pevsner, 'George Walton: His Life and Work', *R.I.B.A. Jnl.*, 3rd Ser. XLVI (Apr. 1939), 537–48, for a detailed account of this versatile artist. Gleeson White made only a brief passing reference to Walton's work when discussing the Buchanan Street Tea Room in *Studio*, XI (July 1897), 92–6. Walton's designs first appeared in the *Studio Special Summer Number, Modern British Domestic Architecture and Decoration* (1901), pls. 197–8.

Jan Toorop, and possibly by Belgian Art Nouveau.[1] The white-robed female figures, entwined in an intricate pattern of plants and branches, anticipate the 'Secessionist' style of the Viennese artist, Gustav Klimt. Other Buchanan Street murals by Mackintosh, notably those in the luncheon-room, hark back to Whistler and Japan in the use of peacock motifs, but the lotus-like shape of the formalized trees is closer to Egyptian art.[2]

Further commissions followed for decorations for Cranston Tea Rooms at 114 Argyle Street and at Ingram Street, but the most complete and distinguished of them all were those at the Willow Tea Rooms, Sauchiehall Street (1903–4), for which Mackintosh was the architect of the whole scheme, including the gently curved street façade, the fabric, interiors, and furniture. The plain, white-painted façade [plate 54A], though divided rather arbitrarily into two unrelated halves at second-floor level, is an astonishing design for its date, with wide horizontal spans of fenestration divided into tall narrow lights to produce an effect of fine mechanical precision, of lightness and elegance, equal to the best work of advanced con-tinental architects. Nothing could be in greater contrast to the ubiquitous sandstone façades favoured by commercial Glasgow at the time. The theme of the interior decorations, which included gesso panels, singing birds, crystal balls, and coloured glass by Margaret Macdonald Mackintosh in addition to Mackintosh's plaster friezes and decorative wrought-iron, was taken from 'Sauchiehall', an old Scots word meaning alley or street of the willows, and the flat, feathery shape of the willow leaf was a leitmotiv throughout. Each of the rooms was given a definite character; the sober, oak-furnished Willow Dining Room below the Gallery was contrasted with the white-painted Tea Room above, and an inner holy of holies was created in the exotic white Room De Luxe, a sort of willow bower [plate 54B]. Here, the shape of the characteristic tall-backed chairs was echoed in the decorative frieze of glass and metal panels which ran around the

[1] Toorop's *The Three Brides* was reproduced in *Studio*, I (1893), 247, and his *The Brides* was included in the International Society's exhibition of 1898 (153). Works by Gustave Serrurier-Bovy, Paul Hankar, and Adolphe Crespin were illustrated in *Studio*, VIII (1896), 118–21, 178. [2] Reproduced in *Studio*, XI (1897), 93.

top third of the wall. This frieze harmonized with the ornate leaded mirror-glass double doors set in a box architrave, then a rarely used feature but now one of the clichés of modernity. Yet for all its brilliance, a strange melancholy air brooded over this room, and a similar feeling is experienced even in the Library of the Art School. Certainly an appreciative German visitor felt this sad enchantment was epitomized in Margaret Macdonald Mackintosh's centrepiece for the room, a tall gesso panel panel inspired by Rossetti's sonnet from *The House of Life*, 'Willowwood':

> O ye, all ye that walk in Willowwood,
> That walk with hollow faces burning white;
> What fathom-depth of soul-struck widowhood . . .
> Ere ye again, who so in vain have wooed
> Your last hope lost . . .
> Ere ye, ere ye again shall see the light![1]

The magic of Rossetti and of Maeterlinck found a visual expression in the art of Charles and Margaret Mackintosh, and we are reminded once again of the strong vein of symbolism that links them with Whistler and the literary movement of the day. Utilitarian considerations, though never disregarded, were frequently subordinated to aesthetic effects, and Mackintosh would gladly attenuate his chair-backs to heights of anything up to five feet if it would enhance the over-all design. This aspect of his work provoked the remark that he designed 'intellectual chambers garnished for fair souls, not for corporeal habitation'.[2] Perhaps not surprisingly, though shamefully, no publicity greeted the achievement of the Willow Tea Rooms in either Scotland or England, and once again, it was left to a continental magazine, *Dekorative Kunst*, to devote a long, unsigned, article to them in its issue of April 1905. The author was most probably Muthesius and he was ecstatic about it all. He acknowledged Mackintosh as one of the

[1] The visitor was almost certainly H. Muthesius, whose anonymous but enthusiastic, detailed, and well-illustrated article on the Willow Tea Rooms, 'Ein Mackintosh-Teehaus in Glasgow', appeared in *Dekorative Kunst*, XIII (Apr. 1905), 257–73. It shows Mackintosh's decorative hoarding erected while construction work was carried out, following a similar innovation by George Walton for the Buchanan Street Tea Room (1896).

[2] A. Julius Meier-Graefe, *Modern Art*, II (1908), 264.

foremost architects in Europe and was surprised to find him so little appreciated in his native city.

It was otherwise abroad, particularly in Austria and Germany—more precisely Munich and Vienna, which were two of the most progressive artistic capitals in Europe around 1900. We know that Mackintosh's designs for the *House for an Art Lover* [plate 44B] were highly thought of in Darmstadt, and considerably influenced Josef Olbrich's work of the early 1900s. The work of the Glasgow School of painters, or the 'Boys from Glasgow', had already aroused great interest and controversy when it was first shown at the Munich International Exhibition in 1890, and in 1894 some Glasgow School work was shown in an exhibition of British painting at Vienna.[1] The first foreign article on 'The Four', in *Dekorative Kunst*, 1898, had prepared the way for their invitation to contribute a room to the eighth annual Vienna Secessionist exhibition of 1900, where they were rapturously received by the Austrian artists and public alike. Indeed, the early issues of the periodical of the Vienna Secession, *Ver Sacrum*, started in 1898, were decorated in a style unmistakably similar to Mackintosh's. We know that Josef Hoffmann greatly admired Mackintosh and travelled to Glasgow, probably in December 1902. Hoffmann seems also to have persuaded Fritz Wärndorfer to make his first visit to Glasgow in the spring of 1900. Wärndorfer went again in September 1902, and in March 1903 sought Mackintosh's advice about the proposed establishment of the Wiener Werkstätte.[2] One immediate practical outcome of Mackintosh's new contact with Vienna was a commission from Mr. and Mrs. Fritz Wärndorfer to design a Music Salon, executed in 1902, two remarkable features of which were the rectangular case he made for a grand

[1] See David Martin, *The Glasgow School of Painting* (1897); Sir James Caw, *Scottish Painting Past and Present 1620–1908* (Edinburgh 1908), 356 ff.; Alistair Auld, William Buchanan, W. R. Hardie et al., *The Glasgow Boys 1880–1900*, I (1968), and II, *The History of the Group and Illustrations* (1971). William Hardie, *Scottish Painting 1837–1939* (1976), 72–82, contains a useful chapter on the Glasgow School painters.

[2] Eduard F. Sekler, 'The Stoclet House by Josef Hoffmann', in *Essays in the History of Architecture presented to Rudolf Wittkower* (1967), 237–41, for a general account of the influence of British artists and architects on their Austrian Secessionist contemporaries; and idem, 'Mackintosh and Vienna', in Richards and Pevsner (eds.), *The Anti-Rationalists* (1973), 136–41.

piano and the wide frieze of twelve large decorative panels inspired by Maeterlinck's *Sept Princesses*, six by Mackintosh and six by his wife, none of which now survive.[1] Some other Mackintosh furniture for the Wärndorfers was shown in the Scottish pavilion he designed for the International Exhibition at Turin in 1902, where the Scots were officially honoured despite some hostile criticism. There is evidence that the Glasgow designers later exhibited in Venice, Budapest, Dresden, and even in Moscow in 1903.[2] Work by Mackintosh and other European Art Nouveau artists was certainly illustrated in several issues of *Mir Iskusstva*, founded in 1899, and some Russian Art Nouveau-inspired decoration and furniture is illustrated in volume nine (1903) of that periodical.[3]

Although so well publicized and enthusiastically received on the European continent, Mackintosh obtained very few foreign commissions. He declined invitations to set up his practice abroad, preferring to try to create a new school in his native city which

[1] Fritz Wärndorfer, a banker, financed the Wiener Werkstätte, founded in June 1903. Howarth, op. cit. (1952), 155, says that there were twelve panels, but McLaren Young has expressed doubts about this in the absence of positive proof.

[2] Mackintosh contributed a completely furnished Drawing-Room and some armchairs to the Architectural Exhibition at Moscow in 1903, all of which were illustrated in *Mir Iskusstva*, Vol. 9, Nos. 1-6 (1903), 116-17. Views of Windyhill House, Kilmacolm, both exteriors and interiors, and an interior of 34 Kingsborough Gardens appeared in Vol. 10, No. 10 (1903), 225-8, borrowed from *Die Kunst* (1902). In the previous year, Vol. 7, No. 4 (1902), 220-3, showed the Mackintosh interior exhibited at the Vienna Secession 1900, borrowed from *Die Kunst* (1901); and Vol. 8, Nos. 9-10 (1902), 211-12, 214, had furniture and decorative panels by Charles and Margaret Mackintosh and by Herbert and Frances MacNair, borrowed from *Arts décoratifs modernes* (1902), as well as a clock by C. R. Ashbee (p. 216). It is possible to see some Mackintosh influence in the furniture by Ivan Fornin, but his interior decoration is probably closest in style to the Viennese School, though flavoured by traditional Russian peasant art. Desmond Chapman-Huston, in his early appreciation of Mackintosh in *Artwork*, VI, No. 21 (1930), incorrectly gave the date of the Moscow exhibition as 1913.

[3] The following British or London-based artists had their work reproduced in *Mir Iskusstva*: Aubrey Beardsley in Vol. 3, Nos. 7-8 (1900), 73-84, with an article by D. S. MacColl, and again in Vol. 7, Nos. 1-6 (1902), 109, 111 ff.; two fan designs by Charles Conder in Vol. 1, No. 10 (1899), 170-1; William Nicholson, in Vol. 3, Nos. 11-12 (1900), 137-44; and J. McN. Whistler, in Vol. 1, Nos. 16-17 (1899), 61-8, was given a longish, well-illustrated article by J. K. Huysmans (a version of the essay in *Certains*), followed by more illustrations in Vol. 8, Nos. 9-10 (1902), 156-9, and Vol. 9, Nos. 7-12 (1903), 61-8.

would compare favourably with the immensely successful European Secessionist groups. As his efforts met with indifference or hostility, so he became increasingly embittered and demoralized; commissions were not forthcoming, and in the summer of 1914 he left Glasgow, to recuperate, moving first to Walberswick, Suffolk, and then to Chelsea. He returned to his old love, water-colour painting, and of the few architectural commissions belonging to his London years, the most important was the replanning and interior decoration of 78 Derngate, Northampton, for the well-known engineer and industrialist, W. J. Bassett-Lowke, in 1916. Continental influence was very marked in some of the furniture designs for the Guests' Bedroom [plate 55], including ladder-back chairs similar to those by Peter Behrens, and other decorative features inspired by the Viennese designers, Josef Urban, Hans Offner, and Otto Prutscher.[1] The house, as modified by Mackintosh, may fairly be claimed the first truly modern house in England, anticipating by some nine years Behrens's 'New Ways', also for Bassett-Lowke. That Mackintosh could develop a style with a distinctive twentieth-century flavour is beyond question when we consider the furniture that he designed for the Derngate house. The suite of oak furniture for the Guests' Bedroom of 1916 is now in the Glasgow University Art Collections, and copies of the mahogany bedroom suite made in 1917 from Mackintosh's designs are in the Victoria and Albert Museum. We must regret that Mackintosh did not have more opportunities to produce work of this quality after leaving Glasgow. The dressing-table [plate 56A] is functional yet elegant, its proportions and decoration unmistakably Mackintosh, though the inlaid squares of aluminium remind us, too, of the Austrian Secession. A small black ebonized Smoker's Cabinet [plate 56B] for the same house, has yellow inlays of Erinoid (a synthetic casein-based plastic) and must be one of the earliest examples of the decorative use of this new material.[2] It must also

[1] Roger Billcliffe and Peter Vergo, 'Charles Rennie Mackintosh and the Austrian Art Revival', *Burl. Mag.* CXIX (Nov. 1977), 739–44, examine the cross-influences between Mackintosh and the Austrian Secessionists in greater detail.

[2] McLaren Young, op. cit. 58–9, cat. nos. 269 and 280, suggests that this material may first have been used in 1917.

be said that the repeated inverted triangle motif, which appears in slightly different guise in the stencilled decoration used for the front hall of the Derngate house, unwittingly foreshadows the excesses of the 'Jazz-Modern' style, which was to flourish most vigorously in cinemas and restaurants of the 1920s and early 1930s. This increasing angularity in Mackintosh's decorative style had begun to make itself felt in the Cloister Room and the Chinese Room of the Ingram Street Tea Rooms, completed by 1912.

It was a tragedy that this rare genius should have died in obscurity, without followers and almost forgotten. We must remind ourselves of the breadth of his achievement during the thirty years or so of his active career. As a graphic artist in the 1890s he had produced his own unmistakable interpretation of Art Nouveau; as an architect he had designed between 1890 and 1920 a great variety of buildings, from offices to schools, churches and cathedrals, country houses, exhibition halls, museums, and restaurants; as a designer, his interiors and furniture won for him international acclaim. He was not an original theorist: indeed he shows a surprising conservatism in his views on building materials and the aesthetic superiority of stone as against iron. His design for Liverpool Anglican Cathedral (1903) epitomizes this predilection, and, although never without originality of detail, his ecclesiastical buildings as a whole are cast in too traditional a mould to rank among his greatest creations. He quickly responded to Lethaby's attempt to discover a philosophical or religious meaning and purpose in the evolution of architectural forms. He also rejected in his work unthinking dependence on outmoded styles and sought, with Lethaby again as his spiritual mentor, to graft new elements on to what he regarded as sound architectural tradition, with the emphasis on craftsmanship rather than technological innovation. He was, in Mies van der Rohe's apt phrase, 'a purifier in the field of architecture'.[1] Nowhere is this process of purification more beautifully shown than in Mackintosh's greatest single masterpiece, the Glasgow School of Art, and, among his domestic architecture, Hill House. These belong to his heroic years, 1896–1907.

[1] Quoted by McLaren Young, op. cit. 5.

Reasons for the swing towards neo-Palladianism in England have already been suggested, yet it would be wrong to suppose that no adventurous buildings in a recognizably twentieth-century style were put up between 1900 and 1914. Professor Pevsner, in a postscript to his *Pioneers of the Modern Movement* (1936), was able to discover a number of interesting buildings, mainly commercial and industrial, which have that 'Back to Fundamentals' approach so eloquently demanded by the anonymous writer in the *Architectural Review* of 1905 and quoted above.[1] Pevsner postulated that at least three criteria must be satisfied before a building could be considered 'modern': there should be an unequivocal acceptance by the architect (and his client) of the function of the building as a determinant of its design and appearance—that is to say, a biscuit factory should look like a factory and not be dressed up as an Italian Renaissance palazzo; there should be a sympathetic and intelligent use of industrially produced materials, and—a corollary of the two foregoing conditions—a distrust of ornament. The emphasis on fitness for purpose, so much a battle-cry of the advance guard in the 1930s, particularly in architecture and industrial design, remains a valid historical yardstick for our judgement of the period as a whole, though we may have strayed a little from the path of puritan virtue since then. Lethaby's Eagle Insurance Buildings (1898–1900) has already been mentioned. Here, he avoids the eccentricities of Art Nouveau in favour of a more functional design which is not, however, entirely free from echoes of the past. Traditional elements mingle more strongly with functional innovations in the Telephone Exchange, Southampton [1900; plate 57A], one of many built for the National Telephone Company by Leonard Stokes, where a stripped-down classicism is discernible in such features as the cornice on brackets, without frieze or orders, punctuating the façade above the third-floor windows. Stokes is probably better-known for his Roman Catholic churches, schools, and convents, but his New Court addition to Emmanuel College, Cambridge, demonstrates his tactful blend of simplified Renaissance ornament and collegiate Tudor, and was

[1] N. Pevsner, 'Nine Swallows—No Summer', *Arch. Rev.* XCI (May 1942), 109–12.

one of his last commissions before ill-health forced his retirement from practice in 1915.[1]

A far bolder architect was Harry Bulkeley Cresswell, a pupil of Aston Webb in 1890, and later a well-known novelist. Cresswell's Queensferry Factory, situated twelve miles from Chester between the Dee Estuary and the London–Holyhead railway, was completed in 1901 and is an uncompromisingly functional building comparable with, though earlier than, Behrens's famous A. E. G. Turbine Factory, Berlin, of 1909. Yet it could never have been as well known, and was not published in the *Architectural Review* until July 1923. Originally a boiler-making factory, it was converted to chemical manufacturing during the 1914–18 War. Its imposing block-shape, battered buttresses, cast-iron window lintels, and no-nonsense square tower all have a functional justification in that it was necessary to distribute the load over shallow foundations set in sandy, waterlogged subsoil. The internal framework is of iron stanchions and girders behind a brick façade, of which the buttresses take up lateral wind pressures exerted on the wide expanses of the lightly-constructed roof. The new steel skeleton construction technique, pioneered in America, like the much later reinforced concrete framework, requires a simplified gridiron treatment of the façade, and probably the earliest example of this type of design in Britain occurs in the reinforced concrete factory built for an American firm, Singer, at Kilbowie, near Glasgow, about 1905, illustrated in the first volume of a new publication, *Concrete and Constructional Engineering*, 1906–7. Other factories with steel or reinforced concrete frames soon followed, usually designed by engineers, since the techniques made no aesthetic appeal to architects. Here again, an exception must be made for the Glasgow architects, James Salmon II and J. Gaff Gillespie, whose Art Nouveau Lion Chambers, Hope Street, Glasgow (1905), was also a graceful and imaginative early exploitation of the Hennebique system of reinforced concrete for a ninety-foot-high office block set on an extremely restricted site.[2]

[1] Illustrated in *Arch. Rev.* XXXVIII (July 1915), 35–7.

[2] Peter Collins, *Concrete: The Vision of a New Architecture* (1959), 82–3; A. McLaren Young and A. M. Doak (eds.), *Glasgow at a Glance, an Architectural Handbook* (1965),

Economy in building costs prompted the chief architect to the Post Office, Henry Tanner, to use the Hennebique system of construction in the extension to the General Post Office main building at St. Martins-Le-Grand, London, in 1906. The method, despite initial misgivings on the part of central and local governments as to its safety, was increasingly used for similar utilitarian buildings in an unadorned state. Although the R.I.B.A., under Tanner's guidance, prepared a standard building code for reinforced concrete which was published in May 1907, all attempts to obtain the support of official legislation remained abortive until after the 1914–18 War. This lack, combined with strong professional prejudice, inhibited the development of a lively modern tradition of ferro-concrete architecture in Britain until well into the 1920s.[1] Where early steel-framed buildings were erected in the West End of London, for example the Ritz Hotel by Mewès and Davis (1906), and Lanchester and Rickards's Central Hall, Westminster (1905–11)—both in their different ways French-inspired, neo-classical designs in the *beaux-arts* tradition—their structural innovations were hidden behind heavy masonry and elaborate ornamentation. The earliest ferro-concrete structures that aspired beyond mere utility also had their bones well clad in respectable pomp, such as Mewès and Davis's Royal Automobile Club, Pall Mall (1910).

A more honest and rational attitude gradually, though by no means universally, prevailed, and to the Glasgow architect, John James Burnet, senior partner of Burnet, Tait, & Lorne, goes some of the credit for the change. He had been trained in the École des Beaux-Arts, Paris, and his Edward VII wing of the British Museum (1905–14) is a most graceful essay in that tradition. Of very different character is his Kodak Building, Kingsway, of 1911 [plate 57B], where the steel frame structure is allowed to show through with the minimum of stone cladding. Burnet

No. 160 (and illus.); A. Gomme and D. Walker, *Architecture of Glasgow* (1968), 224 (illus.). The walls and floors of this building are only four inches thick, despite its great height. The engineer was L. G. Mouchel.

[1] Peter Collins, op. cit. 78–86, for an account of the chief examples of ferro-concrete construction in Britain before 1914, the restrictive building regulations then in force, and the professionals' attitude to the new medium.

had already used a similar solution in the emphatic, vertical mullioned fenestration at second- to fourth-floor levels of his most accomplished warehouse building, for the hardware wholesalers, McGeoch's, in Glasgow (1905, now demolished), but the richly modelled *beaux-arts* detailing makes this a less radical work than the Kodak Office.[1] There is also a strong American influence in Burnet's mercantile architecture, and it should not be forgotten that he went to the United States in 1896 and was, moreover, a friend of McKim, of McKim, Mead, & White. Another gridiron design, equally bold as the Kodak Building, though this time in ferro-concrete, was used by Richard Allison in his new H.M. Stationery Office warehouse at Stamford Street, Lambeth (1913–14), where he frankly introduces into an urban context a type of façade hitherto used only for factories in industrial complexes. The earliest solid reinforced-concrete two-storey private house in England of modern design appears to be The Hopfield, St. Mary's Platt, near Wrotham, Kent, built by Colin Lucas (later of Connell, Ward, & Lucas), in 1932–3; but there is a house, Upmeads, Stafford (1908), by the Manchester architect, Edgar Wood, which, although built in brick, with its flat roof, severe block-like shape, and geometrical ornamentation, anticipates by some twenty years the conventions of the 1930s.[2] Only the Tudor-style windows give a hint of its real date. Wood, and James Henry Sellers, who became his partner sometime between 1903 and 1905, are both deserving of note as pioneers of modern constructional methods in the factories and schools that they built before 1914. Their Durnford Street School, Middleton, Man-

[1] A. McLaren Young and A. M. Doak, op. cit., No. 128 (and illus.); A. Gomme and D. Walker, op. cit. 200, 205–9.

[2] Obituary in *R.I.B.A. Jnl.*, 3rd Ser. XLIII (21 Dec. 1935), 212; John H. G. Archer, 'An Introduction to Two Manchester Architects: Edgar Wood and James Henry Sellers', *R.I.B.A. Jnl.*, 3rd Ser. LXII (Dec. 1954), 50–3; John Archer, 'Edgar Wood and J. Henry Sellers: A Decade of Partnership and Experiment', Service (1975), 372–84, and *Partnership in Style: Edgar Wood & J. Henry Sellers*, Manchester City Art Gallery (Oct.–Nov. 1975), with essays by John Archer and Stuart Evans. Wood's first flat-roofed house, 36 Mellalieu Street, Middleton, dates from 1906. Representative of Wood's earlier, Art Nouveau phase, is the Clock Tower, Lindley, near Huddersfied, of 1899–1902. Sellers also designed some distinguished furniture, of which examples survive at the City Art Gallery, Manchester.

chester, of 1908–10 is a particularly good example of this new approach [plate 58]. It is also evidence of a new attitude to school planning, and the building is sited in such a way as to allow class-rooms to receive as much sunlight as possible. The germicidal effects of sunlight had recently been discovered and this would almost certainly have been known to Wood, who took particular interest in health matters.[1]

Burnet's Kodak Office in Kingsway is, historically, the most interesting building in an otherwise rather dull, monumental, thoroughfare, but Kingsway and the crescent-shaped Aldwych claim attention as an early twentieth-century attempt at town-planning in London.[2] There were several mid-Victorian schemes for the improvement of the area we now know as Kingsway, which had become a slum, but not until 1898 was a definite plan decided on by the L.C.C. Improvements Committee. The hundred foot-wide street, with a carriageway of sixty feet, was exceptionally spacious for its time, beating its nearest rivals Queen Victoria Street (seventy feet wide, improved 1871) and Northum-berland Avenue (ninety feet wide, 1876). The new thoroughfare, stretching from Little Queen Street across High Holborn down to the Aldwych, was formally opened by Edward VII on 18 October 1905. It incorporated several innovations, such as the underground tramway tunnel, and two pipe and service subways below each pavement that enabled gas, electricity, telephone, and water con-nections to be made to individual buildings without constant breaking up of the surface. In 1900, a limited competition had been held to decide the general design of buildings in the street, and the eight architects invited included Ernest George, Reginald Blom-field, William Flockhart, E. W. Mountford, Leonard Stokes, Macartney, Ernest Runtz, and the eventual winner, Henry T. Hare; the assessors were Norman Shaw and W. E. Riley.[3] The

[1] I am indebted for this observation to Mr. John Archer, who has also drawn my attention to Felix Clay's *Modern School Buildings: Elementary and Secondary* (1902), 56–8, in which the 'aspect' (or siting) of schools is discussed in relation to the beneficial effects of sunlight.

[2] 'The Buildings of Kingsway', *Arch. Rev.* XXXVIII (Dec. 1915), 125–32.

[3] The designs for 'The Holborn–Strand Improvement' were published in a supplement to the *Arch. Rev.* VIII (Dec. 1900), 241–4. For earlier discussion of the

prevailing character of the designs was predictably Imperial Palladian. The assumptions determining the competition were rather fatuous, since it was an affair of imaginary façades for buildings none of which had a fixed purpose at the time, and the concept of controlled development was gradually eroded away as investors showed great initial reluctance to build under strict L.C.C. conditions. The L.C.C. gave way, warned no doubt by the controversy over the redevelopment of the Quadrant. By 1915 a number of new commercial buildings, many of them by Trehearne and Norman, had been completed. A contemporary critic in the *Architectural Review* considered that the chamfering of the angles of the buildings at street intersections, done to provide a line of vision across the corners for traffic, confronted the architects with difficult corner sites and broke up the continuity of the elevations. The vista down Kingsway is closed by Bush House set on the inside curve of the Aldwych, a design in convincing if not very appealing *beaux-arts* commercial by the American architects Helmle and Corbett (1925–35), and adorned with two colossal figures, symbolizing England and America, carved by Malvina Hoffman. The Aldwych–Strand improvement was carried a stage further by the completion of a new Waterloo Bridge to Giles Gilbert Scott's design in 1945. This elegant structure, with its five shallow arches, is a worthy successor to Rennie's famous bridge, demolished after much controversy in 1939.

Scott's bridge is very different in conception from another London bridge, built at the end of the nineteenth century, which is both a major feat of engineering and a famous landmark. This is Tower Bridge, constructed to the designs of Horace Jones and John Wolfe-Barry between 1886 and 1894. Jones was a noted architect to the City of London from 1864 until his death in May 1887, when work on the Tower Bridge was continued by the eminent civil engineer Wolfe-Barry in collaboration with Henry Mark Brunel.[1] Both men, incidentally, were the sons of famous

improvement see Mervyn Macartney, 'From Holborn to Strand: An Ideal Street', *Arch. Rev.*VI (Dec. 1899), 239–44; and for other architects' opinions (Shaw, Ricardo, Lethaby, etc.), see *Arch. Rev.* VII (Jan.–June 1900), 118–26, 156–62.

[1] See *D.N.B.* for Sir Horace Jones and Sir John Wolfe Wolfe-Barry; also Charles

fathers, Wolfe-Barry of the architect Sir Charles Barry and Brunel of Isambard Kingdom Brunel. The pinnacled twin towers of the bridge are a Gothic Revival brick-and-stone cladding to the wrought steel framework, intentionally designed to harmonize with the adjacent medieval Tower of London. These towers also carry an elevated footbridge for use when the two bascules, which when closed form the main span of the carriageway, are raised to the vertical position to allow the passage of shipping. Tower Bridge is a typical Victorian mixture of technical ingenuity, hard-headed practicality, and architectural romanticism.

Like Frampton and Gilbert, by whom he was influenced, William Reynolds-Stephens was an accomplished performer in several media. He began his career as a painter, but after 1894, at the age of thirty-two, he worked exclusively as a sculptor and goldsmith. In 1903 he reconstructed and decorated the drawing-room of Norman Shaw's 185 Queen's Gate.[1] Contemporary descriptions and photographs show it to have been an elegant Art Nouveau scheme, but his most complete decorative ensemble was carried out for Evelyn Heseltine at the church of St. Mary the Virgin, Great Warley, Essex, in 1904.[2] Here he designed the reredos, chancel screen, Lady Chapel screen, altar rail, pulpit, bishop's chair, altar frontal, organ front, windows, sanctuary, and nave ceiling decorations and electroliers [plate 59]. The choir stalls and pews were by the architect, Harrison Townsend. The theme of the decorations, according to a contemporary leaflet in which the artist's intentions are explained, is that of the Resurrection. The reredos shows the Risen Christ, and the profusion of floral forms in the church symbolize 'progressive growth in the earthly life, but

Welch, *History of the Tower Bridge* (1894) and the chapter on Tower Bridge in John Pudney, *Crossing London's River* (1972). Jones had first put forward a design for Tower Bridge as early as 1878.

[1] W. K. West, 'Recent Work by Mr. W. Reynolds-Stephens', *Studio*, XXX (Jan. 1904), 292–302; T. Stirling Lee and W. Reynolds-Stephens, 'Sculpture in its Relation to Architecture', *R.I.B.A. Jnl.*, 3rd Ser. XII (10 June 1905), 509.

[2] A. L. Baldry, 'A Notable Decorative Achievement by W. Reynolds-Stephens', *Studio*, XXXIV (Feb. 1905), 3–15; and John Malton, 'Art Nouveau in Essex', *Arch. Rev.* CXXVI (Aug.–Sept. 1959), reprinted in Richards and Pevsner (eds.), *The Anti-Rationalists* (1973), 159–69.

still more of the glorious hope which year by year is emphasised at Eastertide, the time of floral recrudescence'.[1] Reynolds-Stephens obviously had a liking for aluminium and used this metal again for the domed ceiling of the chancel, which rises above a high dado of pale green marble; on the ceiling vault are strings of formalized vine motifs in low relief which branch out into a wide unbroken horizontal frieze above the crowns of the large chancel windows. Dark greens, greys, walnut wood, pewter, bronze, brass, and oxidized silver are set off by grey-green walls. The front of the pulpit is cruciform, in beaten copper with blue pearl ornaments on a base of dark-grey marble, with supporting triple-stemmed trees of green bronze and brass flowers. But the most magnificent feature is undoubtedly the chancel screen, set on a marble base, with tree forms in brass supporting a transom ornamented with brass foliage and mother-of-pearl flowers. An angelic figure of oxidized silver stands in the boughs of each of the six trees, and a rood surmounts the central span of the screen.

It is instructive to compare Reynolds-Stephens's work with the church furnishings of other Arts and Crafts artists of the period. One reason why the comparatively expensive handmade products of these artists found a ready ecclesiastical market lay precisely in their high quality, anything less than which would have been considered unworthy for the greater glory of God by the wealthy church patrons of the second half of the nineteenth century. It would be impossible to discuss more than a tiny fraction of the 159 new Anglican churches built in the Greater London area alone during the forty-odd years up to 1914,[2] but five representative examples will suffice to show the great changes that took place in architectural style and taste. It must also be said that almost without exception the most interesting furnishings of the period are to be found, as might be expected, where a High Church outlook prevailed, which demanded a degree of richness and panoply not

[1] Baldry, loc. cit. 12.

[2] The total of 159 new churches begun between 1870 and 1914 is computed from Basil F. L. Clarke's *Parish Churches of London* (1966), which, in the Introduction, also gives an outline history of church building since the Fifty New Churches Act of 1711, as well as much valuable detail on individual buildings. See also the same author's *Church Builders of the Nineteenth Century* (1938).

to be sought for in Evangelical circles. John Loughborough Pearson's church of St. Augustine, Kilburn (1871–80; tower and spire built 1897–8), represents High Victorian church architecture at its best and, because it is by Pearson, the details are in revived Early English Gothic of textbook accuracy [plate 61]. It is a high church in both the spatial and ritualistic sense of the word, with a long, tall nave and square chancel,[1] narrow side aisles and wider outer aisles, and projecting transepts composed of two aisles, each of equal height and with central piers. Above the inner aisles runs a continuous gallery divided into high vaulted compartments linked by low passageways through the buttresses, and both galleries and buttresses are carried across the transepts in bridge fashion, thus concealing the transepts from the nave. The plan is an adaptation of the system of Albi Cathedral. A low vaulted ambulatory behind the chancel is matched by a similar gangway at the west end—this last feature included as much for aesthetic as for processional requirements. Pearson has used brick rib-vaulting throughout in his characteristic manner; the interior is of yellow London stocks, the exterior of dull red bricks with stone dressings.

Much of the interior is lavishly covered with wall paintings by Clayton and Bell which have weathered rather pleasingly into predominantly sombre reds and yellow ochres. The paintings and the elaborate, though somewhat mechanical, sculptural enrichments by Thomas (?) Nicholls of stone reredos, chancel screen, and other carvings all follow a carefully considered didactic programme drawn up by the Revd. Richard Carr Kilpatrick, the first Vicar. The scheme is a veritable *Biblia Pauperum*, illustrating many scenes from the Old and New Testaments, with images of a large army of saints, some well-known, others obscure to all but the erudite ecclesiologist. The apsidal Lady Chapel is richly gilded, and treated, as in most Pearson churches, as a separate smaller church. Even here, Pearson adds a touch of spatial inventiveness in the row of small arcaded windows behind the reredos. St. Augustine's must also be one of the few Victorian churches able to boast of a small but interesting collection of Italian quattro-

[1] The present Vicar told the author (in 1966) that Pearson is said to have originally designed an apsidal chancel which was rejected by Fr. Kilpatrick as 'un-English'.

cento and cinquecento religious paintings, presented by Lord Northcliffe.

Rather more flamboyant than Pearson's church is St. Cuthbert's, Philbeach Gardens, built by Hugh Roumieu Gough between 1884 and 1887, with the Lady Chapel completed in 1888. The rather gaunt exterior, with its *flèche* belfry and steeply pitched roof, appears to be like any other large suburban church of the period, but it is the inside that raises it far above the ordinary [plate 60A]. The walls, above a dado of coloured marbles, are covered with diaper work by the Guild of St. Peter, and statues of saints in the clerestory are by Boulton of Cheltenham, but the chief ornaments to the church were made by William Bainbridge Reynolds, who was one of the best Arts and Crafts men and a worshipper at St. Cuthbert's. He designed the pulpit (1887), the lectern of wrought-iron, repoussé copper, and leather, the royal arms, the communion rails of the high altar and Lady Chapel, the screens of the chapel, organ, and baptistery, the clock, the sedilia and piscina, the door of the tabernacle, and the paschal candle. He also designed two of the stained-glass windows dedicated to St. Sebastian and St. Oswald. The lectern [plate 60B], with its beaten copper flanking candelabra, has an unusual exuberance which is more often associated with Art Nouveau. More sedate is the pulpit in various marbles, with a few portrait miniatures set in panels around the base of the drum. The elaborately carved wooden canopy over the pulpit (1907) and the Lady Chapel reredos (1908) are by J. Harold Gibbons. A rood screen and loft were put up in 1893, and the Latin inscription on the screen, 'Verbum caro factum est et habitavit in nobis', epitomizes the strongly Anglo-Catholic character of this church, which was also one of the first Anglican churches since the Reformation to reinstate the practice of reserving the Sacraments. Perhaps the most remarkable single feature in this really rather ugly ensemble is the enormous carved wooden reredos designed by the Revd. Ernest Geldart in 1914, with a framework by Gilbert Boulton and carvings by Taylor and Clifton. The theme is 'the worship of the incarnate Son of God, with incense and lights', illustrated with appropriate scenes from scripture. The four Latin Doctors, the four major Prophets, the Apostles, and thirty-

two Saints complete this extraordinary reredos, which must be almost unique in English parish church furnishings. Round the aisle walls are hung Stations of the Cross painted by Frans Vinck of Antwerp, which, though they are in themselves uninspired and seem almost too large for their setting, add the finishing touches to an interior the period flavour of which is both unmistakable and memorable.

Holy Trinity Church, Sloane Street, built for the Fifth Earl Cadogan by John Dando Sedding between 1888 and 1890 to replace an earlier church by James Savage, is the architect's last and most mature work. It is also the most outstanding metropolitan example of the Arts and Crafts Movement in church furnishing, for Sedding was the second Master of the Art Workers' Guild and persuaded many leading artists of the day to collaborate here. Sedding, a keen High Churchman, passionately believed that churches should be 'both sanctuaries for God and homes for men—churches garnished with imagery exceeding magnifical—churches which the poor may be happy in, and the child may love, churches which are not whited sepulchres for torpid audiences, but homes of Grace, whose religious surroundings shall suggest high thoughts and minister to the sanctities of mortal life'.[1] Or, more succinctly, a church ought to be a 'design by living men for living men',[2] and certainly Holy Trinity has ample vitality and freshness [plate 62]. It is a free adaptation of Perpendicular Gothic with some Renaissance-inspired details. It consists of a high wide nave and chancel with a vault, flanked by aisles, narrow on the south, wider on the north. The walls are plain brick except for the front, which is in red brick and stone dressings, embattled with four turrets. The east and west windows are very large and enlivened with flowing tracery, the wide arches of the nave arcade spring out of the main piers without any interposed capitals, the spandrels are pierced with tracery, there is generous use of coloured Italian marbles

[1] John D. Sedding, 'Religion and Art', in *Art and Handicraft* (1893), 38.

[2] John D. Sedding, 'Design', in *Arts and Crafts Essays* (1893), 410. This striking phrase, later taken up by Lethaby, was first used by Sedding in 1889 and published in the Arts and Crafts Exhibition Society catalogue of 1890 (R. Macleod, *Style and Society: Architectural Ideology in Britain 1835–1914* (1971), 109 and n.).

à la Ruskin, and a great deal of sculptural decoration. The whole is, in fact, entirely characteristic of Sedding's style, and it is equally typical of him that the furnishings should all be of the highest quality. Unfortunately, he did not live to see the church completed, but his chief pupil and successor, Henry Wilson, carried on his work. Wilson was responsible for the altar rails, the grille behind the side altar in the north aisle (executed by Nelson Dawson), and the rails outside the church; but Sedding designed the delicately foliated ironwork gates at the entrance to the chancel. Edward Burne-Jones designed the forty-eight small individual panels, each with the figure of a saint, executed in brilliantly-coloured stained glass by William Morris & Company for the east window, for which Morris himself designed the foliage and surroundings. Other stained glass is by William Blake Richmond, who designed three windows in the north chapel (executed by Powell); and two windows in the Resurrection Chapel are by Christopher Whitworth Whall. The figure sculptures on the chancel screen and stalls, the latter in the form of low-relief panels in beaten and cast bronze of cherubs and angels with typical Arts and Crafts decorative surrounds, are by F. W. Pomeroy, and a white marble relief of the Entombment on the front of the High Altar is by Harry Bates. A reredos was designed by Sedding but never completed: in its place is one by John Tweed of the Crucifixion (1901). A font of Mexican onyx has a band of cherubs carved by Frank W. Boucher (or Bowcher) under the supervision of E. Onslow Ford. Only one of the projected sculpture medallions in the spandrels of the arcade was executed, by H. H. Armstead, who also did the bronze angel holding aloft an olive branch, which acts as a supporting figure for the lectern (1890). There were also to be figures of the Apostles carved by Hamo Thornycroft against the nave piers, but these, along with a Burne-Jones frieze destined for the space between the arcade and clerestory, were never carried out. Nevertheless, enough was accomplished to make Holy Trinity a most interesting and harmonious blend of Morrisian medieval and Italianate elements such as the coloured marble baldacchino over the altar in the north aisle, and the Renaissance pulpit. The church attracted warm

admiration and fierce criticism in equal measure. A work of art certainly, but some regarded it as a dangerous manifestation of the *fin de siècle*.

The fourth church in this survey, St. Cyprian's, Clarence Gate, differs considerably from the previous three in that one's first impression is of an extremely spacious and airy building with plain white walls, tall arcade, low clerestory, no pews, and none of the dim religious light beloved by many Victorian church architects [plate 63]. Once again, it is a 'High Church' and was designed throughout by John Ninian Comper, a prominent ecclesiologist who received his training first in the office of C. E. Kempe, and was then articled to G. F. Bodley and his partner, Thomas Garner. C. R. Ashbee's amusing, if slightly malicious, pen sketch of his fellow student at Bodley's office is worth quoting: 'In . . . Bodley's office, is the gentle and pious Comper. I like him, and only wish I could get him to like me, beyond a mere forced toleration of something leprously unorthodox. . . . His only interest is saints and a couple of clergymen; his speciality drawing angels. If he could only get himself to see other people's positions, or recognise that they had any, how much more substantial his angels would be. . . . How does one get round these church people of the narrow type?'[1] Externally rather dull, the church was consecrated in July 1903, but many of the fittings, all by Comper, were not finished until many years later, and it is these for which the church is noteworthy. Comper favoured chiefly Perpendicular Gothic, but was not averse to including elements from other periods and styles in the same church. His object was to move people to worship, and to this end he justified a multiplicity of means. Thus the font cover is a tall gilt classical affair (1930–2), but the large openwork rood-screen (1924) has elaborate fan tracery, with plenty of gilding, ultramarines, and reds, and painted panels of saints and apostles in imitation fifteenth-century style. The panelled roof carved in greyish-brown oak over nave and chancel is an excellent foil to the light colours used elsewhere. Everything has been done with much devotion and care, but it must be

[1] C. R. Ashbee, 'Memoirs', I, 'The Guild Idea' (1938), 21, entry for December 1886 (from typewritten MS. in the V. & A. Library).

acknowledged that such extremely refined medievalism, of which this church is a splendid example, frequently borders on preciosity completely antithetical to the robust honesty of Pearson or Sedding and their contemporaries. On a more positive note, it must be said that St. Cyprian's represents a more disciplined approach to church furnishing, after a period of near-anarchy, which is no doubt partly due to the beneficial effect of the Revd. Dr. Percy Dearmer's *The Parson's Handbook*, a well-illustrated manual based on a sound historical knowledge of Anglican liturgy, first published in 1899, which speedily ran to six editions by 1907.[1]

A more forthright attitude to church design appears in the last of the churches under review, The Annunciation, Bryanston Street, built between 1912 and 1914 by Walter John Tapper, for many years chief assistant to Bodley and Garner, and Lethaby's successor as Surveyor to Westminster Abbey. The Annunciation is a red-brick building in the fourteenth-century Decorated Gothic style that Bodley preferred, with large buttresses that make an impressive feature on the south side, with, on the north, flying buttresses over the aisle roof. Inside, the steel-grey limestone piers and paler stone arches of the tall arcade and triforium stand out against the white walls to create a beautifully cool effect. The church is rib-vaulted throughout, with a narrow tunnel-vaulted outer aisle, beyond the north aisle proper. The church has been given 'baroque' additions since the late 1930s, such as the altar candlesticks and crowned statue of Our Lady in pastel shades, but the original carved oak chancel screen, roodloft, rood, and large painted triptych by J. C. Bewsey (flourished 1917–25) still remain.

Domestic furniture between 1870 and 1914 underwent considerable changes, although here again some of the very best designs were produced by architects and artist-craftsmen rather than by commercial houses, which, then as now, were more adept at vulgarizing a fashion than at creating something really original.

[1] Peter F. Anson, *Fashions in Church Furnishings, 1840–1940* (1960), 305–15, gives a detailed account of this reform movement and much else besides. A reaction to the ascetic attitude or 'British Museum Religion' of Dearmer and the Alcuin Club (founded 1897) set in around 1911 with the foundation of the Society of SS. Peter and Paul, whose adherents favoured a return to the exuberances of the baroque and rococo periods.

One of the most serious problems to be faced or, more often than not, avoided by furniture designers and cabinet-makers of the mid nineteenth century onwards was the reconciliation of new methods of machine manufacture with traditional hand craftsmanship.[1] The notion that there could exist such a thing as a 'machine aesthetic' was but dimly apprehended only at the turn of the century, and even then not quite fully accepted by as enlightened a man as Lethaby. It was a fundamental weakness of William Morris and the Arts and Crafts Movement as a whole that they never success-fully resolved the problem. The Great Exhibition of 1851 had shown that British standards of design left much to be desired, and although basic constructional craftsmanship remained sound, at least in furniture, French cabinet-makers could still produce furniture of a far higher quality than our own. Eleven years later, British exhibits at the International Exhibition of 1862 showed considerable improvement in ornament, and it was here that the work of the firm of Morris, Marshall, Faulkner, & Company made its first public appearance. One must also remember that the elaborate exhibition pieces produced specially for the earlier inter-national shows give very little idea of the type of furniture in everyday use, although after the Paris Exhibition of 1878 this dis-crepancy almost completely disappeared. Trade support for these exhibitions also rapidly declined as illustrated specialist periodicals, which could publicize British manufacturers' work cheaply, in-creased in number and variety, and as a well-established, flourish-ing export trade made them less dependent on these temporary exhibition shop-windows. In 1871 the first of four international exhibitions devoted to Art and Industry, each of which empha-sized a particular trade, was held at South Kensington. The first was very successful and the second moderately so, but the public became bored with the fourfold repetition of much the same idea and this, coupled with administrative difficulties, killed off the

[1] Elizabeth Aslin, *Nineteenth Century English Furniture* (1962), 24, points out that a wide variety of wood-working machinery had been invented by Samuel Bentham before 1800. Apart from the mechanical saw, not only were there few carving and shaping machines in general use by cabinet makers even as late as 1870, but their economic advantages were seriously questioned.

series in 1874.¹ As far as furniture was concerned, the most important development in the 1870s was the advent of 'Art Furniture'. The term was first used in 1868 by the *Building News* and, twice, by Charles Lock Eastlake in his *Hints on Household Taste* of the same year (a third edition appeared in 1872).² Eastlake was the chief theorist of the movement, and deplored the bulbous extravagances, weak construction, and sheer uncomfortableness of most contemporary furniture. He wanted simple, rectangular designs, preferably unadorned and severely Gothic. The style has its origins in the work of Godwin, Burges, Eastlake, and the London firm of cabinet-makers most closely associated with the movement, Collinson & Lock of Fleet Street and Oxford Street. There was also the short-lived Art Furniture Company which had manufactured some of Godwin's designs in the mid-1860s. By about 1875 'Art Furniture Manufacturers' were listed separately in the London Trade Directory, and the distinction, which also had a certain snob appeal, underlines the artificial barriers which had now been erected between art and craft, and between art and manufacture. It was to break down these false divisions that Morris founded his company, which in turn inspired the Arts and Crafts Movement.

Some of the most exotic art furniture was designed by William Burges and he first showed some examples at the 1862 International Exhibition. A keen antiquarian, he was immensely knowledgeable on French and English medieval work of the thirteenth and fourteenth centuries, which, because so little has survived, he concluded must have been sturdily constructed, painted all over, and not carved. When it wore out it was demoted to the servants' quarters and thence to firewood. His appreciation of the delicacy and craftsmanship of Japanese art was quickened by a realization that these were the qualities he had admired in Western European medieval art and found so lamentably absent in the work of his

¹ *A Special Report on the Annual International Exhibitions of the Years 1871, 1872, 1873 and 1874*, drawn up by Sir Henry Cole, K.C.B. . . . H.M.S.O. (1879), gives copious statistical data as well as an analysis of reasons for the ultimate failure of the series.

² N. Pevsner, 'Art Furniture of the Eighteen-Seventies', *Arch. Rev.* CXI (Jan. 1952), 43–50.

own day. (Eastlake, too, admired Gothic and Japanese art.) Burges's furniture was therefore solidly built in chunky trefoil Gothic and elaborately painted, with an occasional Japanese motif included in the decoration. Although he never designed a Japanese interior, he did do a Moorish room for the Third Marquess of Bute at Cardiff Castle which was a precursor of the Oriental-style smoking rooms equipped by Liberty's. The firm of Liberty became an important clearing house of orientalia, and had been founded in 1875 by Arthur Lasenby Liberty, who, as the nineteen-year-old manager of Farmers and Rogers's Oriental Warehouse, had previously taken over the stock of Japanese objects remaindered from the International Exhibition in 1862. Liberty soon enjoyed the friendship of a wide circle of artists and designers, of whom Godwin was one of his principal consultants, and he did much to improve the standards of public taste by providing machine-made textiles that equalled the softer textures and subtler dyes of handmade Oriental fabrics. Like William Morris, he had enlisted Thomas Wardle's technical aid over dyestuffs, but he looked to the East for inspiration rather than to the medieval art of Western Europe, and his reforms run parallel with those of Morris.

The Ladies' Bedroom at Castell Coch, near Cardiff, designed by Burges in about 1875 gives an excellent idea of this artist's relentless polychromatic splendours. Most of his work was for a few wealthy clients, none was commercially marketed, and, since his designs were usually carried out by skilled cabinet-makers, the craftsmanship is superb. A magnificent carved and gilded Wooden Bed still exists [Victoria and Albert Museum; plate 64B], which he designed for the Guest Chamber of his own house ('Tower House') at 9 Melbury Road, Kensington (1875–80). This massive double bed is decorated with a medieval version of the Judgement of Paris painted on the headboard flanked by two large mirrors, with a repeated butterfly motif in red below and a frieze of ten small mirrors above. The sides and posts are set with round crystals, illuminated vellum, and textile fragments under glass, with carved floral decoration at the base of each post. The whole is proudly rounded off with Latin inscriptions: 'Vita Nova' (at the foot) and 'William Burges me fieri fecit Anno Domini

MDCCCLXXXIX' on the posts. There is also a carved and gilded Wash Stand (signed and dated 1880, Victoria and Albert Museum) for the same room, equipped with elaborately fashioned bronze taps, red and yellow marble soap-dishes, and a marble tip basin inlaid with silver fish and a butterfly. Godwin's Anglo-Japanese furniture is exquisitely balanced and delicately proportioned, with the minimum of adornment, and worlds apart from Burges's ponderous medievalism. Although some pieces, such as the Sideboard [Victoria and Albert Museum; plate 64A], were probably designed as early as 1867, their production by William Watt of Grafton Street continued until 1885. In 1877 Watt issued an illustrated catalogue with an introduction by Godwin, *Art Furniture*, which is one of the most comprehensive surveys of his astonishingly revolutionary furniture.[1] The Sideboard is in ebonized wood, with silver-plated fittings and inset panels of Japanese leather paper. Godwin's inspiration was by no means confined to Japan—many ideas for structural details were garnered from his researches among medieval furniture and manuscripts, and Greek vase-paintings at the British Museum, as evidenced by his surviving notebooks in the Victoria and Albert Museum. His 'Greek' chair (Victoria and Albert Museum), for example, dates from 1885. Black or ebonized baywood and black walnut were the favoured Art Furniture woods. Oak, if used at all, would be light oak, often stained green and sometimes left unpolished. Carving was limited to thin incised outline designs emphasized in gold, for painted decoration was the thing: 'One good painted panel is ten thousand times more than all the meretricious carving with which so much of our modern furniture is filled.'[2] T. E. Collcutt's Cabinet [Victoria and Albert Museum; plate 65A] with its slender, turned legs in ebonized wood, painted panels by Woolridge, and incised designs in white and indian reds, is a typical example of the more ornate, though still Japanese-inspired, Art Furniture, and was included in the 1871 International Exhibition by Collinson & Lock. Other Collcutt

[1] *Art Furniture from Designs by Edward W. Godwin, F.S.A., and others, with Hints and Suggestions on Domestic Furniture and Decoration by William Watt*, B. T. Batsford (1877).

[2] John Moyr Smith, *Ornamental Interiors* (1887), 82.

cabinets and a piano case, 'almost the only object of its order that derives value and importance from Art',[1] were also shown by them at the 1872 Exhibition.

Bruce J. Talbert was a professional industrial designer from Dundee, where he began his career as an apprentice woodcarver, but afterwards turned to furniture design and worked for Doveston, Bird, & Hull of Manchester, 1862–5, before coming to London in 1867, where he was employed by some of the leading cabinet-makers and exerted a generally beneficial influence on the trade. The Talbert style, dubbed 'Medieval' by Gillow's in contrast to Puginesque Gothic, or New Palace Westminster style, gradually gave place to Jacobean-inspired designs, first published in Talbert's second book, *Examples of Ancient and Modern Furniture, Tapestries and Decoration* (1876), an example soon followed by other designers. Even Godwin published characteristically elegant 'Old English' or Jacobean designs in the Watt catalogue of 1877. A classic Talbert design is the 'Pet Sideboard' (Victoria and Albert Museum) in oak and carved boxwood, made by Gillow in 1873, where a Japanese style sunflower is repeated amid the naturalistic bas-reliefs of fish and swans, and heralds this ubiquitous motif of the early 1880s, common to Art Furniture and terracotta plaques on Queen Anne revival houses. Another innovation of the period, probably initiated by Godwin in his Butterfly Suite for the Paris Exhibition 1878, was the use of bright mahogany for Art Furniture. Inevitably, 'Japanese' furniture became so popular by the early 1880s that commercial firms began making items for stock, instead of restricting themselves to special orders, and at the same time a reaction against Art Furniture gradually paved the way for the simplicities of modern design.

Most of the good modern furniture produced today has been inspired in some degree by the principles enunciated by Morris and his friends and carried out by the Arts and Crafts societies of the 1880s. Simple honesty of design was their watchword, with the emphasis on a high standard of craftsmanship and finish. That these principles were not incompatible with machine production was left to another generation to prove, but the important thing

[1] *Art Journal*, New Series, XI (1872), 55.

to remember is the acceptance of these principles by an ever-widening group of designers at the turn of the century. There was some faltering during the early 1920s, but the ground had been prepared, and, as in architecture, the initiative which had passed from British to continental designers returned again to these shores as a result of the political upheavals in Central Europe after 1933, which had turned many of these distinguished German and Austrian architects and designers into refugees from their homelands. The aim of Mackmurdo's Century Guild was 'to render all branches of Art the sphere, no longer of the tradesman, but of the artist. It would restore building, decoration, glass-painting, pottery, wood-carving, and metalwork to their rightful place beside painting and sculpture.'[1] The unity of art was also a theme taken up by the promoters of the Art-Workers' Guild in October 1883, when a resolution was passed to invite support for 'a new Society for promoting more intimate relations between Painters, Sculptors, Architects, and those working in the Arts of Design, with the view of advancing the Arts of Painting, Sculpture, Architecture, and Design'.[2] Finally Walter Crane, as the fourth Master of the Art-Workers' Guild, wrote in 1888: 'The true root and basis of all Art lies in the handicrafts. If there is no room or chance of recognition for really artistic power and feeling in design and craftsmanship—if Art is not recognized in the humblest object and material, and felt to be as valuable in its own way as the more highly rewarded pictorial skill—the arts cannot be in a sound condition; and if artists cease to be found among the crafts there is great danger that they will vanish from the arts also, and become manufacturers and salesmen instead.'[3] This is as true for modern industrial design as it was in Crane's own day.

The Arts and Crafts Exhibition Society held the first four of their many exhibitions in 1888, 1889, 1890, and 1893, all at the

[1] *Century Guild Hobby Horse*, VII (1887), 2, publishers' note repeated in all subsequent numbers up to and including 20 (1890).

[2] E. S. Prior, A.R.A., 'The Origins of the Guild', in H. J. L. J. Massé, *The Art-Workers' Guild 1884–1934* (1935), 8.

[3] Preface to the Arts and Crafts Exhibition Society's *Catalogue of the First Exhibition* (1888), 7–8.

large New Gallery, Regent Street, and the first three exhibition
catalogues each contained articles on various aspects of design
contributed by Crane, Lethaby, Reginald Blomfield, Emery
Walker, Cobden-Sanderson, Lewis Day, T. G. Jackson, Sedding,
and others. Individual craftsmen were acknowledged in the cata-
logue entries for each item—this in itself was radical departure
from current commercial practice which caused some manufac-
turers to decline to exhibit with the Society. Prominent con-
tributors, in addition to those already mentioned, were Voysey,
William De Morgan, W. A. S. Benson, The Century Guild
of Artists (Mackmurdo, Horne, Selwyn Image), and Ashbee's
recently-formed Guild and School of Handicraft of Toynbee Hall.
Furniture shown at these exhibitions included pieces by Voysey,
Ernest Gimson, Sydney Barnsley, Blomfield, Day, George Jack
(who in 1890 became chief furniture designer for Morris & Co.),
and Lethaby. An oak cabinet, inlaid with ebony and satinwood,
designed and executed by Lewis Day and decorated with twelve
grisaille panels of the signs of the Zodiac painted by George
McCulloch, was one of the exhibits in the 1888 exhibition [Vic-
toria and Albert Museum; plate 65B]. In some respects it continues
the Art Furniture tradition, but is even more simplified and
austerely proportioned. The same architectural qualities of balance
and proportion may be seen in another oak cabinet with red and
gilt painted floral decorations, designed by Ashbee for the new
Abbotsholme School, Rocester, Staffordshire, and shown in the
second exhibition of 1889 (No. 199), as the joint work of mem-
bers of the Guild of Handicraft [Victoria and Albert Museum;
plate 66A]. Quotations from William Blake's *Auguries of Inno-
cence* adorn the panels and this, too, follows an earlier tradition
of including mottoes or quotations in the decoration.

Ashbee's Guild was the practical outcome of his socialist views,
for socialism was a common faith among many Arts and Crafts
members, and he defined its purpose as a co-operative venture:
'There should be under some collective grouping, a number of
workmen practising different crafts, carrying out as far as possible
their own designs, coming into direct contact with material, and
so organised as to make it possible for the workman to be wherever

necessary in direct touch with the consumer.'[1] The men were to be shareholders 'and have an interest and stake in the concern', since 'personal interest must affect product, especially such product as has an intrinsic personal quality'; furthermore, the men were to have a voice in the management and policy of the business through their own elected representative. Ashbee did not repudiate machinery, but considered that where hand-work was better it should be used. This attitude begged the question. Ashbee tells in his unpublished 'Memoirs' how he belonged to that group of men from King's College, Cambridge, which included the agnostic classical scholar, Goldsworthy Lowes Dickinson, Roger Fry, James Headlam-Morley, the political historian, and Arthur Pillans Laurie, Professor of Chemistry to the Royal Academy; and, at Toynbee Hall, Hubert Llewellyn Smith, Quaker, civil servant, and social investigator. All these men were either socialist or liberal in outlook and greatly influenced Ashbee's own thinking. The mutual warm friendship of this group later cooled somewhat, for Ashbee was a difficult and opinionated man who quarrelled at one time or other with almost all his friends. Although Ashbee did not meet Edward Carpenter until October 1898, he had already been fired by Carpenter's radical socialist teaching and advocacy of the ideals of Walt Whitman, and in 1886 he became the resident architect at Toynbee Hall, founded two years earlier under Canon Sidney Barnett's wardenship. Ashbee started here a Ruskin art class which, despite Morris's gloomy predictions, was successfully expanded into the Guild and School of Handicraft which opened in June 1888 at first with premises in Commercial Street, then in 1891 moved to Essex House, Mile End Road. Ashbee wanted to rescue East London craftsmen from the economic hazards and tyranny of commercial practice, as well as train promising youths, who might otherwise have fallen on evil ways, in a useful trade. In 1902 the Guild, which was now a limited company, moved to Chipping Campden, Gloucestershire, and some 150 men, women, and children set themselves up in a new rural community; but by 1907 the poor financial returns, due in part to a general depression, forced Ashbee to wind up its affairs.

[1] C. R. Ashbee, *Craftsmanship in Competitive Industry* (1908), 18, 20.

The Guild had bought up William Morris's two presses in March 1898, and two of its most outstanding printing achievements were the *King Edward VII Prayer Book* (1903) and the *Essex House Song Book* (1904), set in Ashbee's 'Endeavour' type first used in 1901, which appeared under the Essex House Press imprint.[1] Ashbee's own work as jeweller, silversmith, and furniture designer is firmly Art Nouveau in character, and *The Painter-Stainers' Cup* of 1900 and the *Pendant and Chain* of 1903–6 [both Victoria and Albert Museum; plates 67A and 67B] are representative examples.[2] The Guild had been honoured by a visit from the Grand Duke of Hesse in 1897, and in the following year they made up furniture for the Grand Duke from designs by Baillie Scott.[3] These robust pieces are in carved oak, with boldly patterned coloured inlays and metal relief. Their basic shapes are extremely simple and rugged, recalling perhaps the early furniture by Webb. These same qualities also appear in Baillie Scott's mahogany and inlaid Clock, made by J. P. White of Bedford, *c.* 1900 [Victoria and Albert Museum; plate 66B].

Webb and Morris certainly inspired the solid oak furniture of Ernest Gimson, and of the brothers Ernest and Sydney H. Barnsley, all members of the Cotswold School of designers who set up workshops first at Pinbury, near Cirencester in 1893, then at near-by Sapperton in 1903. Gimson had met Morris at his father's house in Leicester in 1884, and it was Morris who suggested that he should join J. D. Sedding's office, where, incidentally, Gimson first met Ernest Barnsley.[4] After training at a local architect's office and at the Leicester School of Art, Gimson came to London in 1886. Sydney Barnsley, also trained as an architect under

[1] C. R. Ashbee, *The Private Press: A Study in Idealism. To which is added a Bibliography of the Essex House Press*, Essex House, Broad Campden (1909), limited edition.

[2] Shirley Bury, 'An Arts and Crafts Experiment: the Silverwork of C. R. Ashbee', *Victoria and Albert Museum Bulletin*, III (Jan. 1967), 18–25. Mrs. Bury notes the contemporary restatement of a traditional seventeenth-century cup and cover design in *The Painter-Stainers' Cup*.

[3] M. H. Baillie Scott, 'Decoration and Furniture for the New Palace, Darmstadt', *Studio*, XVI (1899), 107–15.

[4] W. R. Lethaby, Alfred Powell, and F. L. Griggs, A.R.A., *Ernest Gimson: His Life and Work* (1924).

Norman Shaw, had joined forces with the other architects, Blom-field, Gimson, Macartney, and Lethaby, to form the short-lived Kenton & Company in 1890. This company had enjoyed a suc-cessful exhibition in 1891, at which some £700 worth of furniture had been sold, but expired from lack of capital a year later. Lethaby's had been the guiding hand behind the company, but Gimson undoubtedly influenced Lethaby's furniture designs. A magnificent carved oak Sideboard by Lethaby of about 1900 is in the Victoria and Albert Museum [plate 68A]. The wood is unpolished and there are inlays of natural ebony, sycamore, and bleached mahogany; the elegant curvilinear inlaid floral patterns on the two cupboard doors are very much in the Morris tradition. Both Lethaby and Gimson worked mainly in oak, and Gimson had apprenticed himself briefly to a village chair-maker called Clissett at Bosbury, near Ledbury in Herefordshire, where he learned to make traditional turned chairs. Afterwards, Gimson never made any of his own furniture, but his early training enabled him to work in close touch with his craftsmen and he frequently modified designs during the course of construction. An early example of his turned chairs is in the Victoria and Albert Museum. It is in ash, with a rush seat, made about 1888, and grace-fully proportioned with the back splats subtly diminished in scale. Many variants of this pattern were later produced in Gimson's Daneway House workshops. More elaborate, but no less graceful, are the very fine Clergy Stalls he made for the St. Andrew's Chapel in Westminster Cathedral (c. 1912), carved in brown ebony and inlaid with bone [plate 69A]. The sturdy Cotswold tradition was continued by Gimson's Dutch-born foreman, Peter Waals, whose Silver Cabinet of about 1925 (Victoria and Albert Museum) is in carved and figured walnut, with the natural grain of the wood used to provide surface pattern.

The honest simplicity of Gimson and his friends impressed itself on Ambrose Heal, who had joined the old-established family firm of Heal & Son in 1893, and it was through his efforts that this new style was introduced on a commercial basis. Heal had served his apprenticeship with a cabinet-maker before beginning to design for the firm in 1896. He produced his first catalogue in 1898, and

it was here that the wooden bedstead, long despised on hygienic grounds, was reintroduced. Contemporary critics thought much of his early work too ugly for their taste, but Gleeson White considered that 'the beauty which many of the pieces undoubtedly possess is due to well-chosen material, admirable proportion, harmonious design, and rigid economy of ornament'.[1] These are sentiments which we would whole-heartedly endorse today. The Cottager's Chest, in chamfered holly wood, painted green and vermilion, of 1899, certainly has 'rigid economy of ornament' based on a Voyseyesque heart motif, but for splendour of another order one must turn to the famous oak Wardrobe inlaid with pewter and ebony which Heal designed in 1900 [plate 68B]. The interesting chequerboard design echoes the motif which Lethaby used at Avon Tyrell. Heal's oak furniture acquired a deservedly high reputation both for its high standard of design and its superb joinery, qualities which appear in a Writing Desk and Chair of 1929 belonging to the Victoria and Albert Museum, where the grain of natural wood is skilfully exploited for decorative effect. Simply designed high-quality bedroom furniture in natural oak was still being produced by the firm as late as the 1950s. The early designs of both Richard Drew Russell and his brother Gordon Russell also owed much to Gimson and Heal, as may be seen from a Writing-Desk by Gordon Russell [Victoria and Albert Museum; plate 70B]. Here he uses a variety of fine woods for enhanced richness of effect. The case is of walnut with burr elm panels, borders of mulberry, and bog oak bosses, set off by a chased silver lock-plate bearing the date 1927.

If the Cotswold School and the Arts and Crafts designers generally had little direct influence on current commercial products, it was otherwise with Art Nouveau, which quickly caught on in the furniture trade, where it was called either 'Fanciful' or 'Quaint', or more generically, the 'Anglo-French' style. The most progressive cabinet-makers and purveyors of this new style were Liberty & Co., J. S. Henry, J. P. White of Bedford, and William Birch of High Wycombe. Light rosewood with contrasting inlays

[1] Joseph W. Gleeson White, *A Note on Simplicity of Design in Furniture for Bedrooms with special reference to some recently produced by Messrs. Heal & Son* (1898), 2.

was the favourite medium and many anonymous pieces showing typical Art Nouveau spindly elongations, often of quite charming design, still survive from the 1890s; even more examples remain of the cheap, nastily proportioned pseudo-Art Nouveau wardrobes, washstands, and desks of the second-generation vulgarizers who did so much to discredit the style. Coarsely carved, elongated tulips, fretwork hearts, fiddly little brackets and wide cornices, all in inferior, yellow-stained wood are the hallmarks of these third-rate imitations. In true Art Nouveau an insistent emphasis on the vertical lines of a building or piece of furniture is the most obvious feature in both English and Scottish work. Legs were continued on and up beyond table or desk-top level, so as to end either under an upper cornice or moulding, or more usually, to remain free-standing square columns topped by a broad overhanging architectural cap. Century Guild furniture of the mid-1880s shows the germ of this feature, which must at times have been a hazard to the users' hips and elbows. Another structural peculiarity was the dropping of chair and table stretchers almost to floor level instead of the more usual six inches or so above. This was still perfectly sound in the solid oak furniture of, say, George Walton or E. G. Punnett, but in flimsier 'Fanciful' pieces it was frequently a cause of instability. Voysey was the most imitated of the leading designers, and although his first furniture did not appear until 1893, it was subsequently much publicized in English and continental journals. The 'Swan Chair' of about 1897 (Mrs. J. Bottard) combines traditional methods of construction with an entirely original shape unmistakably Art Nouveau in character. A Writing-Desk of 1896 [Victoria and Albert Museum; plate 70A] in unstained oak with beaten copper hinges, pierced decorative panel and heart-shaped terminals should be seen in conjunction with one of his typical interiors in order to get the full flavour of his very personal style. One of Voysey's most distinguished followers was George Walton, whose billiard-room for The Leys at Elstree (1901), the house he built for J. B. B. Wellington, is more elaborately formalized than a Voysey interior, but less *outré* than one by Walton's compatriot, Mackintosh, at this time.

Liberty's introduced high-quality Art Nouveau silver and jewel-

lery designs under the Celtic-inspired trade name of 'Cymric' either late in 1898 or early in 1899, followed in late 1901 by the first of the 'Tudric' pewter designs. In common with all Liberty work of the period, the designers' names were not publicized, but it is known that Rex Silver, Archibald Knox, the Gaskins, Jessie M. King of Glasgow, and Bernard Cuzner all produced work for the firm, much of it made by W. H. Haseler of Birmingham.[1] One of the most significant developments during the first twenty years of the twentieth century was the revival of interest in studio pottery created by artist-potters, as distinct from the great commercial houses of Wedgwood, Minton, Doulton, and the famous porcelain manufactories founded in the eighteenth century. Apart from De Morgan's lustred and 'Persian' wares of the 1870s, there were no significant developments in this field until William Howson Taylor perfected his high-temperature flambé 'Ruskin' pottery at his works in West Smethwick, near Birmingham, and William Moorcroft introduced his 'Florian' range of lustre pots which was sold by Liberty's from 1898 onwards. The art schools did little to encourage an interest in pottery until the 1920s, with the notable exception of the Camberwell School of Arts and Crafts, where W. B. Dalton introduced training courses in pottery. One of Dalton's distinguished pupils was Roger Fry. Dalton had also experimented with stoneware in the Chinese manner.[2] Oriental influences and techniques were introduced by the second generation artist-potters, of whom Bernard Leach is one of the most important. He set up a pottery at St. Ives in 1920, after having studied under the Japanese master-potter Ogatu Kenzan, and brought back with him to England a young Japanese assistant, Shoji Hamada. One of Leach's most distinguished pupils was Michael Cardew, who studied with him for two years, 1924–6, before starting his own pottery at Winchcombe, Glos. William Staite Murray, although developing independently of the St. Ives

[1] *Birmingham Gold and Silver 1773–1973*, Birmingham Museum and Art Gallery (1973), Section G. Art Nouveau, n.p.; and *Liberty's 1875–1975: An Exhibition to mark the Firm's Centenary*, V. & A. (1975), Shirley Bury, 'The Cymric and Tudric Schemes', 13–17 and section 'Stile Liberty', 53–81, 89, 93–4.

[2] Muriel Rose, *Artist-Potters in England* (1955, 2nd edn. 1970), gives a succinct account of the principal potters and their work.

group of potters, was also influenced by Hamada's work in the early 1920s. Murray became head of the Pottery School at the Royal College of Art in 1925 and was much admired by the younger artists of the 7 & 5 Society with whom he exhibited. Modern studio pottery is hand-thrown, with the infinite subtle variations in shape and texture that are part of this technique. Glowing earth colours, rich metallic glazes and slips, and crackled glazes in the oriental manner, with simple brushed-in or sgraffito decoration are also hallmarks of the genre.

PART THREE

PAINTING AND SCULPTURE
1900-1930

VII

BLOOMSBURY, CAMDEN TOWN
AND VORTICISM

THE first twenty-five years or so of this century were a
period of unprecedented change and ferment in the visual
arts of Western Europe and, to a lesser extent, of America.
A few English artists were aware of the startling events taking
place in Paris and Munich in the first decade, but it was not until
Roger Fry organized his two exhibitions of Post-Impressionist
painting in 1910 and 1912 that the revolutionary work of Seurat,
Van Gogh, Gauguin, Edvard Munch, and Cézanne, of Matisse,
Braque, Picasso, and Kandinsky, became known to a wider Eng-
lish public. All these exciting new developments were presented
in London within the short space of about eighteen months, and
it can hardly be surprising that some of them were either misunder-
stood or at least ill-digested. Then came the appalling physical and
spiritual anguish of the 1914–18 War, which destroyed the old
order of European civilization and unleashed a powerful nihilistic
ideology that in art and literature was most forcibly expressed by
the Dadaists. The breakdown of traditional formulas affected all the
creative arts. New and often startling harmonic experiments were
being tried by the composers Richard Strauss, Igor Stravinsky, and
Arnold Schoenberg, whose *Harmonie-lehre* was published in 1911.
Alfred Jarry attempted to combine the refinements of symbolist
poetry with the crudities of common speech in his play *Ubu Roi*
(1895); and James Joyce minutely explored the 'stream of con-
sciousness' as experienced by two imaginary Dubliners during the
events of one day, setting down the complexities of their often
semi-incoherent thoughts and words in the form of a novel,
Ulysses (1925).

Yet no new developments, even those which seem to break
most violently with tradition, can be entirely dissociated from

what has gone before, and in reacting against the excesses of nineteenth-century romanticism and naturalism Seurat, Gauguin, Cézanne, and, one must add, the Cubists, who did invent a new pictorial language, were all attempting to restore formal disciplines analogous to those of classical art but very different in their interpretation.[1] The history of art shows a continual ebb and flow between art which is, in infinitely varying degrees, either naturalistic and anthropocentric, or non-naturalistic, mystical, and hieratic. In England the movement towards an art in which the emphasis was increasingly placed on purely formal qualities first appeared in the work of Whistler and developed still further in Art Nouveau, but the lively young painters of the next generation rallied round Sickert, who had returned to England in 1905, and Wyndham Lewis. Their new champions were Fry, Frank Rutter, and T. E. Hulme.

A group of artists, whose careers were just blossoming in 1900, are noted here, two for their importance as teachers and two for the phenomenal success they enjoyed in their lifetimes which, if out of all proportion to their talents, at least provides a revealing comment on contemporary taste. Henry Tonks has already been mentioned as a loyal friend of Steer's, but he was also one of the foremost teachers of his generation. After qualifying as surgeon, he abandoned the medical profession to begin his teaching career at the Slade School in 1893 as an assistant to Fred Brown, his former art master at the Westminster School of Art, and served as Slade Professor from 1918 to 1930.[2] His paintings are notable for a certain dryness of technique which became known as 'Tonking' and consisted of soaking up with absorbent material the excess medium, especially in the layers of underpainting. His striving for those poetic effects that he considered so important often painfully obtrudes on his finished work, but his *Portrait of the Artist* of 1909 (Tate Gallery) has an angular honesty about it, even to the extent of faithfully reproducing the exaggerated scale of his hands

[1] Robert Rey, *La Renaissance du sentiment classique dans la peinture française à la fin du XIXe siècle*, Paris (1931).

[2] John Rothenstein, *Modern English Painters: Sickert to Smith*, I (1952), contains essays on Tonks, William Rothenstein, Ambrose McEvoy, and William Orpen.

and knees as seen in close-up perspective [plate 71B]. Dour and irascible, he set high standards for his pupils, particularly in his own forte, draughtsmanship—in which he was refreshingly unlaboured—and thus continued a Slade tradition of pre-eminence in drawing begun by Legros. Yet his sympathies were limited, and his attitude to the Post-Impressionists and their successors hardened into active, uncompromising hatred, an unfortunate development which cut him off from the more gifted of his younger pupils. William Rothenstein, a pupil of Legros at the Slade in 1888–9, through the early friendship of Whistler was introduced to some of the leading French artists during his student days in Paris, notably Degas, Camille and Lucien Pissarro, and Toulouse-Lautrec. Personal contacts such as these widened his horizons and sympathies, although his earlier work is in the low-toned style of Whistler strengthened by the precise drawing he had learnt to value from Degas's example. It was this last quality in his series of lithograph portraits, *Oxford Characters* (1893–6), which helped to establish his early reputation. A still very Whistlerian painting of 1899, *The Doll's House* (Tate Gallery), shows Augustus John and Rothenstein's wife, Alice Knewstub, whom he had just married, posed as characters in a tense scene from Act III of the play by Ibsen which provided the title of the paintings [plate 71A].[1] 'We were all mesmerised by Ibsen in those days', the artist later recalled, and the literary and dramatic qualities of Ibsen's 'problem plays' were then beginning to effect a much-needed change in the English theatre, encouraged by George Bernard Shaw in his dual capacity as a rising critic and playwright of formidable powers. Rothenstein's style underwent a radical change about 1900 as he became more receptive to Impressionism. His palette brightened and he intensified his observation of nature and the representation of open-air light; he worked more assiduously at landscape, bringing to it, however, something of the preoccupation with structure and deliberate design that characterizes the work of the Post-Impressionists. Not that he uncritically accepted all aspects of

[1] William Rothenstein, *Men and Memories 1872–1900*, I (1931), 210. The painting was included in the British section of the Paris International Exhibition of 1900, where it gained the artist a silver medal.

Post-Impressionism. Pure abstraction was for him 'a cardinal heresy', and his refusal to associate himself whole-heartedly with Fry's advocacy of all the Post-Impressionists led to a permanent alienation between the two men. It was one of the harsh ironies of Rothenstein's career that as his reputation as a writer and teacher increased—he was Principal of the Royal College of Art from 1920 to 1935—his standing, though not his probity as an artist, rapidly declined in later years.

Ambrose McEvoy was encouraged by Whistler to enter the Slade School in 1893, where he met a highly gifted fellow student of his own age, Augustus John, who joined a year later. McEvoy made an intensive study of the methods of the Old Masters and later worked with Sickert in Dieppe c. 1907–8, painting low-toned landscapes and interiors with figures. He developed his technical prowess with surprising slowness and much labour for one who later became renowned for his extraordinary facility and brilliantly luminous palette. Like Lavery, Rothenstein, and John, he exhibited at the New English Art Club and became a founder-member, with Lavery and William Orpen, of the National Portrait Society in 1911—for by now he had begun to develop a more personal style, and soon abandoned interiors for portrait painting of a specialized nature in oils and water-colour. His sitters were almost exclusively beautiful, fashionable women and, after years of struggling poverty, such was his reputation for this genre by 1916 that he was overwhelmed with commissions. At his worst, he was vulgar and flashy, the traditional hazards of a fashionable portraitist working for a capricious and often impatient clientele; at his best, he produced delicate, etherealized likenesses of his beautiful sitters, each one 'transformed into an unearthly being, her most exquisite qualities of body and mind projected in a radiant, many-coloured nimbus'.[1] *The Ear-Ring* of about 1911 (Tate Gallery) is a transitional work, recalling the early sombre interiors yet foreshadowing the fashionable beauties to come, of which *The Hon. Daphne Baring* of 1917 (The Hon. Mrs. Arthur Pollen) is a charming, iridescent example. Orpen's success as an official portrait painter easily transcended McEvoy's, and there could be no greater con-

[1] John Rothenstein, op. cit. I. 210.

trast between their two styles. Orpen, the painter of public figures, had developed a hard, highly polished style that set the pattern for two generations of Academicians' Board Room verisimilitude. Of Anglo-Irish descent, Orpen studied art in Dublin for seven years before going to the Slade School, 1897-9, where he established himself as something of a prodigy. He and Augustus John jointly ran a teaching studio in Flood Street, Chelsea, for several years from 1899, one of their more distinguished pupils being Henry Lamb. Orpen's first mature work and the one that established his name, *The Mirror*, of 1900 (Tate Gallery), shows a model, Emily Scobel, seated before a convex wall mirror in which are reflected the artist at his easel and another figure. Stronger in colour than a William Nicholson interior of this date, though similar in technique, it has a sure draughtsmanship and wealth of minutely observed detail that were to be Orpen's particular distinctions as an artist. But its obvious affinities with the work of such Dutch seventeenth-century masters as De Hoogh and Vermeer warns us that original, imaginative content was henceforth to be an extremely intermittent virtue in his work. Except for a few war paintings in which he was moved to comment on the horrors of life rather than merely diligently to record—as in his portraits of generals and politicians, such as *Peace Conference at the Quai D'Orsay* 1919 (Imperial War Museum)—he had little to say. A harsh verdict which time has endorsed, for his enormous contemporary reputation has now almost faded to nothing. Only his *Hommage à Manet* of 1909 [City Art Gallery, Manchester; plate 72B] gives a hint of better things with its admirably composed group of George Moore, Steer, MacColl, Sickert, Sir Hugh Lane, and Tonks, around a tea-table beneath Manet's *Portrait of Eva Gonzales*, at Lane's house in South Bolton Gardens. This house was later acquired by Orpen, then grown wealthy, and used as his house and studio until his death.

It was a golden age at the Slade School, for a succession of brilliant students passed through the hands of Brown and Tonks between 1895 and 1914. A list, with their dates of attendance, reads like a *Who's Who* of British Art for the period, and the Slade has never again achieved quite the same concentrated

pre-eminence. In addition to Augustus John, Orpen, and McEvoy, there was John's immensely gifted elder sister Gwen (1894–7), then came Harold Gilman (1897), Spencer Gore (1896–9); Wyndham Lewis (1898–1901), J. D. Innes (1905–8), and Matthew Smith (1905–8); followed by a galaxy composed of Duncan Grant (1906), C. R. W. Nevinson (1908–12), Mark Gertler (1908–12), Stanley Spencer (1908–12), Edward Wadsworth (1908–12), William Roberts (1910–13), Paul Nash and Ben Nicholson (both 1910–11), David Bomberg (1911–13), Bernard Meninsky (1912–13), and Stanley Spencer's brother, Gilbert (1913–15). Some of these made but fleeting or irregular appearances at classes, and Nicholson has recalled how he spent as much time sharpening his aesthetic sensibilities by playing billiards at the near-by Gower Hotel as at his studies.[1] The most highly regarded painter at the time was Augustus John. A brilliant draughtsman—as a student he could imitate the styles of Rembrandt and Watteau—he showed in his own style a vivid and accurate grasp of basic forms without ever losing fluency or expressive sparkle in his line, qualities which also characterize the many superlative etchings he produced before 1914. While at the Slade he had won a scholarship and, in 1898, the Summer Composition Prize. After 1899 he travelled extensively in Europe and America during his active career, which included a spell as Professor of Painting at Liverpool University 1901–4, and then, from 1911 to 1914, four years' nomadic life spent in Ireland, Dorset, and his native Wales, where he camped with gipsies and worked with J. D. Innes and Derwent Lees. A handsome, red-bearded man of striking appearance and colourful personality, he quickly earned a well-deserved and zestfully maintained reputation for 'bohemianism' which spread well beyond the closely-knit society of artists and writers that frequented the Café Royal of pre-1914 days. He was widely regarded as the great hope of British art, and at the New York Armory Show of February 1913, for example, over forty of his oils and drawings were included, many of them lent by John Quinn. That this hope was only partly fulfilled may perhaps be explained by the lack of a

[1] John Summerson, *Ben Nicholson* (1948), 6; John Rothenstein, *Modern English Painters: Lewis to Moore*, II (1956), 262 and n.

suitable opportunity and subject matter for the large-scale decorative work that it was once John's ambition to achieve, coupled with a flaw in his temperament which made it impossible for him to sustain continuous interest in a necessarily protracted undertaking. He always seemed to be searching unsuccessfully for an inspiring theme. Nevertheless, he was open to new ideas, and if not whole-heartedly in sympathy with the most advanced French painting at the Salon des Indépendants, he had assimilated traces of Gauguin's style into his own work as early as 1902.

The trend towards an increasing number of independent exhibition societies and groups which had begun with the foundation of the New English Art Club in 1886 and continued with the International Society in 1898 gathered further momentum in the early decades of the twentieth century. Some were only mildly radical, like the Society of Twelve which organized eight exhibitions between 1904 and 1915, and was limited to showing drawings, original engravings, etchings, lithographs, and woodcuts. Its founder members were Clausen, Gordon Craig, William Nicholson, William Strang, Sturge Moore, William Rothenstein, Ricketts, Shannon, D. Y. Cameron, John, Conder, and Muirhead Bone. Later distinguished recruits were Legros (as an Honorary Member), Francis Dodd, Orpen, Havard Thomas, Lamb, and Sickert. Others were much wider in scope, like the now forgotten Society of 25 English Painters, whose first exhibition was held at the Dowdeswell Galleries in 1905. Of its members only Anning Bell, Gerald Moira, and Dudley Hardy achieved a lasting reputation. The Friday Club should be mentioned here as an interesting informal group, founded by Vanessa Bell in 1905, which brought together many artists of a wide diversity of talents and loyalties.[1] Their first exhibition was held in November 1905, and by June 1910 the Club had become established at the Alpine Club Gallery, where it continued until 1918. The February 1911 exhibition was dominated by Fry, Duncan Grant, Vanessa Bell, Nevinson, and Gertler, but by 1914 the first three had left, and Bomberg, Frederick Etchells, Meninsky, Wadsworth, and the

[1] Richard Shone, 'The Friday Club', *Burl. Mag.* CXVII (May 1975), 279–84. The Club's last exhibition was held in April–May 1922.

two Nash brothers were among the new members. Rothenstein, Ethel Walker, and Robert Bevan's wife, Stanislawa de Karlowska, joined in 1916. By 1921 the scene had changed again, and among the new faces were Bevan, Ginner, E. McKnight Kauffer, Henry Rushbury, Elliott Seabrooke, Eric Kennington, Frank Dobson, Roberts, Lucien Pissarro, Eric and Macdonald Gill, Charles Rennie Mackintosh (who had returned to painting), Boris Anrep, and Alan Durst. These changes reflect in microcosm the cross-currents of the years 1910–20 and will only become fully intelligible when the main events of this decade have been discussed.

Much the most important society was the Allied Artists' Association, the first of whose seven annual exhibitions in the Albert Hall, *The London Salon*, was held in 1908, with a further five, much smaller Salons at the Grafton Galleries between 1916 and 1920. The demand for a new independent forum had by now become more insistent as the New English gradually lost its original vitality and impetus, particularly among the younger artists who met informally from about 1905 onwards at Sickert's studio, 19 Fitzroy Street, where small, semi-private exhibitions of their work also were held. As a result of these meetings, Frank Rutter, the critic, proposed an annual exhibition of independent progressive artists, inspired by the Paris Salon des Indépendants, and thus came into being the Allied Artists' Association. In a Foreword to the catalogue of the first exhibition, Rutter, the new Association's Secretary, wrote: 'The Association accords the same treatment to all artists, irrespective of their positions and reputations. No artist who has made his application to exhibit before the first day of June has been refused. Each exhibitor has the right to exhibit works, not exceeding five in number, without submitting them to any selecting jury.'[1] It aimed to be a co-operative, international venture, open to engravers and craft-workers in addition to painters and sculptors. There was a hanging committee of forty, elected by the members, and, at Sickert's suggestion, this committee decided by ballot both the order in which the works were to be hung and the sections for which each committee member was

[1] *The London Salon* (July 1908), 5; the catalogue of *The Twelfth London Salon* (July 1920), v–viii, contains a brief history of the A.A.A. by Rutter.

to be responsible, in order to give equality of opportunity to all. Foreign painters were invited to contribute, and the first works by Kandinsky to be shown in England appeared in the 1909, 1910, and 1911 A.A.A. exhibitions; and in 1913 sculptures by Constantin Brancusi and Ossip Zadkine were included, as were six works by Henri Gaudier-Brzeska, including the plaster for his life-size bust of Horace Brodzky, a cast of which is in the Tate Gallery. The first of these exhibitions contained over 3,000 works, and although subsequent ones were usually less than half this size they were still far too large for any one group to make itself effectively felt. 'Simplicity, Sincerity, Expression' were the qualities most valued by the organizers of these exhibitions, so Rutter later recalled,[1] but these were the watchwords all over Europe at that time.

The Fitzroy Street group, in deference to John and Sickert's opposition, had abandoned their attempts to take over the New English, and in May 1911 decided to exhibit together at the Carfax Gallery as the Camden Town Group. They chose their name in salute to the drab working-class area first made popular by Sickert which provided subjects for many of the Group's pictures. As Sickert had remarked, it was a district so watered by his tears that something good must come from its soil. The Camden Town Group was dominated by four young painter friends of Sickert, all of whom had been familiar with the work of Cézanne, Gauguin, and Van Gogh from their student days—Harold Gilman, Charles Ginner, Robert Bevan, and the first President of the Group, Spencer Gore. Bevan had met Gauguin at Pont Aven in 1894, and Gore went to Paris in 1906 to study the Gauguin memorial exhibition. The early works of Gilman and Gore, in particular, are derived stylistically from Impressionism as distilled by Sickert, and many of his followers imitated his method of 'squaring-up' their compositions both in preliminary drawings and in finished oils. Other members of the Group brought more independent talents to it: Walter Bayes, Malcolm Drummond, Duncan Grant, J. D. Innes, Augustus John, Lamb, Wyndham Lewis, M. G. Light-foot, Lucien Pissarro, William Ratcliffe, with James Bolivar

[1] Frank Rutter, *Art in my Time* (1933), 131.

Manson as Secretary. They held two exhibitions in June and December 1911, and a third (and last) in December 1912, all at the Carfax Gallery. It is not surprising that so extraordinarily diverse an assembly should have enjoyed only a short life, but its demise was speeded by the Carfax Gallery's decision to cut its financial losses rather than promote further Camden Town Group shows, although the gallery continued to give exhibitions to a few individual members. A new alliance was formed in November 1913, under the Presidency of Harold Gilman, ever a fierce advocate of the independent artist, which included the new English *avant-garde*: Wyndham Lewis, David Bomberg, Jacob Epstein, C. R. W. Nevinson, William Roberts, and Edward Wadsworth—that is to say, the English Futurists and the Vorticists. Thus were the two most advanced, but very different, wings of English art briefly united in one society, a society which was to be the foundation of the London Group in March 1914.[1] This new group meanwhile organized an exhibition at the Brighton Art Gallery which ran from December 1913 to January 1914, and although nominally the Camden Town Group, a sub-title proclaimed the wider loyalties of the association: 'An Exhibition of the Work of English Post Impressionists, Cubists and Others'. Sickert spoke briefly at the opening and stressed that art should not be tied to any one faction or academy. Manson and Lewis contributed forewords to the catalogue, and Manson refers in his to the imminent formation of the 'London Group': 'More eclectic in its constitution, it will no longer limit itself to the cultivation of one single school of thought, but will offer hospitality to all manner of artistic expression provided it has the quality of sincere personal conviction. . . . Cubism meets Impressionism, Futurism and Sickertism join hands and are not ashamed . . .'[2] Lewis wrote on 'The Cubist Room' in the exhibition in characteristically provocative prose, and dis-

[1] D. Farr and A. Bowness, 'Historical Note', in *London Group 1914–64: Jubilee Exhibition*, Tate Gallery (1964); Malcolm Easton, '"Camden Town" into "London": some intimate Glimpses of the Transition and its Artists, 1911–1914', in *Art in Britain 1890–1940*, University of Hull (1967), 60–75, publishes valuable documents which correct earlier accounts of the history of the Group.

[2] J. B. Manson, in *Exhibition by the Camden Town Group and Others*, Brighton (16 Dec. 1913–14 Jan. 1914), 8.

missed the term 'Post Impressionism' as 'an insipid and pointless name invented by a journalist, which has naturally been ousted by the better word "Futurism" in public debate on modern art'.[1] The 'journalist' so slightingly referred to can only have been Roger Fry, with whom Lewis had quarrelled earlier in the year, but Lewis was himself to have second thoughts about the use of the term Futurism. Credit for suggesting the name 'London Group' is usually given to Epstein, and under this title was held the first exhibition at the Goupil Gallery in March 1914, when membership of the group was increased from sixteen to thirty-two. Sculptors were admitted and the ban on women artists lifted—not, as might be thought, a timely gesture to Mrs. Pankhurst, but a resolution of an earlier difficulty to do with individuals. The members elected their own hanging committee, and after the first exhibition an increasing number of non-members were encouraged to submit works, a practice that has continued to this day.

The London Group provided a platform for the most advanced trends in English art, but its birth had been preceded by other important events which must be related in order to understand the work of its most prominent members. One of the key figures of this period is Roger Fry, artist, art critic, and widely regarded as a scholarly expert on the Italian Old Masters. By 1905, at the age of thirty-nine, he had established a reputation high enough to merit serious consideration for the vacant Directorship of the National Gallery, but the appointment was not offered him until after he had already accepted the post of Curator of Paintings at the Metropolitan Museum, New York, in January 1906, and felt bound to honour his decision. He remained at the Metropolitan until 1910, but spent a great deal of time in Europe on buying expeditions with Pierpont Morgan. It was in 1906, however, that his tastes began to change after seeing for the first time the work of Cézanne, a painter in whom he recognized qualities of colour sensitivity and structural logic which seemed to him to combine the adventurousness of Impressionism with the formal disciplines of the Old Masters. After Cézanne, he discovered Gauguin, Van Gogh, Matisse, and Maillol, whom he championed in articles for the

[1] P. Wyndham Lewis, ibid. 10.

Burlington Magazine (which he had helped to found in 1903 and subsequently edited). Thus began a long and often thankless crusade not only to awaken public interest and understanding of modern art in England, but also to lift English art out of its besetting provincialism. He alienated his reactionary old cronies MacColl and Tonks, but in the process gained new adherents, of whom the most prominent were Duncan Grant and Vanessa Bell, artist wife of Clive Bell, the writer and critic. Unashamedly partisan and empirical, Fry brought exceptionally alert sensibilities and acute analytical faculties to the task, and was at his best when deriving his conclusions from direct analysis of actual works, as in his book, *Cézanne, a Study of his Development* (1927). He gradually evolved the doctrine of 'significant form', first tentatively enunciated in an *Essay on Aesthetics* published in the *New Quarterly* in 1909. The actual term 'significant form' was invented by Clive Bell to describe the element common to all works of art, yet never found in nature. Beauty as a concept was abandoned by Bell, whose new doctrine appeared in *Art*, published in 1914. Fry's theory was that forms and combinations of forms could be isolated from the emotional responses with which they were traditionally associated.[1] In 1910 he organized the exhibition of over 200 works (including fifty drawings), *Manet and the Post-Impressionists*, at the Grafton Galleries, which opened on 8 November and continued until 15 January 1911.[2] Fry explained in a foreword to the catalogue that Manet was included not only as a progenitor of Impressionism but also as one who had influenced Cézanne. There were eight paintings by Manet, including the famous *Un Bar aux Folies-Bergère* (Courtauld Collection), lent jointly by Bernheim Jeune, Paul Cassirer, and Durand-Ruel; then came twenty-

[1] For a critical examination of Bell's and Fry's formalist aesthetics see Solomon Fishman, *The Interpretation of Art*, University of California Press (1963), 73–99, 101–42; and Jacqueline V. Falkenheim, *Roger Fry and the Beginnings of Formalist Art Criticism*, U.M.I. Research Press, Ann Arbor, Michigan (1980).

[2] An exhibition, *Modern French Artists*, which had been organized by Robert Dell at Brighton, June–August 1910, attempted a wider survey of French art and included Corot, Puvis de Chavannes, Legros, as well as several minor Impressionists. There were, however, works by Bonnard, Boudin, an early Cézanne portrait of Valabrègue, Degas, Denis, Derain, Gauguin, Matisse, Monet, C. Pissarro, Renoir, Rouault, Sérusier, Signac, Vlaminck, and Vuillard.

one Cézannes, including the *Dame au chapelet* (National Gallery, London) and several landscapes of L'Estaque and Mont Ste Victoire. There were thirty-six oils and pastels by Gauguin, including some of his major Tahitian Symbolist works—the preponderance of Gauguin may be an indication of his importance, in English eyes, as the leading Post Impressionist. Van Gogh was represented by twenty-two oils, including *La Berceuse* and two copies after Delacroix and Rembrandt. Most of the paintings were lent by well-known French dealers, and the exhibition, although far from a balanced historical survey of modern art, must have been most impressive. There was also a sizeable group by the Symbolists, Redon, Maurice Denis, Sérusier, and Pierre Girieud; but only seven by the neo-Impressionists, Cross, Signac, and Seurat (including the *Phare à Honfleur* now in the Paul Mellon Collection); but the Fauves were better shown, with thirty-nine works, with emphasis given to Vlaminck and Rouault, although there were three Matisse oils and eight of his bronzes. Only two Picassos were included, an early nude and an early Cubist portrait of *Clovis Sagot*, although there were also several Picasso drawings. The general bias of this exhibition in favour of 'Expressionism' was soon to be redressed by Fry, but it still made a tremendous impact, and English art was never to be the same afterwards.[1] Sickert, who ought perhaps to have known better, was inclined either to mock at the leaders of French Post-Impressionism, or to adopt a blasé 'known-'em-all-years-ago' attitude. The Stafford Gallery held an exhibition of Gauguin and Cézanne in November 1911, and in April 1912 gave Picasso his first English one-man show, although it was limited to pre-Cubist drawings. The theoretical groundwork had been prepared by the appearance in 1908 of the English edition of Meier-Graefe's *History of Modern Art*, but henceforth Fry—who was much indebted to Meier-Graefe's 'system of aesthetics'—Rutter, and Clive Bell were the chief English apologists of the movement. In 1912, Rutter became Director of Leeds City Art Gallery, an influential post he held for five years.

Fry's *Second Post-Impressionist Exhibition* opened at the Grafton

[1] Douglas Cooper, *The Courtauld Collection* (1954), 52–9, gives an account of the public reaction to Fry's two Post-Impressionist exhibitions.

Galleries on 5 October 1912 and continued to the end of the year, when a rearranged version of it, containing many new substituted exhibits, opened for the whole of January 1913. Cézanne, not Manet, was the *clou* of the exhibition, with the Fauves and Cubists now given much greater prominence. The international flavour of the movement was stressed by the inclusion of an English group selected by Bell, and a Russian section organized by Boris Anrep, while the French painters were Fry's choice. Grouped around the eleven Cézannes, later increased to thirty-three, were forty-one Matisses, half of them drawings and sculpture, sixteen Picassos (including Cubist works), and a good representation of Derain, Friesz, Vlaminck, Van Dongen, Puy, Marquet, most of whom were now working in a Cézannesque or Cubist style. Braque had four pictures, three of them Fauve, one Cubist; and Bonnard appeared for the first time, with three oils. Among the English artists chosen by Bell were Duncan Grant, Frederick Etchells, Vanessa Bell, Fry, Henry Lamb, and Bernard Adeney, most of whom were 'Bloomsbury Group', with Spencer Gore, Wyndham Lewis, and, in the rearranged exhibition, Wadsworth and Cuthbert Hamilton representing the more radical wing. Eric Gill, who had begun figure sculpture in 1910, showed eight pieces, and Stanley Spencer was represented by three oils, including his visionary *John Donne arriving in Heaven*, 1911 (Mrs. G. Raverat). The English artists must have seemed rather unadventurous in juxtaposition with their continental colleagues, for none of them had advanced beyond a cautious interpretation of Cézanne, the Synthesism of Gauguin, and the brilliant colour of the Fauves. Nevertheless, the exhibition created violent controversy and ferment among English artists. Roger Fry's own persuasive charm and rapid commitment to some of these new ideas emerges from an entry in Ashbee's Journal for 11 October 1912: 'A delightful morning with Roger [Fry] at the Grafton. He took me round his post-Impressionists. I put myself unreservedly in his hands and let him spoon feed me. I stuck at Picasso. I enjoyed the colour of Matisse. But the art criticisms, how hopeless they are! I wanted to know of Roger what he thought of the Futurists. He would have none of them—waved them aside as impossible. "All they do"

said he "is to paint the confusion of the brain in a railway journey."
I battled with Roger for some time and then delightedly let myself
be trampled on—it's no good with Roger—he's so in earnest, and
his next mood is equally so.'[1] Fry's antipathy to Futurism un-
doubtedly had its roots in his own Quaker heritage, early scientific
training, and intellectual temperament. It is but part of his more
general prejudice against Expressionist art, and hence against Ger-
man art as a whole. To this must be added his distaste for French
and German romantic painting, his failure to appreciate the
linearism of northern art, and his indifference to technical experi-
ment.[2] All these deficiencies, if one may so describe them, limited
his understanding of the anti-classical trends towards non-objective
art that were to become so-significant by the late 1940s, and in his
own day contributed to the rupture between 'Bloomsbury' and
the Vorticists, led by Wyndham Lewis. Fry's own theory of
'significant form' was never satisfactorily defined, nor did it
prove capable of successful development. A few of the surviving
English paintings known to have been shown at the *Second Post-
Impressionist Exhibition* give an idea of the general tenor of this
country's contribution. Duncan Grant's *The Queen of Sheba*, 1912
(Tate Gallery), had been lent by Roger Fry and was a sketch for
part of an abortive scheme of decoration at Newnham College,
Cambridge. It is a curious mixture of the coarse pointillist tech-
nique of Signac, the hieratic conventions of the Byzantine mosaics
at Ravenna, and Fauve colour. An earlier scheme of seven large
decorations on the theme 'London on Holiday', for the students'
dining-room of the Borough Polytechnic had been successfully
accomplished under Fry's guidance in 1911. The artists were Fry,
Grant, Etchells, Adeney, Macdonald Gill (brother of Eric Gill),
and Albert Rutherston, and all the murals were acquired by the
Tate Gallery after the room was demolished in 1929. At the time,
Fry regarded the project as a practical vindication of his view of the
social function of art in a modern state, for it should be recalled
that Fry had earlier taken classes for decorative painting first at
Toynbee Hall and then for a year at Ashbee's Guild of Handi-
craft.

[1] C. R. Ashbee, 'Memoirs', III (1938), 264. [2] Fishman, op. cit. 141.

Another work shown at the *Second Post-Impressionist Exhibition*, Henry Lamb's *Portrait of Lytton Strachey* (Mrs. Igor Vinogradoff), is a head-and-shoulders study. This, and the smaller, earlier version of the large portrait now in the Tate Gallery [plate 73A] were painted in 1912 at the artist's studio in the Vale of Health.[1] It is instructive to compare the Tate portrait, completed in 1914, with Gerald Kelly's *The Jester (W. Somerset Maugham)* of 1911 [Tate Gallery; plate 73B], painted when the artist was thirty-two and only recently returned from a protracted stay in Paris. At first influenced by Whistler, Kelly soon became more fully aware of the Impressionists and their successors, and himself exhibited at the Société du Salon d'automne, Paris, of which he became a Sociétaire a year after its foundation in 1903. It was at the Salon d'automne that the Fauves made their first public appearance in 1905 which earned them their famous sobriquet. Maugham's dandified pose is a conscious echo of Whistler, but the highly-keyed palette and broad brushwork are closer to the *intimiste* style of Bonnard and Vuillard. The carefully contrived pyramidal composition of the *Maugham* was a favourite classical mode to be used many times by Kelly during his long career as a portraitist, but his brushwork became suaver and a trifle stereotyped, the same formula served for a society belle as for a Burmese dancer—the latter an abiding 'fancy' theme first inspired by the artist's visit to Mandalay in 1909. The Lamb portrait of Strachey is altogether more exciting. Apart from the substitution of two small background figures for some trees, the large version in the Tate is a faithful reproduction of the earlier composition, though necessarily less freely painted and more monumental than the oil sketch. The prevailing tonality is a peculiar purplish-brown which constantly reappears in Lamb's later work. There is a subtle mixture of irony, affection, and respect worthy of the sitter's own approach to the biographies of eminent personages, although this was painted well before he achieved fame with *Eminent Victorians* (1918). The languid, off-centre pose, drooping shoulders, sagging

[1] Michael Holroyd, *Lytton Strachey: The Years of Achievement 1910–1932*, II (1968), 45 and n. 2, 46–7, lists the various Lamb portraits of Strachey and discusses Lamb's attitude to his sitter, whom he obviously found a fascinating subject.

tweed suit, and Strachey's extraordinary wedge-shaped head, complete the picture of a prematurely aged valetudinarian (he was only thirty-four when the portrait was finished) that treads a tightrope between caricature and acute psychological observation. Even the branches of the trees on Hampstead Heath appear to droop in sympathetic *Weltschmerz*, their formalized outlines an eloquent testimony to the artist's intelligent study of Gauguin and the Nabis. Yet both the Kelly and Lamb portraits appear rather less adventurous in technique when compared with Sickert's *Harold Gilman* [plate 74A] of about 1912 (Tate Gallery), in which he experiments with a bright palette and, in parts, Fauve-like brushwork. Strachey and Lamb both belonged to that glittering circle of intellectuals, artists, and Liberal politicians, predominantly but not exclusively 'Bloomsbury', that revolved around the imperious and extravagant personality of Lady Ottoline Morrell at Garsington Manor.[1] Lady Ottoline's formidable presence has been recorded in a memorable portrait of about 1919 by Augustus John [Mrs. Igor Vinogradoff; plate 74B], one of many artists to feel grateful for her enlightened patronage and encouragement.

Although none of the paintings by Spencer Gore included in the *Second Post-Impressionist Exhibition* have yet been certainly identified, two works of the period show him to be one of the most gifted of the advanced British artists, whose untimely death in March 1914 was particularly unfortunate. An interesting record by him of the Gauguin and Cézanne exhibition at the Stafford Gallery in November 1911 survives, *Connoisseurs at the Stafford Gallery*, c. 1911–12 (Collection of Sir William Keswick). Portraits are included of Augustus John and Wilson Steer as visitors to the exhibition, and three pictures by Gauguin are shown on the end wall of the gallery: *Manao Tupapao*, *Christ in the Garden*, and *The Vision after the Sermon*. In this, as in the *Sketch for a Mural Decoration for The Cave of the Golden Calf* of 1912 [Tate Gallery; plate 74C], the figures are all strongly outlined in a manner which recalls Gilman's jocularly entitled painting, *Thou shalt not put a blue*

[1] R. Gathorne-Hardy (ed.), *Ottoline: The Early Memoirs of Lady Ottoline Morrell 1873–1915* (1963) and *Ottoline at Garsington: Memoirs of Lady Ottoline Morrell 1915–1918* (1974), recaptures some of the flavour of Lady Ottoline's salon.

line round thy Mother, which he exhibited at the Allied Artists' show in July 1912.[1] Broad, flat areas of bright colour, a high view-point with flattened-off perspective all bespeak the liberating in-fluence of Gauguin in the *Connoisseurs*. Still more advanced is the brilliantly coloured Cave of the Golden Calf sketch which shows a mounted huntsman pursuing a wild antelope through a verdant forest populated with lions and tigers. Here the dual inspiration of Matisse and Kandinsky is paramount. The Cave of the Golden Calf, later known as the Cabaret Theatre Club, was a basement night-club in Heddon Street owned by Mme Strindberg, the dramatist's second wife, which later became a rendezvous for the Vorticists. Ginner also painted a mural decoration similar to Gore's, and Wyndham Lewis a drop curtain; Epstein contributed decorative reliefs for the columns supporting the ceiling. Except for preparatory sketches by Gore and Ginner, all trace of the final decorations has been lost since their reputed removal by Mme Strindberg to the United States during the 1914–18 War. Gilman and Ginner held a joint exhibition at the Goupil Gallery in 1914, when they styled themselves 'neo-Realists', and in Ginner's article on neo-Realism for A. R. Orage's *New Age*, he defined it as opposed to 'the headlong destructive flow of the New Academicism, i.e., Post-Impressionism. The aim of neo-Realism is the plastic interpretation of Life through the intimate research into Nature. Life and Nature are the sources of the greatest variety. . . . neo-Realism must oppose itself to slave-ridden formula and be creative.'[2] Ginner had enormous admira-tion for Van Gogh, and his own highly individual use of thick impasto and near-obsessive rendering of detail was inspired by the Dutchman's art. A year later, Gilman and Ginner, with Bevan and John Nash, exhibited together at Goupil's as the Cumberland Market Group, a title derived from a favourite haunt in north-west London, not far from where Sickert had once lived and the fruitful source of neo-Realist subject-matter at the time. Gilman's *Leeds Market* [plate 75A] of about 1913 (Tate Gallery)

[1] F. Rutter, *Art in my Time* (1933), 130–1, and n.
[2] The full text of this article was reprinted in *An Exhibition of Paintings by Harold Gilman and Charles Ginner*, Goupil Gallery (1914), 3–12.

and Ginner's *Roberts 8, East Leeds* of 1916 (formerly Edward Le Bas), both of which were shown at early London Group exhibitions, demonstrate the qualities of these two artists. Gilman is the more poetic master, lighter in touch and colour than Ginner, whose rather literal transcriptions of nature were later to border on that 'monotonous Formula' against which he had himself warned in 1914. This gradual loss of freshness occurred after he had been bereft, by the death of Gilman in the influenza epidemic of 1919, of a stimulating companion and was left to carry the standard alone.

'For we are young and our art is revolutionary... We have declared in our manifesto that what must be rendered is the *dynamic sensation* ... every object influences its neighbour, not by the reflections of light (the foundation of *impressionistic primitivism*), but by a real competition of lines and by real conflicts of planes, following the emotional law which governs the picture (*futurist primitivism*).... We thus arrive at what we call the *painting of states of mind*.'[1] Thus, in characteristic declamatory style, did the Italian Futurists explain their cause to the British public in March 1912, when the Sackville Gallery organized an exhibition of their work. In this way several Futurist masterpieces appeared for the first time in London: Boccioni's *Farewells*, 1911 (Nelson A. Rockefeller, New York), *A Modern Idol* (Eric Estorick); Carrà's *The Funeral of the Anarchist Galli*, 1911 (Museum of Modern Art, New York, Lillie P. Bliss Collection), and Severini's *The Can-Can Dance at the Monico*, 1912 (Museum of Modern Art, New York). Marinetti had visited London in 1910, Severini had a one-man show at the Marlborough Gallery in April 1913 and was the only Italian Futurist painter represented in Frank Rutter's *Post-Impressionist and Futurist Exhibition* at the Doré Galleries in October 1913.[2] However, in April 1914 the Doré

[1] Umberto Boccioni and others, 'The Exhibitors to the Public', in *Exhibition of Works by the Italian Futurist Painters*, Sackville Gallery (1912), 9, 12, and 14. The catalogue also contained F. T. Marinetti's *Initial Manifesto of Futurism* and *Manifesto of the Futurist Painters*. There were thirty-four paintings, including works by Boccioni, Carrà, Russolo, and Severini, but none by Giacomo Balla or Ardengo Soffici.

[2] Rutter, *Art in my Time* (1933), 149–50, appears to have telescoped the two Doré Galleries exhibitions of 1913 and 1914 in his account.

Galleries showed a selection of seventy-three oils and drawings, plus six 'plastic ensembles' or 'dynamic combinations of objects', by all the Italian Futurist painters and sculptors. Each exhibition was promoted with great publicity and all the aggressive Futurist panoply of noisy lectures, provocative manifestos, and beating of drums. By 1913 Wyndham Lewis had become the unofficial leader of the more intransigent spirits among his compatriots and, as we have seen from his remarks in the Camden Town Group exhibition catalogue at Brighton, regarded himself as a Futurist. One of his most militant supporters was Nevinson, who had studied at the Académie Julian and at Matisse's short-lived *Cercle Russe* in Paris, 1912–13, had shared a studio with Modigliani, and, after meeting Picasso, had turned to Cubism. He became friends with Marinetti in 1913, met Lewis, and became an orthodox Futurist. Other representatives of the English Cubo-Futurists, who were shown in Rutter's *Post-Impressionist and Futurist Exhibition*, included Wadsworth, Cuthbert Hamilton, Alfred Wolmark—who flirted briefly with a form of decorative Cubism—Horace Brodzky, and, of course, Lewis and Nevinson.[1] Many of these artists were associated with Roger Fry's Omega Workshops, Ltd., founded in July 1913 at 33 Fitzroy Square. Here, inspired by the ideals of Ruskin and Morris, and with Ashbee's co-operative experiment still fresh in his mind, Fry joined a long line of artist–social reformers, but, unlike most of them, he worked armed more with enthusiasm than expert technical knowledge. He disliked the smooth finish of machine products, preferring the irregularities of hand craftsmanship. His attempts to fuse decoration based on 'significant form' with the realities of designing fabrics, carpets, wallpapers, pottery, furniture, and even stained glass met with limited success and in June 1919 the remaining Omega Workshop stock was sold off and the company wound up. Fry's admirers contest the criticism that he was an unbusinesslike amateur, but Virginia Woolf admitted there were early constructional failures to be overcome before he was able to persuade English, French, and

[1] Rutter's exhibition went beyond Fry's *Second Post-Impressionist Exhibition* and included some 'Orphist' works by Delaunay, two Franz Marcs, and graphic work by the German Expressionists, Max Pechstein, Emil Nolde, and Gabriele Münter.

German commercial firms to manufacture Omega designs for the company. Perhaps Fry tried to do too much single-handed—as it was, the 1914–18 War only added to his difficulties, and he often found it hard to pay his artists their weekly retaining fee of thirty shillings.[1]

Some of the surviving Omega Workshop products now strike us as somewhat bizarre and even contrary to what have become accepted as good principles of modern design, yet many of them retain their original freshness and *élan*. The most gifted Omega designer was undoubtedly Duncan Grant, who continued to use his natural flair for decorative work, particularly in designing furnishing fabrics, long after the demise of Fry's enterprise. The influence of Post-Impressionism and, to a certain degree, of the Russian Ballet, on the Omega artists' designs was to be expected, but an undated Dressing Table [Victoria and Albert Museum; plate 69B], made by a professional cabinet-maker, is an excellent, simply proportioned modern design. A four-leaf folding screen of 1913–14, *Bathers in a Landscape*, by Vanessa Bell [Victoria and Albert Museum; plate 76B], is clearly inspired by Matisse's large decorative works such as *The Dance*, 1909–10, a sketch for which was shown in the *Second Post-Impressionist Exhibition*.[2] Fry's efforts to help young artists in the Omega Workshops soon ran into trouble of a more intractable nature, involving a clash of artistic temperaments. Wyndham Lewis, supported by Etchells, Hamilton, and Wadsworth, complained in a vituperative round robin of October 1913, that Fry had tricked Lewis and Spencer Gore (not an Omega member) out of a commission from the *Daily Mail* to decorate a room for the Ideal Home Exhibition to be held that same October, and appropriated it for the Omega, whose members, incidentally, always worked anonymously for the company. The four signatories left the Omega, but not before

[1] Among the artists who worked for Fry were: Duncan Grant, Vanessa Bell, Nina Hamnett, John Turnbull, Winifred Gill, Etchells, Lewis, Hamilton, Paul Nash, and Wadsworth. William Roberts, at Laurence Binyon's suggestion, joined late in 1913 and left in the spring of 1914, after exhibiting with Fry's Grafton Group at the Alpine Club Gallery in January 1914.

[2] Probably the sketch for the Shchukin mural now at Philadelphia (Chrysler Collection).

a stormy confrontation had taken place between Lewis and Fry. After this, Lewis and Gore repeated their accusations against Fry in a letter to the Press. The cause of the misunderstanding seems to have been that a verbal message about the *Daily Mail*'s offer left for Fry by Gore with Grant, in Fry's absence, never got through to its destination. The *Daily Mail* officials maintained that they had dealt directly only with Fry, but a reasonable doubt exists that there was some duplication of effort on their side which may have caused the confusion.[1] It is hard to believe evil of Fry, but his Quaker-like calm and refusal publicly to rebut the charges must have infuriated Lewis, a younger, impulsive man with a reputation for prickliness, who had already become dissatisfied with Fry because of his known distaste for Futurism. The gulf between the two men was too wide to be bridged, and Fry's associates, if not Fry himself, did not conceal their dislike for Lewis henceforth. Although Lewis no doubt greatly exaggerated the extent and power of their antagonism, they, in turn, underestimated the strength of Lewis's genuine sense of grievance and injustice. Thus Lewis came to believe that there was an organized conspiracy against him—but his public role as 'The Enemy' was largely self-imposed, for, like Whistler, he quickly took offence and was only equalled at caustic verbal sword-play by his friend, Ezra Pound.

Internal dissensions were not confined to the Omega Workshops, for a split was about to occur in the Futurist camp. Lewis obtained the financial support of Miss Kate Lechmere and founded the Rebel Art Centre at 38 Great Ormond Street in the spring of 1914.

[1] The voluminous correspondence and partisan accounts of the quarrel appear in the following: V. Woolf, *Roger Fry* (1940); Wyndham Lewis, *Rude Assignment* (1950), 23–4; John Rothenstein, *Modern English Painters*, II (1956), 26–7; W. K. Rose (ed.), *The Letters of Wyndham Lewis* (1963); Quentin Bell and Stephen Chaplin, 'The Ideal Home Rumpus', *Apollo*, LXXX (1964), 248–91; Walter Michel, 'Tyros and Portraits, the early 'twenties and Wyndham Lewis', *Apollo*, LXXXII (1965), 128–33; and Bell and Chaplin's reply, with a rejoinder by Michel, *Apollo*, LXXXIII (1966), 75. Quentin Bell, *Bloomsbury* (1968), 54–65, comments perceptively on the affair as it must have appeared to Lewis, and Denys Sutton (ed.), *Letters of Roger Fry*, II (1972), 371–6, publishes Fry's letters, including one to Simon Bussy (28 Dec. 1913) in which he remarks that 'Lewis's vanity touches on insanity . . .'. Sutton adds further comment on the affair in his introduction to the *Letters*, I, 50–1.

Here, the home of 'The Great London Vortex', it was intended that Lewis and his friends should give classes and lectures, and hold exhibitions, but by the autumn of the same year the Rebel Art Centre had closed down, having achieved little beyond some startling publicity for its activities. Lewis's bold enterprise was vitiated by his inordinate possessiveness, love of intrigue, and divisive suspicion of his colleagues. (Symptomatic of the lengths to which Lewis would go to secure privacy were his use for many years of the Pall Mall Deposit Company as a forwarding address, and the smoke-screen he produced to conceal the date of his birth.) Nevinson joined forces with Marinetti to produce a manifesto, *Vital English Art*, which was published in the *Observer* on 7 June 1914 as emanating from the Rebel Art Centre, inviting public support for 'the great Futurist painters or pioneers and advance-forces of vital English Art: Atkinson, Bomberg, Epstein, Etchells, Hamilton, Nevinson, Roberts, Wadsworth, Wyndham Lewis'.[1] The manifesto contained the usual Italian Futurist attacks on traditions, institutions, conservatism, academicism, etc., to which were added as local flavouring specifically English targets of abuse: 'The pessimistic, sceptical and narrow views of the English public, who stupidly adore the pretty-pretty, the commonplace, the soft, sweet, and mediocre, the sickly revivals of medievalism, the Garden Cities with their curfews and artificial battlements, the Maypole Morris dances, Aestheticism, Oscar Wilde, the Pre-Raphaelites, Neo-primitives and Paris.' The 'sham revolutionaries' of the New English Art Club and 'the indifference of the King, the State and politicians towards all arts' were also seen as part of the general conspiracy which allowed such 'passéist filth' to prosper within these shores. The manifesto demanded instead 'an English Art that is strong, virile and anti-sentimental . . . a fearless desire of adventure, a heroic instinct of discovery, a worship of strength, . . . physical and moral courage'. And, rather inconsequentially, but perhaps to emphasize virility, 'Sport to be considered an essential element in Art'. The repudiation and counter-attack were soon forthcoming. A week later the *Observer* published a letter from

[1] F. T. Marinetti and C. R. W. Nevinson, *Vital English Art: Futurist Manifesto* [n.d., June 1914], later reprinted in the Futurist organ, *Lacerba* (Florence).

Lewis, with nine supporting signatures,[1] disowning Marinetti, who, as was his way, had taken the wish for the deed and neglected to obtain the actual signatures for his manifesto. On 20 June 1914, Lewis published the first number of *BLAST*, which contained an acrid attack on *Vital English Art* in the form of his own *Vorticist Manifesto*.[2]

BLAST: Review of the Great English Vortex, 'the great MAGENTA cover'd oposculus', as Pound called it, appeared in two thick quarto volumes: the first carried the word 'BLAST' in huge block capitals set diagonally across the puce cover with, inside, an abundance of harsh typographical shock tactics in the Futurist idiom, which perhaps were even rawer than their Italian prototype. Pound had chosen the term Vorticism and contributed several poems and a manifesto to the first volume, and more poems and *Chronicles* (in which he excoriated Laurence Binyon) to the second, which appeared in July 1915. Short stories by Rebecca West and Ford Madox Hueffer (later Ford) were also included in *BLAST*, No. 1, and in No. 2 were poems by T. S. Eliot, to whom Lewis had recently been introduced by Pound. Lewis's play, *The Enemy of the Stars*, also appeared in *BLAST*, No. 1, for he was already laying the foundations of a distinguished literary career, which was to earn him the lifelong esteem of Pound, Eliot, and James Joyce. Vorticism was not easy to define— even Lewis found it hard to distinguish it adequately from Futurism, to which it owed so much, and a careful examination of his writings reveals some inconsistencies. In a catalogue note to the first and only *Vorticist Exhibition* at the Doré Galleries, 10 June–July 1915,[3] Lewis wrote: 'By Vorticism we mean (a) ACTIVITY as opposed to the tasteful PASSIVITY of Picasso; (b) SIGNIFI-CANCE as opposed to the dull or anecdotal character to which

[1] Republished in Rose, *Letters of Wyndham Lewis* (1963), 62. New recruits to the Lewis fold were Richard Aldington, Ezra Pound, Laurence Atkinson, and Gaudier-Brzeska. In the autumn of 1913, Nevinson and Lewis had jointly organized a dinner at the Florence Café to welcome Marinetti; on 5 May 1914 Lewis and his Vorticists made a noisy disturbance at Marinetti's Futurist demonstration at the Doré Galleries.

[2] The first number actually appeared on 2 July 1914 according to R. Cork, *Vorticism*, I (1976), 235.

[3] The members were: Jessica Dismorr, Etchells, Gaudier-Brzeska, Roberts, Helen Saunders, Wadsworth, and Lewis; those invited to show were Adeney, Atkinson, Bomberg, Grant, Jacob Kramer, and Nevinson ('Futurist').

the Naturalist is condemned; (c) ESSENTIAL MOVEMENT and ACTIVITY (such as the energy of a mind) as opposed to the imitative cinematography, the fuss and hysterics of the Futurists.' Over forty years later, in 1956, he recalled that Vorticism 'was dogmatically anti-real. It was my ultimate aim to exclude from painting the everyday visual real altogether. The idea was to build up a visual language as abstract as music . . . Another thing . . . is that I considered the world of machinery as real to us, or more so, as nature's forms . . . and that machine forms had an equal right to exist in our canvases.'[1] The *Vorticist Manifesto*,[2] couched in fierce apophthegmatic style, contains several far-reaching ideas: 'We need the Unconsciousness of humanity—their stupidity, animalism and dreams . . . We do not want to change the appearance of the world, because we are not Naturalists, Impressionists or Futurists (the latest form of Impressionism), and do not depend on the appearance of the world for our art. We only want the world to live, and to feel its crude energy flowing through us . . . The Art-instinct is permanently primitive.' Then came praise of the Nordic spirit in art and some beating of the nationalist drum. The exaltation of the primitive and primordial, of the unconscious life as the well-spring of art, originated with Pound, who expresses similar ideas in 'Vortex-Pound', and this explains what might otherwise appear to be a contradictory element in Lewis's thought.[3] Lewis's anti-naturalistic bias implied abstraction and *BLAST*, No. 1 contained extracts from Kandinsky's *Über das Geistige in der Kunst* (1912), translated by Wadsworth under the title *Inner Necessity*.[4] But Lewis, while respecting the accomplishments of Cubism, Futurism, and Expressionism, was dissatisfied with aspects of each of these movements, and in *A Review of Contemporary Art*, in *BLAST*, No. 2, sought to clarify

[1] Wyndham Lewis, 'Introduction', in *Wyndham Lewis and Vorticism*, Tate Gallery (1956), 3, 4. In 'Vortex-Pound', Pound misquotes approvingly Pater's 'All the arts constantly aspire to the condition of music.'
[2] The signatories were Aldington, Arbuthnot, Atkinson, Gaudier-Brzeska, Dismorr, Hamilton, Pound, Roberts, Saunders, Wadsworth, and Lewis.
[3] W. Haftmann, *Painting in the Twentieth Century*, I (1960), 153–4.
[4] M. T. H. Sadler's translation of Kandinsky's book appeared as *The Art of Spiritual Harmony* (1914).

his own attitude. He is concerned that artists should draw from their experience of life around them, in a predominantly urban and mechanistic environment: 'We must constantly strive to ENRICH abstraction till it is almost plain life, or rather to get deeply enough immersed in material life to experience the shaping power amongst its vibrations, and to accentuate and perpetuate these.' There must be a dynamic coherence in a composition without lapsing into formula or apriorism on the one hand (the Futurists), or lifeless decoration on the other (a quality which Lewis so much deplored in the dilettante Fry circle). Nor must abstraction become imprecise, 'lyrical and cloud-like', as in Kandinsky, whose 'spiritual values and musical analogies seem', to Lewis, 'to be undesirable, even if feasible'. For Lewis the Vortex meant a still centre in the maelstrom of life: it was a unifying element in a chaotic and diverse environment. He was essentially a classicist. He shared with his Imagist friends, Hulme, Pound, and Eliot, a love of rational order and rated the intellect superior to feeling. Although his Vorticist work is almost entirely abstract, he gradually, and logically, moved away from abstraction towards a naturalism in which the forms are crisply outlined in precisely defined compositions, their colours often cool and metallic. Like Hulme, Lewis had absorbed from his early days at the Collège de France in Paris the teaching of Henri Bergson, and of the anti-Bergsonians, the French classical revivalists led by Baron Ernest Seillière, Henri Massis, Pierre Laserre, Georges Sorel, and others. Lewis allied himself with the rebellious young anti-Bergsonians and remained faithful to them throughout his life.[1]

Lewis, both as a painter and theorist, stood head and shoulders above his followers, although his later insistence on his preeminence provoked a series of tart rejoinders in pamphlet form from William Roberts, which were privately published between 1956 and 1958.[2] The English variant of Cubism seems to have

[1] Lewis's aesthetic theories are perceptively analysed by Geoffrey Wagner in *Wyndham Lewis. A Portrait of the Artist as The Enemy* (1957), particularly chapters six to nine.

[2] W. Roberts, *Cometism and Vorticism: a Tate Gallery catalogue revised* (1956); *The Resurrection of Vorticism and the Apotheosis of Wyndham Lewis at the Tate* (1956);

been based on an imperfect understanding of the Franco-Spanish prototype for which Lewis must bear some responsibility. He attacked the Cubists, as we have seen, for their imagined preference for presenting a single instant of time, whereas the French Cubist apologists were agreed that Cubism aimed at creating 'a moment of stasis into which is poured a series of unknown moments, from past, present, and future'.[1] Artistic competence apart, it is notable that such Cubist-inspired paintings as survive of Lewis, Bomberg, and Wadsworth, for example, all show a greater concern with surface pattern, with the dynamic conflict of abstract lines and curves in shallow space, rather than with presenting a multiplicity of facets of recognizable figures and objects, the three-dimensional solidity of which is always implicit. This Vorticist concept of dynamism may owe more to the Futurists than the Cubists, but in the actual paintings all reference to specific events, people, or machines is frequently eliminated. Lewis's water-colour, *Composition* of 1913 (Tate Gallery), related to the *Timon of Athens* drawings shown in the *Second Post-Impressionist Exhibition*, and the oil, *The Crowd (Revolution)* (Tate Gallery), shown at the second London Group exhibition of March 1915 [plate 76A], are typical of this extreme degree of abstraction, only surpassed by Bomberg's large kaleidoscopic canvas, *In the Hold*, 1913–14 [Tate Gallery; plate 75B], exhibited at the first London Group show. Roberts never completely abandoned figurative allusions, even in the most abstracted of his works such as the painting, *Dancers*, and a drawing, *Religion*, both of which were published in *BLAST*, No. 1 (plates XIII and XIV). A pen, ink, and gouache, *The Toe Dancer*, of 1914 (Victoria and Albert Museum), also in the second London Group exhibition, and the decorative 'panel', *The Diners*, 1919 [Tate Gallery; plate 84A], are both, in their different ways, hybrid variants of a Cubo-Futurist style. *The Diners*, with its vibrant zigzag rhythms, acid reds, and greenish-yellows,

A Press View at the Tate Gallery (1956); *A Reply to my Biographer, Sir John Rothenstein* (1957); and *Abstract and Cubist Paintings and Drawings* (1957).

[1] Wagner, op. cit. 139. O. Raymond Drey, 'Indépendants and the Cubist Muddle', *Blue Review*, I, No. II (1913), 146–8, betrayed a lack of understanding of Cubism that was probably fairly general at the time in England.

is a deliberately mundane subject treated in a slightly ironic mood, which anticipates the highly individual characteristics of Roberts's mature work. It is one of two surviving panels of three commissioned for an ante-room in the Restaurant de la Tour Eiffel, Percy Street, by the Viennese proprietor, Rudolph Stulik in 1919. This is one of the few works in which Roberts completely accepts the Vorticist idiom for his own. The Tour Eiffel was a favourite haunt for several generations of artists, and in about 1915 Lewis had designed three abstract decorations for a private ante-room known, appropriately, as the Vorticist Room.[1] After the 1914–18 War, Lewis organized one more exhibition of work by his friends and associates, which he called Group X, at Messrs. Heal's lively Mansard Gallery in March–April 1920.[2] This was the swan-song of the old Vorticist cadre, but two new names emerge, those of the sculptor, Frank Dobson, and the American-born painter, Edward McKnight Kauffer, who had settled in England in 1914 and began exhibiting with the London Group in 1916. He was later to become famous for his posters and book-illustrations. After the dissolution of Group X, the artists went their separate ways. Etchells turned to architecture, Wadsworth developed a style initially influenced by Léger, and Lewis became increasingly involved in writing and political polemics, though never to the total exclusion of painting.

Jacob Epstein has already been mentioned in connection with the Camden Town Group, for his part in the foundation of the London Group, and as an associate of Wyndham Lewis. He had become a controversial figure as early as June 1908, when the scaffolding was removed from the first four figures on the British Medical Association's new, and rather austerely designed, head-

[1] The restaurant, now the White Tower Restaurant, changed hands in 1937, and all the old decorations have disappeared with the exception of the two paintings by Roberts (*The Dancers* is the other surviving work and was shown in *Vorticism and its allies*, Arts Council (1974), cat. no. 464. Both this and *The Diners* are oil on canvas.) Wyndham Lewis also decorated an overmantel in Lady Drogheda's house and a room in South Lodge, the home of Violet Hunt, in 1913; neither work has survived.

[2] Lewis showed seven self-portraits. The other members were: Dismorr, Frank Dobson, Etchells, Ginner, Hamilton, McKnight Kauffer, Roberts, John Turnbull, and Wadsworth.

quarters in the Strand.[1] The architect, Charles Holden, had the previous year courageously chosen Epstein, then quite unknown, to carve eighteen over-life-size and mostly nude figures in Portland stone for exterior niches flanking the windows on the second floor. Epstein, who completed them all in the surprisingly short time of fourteen months with the help of two assistants, explained their symbolism thus: '. . . I tried to represent man and woman, in their various stages from birth to old age—a primitive, but in no way a bizarre programme.'[2] The first eight figures, seen left to right beginning with the Agar Street façade, represented 'Youth, Joy and Life'; numbers nine, ten, and eleven symbolized Motherhood (a young pregnant mother fondling a baby), Manhood, and the continuity of life (an old woman holding a new-born babe); the remaining figures on the Strand side, fifteen to eighteen, represented 'Chemical Research', 'Hygeia', 'Birth', and 'Primal Energy'. The sculptures have suffered grievously from the combined attacks of weather, and vandalism by the Rhodesian government, which, in 1937, began to destroy them. From casts and such photographic records as survive, the sculptures appear to be an odd mixture of lyricism and unsentimental realism, but none merit the furious accusations of indecency levelled at them at the time by self-appointed guardians of public morals. Several are of classical inspiration, others recall Rodin, particularly the twelfth, of a man with upraised arms crossed over his forehead, which echoes the *Age of Bronze*.

English philistia received surprising support from their French counterparts four years later when Epstein's magnificent tomb to Oscar Wilde at Père Lachaise cemetery in Paris was banned as indecent until a bronze plaque had been fixed over the sexual organs of the angel [plate 77]. This fig-leaf was soon removed in a night raid by a band of artists and poets, and the statue had again to be hidden under a tarpaulin which was discreetly taken off at the outbreak of the 1914–18 War. Carved in Hopton Wood stone,

[1] Richard Buckle, *Jacob Epstein, Sculptor* (1963), illustrates all the B.M.A. sculptures in their various stages. The B.M.A. building (since 1935, Rhodesia House) stands on the corner of Agar Street and the Strand (No. 429).

[2] Jacob Epstein, *Epstein: An Autobiography* (1955), 22; and for the press correspondence on the Strand sculptures, 23–41, and Appendix One.

the Tomb is in the form of a simple plinth surmounted by a slab set back to take the dramatic, stylized figure of a winged angel, a fallen angel of debauch it may be added, inspired by ancient Assyrian tomb-sculpture. The sculpture is an eloquent witness to Epstein's inventiveness and also to his wide-ranging eclecticism at this time. He rapidly assimilated ideas from Mexican, Buddhist, and African, as well as Western European traditions, and in a *Female Figure* carved from green serpentine of 1913, there briefly appears a similarity to work by Gaudier-Brzeska, such as *The Red Stone Dancer* of *c.* 1913 [Tate Gallery; plate 79A], where both men were influenced by African sculpture. Henri Gaudier-Brzeska, although French-born, spent much of his short working life in England and was one of the most gifted and influential sculptors in the Vorticist camp. Ezra Pound greatly admired his work, and said of *The Red Stone Dancer* in 1918 that it 'is almost a thesis of his ideas upon the use of pure form. We have the triangle and the circle asserted, *labled* almost, upon the face and right breast. Into these so-called "abstractions" life flows, the circle moves and elongates into the oval, it increases and takes volume in the sphere, or hemisphere of the breast. The triangle moves towards organism, it becomes a spherical triangle (the central life-form common to both Brzeska and Lewis). These two developed motifs work as themes in a fugue. We have the whole series of spherical triangles, as in the arm over the head, all combining and culminating in the great sweep of the back of the shoulders, as fine as any surface in all sculpture.'[1] But the most original work of this period first saw the light, as a drawing, in the Camden Town Exhibition at Brighton in 1913. This was *The Rock Drill*, for which at least four pencil-and-crayon studies exist, and from the plaster model of which several bronze casts were made after modifications to both the arms in 1916 [Tate Gallery; plate 79B].[2] Epstein showed the plaster, also of 1913, at the London Group in 1915, where the figure was mounted on an actual rock drill and

[1] Ezra Pound, 'Prefatory Note', in *A Memorial Exhibition of the Work of Henri Gaudier-Brzeska*, Leicester Galleries, London (May–June 1918).

[2] Richard Cork, *Jacob Epstein: The Rock Drill Period*, Anthony D'Offay (Oct.–Nov. 1973), 5–15, summarizes the evolution of this piece.

was complete with the lower torso and legs, subsequently cut off by the sculptor. This sculpture is Epstein's only known excursion into the world of mechanization, then so much of a novelty, and is in line with the prevailing preoccupations of the Cubists and Futurists. The sculptor has said of *The Rock Drill* that it was not entirely abstract, 'It is a conception of a thing I knew well in New York and is my feeling of that thing as a living entity, translated into terms of sculpture. It is . . . prophetic of much of the great war and as such . . . has therefore very definite human associations.' Later on he referred to it as symbolizing 'the terrible Frankenstein's monster we have made ourselves into'.[1] As Epstein finally modified *The Rock Drill*, it lost its original symbolism of male virility and became an emasculated victim, so to speak, of mechanization. Epstein's attempt to follow the precepts of his friend T. E. Hulme, who advocated the creation of a 'new geometrical and monumental art making use of mechanical forms', undoubtedly had strong personal associations and it has been suggested that *The Rock Drill* might well be a covert self-portrait.[2]

Epstein had stayed in Paris again between June 1912 and early 1913, and had met Picasso, Brancusi, and Modigliani. It was then that he became interested in African sculpture, examples of which he began to collect; but the pure abstractions of Brancusi were to exert a powerful effect on his own carving of the 1913–15 period, in such works as the marble *Mother and Child*, 1913 (Museum of Modern Art, New York), and the series of *Marble Doves* of which he did three versions between 1913 and 1915 [plate 78B]. There was already developing a division in his work: portrait busts and full-length figures on the one hand, and monumental pieces, often extremely original interpretations of Old Testament subjects, on the other. Common to both types was a vehement expressionist

[1] J. Epstein and Arnold Haskell, *The Sculptor Speaks* (1931), 45, and Epstein, *Autobiography* (1955), 56. A reconstruction of the original plaster was made and exhibited at *Vorticism and its allies* (1974), cat. no. 244, complete with a rock drill of about the same type and date as that used by Epstein.

[2] Albert Elsen, *Origins of Modern Sculpture: Pioneers and Premises* (1974), 39 (and in *Pioneers of Modern Sculpture*, Arts Council (1973), 31), where a comparison is made with Epstein's *Self-Portrait with Visor* of 1912. T. E. Hulme's exhortation appeared in 'Modern Art—III. The London Group', *New Age* (26 Mar. 1914).

character rooted in Epstein's own virile temperament, which he inherited from his Central European Jewish ancestry. This passionate self-identification with the joys and sorrows of humanity lends an extra dimension of nobility and controlled fervour to all of Epstein's finest works, qualities which are also found in Chagall and Soutine. The early female portrait bronzes, *Euphemia Lamb*, 1908 (Tate Gallery), and *Mrs. Mary McEvoy*, *c.* 1910 [Tate Gallery; plate 78A], are meditative, carefully disciplined, and smoothly finished pieces in which the sculptor set out to achieve an accurate likeness; but by 1916 Epstein had reached a degree of technical accomplishment that allowed him to attempt more forceful characterization, to seize upon and subtly accentuate the salient features of his sitters in such a way as almost to capture a fleeting glimpse into the soul of his subject. Wherever the sculptor has felt a sympathetic link between himself and the sitter, he produces his most inspired portraits, as in that of the Welsh poet, *W. H. Davies*, of 1916, or of the painter, *Augustus John* (1916), for long one of Epstein's closest friends. In these, as in many later works, the vigorous modelling seems to suggest that Epstein, like his admired Rodin, was pre-eminently a modeller, and clay his most congenial medium. Many of his famous sitters could rarely give him more than a few sittings, and although he sometimes complained bitterly at this, it often meant he had to work at inspired white heat. The over-life-size *Risen Christ* of 1919 had begun as a portrait of Bernard Van Dieren, an early biographer of Epstein, and is the first of his 'didactic' works, stemming, as it does, from the sculptor's revulsion against the horrors of war and against that hatred of man for man which Christ had condemned. The *Christ* is a dramatic blend of realism and the hieratic, qualities to reappear in several later major religious monuments such as the *Virgin and Child*, Cavendish Square (1953), and the *Christ in Majesty* for Llandaff Cathedral (1957). When the *Risen Christ* was first exhibited at the Leicester Galleries in 1920 it provoked a shameful racialist attack from Father Vaughan, S.J., which received a well-merited and crushing rejoinder from George Bernard Shaw.

A sculptor of very different temperament was Eric Gill. To his accomplishments as a stone-carver and designer of alphabets, he

added those of wood and line-engraver, and writer on art, religion, and sociology. He had begun his career in 1900 at the age of eighteen, when he was apprenticed to W. D. Caröe, architect to the Ecclesiastical Commissioners in London. He studied at the Central School under Lethaby and Edward Johnston, the designer of the famous sans-serif typeface [plates 80A and 80B]. This simple typeface of beautifully-shaped block letters was developed between 1916 and 1931 at the request of the great design and transport reformer, Frank Pick, for the joint London Underground Railways and Omnibus companies, which in 1933 were to become the London Passenger Transport Board. Of both his teachers Gill later spoke with great affection, particularly of Johnston: 'I owe everything to the foundation which he laid. And his influence was much more than that of a teacher of lettering. He profoundly altered the whole course of my life and all my ways of thinking.'[1] At first Gill concentrated on lettering and carving inscriptions, and taught lettering at the Westminster Technical Institute, where he had himself learnt masonry and stone-cutting. After living some years at Hammersmith, he moved with his young family in 1907 to Ditchling, Sussex, and early in 1910 carved his first figure piece, a female nude in low relief supporting a plaque. Later that year came *Mother and Child*, carved in Portland stone. A sensuous amplitude of form in this work was inherent in the subject-matter, yet there is a certain 'primitive' directness of conception, which becomes intelligible in the light of Gill's professed admiration for Maillol and an awareness that his own 'inability to draw naturalistically was, instead of a drawback, no less than my salvation. It compelled me . . . to concentrate upon something other than the superficial delights of fleshly appearance . . . to consider the significance of things.'[2] The archaism of his style was to some extent the outcome of an original mind grappling with unfamiliar problems, but Gill was not entirely isolated in his search for a style.

[1] Eric Gill, *Autobiography* (1940), 118. The 'Gill Sans' alphabet for Monotype (1927–31) was a development of Johnston's typeface. Much credit must also go to Stanley Morison, the scholar-artist, who advised the Monotype Corporation on the production of this new typeface (see Ashley Havinden, *Advertising and the Artist* (1956), 11).

[2] Gill, op. cit. 160.

At this time he was friendly with Rothenstein, Fry, and Epstein, friendships between forceful men that inevitably had to endure some bumpy passages. It is interesting to compare a *Cupid* by Gill of 1910, with Epstein's *Sun God* (begun 1910, but not finished until 1933), in both of which the sculptors appear to be working from a common archaic Egyptian prototype, particularly in the stylized treatment of the heads. Epstein and Gill had also worked together on a carving.[1] Early in 1913 Gill was received into the Roman Catholic church and not long after was commissioned to carve the fourteen *Stations of the Cross* for Westminster Cathedral [plate 80c]. These were not carved in their correct liturgical sequence, but as each particular event along the Via Dolorosa caught Gill's imagination. He began with the Tenth Station, then followed the Second, Thirteenth, and First, all of which were ready by June 1915; the remaining *Stations* were completed by March 1918.

The *Stations* were carved in low relief from Hopton Wood stone and are the most important of Gill's church commissions. They were criticized by P. G. Konody as affected or 'neo-primitive', and unsuited to their architectural background. Gill was well aware how unsympathetic the green marble interior cladding of the Cathedral would be to his work when completed, and much preferred the unadorned surfaces of the pale London brick foundation. Touches of colour had been added to the earlier Stations, but Gill later erased these as unsuitable. After Gill's death, the Church authorities had the inscriptions coloured in red and the haloes gilded. Gill denied that he was striving after an antiquarian style, but it is no discredit to him to say that the spirit of these carvings is Giottesque. They have a noble, impressive simplicity that raises them far above the usual run of modern ecclesiastical art. Certain formal stylizations in Gill's carvings recall the early work of Stanley Spencer, whose *Joachim Among the Shepherds* (J. L. Behrend) and *The Nativity* [University College, Slade School, London; plate 92A], both of 1912, were influenced by a book containing Dalziel's woodcuts after Giotto's Arena Chapel frescoes. It was Gill's direct 'diagrammatic' approach that enabled him to

[1] Robert Speaight, *The Life of Eric Gill* (1966), 48–9, 56.

breathe fresh life into a subject circumscribed by tradition, and these canonical limitations provided not a cage but a framework within which he could work with ease.[1] Gill's hard, linear style is well suited to the conventions of bas-relief carving, for even in his free-standing pieces there is often a flattening of the frontal planes, a conscious underemphasis of plasticity, that seems to keep the figure still imprisoned within the slab from which it was carved. This predilection for limited three-dimensional volumes was carried over from Gill's early training as a monumental mason and letterer.

Two painters who stood a little outside the English art coteries of the period were John Duncan Fergusson and Matthew Smith. Fergusson, a Scot of Highland descent, had abandoned medicine to study painting first in Edinburgh and then in Paris at the Académie Colarossi and possibly the Académie Julian, c. 1894–8. He was largely self-taught and probably learnt more from his visits to the Luxembourg and to Durand-Ruel's exhibitions than from any formal instruction. After a visit to Spain and Morocco in 1899 he made regular pilgrimages to France until, in 1905, he settled there, only to return to London at the outbreak of war in 1914. His early career is not easy to chart precisely, for although he dated punctiliously almost every painting he completed, these dates do not always correlate with external evidence and must be treated with caution.[2] His early work, like that of many of his contemporaries, is Whistlerian in style; later he paid increasing attention to Manet's painting of the 1860s and 1870s until by about 1907 he had adopted the bold palette and firm outlines of the Fauves. Indeed, of all the British painters, Fergusson was the most uncompromising interpreter of this style at the time,[3] and in the series of portraits of the American painter, Anne Estelle Rice, such

[1] Gill described his artistic intentions in *The Stations* in an article for the *Westminster Cathedral Chronicle*, Mar. 1918, signed under a pseudonym, 'E. Rowton'.

[2] A. McLaren Young, *John Duncan Fergusson Memorial Exhibition*, Scottish Arts Council (1961–2), is the first scholarly attempt at a chronology but makes no claim to be definitive.

[3] W. Egerton Powell, 'Recent Art Exhibitions', *Artwork*, IV, No. 13 (1928), points out that Fergusson was accepted in Paris, 'even before 1914 . . . as a *chef d'école* and painter of importance' in the Post-Impressionist movement.

as the *Blue Beads, Paris,* 1910 [Tate Gallery; plate 81A], not only does he show a complete mastery of the style but also how he could contribute a rhythmic vigour entirely his own. The ancient Celtic love of colour and pattern reasserted itself in this Francophile Scot. Fergusson was one of the members of the Anglo-American Artists' Group in Paris, as well as contributing to both the Salon d'automne and Salon des Indépendants, becoming a member of the Indépendants in 1911. *Rhythm,* in fact, was the title of a stimulating new magazine founded in the summer of 1911 by John Middleton Murry and Michael Sadler, with Fergusson as its art editor. Devoted to art, music, and literature, it first appeared as a quarterly, becoming a monthly publication a year later. The cover had a boldly stylized female nude designed by Fergusson, who had adapted the composition of an oil, *Rhythm* (University of Stirling), and original illustrations by Jessica Dismorr, Anne Estelle Rice, S. J. Peploe, and Othon Friesz graced the inside pages. Reproductions of pre-Cubist drawings by Picasso, and work by Augustus John, Herbin, Derain, Marquet, Gaudier-Brzeska, Goncharova, and Larionov, appeared in subsequent issues until the magazine was succeeded by the *Blue Review* in May 1913, and a change of artistic direction introduced. The philosophical tone of *Rhythm* is openly Bergsonian, in its acknowledgement of intuition as a superior creative force to reason, anti-mechanistic (Gilbert Cannan's anti-machine article, *Machines,* appeared in a later issue), and takes a directly contrary standpoint to that adopted by Wyndham Lewis, if not to Ezra Pound's. Murry, who was then only twenty-two, wrote 'The artist . . . must return to the moment of pure perception to see the essential forms, the essential harmonies of line and colour, the essential music of the world. Modernism . . . penetrates beneath the outward surface of the world, and disengages the rhythms that lie at the heart of things, rhythms strange to the eye, unaccustomed to the ear, primitive harmonies of the world that is and lives.'[1] In a later number, Sadler, who was already a very distinguished educationist, reviews Kandinsky's *Über das Geistige in der Kunst* and discusses his ideas about 'primitive' art being more directly expressive of the

[1] J. M. Murry, 'Art and Philosophy', *Rhythm,* I, No. I (1911), 12.

soul, touching on aspects of synaesthesia and warning us against too systematic an approach to the consonances between the arts of poetry, painting, and music.[1]

Matthew Smith, after overcoming parental opposition to his choice of a career, left the Slade in 1908 (where he had not been particularly happy) to live at Pont-Aven, then at Étaples, 1908–9, and came in 1910 to Paris for three years, where he attended Matisse's school early in 1911 and exhibited at the Salon des Indépendants. After his marriage he returned to France and, apart from three years' commissioned service in the army, 1916–19, lived for long periods in that country, gravitating to Aix-en-Provence, where the climate and dramatic countryside proved as stimulating to him as it had to two generations of French artists. Delicate in health and of a nervous disposition, Smith's shy personality could hardly be deduced from the riotous palette and boldly modelled, sensuous nudes that dominate his mature work. That he was regarded as a somewhat *farouche* innovator explains the rejection by the London Group in 1916 of his *Nude, Fitzroy Street, No. 1* (Tate Gallery), although his *Still Life, Lilies* of 1913–14 (City Art Gallery, Leeds) was included in the London Group show of November 1916. The *Nude, Fitzroy Street, No. 1* [plate 82A] and its companion work, *Nude, Fitzroy Street, No. 2* (British Council), were both painted in 1916 in the artist's studio at 2 Fitzroy Street, from the same model. Smith's earlier work shows a rapid assimilation of Cézanne, early Vuillard, and the Fauves; perhaps because he had had to mark time for four years or more at the Manchester Art School, where, at his father's insistence, he was only allowed to study design, Smith worked all the more feverishly to make up that lost time when he was eventually given his freedom. The two *Fitzroy Street Nudes* are key works of the period. Boldly outlined, the figures are modelled in broad areas of complementary greens, yellows, and blues, the background space flattened out, as in the Fauve works of Matisse and Derain. The firm, architectural treatment of the nude in these two works was also inspired by Smith's great and abiding admiration for Ingres, which had been awakened by a visit to Montauban a few

[1] Michael Sadler, 'After Gauguin', *Rhythm*, I, No. IV (1912), 23–9.

years earlier. Wounded in 1918, he spent his convalescent leave in Paris where he met Roderic O'Conor; the following year he was demobilized. A visit to Cornwall in June 1920 induced the painter to stay on at St. Columb Major for six months. The Cornish scenery recalled happy days in Brittany, but Smith's wartime experiences had affected him deeply, though he rarely spoke of them, and his Cornish landscapes are painted with an extraordinary expressionist intensity almost as if he were exorcizing some secret anguish. Strong purples, viridians, glowing reds, and blue-black skies constantly recur, and *A Winding Road: Cornish Landscape* (British Council) is a splendid example of this phase [plate 82B]. Gauguin, of course—but it would be truer to think of Emil Nolde, and Smith is perhaps the only English artist whose work, at this particular moment, has a spiritual rapport with German Expressionism.

The war and all its horrifying carnage inevitably affected artists in one way or another. Gaudier-Brzeska had been killed fighting with the French army in 1915, and many British artists had seen active service in various theatres of war. Some of Nevinson's most effective paintings were inspired by war, perhaps as befitted a Futurist, but he emphasized its bitter poignancies rather than its glories. In both *La Mitrailleuse*, 1915 (Tate Gallery), and the steel-grey *Returning to the Trenches*, 1914–15 [National Gallery of Canada; plate 83A], he adapts the agitated Futurist stylizations of, say, *The Arrival*, c. 1913 (Tate Gallery) to more sombre themes. The British Government, in one of its few inspired moments during the war, belatedly recognizing the value of visual records of the nation's multifarious wartime activities, in the middle of 1916 evolved the Official War Artists scheme as an additional part of the existing propaganda machine. Under this scheme practising artists were recruited to serve, with appropriate military ranks, in the capacity of chroniclers.[1] Muirhead Bone was the first to be sent in 1916, followed soon afterwards by Orpen, Eric Kennington,

[1] The Germans were already doing this at least by 1915. The British Ministry of Information was advised on whom to send to the front by a committee whose members included C. F. G. Masterman, Ernest Gowers, Campbell Dodgson, and Eric MacLagan (William Rothenstein, *Men and Memories*, II (1932), 307–8; *A Handbook of the Imperial War Museum* (1963), 60–1).

Philip Connard, Francis Dodd, Henry Lamb, James McBey, Nevinson, Paul Nash, Roberts, and William Rothenstein. Later on, Lavery, John Nash, Wyndham Lewis, Augustus John, Richard and Sydney Carline, Alfred Munnings, and Sargent went to France as War Artists. In 1918, J. D. Fergusson was attached to the Royal Navy as a probationer War Artist. The decision to found the Imperial War Museum dates from March 1917, and the Museum was formally opened at the Crystal Palace on 2 July 1920. Sixteen years later it went to its third and permanent home, the former Royal Bethlehem Hospital, perhaps an unintentional touch of irony. War paintings fall into roughly three groups: on-the-spot records of events, places, and things; imaginative reconstructions of events; and portraits of the participants, from leading statesmen and Field Marshals down to the humblest munition workers and other ranks. A cross-section of most types of visual war reportage appeared in two volumes published, in ten parts, under the authority of the War Office, *The Western Front: Drawings by Muirhead Bone* (1917); a third volume, *British Artists at the Front*, was published in four parts by *Country Life* in 1918, each part devoted to a single artist: Nevinson, Lavery, Paul Nash, and Kennington. Nearly all the illustrations were in colour. The journalist C. E. Montague provided general introductions to all the volumes based on first-hand knowledge of the battle-front, and Campbell Dodgson, Robert Ross, and John Salis (a pseudonym for Jan Gordon) wrote biographical notes on individual artists.

Muirhead Bone's drawings vary from swift, thumbnail sketches to elaborate architectural compositions. The fearsome engines of war and the destruction they wreaked are recorded in sober impartial detail with, wherever appropriate, a fine grasp of dramatic effect. Nevertheless, they give a somewhat muted version of war, and Montague attempted to refute a criticism of Bone that he did not draw 'war as it is' in his preface to the second volume by saying, in effect, that Bone's restrained objectivity emphasized not so much the horrors of war as its tedium and the fortitude of individuals caught up in it. In fact, such photographs as survive of the Western Front often give a far more harrowing account

of the mud and blood of the trenches. There is always the danger that an artist, by overdramatizing isolated incidents, may lapse into unconvincing emotive theatricality that, calmly seen in retrospect, fails to stir our imagination. A further complication lay in the changed conditions of modern trench warfare as it evolved between 1914 and 1918, for this was essentially a static, attritional operation. Gone were the glorious cavalry charges of previous battles that readily lent themselves to the romanticized treatment of a Caton Woodville or a Meissonier, or even of a Lucy Kemp-Welch, whose painting, *Forward the Guns!* (Tate Gallery), done from studies of horse artillery manœuvres on Salisbury Plain in 1917, now seems utterly anachronistic. On the other hand, Munnings's war paintings of the Canadian Cavalry Brigade in France are much more telling, partly because he was a more accomplished artist, chiefly because he could draw upon first-hand experience.

Other artists, notably Kennington and Sargent, whose long frieze of blinded soldiers, *Gassed*, 1918 (Imperial War Museum), is a masterly evocation of the horrors of this new form of warfare, could probe the psychological effects of war upon humanity [plate 83B]. The Vorticists were particularly well equipped to render the disintegrating shock of battle, and both Lewis in *A Battery Shelled*, 1919 (Imperial War Museum), and Roberts in *The First German Gas Attack at Ypres* (1915), 1918 [National Gallery of Canada; plate 84B], recreate powerful images of war that spring from personal experience (both had served in the Artillery), but aspire to universal statements. Similarly, Bomberg, in *Sappers at Work: A Canadian Tunnelling Company, Hill 60, St. Eloi, c.* 1918–19 (National Gallery of Canada), could successfully commemorate a particular event—a gigantic sapping operation which totally destroyed an enemy hill stronghold in the Battle of Messines, 7 July 1917—in pictorial language which remains faithful to its own conventions.[1] The most haunting interpretations of the Flanders battlefields came from Paul Nash, who had served in the Artists' Rifles from 1914 until his appointment as an Official War Artist

[1] Bomberg's first version, however, was rejected by the Canadian Government, which had commissioned it for the Canadian War Memorial, as being too Cubist. The final version contained more realistic detail to satisfy the requirements of the military authorities.

in 1917 on the strength of his exhibition of twenty drawings, *Ypres Salient*, at the Goupil Gallery. He brought rare poetic gifts to bear on the subject and transmuted its grim baseness into works of great beauty. He alone penetrated beyond its superficial aspects and captured its desolate essence in enduring symbolical language. Paul Nash had studied at the Chelsea Polytechnic, 1906–7, and at L.C.C. evening commercial art classes at Bolt Court, Fleet Street, from 1908 to 1910, where he was discovered by William Rothenstein, who, recognizing his unusual imaginative powers, urged him to transfer to the Slade School. At first Nash found the Slade atmosphere rather chilly and not unlike that of his old public school, St. Paul's. He recalled that Tonks had once appealed to the students not to risk contamination by visiting Fry's Post-Impressionist exhibitions.[1] Nash had already begun to write poetry and do book illustrations, and had made the acquaintance of Gordon Bottomley and, later, of Sir William Blake Richmond, who had reinforced his interest in Blake and had seen that Nash's true bent lay in landscape painting. Nash's early drawings, such as *Bird Garden*, 1911 [National Gallery of Wales, plate 81B], are visionary landscapes which stem from Blake, not, as one might expect, from Samuel Palmer, whose work he did not see 'until five or six years later. But a love of the monstrous and the magical led me beyond the confines of natural appearances into unreal worlds or states of the known world that were unknown.'[2] The 'monstrous and the magical' were elements much in evidence in the war-torn landscapes of France and Belgium, but to most observers only the monstrous was immediately apparent. Only an artist of Nash's special sensibilities could find the magical in the stagnant, cratered, and haunted battlefields. A coloured chalk drawing, *Sunrise; Inverness Copse*, 1918 (Imperial War Museum), shows just such an eerie scene, the ravaged tree stumps pointing skywards like maimed human fingers, lit by the rays of the rising sun. From this same drawing Nash worked up an oil, *We Are Making a New World*, 1918 [Imperial War Museum; plate 85], in which a double symbolism

[1] Paul Nash, *Outline: An Autobiography and Other Writings* (1949), 82, 83, 86–7, 89–93.
[2] P. Nash, *Aerial Flowers* (1945), reprinted in *Outline*, 260.

is now made explicit by the changed title. Another significant change in the oil was the substitution of a mass of blood-red-tinged cloud around the white sun and pale blue sky, instead of the brown clouds of the drawing: '. . . as if the very source of light had spilt all its blood. Yet it rises, and may even yet regenerate the waste.'[1] Nash's war pictures are the visual counterpart to the poems Wilfred Owen wrote in the trenches, before he was killed in action in November 1918:

> I have perceived much beauty
> In the hoarse oaths that kept our courage straight;
> Heard music in the silentness of duty;
> Found peace where shell-storms spouted reddest spate.
> (from 'Apologia pro Poemate Meo')

[1] Anthony Bertram, *Paul Nash : the Portrait of an Artist* (1955), 104.

VIII

SPENCER, PAUL NASH
AND THE
NEW GENERATION

AFTER the turbulent decade of ferment, war, and revolution, some slackening of tension and consolidation might be expected. In Italy, France, Holland, and England, at least, there was a noticeable return to the classical virtues of order and stability in the visual arts during the early 1920s. As the horrors of 1914–18 gradually faded, a new, if slightly frenetic, playfulness appears in some of the more ephemeral arts, particularly fashion, which was to lead to the 'jazz-modern' or 'playboy' style, of which a few examples still survive today in the architecture and applied arts of the period. The word 'jazz' was imported from the United States of America towards the end of 1918, and its adjectival use soon extended far beyond the confines of the unselfconscious, improvised American Negro folk music from which it originated. As we shall see, this terminology was to be supplanted by the words 'Art Déco' which has now become the generic description for art of the period. Whichever description is preferred, jazz or Art Déco, it symbolized a throwing-off of conventional inhibitions —a social permissiveness that could be regarded as the direct result of the war which caused the destruction of the old order of society, and as a form of escapism from the privations engendered by that war. The syncopated rhythms of the 'Blues' were echoed in decorative art, but it should be remembered that some of the zigzag patterns typical of Omega Workshop ornament and Charles Rennie Mackintosh's Derngate interiors anticipate the jazz idiom. Omega designs were also derived from Negro, this time African Negro, art. The ethnographic researches of Picasso and his friends long before the war had to some extent prepared the way for the jazz

age of the 1920s.[1] The statement printed in the first exhibition catalogue of a new group, the Seven and Five Society, in the spring of 1920 reflects the thinking of some middle-of-the-road artists who were weary of the recent upheavals. They were not a group 'formed to advertise a new "ism"': they were 'grateful to the pioneers', but felt 'that there has of late been too much pioneering along too many lines in altogether too much of a hurry, and themselves desire the pursuit of their own calling rather than the confusion of conflict'.[2] Not surprisingly, perhaps, in the light of this somewhat unadventurous spirit, none of the earlier members of the group achieved any lasting reputation, with one exception, Ivon Hitchens, who was a foundation member. But the 7 & 5 were later to undergo a palace revolution led by the uncompromising activists of abstract art.

The London Group, much more radical in origin, also underwent a change of orientation in the 1920s, and was to alter again as particular groups within its membership were able to use it as a platform for new or unfashionable ideas. This flexible, permissive attitude has enabled the London Group to survive such fluctuations and maintain a standard of serious painting and sculpture independent of external pressures. Its tolerant diversity was, and still is, its greatest strength. Roger Fry was elected to the London Group in 1917 and soon became a most active member. 'Bloomsbury' strengthened its forces in 1919 with the election of Duncan Grant, Vanessa Bell, and Boris Anrep to the Group, and they, with Dobson, Bernard Meninsky, Mark Gertler, and Matthew Smith set the tone for the exhibitions of the 1920s. Sickert, Roberts, and the Nash brothers were also regular contributors. The big *London Group Retrospective Exhibition 1914–1928*, held at the New Burlington Galleries in April and May 1928, provided a fitting conclusion

[1] Clive Bell, 'Plus de Jazz', in *Since Cézanne* (1922), 213–30, a premature obituary notice of Jazz.

[2] The Seven and Five Society appears to have been formed some time in 1919, and its title derived from the nucleus of seven painters and five sculptors who originated it. Their first exhibition at Walker's Galleries (12 Apr.–1 May 1920) contained work by eighteen members. A complete set of catalogues and other archive material relating to the '7 & 5' (the abbreviated title by which it was later known) is in the Tate Gallery.

to this phase of its history. Roger Fry contributed a note on 'The Modern Movement in England' to the catalogue, in which he remarked that after the years of experiment, during which Post-Impressionism was assimilated into British art, 'the tendency became more and more marked to revert to construction in depth; to abandon the essentially decorative surface organisation in favour of the more essentially pictorial effects of recession. Little by little light and shade returned and the pictures of these artists took on much more of the general appearance of the older Impressionist practice.' He also noted a renewed interest in rigorously planned construction, and increased coherence of design—but that some of the adventurousness of the early years had been lost could not be gainsaid. Gone also were large-scale compositions, for now artists worked to meet 'the exiguity of modern apartments'. Fry's signed and dated portrait of *Nina Hamnett*, 1917 (Courtauld Institute), included in the 1928 retrospective exhibition, shows how much he valued the qualities of coherent construction in his own work and explains his particularly sympathetic treatment of purely architectural subjects. One might also observe that there was a general tendency away from any form of abstraction during the 1920s—the human figure regains its traditional pre-eminence. This was also the period of Picasso's monolithic, neo-classical female nudes, and of Derain's return to a formalized naturalism compounded of Corot and Renoir. It is no accident that Derain should have become one of the darlings of the Bloomsbury Group: the peculiar blend of decorativeness and solid forms in his work met the canons of Bloomsbury taste, and it was rumoured that even the cows in the meadows at Garsington lowed 'Doë-rain' in his honour.[1] The seal had been set on Derain's success in England with the first performance of *La Boutique fantasque* at the Alhambra Theatre, London, on 5 June 1919.[2] Diaghilev had commissioned him to do the sets, curtain, and costumes; the choreography was by

[1] Osbert Sitwell, *Laughter in the Next Room* (1949), 149. The Sitwell brothers and Léopold Zborowski had collaborated to organize the exhibition *Modern French Art* at the Mansard Gallery in August 1919. British collectors preferred to buy work by Derain, Modigliani, and Utrillo, rather than the pictures of Matisse and Picasso.

[2] Clive Bell, *Old Friends: Personal Recollections* (1956), 170 ff., for an account of Derain and Picasso in London.

Massine, and the conductor Ernest Ansermet. Picasso did the sets for Diaghilev's London production of *Le Tricorne* in the same season, and both artists made personal appearances in the capital.

Duncan Grant and Mark Gertler are two artists whose work bears the imprint of Derain's style, although in very different ways. Gertler, born of impoverished Polish-Jewish parents in the East End of London, carried with him into adult life something of the exotic separateness that had characterized his early upbringing, and it was this aspect which captured Gilbert Cannan's imagination in his novel, *Mendel* (1916), inspired by Gertler's life story. Gertler attended art classes at the Regent Street Polytechnic in 1907, but had to work in a stained-glass factory until the Jewish Educational Aid Society came to his rescue and, on William Rothenstein's recommendation, financed his studies at the Slade School, where his precocious talent won him several scholarships and prizes. An early portrait, *The Artist's Mother*, 1911 (Tate Gallery), once in the collection of Michael Sadler, one of Gertler's early patrons and an important collector of contemporary British art, is a searchingly observed characterization of a remarkable woman. The firmly modelled hands and face are highly accomplished feats of painting that recall the noble breadth of a superior archetype, Rembrandt. But Gertler's next step took him into a more personal world of what can only be described as Eastern European folk art. What exactly triggered off this excursion will probably never be known, although it was popular art, in the shape of a poster advertising meat extract, that had first inspired Gertler to draw in childhood. This new phase is best represented in *Gilbert Cannan at his Mill* (Ashmolean Museum, Oxford) and *The Merry-Go-Round* (Ben Uri Art Gallery), both of 1916. When the artist sent a photograph of *The Merry-Go-Round* [plate 86A] to D. H. Lawrence, his reaction was one of mingled horror and admiration: 'Your terrible and dreadful picture has just come . . . : it is the best *modern* picture I have seen: I think it is great and true. But it is horrible and terrifying.'¹ The fierce blues, reds, and brazen yellows of the picture only point up the mood of

¹ Noel Carrington (ed.) *Mark Gertler: Selected Letters* (1965), 129, letter dated 9 Oct. 1916.

sinister hilarity conveyed by these strange, puppet-like figures as they whirl round and round. After a brief flirtation with sculpture during the winter of 1916–17, Gertler resumed painting, and by the 1920s he had consolidated the style announced in the early portrait of his mother with certain formal sophistications derived from Post-Impressionism and Derain. *The Queen of Sheba*, 1922 (Tate Gallery), is a Jewish odalisque in royal guise, rich, earthy, and voluptuous [plate 86B]. She fills the canvas and seems almost to be bursting out from the narrow confines of her couch. Gertler's powers had begun to decline by the end of the decade only to undergo a rejuvenation, much inspired by Picasso's 'classical' nudes of the 1920s. But his health gave way, and fits of depression, which had been a chronic affliction since childhood, increased in intensity and frequency, until, in June 1939, he committed suicide, his creative powers prematurely cut short.

By 1920, Duncan Grant had already produced a considerable body of work, including several mural decorations and the costumes for two productions by Jacques Copeau, 'Twelfth Night' and 'Pelléas et Mélisande'. He had become the court painter, so to speak, of the Bloomsbury Group (he was a cousin of Lytton Strachey), and contributed to Fry's *New Movement in Art* exhibition at the Mansard Gallery in 1917. The first book on him was published in 1923, with a discerning introduction written by Fry in which he generously praised Grant for his gifts as a decorative artist, although Fry's own sympathies, as we have seen, were for a more defined, plastic conception. It seems at least arguable that it was Fry who persuaded Grant to attempt to strengthen the formal construction of his compositions, although Grant's portrait of *James Strachey*, 1910 (Tate Gallery), already shows considerable mastery in this respect. As early as 1922, in *South of France* (Tate Gallery), a landscape painted near St. Tropez in the winter of 1921–2, this preoccupation with structural logic again makes itself felt [plate 87A]. The spatial inspiration is clearly Cézanne's, for we see how the path is made to cut off sharply to the left so as to avoid too blatant an effect of recession, but the atmospheric light and simplified shapes remind one of Corot as seen through the eyes of Derain. This solemn mood passes, and in another southern

landscape, *View from a Window, South of France*, 1928 (City Art Gallery, Manchester), Grant happily combines the decorative element of patterned wallpaper surrounding the open window with the solid planes of the sun-drenched landscape stretching away into the distant, shimmering Mediterranean [plate 88B]. Augustus John also used a Cézannesque composition in *The Little Railway, Martigues*, 1928 (Tate Gallery), but with a looser technique that was to characterize his work of the late 1920s and early 1930s [plate 87B]. Duncan Grant was a supporter of the London Artists' Association, an organization formed in 1925 by Samuel Courtauld and John Maynard Keynes with the object of providing exhibitions for promising young artists free from the financial trammels usual with dealers' galleries. A minimum wage of between £3 and £5 a week was guaranteed to artist members of the Association. This salary was only paid if an artist failed to earn more than his fixed income in a particular year from the sale of the work he contributed to the L.A.A. A commission was levied on all sales solely to meet running expenses and never to bridge the gap between an artist's earnings and his guaranteed income.[1] The Association's first exhibition was held at the Leicester Galleries in May and June 1926, where works by Adeney, Baynes, Vanessa Bell, Dobson, H. E. Du Plessis, Fry, and the New Zealander F. J. Porter were shown. Their ranks were later swelled by the addition of Edward Wolfe, Ivon Hitchens, Paul Nash, Roberts, Raymond Coxon, Morland Lewis, and Vivian Pitchforth; in the 1930s, with headquarters at the Cooling Galleries, among the more distinguished recruits were William Coldstream, Robert Medley, Henry Moore, Ben Nicholson, Victor Pasmore, and Claude Rogers. That the London Artists' Association gave Coxon, Morland Lewis, Pitchforth, Coldstream, Medley, Pasmore, and Rogers their first one-man exhibitions is a tribute to their perceptiveness. The Association was wound up with a retrospective exhibition in

[1] The original guarantors were Samuel Courtauld, Lord Keynes, Leo H. Myers, the writer, and Frank Hindley Smith; the first secretary was Fred Hoyland Mayor, later to become well known as a dealer in modern art and the Managing Director of the Mayor Gallery. A commemorative exhibition of work by members of the London Artists' Association was held at the Ferens Art Gallery, Hull, Aug.–Sept. 1953, with a foreword by Clive Bell explaining the workings of the L.A.A.

March 1934. Although short-lived, it performed a valuable ser-
vice for the younger artists whose reputations had still to be made.
The promising young artist also benefited to some extent by the
activities of the Contemporary Art Society, founded in 1910 with
the object of providing funds, from members' subscriptions and
donations, with which to purchase works by living artists to be
given to national and provincial museums and art galleries. The
Contemporary Art Society was formally inaugurated on 18 May
1910 at 44 Bedford Square, the home of Philip and Lady Ottoline
Morrell, who, with Campbell Dodgson, D. S. MacColl, Bowyer
Nichols, Robert Ross, Charles Aitken, Arthur Clutton-Brock, Sir
Charles Holmes, Sir Cyril Butler, Fry, and Clive Bell, were the
original committee members. The C.A.S. was the counterpart, in
the modern field, of the National Art-Collections Fund, founded
in 1903 to raise privately-subscribed capital to assist our public
collections in their purchases of outstanding examples by the old
masters, as well as sculpture, a wide variety of *objets d'art*, rare
books, and illuminated manuscripts.

The *London Group Retrospective* of 1928 not only provides a use-
ful survey of the earlier achievements of its members but a guide
to their development up to that date. Matthew Smith's monu-
mental *Woman with a Fan* of 1925 (Walker Art Gallery, Liverpool)
had been lent by Jacob Epstein, and is a superb example of Smith's
expressive painting of the female nude, in which he had already
begun to adopt a more intuitive, 'hit or miss' approach to the
delineation of form [plate 88A]. This new-found freedom, which
dates from the figure paintings he did from the model, Vera
Cunningham (herself a gifted painter), in Paris between 1924 and
1925—of which *Woman with a Fan* is an example—brought with it
the danger of structural incoherence, which the artist was prepared
to face for the sake of greater spontaneity and richness of colour
and texture. There was also a remarkable group of four Sickerts,
two of which, *The Bar Parlour*, 1922 (Lady Keynes), and a version
of *Battistini Singing*, 1925 (Earl and Countess of Harewood), show
him moving towards the broad simplifications of form which
culminate in the two portraits of *Hugh Walpole* [Fitzwilliam
Museum 1928, and Glasgow Art Gallery 1929; plate 89A], and

his major work of this period, *The Raising of Lazarus*, c. 1929–32 [National Gallery of Victoria, Melbourne; plate 89B]. Simplification was not in itself new to Sickert's style, for he had learnt from Whistler the necessity to paint in tonal values, but the degree of abstraction is far more advanced in the work of the 1920s and 1930s, and the tonalities much brighter. From about 1927 he relied increasingly on photographs and Victorian engravings for pictorial themes—the famous and controversial Victorian 'Echoes', which to some purists represent a failure of his powers and to others a brilliant new artistic breakthrough. Undoubtedly, these photographs, in some of which the forms are accidentally simplified through over-exposure or contre-jour effects, suggested to Sickert interesting new formal possibilities that he fully exploited. In so doing, he continued his intense interest in painting techniques *per se* and anticipated the work of Francis Bacon in the late 1940s. In a deceptively light-hearted manner, Sickert reminds us that he is one of the most inventive, if uneven, artists of his generation, who should be taken seriously. Of the few sculptors showing at the London Group in the 1920s, Epstein apart, only two names need be recalled: Frank Dobson (who was President of the London Group, 1923–7), and Alan Durst, who, in 1920, turned to carving religious subjects, figures, and animals, usually directly in stone or wood.[1] Dobson's highly stylized early portrait heads had won for him wide recognition, none more so than his *Sir Osbert Sitwell*, 1923 [Tate Gallery; plate 90A] in polished brass, which was purchased from him by T. E. Lawrence and lent to the Tate Gallery from 1923 until later presented by Lawrence's executors in accordance with his wishes. When offering to lend the work, Lawrence wrote that it was Dobson's 'finest piece of portraiture and in addition it's as loud as the massed bands of the Guards'. Dobson's earliest surviving works of 1920–1 are influenced by his study of ancient Egyptian, Assyrian, Peruvian, and African art in the British Museum, as well as by Modigliani and Brancusi, but his

[1] *Frank Dobson, C.B.E., R.A., 1886–1936. Memorial Exhibition*, Arts Council (1966). See also Malcolm Easton, 'Frank Dobson's "Cornucopia" (Hull University Art Collection)', in *Burl. Mag.* CXI (June 1969), 382–6, where the influence of Sinhalese sculpture on the genesis of this piece is noted.

style changed soon afterwards, when he became influenced by Indian sculpture and Maillol. *Cornucopia*, 1925–7 [University of Hull; plate 90B], in Ham Hill stone, already shows this pre-occupation with neo-classicism both in subject and treatment, but reinterpreted with the experience of Ceylon and India fresh in Dobson's mind. By the early 1930s, however, Dobson had de-veloped a more personal 'modernistic' interpretation of classical canons in his life-size Portland stone reclining figure *Pax*, 1934 (Mrs. Dobson), and in the glazed pottery reliefs for Hay's Wharf, executed in the same year. Dobson was, in the best sense, an academic sculptor, who had the cruel misfortune of seeming to be more radical to his contemporaries than in fact he was, so that with the rise of a younger generation led by Henry Moore, by contrast and through no fault of his own he appeared to be an old-fashioned traditionalist and 'dated'. So superficial a verdict ignored Dobson's superb craftsmanship, his importance as a teacher at the Royal College of Art, and, above all, the intrinsic merits of his work.

There are some intriguing resemblances between the heavy, monumental figures by Dobson and those that populate the canvases of William Roberts from the mid-1920s onwards.[1] The jazzy, angular rhythms of his later Vorticist works, with their puppet-like personnel, give place to statuesque tubular figures, a little reminiscent of those of Fernand Léger, frozen into rigorously controlled groups often seen as if on a steeply-tilted stage. Roberts frequently takes events from cockney life or popular pastimes, such as *Jockeys* (sometimes known as *The Paddock*), 1928 [Bradford City Art Gallery; plate 91A], and his style has remained remark-ably consistent over the past forty years. His early training first as a poster artist, then at the Slade School on an L.C.C. drawing scholarship, undoubtedly instilled in him a feeling for bold formal simplification and mastery of design. Roberts's mature style carries over certain conventions he. had learnt from Cubism and his association with the Vorticists, but transformed into a highly personal idiom.

[1] Ronald Alley, *William Roberts, A.R.A.: Retrospective Exhibition*, Arts Council (1965).

Stanley Spencer, some of whose chief major works belong to the 1920s and early 1930s, was the English eccentric visionary of his time, in some respects a latter-day William Blake, who defies glib classification. A brilliantly precocious student, 'Cookham', as he was nicknamed after his native Berkshire village, had an extraordinary physical appearance. Somewhat undersized, uncouth, dishevelled, with a low fringe of dark hair, and apple-cheeked, he was frequently mistaken for an errand boy or, in later years, a tramp. Once when still a student he was peremptorily called upon to carry from Euston station the bags of a distinguished personage visiting University College on prize-giving day, only to reappear before this same person later that morning to receive a Slade Scholarship. That was in 1910. Spencer possessed that combination of qualities not infrequently found in supremely gifted men, unaffected humility and unwavering resolution in matters of fundamental concern. He won the Summer Composition Prize for his *The Nativity* [University College, London; plate 92A] in 1912. Like so many of Spencer's religious compositions, this powerful work, with its Giottesque tension and the monumentality of a Masaccio (both artists whom he admired) is set in Cookham, which for him was the 'new Jerusalem'. Spencer also uses the old medieval convention of simultaneously representing in one picture two or more separate events, in this instance the meeting of Joachim and Anna. Spencer afterwards came to regard the years before the 1914–18 War as the period in which his inner vision was at its purest intensity; he felt it to be a time of especial grace and innocence which he was never again to experience so fully. Certainly all the compositions of this date are suffused with an aura of intense mysticism, which might more accurately be defined as intuitive religious experience.[1] The artist himself considered *Apple Gatherers*, 1912–13 (Tate Gallery), to be 'an achievement of vision', and the work is unusually thickly painted, partly because the two central figures and much of the composition were reworked several times over a period of a year. The theme was a Slade Sketch Club subject without conscious reference to Adam

[1] Elizabeth Rothenstein, *Stanley Spencer* (1945), distinguishes between mysticism as such, and intuition, in relation to Spencer.

and Eve, and the picture was bought by Edward Marsh in 1913 through the good offices of Henry Lamb. When war came, Spencer joined the R.A.M.C. in 1915, and later served with the Royal Berkshires in Macedonia. His wartime experiences, while they shattered his peace of mind, were to inspire the picture commissioned for the Imperial War Museum, *Travoys arriving with Wounded at a Dressing Station, Smol, Macedonia*, 1919, and the series of mural decorations for the Oratory of All Souls, Burghclere, which he painted at Burghclere for Mr. and Mrs. J. L. Behrend between 1926 and 1932. For the first of these war pictures, Spencer chose a high viewpoint, a compositional device used most effectively in *Swan Upping at Cookham*, 1914–19 [Tate Gallery; plate 91B], the second picture which Behrend had purchased from him. In many subsequent works the artist exploited the unusual visual effects that such a viewpoint provided, but Spencer paid particular attention to the formal construction of the composition in *Travoys Arriving*, his first really large picture (it measures 183 × 218·5 cm, and is over twice the size of *The Nativity*). The converging lines of the travoys form a fan-shaped pattern around the open window of the brightly-lit makeshift operating theatre, against which are silhouetted the heads of the mules. Henry Lamb also used an aerial viewpoint in the first of his two Macedonian war paintings, *Irish Troops surprised by a Turkish bombardment in the Judaean Hills*, 1919 [Imperial War Museum; plate 92B], and there are close stylistic affinities between the work of the two artists at this time. Lamb, who had first got to know Spencer through Darsie Japp in 1913,[1] lent him a room in his house at Poole in 1922–3 and, again in 1923, his Hampstead studio on the top floor of the Vale Hotel, Vale of Health. Lamb's signed and dated portrait group, *The Round Table*, 1926 (Lord Moyne), contains certain Spencerian distortions in the treatment of the figures. On the other hand, the thinner brushwork and subtler tonalities that Spencer introduces into his paintings from now on may be due to the example of Lamb. The close observation of natural details in Spencer's Dorset landscapes of 1920, which set the pattern for a series of landscapes that continue well into the 1940s, may also owe some of their original impetus to

[1] Gilbert Spencer, *Stanley Spencer* (1961), 123–5, 138–41.

Lamb. Landscapes gradually became anathema to Spencer: they were readily saleable and at times he found it difficult to resist the financial pressures brought to bear on him to produce them. He stoutly maintained in later years that his younger brother, Gilbert, was much the more accomplished landscape painter.[1]

Spencer was well acquainted with the Old and New Testaments from early childhood. His father, the village organist and music teacher, was a kindly Victorian patriarch who read from the Bible to his wife and children in the evenings with such conviction as to make it seem almost as if the biblical events had taken place in their own familiar village. Like Blake, who envisaged the British Isles as a centre of primitive goodness, Spencer came to associate Cookham with a vivid spiritual experience in which 'past and present, the living and the dead, good and evil all exist together in a vast undifferentiated flux'.[2] *Christ Carrying the Cross*, painted in 1920, was Spencer's first public success, when in the following year it was purchased by the C.A.S. and subsequently presented to the Tate Gallery [plate 93A]. The theme was partly inspired by a newspaper report of Queen Victoria's funeral recounted to the artist, which suggested that in this more tragic circumstance the Virgin, seen in the foreground of the painting, might have slipped into a side street to be unobserved. The topography is the artist's house and that of his grandmother in Cookham, and the motif of men carrying ladders was based on some builder's men whom Spencer had observed in the village while he was pondering his picture. Other features are taken from scenes of Cookham life remembered from childhood. As in so many of his paintings, the mood is one of joy and love, not sadness: 'It was joy and all the common everyday occurrences in the village were re-assuring, comforting occurrences of the joy. . . . I had as a child no thought than that Christ had made everything wonderful and glorious and that I might be able later on to join in that glory.'[3] Spencer's religious background was a hybrid nonconformist-evangelical Anglicanism, and the emphasis was on God's omnipotent goodness

[1] In conversations with the author, 1955–6.
[2] John Rothenstein, 'Stanley Spencer', in *Modern English Painters* (1956), 168.
[3] *Stanley Spencer: a retrospective exhibition*, Tate Gallery (1955), 15.

and love rather than on His wrath and the perils of hellfire. In this, Spencer shared to some degree the sentiments of Voysey and his dissenting clerical father, for like them he could not bring himself to believe in eternal damnation. The punishment of the Bad in his *The Resurrection, Cookham*, 1923–7 (Tate Gallery), 'was to be no more than that their coming out of the graves was not so easy as in the case of the Good'.[1] There are some strangely beautiful passages in *Christ Carrying the Cross*, where everything is bathed in eerie, silvery moonlight which transmutes the warmer colours of day into delicate pinks, greys, and willow greens. The curtains which billow around the curious villagers leaning out of their windows give them the appearance of winged angels or gargoyles. The *Resurrection* brought the artist before the public eye as a controversial figure when the picture was presented to the Tate Gallery by Lord Duveen in 1927. It was his largest work (366 × 549 cm) and the subject, which had been maturing in his mind since 1913, took him four years to complete. It was his practice to make detailed drawings to scale, often on quite minute scraps of paper, which would then be squared up and pieced together, and the design transferred to the final canvas. Once this stage had been reached, few, if any, alterations to the composition would be necessary, and the artist would then colour in the outlines, as he put it. Spencer had to an astonishing degree the facility to picture in his mind's eye all the details of the most complicated compositions, and, once these were fixed, could begin at some quite arbitrary point to work them out on paper. The setting for the *Resurrection* is Cookham churchyard, 'the holy suburb of Heaven' and for Spencer a place of peace and joy, and the near-by Thames has become the River of Life. It is an intriguing mixture of the universal and the particular. God the Father, Christ, and the little children occupy the porch in the centre of the composition and they are flanked by Moses and other 'thinkers'; elsewhere Spencer has included several portraits of himself, his wife, and the Judge, Sir Henry Slesser. As in the *Travoys*, he again makes use of a fan-shaped composition, with the main diagonals converging on the central

[1] Ibid. 12, and *Catalogue of the Modern British Paintings, etc.*, Tate Gallery (1964), II. 662.

figures under the porch, but the complex composition, beautiful though it is in its parts, lacks the over-all coherent energy of his earlier works. Even so, it must surely rank as one of the great religious paintings of this century.

The *Resurrection* is part of a larger vision which had occupied the artist since his return from the war. He had begun to plan a series of paintings which would embellish a chapel and, although there seemed no prospect of the project's ever being accomplished, during the fortnight of his stay with Henry Lamb at Poole in 1922 he produced big cartoons in pencil and ink for the two side walls of a chapel, each of which was divided into four arched panels, with these again subdivided into two, the lower, smaller section forming a kind of predella. The whole was surmounted by continuous panoramic friezes which filled the space between the ceiling and the tops of the arched panels. Mr. and Mrs. Behrend chanced to see these cartoons on a visit to Lamb, and expressed a wish to commission Spencer to carry them out as a memorial to Mrs. Behrend's brother, who had been killed in the war. After an initial refusal, the terms of the offer were improved and subsequently accepted, and to the murals already planned Spencer added *The Resurrection of Soldiers* for the end wall of the Oratory of All Souls at Burghclere, behind the altar [plate 94]. The chapel forms the centre building of a range of almshouses at Burghclere, and was designed by the architect Lionel Pearson, of Adams, Holden, & Pearson, to meet the artist's extremely exacting specifications.[1] After a lapse of ten years, during which Spencer meditated upon his experience of war in the bleak Macedonian valley of Kalinova and worked out his grand design, he was enabled in 1927 to begin to consummate the vision that had haunted him for so long. Another seven years were to pass before the work was finished, all of it accomplished unassisted. Fighting was abhorrent to Spencer, so instead of heroic battle scenes we are shown the humdrum routine of military life, each scene presented with the vigour of an

[1] Gilbert Spencer, op. cit. 144–50; George Behrend, *Stanley Spencer at Burghclere* (1965), for a detailed descriptive account of the paintings with fifty-one illustrations. The property was given to the National Trust in 1947 and is known officially as the Sandham Memorial Chapel. See also Duncan Robinson, 'The Oratory of All Souls, Burghclere', in *Stanley Spencer 1891–1959*, Arts Council (1976), 18–20.

intensely-felt shared experience, whether it be soldiers checking laundry, performing ablutions, tending the wounded, or pitching camp [plate 93B]. Each of the eight larger individual scenes above the predella is seen in steep, foreshortened perspective, as are the panoramas of the camp and the *Resurrection* on the end wall. Thus Spencer both preserves the unity of the plane surfaces on which they are painted, and takes into account the spectators' changing angles of vision as they look from the lowest registers, which are more or less at eye-level, to the upper ones, which are well above it. Gilbert Spencer has spoken of the 'spirit of tranquillity' which imbues these murals, and which culminates in the large *Resurrection*. For here, in a mood of quiet ecstasy, the dead soldiers gradually realize the meaning of Christ's Passion and Resurrection, as, bearing their white crosses, they crowd round the seated figure of the Redeemer at the centre of the cruciform composition, where He seems to be the remote yet inevitable focus of attention beyond the forest of crosses in the foreground. The murals in the Oratory at Burghclere must be rated one of the supreme achievements in British painting of this period and deserve to be much more widely known than they are.

The future course of the 7 & 5 Society was set when, in 1924, Ben Nicholson joined, and among the works shown at the Society's fifth exhibition that year were *Striped Jug*, *Bertha*, and, significantly, *Abstraction, November*.[1] None of these works can be identified with certainty, and twenty-five guineas, for *Striped Jug*, was the highest price asked. Eighteen months later, the exhibitors' ranks were swelled by the inclusion of Jessica Dismorr, Evie Hone, Winifred Nicholson, and Edward Wolfe, and at the A.G.M. of February 1926, Ben Nicholson was elected Chairman for the year and Sophie Fedorovitch a member. At another meeting in December 1926, among the new members elected for the coming year were Christopher Wood and Cedric Morris, both with the support of Ben and Winifred Nicholson, and within the next twelve months

[1] P. G. Konody, writing in the *Daily Mail*, described *Abstraction, November* as 'a dadaistic futility . . . a picture that consists merely of superimposed squares of flat tints and looks uncommonly like a sample sheet of paripan wall paints'. Quoted in *Decade 1920–30*, Arts Council (1970), 22.

the sculptor Maurice Lambert, the potter William Staite Murray, and David Jones had also been enrolled at the suggestion of Nicholson and his friends. In 1929 the New Zealand-born Frances Hodgkins became a member, having evolved since 1920 a more modern style influenced by Matisse, instead of her earlier *plein air* work mainly in water-colour; among the new non-members exhibiting with the Society was the Cornish 'primitive' Alfred Wallis. The 7 & 5 held its seventh exhibition in January 1927 at the Beaux Arts Gallery (which had been opened in 1923 by Sickert's brother-in-law, Major Frederick Lessore, formerly a portrait sculptor), to the catalogue of which H. S. Ede contributed an illuminating foreword very different in tenor from that of 1920. 'We are still', he wrote, 'slaves to the insulting habit of comparing the depicted object with the object depicted—not allowing the picture to stand on its own merits. This is an age of surface values, an age which gives glory to the right thing done at the right moment; it isn't concerned with the past or the future, it has no past, present or future—it is a state of being. "Fleeting" is the watchword . . . Painting is not now for eternity, it is the expression of the moment, and each moment will bring its own new expression. Perhaps it is really an approach to the musical idea . . . The line of the Seven and Five is, I think, to break quite clearly from the representational in its photographic sense, though not like the Cubists to abandon known shapes. It is to use everyday objects, but with such a swing and flow that they become living things, they fall into rhythm in the same sort of way that music does, but their vitality comes through colour and form instead of sound and time.' This passage contains many of the ideas that were to be developed still further in the 1930s: the preoccupation with surface textures, the sovereignty of colour and form, the non-representational, and even the conscious analogy with music are all present in the work and writings of Nicholson, Moore, Hepworth, Hitchens, and their associates.

Nicholson's art went through a long period of painful gestation before he discovered his own way. The eldest son of the painters William and Mabel Nicholson (sister of James Pryde), his earliest known painting, *Striped Jug*, *c.* 1911 (now destroyed), is a meticu-

lous essay in spatial relationships of the simplest kind, executed in a somewhat fastidious manner derived from his distinguished father. For almost nine years after leaving the Slade, during which he travelled to France and Italy to learn the languages of those countries, and to Madeira for health reasons, followed by a stay in Pasadena, California, he produced only a few still lifes which were never exhibited. It was almost as if his strong artistic background inhibited his own development. Of a very independent mind, he was virtually self-taught, finding very little to inspire him in the painting then being done in England. The attitude of Wyndham Lewis and Group X fostered his own rebelliousness, but the first real gleam of light came to him in about 1921 when he discovered the Cubists in Paris. He spent the winters of 1920–5 near Lugano, and stimulated by the example of his first wife, Winifred Nicholson, he began to paint with more self-assurance and fluency, so that by 1922 he could hold his first one-man show at the Adelphi Gallery, mainly of landscapes and still lifes. These early works are lyrical, intuitive interpretations, and always very fresh and luminous. They show Nicholson's analytical approach to his subject-matter, a paring away of the inessential incidents which was to be an abiding characteristic of his style. The completely abstract and the simplified representational are but two aspects of the same creative purpose as far as Nicholson is concerned, for the two continuously coexist throughout his work. As early as 1923–4 he produced such remarkable canvases as *Painting (Trout)*, 1924 [C. S. Reddihough, Yorkshire; plate 95A], in which all reference to natural objects is suppressed in favour of a subtly balanced pattern of superimposed coloured planes that anticipate his work of the 1930s. A series of Cumbrian landscapes painted between 1928 and 1930, of which *Walton Wood Cottage No. 1*, early 1928 [Scottish National Gallery of Modern Art; plate 95B], is a good example, have a quality of childlike enchantment and arbitrariness of scale that helps to explain why Nicholson and Christopher Wood (whose mature paintings also bear this fairy-tale magic) should have greeted the work of Alfred Wallis with such sympathetic enthusiasm, when they discovered his work by chance on a day visit to St. Ives in August 1928. Ivon Hitchens,

a year older than Nicholson, was also the son of a painter and had studied at the St. John's Wood and Royal Academy Schools under Sargent and Orpen, but the artists most to influence him were Cézanne, Matisse, and Braque. His landscapes of the early 1920s are tentative essays either in the manner of Cézanne, *Farm Buildings*, *Study in Planes, No. 1*, or in a curious stylized mode reminiscent of early Delaunay, *Curved Barn*, both of 1922.[1] By 1929 a more personal style is emerging, with the emphasis on broad areas of rhythmically brushed-in colour, simplified forms, and sensitivity to light—the collective qualities, in fact, of the 7 & 5 Society at that time. Hitchens's mature work, however, belongs to the next decade.

The 1920s in Britain were not very conducive to the fostering of youthful imaginative talent, and looking back over the period one has the impression if not of actual stagnation in the visual arts, at least of uncertainty. Fry's aesthetic of 'significant form' or 'design' appeared to lead to a dead end. Artists like Nicholson and Hitchens were still groping for a new formal language, and even Paul Nash went through a period of marking time. His third exhibition in 1928, at the Leicester Galleries, was a much-needed success following a difficult time, and soon afterwards he began his search for 'a new vision and a new style'.[2] The stimulus of war had faded and, except for an excursion into theatre décor and wood-engraving in 1920–1, and some evocative seascapes done at Dymchurch in Kent between 1922 and 1925, Nash's landscapes and interiors with still life were becoming a trifle languid, even banal. Yet landscape and the intuitive apprehension of the *genius loci* are central to Nash's art and his imagination was nourished by the natural world around him, which he observed with extraordinary acuity.[3] A key work in the transition from old to new vision is *Swan Song*, painted at Iden near Rye in Sussex, 1928 [plate 96A], of which the title is an allusion to the fading of summer into autumn. Here, in the sharp focusing upon isolated, yet interrelated, elements of a landscape, and the presenting of them

[1] Illustrated in *Ivon Hitchens: a retrospective exhibition*, Arts Council (1963), pls. 2, 4.
[2] Paul Nash, *Outline* (1949), 221.
[3] Herbert Read, *Paul Nash* (1944), 10–14.

in a formalized close-up, Nash is experimenting in a technique that directly foreshadows his surrealist works of the 1930s. Here, too, in embryo are the deliberate ambiguities or double-meanings: the hectic red toadstool can be read as a setting sun or dying swan; the dried, windswept autumnal leaves look like chrysalids, symbolizing hibernation and rebirth, or fossils suggestive of the earth's antiquity. Eric Newton once pointed out to Nash that the general composition resembled that of Botticelli's *Birth of Venus*, and the similarity in mood, of joy mingled with sadness, in the work of both painters is eloquent proof of Nash's deeper sympathy with Dante, Botticelli, Blake, and Rossetti.[1] For Nash was a literary painter in that his imagination was caught by evocative phrases and poetical symbolism—a predilection he shared with the great romantic painters of the nineteenth century—but his painterly gifts enabled him to invent a purely pictorial language fully adequate to his poetic vision. A further stage on the road to surrealism was reached in *Northern Adventure*, 1929 [Aberdeen Art Gallery; plate 96B], shown at the London Group in 1930. Seen partly through the empty yellow lattice work of an uncompleted poster hoarding is the curved carriage approach to St. Pancras Station, and, apart from the attractiveness of the architectural shapes for their own sake, the lattice symbolizes a penetrable barrier between the present and the future, that is to say, the journey in time and space northwards. The tilted window with its irrational azure background heightens this sense of a metaphysical adventure. At the time *Northern Adventure* was painted Nash lived in a flat high up in Alexandra Mansions, which were opposite St. Pancras, across what was then a vacant lot. This was the inspiration for the painting.

London Transport, guided by Frank Pick, has already been mentioned as an enlightened public patron, and in 1928 the architect of its headquarters over St. James's Park station, Westminster (1927–9), Charles Holden, again demonstrated his courage and persistence by commissioning Epstein to carve the two groups of *Day* and *Night* above the doors of the new building. Although the building itself now seems functionally ingenious rather than bold (its monolithic block-like composition in Portland stone is really

[1] Anthony Bertram, *Paul Nash* (1955), 165.

rather elephantine, with a backward look to neo-Georgian propor-
tions in the fenestration and classically inspired columniation), the
choice of sculptors was adventurous enough. Eric Gill led the team
of Henry Moore, Allan Wyon, Eric Aumonier, A. H. Gerrard,
and F. Rabinovitch who were commissioned to carve the eight
horizontal male and female figures representing the Winds high
up on the seventh-floor flanking parapets of the cruciform wings
around the central tower. As usual, Epstein's activities were
shrouded in secrecy for fear of premature publicity. His monument
to W. H. Hudson, *Rima*, 1925 (Kensington Gardens) an unexcep-
tional bas-relief panel indirectly based on the Ludovisi Throne
Birth of Venus,[1] had caused the by now familiar uproar after it
was unveiled. A similar outcry greeted the London Underground
figures in 1929, and over twenty years were to elapse before Epstein
again received a public commission. Appropriately, *Day* was
placed over the south-east doorway, and shows a naked boy
reaching up to embrace his father, a seated sun-god figure. *Night*
[plate 97B], over the north-east door, is in the form of a Pietà: the
draped and seated goddess of darkness supports a recumbent youth
on her lap, the tips of her outstretched left hand and arm resting
on his eyelids in a symbolic gesture of sleep. An ancient Mexican
splendour emanates from *Day*, acting as a foil to the heavy-lidded
Buddha-like calm of the mother in *Night*. Both groups are mas-
sively simplified and harmonize well with the architectural setting.
The siting of all the four pairs of reliefs at such a height above
street-level makes it difficult to view them properly: one of them
can hardly be seen, and another is completely invisible from the
street because of the restricted site on which the building stands.[2]

[1] The theme is taken from a passage in Hudson's *Rima* which describes her fall to
death from a treetop.

[2] Walter Bayes, 'Sense and Sensibility: The New Head Offices of the Underground
Railway, Westminster, London', *Arch. Rev.* LXVI (1929), 225–39; and 'Myras', 'The
Temple of the Winds', ibid. 240–1. Gill's reliefs are on the E. side of the N. and S.
wings (*South* and *North Winds*), and N. side of W. wing (*East Wind*); Moore's on
N. side of E. wing (*West Wind*, but incorrectly called *North Wind* in Read, *Henry
Moore, Sculpture and Drawings* (1944 and 1957), pls. 11a and b, 58); Wyon's, S. side
W. wing (*East Wind*); Aumonier's, W. side, N. wing (*South Wind*); Gerrard's, W.
side, S. wing (*North Wind*); and Rabinovitch's, S. side, E. wing (*West Wind*). Each
relief is approximately eight feet long.

The relationship of the sculptural enrichment to the building is not entirely happy, for the reliefs look a little lost against the mass of this ten-storey structure surmounted by a seventy-five-foot-high central tower. It was a brave attempt, given the circumstances at the time, but it shows up the divorce that had occurred between sculpture and an architecture in which the old traditions and scale of proportions no longer obtained, and no satisfactory new *modus vivendi* had yet been achieved. The same problem was faced, but not completely resolved, by Charles Wheeler in 1930, in his reliefs and six large-scale buttress figures for Herbert Baker's singularly unfortunate rebuilding of the Bank of England. One may add that Wheeler was at his best when applying his lyrical academicism to smaller-scale work, although his bronze group for the Jellicoe fountain, Trafalgar Square (begun in the late 1930s, unveiled 1948), with its Scandinavian air, is a delightful public monument in a period not well endowed in this respect. Turning again to the London Transport commissions, individually, Aumonier's firmly carved male figure of the *South Wind* (invisible from street-level) is one of the more successfully related to its architectural setting; Gill's three suavely-shaped figures are each set against horizontal or near horizontal folds of stylized drapery which detach them from their background without any gain in dynamic effect, and Wyon's suffers from a similar disadvantage. Gerrard's is a confused, poorly designed piece: Rabinovitch, who carved his figure in much the same pose as Gerrard's, is infinitely more successful with his architecturally stylized forms. Only Moore, in this his first public commission, fully grasped the possibilities and produced a figure which is telling in its monumental simplicity and entirely appropriate to its setting [plate 97A]. It has a weight and solidity that complement the plain mouldings and bold massings of Holden's building, and has weathered well over the years. Although he later remarked, 'Only to make relief shapes on the surface of the block is to forego the full power of expression of sculpture',[1] *West Wind* is Moore's first mature work with all the essential characteristics of his style present.

[1] H. Moore, 'The Sculptor's Aims', in *Unit One* (1934), 128. Henry Moore told the author (Dec. 1971) of a note he had made in an early Sketch Book that according

Moore was born at Castleford, Yorkshire, the son of a miner, and after war service was able to fulfil his ambition to become a sculptor when, at the age of twenty-one, he was awarded an ex-serviceman's education grant which took him to the Leeds School of Art in 1919. From there he won a Royal Exhibition scholarship in sculpture to the Royal College of Art two years later, started to frequent the British Museum, where he was particularly attracted to antique and primitive sculpture, examples of which he saw for the first time in the original, and began regular visits to Paris in 1923. After four years at the R.C.A., he went to France and Italy on a travelling scholarship for six months in 1925, having meanwhile been appointed an instructor in the Sculpture School of the R.C.A., where he taught two days a week for seven years. A further seven-year teaching appointment followed at Chelsea School of Art. It was on the strength of his first one-man exhibition at the Warren Gallery in 1928 that he received the commission to do the carved relief for the London Transport Headquarters. This brief recital of biographical detail already gives some hint of Moore's quality. In twenty years' time he was to win the coveted International Sculpture Prize at the Venice Biennale in 1948, the first British sculptor ever to do so, and thus consolidate his position as one of the leading international sculptors of our time. Although beyond the scope of this volume, it must be noted here that it was pre-eminently due to Moore's powerful inspiration that a first-rate school of younger British sculptors emerged after 1945. In this connection, Moore himself paid generous tribute to Epstein (an early admirer and purchaser of his work) a few days after he died, for it was Epstein who encouraged the young and 'took the brickbats . . . the insults . . . the howls of derision with which artists since Rembrandt have learned to become familiar. And as far as sculpture in this century is concerned, he took them first.'[1] Closely associated with this revival of

to early mythology the North and South winds were masculine and the East and West feminine. He also said that he was not at first very keen to accept the commission, as he was against sculpture being 'stuck on' to a building.

[1] *Sunday Times*, 23 Aug. 1959. The obituary tribute is reprinted in full in Philip James (ed.), *Henry Moore on Sculpture* (1966), 194–7.

sculpture in Britain was Barbara Hepworth, Yorkshire-born like
Moore, whom she met while a student at Leeds School of Art
and was also his contemporary at the Royal College of Art. After
winning a travelling scholarship, she married the sculptor John
Skeaping in Florence in 1924, and spent two years in Rome learn-
ing the technique of carving. She shared her first two exhibitions
with Skeaping at the Beaux Arts Gallery in 1928 and at Tooth's
in 1930.

One of the most significant features of this new informal group
was the importance its members attached to carving, and a great
revival of interest in this hitherto neglected aspect of sculpture
dates from the mid-1920s. Whereas the generations of Alfred
Gilbert and, later, of Thornycroft and Havard Thomas, had been
disposed to model in clay and cast in bronze, with only an occa-
sional carving, it is very rare to find bronzes among the earlier
works—that is to say those belonging to the period 1920–40
—of either Moore or Hepworth. Marble, Hopton Wood stone,
granite, alabaster, concrete, and a variety of hardwoods are their
favourite media. This revival is to some extent due to Epstein,
whom Moore justly regards as temperamentally more a modeller
than a carver, but Gill and Dobson in their different ways also did
much to restore this unregarded discipline to favour. Carving
makes greater physical demands on a sculptor, but its aesthetic
rewards are probably higher; it may also have been regarded as
a purer art form by those to whom the doctrine of 'truth to
material' then made so strong an appeal. To these same artists,
intent on exploring a wide variety of surface textures, carving in
a multiplicity of media afforded the necessary means of experi-
ment. Above all, there were the examples of ancient Mediterranean,
African, and pre-Columbian cultures in which carving took its
place as the highest form of sculpture. Barbara Hepworth described
the prevailing mood of her career before 1930 as 'the excitement of
discovering the nature of carving', and speaks of the general
antagonism to 'direct carving' that gave her and her friends 'a
sense of united purpose'.[1] 'Carving', she wrote in 1952, 'is to me
a necessary approach—one facet of the whole idea which will

[1] *Barbara Hepworth: Carvings and Drawings* (1952), vii, xvii.

remain valid for all time. It is, in fact, a biological necessity as it is concerned with aspects of living from which we cannot afford to be deprived.' Barbara Hepworth's early carvings of doves and the human torso make an interesting comparison with her life drawings of the same period. A process of abstracting the essential shapes appears in both, but the severe sculptural demands of a hard medium impose an ever greater economy of statement in three instead of two dimensions. She was inspired by much the same traditions of ancient sculpture as Moore, and her work, at least until the mid-1930s, bears a strong family likeness to that of her older contemporary, but thereafter she diverges to evolve her own, quite distinct style. For, as Herbert Read has observed, there are innate differences of temperament between the two artists.

PART FOUR

ARCHITECTURE AND DESIGN
1920–1930

IX

YEARS OF TRANSITION
ART DÉCO, DESIGN
AND INDUSTRY

ARCHITECTS had already begun to lose their sense of direction in England before the outbreak of the 1914–18 War. Even the innovators of the 1900s had for the most part lost much of their creative zest by the end of the first decade, and the initiative passed to continental architects. This is not to say that no interesting work was done between 1910 and 1930— far from it; but the enterprising architects appeared to be working in a spiritual vacuum and to lack the cohesion needed to set new professional standards and launch new ideas—in particular, to meet the challenge offered by new materials. Perhaps the malaise is nowhere better shown than in English domestic architecture of the period, and a second survey of domestic building published in the *Architectural Review* of June 1922, edited by W. G. Newton since the death of his father Ernest Newton in January of that year, is a convenient and reasonably reliable guide. In an introductory article, W. G. Newton makes the point that the common ground which frequently existed between cultivated client and architect in the eighteenth century had now gone. The architect was much more concerned with form; the layman with colour and details and was often quite unable to discuss architectural principles even if knowledgeable about, say, music or literature. Newton quotes from Henry Fielding's article on 'Taste': 'As for the bulk of mankind, they are clearly void of any degree of taste.'[1] In an age of almost universal literacy and unparalleled opportunities of higher education, such as we now enjoy in Britain, this sobering comment

[1] W. G. Newton, 'Taste in Architecture', and H. S. Goodhart-Rendel, 'Modern British House Planning. A Note on Recent Tendencies', *Arch. Rev.* LI (June 1922), 135, 151–2. The survey had been begun by Ernest Newton.

from the early eighteenth century is still relevant. Goodhart-Rendel, in his contribution to the survey, notes a trend away from the picturesque informality of Norman Shaw and Nesfield towards sterner symmetricality of plan and elevation. Symmetry of plan and classical restraint certainly characterize the houses by Ernest Newton which are illustrated in this survey, but most of them date from before 1914 and are gracious relics of a more spacious age. The majority of the houses by other architects are in the Wrenaissance or neo-Georgian idiom, with the exception of a Tudor mansion by Baillie Scott, Home Close, Sibford, near Banbury. The most imposing country house is Polesden Lacey, Dorking, by Sir Ambrose Poynter, Bt., which consists of a massive rebuilding around the centre section of the old south front. Three dignified houses by Raymond Unwin, including Boundary House, Hampstead Garden Suburb, raise the spirit a little, but a series of town houses by Ronald P. Jones in Heath Drive, Gidea Park, Romford, are a *reductio ad absurdum* of the detached Georgian town house, complete with pedimented door hoods and broken pedimented cornices. Arthur L. Horsburgh's bungalow at Yardley, Birmingham, described as a labour-saving house within the means of 'the average professional man', with its white stucco walls, heavy pantiled hipped roof and pretentious lych-gate, is the precursor of thousands more like it built during the inter-war years up and down the country mainly in outer suburbia, and still in vogue even today.

Six years later the *Architectural Review* devoted another special issue to modern house building in England, and the quickening tempo of debate and design are much more encouraging.[1] The editor had invited Le Corbusier and Michael Rosenauer to contribute articles and the difference in approach between the two architects is most revealing—as is also the somewhat conservative attitude of the editor, although he acknowledges Le Corbusier as 'a poet of the machine' who has challenged stale standards. Le

[1] 'Europe discusses the House', with contributions from Le Corbusier, 'The Town and the House' (trans. by P. Morton Shand), and Michael Rosenauer, 'The House—and the Town', *Arch. Rev.* LXIV (Dec. 1928), 221–336. Le Corbusier's original French text also is reproduced.

Corbusier, with characteristic panache, asserts that since new shapes have been made possible with new materials, the house should 'discover a new shape'. Rosenauer counters this by saying new shapes are only dictated by new needs, and since the house expresses an ancient need fully satisfied, it demands no new shape. But Rosenauer, trained in Vienna under Karl König, belonged to the conservative wing of the modernists, as his various flat-blocks and office buildings in London demonstrate, such as Arlington House, St. James's, of 1935. Both he and the editor miss the point of Le Corbusier's argument, which is that new materials liberate the architect from the limitations of traditional materials, and above all make it possible for the architect to organize the internal space of a building in a radically different manner by the use of 'piloti', or point-support reinforced concrete columns. In this way, the architect no longer has to treat the walls as traditional load-bearing elements, allowing him much greater flexibility of fenestration. The same creative, prophetic approach to the wider problems of town-planning in this article marks Le Corbusier as one of the great architectural theorists of this century. In a later contribution to the *Studio*, Le Corbusier answers his critics and questions the theory that modern architecture is the direct and automatic result of new methods of construction, as well as tilting at the *Neue Sachlichkeit* architects who exalt function to the almost total exclusion of aesthetic considerations. 'The house is a machine to live in' (*L'Esprit nouveau*, 1921); but Le Corbusier points out his qualification of this now famous catchphrase—that it must also 'satisfy both the body *and* the mind'.[1] Much that was debated in the 1920s and early 1930s now seems, in retrospect, more a question of emphasis than principle in a larger battle to rid architecture of outworn conventions and create a new style satisfying both practical and aesthetic needs. The important thing for this country was that English architects now took up the argument. The 1928 *Architectural Review* survey was arranged chronologically and by 'styles', that is by pastiches of Tudor, Jacobean, and Georgian, ending with Modern. Of the period-essays little need be said:

[1] *Studio Yearbook of Decorative Art* (1929), 3–5, letter to the editor written in response to an editorial request.

there were twenty 'Tudor/Jacobean' examples and fifty 'Georgian'; of the 'Moderns' there were nine, of which only three could really be called so, in that they reflect the use of modern building methods and materials. The most striking and indeed the earliest of them, New Ways, 508 Wellingborough Road, Northampton, was designed in 1923–4 by Peter Behrens for W. J. Bassett-Lowke, the enlightened patron of Mackintosh. The title of the house is well-chosen and symbolic. No less symbolic, perhaps, is the fact that the architect was a great German pioneer of the modern movement. While its importance as an exemplar to British architects should not be overstated, since they could travel abroad and discover for themselves the new continental trends, it does seem to have been influential and, even if Behrens may not himself have come to England to supervise its construction in 1925–6, the quality of the design is in no way inferior to other work of his expressionist phase.[1] The wheel had turned full circle since the day Hermann Muthesius came to study English domestic architecture.

New Ways represents the first fully-fledged specimen of the modern architectural idiom in this country, and its arrival here was as abrupt and surprising as its stark geometric outlines must have been to Bassett-Lowke's neighbours. It stands like a white, flat-roofed Foreign Legion fort in a prosperous provincial suburban desert. The original black-painted vertical spike ornament repeated along the moulded trim must have emphasized the battlement effect, although this feature has now gone (the present owner hopes to restore it). The brick cavity walls are cement-rendered, the windows are metal casements, originally painted black, and the door was ultramarine blue, a colour that became extremely fashionable in the 1930s. Compact in plan, the house has clean, crisp details and a taut austerity. Certain features, such as the triangular vertical steel-frame window above the front door which lights the hall and stairs, impair its stylistic purity, and were to become the clichés of the jazz-modern style of the next decade,

[1] Professor Dr. Tilmann Buddensieg of Bonn has drawn my attention to the reference contained in Behrens's article in Velhagen and Klasings, *Monatshefte*, 39, vol. II (1924–5), 103, which suggests he was designing New Ways as early as 1923–4: 'Ich baue zur Zeit ein Haus in England . . .'

notably in cinemas. New Ways was completed in 1926, the same year in which the first houses were built in a new modern garden village at Silver End, Braintree, Essex [plate 98A]. Designed by Thomas S. Tait of Sir John Burnet, Tait, & Partners (Burnet, Tait, & Lorne), Le Chateau and its companions ranged in cost from a maximum of £3,000 down to £2,000 and £1,250, and were intended for middle- to upper-income professional clients. Le Chateau in fact was built for D. F. Crittall, the steel window-frame manufacturer. These are a brave attempt at the modern style, but none approaches the poetic brilliance of Le Corbusier's houses, with their imaginative, flexible internal planning and sculptural exteriors. Behrens's spiky vertical feature appears again over the verandah of another Tait house at Silver End,[1] and in all of them the awkward treatment of the chimneys shows that certain formal problems had still to be resolved. In some, the steel casement windows wrap round the corners, and all are flat-roofed with joints carrying boards covered by asphalted canvas or roofing felt. The drainage problems of flat roofs were not always solved in these early modern houses, and the use of cement rendered brick or concrete was expensive and difficult to maintain in gleaming pristine condition—to say nothing of its questionable appropriateness for northern climates. Where concrete was used throughout, the mechanical shapes to which this material lent itself were mostly cast on site by unskilled labour, and a certain crudeness of effect was inevitable.

Amyas Connell (of Connell, Ward, & Lucas) built High and Over, Amersham, Bucks., in 1929, for Professor Bernard Ashmole [plate 98B]. This is an uncompromisingly modern house, and more advanced than Behrens's New Ways. It is, in fact, the first English house to be designed and built in the pure modern idiom developed by Gropius and Le Corbusier. The splayed wings of this three-storeyed building, crowning a hill above Amersham, and set on a Y-shaped plan, give it a sense of lightness which is heightened by the lines of the two wing-like sun-balconies springing from the central stair-well and supported on piloti. The long horizontal bands of windows enhance this effect of poised tension. There is a

[1] Illustrated in *Arch. Rev.* LXIV (Dec. 1928), 332–3.

classical severity, an angularity of outline, which is perhaps closer to contemporary German and Austrian architecture than French. Nor is it without interest that Connell had spent a year in Rome (having won the Rome Scholarship) before designing High and Over. A more playful element is the separate turret-like circular open walkway feature which incorporated a water-tower on the left of the main façade. This feature has now been demolished and the stark appearance of the house is almost completely hidden by the mature trees and shrubbery which surround it. The house is of reinforced concrete frame and slab construction, with brick infill under the windows. A point-load system has been used, with the floor slabs projecting beyond the columns, thus allowing a much greater freedom in the fenestration.[1] Connell's partner, Basil Ward, also built four houses in Station Road, Amersham, between 1929 and 1934. As we shall see, much of the most adventurous post-war modern architecture was in private houses and largely, though not exclusively, confined to the Home Counties and southern England. Nor is it entirely coincidental that this was where many of the modern light industries, such as those for radio and electrical equipment, were located, well away from the old depressed regions of the north. Apartment blocks, or flats, also provided scope for the progressive architect, but for the first of these in a recognizably modern idiom one must wait until the early years of the next decade. Probably the first authoritative account of the modern movement in architecture to appear in England was Bruno Taut's *Modern Architecture*, published by the *Studio* in 1929. Taut was himself a distinguished exponent in this field, and in his book he traces the origins of the modern style, and illustrates key examples of continental building, with special emphasis on Germany and Austria. His attitude to Le Corbusier is lukewarm, for he follows the Central European school in his insistence on the pre-eminence of construction and use as the determining factors of architectural design. Taut's 'collectivism' now

[1] I am much indebted to the late Basil Ward for technical information about this house, both the exterior and interior of which are well illustrated in *Architect and Building News* (26 June 1931), 418, 428–35 and (3 July 1931), 6–13. See also F. R. S. Yorke, 'The Modern English House', *Arch. Rev.* LXXX (Dec. 1936), 234–326.

seems a somewhat naïvely idealistic socio-political credo, although his contention that public authorities had now become the new principal patrons of architecture is true.

Modern architecture did not fully take root in this country until the 1930s, and British industrial design showed a similar pattern of development and improvement after a period of uncertainty, if not stagnation. The impetus of the Arts and Crafts Movement had been lost, and British manufacturers seemed unaware that any problem existed. It was otherwise in Germany, where strong-minded men like Muthesius had seen to it that the ideals of Ruskin, Morris, and the Arts and Crafts pioneers were translated into action with the foundation of the Deutscher Werkbund in 1907. The Deutscher Werkbund was established as a liaison body between artists, architects, producers, and distributors. Its first action group consisted of twelve artists and twelve manufacturers, and despite some initial opposition, by 1908 the Werkbund had 492 members; by 1914 the membership had grown to 1,870, and from 1930 it averaged about 3,000.[1] The Werkbund held its first exhibition at Cologne in 1914, and its impact was considerable. As early as 1906 the Kunstgewerbe-Ausstellung at Dresden had included mass-produced items of quality, but the Cologne exhibition was further affirmation of the productive marriage of 'machine culture' with artistic design. Austria, Switzerland, and Sweden had already followed Germany's lead before 1914, but Britain only belatedly took note from an exhibition of German industrial art, organized at the Goldsmiths' Hall by the Board of Trade and Arts and Crafts Society in March 1915, just how much Germany had profited from our earlier advanced thinking. By July 1915 the Design and Industry Association was in being as an 'Association of Manufacturers, Designers, Distributors, and others . . .' willing to further its aims, the key one of which was 'not merely to insist that machine work may be made beautiful by appropriate handling, but also to point out that many machine processes tend to certain qualities of their own, and that an intelligent study of these would

[1] Deutscher Werkbund, *50 Jahre Deutscher Werkbund* (Berlin, 1958), 11; contains five essays by Hans Eckstein, Theodor Heuss, H. van der Velde, Richard Riemerschmid, and H. Muthesius.

yield finer results and at the same time conduce to economy of production'.[1] The Council of the D.I.A. included a ship-owner, Sir Kenneth Anderson, cotton and fabric manufacturers, furniture designers and distributors such as John Marshall of Marshall & Snelgrove, C. H. St. John Hornby (W. H. Smith), the principals of three leading art schools, Frank Pick, and W. R. Lethaby; the architects Smith and Brewer were joint honorary secretaries, and Ambrose Heal honorary treasurer.[2] In a later publication appear two fundamental concepts: 'the first necessity of sound design is FITNESS FOR USE' and 'to attract the best brains... the name of the Designer' should be associated 'with the article produced, and this should be recognized as a commercial asset to both Manufacturer and Distributor'.[3] Fitness for use, or fitness for purpose, became a watchword of the 1930s; while the emergence of the designer in his own right was an important and overdue recognition of his professional status, for, although the Arts and Crafts Society had championed this cause as early as 1888, manufacturers had continued to resist the idea.

The foundation of the D.I.A. did not go unremarked in Germany, for, despite the war, the news soon reached the ears of Deutscher Werkbund members. The essays contained in the D.I.A.'s *A New Body with New Aims* and the *Aims, Methods and Rules* were translated and published in Munich within months of their appearance in London.[4] The obvious point was made about imitation being the sincerest form of flattery, even from an enemy, and the order of the essays rearranged so that Sir Leo Chiozza Money's 'The War and British Enterprise', in which he itemized the wide range of manufactured commodities Britain imported from Germany before August 1914, was given not last but pride of place!

[1] *Design and Industry*: 'A proposal for the Foundation of a Design and Industries Association' [1915], 3. The inaugural meeting of the D.I.A. took place at the Great Eastern Hotel, London, 19 May 1915, and the proceedings were later published.

[2] Design and Industry Association, *A New Body with New Aims* (July 1915), 41.

[3] Design and Industry Association, *Aims, Methods and Rules* (Aug. 1915), 4.

[4] *Englands Kunst-Industrie und der Deutsche Werkbund. Übersetzungen von Begründungs- und Werbeschriften der englischen Gesellschaft 'Design and Industries Association'*, 2nd edn. (Munich, 1916).

The D.I.A.'s insistence on the rightful place of machine production as a legitimate field of design within a modern industrialized society was a direct repudiation of Morris's anti-machine attitude. The D.I.A.'s growth was much slower than the Deutscher Werkbund—from 292 members in 1916 to 602 in 1928 and 819 in 1935 and its early publications were not very successful.[1] Even semi official bodies like the British Institute of Industrial Art (incorporated February 1920) had to rely on private support after an initial government grant was withdrawn because of the national economic depression, and its role was thus severely limited. Its activities lay mainly in publishing pamphlets and promoting exhibitions of industrial art and handiwork at the Victoria and Albert Museum and in provincial towns. In 1921 the Federation of British Industries' Industrial Art Committee was established, and this committee was to play an important role in the education and employment of industrial designers in the 1930s. From 1922 onwards, the D.I.A. produced a series of well-illustrated *Year-Books*, comparable to the Deutscher Werkbund's pre-war *Jahrbücher*, but a limited membership meant that only a limited attack could be made on current design evils, and a modest start was made in printing, pottery, furniture, and textiles.[2] The lukewarm reception of the British exhibits at the *Exposition internationale des arts décoratifs et industriels modernes*, Paris 1925, only increased the frustration felt by the D.I.A. members with their efforts at improvement.[3] The gap between exhortation and reality shows clearly in the *Studio Year-Book of Decorative Art* for 1925, where Frank Brangwyn reflects many of the D.I.A. ideals in his introduction, but the accompanying illustrations tell a different, sadder tale. Apart from the traditional Arts and Crafts work by Gordon Russell and Peter Waals, there is little to quicken the pulse. Even the American and continental examples chosen seem unimaginative, with the exception of the discreetly modish jazz-age productions of Atelier Primavera, Paris, and the metalwork of Louis Süe and André

[1] N. Pevsner, *An Enquiry into Industrial Art in England* (1937), 161.
[2] Noel Carrington, '21 Years of D.I.A.', in *Trend in Design of Everyday Things*, 1 (spring 1936), 39. This D.I.A. publication survived for only two issues.
[3] *Studio Year-Book of Decorative Art* (1926), 2.

Mare (Compagnie des Arts Français, Paris), which has a florid elegance and zest notably absent from much of the other contemporary work illustrated. Germany was unrepresented at the 1925 Paris Exhibition, but an interesting first-hand account by Sir Lawrence Weaver of the state of design in that country appeared in the *Year-Book of Decorative Art*, 1927. Weaver visited the Leipzig Fair in March 1926 and noted the 'vitality and modernity' of the Deutscher Werkbund craftsmen which could not be equalled by their English counterparts. But in his opinion the bulk of German manufacturers' goods failed to come up to Werkbund standards. He then went to Wertheim's department store in Berlin, looking particularly at furniture and pottery, and was greatly impressed not only by the high standard but also by the willingness of a distributing firm, run on strictly commercial lines, to regard good design as a sound proposition.[1] It took most English manufacturers and distributors rather longer to learn that simple lesson, although Weaver saw hopeful developments in the mass-production of well-designed furniture by Heal's and others. Modern designs by Serge Chermayeff for Waring & Gillow were being published as early as 1929 and 1930 [plate 99A].

The years 1929–30 form a watershed for British architecture and design. The *Year-Book of Decorative Art* for 1930 was completely redesigned in a recognizably modern style and the contents are much more exciting. A tribute to Charles Rennie Mackintosh (who had died in 1928) was published in this number and he was hailed as a prophet of the new style. The pace of change was certainly quickening, and Chermayeff makes use of tubular steel, leather, glass, and abstract-patterned carpets in his interiors for Waring & Gillow. These have an exuberance closer to French styles than the more rigorous simplicity of Marcel Breuer and Ludwig Mies van der Rohe, whose work appears in the same issue. Joseph Emberton also had furniture designs included for the Bath Cabinet Makers' Company, a go-ahead West Country firm akin to Heal's. Three buildings designed between 1928 and 1930 represent, in

[1] Sir Lawrence Weaver, 'The Year's Progress', *Studio Year-Book of Decorative Art* (1927), 3–4. Lawrence Weaver was a journalist, architectural critic, and Director-General of the British Section of the British Empire Exhibition 1923–5.

their different ways, trends in English architecture that were to burgeon in the next decade. First comes Ideal House, Great Marlborough Street, London, by the American architect Raymond Hood, in collaboration with Gordon Jeeves, of 1928, aptly described by Pevsner as 'an architectural parallel to the Wurlitzer in music' [plate 99B]. The stark black granite façade sets off an ornate gilded entrance surmounted by extravagant, highly stylized, floral motifs with succulent tendrils framing the door surround. The source of inspiration was the 1925 Paris Exhibition, and the style of which it was a climax and epitaph historians now call Art Déco, in homage.[1] The aetiology of this strange hybrid, which underwent a fashionable revival in the early 1970s, is complex, and the stylistic influences it subsumes many and various. The Russian Ballet, the art of Old and New Mexico, of Ancient Egypt and Brazil, Art Nouveau, Cubism, and even the Bauhaus have all been adumbrated as contributory factors to Art Déco or Jazz Modern. Cinemas, those people's palaces of wish-fulfilment or innocent escapism, were particularly susceptible to the wilder forms of Art Déco. As architecture they had to serve a different purpose from the traditional theatre. The new exotic glamour of Hollywood mythology, then attaining undreamt-of pinnacles of fame and fortune, demanded a style which would transcend old forms and conventions. The New Victoria Cinema, Vauxhall Bridge Road, by Trent and Lewis, 1929, while it has its share of these aids to popular luxury, is also one of the earliest essays in the continental style of horizontal bands and horizontal windows [plate 100A]. More aggressively 'modernistic' designs were to come in the 1930s, such as the New Odeon Cinema, Weston-super-Mare, by T. Cecil Howitt (c. 1935), complete with stone-coloured faience finishes to the main elevations, wide overhanging canopy, and flat-capped rectangular central tower. Neon lights pick out the main horizontal lines of the cinema at night. Jade-green woodwork and lines of green faience

[1] Musée des Arts Décoratifs, *Les Années 25: Art Déco* (exh. cat., Paris, 1966); Bevis Hillier, *Art Deco of the 20s and 30s* (1968), 10–13. Martin Battersby, *The Decorative Thirties* (1969), 10, remarks that the term Art Déco had first been used as early as 1935. He also argues that by the time of the Wall Street crash in 1929 the style had died out.

tiles along the parapets offset ground-floor shop surrounds in black glass.[1] A more austere, but no less extrovert, Odeon Cinema was designed by Mather and Weadon for Leicester Square, London, in 1937, with elevations in black faience. The foyer of the Strand Palace Hotel, completed in 1930 by Oliver P. Bernard, is another excellent glittering Art Déco survival, which, following its dismantling, is now in the Victoria and Albert Museum [plate 101A]. The jazzy interiors of several of the large pre-war 'Corner Houses' of Messrs. J. Lyons & Co., most of which have now been completely redesigned, are also notable exercises in Art Déco and were popularly regarded as the last word in modernity. One of the most opulent of these was Oliver Bernard's marble extravaganza at the Tottenham Court Road Corner House, where his early training as a theatrical scene painter bore exotic fruit.

Reverting to a purer modern style, and a convenient summation of it in this country for the period, is Frederick Etchells and Herbert A. Welch's corner office-block for W. S. Crawford Ltd., 233 High Holborn, of 1930 [plate 100B]. The clients for this building had become one of the most go-ahead firms of advertising agents in the country, under the leadership of William Crawford. The building consists of a simple façade of black marble on the ground floor, with cement-rendering above, and long unbroken bands of windows subdivided by simple step-moulded stainless-steel mullions which are carried up beyond the sixth storey to form finial-balusters for the safety rail. The main entrance, set on the left of the façade, is served by low-relief panelled stainless-steel double doors which, with clear sans-serif modern numerals above, provide the finishing touches to this distinguished example of the new urban architecture. Etchells also has a niche in history for his English translations of Le Corbusier's *Towards a New Architecture* in 1927, and *The City of Tomorrow* in 1929.

[1] *Arch. Rev.* LXXXVIII (July 1935), 23–4.

PART FIVE

THE MODERN MOVEMENT
IN ENGLAND

X

PAINTING AND SCULPTURE
1930—1940

THE decade 1931–40 was to be one of the most decisive in the history of English Art since the turn of the century, and the time when the foundations were laid for the international achievements of our artists, sculptors, architects, and designers after the Second World War. Doubts and uncertainties were resolved and a new self-confidence was born. Political and racial persecution in Germany and Russia brought many gifted refugees to these shores, not for the first time in our history, some to stay for a year or so, others to settle permanently. The enrichment of the nation's artistic and cultural life, no less than in the various fields of learning and scholarship, was incalculable but tangible. English artists were once again aware of the mainstream of European ideas and willing to explore them and contribute to their development. In Germany, Dada, and in France and Belgium, Surrealism, had made their impact on painting and literature; while in architecture and design, the Dutch-inspired De Stijl movement, Le Corbusier in France, and Gropius and his Bauhaus colleagues in Germany were evolving completely new forms based on the application of first principles to the exciting possibilities opened up by radically new methods of construction and planning techniques. Yet by 1933 these bright hopes for the future had to be seen against a darker backcloth of impending international crisis and war. Italy had already succumbed to a totalitarian regime, Germany was soon to be set on an aggressive *Lebensraumpolitik*, and Spain was a cockpit of civil strife and international intrigue. Artists and writers could not remain untouched by these political events, whichever side of the English Channel they happened to be. Scientific 'progress' was also challenged,

notably by Aldous Huxley in *Brave New World* (1932) where a frightening vision of bio-medical social engineering is conjured up as a warning against the perversion of science in the service of a ruthless state system. George Orwell's *Homage to Catalonia* (1938) conveys a message of profound political disillusionment born of harsh experience. It was a sobering challenge to H. G. Wells's earlier optimistic belief in human progress. In lighter, but no less deadly, vein Evelyn Waugh exercised a court jester's privilege by brilliantly parodying English society and its lunatic fringes in his novels of the period. The seamier side of society, the persisting evils of unemployment and widespread poverty had been vividly caught by Orwell in *Keep the Aspidistra Flying* (1936) and *The Road to Wigan Pier* (1937), and, most widely known of all at that time, by Walter Greenwood in *Love on the Dole* (1933). The polarities of European politics were also reflected in Britain, where the challenge of Sir Oswald Mosley's British Union of Fascists was met four years later by Victor Gollancz's Left Book Club, founded in 1936. As the decade wore on, the nation's hopes for peace and stability were ill served by a policy of appeasement and economic ineptitude, and were finally dashed by the declaration of war against Germany on 3 September 1939.[1]

There were polarities in the arts. For many, the Royal Academy of Arts represented the last bastion of sanity in painting and sculpture. The committees of many municipal galleries still made a solemn annual pilgrimage to the Summer Exhibition with the laudable intention of supporting living art, but an art on which the seal of official respectability had been safely laid. A further opportunity for provincial patronage was provided by the annual touring of large selections from the Summer Exhibitions to the art societies of Birmingham, Liverpool, and Manchester. Many of our most interesting artists refused to send in to the Royal Academy, preferring to support either the London Group or the more radical 7 & 5 Society. The Academy had long since lost its virtual monopoly of prime exhibition space in London, and in addition to the independent societies there was a growing number of

[1] Alice Prochaska, *London in the Thirties*, London Museum exhibition catalogue (1973), provides a useful essay on the period.

commercial dealers willing to show younger artists' work. But it would be most misleading to present too optimistic a picture of the exhibition opportunities open to painters and sculptors between the wars. In a depressed economy, practitioners of the arts are usually among the first of the professionals to suffer from cutbacks in public and private expenditure.[1] There was no continuing state support for the living arts, no Arts Council of Great Britain to encourage and help finance artists and galleries. The British Council, founded in 1934, was intended to promote knowledge and study of our history and culture abroad—an activity which by some eminent politicians and men of affairs was regarded as in itself un-British, if not superfluous.[2] Apart from its work in sending out exhibitions to the Venice Biennale, a function its Fine Art Committee inherited from the Department of Overseas Trade, its help to living artists could only be limited, without a complementary organization at home to foster them until they were ready to step into the international arena. The British Council had begun to initiate touring exhibitions of the work of living artists, and by 1939, through the private generosity of Lord Wakefield, was able to begin to acquire examples of contemporary British graphic art for inclusion in its circulating exhibitions. This modest enterprise was to be greatly enlarged in scope with public funds after the Second World War.

In addition to its free schools of art, the Royal Academy did perform one other great service to artists, students, art historians, and the general public. For many years the Academy had organized annual winter exhibitions of Old Master paintings, the first of which had been held in 1870; but, during the late 1920s and early 1930s, a splendid series of Academy exhibitions devoted to the art of a particular country or civilization greatly enriched our

[1] Francis Watson, *Art Lies Bleeding* (1939), ch. 7, 'Blind Mouths', 136–53, examines the economics of modern art dealing. The annual pilgrimage to the R.A. died hard, for even in the 1950s a few art gallery committees still made it the highlight of their year's art purchasing.

[2] *The British Council 1934–1955: Twenty-first Anniversary Report* (1955), sets the scene, especially the essay by Sir Harold Nicolson, 4–30. The first grant-in-aid was £6,000 in 1935, which by 1939 had increased to £386,000. The British Council received a Royal Charter in October 1940.

knowledge and enjoyment in a way only equalled by the Art Treasures Exhibition at Manchester of 1857. Organized by committees which included the President and some of his colleagues, and the leading international experts of the day, the first exhibition (1920–1) was devoted to Spanish Art, followed after a six-year gap by *Flemish and Belgian Art*, A.D. *1300–1900* (1927); then came in quick succession *Dutch Art*, A.D. *1450–1900* (1929), *Italian Art*, A.D. *1200–1900* (1930), Persian Art ('from the earliest times to the present', 1931), *French Art*, A.D. *1200–1900* (1932), *British Art*, A.D. *1000–1860* (1934), rounded off by Chinese Art in the winter of 1935–6, and a survey of British Architecture in 1937. The organizers of the British Art exhibition, which encompassed sculpture and the decorative arts, included nothing after 1860, yet the joint international committees for the Belgian, Dutch, Italian, and French exhibitions all closed theirs at 1900, although admittedly they each chose a later starting-point. Professor W. G. Constable, in his Introduction to the Illustrated Souvenir of the British Art Exhibition, reveals a pre-Victorian Society attitude to the period in that he regarded the 'slough of commercialism' which engulfed architecture and the crafts as completely disastrous and divisive, turning artists away from society into 'the enclosed garden of their own imagination'.[1] The analysis is correct, but this situation was not peculiar to England, though the baneful side-effects of the Industrial Revolution were undoubtedly more widespread and felt sooner and more acutely in this country. In retrospect, it seems an astonishing reflection of the lack of confidence in and, possibly, lack of sympathy with the art of the last forty years of the nineteenth century in England that in a major survey of this kind the terms of reference were framed in such a way as to exclude everything from this period. No later work by Rossetti and Burne-Jones, no Arts and Crafts work, no Art Nouveau, nothing by the social realists of the 1870s; Whistler, Sickert, Steer, and the New English Art Club were automatically ruled out. While it cannot be gainsaid that the French contribution, in particular, to nineteenth- and early twentieth-century art was formidable, the

[1] W. G. Constable, *British Art: an Illustrated Souvenir of the Exhibition of British Art at the Royal Academy of Arts*, London (1934), xiv.

under valuing of our own artists' positive achievements seems now at best misguided if not harmful.

Polarization may often bring with it tension, and in the creative arts tension can be a healthy stimulus, an essential ingredient. The English *avant-garde* of the 1930s certainly benefited from the radical differences of approach and method which separated the constructivist wing, led by Ben Nicholson, and the Surrealists grouped around Paul Nash. As we shall see, however, the arrival in London of a number of distinguished refugee artists and architects transformed the scene and purged us of any lingering traces of provincialism. Nor did this foreign invasion go unchallenged, and a group of young English painters, led by William Coldstream, formed themselves into the Euston Road Group as a neo-realist antidote to what they considered to be the extravagancies of the Surrealists, in particular. But this is to anticipate.

An exhibition, *Recent Developments in British Painting*, held at Arthur Tooth & Sons in October 1931, provided an interesting survey of work by artists outside the mainstream of contemporary British art, yet, as Paul Nash later observed, 'however diverse in their ways and means, the majority . . . were somehow allied in purpose'.[1] This prompted him to explore the possibility of some concerted action. It says much for the respect in which Nash was held by his contemporaries that he could win allegiance from so disparate a group as that which made up Unit One, whose birth was announced in Nash's long letter to *The Times* published on 12 June 1933. While Nash felt the need for a common front against an indifferent public, this did not imply rigid uniformity: 'the peculiar distinction of Unit One is that it is not composed of, let us say, three individuals and eight imitators, but of 11 individuals. And yet there is still a quality of mind, of spirit perhaps, which unites the work of these artists . . . Unit One may be said to stand for the expression of a truly contemporary spirit, for that thing which is recognised as peculiarly *of today* in painting, sculpture and architecture.' Nash also declared 'that English art has always

[1] Paul Nash, 'Unit One', *Listener*, 5 July 1933. The artists in the Tooth exhibition were Edward Burra, Nash, J. W. Power, Wadsworth, Nicholson, John Bigge, John Armstrong, and John Aldridge; drawings by Moore and Burra were also included.

suffered from one crippling weakness—the lack of structural purpose' and an 'immunity from the responsibility of design'.[1] The pitfalls were perhaps more clearly defined than the road to artistic salvation, but a strong eleven was in the field: the painters Nash, John Armstrong, John Bigge, Edward Burra, Tristram Hillier, Nicholson, and Wadsworth; the sculptors Hepworth and Moore; and the architects Wells Coates and Colin Lucas. Herbert Read was their spokesman and edited *Unit One: The Modern Movement in English Architecture, Painting and Sculpture*, published in April 1934 and intended as the first of an annual series, which contained essays by members of the group, reproductions of their work, and photographs of each artist's hands and studios. Read explained that the name was chosen because 'though as persons, each artist is a *unit*, in the social structure they must, to the extent of their common interests, be *one*'.[2] The first and, as it turned out, only exhibition of the group as such was held in the same month at its new headquarters, the Mayor Gallery, founded twelve months earlier by Freddy Mayor, one of the most progressive art dealers of the day.[3] The secretary for the exhibition was Mayor's wealthy partner, Douglas Cooper, who had already begun to collect Cubist paintings by Braque and Picasso. The exhibition subsequently toured six municipal galleries, including Liverpool, Manchester, Swansea, and Belfast. Press coverage was fairly extensive, if not entirely favourable, and one of the group's main aims, publicity, was certainly achieved. But within less than two years Unit One had fallen

[1] 'Unit One: A New Group of Artists', *The Times* (letter dated 2 June, published 12 June 1933), 10. Frances Hodgkins was listed in Nash's published letter, but later resigned and Tristram Hillier took her place.

[2] Herbert Read, *Unit One* (1934), 12.

[3] The Mayor Gallery's first exhibition at its new premises in Cork Street was held in April 1933: *Exhibition of Recent Paintings by English, French and German Artists*. The Unit One painters and sculptors were given an airing in a European context six months later (Oct. 1933) in the *Art Now* exhibition, linked with the publication of Herbert Read's book of that title. Arp, Francis Bacon, Baumeister, Braque, Dali, Ernst, Alberto Giacometti, Kandinsky, Klee, Léger, Miró, Picasso, and Soutine were just some of the illustrious names in what must have been a most stimulating exhibition. See also *Unit One* (based on the 1934 exhibition held at the Mayor Gallery), Portsmouth Festival Exhibition, Portsmouth City Museum and Art Gallery (May–July 1978).

apart, and Nash's now chronic ill health prevented him from exerting himself as a peacemaker. Geographical, if not ideological proximity, provided some coherence for the nucleus of artists and architects living just off Haverstock Hill, Hampstead, some of whom had been members of Unit One. A row of studios, The Mall, housed Nicholson and Barbara Hepworth, Moore, Herbert Read, and John Cecil Stephenson in 1933; Nash came to Eldon Grove, on the other side of the Hill, early in 1936. Walter Gropius had already arrived in England (in 1934), and had taken one of the flats in Lawn Road recently built by Wells Coates; Marcel Breuer arrived towards the end of 1934, Laszlo Moholy-Nagy and Naum Gabo came in 1935, to be followed in 1938 by Piet Mondrian, who settled in near-by Parkhill Road.[1] Other artists, writers, and collectors connected with the modern movement who lived in this area at the time were H. S. Ede, Margaret Gardiner, Geoffrey Grigson, Roland Penrose, Adrian Stokes, and John Summerson (who in 1938 married Barbara Hepworth's sister, Elizabeth).

Nash's painting had already begun to take a new direction in the late 1920s. Contact with continental Surrealism led him to explore in a more intellectual fashion the mechanics of dream imagery, and Herbert Read noted that he radiated 'a more polemical spirit than most of us' at this period.[2] It was this side of his character, as reflected in his painting, that led C. Day Lewis (who had not known the painter personally) to distinguish between the hallucinatory and the visionary when describing his work of the 1930s many years later with the knowledge of the more poetic, intuitive paintings Nash created in the last years of his life. Certainly Nash wrote appreciative articles on de Chirico and Magritte for the *Listener* in 1931, and had visited an important Surrealist exhibition in Paris the year before.[3] The *objet trouvé*, so dear to the Surrealists, was

[1] *Art in Britain 1930–40 centred around Axis, Circle, Unit One*, Marlborough Fine Art Ltd., London (1965), for essays by Sir Herbert Read and documentation by Jasia Reichardt, especially the map of Hampstead showing where artists and writers were living in the 1930s.

[2] Herbert Read, 'A Nest of Gentle Artists', *Apollo*, LXXXVI (Sept. 1962), 537.

[3] Margot Eates, *Paul Nash 1889–1946: The Master of the Image* (1973), with an appreciation by C. Day Lewis, xii, 47. For a discussion of mysticism in relation to Nash's art see pp. 51–3. Andrew Causey, *Paul Nash* (1980), 148–9, calls attention to the importance for Nash of the de Chirico exhibition at Tooth's in 1928.

also to fascinate Nash, and indeed Magritte was later to call him 'Master of the Object'. Nash's comments on Max Ernst show the nature of his own interests—'the disconcerting association of birds and flowers, suns and forests—suns which look like targets, forests which more resemble seas'.[1] The poetic and the metaphysical speculations of an earlier age were imaginatively reinterpreted by Nash in his thirty illustrations to Sir Thomas Browne's *Urne Buriall* and *The Garden of Cyrus* which were published by Cassells as a single *de luxe* volume in 1932. The lattice motif is developed further in *The Soul Visiting the Mansions of the Dead* for the *Urne Buriall*, suggesting empyreans independent of time and space where the immortals dwell. The successful marriage of symbol and image; the development of a pictorial language to convey a deeper meaning rooted in poetic experience, were now to pre-occupy the artist even more intensely. This book is also important as one of the most beautiful English publications of the century. Another, complementary line of exploration began in 1930, when Nash took up photography.[2] He quickly saw it not simply as means of documenting landscapes, coastlines, rocks, and man-made objects, but as an art form in its own right. Found objects, such as driftwood sculpted by the sea, take on a special significance as unique natural phenomena, beautiful in colour, shape, and texture. Nash's photographs not only capture these qualities of the objects but are themselves aesthetically satisfying. Not a few of his paintings from now on germinate from images captured by photography. Another crucial experience of the period was the discovery by Nash in July 1933 of the megaliths at Avebury. Just as the Wittenham Clumps had earlier cast their spell on him, so the primeval mystery of the Avebury stones and ramparts fired his imagination. *Landscape of the Megaliths*, 1934 (British Council) was among the first paintings directly inspired by them and, incidentally, was sent by Nash to the *International Surrealist Exhibition* two years

[1] 'Art and the English Press', *Week-end Review* (17 June 1933), quoted by Bertram, op. cit. 234.

[2] James Laver and Margaret Nash (ed.), *Fertile Image* (1951), and Andrew Causey, *Paul Nash's Photographs: Document and Image* (1973): two most useful illustrated compilations with historical notes. Nash's wife presented him with a camera in September 1931.

later [plate 102A]. This approach to landscape, of seizing upon some curious feature of it and, by so doing, drawing attention to some hitherto unrevealed mysteriousness within, was greatly to influence and encourage the young Graham Sutherland. As Nash himself wrote: 'Last summer I walked in a field near Avebury where two rough monoliths stand up, sixteen feet high, miraculously patterned with black and orange lichen, remnants of an avenue of stones which led to the Great Circle. A mile away, a green pyramid casts a gigantic shadow. In the hedge, at hand, the white trumpet of a convolvulus turns from its spiral stem, following the sun. In my art I would solve such an equation.'[1]

Herbert Read, himself a distinguished poet and writer, reflecting on this decade nearly thirty years afterwards, observed that an element of the fantastic or the surreal could be found recurring in British art and literature at least from Elizabethan times onwards. For this reason, he argued, the Surrealist movement found no permanent following in this country since its exponents added little that was essentially new to the native literary and artistic traditions.[2] It could also be argued that Surrealism, primarily a literary movement, had to battle against the English distaste for nihilistic extremism and a strong counter-current of rational constructivist art. Nevertheless, the *International Surrealist Exhibition* held at the New Burlington Galleries in June 1936 brought to this country the leading European practitioners of the movement in a full-blooded retrospective exhibition, the scale of which—nearly 400 works—was only to be surpassed by the Fantastic Art, Dada, and Surrealism exhibition organized by the Museum of Modern Art, New York, the following December. The London exhibition included André Breton, who opened the exhibition, and Paul Éluard, Georges Hugnet, Man Ray, E. L. T. Mesens, and Dali, who also attended as members of the international committee; Read, Roland Penrose, Nash, and Moore were the leading spirits of

[1] *Unit One* (1934), 81. Sutherland had admired Nash's illustrations to *Urne Buriall*, which he described as 'a poetic and imaginative achievement without equal today in this country' (*Signature*, No. 3, July 1936, 7–13).

[2] Read, 'British Art 1930–1940', in *Art in Britain . . . Unit One* (1965), 6. Read and his colleagues were far less violent and politically active than their continental Surrealist colleagues.

the British organizing committee. British interest in Surrealism owed much to the missionary zeal of Penrose, Read, and another poet-critic, David Gascoygne, whose book, *What is Surrealism?*, had been published the previous year. Early work by de Chirico, Marcel Duchamp, Picabia, and Man Ray represented Pittura Metafisica and Dada; then came Masson, Miró, and Tanguy, Dali, Ernst, and Magritte, to show different aspects of Surrealism, the imaginative and the 'veristic'; and there were fifteen works by Paul Klee.[1] The British contribution had not the same doctrinaire coherence and could not show a consistent application of Surrealist principles over the past decade or so. The techniques of automatism, the images of the unconscious, the illogical play of associations, the juxtaposition of incongruous objects, the magical, and the whole armoury of Freudian psychology as exploited by continental writers and artists—all these were paraded before the English public. There were 'happenings' and Dali, with his usual flair for publicity, stole the show, but nearly asphyxiated himself while declaiming a lecture on 'Paranoia' inside a diving suit.[2] The paintings by Nash and Burra were closest in spirit to Ernst and Magritte. Nash also contributed, in addition to four oils, two collages, three photographs, and two 'Designed Objects', a wooden *Found Object Interpreted*, which although presented in the manner of traditional sculpture left its natural origins undisguised. The 'objects' by Penrose, including *Captain Cook's Last Voyage*, a striped plaster torso of a Cnidian Aphrodite caged within a wire globe, though eminently Surrealist, were more amusing than disquietingly sinister [plate 103A]. Other objects shown were masks from

[1] Werner Haftmann, *Painting in the Twentieth Century*, I (1960), 290-1, gives a detailed analysis of the exhibition. Also on the British committee were Hugh Sykes Davies, David Gascoygne, Humphrey Jennings, McKnight Kauffer, Rupert and Diana Brinton Lee.

[2] A programme of five lectures was organized around the Surrealist Exhibition, with contributions from Breton, Read, Éluard, Hugh Sykes Davies, and Dali, who was billed as speaking 'on one of the following subjects: "Paranoia" "The Pre-Raphaelites" "Harpo Marx" "Phantoms"'. Dali chose the first topic, and the title of his lecture was later reported as 'Fantômes paranoïaques authentiques' (*International Surrealist Bulletin*, No. 4 (Sept. 1936), 2). At the Galerie des Beaux-Arts, Paris, a third International Surrealist Exhibition opened in January 1938, to which a number of British artists contributed (Ian Dunlop, *The Shock of the New* (1972), 203-4, 216).

Oceania and Africa, and photographs of fetishes and masks from the Ethnographic Collection of the British Museum. There was also a section devoted to children's art. Sutherland, invited by Penrose with the unanimous approval of his colleagues, sent two works which bore little relationship to Surrealism, but belonged much more to the Romantic tradition of English landscape painting. Moore, although predisposed towards Surrealism, could see common ground between the rival factions: 'The violent quarrel between the abstractionists and the surrealists seems to me quite unnecessary. All good art has contained both abstract and surrealist elements, just as it has contained both classical and romantic elements—order and surprise, intellect and imagination, conscious and unconscious. Both sides of the artist's personality must play their part.'[1] Breton contributed a preface to the catalogue in which he paid tribute to Freud. This was followed by an introduction by Read, who stressed the importance of 'the untrammelled imagination', which had become despised and 'romanticism a term of contempt'. He claimed that 'Superrealism in general, then, is the romantic principle of art' (Superrealism, with its Hegelian overtones, was a term then preferred by Read), a theme he developed in Surrealism, published in 1937, reiterating his belief in the value of spiritual experience unfettered by the tyranny of academic or idealist principles.[2] To the heirs of the visionary art of William Blake, of Coleridge and Rossetti, the superficially shocking aspects of Surrealism soon lost their impact, and the cult of the irrational was accepted as a continuation of a much older tradition.

Surrealism retained a following in this country, with headquarters at the London Gallery in Cork Street, where the Belgian artist and poet, E. L. T. Mesens, directed activities. An important illustrated documentary source for the period is the London Bulletin, twenty issues of which appeared between 1938 and 1940 under the editorship of Mesens, assisted by Penrose and Humphrey

[1] Henry Moore, 'The Sculptor Speaks', Listener, XVIII (18 Aug. 1937), 338–40, reprinted in Philip James (ed.), Henry Moore on Sculpture (1966), 67.

[2] In a letter to The Times Literary Supplement (11 Jan. 1936) Read also argued the etymological merits of Superrealism as a more accurate English equivalent of surréalisme.

Jennings. Mesens organized exhibitions by leading contemporary European and American Surrealists, and in January 1939 of *Living Art in England*. This consisted of work by thirty-five men and women, including resident foreigners in this country like Oskar Kokoschka and Mondrian, who were active protagonists of the modern movement. The British Surrealist Group, founded in 1936, included some artists, like Ceri Richards, who had not shown in the *International Surrealist Exhibition*, but whose work was fully in accord with the movement. Richards's *Two Females*, 1937–8 (Tate Gallery), a painted wooden relief construction with brass ornaments, is last but one of a series of twelve begun in 1934 and inspired by Picasso's wood-reliefs of 1917 [plate 103B]. They are remarkably self-assured and witty variations on the theme of feminine sexuality, winning admiration from both Arp and Mondrian.[1] The sculptor F. E. McWilliam exhibited with the Surrealist Group in 1938 and contributed *Profile*, 1939–40 (Tate Gallery) to the exhibition *Surrealism Today* held at the Zwemmer Gallery in June 1940 [plate 103C]. This was part of *The Complete Fragment*, an impressive series of carvings 'of part or parts of the human head, greatly magnified and complete in themselves'.[2] These carvings at first disconcert, then stimulate us to explore the interplay of void and solid in a most satisfying way. There are links with Arp, Picasso, Miró, and Tanguy in the use made by both Richards and McWilliam of ambiguous biomorphic shapes. Moore also worked in this idiom in the 1930s, but, true to his belief in the comprehensiveness of all great art, he explored a wide range of formal ideas at this time, now more abstract, now closer to Surrealism. Speaking in 1973 of an early surrealist piece, *Composition*, Blue Hornton stone, 1931 (artist's collection), he stressed its sculptural qualities as a combination of forms each realized as a nearly self-sufficient entity; yet the human 'presence', however much disguised, remains.[3] *Square Form*, 1936 (Sir Robert and Lady Sainsbury Col-

[1] David Thompson, *Ceri Richards* (1963), n.p.

[2] Artist's statement in *Tate Gallery Modern British Catalogue*, II (1964), 422. *Eye, Nose and Cheek*, 1939, in Hopton Wood stone, has also been acquired by the Tate Gallery (T. 871).

[3] 'Henry Moore at Home', recorded televised interview B.B.C. 2 (broadcast 8 Jan. 1974).

lection, University of East Anglia), with its reference back to ancient Mexican carving, subsumes the abstract bas-relief of the constructivists and the biomorphic in an entirely personal statement [plate 107A]. This creative oscillation can be most clearly followed in Moore's treatment of the reclining full-length female nude, a theme to which he has constantly returned, as have many great masters of the past. The figure is never passive. The sculptor always chooses a dynamic twisting pose which allows him to exploit the formal problems of mass and power thus provided. Such is his sense of scale that even small maquettes have a weight and plasticity which often belie their actual size. The series starts with the chunky Toltec-Mayan-inspired *Reclining Figure* of 1929 [Leeds Art Gallery; plate 104A]; moves through a surrealist abstract *Four-piece Composition: Reclining Figure*, 1934 (ex-Martha Jackson, New York), where the macabre bone-like elements and scooped-out sphere suggest some strange fossilized remains; then back again to the Green Hornton stone *Recumbent Figure* of 1938 (Tate Gallery), a majestic earth mother, primeval Rhea [plate 104B]. Here is classical serenity, manifestly of our time yet imbued with the weathered timelessness of a natural phenomenon. The air of timelessness is heightened by the far-seeing gaze of the figure, an effect deliberately sought by Moore when he sited this piece on the open terrace of Chermayeff's Sussex country house which overlooked the Downs.

Nash continued his exploration of dream imagery, in good Surrealist fashion, in such paintings as *Landscape from a Dream*, 1936–8 [Tate Gallery; plate 102B] and *Nocturnal Landscape*, 1938 (Manchester Art Gallery), where the irrational is presented with hallucinatory clarity. But Nash's ability to distil startling imagery from, say, gnarled fallen tree trunks, as in *Monster Field*, 1939 (Durban Art Gallery), is part of the romantic tradition linking him with James Ward and, in our own day, Graham Sutherland, whose *Blasted Tree* studies of 1937–8 lead on to *Green Tree Form: Interior of Woods*, 1940 [Tate Gallery; plate 105A]. Sutherland also found inspiration in the early work of a nineteenth-century precursor, Samuel Palmer, as his etchings of 1925–6 show. By 1930 a more personal style had emerged, in which the pastoral themes become

vehicles for a highly subjective response to nature. The rich, intense colour, so characteristic of much of his work, was a legacy from late Turner, whose colour he much admired, and the swirling composition echoes Blake's Dante illustrations which had also greatly moved him. Francis Bacon, largely self-taught, began painting in about 1928 in a Cubist style akin to Juan Gris and Lurçat. He also designed rugs and furniture, including those for his own studio, which in 1930 had a Bauhaus-like austerity.[1] He then painted in the early 1930s semi-surrealist figure pieces, most of which he destroyed. His concern with man's predicament, beset by the irrational and the horrific, is the general theme of his paintings, which 'are just an attempt to make a certain type of feeling visual . . . Painting is the pattern of one's own nervous system being projected on the canvas'.[2] He is keenly aware that real life can be bleak and terrifying. Though his major achievements belong to the period after 1940, when he became an artist of international stature, his artistic roots were put down in the 1930s.

In his very influential book, *Art Now: An Introduction to the Theory of Modern Painting and Sculpture* (1933), Herbert Read devoted a chapter to 'Subjective Realism', later retitled 'Expressionism'. Here, as in other chapters devoted to Abstraction and Surrealism, he guides his reader lucidly through the historical and theoretical background of the movement—but Expressionism was the hardest to assimilate in England. Not only was the French influence still too strongly felt—and Fry's antipathy has already been discussed—but Expressionism was by its nature distinctly 'un-English'. Of the older generation, only the Irish painter, Jack Butler Yeats, and David Bomberg, who had moved away from his remarkable abstract Vorticist style, worked with a thickly impasted brush-stroke and rich colour. Yeats worked mainly in Ireland, painting subjects inspired by Irish life and Celtic mythology. Although his style was originally formed by a study of French Impressionism, he developed a more personal and highly expressionist idiom in the 1930s. Only now is the true stature of these two

[1] 'The 1930 Look in British Decoration', *Studio*, C (Aug. 1930), 140-1. A painting, *Francis Bacon's Studio*, 1932, by Roy de Maistre, shows several paintings of this transitional period. [2] Reported interview in *Time*, LIV (21 Nov. 1949), 28.

painters realized, and only in 1947 did Bomberg attract a following of younger artists known as the Borough Group, when he taught at the Borough Polytechnic. His comparative isolation, artistically speaking, in the 1930s was ended by the arrival in Britain of Oskar Kokoschka in 1938, and of two Polish-born artists, Jankel Adler and Josef Herman. Kokoschka settled in London, but Adler and Herman first introduced their interpretations of Central European Expressionism to the Glasgow independent painters, before moving south. There had been a curtain-raiser when in July 1938 the *Exhibition of Twentieth Century German Art* was shown at the New Burlington Galleries. Some sixty or more of the finest German Impressionist, Cubist, and Expressionist painters and sculptors were represented in a remarkably comprehensive exhibition of 269 works, and the first book in English on the subject, *Modern German Art*, was published as a Pelican Special. For political reasons, its German author, Oto Bihalji-Marin, hid his identity under the pseudonym 'Peter Thoene', and likewise a special note appeared in the exhibition catalogue introduction to explain that no artist still living in Germany had been asked to participate in the exhibition: works had come from private collections outside Germany and were included without the artists' knowledge or consent. The Nazi campaign against *Kulturbolschewismus*, a generic term which included everything that in the opinion of the *Reichskulturkammer* officials led by Goebbels was subversive or non-Aryan, had terrible consequences for art in Germany. A major masterpiece directly inspired by a political event of this period was Picasso's *Guernica*, which, with sixty-seven preparatory studies and drawings, was shown under the auspices of the National Joint Committee for Spanish Relief first at the New Burlington Galleries in October 1938, and then at Whitechapel, where it was seen by a total of some 15,000 Londoners.[1] It then went to Oxford and Leeds, and thence to New York. The terrors of war as experienced by the Spanish villagers of Guernica in 1937 is the theme of this monumental work, which comprehends and transcends surrealism,

[1] R[oland] P[enrose], 'Notes', *London Bulletin*, 8–9 (Jan.–Feb. 1939), 59. Only 3,000 visitors were recorded at the month-long showing in the West End, and 12,000 in the fortnight at the Whitechapel Art Gallery. Penrose recalled that it was also shown at Liverpool (*The Times*, 10 Sept. 1981, 10).

abstraction, and expressionism, to convey a simple yet profound message of universal significance.

The abstract-constructivist wing of British art centred around Ben Nicholson and the 7 & 5 Society underwent further radical change at his instigation in the 1930s. By 1932 Moore and Hepworth had become members, and in May 1934 the rules were revised to make the Society a forum for non-representational work only: 'the exhibition is to be non-representational the hanging committee are only empowered to select non-representational work the exact definition of "non-representational" is left to the discretion of the hanging committee'.[1] This draft, in Nicholson's handwriting, was sent to the Hon. Secretary, John Piper, and later incorporated in the rules, with a rider '. . . but as a general guiding principle a work will be excluded if it possesses any element dictated *only* by natural appearances'. Frances Hodgkins resigned immediately, followed later by John Aldridge, Edward Bawden, P. H. Jowett, and Len Lye. The tenth exhibition of the 7 & 5, held at the Leicester Galleries in January 1931, contained a memorial group of works by Christopher Wood, who had died in tragic circumstances four months earlier at the age of twenty-nine. Greatly gifted, he had won easy entry to the glamorous world of Alphonse Kahn, Diaghilev, Jean Cocteau, and Picasso, whom he idolized. A few years younger than Nicholson, he held his first exhibition with him at the Beaux Arts Gallery in 1927, to the catalogue of which Cocteau contributed a preface. Like Nicholson, he was very widely travelled, but had become increasingly attached to Brittany and St. Ives, where much of his best work was done during the last three years of his career. His mature style is instantly recognizable but defies exact analysis. His compositions

[1] The original draft belongs to John Piper, but copies of this, the Minutes, and catalogues are in the Tate Gallery archives. The 14th (and last) 7 & 5 exhibition, held at the Zwemmer Gallery in October 1935, included one work from each of the ten members: Francis Butterfield, Winifred Dacre (Nicholson), Hepworth, Hitchens, Arthur Jackson (i.e. A. J. Hepworth), David Jones, Moore, Staite Murray, Nicholson, and Piper. The Zwemmer Gallery was more adventurous and prepared to accept the radical aims and work of the reformed 7 & 5. For a note on other artists who experimented with abstraction in the late 1920s see C. M. Kauffmann, 'Abstract Water-colours of the 1930's', *Burl. Mag.* cxx (May 1978), 293-4.

have a classical balance and simple grandeur, yet joined to these qualities is a lyrical intensity of vision and colour which may spring from his Cornish ancestry. The mingling of the magical and the sinister appears in *The Yellow Man*, 1930 [Brinsley Ford; plate 105B], while in *Boat in Harbour, Brittany*, 1929 (Tate Gallery) a more innocent world is revealed to us, like that created by Alfred Wallis, whose 'primitive' style had made so powerful a first impression on Wood and Nicholson in 1928. By his early death, British painting was robbed of a brilliant star at a crucial moment, but Wood's cosmopolitanism was shared by other of his compatriots. About 1932–4 Nicholson and his second wife, Barbara Hepworth, made several long stays in Paris, and visited the studios of Picasso, Braque, Arp, Brancusi, Mondrian, and other leading artists. Perhaps the most influential encounter was with Mondrian in 1934, and the visit left a deep and lasting impression which Nicholson could still vividly recall ten years later.[1] He did not at first fully understand Mondrian's paintings, but undoubtedly the older artist's work and conversation encouraged him to pursue his own experiments with abstract art. Both he and Barbara Hepworth had accepted Herbin's and Hélion's invitation to join the Association Abstraction-Création in Paris and were members from 1933 to 1935. Just as *Unit One* had been conceived as an annual forum for the *avant-garde*, so *Axis*, the first number of which appeared in January 1935, was intended as 'a quarterly review of contemporary abstract painting and sculpture'. The editor, Myfanwy Evans, had been encouraged by Hélion in 1934 to start an art review in England, and she was assisted by John Piper (who later married her). *Axis* ran for eight numbers and at first sought to define the meaning and purpose of abstraction, setting British art within an international context by illustrating the work of Picasso, Mondrian, Kandinsky, Gonzalez, Arp, Miró, Giacometti, and Calder; with Moore, Hepworth, Nicholson, Nash, and constructions by Piper and Richards. Nash's statement, entitled 'For but not with', succinctly defined his position. *Axis* also sponsored the first 'exhibition of abstract painting, sculpture and construction' organized by Nicolete Gray (Mrs. Basil Gray) as *Abstract and*

[1] Letter of 3 Jan. 1944, quoted by John Summerson, *Ben Nicholson* (1948), 12–13.

Concrete at Oxford in February 1936, which was then taken to the Lefevre Gallery, London, and subsequently toured to Liverpool and Cambridge. It seems to have been somewhat overshadowed by the *International Surrealist Exhibition* later in the year. But the bastion of abstract art had slowly begun to crumble: the quarterly intervals of *Axis* became almost half-yearly and the editor adopted a more pragmatic approach to contemporary art, including surrealism. The last issue appeared in the winter of 1937, by which time entirely new interests had been introduced. Nevertheless, *Axis* had performed during its short life a most valuable service for British art. The same shift in emphasis is also apparent in *The Painter's Object* (1937), an anthology of European abstract art edited by Myfanwy Evans, to which Nash and Sutherland were key British contributors.

Work had also begun in 1935 on another publication, *Circle*, which was published in 1937. Originally intended as an annual, its sub-title, *International Survey of Constructive Art*, proclaims the allegiances of its editors, J. L. Martin, the architect, Nicholson, and the Russian constructivist sculptor, Gabo. They sought to be cosmopolitan and comprehensive by including contributions from those painters, sculptors, architects, and writers who they felt were united by a progressive outlook however diverse their individual specialisms might be. Gabo's editorial, 'The Constructive Idea in Art', set the tone: 'Art and Science are two different streams which rise from the same creative source and flow into the same ocean of the common culture . . . The force of Science lies in its authoritative reason. The force of Art lies in its immediate influence on human psychology and in its active contagiousness.'[1] Thus J. D. Bernal wrote on art, the scientist Karel Honzíg on biotechnics, and Lewis Mumford on old and new concepts of the city; Gropius wrote on art education and the state, Leonide Massine on choreography, Jan Tschichold on typography, and Siegfried Giedion on engineering and aesthetics. There were also essays by Mondrian, Le Corbusier, Breuer, and Richard Neutra; by Read, J. M. Richards, Maxwell Fry, Hepworth, Moore, and Nicholson. *Circle*, for the layout and production of which Hep-

[1] *Circle* (1937, reprinted 1971), 8, 9.

worth took much of the responsibility, is an impressive compila-
tion by any standard. In the context of British art of the 1930s, it
not only provided the key to much that was most vital and exciting
on the international front, but showed, too, there were English-
men able to make a significant contribution to the modern move-
ment in art and architecture.

The transition from Cubism to constructivist principles in
Nicholson's work can be neatly exemplified by two paintings: the
Au chat botté of 1932 [Manchester City Art Gallery; plate 106A]
and the magisterial, uncompromising *White Relief* of 1935 [Tate
Gallery; plate 107B]. The artist has this to say about the first,
a shop-window in Dieppe, and the construction of pictorial space:
'the words [Au chat botté, Dieppe] themselves had also an abstract
quality—but what was important was that this name was printed
in very lovely red lettering on the glass window—*giving one plane*
—and in this window were reflections of what was behind me as
I looked in—*giving a second plane*—while through the window
objects on a table were performing a kind of ballet and forming the
"eye" or life-point of the painting—*giving a third plane*. These three
planes and all their subsidiary planes were interchangeable . . .'[1]
This interaction of planes moving towards and away from the
picture surface was explored by the Cubists, but none had at-
tempted quite so complicated a variation on this theme as Nicholson
in his *Au chat botté*. The variety of surface textures and subtle tonal
gradations in this picture are refinements of stylistic developments
foreshadowed in the late 1920s. Nicholson created his first abstract
relief in December 1933, and the first of his geometrical 'white
reliefs' in 1934. Purged of any representational elements though
they are, these reliefs also invited the spectator to explore planar
relationships in a rigorous geometrical format such as Mondrian
had used in his paintings—but there are differences, for in these
reliefs light strikes the edges of the shallow surfaces and the sensa-
tion of space thus created is subconsciously apprehended. The artist
warns us not to approach abstract art in a purely intellectual way

[1] Ben Nicholson, 'Notes on Abstract Art', *Horizon*, IV (Oct. 1941), 272–6 (a revised
version appears in Read, *Ben Nicholson, Paintings, Reliefs, Drawings* (1948), 23–7); see
also *Ben Nicholson*, Tate Gallery exh. catalogue (1969), 22–5.

'—a square and a circle are nothing in themselves and are alive only in the instinctive and inspirational use an artist can make of them in expressing a poetic idea . . . You can create a most exciting tension between these forces . . . [i.e. the interplay of geometrical forms].'[1] Important, too, was the craftsmanly skill with which he had constructed these reliefs. Nicholson's paintings had also become uncompromisingly geometrical by 1935 and *Painting*, 1937 (Tate Gallery) relies on the precise balance struck between rectangular areas of colour ranging from stark black, yellow, and red to cool greys and ice blue [plate 106B]. John Cecil Stephenson should also be mentioned for his constructivist paintings of this period. John Piper, influenced more by Hélion than Mondrian, also produced between 1934 and 1938 an extremely distinguished range of abstract constructions and paintings, before turning overtly towards the architectural and topographical, in which he had kept an antiquarian interest even during his radical phase. Interest in Victorian architecture had been stimulated by the publication some years earlier of Kenneth Clark's pioneer book, *The Gothic Revival* (1929). Ivon Hitchens, in more lyrical mood than either Nicholson or Piper, was prepared to push his painting towards a non-figurative idiom, akin, in some respects, to Hans Hartung, and *Coronation*, 1937 (Tate Gallery) is a glorious paean of vibrant colour comparable to Matisse's later *gouaches découpées* [plate 108B].

Although Moore and Hepworth were both associated with *Circle*, Hepworth had begun to chart her own course from the early 1930s, and her meeting with Ben Nicholson in 1931 was a decisive moment in her life. Shared aims were undoubtedly a great encouragement, and each beneficially influenced the work of the other; Nicholson's coloured reliefs and Hepworth's sculpture with colour are tangible proof of this interaction. Certainly Hepworth, greatly impressed by Brancusi's innovations, moved towards abstraction sooner and more decisively than Moore, and in 1931 had carved an abstracted torso completely pierced by an arbitrary hole below the breasts to produce an abstract form and space.[2] By 1935 the process was complete, and the three ovoid or

[1] Quoted in *Tate Gallery Modern British School Catalogue*, II (1964), 486.
[2] Ronald Alley, *Barbara Hepworth*, Tate Gallery exh. catalogue (1968), 8–9, 11.

spherical white marble shapes in *Three Forms* [Tate Gallery; plate 108A] have a purity of form, texture, and balanced tension analogous to the qualities in Nicholson's *White Relief*. The interplay of basic forms in juxtaposition becomes the dominant theme of her work and, just as a musician develops a theme by using increasingly complex harmonics, so Hepworth builds up variations in her sculpture. Ovoids are sliced through and hollowed out, creating concave forms against convex, or pierced, so that light is let in from behind. The linear profile of her cut forms thus assumes new formal significance of great beauty and purity. In 1939 she made the first of her hollowed-out carvings incorporating strings threaded across the concavity, which had been painted blue. Broadly one may say that, if in Moore's work the forms are preponderantly biomorphic, Hepworth's tend to become a finely balanced counterpoint between organic and geometric rhythms. 'In the contemplation of Nature we are perpetually renewed, our sense of mystery and our imagination is kept alive, and rightly understood, it gives us the power to project into a plastic medium some universal or abstract vision of beauty.'[1]

The abstract movement also produced an interesting, if short-lived, group which exhibited paintings at the Zwemmer Gallery in March and April 1934 under the generic title, *Objective Abstractions*. The nucleus of the objective abstractionists was formed around Rodrigo Moynihan, Geoffrey Tibble, and Graham Bell; for the others who exhibited—Hitchens, Pasmore, and Richards—were by no means abstract painters at that time. Tibble was the first of the group to paint non-representational works in the autumn of 1933, followed briefly by Bell and by Moynihan, who, with Tibble, continued to paint in this style until the winter of 1936–7, when they reverted to realism.[2] Such evidence as survives suggests that the artists were working in a form of Abstract Expressionism long before that term became current, as distinct from the linear or geometrical abstract painting of the time.

Politics, in the ordinary sense of the word, and the polarities

[1] Barbara Hepworth, statement in *Unit One* (1934), 20.

[2] An account of the episode appears in the entry for Moynihan's *Objective Abstraction*, 1935–6 (T. 172), *Tate Gallery Modern British School Catalogue*, II (1964), 462–3.

we have already mentioned at the beginning of this chapter, did not find expression through any British art organizations of the time, with one important exception. This was the Artists' International Association, founded in the September of that crisis year, 1933, at the instigation of Clifford Rowe the painter. Rowe had been inspired by a vast international painting exhibition in Moscow to which he had contributed in 1932–3. Among the founder members were Misha Black, the designer, and the social realist illustrators James Boswell, James Fitton, and James Holland, all of whom regularly contributed satirical cartoons to the *Left Review* in a style owing much to Georg Grosz.[1] For the A.I.A. started off as a distinctively left-wing organization, and its first major exhibition, *Artists against Fascism and War* (1935), had an explicit political purpose, as did the lectures and discussions it organized.[2] The A.I.A. published its own Bulletin and arranged for artists to 'cover' Trafalgar Square rallies with banners bearing suitable anti-war and anti-Fascist slogans. Funds were raised in aid of the Republicans in the Spanish Civil War, and an Artists' Refugee Committee was formed. As the membership grew, adherence to labour party politics became subsumed in a much more general commitment to 'Unity of Artists for Peace, Democracy and Cultural Development', the slogan under which the two massive exhibitions of April 1937 and February 1939 were held. Support for these came from most of the leading artists of the English Surrealist and Constructivist groups, as well as others, such as the Euston Road School members, Kenneth and Mary Martin, Eric Gill, and Fred Uhlman, whose artistic allegiances lay elsewhere.

If the neo-romanticism of Piper and Sutherland was in some measure a reaction against abstraction and 'modernism', it was also

[1] *A.I.A. 25: An Exhibition to celebrate the Twenty-fifth Anniversary of the Foundation in 1933 of the Artists International Association*, R.B.A. Galleries (Mar.–Apr. 1958), n.p., historical notes by Andrew Forge.

[2] One such debate organized by the A.I.A. was devoted to Surrealism and its political position (Conway Hall, 23 June 1936). Herbert Read spoke of the Surrealists' role as Marxist-socialist revolutionaries in art and society, but he also attacked 'the vulgar ineptitude of so-called Socialist realism'. Left-wing critics, especially those writing in the Communist *Daily Worker*, were predictably anti-Surrealist (see *International Surrealist Bulletin*, No. 4 (Sept. 1936), 7–13).

symptomatic of a latent isolationism which was to become an enforced condition with the outbreak of war in 1939. Even Nicholson and Hepworth, by moving 300 miles from London to settle in St. Ives, succumbed to the Cornish landscape, which ingratiated itself into their work and softened their hitherto rigorous adherence to abstraction.[1] There were other artists who consciously turned to realism, and preached the virtues of tonal painting from nature. Corot, early Degas, and Cézanne, with Sickert as the living link with this tradition, were their mentors. In 1937 Victor Pasmore and Claude Rogers opened a teaching studio in Fitzroy Street, which later that year blossomed into 'A New School . . . of Drawing and Painting' under the direction of William Coldstream, Rogers, and Pasmore as the three co-founders, but 'associated with Vanessa Bell, Augustus John, R.A., Duncan Grant, John Nash'.[1] It subsequently became known as the Euston Road School, on changing its physical location, and the title was soon to acquire a wider generic significance as descriptive of a group of painters with common aims. After studying at the Slade School from 1926 to 1929, Coldstream had exhibited at the London Group from 1929, but lack of money forced him to give up painting full-time and for three years, 1934–7, he worked with John Grierson on documentary films for the G.P.O. Film Unit. One of the most notable of these films was *Night Mail* (1936), to the soundtrack of which the poet W. H. Auden contributed a letter-poem composed in a metre that suggested the rhythmic beat of train wheels.[3] This contact with the workaday world and the disciplines

[1] Nicholson has defended this development by saying, '. . . the kind of painting which I find exciting is not necessarily representational or non-representational, but it is both musical and architectural, where the architectural construction is used to express a "musical" relationship between form, tone, and colour and whether this visual "musical" relationship is slightly more or less abstract is for me beside the point' (1948, quoted in *Ben Nicholson*, exh. catalogue Tate Gallery 1955). The analogy with music takes us back to Whistler.

[2] The School had its headquarters first at 12 Fitzroy Street, then at 316 Euston Road. Copies of the Prospectus are at the V. & A. Library and Tate Gallery, with amended addresses typed in.

[3] Roger Manvell, *Film* (1950), 101–2. Auden and his fellow poets, Louis MacNeice, Stephen Spender, and C. Day Lewis, were all left-wing and pro-Republican Spain at this time. J. B. Priestley also contributed scripts; Benjamin Britten, Walter Leigh,

of a different visual medium helped Coldstream to achieve artistic maturity and resolve any lingering uncertainties about his own role as a painter. He discovered that photography, far from having 'forced painting into a position of permanent preciousness', over-lapped the province of painting 'only to a very small extent'.[1] The conflict between abstraction and realism had to be resolved: 'After 1930 I worked only from nature, but always in the direction of abstractions. That is to say I did not alter or invent shapes, but selected very consciously from the objects I was painting, used a rather formalised colour and tone scheme and usually left out the features, if I was painting a head. Putting in any facial expression was absolutely taboo as being vulgar particularisation.' The *Studio Interior* 1932–3 [Tate Gallery; plate 109A] epitomizes this approach. The slump, which had adversely affected Coldstream and many other artists, also made him aware of social problems: '. . . I became convinced that art ought to be directed to a wider public; whereas all ideas which I had learned to regard as *artistically* revolutionary ran in the opposite direction. It seemed to me important that the broken communications between the artist and the public should be built up again and this . . . implied a movement towards realism.'[2] This was to run counter to the canons of modern art by which realism was judged to be 'artistically reactionary'. Just as Sickert and the Camden Town painters had chosen the everyday life and surroundings of working-class London, so did Coldstream and his colleagues. Coldstream also painted townscapes of the industrial north and St. Pancras Station. Graham Bell, whose published art criticism reflects a consistent socialist attitude to the arts, captures this world in *The Café*, 1937–8 [Manchester City Art Gallery; plate 109B]—although the dramatis

and Maurice Joubert wrote musical scores for the films. The initiative for creating a documentary film unit belongs to Sir Stephen Tallents, Secretary of the Empire Marketing Board, who gave Grierson his chance with the film *Drifters*, made in 1929 to promote the herring industry then in decline. The E.M.B. Film Unit was dissolved in 1933 and its staff followed Tallents to the G.P.O., becoming the G.P.O. Film Unit and eventually Crown Film Unit.

[1] William Coldstream, 'Painting', in R. S. Lambert (ed.), *Art in England* (1938), 102–3 (first published in *Listener* (15 Sept. 1937), 570–2).
[2] Coldstream, op. cit. 101–2.

personae in this picture consist of the Café Conte's proprietor's daughter, Tibble, Pasmore, Rogers, Igor Anrep, and Coldstream. Pasmore and Rogers practised a low-toned, more sensuous Post-Impressionism than Coldstream, owing something also to Bonnard; Pasmore's obsession with construction took a radically different form from Coldstream's, and by the 1950s he had, in fact, turned completely away from representational painting, declaring easel painting to be dead. The Euston Road School prospectus contained this statement: 'In teaching, particular emphasis will be laid on training the observation, since this is the faculty most open to training. No attempt, however, will be made to impose a style and students will be left with the maximum freedom of expression.' Thus the School's aims were twofold: to encourage a return to sound academic training in the painting of objective reality, under the guidance of teachers who were themselves practising artists; and to end the isolation of the artist from his public. Despite the eloquence of Herbert Read preaching the merits of revolutionary art, or the terrifying imagery of *Guernica*, neither abstraction nor surrealism seemed capable in the eyes of the Euston Road School of bridging this gulf. Not perhaps for the first time, *avant-garde* art was neither understood by nor was acceptable to the majority of socialist or conservative followers—indeed their attitudes to art might often afford a rare occasion for unanimity as to its means if not its subject-matter. Away from these metropolitan polemics, the Manchester-born painter L. S. Lowry had pursued since the 1920s, first in Salford then in Pendlebury, his own highly idiosyncratic form of urban and industrial reportage. At the age of fifty-one, he held his first London exhibition at the Lefevre Gallery in February 1939, but only after 1945 did his work receive wide recognition.

The Royal Academy Summer Exhibitions were more broadly popular in appeal. The Secretary to the Academy, Walter Lamb, brother of the painter Henry Lamb, wrote in 1937 that the Academy 'is mainly concerned with the unsophisticated visitor [to the Summer Exhibition] who hopes to apprehend readily what he sees and to cultivate a personal taste in contemporary work; and he, and . . . the advanced amateur, rely on the members, as the

approved technicians of some maturity and breadth of view, to provide . . . a fair conspectus of the year's achievement'.[1] Innovation and invigoration of the arts are allowed, even from 'primitive impulses and alien influences', provided the results are 'without the crudities of mere novelty or exercise'. The breadth of view might be questioned, and certainly did not extend to include Epstein when, in 1935, his British Medical Association sculptures in the Strand were threatened with destruction. The then President of the Royal Academy, Sir William Llewellyn, refused to sign in his personal capacity, with some distinguished contemporaries, a letter of protest to *The Times*, apparently fearing to commit his Academician colleagues by doing so without previous consultation. Sickert, elected a full Academician only the previous year, promptly resigned. Stanley Spencer also resigned his Associateship in 1935, after the rejection of two of his paintings, *The Lovers* and *St. Francis and the Birds*, and did not rejoin the ranks until 1950. In April 1938 Wyndham Lewis's *Portrait of T. S. Eliot* [Durban Art Gallery; plate 110A] was rejected by the Hanging Committee, and Augustus John, an Academician since 1928, resigned for two years in protest. Lewis, in four pungent published letters on the subject, made some telling points against the Academy, and took Winston Churchill to task for his defence of an institution which had become ultra-conservative.[2] None of the artists involved could then still be considered revolutionary in comparison with, say, Nicholson and his friends. Some idea of what was considered generally acceptable at the time may be gathered from the choice for 'Picture of the Year' at successive Royal Academy Summer Exhibitions. A few examples will suffice: in 1930 Mark Symons's elaborate *Were you there when they crucified my Lord?*; James Gunn's brilliant portrait of *Frederick Delius* [City Art Gallery,

[1] W. R. M. Lamb, 'What the Royal Academy Stands For', in R. S. Lambert (ed.), *Art in England* (1938), 53.

[2] W. K. Rose (ed.), *The Letters of Wyndham Lewis* (1963), 251–7. Sidney C. Hutchison, *The History of the Royal Academy 1768–1968* (1968), 176–8, publishes details of correspondence from Spencer, Sickert, and John to W. R. M. Lamb at the time of their resignations. It is only right to record that under the Presidency of the late Sir Thomas Monnington the Royal Academy adopted a much more liberal attitude to contemporary art in the early 1970s.

Bradford; plate 110B] in 1933; and in 1936 two works, George Belcher's *I dreamt that I dwelt in marble halls* (Lady Lever Art Gallery) and L. Campbell Taylor's *The Harpist*; while in 1939 Charles Spencelayh's topical *Why War?* was voted 'top of the pops'. Attendance at the Summer Exhibitions averaged around 130,000 annually, and this does not compare unfavourably with the major Winter Exhibitions, which attracted, for example, 350,000 (French Art), 300,000 (Persian Art) and 400,000 for the Chinese exhibition. But the record number of 600,000 for the Italian exhibition of 1930 has yet to be surpassed.[1] Looking through the *Royal Academy Illustrated* volumes for the period is now a strange experience, for here are paraded each year a selection of some 170 paintings, drawings, and sculpture (out of a possible average of about 1,500 exhibits) which presumably were regarded by the publishers as the most lustrous from each exhibition. It is rather like seeing a very familiar Shakespeare historical play performed in modern dress. The state and boardroom portraits, heads of colleges and bank chairmen, the informal equestrian group, the hunting and racing scenes, the occasional examples of other genres—almost all appear to be reworkings of earlier pictorial formulas, particularly those of the eighteenth century. The impression is very depressing and certainly less than fair to the Royal Academy, since such adventurous work as was admitted rarely, if ever, received the accolade of inclusion in the *Royal Academy Illustrated*. Yet it comes as no surprise to learn that top hats and tailcoats were required dress for Private View Days, a practice which died only in 1940.[2]

[1] Hutchinson, op. cit. 172–3. All the 'Pictures of the Year' were featured in *Royal Academy Illustrated*.
[2] Hutchinson, op. cit. 181.

XI

ARCHITECTURE AND DESIGN
1930-1940

WHEN F. R. S. Yorke published his *The Modern House* in 1934, he had some difficulty in finding enough examples of modern British houses to fill the fourteen pages allocated to this country. Two years later he was able to report a considerable improvement, with the promise of still more to come, and, since the previous survey of domestic architecture published by the *Architectural Review* in 1928, the situation had been transformed almost beyond recognition.[1] His optimism was not misplaced, and a study of the architectural press for the decade shows that there were British architects both willing and able to work in an internationally valid twentieth-century style. The *Architectural Review*, which under H. de C. Hastings's direction now became a consistent and powerful supporter of the modern movement, provides an invaluable record of the period. Welcome though these portents were for the future development of British architecture, a note of caution must be sounded. First, the economic depression of 1929-32 hit architects severely and work was difficult to come by. When commissions were obtained, stringent cost limits were enforced. Second, a very large proportion of the modern buildings were private houses and apartment blocks, and, apart from a few commercial and industrial buildings of note in the new idiom, most corporate and civic patronage still favoured traditional styles. Towards the end of the 1930s, a number of hospitals and schools had also been built in contemporary style, setting a pattern of development which was to be continued in the post-1945 era. Third, although these new buildings were generally excellent examples of their kind, none was of outstanding originality or significance in a wider European or American context.

[1] F. R. S. Yorke, 'The Modern English House', *Arch. Rev.* LXXX (Dec. 1936), 237.

The rising generation of British architects had to find a new sense of purpose, and re-establish here a vigorous, radical architecture relevant to the needs and opportunities of their day. Like their artist colleagues, they were greatly encouraged in this task by the arrival in England of several major European architects during the mid-1930s. But the modern movement in British architecture did not win full public acceptance and international acclaim until the 1951 Festival of Britain buildings on the South Bank, London, triumphantly showed what could be achieved in genuinely mid-twentieth-century terms.

The historian, in selecting what seems to him to be the key progressive buildings to support his argument, must at least remind his readers of the post-Industrial Revolution context in which these artefacts are set, if he is to avoid the charge of distorting history. Some of the consequences of urban sprawl, of uncoordinated industrial and residential development have already been referred to in the discussion of the Garden City idea. The evil of 'ribbon development' blighted acres of farmland and blurred the demarcations between town and country, and even between neighbouring towns, as miles of our arterial roads became lined with ugly semi-detached houses during successive speculative building booms of the 1920s and later 1930s. The huge conurbations spawned in the nineteenth century stretched out their tentacles still further in this period, and even in post-1945 Britain, the insidious process of 'infilling' has compounded the earlier evils. The Western Avenue bypass out of London is a notorious example of industrial ribbon development, with factories in a hideous diversity of debased historicist styles, some of which are now in their turn, such is the perversity of history, almost regarded as architectural monuments. It is against this depressing general background of environmental chaos that we must view the creation of a nobler ideal.

On the theoretical level, it has been suggested that Lethaby's genuine concern to see contemporary architecture evolve from a 'fulfilment of function shaped by the social and psychological influences' of the society it served, as in all the great artistic periods of the past, was in part frustrated by his own inability to practise

what he preached. Also implicit in his teaching was the denial of an explicit visual imagery or arbitrarily imposed aesthetic: '—ye olde modernist style—we must have a style to copy—what funny stuff this art is!'; and '. . . this "modernism" is regarded as a style, whereas being truly modern would be simply right and reasonable' (1929).[1] Geoffrey Scott, in his *Architecture of Humanism* (1914), had crossed swords with Lethaby for attacking Renaissance architecture and, as he thought, by inference, the principles of classical architecture. Taste and style were again asserted by Scott as the architect's prerogatives at a time when the design and construction process was becoming increasingly complex and subject to specialist expertise in mechanics, law, and economics—threatening, in fact, the architect's newly-won status and independence. The superiority of pure classicism, of a generally accepted set of guiding principles, prepared the way, so it is argued, for the international modern style as it emerged from Germany and France. The architect's role as town-planner concerned with the social implications of building rather than simply being the creator or interpreter of 'style' has already been touched upon, and this was at the heart of Lethaby's teaching. Questions of style should be left to the architectural historian: architects should concentrate on building for their own generation. Again, the opportunities for large-scale town-planning in this country did not arise until after 1945.

Two commercial buildings in Fleet Street, almost neighbours and built within three years of each other, neatly contrast revivalist with assertive modern architectural styles. The Daily Telegraph building by Elcock and Sutcliffe, with Thomas Tait, of 1928, a pretentious mixture of neo-Graeco-Egyptian detail and modernistic fluting, is quite outshone, in more senses than one, by its rival, the Daily Express building of 1931. The architects for the Daily Express were Herbert O. Ellis & Clarke, in collaboration with E. Owen Williams, whose chemical factory for the Boots Pure Drug Company at Beeston in Nottinghamshire, built in two sections between 1930 and 1938, also broke new ground in

[1] Quoted by R. Macleod, *Style and Society* (1971), 67, 135. Macleod's observations on the roles of Lethaby and Scott in the 1920s carry conviction.

British architecture [plate 111A]. The Express Building is of concrete construction with black polished glass curtain walls, the panels of which are set in Birmabright (chromium) strips; an innovation in the City, and permissible only because, under the current Buildings Act, the Express office was classed as a warehouse.[1] This legal idiosyncracy also highlights once again the sort of difficulties architects could encounter with planning authorities, many of which were either prejudiced against or ignorant of modern construction and design. Williams's spectacular external elevation is complemented by Robert Atkinson's brash entrance-hall, which, with its opulent metal handrails, glass and stainless-steel furniture upholstered in emerald green leather (designed by Betty Joel), jagged-edged fluted ceiling, travertine marble walls, and blue and black wavy rubber-strip floor, strikes an authentic note of hideous newspaper baronial splendour [plate 101B]. The concrete frame on mushroom pillars (a system pioneered by Robert Maillart) and glass curtain wall technique was used by Williams in his Boots Factory 'packed goods wet' building, which came first, for here, as in the Express Building, maximum flexibility in the use of floor space and loading was most important. The clean lines of this three-storey building matched the best of continental examples, yet sadly, apart from Dunston Power Station, County Durham, by Merz and McLellan (1933), appears to have been the only important industrial building in this style before 1940.[2]

Owen Williams, who received a knighthood for his work as consultant to the British Empire Exhibition, Wembley, of 1924, was one of that comparatively rare breed of civil engineers who also played an important role as architects. He was at his best when called upon to design structures in which a basically engineering problem had to be solved, and the building in its finished state clearly expresses that solution. The Empire Pool, Wembley (1934), then described as the 'world's largest covered bath', was just such a building, where the huge reinforced concrete supports have both

[1] Serge Chermayeff, 'The New Building for the Daily Express', *Arch. Rev.* LXXII (July 1932), 3–12.

[2] Paul Thompson in Kidson, Murray, and Thompson, *A History of English Architecture* (1965), 314.

a structural and aesthetic function. The three-storey glass-and-concrete-frame Pioneer Health Centre, St. Mary's Road, Peckham (1934–5) was another.[1] This is built around a central swimming pool on the first floor, which is surrounded by cafés, kindergartens, and gymnasium, only separated from them by glass walls. On the top floor are consulting-rooms. A distinctive feature is the central elevation with its six convex bays punctuated at either end by pavilions. These bays give to the whole façade a gentle undulating rhythm, and the hint of nautical flavour is emphasized by the metal-railed balconies. The modern style lent itself particularly well to seaside architecture, it may be noted. The Health Centre was also important as a socio-medical experiment by Dr. G. Scott Williamson and Dr. H. Innes Pearse, providing a community centre for regular medical care, leisure, and physical recreation. Williams's uncompromising yet pleasing solutions in these two buildings were not repeated in his post-war work, which is characterized by an almost obsessive neo-baroque non-functional massiveness. Unlike his great French rival and contemporary, Eugène Freysinnet, Williams had a deep-rooted suspicion of the structural merits of pre-stressed concrete and for many years refused to use this lighter method of construction in preference to reinforced concrete.[2] Curtain-walling, so suited to factory and office buildings, and later to become a standardized constructional method, was also effectively adapted to modern department stores. The first of these in London was Peter Jones's, Sloane Square, designed in 1935–6 by William Crabtree of Slater and Moberly, advised by Professor Sir Charles H. Reilly, and completed in 1939 [plate 111B].[3] Delicate mullions link five of the seven

[1] 'The World's Largest Covered Bath', *Arch. Rev.* LXXVI (Sept. 1934), 92–6; 'The Pioneer Health Centre', *Arch. Rev.* LXXVII (Apr. 1935), 203–6. The Empire Pool was built very quickly; drawings were begun in October 1933 and constructional work was completed by the end of May 1934.

[2] I am indebted to Sir Charles Husband, who had worked as an Assistant Resident Engineer to Sir Owen Williams on the first part of the Boots Factory buildings 1931–3, for this and other information.

[3] *The Times*, 10 Dec. 1945, 5, letter signed by Reilly and Crabtree in which they state that they were responsible for the design. Sir Charles Reilly was head of the Liverpool School of Architecture which, under his direction, had become one of the most advanced schools in the world at this time. J. Alan Slater and Arthur Hamilton

storeys, and on the fifth floor is a recessed balcony under a heavy cornice. A double curve on the Kings Road elevation provides that necessary extra emphasis to the splayed corner off Sloane Square by accentuating its bulbousness. A year earlier (1935), Joseph Emberton had designed Simpson's, Piccadilly, in a refreshingly modern idiom, making the façade elegantly proportioned and using the firm's name as an integral part of the format; Emberton followed the same principle in his showroom for His Master's Voice, Oxford Street (1938–9), where the combination of glass bricks and polished black granite slabs for the façade must have seemed rather startling at the time. Wells Coates's façades for Cresta silks shops, especially that in Brompton Road, Kensington, of 1929, also deserve mention for their combination of bold simplicity and intelligent use of modern typography to produce an instantly recognizable house-style for each of this firm's branches in Bournemouth, London, Brighton, and elsewhere. Coates, who originally trained as a mechanical engineer, also designed the tubular steel furniture for these shops.[1]

Of all the buildings of the early 1930s which, by reason of function, should have reflected a truly contemporary approach to architecture, one might have expected the headquarters of radio broadcasting to rise to the challenge of modernity. In the event, Broadcasting House, designed by Lieut.-Col. George Val. Myer in 1931, is an unfortunate stone intrusion into Portland Place completely out of scale with Nash's All Souls', Langham Place near by, and quite undistinguished externally except for Eric Gill's bas-reliefs and his splendid free-standing group of *Prospero and Ariel*. A contemporary account refers to its battleship-like elevation: this was presumably intended as praise. Internally, it is a different story. The studio interiors by Raymond McGrath, Wells Coates, and Serge Chermayeff, although now much altered, were among the best of their kind, and capture something of the excitement of an entirely new medium with its own specialized

Moberly had designed Bourne & Hollingsworth's new store, Oxford Street (1924), in simple monumental style with classical overtones.

[1] *Arch. Rev.* LXIX (Feb. 1931), 43–6; LXX (Dec. 1931), 174–5, pl. V; and LXXIII (June 1933), 261.

requirements.[1] Smooth, geometric forms, the minimum of mould-
ings, and expanses of fine-grade laminated surfaces give a clean
modern feel to, for example, the Dramatic Control Room No. 1
by Wells Coates [plate 113B], McGrath's Vaudeville Studio
Waiting Room and Dance Band Studio, and Chermayeff's
Orchestral Studio 8A [plate 112B]. They have an authentic 1930s
'functional' appearance, which is akin to the Purist aesthetic, and
distinct from, say, the Express Building interiors with their regres-
sive expressionist-jazz overtones. Val. Myer's Entrance Hall and
Council Chamber are more pompous, though the Concert Hall
auditorium has a certain chunky drama. Myer's repetition of heavy
rectangular forms is characteristic of a certain type of dogmatic
stripped-down neo-classical modernism favoured by the slightly
more adventurous-minded civic authorities. In 1930 Frank Pick
and Charles Holden were planning the extensions to the Picca-
dilly Line of the London Underground out to Cockfosters, and
during the summer they went on a tour of Sweden, Denmark,
Holland, and north Germany to see recent architectural develop-
ments in those countries.[2] Holden had already begun to standar-
dize Underground station design in 1925-6 when the Morden
extension was built, but now, perhaps a little influenced by the
work of W. M. Dudok, he began to design simple, functional
brick stations with reinforced concrete supports, which are models
of clarity and harmonize with their semi-rural settings. The first
station in the new manner was Sudbury Town (replacing an
earlier station) of 1931, followed by Arnos Grove [1932; Plate
113A], the central feature of which is the circular booking-hall,
and which is now an acknowledged classic of the 1930s. The
detailing here was by Charles Hutton, working within Holden's
general format and subject to his final approval. Other assistants
worked on the many more stations which followed during the
decade, all of them variants of a well-tried formula, a few less suc-
cessful than the majority. One of Holden's greatest qualities as an

 [1] 'Broadcasting House', *Arch. Rev.* LXXII (Aug. 1932), 47–78, contains good
illustrations (including some colour plates) and assessments of the building.
 [2] N. Pevsner, 'Patient Progress: the life work of Frank Pick', *Arch. Rev.* XCII
(Aug. 1942), 31–48.

architect was his ability to plan the internal disposition of space in any given building so as to provide the most practical solution to a client's requirements. It was this sound practicality, coupled with the reputation he had already achieved for an interesting new approach to architecture earlier in this century, which recommended him to the University of London authorities, for whom he began planning the new Bloomsbury complex in 1931. The clients had asked for monumental buildings of a high quality that would last for five centuries as well as provide the over-all grand design to which any later additions would need to conform. The decision to use Portland stone as facing material undoubtedly inhibited a more adventurous solution.[1] Holden worked out his own modular format in response to the clients' specification of wing blocks not more than thirty feet deep to allow maximum amount of daylight. What had been acceptable for the London Transport headquarters in 1926, now became somewhat arid when expanded in scale. The stony-faced Senate House and University Library tower, completed in 1937, glower over us, and the scale of fenestration in the tower seems oddly uncomfortable, although the internal planning and detailing is always excellent. One has no reservations about Holden's beneficent influence along London's train and bus routes, where it was all pervasive, for he designed bus shelters, kiosks, route and bus stop posts, ticket machines, clocks, and platform seats, as well as Bus Stations and Booking Halls, of which that for Piccadilly Station is an outstanding example of harmonious design. In 1938-9, Pick and Holden commissioned upholstery designs from such leading designers as Marion Dorn. The electric trains were also completely redesigned and standardized to meet the special needs of a fast, heavily-used urban transit system. Externally, the carriages and traction units were combined into one articulated link and their streamlining harmonized with the circular or oval section of the tunnels through which they passed. The same severely practical considerations of patterns of use determined the internal layout of the seats, both in relation to

[1] I am grateful to Mr. Charles Hutton and the present partners of Adams, Holden, & Pearson, Mr. William Guttridge and Mr. Charles Tarling, for discussing the work of Charles Holden with me, but the views expressed here are mine alone.

the sets of remotely-controlled sliding doors, and the proportion of space devoted to passenger standing-room.

Blocks of flats, like hotels, are by their nature large-scale buildings and pose a special problem. Norman Shaw solved, or perhaps ignored, it in his Albert Hall Mansions, but more recently architects have tried to reconcile such buildings with their surroundings. The Mount Royal block, Oxford Street, by Francis Lorne of Sir John Burnet, Tait, & Lorne, makes such an attempt. It was built of two shades of red brick in 1932–3, and the long broad bands of fenestration give its main elevation a sober horizontal emphasis broken only by vertical glazed stair-wells in the centre. Much more brutal, with emphatic concrete external ramps and canti-levered balconies, narrow windows on the street façade, and blank tower-like end walls, are Wells Coates's Lawn Road flats, Hampstead (1934), built for Jack Pritchard, founder of the developers, Isokon, on the 'minimum flat' concept which he had devised in 1932. This was an attempt to provide the basic necessities at relatively low cost in a good residential district by the intensive, but well-planned, development of a site. The sculptural treatment of these flats appears in another block by Wells Coates, Embassy Court, on the sea-front at Brighton, of 1934–5 [plate 112A]. It is twelve gleaming white storeys high; the top three are stepped back, leaving eight main floors to be accentuated by concrete bands which become balcony parapets between the windows, and at the ends curve round uninterruptedly along the return façade, where some bands rise diagonally in tiers to express an external staircase.[1] The sculptural qualities of reinforced concrete were exploited in a more novel manner by Messrs. Tecton at the London Zoo, Regent's Park, under the enlightened patronage of the Zoological Society's Secretaries, Peter Chalmers Mitchell (until 1935) and then Dr. Julian Huxley. The Gorilla House and the Penguin Pool were completed between 1933 and 1935, and the same firm constructed a simpler variant of the Penguin Pool, and several other buildings at Dudley Zoo in 1937. Tecton was started by the Russian emigré

[1] Mount Royal, analysed by E. Maxwell Fry, *Arch. Rev.* LXXVII (Jan. 1935), 11–19; 'Modern Flats at Hampstead', *Arch. Rev.* LXXVI (July 1936), 77–82; and 'Embassy Court, Brighton', *Arch. Rev.* LXXVIII (Nov. 1935), 167–73.

architect, Berthold Lubetkin, in 1930, and he soon attracted a lively group of six young architects around him.[1] The Penguin Pool at London, brilliantly conceived as a magnificent stage for these solemn creatures, consists of a series of interlocking spiral ramps and pools set within an oval of thin, pierced walls [plate 114B]. It has fairly been described as a gigantic piece of constructivist sculpture. Designing houses for animals rather than human beings is distinctly less inhibiting, and Lubetkin's Elephant House at Whipsnade Zoo (1936), with its four linked circular pens, moat, and wide curving canopy, shows the same sure grasp of form and spatial organization. Nevertheless, Lubetkin and Tecton's first major essay in flat building, Highpoint I, North Road, Highgate Village, begun in 1933 and completed at the end of 1935, won great admiration at the time [plate 114A]. Le Corbusier hailed this, the first reinforced concrete monolithic point-support block to be constructed in England, as 'the seed of a vertical garden city'. Even if this brilliant mixed metaphor is inaccurate, one can understand the enthusiasm of the author of the *Ville Radieuse* concept for this practical application of his theory. A symmetrical double cruciform plan ensured privacy for each of the flat units, which came in two standardized types of two and three bedrooms plus sitting/dining room, bathroom, and kitchen. Soaring up from a hill site to eight storeys and crowned with a penthouse, the gleaming white elevations are enlivened by elegant cantilevered balconies with cyma-shaped concrete facings. J. M. Richards, who had recently joined the *Architectural Review* as Assistant Editor (and was to succeed Christian Barman as Editor in 1937), drew attention to the high quality of the detailing in Highpoint I, and to the fact that the architect had to design and specially commission even items such as flush electric-light switches and door handles, because industry at that time was still unable to produce standardized fittings designed to a sufficiently high standard.[2]

[1] Robert Furneaux Jordan, 'Lubetkin', *Arch. Rev.* CXVIII (July 1955), 37–44. The group consisted of Godfrey Samuel, Michael Dugdale (but only briefly), Anthony Chitty, Val Harding, Lindsey Drake, Denys Lasdun, and Freddie Skinner, almost all of whom had studied at the Architectural Association.

[2] Le Corbusier, 'The Vertical Garden City', and J. M. Richards, 'The Building', *Arch. Rev.* LXXIX (Jan. 1936), 8–16.

Admittedly, these were luxury flats, and rents varied from £145 to £225. Compare Highpoint I with a larger development by Frederick Gibberd, Pullman Court, at Streatham Hill, described in the same issue of the *Architectural Review*, and it becomes obvious that Pullman Court is a rather more spartan version aimed at the lower-income groups (rents were £68 to £130 for one-, two-, or three-room units). The elevations, though good of their kind, are less subtle, and the interior detailing, as one might expect on a limited budget, less perfectionist than Lubetkin's. Highpoint II, built between 1937 and 1938 on a closely adjoining site to Highpoint I and conceived as a complementary building, does not have the same strong functional clarity that made its predecessor a symbol of the modern movement to the younger generation of British architects. It could be argued that the use of glazed tiles, brick infill between the concrete frame, and a more plastic treatment of the main elevation of Highpoint II gives it a warmer effect. Lubetkin considered it a more mature statement. The curved entrance canopy, for example, is 'supported' on copies of the caryatids from the Erechtheion, which are made to face opposite ways—a surrealist touch that offended young purist architects at the time, and even now seems to be not so much wit as whimsy.[1]

A steady stream of private houses in the international modern style were built in this decade; the same architects' names frequently recur: Connell, Ward, & Lucas; Chermayeff, Lubetkin, and another Russian, A. V. Pilichowski; Oliver Hill, and F. R. S. Yorke. Most were in ferro-concrete or brick, but some steel frame and compressed wooden fibre constructions were also attempted and are also of interest as essays in the use of prefabricated parts. We have seen how the Royal Academicians of the 1880s patronized Norman Shaw, so it is of interest that Augustus John, in 1934-5, commissioned a handsome new studio on pilotis from Christopher Nicholson, to stand in the grounds of his house at Fordingbridge,

[1] Anthony Cox, *Focus*, 2 (winter 1938), 71-9, considered Highpoint II showed a movement away from function to 'formalism'. Even the *Arch. Rev.* LXXXIV (Oct. 1938), 161-76, in an otherwise favourable article, expressed reservations about this feature. The caryatids do not have any load-bearing function.

Hampshire.[2] There are two houses, built side by side in Old Church Street, Chelsea, which will serve not only as excellent examples of the genre, but also commemorate two remarkable architectural collaborations, No. 64 by Erich Mendelsohn and Chermayeff, and No. 66 by Gropius and E. Maxwell Fry (in partnership with Gropius from 1934 to 1936). Erich Mendelsohn had arrived in England in 1933, remaining some three years before settling first in Israel and then in America. Both houses were completed in 1936 and had been designed to complement each other [plates 116A and 116B]. The roof lines and exterior garden walls were matched so as to give formal coherence to the whole, and the two families agreed to dispense with a dividing wall in the garden, and shared, as a result, a greater spaciousness on a relatively restricted London site. The bulk of the Gropius–Fry house was sited at right-angles to the street, with the west end close to it so as to obtain maximum garden space. If its street façade is less coherent than that of the neighbouring house, there are interesting spatial effects on the garden elevation with an open cantilevered steel canopy to the upper terrace emphasizing the horizontal lines of the house. The internal organization of the house is frankly reflected in its plan [figure 4] and elevations, un-like the Mendelsohn–Chermayeff house, which has a very simple, rectangular form and, especially on the street elevation, a severely geometrical fenestration which largely conceals the precise dis-position of rooms. These two houses, so different in character, are landmarks in the history of English domestic architecture. Con-structed of brick and concrete, with external cement renderings, they require careful and continuous maintenance, in the same way that Regency stuccoed houses do, and, like these, they show clean lines with smooth transitions from one form to another. White-painted exteriors may look too harsh in a soft northern light and particularly so if juxtaposed with traditional brick-faced houses. Connell, Ward, & Lucas, in their house at 66 Frognal, Hampstead (1937–8), overcame this difficulty by using brick boundary walls and brown painted concrete on the street elevation. This house,

[1] J. M. Richards, 'Augustus John's Studio: Analysis', *Arch. Rev.* LXXVII (Feb, 1935), 65–8.

with its beautifully proportioned fenestration and projecting stair-well, compares most favourably with the two Chelsea houses. A forty-five-foot-long living-room on the first floor faces east and overlooks the garden terrace, to which direct access is gained by sliding back half the expanse of eight-foot-high windows [plate 117A]. The garden elevation is predominantly brick.

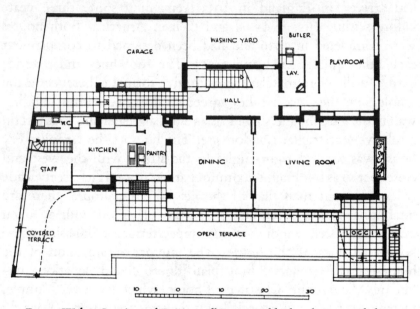

FIG. 4. Walter Gropius and E. Maxwell Fry: 66 Old Church Street, Chelsea, London. Ground-floor Plan

In 1935 Faber & Faber published an English translation, by P. Morton Shand, of Gropius's *The New Architecture and the Bauhaus*, in which he states his position.[1] Written in German between 1934 and 1935 while he was in England, it was intended by Gropius to be translated; the dust cover was designed by Moholy-Nagy. Frank Pick, in his introduction, endorses Gropius's historical analysis of the modern movement, in which he notes that the 'new architecture' begins by being stark and formal, and seeks norms or stan-

[1] Walter Gropius, *The New Architecture and the Bauhaus* (1935), translated from the German by P. Morton Shand with an introduction by Frank Pick. An American edition (Museum of Modern Art, New York) appeared in 1936, and a German edition in 1965: *Die neue Architektur und das Bauhaus: Grundzüge und Entwicklung einer Konzeption*, mit einem Vorwort von Hans M. Wingler ('Neue Bauhausbücher').

dards in reaction against the previous welter of period eclecticism. This negative phase has almost passed and now it is not so much what is omitted or discarded, but much more what is conceived and invented by the modern architect within the new framework of technical possibilities that is important. Gropius discusses such themes as standardization and rationalization, and the teaching aims and methods adopted at the Bauhaus. He rejects superficial catchphrases such as 'functionalism' ('die neue Sachlichkeit'), and 'fitness for purpose equals beauty' as confusing distortions of the innovators' fundamental aims. 'For instance, rationalisation, which many people imagine to be its cardinal principle, is really only its purifying agency.' And later in this first chapter he writes, '. . . the aesthetic satisfaction of the human soul, is just as important as the material. Both find their counterpart in that unity which is life itself.' Of the Bauhaus, too, 'this idea of the fundamental unity underlying all branches of design was my guiding inspiration in founding the original *Bauhaus*'; and he tried to solve the 'problem of combining imaginative design and technical proficiency' by eliminating 'every drawback of the machine without sacrificing any one of its real advantages. We aimed at . . . standards of excellence, not creating transient novelties.'[1] Thus we see that Gropius and Le Corbusier shared a common approach to architecture and design, and acknowledged the great importance of the creative imagination in humanizing the new technological era. As might be expected, Gropius's book was enthusiastically reviewed by English protagonists of the 'new architecture' such as J. M. Richards and Raymond McGrath.[2]

Indeed, there was a conscious acknowledgement that modern architecture was a 'cause' to be fought for, even as part of a wider political commitment to a degree of social rearrangement. This sense of collective purpose found its formal expression in the Modern Architectural Research Group (M.A.R.S. Group), which was started in 1934, probably by P. Morton Shand but certainly quickly embracing Wells Coates (its first Chairman) and a distinguished

[1] Gropius, *The New Architecture . . . Bauhaus* (1935), 8-9, 11, 19, 20, 35-6, 38.

[2] J. M. Richards, *Burl. Mag.* LXVII (Nov. 1935), 235; R. McGrath in *R.I.B.A. Jnl.*, 3rd Ser., XLII (Aug. 1935), 1052-3.

group of young Turks.[1] Affiliated to the C.I.A.M. (*Congrès international de l'architecture moderne*), the aim of the M.A.R.S. Group was also to include planners, engineers, and even quantity surveyors in the belief that the problem of creating an architecture in accord with modern technology and social aims could best be done by a group—an idea which persists in the 'building team'. The M.A.R.S. Group itself did not build, but its propagandist work found tangible expression in *New Architecture: An Exhibition of the elements of modern architecture*, held at the New Burlington Galleries in January 1938. The gallery was ingeniously transformed into a number of set-pieces to provide the context of a didactic modern exposition of the essential conditions, laid down by Vitruvius, and paraphrased by Sir Henry Wootton in the seventeenth century as 'Commodity, Firmness and Delight'. In the Epilogue, the visitor is exhorted to recognize the inestimable contribution modern architecture, as exemplified in the exhibition, can make to everyday life: 'to win your recognition of this fact and your loyalty to the cause of modern architecture has been the purpose of this exhibition'. Le Corbusier came and the exhibition attracted large crowds and a very big deficit. Summerson, who wrote the captions for the exhibition, recalls that it must have struck Corbusier as belated missionary work among the savages, in comparison with the achievements of the continental vanguard. The printed catalogue also lists 139 photographs of recent buildings and sixteen architectural models, for some of which a special display method appears to have been evolved, so as to give a multiplicity of viewpoints both at eye-level and from the air. Of particular interest to us now is the list of seventy-one members of the M.A.R.S. Group, and of their collaborators, which appears at the end of the catalogue.[2]

[1] John Summerson, Introduction to Trevor Dannatt, *Modern Architecture in Britain* (1959), 14–15; and private information from Summerson and Dannatt, who was its Secretary after the war until the M.A.R.S. Group was wound up on 28 Jan. 1957. Maxwell Fry, *Fine Building* (1944), 86 n., gives a short list of those M.A.R.S. architects, 'chiefly concerned' in the work of preparing a new plan for London.

[2] A random selection will give some idea of the range: Ove Arup, C. R. Ashbee, John Betjeman, Breuer, Hugh Casson, Chermayeff, Coates, Amyas Connell, Emberton, Maxwell Fry, Frederick Gibberd, Ernö Goldfinger, Gropius, H. de C. Hastings,

Certainly a new maturity and sophistication in handling the new architectural vocabulary becomes apparent in England from the mid-1930s. Gropius and Fry's Impington Village College, Cambridgeshire (1936-9), built of red and yellow bricks, has for its focal point the assembly hall with splayed walls and sloping roof, set against plainer rear wings.[1] This is much less starkly formal than the work of the American architects, George Howe and William Lescaze, at Dartington Hall, Totnes, where the Headmaster's House (1933) and Boarders' House (1934) are very much in the Cubist spirit. Another school in the more relaxed manner of Gropius and Fry is Luton Modern School (now Luton VIth Form College), Bedfordshire, which was the prize-winning design in an open competition held in 1936 [plate 117B]. The design was submitted by Marshall and Tweedy, but it was actually the work of their senior assistant architect, Turok, and their assistant architect, J. E. Moore, supervised it from the drawing-board to the final stages of its completion in September 1938.[2] The competition assessor, Professor W. G. Newton, singled out for special praise the open plan of the school, which marked a complete break from the centuries-old tradition of collegiate and school architecture characterized by enclosed courtyards and cloisters; but Wood and Sellers, by using a T-shaped plan for their Durnford Street School of thirty years before, must also be given credit for anticipating this

William Holford, Arthur Korn, Lubetkin, Colin Lucas, J. L. Martin, McGrath, Moholy-Nagy, Raymond Mortimer, David Pleydell-Bouverie, Herbert Read, J. M. Richards, Godfrey Samuel, Ralph Tubbs, Basil Ward, and F. R. S. Yorke.

[1] The genesis of this building may be seen in plans, elevations, and a perspective drawing for it reproduced as 'Project for a School at Papworth [Cambridgeshire], 1937', *Circle* (1937), pls 21-2, where a much more symmetrical plan than that subsequently used is shown; see also 'Impington Village College', *Arch. Rev.* LXXXVI (Dec. 1939), 227-34.

[2] Information from J. E. Moore, F.R.I.B.A., and S. F. Burley, F.R.I.B.A., who was Chief Assistant to C. Beresford Marshall at the time. It has not been possible to trace Mr. Turok, who came to England as a Hungarian refugee, having worked in the State Architect's Department of the Austrian government in Vienna. Turok left Marshall and Tweedy shortly after winning the competition to set up in practice on his own. For details of the competition and assessor's report see 'The Luton Competition', *Architect's Journal* (25 June 1936), 972-7 (and editorial, 2 July 1936); for discussion of completed building see 'Luton Secondary School', *Architect and Building News* (13 Jan. 1939), 55-9.

innovation. Predominantly in London yellow brick, with concrete coping-stones and detailing, the Luton school is planned so as to utilize a gently sloping curved site to great advantage. Its splay-fronted assembly-hall, which links the dining-room with the administrative block, is punctuated by a clock-tower that marks the transition to the long two-storey classroom wing, sited along the main north–south axis. Later insensitive additions have spoilt some of the distinction of this building. Just how far school architecture had come may be judged by comparing these examples with the bland Georgian revival buildings completed in 1932 by Percy Worthington and Francis Jones for Manchester Grammar School, or the new King Edward VI School, Birmingham, in timid Tudor and neo-Georgian, by Holland W. Hobbiss, completed as late as 1940. At least the Shakespeare Memorial Theatre, Stratford-upon-Avon (1928–32), by Elizabeth Scott, cousin of Giles Gilbert, had shown the way to a more adventurous use of brick at the beginning of the decade (even the sculptures by Eric Kennington are in cut brick), and the building has retained an agreeable period flavour.

Public school governors and civic corporations are, perhaps by their very nature, resistant to change in taste. In March 1935 Charles Reilly was writing about 'The Town Hall Problem', as well he might.[1] E. Vincent Harris had completed Leeds Civic Hall in 1933, using a curiously emasculated classicism with bastard baroque details such as the twin steeples. The 'civic temple' mentality was to persist, in various guises, throughout the period. Percy Thomas's Guildhall, Swansea (which houses the ill-fated Brangwyn murals, intended for the House of Lords, but rejected in 1930), attempts to cast off porticoes and colonnades, but the result is an uncomfortable cross between Third Reich neo-classical monumentality and streamlined modernism. The nadir was reached in Luton Town Hall (1934–7) by Bradshaw, Gass, & Hope, where giant Ionic order and pediment, surmounted by a chunky clock-tower, all in Portland stone, epitomize uninformed civic pride. On the credit side may be listed the City Hall, Norwich (1932–8) by Charles H. James and S. Rowland Pierce. This is the foremost

[1] C. H. Reilly, '1. The Town Hall Problem', *Arch. Rev.* LXXVII (Mar. 1935), 113–15.

public building of the inter-war years, and the architects, who had won the commission in an open competition, make admirable use of a fine site. Swedish influence, especially that of Ivar Teng-bom and Ragnar Östberg, is frankly acknowledged, but it is an honest and successful attempt to provide a civic building recognizably of the twentieth century. Illustrative of the muddled insensitivity which can shape official policy is the Carlton House Terrace controversy, which dragged on for almost four years from 1930 to 1933. In essence, the Commissioners of Crown Lands wished to redevelop Nash's famous terrace, and Sir Reginald Blomfield had prepared a comprehensive scheme, of which only 4 Carlton Gardens (1932-4), rebuilt to twice the height of its surrounding buildings, remains to remind us of a colossally arrogant idea. Blomfield had planned a *beaux-arts* classical solution in Portland stone, and to distinguished opponents of the scheme roundly asserted: 'To describe Carlton House Terrace as "a gem in London's heritage of beauty and history", is surely going rather large. The Regency did not produce "gems" either in architecture or anything else.'[1] Fortunately, the scheme was dropped; but another great monument of the nineteenth century, Joseph Paxton's Crystal Palace, which had been re-erected at Sydenham Hill in 1854, was destroyed by fire on the night of 30 November 1936. Many mourned the loss of this triumph of architectural engineering, which had become a talisman and inspiration for their own generation.

We have seen how there was an increasing awareness in this country of the importance of good industrial design and of the need to reconcile craftsmanship and machine production. But it was a very slow process, and a good indication of just how much progress had been made in this direction by 1937 is given by Nikolaus Pevsner's *An Enquiry into Industrial Art in England*, published in the middle of that year. The author stressed the tentative nature of his deductions, being well aware of the difficulties he

[1] Letter to *The Times*, 14 Dec. 1932, 13; 'Carlton House Terrace', *Arch. Rev.* LXXIII (Jan. 1933), 8-16, gives an account of the battle; see also House of Lords Debate, 13 Dec. 1932, *Parliamentary Debates*, 5th Ser., House of Lords, LXXXVI, I (1932-3), 376-92. A photograph of Blomfield's scheme was published in *The Times*, 13 Dec. 1932, 18.

had encountered in gathering adequate comparative material and the crude methods of evaluation available to him. The book, written by a scholar who had left Germany for England in 1933, is in the same tradition of objective critical analysis as Pevsner's distinguished compatriot, Muthesius, had brought to bear on English architecture over thirty years earlier, in happier circumstances. Like Muthesius, Pevsner had travelled the country widely in search of material. The first part of his book surveys the design and manufacture of furniture and fittings, textiles (including furnishing and dress), carpets, wallpapers, pottery and glass, radio cabinets, and motor-cars. He then examines the teaching of design in some of the principal provincial and London art schools; the recommendations for improvements made by government committees such as those chaired by Lord Gorell (1931, first report 1932), and Frank Pick (1934, reported January 1937); the work of the Design and Industries Association, and the Society of Industrial Artists (founded 1930); exhibitions, periodicals, and books on the subject. Pevsner's conclusions and suggestions for improvements are contained in the second part of his book. There had been other books on the subject, notably Paul Nash's six essays in *Room and Book* (1932), in which he adumbrates principles of good design; and Nash's contribution to industrial design had led to his election as President and Chairman of Council by the Society of Industrial Artists (1932–5).[1] But by far the most important and coherent argument in favour of a new philosophy of design based on acceptance of the laws of machine art was put forward by Herbert Read in *Art and Industry* (1934). That the argument needed to be put is borne out by Pevsner's damning conclusions, three years later, that ninety per cent of the commercial goods produced in England were artistically objectionable—and in some types of manufactures the percentage was an underestimate. The ratio of good to bad design was higher in a few continental countries, particularly in Germany and Czechoslovakia.[2] A mass market

[1] Bertram, *Nash* (1955), 174–5.
[2] Pevsner, *An Enquiry into Industrial Art in England* (1937), 179 ff. The author quotes from Pick, Read, and others, as well as from his own observations, in support of his assertions.

offered the worthwhile challenge of improving standards by reducing the ratio of badly designed goods from ninety per cent to, say, seventy-five per cent; in this connection, the size of individual firms was of no significance in relation to quality of goods produced: of paramount importance was the attitude of the manufacturer to good or bad design. Some old industries, for example textiles, saddlery, and Wedgwood pottery, maintained the very highest quality of design because of a stable tradition, not in spite of it; whereas the carpet industry, for a variety of reasons, not least of which was a hidebound provincialism, produced appalling designs. Some modern industries, such as aeroplane, car, and radio manufacture, posed new design problems which had to be met in their own terms and not in some form of period imitation. Objects for use were generally less susceptible to aesthetic enfeeblement than those for adornment or show: for example, expensive electric fires with imitation coal or 'Regency' embellishments were usually hideous in comparison with the cheap models designed to perform a basic function with maximum efficiency. Finally, and in the context of the 1930s it was a tenable argument, Pevsner considered architects to be best fitted to become design consultants.

The recommendations of Gorell, Pick, and Pevsner all pointed towards a better system of art education at every level, with better training and career prospects for industrial designers. Standards could only be improved if the public were also made more art- and design-conscious, and this meant that art should be regarded as equal in status with languages, mathematics, or science. Craft teaching in English schools was, and had for many years been, far ahead of continental schools. Art schools should not cater solely for painters and sculptors, for even the Royal College of Art, where the courses had once been firmly tied to industrial design, had gradually become more a drawing-school than a design centre, despite attempts by Crane and Lethaby to redress the balance. Pevsner quotes the example of Leicester College of Art which was housed with the College of Technology, and where interchange of students between the two was encouraged. Leicester was one of the first to gear its courses to the needs of modern industry. The wheel has since come full circle, and in 1937 the Hambledon Committee's

Report on Advanced Art Education recommended the Government to re-orient the Royal College of Art 'so that it should take the advanced study of all forms of applied art for its primary purpose' (p. 14). Other recommendations were not implemented until after the 1939–45 War, but Gropius's warning about academies producing 'an artistic proletariat foredoomed to semi-starvation' is still apposite. In 1967, the proposal to place art schools under the administration of colleges of technology aroused fierce protest, but from 1970 onwards this pattern has been followed. Birmingham provides an interesting case history, for now all the departments of art and design are under the umbrella of the Birmingham Polytechnic. Yet the Birmingham Central School of Arts and Crafts, founded 1884, was one of the first of the municipal art schools, and its Vittoria Street School for Jewellers and Silversmiths was an example of local initiative meeting a specialized local demand. The Vittoria Street School grew out of a series of evening classes for apprentices at the Central School, supported by the Birmingham Jewellers' & Silversmiths' Association.[1] In the 1930s, whilst there was not much provision for machine production designing, handicrafts and allied skills, especially jewellery, were well taught at Birmingham, although still very much under the Arts and Crafts tradition of successive masters like Robert Catterson-Smith, John Paul Cooper, Arthur Gaskin, and his pupil W. T. Blackband. It is significant that the most radical designs were made by the head of the School of Industrial Design at Birmingham, A. E. Harvey, whose Cup and Cover [plate 118A] was shown in the Royal Academy's British Art in Industry exhibition of January 1935. Harvey had trained as an architect and industrial designer abroad and in London, and had no links with the craft traditions. The chunky rectangular Art Déco Tea Service by Harold Stabler of 1936 [plate 118B], made by Adie Brothers of Birmingham, shows how much more responsive London designers were to current fashions.

The British Art in Industry exhibition, organized jointly by the

[1] The foundation of a Central School at Birmingham dates back to 1842, but full responsibility for its running was assumed by the Corporation in 1884. See also Birmingham Gold and Silver 1773–1973, Birmingham Museum & Art Gallery (1973), Section F 'Arts & Crafts', n.p.

Royal Academy and Royal Society of Arts was well intentioned but misconceived. It was an enormous concession by the Academy to allow industrial art to be shown on its premises, but by not setting standards and refusing to admit items already on the market the selection committee (composed of no fewer than thirty-one experts) failed to meet the wishes of its President, the Prince of Wales, who had pleaded that the exhibition should uphold the principles of fitness of purpose and simplicity and should cater for the majority. Instead, traditionalism, expensive and exclusive handcraftsmanship, the modish, or the eccentric prevailed over sound mass-produced designs. Pevsner called it a slap in the face to the modern movement; 'Novelism' was Herbert Read's contemptuous description, and only Maxwell Fry's Glassware Gallery came out with honour.[1] Like the 1851 Great Exhibition, the 1935 exhibition at least had the negative merit of calling attention to the problem. One practical result of the exhibition was the institution by the Royal Society of Arts of the Faculty of Royal Designers in Industry (R.D.I.) in 1936. This was a laudable and successful attempt to enhance the general status of industrial designers in this country by conferring the award on distinguished practitioners in the field. There had already been other hopeful auguries. Tubular steel chairs, based on the Mies van der Rohe or Marcel Breuer ('Wassily') prototypes, were introduced into England by Practical Equipment Limited (P.E.L.) in 1930, three years after Rohe had patented his design and five years after Breuer had designed his Bauhaus furniture. Breuer, as we have already noted, came to England towards the end of 1934 and went into partnership with F. R. S. Yorke. One of his most interesting links, however, was with Pritchard's Isokon Furniture Company, for whom Gropius was design consultant. Finnish bentwood or laminated moulded birchwood furniture designed by Alvar Aalto was marketed in

[1] Herbert Read, 'Novelism at the Royal Academy', *Arch. Rev.* LXXVII (Jan. 1935), 45–50. The remarks of the Organizing Secretary for the R.A. exhibition, John de la Valette, *Studio Yearbook of Decorative Art* (1934), Preface, 'Back to Decoration?', in which he forecast that the limits of functionalism had been reached in 1933, paving the way for a more personal approach to decoration, take on a new significance in this context. It is very doubtful if he had in mind the same reasons for saying this as Gropius!

this country under the trade name 'Finmar' from about 1933; and a more sensitive use of plain, high-quality veneered panels is discernible in modern interiors publicized by the architectural and art press in the mid-1930s.

Breuer designed a range of bentwood furniture for Isokon, including the long chair which has now become a classic. Isokon's Bristol agent was the old-established firm, P. E. Gane Ltd., and it was Crofton Gane who, in 1936, commissioned Breuer to redesign completely the interior of his private house in Clifton. In the same year he also asked Breuer to design an Exhibition Pavilion for the Royal West of England Show at Bristol.[1] There were other British firms like Murphy Radio Ltd. and Eric K. Cole & Co. (Ecko) prepared to commission radio cabinets from Richard Drew Russell and his elder brother Gordon, Chermayeff, McGrath, and Wells Coates, between 1932 and 1936, with excellent results [plates 118C and 118D]. Period imitations or 'modernistic' cabinets were supplanted by functional designs in wood or, increasingly, bakelite, as the result of collaboration between engineers, sales managers, and designers. These designs were also a commercial success, proving that an outstandingly good design can greatly help in projecting a distinctive 'brand image'. A truism now, but still a novel idea in the 1930s.

The Prince of Wales, on his accession to the throne as Edward VIII in January 1936, was able to give a practical expression to his earlier plea for simplicity of design when he approved the excellent series of postage stamps for his brief reign. This design, for which no designer's name is given, broke completely with the rather more elaborate issues of his father's reign, and was criticized for its starkness. The legend 'Postage' and the denomination were in a bold sans-serif type, but all the usual royal and national symbols were dispensed with, except the crown itself, and the king's head was set against a plain background. There were good precedents

[1] *Furniture by Godwin and Breuer*, Bristol City Art Gallery (exh. cat., May 1976), usefully summarizes the Breuer–Gane commissions. The Gane House was described in *Arch. Rev.* LXXIX (Mar. 1936), 139–42. Breuer's furniture for the Gane House is now in the Bristol City Art Gallery. The Exhibition Pavilion is illustrated in *Arch. Rev.* LXXX (Aug. 1936), 69–70. A Nest of Three Tables by Breuer in bent plywood *c.* 1936 is in the Victoria and Albert Museum (Circ. 314 to 316–1965).

for this in the simple engraved stamps of Queen Victoria which had introduced the penny post in 1840. A fresh approach was also apparent in the George V Jubilee stamp of 1935, for which Barnett Freedman's striking design had been accepted at the suggestion of Kenneth Clark.[1] Although more traditional in format, George VI's stamps of 1937–8 and the 1940 commemorative were also characterized by a welcome clarity and simplicity. The Coronation stamp was designed by Edmund Dulac and the general issues were designed by Dulac in collaboration with Eric Gill.

An interesting phenomenon in the 1930s was the emergence of a number of highly talented interior designers, and their establishment as a separate entity from the architectural profession. Old-established furnishing and decorating firms were challenged by a new breed of often ruthlessly determined career women with good social connections, of whom Syrie Maugham (Mrs. Somerset Maugham) and Sybil Colefax (Lady Colefax) were among the most influential exponents in this country (although it must also be said that there were distinguished male designers such as Basil Ionides, Oliver Hill, Duncan Miller, and Arundell Clarke). They worked for those of the rich who either took a genuine interest in the art of interior décor or were simply anxious to be *à la mode*. Essentially an ephemeral art—for the taste of the day before yesterday is supplanted by the latest craze—the genre exists on the periphery of the main developments in art and architecture, though its practitioners, ever alert for new ideas, may borrow, parody, or transform elements taken from contemporary art and design. While it is beyond the scope of this survey to examine in detail this somewhat exotic hothouse plant, the adoption and adaptation of the functional white interior makes an amusing and instructive comment. The ancestry of the predominantly white interior can be traced back to Mackintosh and, in the 1920s, to Le Corbusier and the Bauhaus, but it acquired a voguish popularity among the smart set around 1930.[2] The bare, functional approach advocated

[1] Letter to the author, 4 Feb. 1975. Clark served as a member of the Post Office Committee under the chairmanship of Sir Stephen Tallents.

[2] Martin Battersby, *The Decorative Thirties* (1969), 69, 72–8. Mr. Battersby is a most instructive guide in this field and I am much indebted to him.

by Arundell Clarke made a virtue of economic necessity. It was so much cheaper to furnish with cheap materials and the bare minimum of pieces. In the depression years this was a vital consideration. However, too much austerity could produce a monotonous effect, in every sense, and this was indeed a general criticism levelled against some modern interiors of this date. Besides this, it could ultimately be self-defeating so far as the interior designer was concerned. He would do himself out of a job. Novelty was at a premium, and even in apparently 'simple' designs, expensive materials lent their own richness of effect. The white interior had been developed by Syrie Maugham in a series of luxurious settings including her own drawing-room of 1933, where every nuance of white, ivory, pearl, oyster, and so on was used, but never the dead white or cream of suburbia. But by 1934 it was out of fashion. Elegant French eighteenth-century furniture, mostly reproduction, which was now painted over in tasteful shades of shell pink, sage green, or dark orange, came back into fashion among those able to afford the services of a smart London interior designer. Peach-coloured mirror glass also came into fashion as a glittering cladding for furniture, especially the ubiqui-tous cocktail cabinets. In the previous decade, lacquer cabinets in the Chinese or Japanese style were pressed into this service and, if they were genuine period pieces, the internal drawers would be shamelessly gutted to make room for the bottles and glasses. The delights of the neo-Regency style—not perhaps so highly regarded as the Robert Adam period had been in the 1920s—and even of a Victorian revival were to be savoured before the end of the decade. Surrealism, after the 1936 London exhibition, also made itself felt in interior decoration.

Some major commercial firms and corporations were also will-ing to commission first-class artists to design posters advertising their products or services. According to Martin Battersby, there were three advertising and commercial artists listed in the London Post Office Directory for 1902; by 1925 the number had increased to 103, and neither figure included the designers who worked part-time or on special commission.[1] This increase does show the

[1] Martin Battersby, *The Decorative Twenties* (1971), 185.

growing importance of advertising and the need to use artists specializing in this field. The railways had learnt the value of good posters by artists like John Hassall, whose *Skegness is so Bracing* [plate 119A] for the Great Northern Railway of 1909, a classic of its kind, is typical of the clear-cut style pioneered by the Beggarstaffs which was to be imitated by many, including Cecil Aldin and Will Owen among the more notable.[1] Once again, Frank Pick was to set an example by employing McKnight Kauffer to do posters for the London Underground as early as 1915, but perhaps one of Kauffer's most striking creations was the *Early Bird* design for the *Daily Herald* of 1919, with its echoes of Vorticism [plate 119B]. McKnight Kauffer had the ability, essential in a poster designer, of meeting the challenge of a particular theme with a witty composition which evoked the appropriate association in the spectator's mind. His *London Museum* poster of 1922, with its reference back to the Great Fire, is a brilliant example of this technique. Posters for Shell Mex, British Petroleum, and the Orient Line [for whom he also designed baggage labels; plate 119C] in the 1930s show his consistent approach to design and typography which allowed him to make amusing stylistic pastiches if he thought the occasion demanded it, without losing his own artistic personality.[2] Ashley Havinden, who joined the advertising agents W. S. Crawford Ltd. in 1922, was able to contribute poster designs under the *nom de brosse* 'Ashley' of such startling simplicity as that exhorting us to drink milk [1936; plate 119D], as well as promote modern techniques by recommending artists of the calibre of Moholy-Nagy to organize window displays for Simpsons. Havinden also designed a range of rugs for the Edinburgh Weavers in 1937. Others engaged in poster design included artists as diverse as Paul Nash, Rex Whistler, Graham Sutherland, Frank Dobson, John Armstrong, Tristram Hillier, and Ben Nicholson, all of whom worked for Shell and B.P. Ltd. in the 1930s.[3] And this by no

[1] Bevis Hillier, *Posters* (1969), 86-91, gives Hassall's own account of the idea behind the poster.

[2] *E. McKnight Kauffer: Memorial Exhibition*, V. & A. (1955).

[3] Cyril Connolly, 'The New Medici', *Arch. Rev.* LXXVI (July 1934), 2-4. Ben Nicholson, Paul Nash, and Duncan Grant also made designs for textiles in the 1930s, and examples of their work are in the Victoria and Albert Museum.

means exhausts the list. Less exalted, though no less effective, were the humorous 'My Goodness, My Guinness' posters of John Gilroy of the mid-1930s, which were a continuation of the Hassall tradition of cheerful, boldly simplified images, immediate in their impact. The Shenval Press published the lively quarterly *Typography* from 1936 to 1939, which under the editorship of Robert Harling also did much to keep the professionals abreast of new developments in advertising and printing, as well as the history of the printer's art. The old debilitating distinctions between 'high' and 'low' art had ceased to have meaning. The ideals of the Bauhaus and the modern movement, of which it formed so important a part, were at last beginning to flourish in England.

PART SIX

PATRONAGE AND COLLECTING
1870–1940

XII

PUBLIC AND PRIVATE
COMMISSIONS: THE NATION'S
COLLECTIONS: DEALERS
COLLECTORS, AND
ART HISTORIANS

P ATRONAGE in England only remained exclusively the
prerogative of kings, princes, the church, and the aristocracy
until the mid-seventeenth century, by which time the landed
and newly-rich mercantile classes shared in this pursuit. State
patronage in the sense that Parliament specifically voted funds to
provide for a National Gallery, a School of Design, or a scheme of
decorative murals for the rebuilt Houses of Parliament—in other
words, state support for the arts and their practitioners—only
began to assume some importance from the 1820s, and owed much
to the enthusiasm first of a few enlightened statesmen such as Sir
Robert Peel and then of the Prince Consort. A notable exception
had been the encouragement given by the government of the day
to the establishment of the British Museum in 1753, but even here
much was provided by royal generosity and private munificence.
The involved history of the first decorative scheme for the Houses
of Parliament has already been told in a previous volume, but
whatever its merits and failings may have been, it was to inspire
others at Westminster and elsewhere. Moreover, the principle
that the nation had some responsibility for the well-being of the
creative arts, once accepted and established, was to be acted upon,
although it must also be said that progress was often slow and un-
certain. A powerful factor in bringing about the change from pri-
vate to public patronage was the progressive diminution of private
wealth, whether inherited or accumulated within a generation, by
government fiscal policies designed to finance an increasingly wide

range of public services. The process began in 1889, with the introduction of a new tax—estate duty, perfected five years later and made more comprehensive in its impact. The way had been prepared for the disintegration of the great family collections, hitherto regarded as inviolate, by the passing of the Settled Land Act 1882, which set aside the legal restrictions on the sale of family heirlooms. The Act allowed trustees of settlements, on application to Chancery, to sell off land and chattels, provided that the money thus realized remained under trusteeship. This measure was passed to meet the acute financial problems which many of the great hereditary landowners faced as a result of the collapse of British agriculture in the late 1870s. Among the first of the treasures to be sold as a direct result of this new legislation were those from Sir Philip Miles's collection at Leigh Court and the Duke of Marlborough's at Blenheim. The Estate Duty tax was to undergo further refinements, notably in the Finance Acts of 1910 and 1930, some of which were intended to stem the disposal of art treasures abroad and the decline of country houses and estates that followed on an alarming scale from its implementation.[1] Aspects of public and private patronage have been touched on directly in earlier chapters and we have seen within a general historical context how artists and architects have fared and how taste has changed, but the underlying trends, the strengths and weaknesses of patronage and its allied activity, collecting, have still to be surveyed.

The cycle of twelve wall-paintings for Alfred Waterhouse's Great Hall of Manchester Town Hall is probably the most ambitious civic commission of its kind in the nineteenth century, and the City Fathers undoubtedly took the Palace of Westminster scheme for their model. Instead of scenes from the history of England, they chose events from the history of Manchester, beginning with the Romans building a Fort of Mancenion, A.D. 80, and the expulsion of the Danes from the city, c. A.D. 910, and ending with the opening of the Bridgewater Canal in 1761, and the experiments of John Dalton, the Manchester chemist and meteorologist. The

[1] R. C. K. Ensor, *England 1870–1914* (1936), 86–7, 116, 119, 217–18 and n., 327, 414, 543; Lord Curzon and his fellow National Gallery Trustees drew the government's attention to the harmful effects of this legislation in their Report of 1915.

Town Hall had been finished in 1877, and the following year the paintings were commissioned jointly from Frederic Shields and Ford Madox Brown, but Shields used his influence to see that the whole commission was eventually entrusted to Madox Brown.[1] It was Brown's last important work and took him until 1893, the year of his death, to complete. For the first eight, he used the Gambier Parry method of spirit fresco painting and worked *in situ* on the wall; the remaining four are oil on canvas.[2] The earlier paintings still retain some of the punctilious attention to detail and vividness of facial expression that are the hallmarks of Madox Brown's mature style and link him with the Pre-Raphaelite movement. These qualities became coarsened in the later pictures, where the artist worked in adverse conditions and was forced to hurry— nevertheless, the vigorous richness of colour and broad style of these heroic works match the Gothic splendours of their architectural setting.

Another public commission for new mural decorations was begun in the Town Hall at Birmingham in 1891 as part of a more general scheme of refurbishing and redecoration of Joseph Hansom's building. Although the official histories do not say so, it is reasonable to assume that the promoters of the scheme were well aware of the Manchester precedent. Predictably, incidents from the history of Birmingham (granted full city status in 1889) were depicted, but the artists were selected from the most promising senior students at the Municipal School of Art, who worked under the supervision of their headmaster, Edward R. Taylor. The instigator was J. Thackray Bunce, chairman of the Museum and

[1] F. M. Hueffer, *Ford Madox Brown, A Record of his Life and Work* (1896), 338–9, 347–9, 352–3, 360–1, 366, 369, 371–2, 374, 378–80, 384–8, 394, and 421; Mary Bennett, *Ford Madox Brown 1821–1893* (1964), 26–8. Miss Deborah Cherry has kindly informed the author that according to the Manchester Town Hall archives Brown received £275 for each of the first six panels; in 1880 he requested an increase of £100 per panel but the Town Hall Committee deferred a decision until the first six were completed. On 19 January 1884 a contract was signed for the remaining six panels at a price of £375 each, with a retrospective payment of an additional £100 per panel for those already finished. A copy of the contract is now in a private collection.

[2] Spirit fresco was a technique devised by Thomas Gambier Parry, who published it in 1880. Pigments were ground in varnish, and murals executed by this method were supposed to be more resilient to the rigours of the British climate.

School of Art Management Sub-Committee, who was also a civic historian and had suggested the subject-matter for each of the decorations. The close links between the Museum and School of Art were deliberately fostered, and Taylor had already made his mark as an innovating headmaster by teaching drawing and the crafts side by side, thus ignoring the rigid divisions of the curricula set by the South Kensington School of Design. As a consequence of this, a distinctive Birmingham School of painters and craftsmen evolved around the turn of the century. From such photographs and records as still exist it is possible to deduce the style and general appearance of the decorations, which have now been lost.[1] There were eight long horizontal 'panel paintings on canvas' in the original scheme, placed at main gallery level in the spaces beneath each of the large vertical windows, with a further two 'large panels' by Sidney H. Meteyard and Henry A. Payne representing *Instrumental Music* and *Vocal Music* on the left and right sides of the organ. Four of the panels were given by William Kenrick, M.P., and three more murals were added between 1900 and 1902. Although experiments in tempera painting and a revival of fresco were being pioneered by another Birmingham painter, Joseph Edward Southall, it would seem from the descriptions and other evidence that the Town Hall decorations were executed in oil on canvas from full-sized cartoons after a preliminary sketch and colour study had first been approved by Taylor. Meteyard's *Laying the Foundation Stone of the Guildhall*, with its clear-cut outlines to the main figures set against a heraldic-like backdrop, is very much influenced by Burne-Jones; whilst M. Jannette Bayliss's *Edward the Sixth Founding the Grammar School* has the more atmospheric type of crowded composition found in Rossetti. Charles Gere's *Birmingham Riots: Escape of Priestley (1791)* is quite dramatically conceived, but the artist's preference for the medieval period must have made this an unsympathetic commission.

[1] 'The Wall Paintings by Art Students in the Town Hall, Birmingham', *Studio*, I (Sept. 1893), 237–40; C. A. Vince, *History of the Corporation of Birmingham (1885–1899)*, III (1902), 257–8, and *Hist. of . . . Birmingham (1900–1915)*, IV (1923), 388, for a complete list of artists and subjects. The decorations were removed when the Town Hall was again refurbished in 1926, and were exhibited at Cannon Hill Museum until 1939.

During the last thirty years of the century, no major public decorative schemes were promoted in London. There were, however, the decorations of the Cole Staircase (1868–76) and Leighton's two lunettes in the Gambier Parry spirit fresco technique for the eastern part of Fowkes' Court at the Victoria and Albert Museum in the early 1880s. A further chapter in the protracted story of the decoration of the Houses of Parliament was not opened until 1906 when a Select Committee of Peers was appointed to consider what should be done with the remaining empty spaces. Poynter, Alma-Tadema, Lethaby, Norman Shaw, and Gilbert Scott were among the luminaries consulted by the Committee, which recommended a grant of £4,000. Nothing was achieved until 1908 when a group of artists, under the supervision of Edwin Abbey, was commissioned to paint some Tudor scenes for the East Corridor. Among the more notable were Frank Cadogan Cowper, Frank O. Salisbury, Henry A. Payne, and John Byam Shaw, all of whom produced sound academic work in cheerful colours but in a style already somewhat *demodé*. Typical subjects are *Queen Mary's Entry into London*, by Byam Shaw, and Payne's *Choosing the Red and White Roses*. No longer was there any attempt at fresco; instead, a system of marouflage, wooden panels faced with canvas, was employed, Although a grant of money had been recommended, each painting was, in fact, presented by an individual peer. Thus, what had begun as an exercise of state patronage became, by an ironic inversion of circumstances, a revival of aristocratic patronage, which was continued in 1927 when the decorations for St. Stephen's Hall were completed. Here the theme chosen was 'The Building of Britain', and the subjects were selected by Henry Newbolt in collaboration with Lord Peel, the First Commissioner of Works, the Earl of Crawford and Balcarres (Chairman of the Royal Fine Art Commission, which had itself only been set up in 1924), and the Speaker of the House of Commons. The final list was only agreed after further discussion with D. Y. Cameron and the artists to whom he had allocated the eight subjects.[1] The three conditions of the scheme were that 'the

[1] Sir Henry Newbolt, *The Building of Britain: a Series of Historical Paintings in St. Stephen's Hall, Westminster* (n.d.), 2. The Royal Fine Art Commission was originally

paintings must represent striking aspects of the national life' and only commemorate those events 'of the highest and most far-reaching significance' from the reigns of King Alfred to Queen Anne; they must form a homogeneous series, and, to ensure this, must be the work either of a single artist or of a team working together in close collaboration and understanding. A new generation of artists was involved and the most recent episode of British history to be included went, as it happened, to the youngest painter, Thomas Monnington, for whom the painting of *The Parliamentary Union of England and Scotland* was his first major commission. Newbolt's observation that events from the last two hundred years of national history would provide 'no very happy subject for the art of today' for fear of reviving old party strifes, was predictably borne out by the Scottish Nationalists' vigorous protest about the inclusion of the Act of Union of 1707.[1] The general effect of these murals is one of lively colour, much higher in key than any of the earlier decorations, and the over-all broad decorative masses within each composition are unimpaired by over-elaborate detail. Some are treated in an almost heraldic convention not inappropriate to their setting, particularly Glyn Philpot's *Richard I* and A. K. Lawrence's *Queen Elizabeth and*

an advisory body appointed 'to enquire into such questions of public amenity or of artistic importance as may be referred to them' by any Department of State or public or quasi-public body, to whom the Commission could, if it considered it 'advantageous', offer advice. Its powers were strengthened in August 1933 to enable it to take the initiative in questioning the merits of a project, e.g. the Carlton House Terrace proposals, but not until 1946 was it fully empowered to summon witnesses and examine documents, plans, etc., as of right.

[1] A detailed description of painters and subjects, with names of the noble donors, appears in Newbolt, op. cit., but an abbreviated version is given here: *King Alfred's Attack on Danish Invaders at Swanage, 877*, by Colin Gill (Duke of Devonshire); *Richard I leaves for the Crusades, 11 December 1189*, by Glyn Philpot (Viscount Devonport); *King John signs Magna Carta, 1215*, by Charles Sims (Viscount Burnham); *The Reading of Wycliffe's English Bible*, by George Clausen (Duke of Portland); *Speaker Thomas More Refusing to Grant Henry VIII a Subsidy without Due Debate, 1523*, by Vivian Forbes (Viscount Fitzalan); *Queen Elizabeth Commissions Sir Walter Raleigh to sail for America, 1584*, by A. K. Lawrence (Earl of Derby); *James I's Envoy to the Moghul Emperor lays Foundation of British Influence in India, 1614*, by William Rothenstein (Duke of Bedford); and *The Parliamentary Union of England and Scotland, 1707*, by Thomas Monnington (Viscount Leckie of Younger).

Raleigh, whilst William Rothenstein captures the exotic setting of the Mogul Court of Ajmir with panache. Most of the artists were attempting a task for which they had had no previous experience, and a uniformly high success rate could hardly be expected.

Frank Brangwyn was an artist for whom mural painting held no terrors, and his facility was such that Sigfried Bing commissioned him in 1895, at the age of twenty-eight, to paint a frieze 180 feet long of *Le Roi au chantier* and two large panels *Music* and *Dancing* for the entrance hall of his Hôtel de l'Art Nouveau, Paris. Patronage from such an influential man as Bing ensured Brangwyn recognition in Europe where, eventually, his reputation stood higher than in his own country—for, although he was born in Bruges, both Brangwyn's parents were English. It is true he was called upon to paint two groups of four panels each for the British Pavilion at the Venice Biennales of 1905 and 1907 representing British industry and agriculture.[1] In 1906 he executed a fresco for the Royal Exchange, London, depicting modern commerce, and during the next thirty years commissions for large-scale decoration flowed in from the United States, Canada, and Japan. Brangwyn was a brilliant draughtsman, as shown by his many fine preliminary studies and cartoons, besides being well endowed with a facile inventiveness. The hallmarks of his style are unmistakable and it was undoubtedly shaped by his study of medieval tapestries in William Morris's workshop during the early 1880s. In his early paintings the forms are delineated by broadly brushed-in outlines which endow his compositions with a superficial pulsating energy. Every inch of space is crowded with incident and if, in his later work, he defines his forms more crisply and lightens his palette, modelling by shadow or colour is kept to a minimum. By 1925, although now something of a recluse in Ditchling, Sussex, Brangwyn enjoyed an international reputation and in spite of ill health was still immensely prolific. The previous year a large retrospective exhibition of his work had been opened by the Prime Minister,

[1] The 1905 set were acquired by S. Wilson of Leeds, who commissioned a fifth and presented them to Leeds City Art Gallery (*Catalogue of the Works of Sir Frank Brangwyn R.A. 1867–1956*, William Morris Gallery, Walthamstow (1974), 87–90).

Ramsay MacDonald. Who could be more natural a choice than Brangwyn to complete the decoration of the Royal Gallery of the House of Lords, where Maclise's gloomy frescoes of war and bloody victories held sway? The First Earl of Iveagh had agreed in 1924 to pay the cost (£20,000) of filling the remaining empty panels as part of a memorial to Peers and their relatives killed in the First World War, and it was agreed that the theme should now be a celebration of the products of Empire and not, as originally intended, a continuation of the Maclise theme. The change, which had been proposed by Brangwyn, was certainly better attuned to his temperament and proven abilities.

The eighteen British Empire Panels were to be the culmination of Brangwyn's career, and two sets of three panels each were intended for the upper spaces of the two end walls of the Royal Gallery. Each of these panels measures twenty feet high by about thirteen feet, and a further ten smaller panels, each approximately twelve feet square, were to occupy the lower spaces.[1]

The deaths of Lord Iveagh in 1927 and in the following year of Lord Lincolnshire, the Lord Chamberlain, robbed Brangwyn of two of his staunchest supporters, but the work proceeded until in February 1930 five panels were ready for inspection by the Royal Fine Art Commission *in situ*. The Commissioners reported adversely and recommended against the erection of the completed scheme as a permanent feature in the Royal Gallery. This sparked off a public controversy, and following a debate in the House of Lords, 3 April 1930, the Panels were finally rejected.[2] Lord Iveagh's son and heir to the title honoured his father's commitment and Brangwyn, although deeply disappointed by the verdict, completed the scheme, which was shown at the *Daily Mail Ideal Home Exhibition* in 1933. In October of that year the city of Swansea successfully bid to have the Panels incorporated in the decoration of the Assembly Hall of its new Guildhall, then nearing completion, and they were unveiled in 1934. Contemporary

[1] David Bell, *The British Empire Panels*, County Borough of Swansea (1959), 3–8.

[2] *Parliamentary Debates*, 5th Ser., House of Lords, LXXVI, 2 (1929–30), 1195–1228.

opinion about the merits of the Panels was guarded, and public indignation centred more on the affront to the artist and his late patron. The Panels contain an extraordinary profusion of motifs drawn from all over the world, a rich, brightly-hued tapestry of allusions to Africa, India, Burma, and Canada, teeming with humanity and exotic birds and beasts [plate 120A]. No set sequence of the four continents was intended and it was perhaps this de- liberate illogicality, combined with a disregard for scale in the smaller panels, where human heads, and birds and animals peer through an undergrowth of gigantic flora, that aroused mis- givings in the minds of the arbiters. Nevertheless, the Panels have a joyous vigour, a decorative *élan* which would have comple- mented Maclise's *Nelson* and *Wellington*. As so often happens, the panjandrums of official taste played for safety.

No more commissions for the decoration of public buildings were forthcoming after the Brangwyn fiasco, but contemporary with the Empire Panels, though vastly different, were the murals Rex Whistler painted for the restaurant of the Tate Gallery be- tween March 1926 and November 1927. He had just left the Slade School at the age of twenty, when Henry Tonks, as part of a scheme to encourage and give practical experience to young artists, recommended Whistler to Lord Duveen, who agreed to finance the commission. The charming decorations, *In Pursuit of Rare Meats*, brought about by this act of perceptive encouragement, are also a tribute to Whistler's precocious talent. A guide to the events illustrated in the murals, written by Whistler and Edith Olivier, was published by the Trustees of the Tate Gallery in 1954. Set in an Arcadia where elegant buildings in the manner of Inigo Jones and his eighteenth-century successors punctuate the hillsides, we are invited to follow the adventures of an Edwardian hunting party journeying from Epicurania to China and back, whose identities and the places they visit are thinly disguised by anagram- matic titles. Rex Whistler's old teacher, Tonks, appears as Dr. Knots, Pugin as Ugpin, and Bernard Shaw, who opened the room in November 1927, as Count Brendar Wahs, the 'Palace Librarian and Public Orator'. Painted for the most part in oil mixed with wax and turpentine on canvas, on one side the mural is painted

direct on to the plaster. The scheme was left in the sketch stage in one or two areas, notably around the windows. These murals deservedly established Whistler's reputation. His outstanding gift for synthesizing the distinctive elements of the late baroque and rococo periods, for which he felt an especial sympathy, was put to good use in the theatre, book illustration (such as those for A. E. W. Mason's *Königsmark*, 1940–1, Tate Gallery), posters for museums and the London Underground, but above all in interior décors. The Dining Room at Port Lympne (1930–2), which Sir Philip Sassoon commissioned from him in 1930, is Palladian in theme, but given an elegant rococo flavour with a festive striped tent supported on real poles framing architectural capriccios on each of the main walls. For Mrs. Gilbert (Maud) Russell, between December 1938 and October 1939, Whistler produced, at Mottisfont Abbey, Hampshire, an entire room decorated in Strawberry Hill Gothic Revival, with one of his favourite motifs, a *trompe l'œil* niche to set off the delicate traceries. Although also adept at interpreting Regency, Victorian, and Edwardian modes, his most important commission was the decoration of the dining-room at Plas Newydd for Lord Anglesey in 1937, which was conceived as a witty but accurate transformation into a baroque loggia with ceiling coffered in *trompe l'œil* [plate 120B]. Incorporated into the scheme were false perspectives and a view of an idealized landscape with mountain-girt harbour complete with sailing vessels at anchor. This ability to create an enchanting illusionary world soon brought him to the notice of impresarios such as Charles B. Cochran, who commissioned a scene from him for the 1931 Cochran revue at the old London Pavilion Theatre. Settings for *Fidelio* at Covent Garden (1934), the costumes and décor for *The Rake's Progress* (1935), based on Hogarth's engravings, and for *Pride and Prejudice* (1936) also brought his work before a much wider and appreciative public. Sadly, this bright talent was prematurely extinguished at the battlefront in 1944.

Patronage in another and more unusual sphere should be recorded here, although its results are also a significant extension of the history of architecture and design in the 1930s. For almost a century, major British shipping companies had built ocean-going

liners to cater for the passenger traffic to America and the Antipodes, in competition with their principal Dutch, German, and French rivals. By the late 1920s, national prestige was considered to be at stake, and the French and German governments began to subsidize the cost of constructing luxury liners for the transatlantic run. The *Normandie*, launched in 1932 and put into service three years later, was not only a showpiece of French artistry and superb craftsmanship but the largest liner afloat—at least until the launching of the Cunard Line's *Queen Mary* in 1935. This liner was also the first to be subsidized by the British government so as to provide employment in the depression-hit Glasgow shipyards. In 1879 the Orient Line had employed J. J. Stevenson to design the main rooms of the *Orient*, and this architect also worked on the interiors of several of her successors. This in itself was something of a breakthrough, for hitherto shipowners were content to leave the interior design to their shipbuilders who, in turn, subcontracted firms like Maples, Waring & Gillow, or, in Glasgow, Wylie & Lochhead Ltd. to provide comprehensive schemes of decoration and furnishing.[1] Interior designers as a distinct breed from architects were not to appear for another generation or so, and, in any case, the prevailing fashion was to transpose the architectural conventions of the day on board ship, as accurately as possible and almost in defiance of the structural restraints imposed by the basic requirements of marine engineering. The results were often intriguing floating hotels of palatial dimensions, and it is no coincidence that about 1905–14 Cunard competed with the Hamburg-Amerika Line for the services of Mewès and Davis, who had already established themselves as skilled exponents of *beaux-arts* neo-classicism, of which their Ritz Hotel in London is a prime example.

It is against this tradition in British shipping, at least, that we must judge the Orient Line's courageous decision in 1932 to allow one of their junior directors, Colin Anderson, to put into practice

[1] Sir Colin Anderson, 'Ship Interiors: When the Breakthrough Came', *Arch. Rev.* CXLI (June 1967), 449–52, and letter to the author, 17 Nov. 1972. I am also indebted to Mr. Stephen Rabson of the P. & O. Group and to Mr. Colin Sorensen for additional information.

his proposals for a thoroughly contemporary design for a new ship *Orion*. Perhaps they were also conscious of the example set by the *Normandie*, but by October 1933 Anderson had successfully found and briefed a young New Zealand architect, Brian O'Rorke, with whom a long and happy collaboration ensued. O'Rorke had just designed, with Arundell Clarke, the new Mayor Gallery, which instantly became a byword for uncompromising modernity. There were immense practical difficulties to overcome, and ancient conventions to discard. O'Rorke not only had to find designers capable of producing new designs for virtually every item, from doorhandles to glasses, and from carpets to cutlery: he also had to design all the furniture and light fittings [plate 115]. There were hardly any acceptable standard fittings to be had from the trade manufacturers. It will be remembered that Lubetkin and Tecton were facing similar problems with Highpoint I at exactly the same time. Anderson has recalled the help received from McKnight Kauffer, who designed a sandblasted representation of Orion the Giant and his constellation on the glass mirror wall for the first-class dining-saloon, and his wife, Marion Dorn, who designed the hand-tufted carpets and textiles; and from Lynton Lamb, and Allan Walton and Alastair Morton of Edinburgh Weavers. Other colla-borators were A. B. Read, Keith Murry, Barnett Freedman, and Ceri Richards, who designed the publicity booklet for the ship. Nor was the external appearance of the ship ignored, and even the life-boat davits were redesigned without any loss of efficiency. Launched in December 1934, *Orion* began her maiden voyage to Australia on 28 September the following year. Painted buff and white, she broke with the Orient Line's traditional black hull livery, a change made practicable by the use of oil-burning turbines. Photographs of the ship, now long since broken up, and of its interiors convey a pleasing atmosphere of carefully modulated modernity far more appealing and less 'dated' than the lush splendours of the *Nor-mandie*. The revolutionary example set by *Orion* undoubtedly in-fluenced the interior designs of other ships, as well as of trains, aeroplanes, and even hotels. Some years later Anderson summed up his belief in the value of modern design by saying 'I cannot prove that my design policy has added one passenger to my lists.

But I know it has been well worthwhile.'[1] The interior design of the Cunarder, *Queen Mary*, was not so rigorously and comprehensively controlled, and among the casualties were the three very large decorative panels painted by Duncan Grant for the main lounge. Kenneth Clark had persuaded the architect in charge to commission Grant, and his work was duly installed, only to be removed after the chairman and other Cunard directors had strongly objected to them.[2] Over thirty different artists were employed on the many murals, sculptures, and carvings in the ship, but the main staterooms continued the Art Déco tradition set by the *Normandie*. The murals were for the most part uncontroversial pieces by academic artists like Laura Knight, Algernon Newton, Doris and Anna Zinkeisen, and Philip Connard; only Vanessa Bell's garden landscape and Edward Wadsworth's symbolical murals on a nautical theme showed a more adventurous spirit.

The foundation of the National Gallery in 1824 and the skilful efforts of successive Keepers and Directors, assisted by public funds and some outstanding bequests and benefactions, had ensured for the nation a collection of European Old Master paintings which, by the 1890s, was unquestionably of international importance. In Edinburgh, the National Gallery of Scotland, built primarily on the Old Master collections of the Royal Institution and the collection of contemporary art bought by the Royal Scottish Academy, was established in its new building in 1859.[3] The National Gallery of Ireland had been founded in Dublin by 1864 but the National Museum of Wales at Cardiff only came into being in 1907. All these establishments were pre-eminently for Old Master paintings, and the achievements of the national school (using that term to include the whole of the United Kingdom) were inadequately represented, a fact which caused informed people increasing concern during the nineteenth century. Although the National Gallery in

[1] Quoted by Sir Paul Reilly, 'Designing for the European Market', *Journal of the Royal Society of Arts*, CXXIV (July 1976), 452.

[2] Kenneth Clark, *Another Part of the Wood: A Self-Portrait* (1974), 248. The panels are now owned by the Hon. Alan Clark.

[3] Colin Thompson, *Pictures for Scotland: The National Gallery of Scotland and its collection*, Edinburgh (1972), 7 ff. This also contains much interesting material about patronage and collecting in Scotland and the United Kingdom.

London contained some fine examples by British masters of acknowledged stature, there was no coherent acquisition policy in this field. Surprisingly minor painters were included, while much more meritorious artists went unrepresented at Trafalgar Square. The first attempt to remedy this state of affairs was made by the sculptor, Sir Francis Chantrey, R.A., who in his will of 31 December 1840 bequeathed his considerable fortune to the Royal Academy on certain conditions. The money was to be used for 'the encouragement of British Fine Art in painting and sculpture only' by the purchase 'of works of Fine Art of the highest merit in painting and sculpture that can be obtained either already executed or which may hereafter be executed by Artists of any nation Provided such artists shall have actually resided in Great Britain during the executing and completing of such works'. There was a specific provision that no work of art could be purchased unless it had been entirely executed within the shores of Great Britain. The will became effective after Lady Chantrey's death in 1876, and its provision that the President and Treasurer of the Royal Academy be added to the three trustees already appointed by Chantrey was observed. Chantrey's will also envisaged the establishment of a separate national collection of British art, an enlightened aim that was given additional impetus by the gift or bequest to the nation of three important collections of British art which together comprised 672 paintings and over 19,000 water-colours. First came Robert Vernon's Gift in 1847, next the magnificent Turner Bequest to the National Gallery in 1856, and, finally, the Sheepshanks Gift in 1857 to the then newly established South Kensington Museum, renamed at Queen Victoria's command the Victoria and Albert Museum in 1899. Miss Isabel Constable's very important gift and bequest (both of 1888) of some 400 examples of her father's work to the V. & A. must also be noted here. Excellent benefactions such as these only intensified the demand for a British equivalent of the Luxembourg in Paris, which had been founded in 1818 and was, in fact, the first museum of modern art as we understand that concept.[1] The Sheepshanks

[1] Michael Compton, 'The Role of the Museum of Modern Art', in *Art Museums:*

and Chantrey pictures were at South Kensington, while the Turner Bequest and Vernon Gift were kept at the already over-crowded National Gallery but hardly ever shown. There was therefore still no central place for the display of our national painters.

Early in March 1890 matters came to a head when newspaper reports began to appear that the sugar merchant, Henry Tate of Streatham, had offered in October 1889 to give sixty of his modern English pictures to the National Gallery. James Orrock the land-scape painter had pleaded for more adequate representation of the British School at the National Gallery in a paper to the Royal Society of Arts on 12 March, and the next morning *The Times* published a leading article not only in support of Orrock but advocating the creation of 'a really representative and choice col-lection of our art gathered together in some great central gallery . . . a gallery that shall do for English art what the Luxembourg does for French'.[1] Henry Tate's original offer to the Trustees of the National Gallery posed difficulties for them, and he made public another offer, this time to the Chancellor of the Exchequer, of which the essentials were that the government should agree to the founding of an autonomous national gallery of British art, where, in addition to Tate's own collection, there should be as complete a representation of the national school as possible, even if to achieve this meant transferring some of the British paintings from South Kensington and the National Gallery. Tate was to be unfairly attacked for seeking the establishment of a public gallery solely to house his own collection. His motives were far more honourable and generous. As well as commemorating past achieve-ments, he sought to benefit living artists by founding a gallery 'for the encouragement and development of British art and as a thank-offering for a business career of sixty years'.

Negotiations between Tate and his friends and the government dragged on, and at one stage Tate withdrew his further offer to pay

The European Experience, The European–American Assembly on Art Museums, Ditchley Park (1975), 52–82, for a general consideration of the subject.

1 John Rothenstein, *The Tate Gallery* (1962), 12, quotes from this and many other contemporary sources in his account of the Tate's history up to recent times.

the cost of erecting a new building, partly because no suitable site for it could be found. He had also to meet opposition from those who feared that the new gallery might become yet another bastion of the Royal Academy. It was true that Tate enjoyed the friendship of several Academicians, three of whom, Millais, Watts, and Leighton, were enthusiastic supporters of the idea. Millais, who was particularly fervent, lived long enough to see photographs of the building still shrouded in scaffolding and Tate records how he wrote 'quite satisfied' beneath them.[1] It is also true that Tate's own purchases were mainly from Royal Academy summer exhibitions. However, in November 1892, negotiations were resumed and the government agreed to use three acres of the site of the old Millbank Prison overlooking the Thames for the new building. By the autumn of 1894, Sidney R. J. Smith, Tate's choice for architect, had completed the designs, and the Tate Gallery was officially opened by the Prince of Wales on 21 July 1897. Tate was created a baronet and appointed a Trustee of the National Gallery. His great plan had been realized, although not so completely as he had wished, for the control of the Tate Gallery was vested in the Trustees and Director of the National Gallery, and instead of its comprehending the whole of British art since the Renaissance, only those artists born after 1790 were eligible for inclusion. Nevertheless, the Tate was clearly regarded as a 'Musée de Passage', like its French prototype, and if, unlike the Luxembourg, no clearly defined rules were laid down about the length of time that was to elapse after an artist's death before he could be considered for promotion to the National Gallery, at least the principle was implicitly accepted.

Tate's original gift consisted of sixty-seven paintings and three bronzes. Apart from a Hoppner portrait, the rest were by living or recently deceased artists, foremost among whom was Millais, represented by five works including two important early paintings, the superb *Ophelia* (1852) and *The Vale of Rest* (1858). Other High Victorian subject pictures accurately reflect Tate's taste: Luke Fildes's *The Doctor* (1891), three by J. W. Waterhouse, including *The Lady of Shalott* (1888)—almost a pendant to Millais's *Ophelia*—

[1] *Daily Mail*, 8 May 1897, interview with Tate, quoted by Rothenstein, op. cit. 18.

three large Orchardsons, two late John Linnells, Leighton's *And the Sea gave up the Dead which were in it* (1891–2), one small work each by Landseer and Alma-Tadema, and Stanhope Forbes's *The Health of the Bride* [plate 9B]. To these were added some paintings transferred from the Vernon Gift and a few works by Constable, J. F. Lewis, Wilkie, Rossetti's *Beata Beatrix*, and eighteen paintings by Watts which the artist had presented in 1897. Frith's *Derby Day* and Dyce's *Pegwell Bay* were also on view. The Chantrey purchases must also be included. Of the total of 279 works by 166 artists recorded in the 1897 Tate Gallery catalogue the great majority were by Academicians. The growing number of independent artists were not represented, nor was Turner. In the very early years of the Tate's history, its collections were less catholic than those of the great provincial museums at Birmingham, Liverpool, Manchester, and Glasgow.

By 1939 some 680 artists were represented at the Tate in a collection which exceeded 2,600 works. The original eight galleries had been increased to seventeen in 1899, through Tate's continuing generosity; and a further nine galleries were added in 1910 to house the Turner Bequest as a result of benefactions from Joseph Duveen senior and his son, later to become Lord Duveen of Millbank. It was Lord Duveen who provided the Sargent gallery and a gallery for modern foreign art (1926) as well as the grand Sculpture Gallery, first opened to the public in June 1937. Private patronage thus played a vital role in the Tate's development, as it did for other national art institutions. The new building for the National Portrait Gallery, opened in 1897, was paid for by William Henry Alexander, although the site was provided by the government, which voted an annual purchase grant of only £750. Against this public parsimony must be set the £135,000 the state spent on the purchase and renovation of Hertford House to receive the Wallace Collection, bequeathed by Sir Richard Wallace's widow in 1897 and opened to the public in 1900. A further £800,000 was spent on the new Aston Webb building for the Victoria and Albert Museum between 1899 and 1909.

Municipal and private enterprise had brought important new permanent collections into being since 1870: the Guildhall Art

Gallery of the City of London (1886), the Whitworth Art Institute (as it was then called) at Manchester (1889), and the Municipal Gallery of Modern Art at Dublin. Similar acts of private munificence can be recorded at Birmingham, where John Feeney endowed an addition to the original 1885 City Museum and Art Gallery building of eighteen new galleries (1912–19); and at Bradford, where, between 1898 and 1904, Lord Masham contributed £47,500 to build the Cartwright Memorial Hall in which to house the Art Gallery, founded in 1879. In another Yorkshire city, Sheffield, John Newton Mappin and Alderman J. G. Graves each contributed entire new museum and art-gallery buildings in 1887 and 1934; Mappin's nephew, Sir Frederick Mappin, Bt., M.P., generously supplemented the original Mappin bequest by further gifts of 150 paintings, a bronze, and a sum of £15,000, before his death in 1910. The Mappin Art Gallery is probably one of the most elegant late neo-classical revival buildings of its time, with surprisingly pure Ionic orders designed by William Flocton and E. Mitchell Gibbs in 1886–8. In 1927 at Hull, the Rt. Hon. Thomas R. Ferens gave £45,000 to build the gallery which bears his name, as well as providing an endowment of £20,000 in Reckitt and Colman shares for the purchase of paintings. The list cannot be exhaustive, but it can be considered representative of a new type of Maecenas. Aristocratic patronage on the grand scale had largely, though by no means entirely, given place to that exercised by merchants, manufacturers, art dealers (the Duveens), and a newspaper proprietor, John Feeney, founder of the *Birmingham Post*.

Patronage of a rather less disinterested nature became the target for increasingly sharp attack when, in 1903, D. S. MacColl loosed off two broadsides against the administration of the Chantrey Bequest.[1] He pointed to the perversion of the terms of the will by the President and Council of the Royal Academy, who, he asserted, 'considered their duties accomplished when they had strolled round their own exhibition, and distributed his national

[1] D. S. MacColl, 'The Maladministration of the Chantrey Bequest' and 'Parliament and the Chantrey Bequest', *Saturday Review*, 25 Apr. and 6 June 1903. These were reprinted with further details as a pamphlet in 1904. MacColl was Keeper at the Tate Gallery, in succession to Charles Holroyd, from 1906 to 1911.

trust as a prize-fund for the exhibition', and so manipulated it 'to penalize those who do not exhibit'. When it is recalled that Chantrey left a capital fund of £105,000 from which was derived an annual income of between two to three thousand pounds, and when allowance is made for the much greater purchasing power of such sums at the turn of the century, it is clear that a considerable amount of patronage was at stake. Hostile questions about its abuse had been asked by Sir Robert Peel in Parliament as early as 1884, and his call for an inquiry was repeated by MacColl, who also contrasted the merits of the Chantrey Trustees' purchase of a water-colour by a nonentity within the academic fold for £150, with the French government's purchase of Whistler's *Portrait of his Mother* for £160.[1] The Chantrey Trustees' silence in the face of these and many other damning points skilfully put by MacColl and his allies (among them Roger Fry) provoked adverse comment from *The Times* and other journals. The Report of the Select Committee of the House of Lords which was set up under Lord Crewe's chairmanship in 1904 to inquire into the affairs of the Chantrey Bequest endorsed the view that successive Councils, through too narrow an interpretation of certain terms of the will, had failed to achieve Chantrey's explicit aim of a collection of works of art of the highest intrinsic merit purchased without regard to the artist or his family. The Crewe Committee's recommendations were mostly ignored and it was left to a committee of Trustees of the National Gallery formed under Lord Curzon's chairmanship in December 1911 to review the National Art Collections. The Curzon Committee's other objective had been to inquire into 'The Retention of Important Pictures in this Country', and its findings and recommendations on this matter will be discussed below—but its Report published in 1915 contained far-reaching proposals for the Tate Gallery. These were implemented in March 1917, surprisingly prompt action at a time

[1] The price of 4,000 francs paid by the French government in November 1891 for this picture was admittedly an exceptionally low one. The City of Glasgow had bought the *Carlyle* for 1,000 guineas in March of that year. John Rothenstein, op. cit. 22, also refers to an analysis in the *Pall Mall Gazette* (20 Oct. 1903) which showed that of the £60,064 spent by the Chantrey Bequest Trustees since 1876, £46,314 went to R.A.s and A.R.A.s, the balance of £13,750 going to outsiders.

of dire struggle for national survival. A Gallery of Modern Foreign Art was created, thus legalizing a situation that had obtained since 1900 when the National Gallery began dumping its lesser modern foreign pictures at the Tate; the scope of the Tate's British collection was widened to embrace all British art, with particular emphasis on the modern period; a separate Board of Trustees was appointed for the Tate on which the National Gallery Trustees were represented, and, finally, the Keeper was promoted to Director. Henry Tate's original concept was thus essentially fulfilled and given a new dimension.

The Tate's new role as a gallery of modern foreign art had been made feasible by the bequest of Sir Hugh Lane's magnificent collection of thirty-nine Impressionist paintings to the National Gallery in 1915. Unfortunately Lane's original offer to lend these paintings in 1913 had been met with a singularly tactless response from the National Gallery Trustees, who proposed showing only fifteen of the collection and sought clarification of Lane's intentions as to its future disposition. This cautious attitude may have been due to some lingering doubts about the merits of the Impressionists, and to physical problems of displaying them. Either way, it aroused Lane's indignation, for he was clearly hopeful of persuading the British government to create a national gallery of modern foreign art in London, but, as an Irishman by birth, he had also previously negotiated unsuccessfully with Dublin Corporation to the same end. The complications which arose from Lane's unexpected death in the sinking of the *Lusitania* in 1915, the discovery of an unwitnessed and therefore legally invalid codicil to his will shortly afterwards, in which he bequeathed his collection to the City of Dublin on condition that a suitable gallery be built for it within five years of his death, are now part of history.[1] The Lane pictures went on show at the Tate in 1917 and their impact on some visitors was, to say the least, notably produc-

[1] Rothenstein, op. cit. 30–3, summarizes the main points of the controversy and of the compromise agreement reached in 1959 between Dublin and London. Lane had offered to lend sixteen paintings to the National Gallery as early as January 1907 (R. Alley, *Tate Gallery: the foreign paintings, drawings and sculpture* (1959), 278, entry for No. 3271).

tive. Some indication of the range and quality of Lane's collection may be given by a brief list of the key works: Manet's *Musique aux Tuileries*, Degas's *Plage à Trouville*, Renoir's *Les Parapluies*, Berthe Morisot's *Été*, Monet's *Vétheuil, effet de neige*, Daumier's *Don Quixote and Sancho Panza*, Puvis de Chavannes's *Martyrdom of St. John the Baptist*, and Vuillard's *La Cheminée* of 1905.

One visitor was the rayon manufacturer Samuel Courtauld, and in 1923 he gave £50,000 to create a fund for the purchase of modern French pictures. The fund was administered by a committee, and within ten years it had transformed the Tate's modern foreign collection by acquiring outstanding examples of Impressionist and Post-Impressionist art at a time when it was still just possible to buy these at relatively low prices.[1] Renoir's *La Première Sortie* (£7,500) was, perhaps appropriately, among the first of the Courtauld Fund gifts, along with four Van Goghs, of which *Les Tournesols* (£1,304), *La Chaise et la pipe* (£696), and *Champ de blé et cyprès* (£3,300) are the best known. By far the most spectacular acquisition was Seurat's monumental *Une Baignade, Asnières* (£3,917), but the uniformly high quality of all the Courtauld purchases is such as to make it invidious to single out for special praise more than a few of them. It is enough to say that superb works by Manet, Monet, Bonnard, Cézanne, Sisley, Utrillo, Toulouse-Lautrec, Degas, and Camille Pissarro had been given to the Tate by 1936, and that most of those artists were represented for the first time in an English public collection as a result of Courtauld's initiative. Nor should it be forgotten that since 1922 he had been building up a magnificent private collection of the work of these artists he so much admired, most of which was to be bequeathed to the Courtauld Institute of Art. The University of London thus became owners of such masterpieces as Manet's *Bar aux Folies Bergères*, Renoir's *La Loge*, Cézanne's *Mont Sainte Victoire*, Van

[1] The committee consisted of Lord Henry Bentinck, Sir Michael Sadler, Sir Charles Holmes (Director of the National Gallery), Charles Aitken (Director of the Tate Gallery), and Samuel Courtauld. They were known as Trustees of the Courtauld Fund and under the Trust Deed had power to sell or exchange works, which they and their successors exercised on two occasions in 1926 and 1944. Between 1924 and 1954 twenty paintings were presented by the Fund, and three were given personally by Courtauld.

Gogh's *Self-Portrait with Bandaged Ear*, and Gauguin's *Nevermore*. Our admiration for Courtauld's munificence should not allow us to forget that Lord Duveen, in addition to his other benefactions, contributed through the National Art-Collections Fund the Tate's first Degas, *Carlo Pellegrini*, in 1916, and an important Gauguin, *Faa Iheihe*, in 1919. One of the first English collectors to become interested in Gauguin was Michael Sadler, who bought four Gauguins from Paris in the autumn of 1911. One of them, *The Vision after the Sermon*, was bought from him in 1925 by the National Galleries of Scotland. Courtauld's example undoubtedly encouraged C. Frank Stoop first to give a fine Braque still-life, *Guitare et pichet* (1927), in 1928 and eventually to bequeath another seventeen first-rate modern foreign pictures in 1933, including a Braque figure-piece. Stoop's bequest enabled the Tate to represent Matisse (with two works of *c.* 1916 and *c.* 1900), Modigliani, and Henry Rousseau ('Le Douanier') for the first time, besides adding two Degas pastels, four Van Goghs (including two drawings), and three Picassos, two of which, *Femme en chemise, c.* 1905, and *Femme assise*, 1923, rank among his major masterpieces.

Although the Tate now had its own governing body, it remained financially dependent on the National Gallery, and apart from certain trust funds received no proper purchase fund until 1945. This was one of several compelling reasons for yet another attempt to resolve the impasse over the Chantrey Bequest. As a result of negotiations with the Royal Academy, the Tate Trustees achieved a more acceptable *modus operandi*, confirmed in 1922 (and modified in 1949), which provided for proper consultation between the two institutions before purchases were made. For the first time, too, the Tate Board was entitled to representation on two specially formed Recommending Committees, one for painting and one for sculpture. The principle was also established that the Tate could make proposals for the buying of work by both deceased and living artists. The first fruits of this new *entente* were the welcome addition of Holman Hunt's *Claudio and Isabella*, ten water-colour studies for the *Perseus* cycle by Burne-Jones, thirteen cartoons and sixty drawings by Alfred Stevens (to add to an already formidable collection of his work), Wilson Steer's *Mrs. Raynes*, and,

rather surprisingly perhaps, Epstein's bronze head, *Nan*, of 1909. But the institutions which gave the most enlightened support were the Contemporary Art Society and the National Art-Collections Fund.[1] In 1905 the Fund bought and presented to the Tate its first painting by Whistler. This was the famous *Nocturne in Blue and Gold: Old Battersea Bridge* [plate 3A], which had been hissed when it was sold from William Graham's collection at Christie's in April 1886. In 1917 the Contemporary Art Society presented to the Tate the first of its Gauguins—the unfinished *Tahitiens* which had been on sale for a mere £30 in the 1910 *Manet and the Post-Impressionists* exhibition—and *Euphemia Lamb*, the first of the Epstein sculptures to enter the collection. Works by Sickert, Ginner, Gore, Grant, Augustus and Gwen John, William Nicholson, and Stanley Spencer's *Christ Carrying the Cross* [plate 93A] are among the earliest of many gifts from the Society and set a consistently high standard of quality. Provincial galleries have also benefited greatly from the Society's gifts since its inception in 1910.

It is difficult to realize now just how meagre the historic British collections at the Tate were before 1940. The conventional starting-point for the national school was then Hogarth, whose six *Marriage à la Mode* pictures, a portrait or two, and the *Scene from the Beggar's Opera* served as a nucleus, while Gainsborough, Reynolds, and Wilson were also tolerably well represented. There was one work by Lely, none by Kneller, and none by the sixteenth-century British artists whose work was just beginning to arouse the interest of scholars like C. H. Collins Baker and Lionel Cust. Symptomatic of this new interest in British art was the formation by Alexander Finberg and others of the Walpole Society in 1911, devoted to the publication in its annual volumes of articles and archival material relevant to the history of the arts in Great Britain. Some of the Tate's deficiencies were later made good by transferring works from the National Gallery, and after 1945, with the allocation of a regular purchase fund, by following a consistent purchasing policy. An opportunity to buy twenty illustrations in water-colour by Blake to Dante's *Divina Commedia* when they

[1] *The First Fifty Years: Contemporary Art Society 50th Anniversary Exhibition*, Tate Gallery (1960), gives a useful summary of the Society's achievements.

appeared in the Linnell sale in March 1918 as part of a lot of 102 drawings was eagerly taken. A consortium of interested institutions and collectors put up the £9,022 purchase price, and shared out the collection according to their respective contributions. The National Art-Collections Fund played its part as contributor and banker, and the British Museum, Birmingham Museum and Art Gallery, the Ashmolean Museum, and the National Gallery of Victoria, Melbourne, also benefited. The Lane, Courtauld, and Stoop collections provided a magnificent foundation which was not actively built on during the 1930s. J. B. Manson, Charles Aitkens's successor as Director from 1930 to 1938, was quite unsympathetic to the new-generation École de Paris painters. Even gifts from the Contemporary Art Society, notably Rouault's superlative *Têtes à massacre* (*La Mariée*) and Matisse's *Liseuse à l'ombrelle*, both purchased in 1926 for presentation, were declined in 1932. The Rouault was finally accepted in 1935, but the Matisse, after being refused twice, only in 1938. Manson is said to have refused to accept the Stoop Bequest because it contained works by Matisse and Picasso.[1] The Board Minutes show that other highly desirable proposed gifts and cheaply priced modern works offered for purchase by perceptive dealers like Freddy Mayor were not taken up. Once again, private generosity helped to remedy the situation. In 1940 Montague Shearman bequeathed, through the Contemporary Art Society, fine paintings by Matisse, Rouault, Sisley, Lautrec, Utrillo, and Vuillard; and in the same year came the Frank Hindley Smith bequest of six French pictures, two of which, the Othon Friesz and the André Lhote, represented these artists in the Tate for the first time. The new vanguard of British artists, Hepworth, Moore, Ben Nicholson, and their contemporaries, received no encouragement from the Tate during the mid-1930s at a difficult time in their careers when official recognition from the national gallery of British art would have been of immense value to them. As it happened, the Contemporary Art Society presented Moore's *Recumbent Figure* [plate 134B] in 1939—the year after it was completed for Chermayeff—and Nicholson's *Guitar* (1933) in 1940.

[1] Kenneth Clark, op. cit. 233, but Clark's memory betrayed him; see D. Farr, 'J. B. Manson and the Stoop bequest', *Burl. Mag.* CXXV (Nov. 1983), 689–90.

Between 1870 and 1890 the National Gallery increased the size of its collections by fifty per cent, and the building was twice extended, in 1876 and 1885.[1] The purchase of Sir Robert Peel's collection with a special Treasury grant of £75,000 in 1871 brought seventy-seven pictures into the Gallery, of which fifty-five were Dutch and twelve Flemish, thus greatly strengthening this part of the national collection with works of very high quality such as Hobbema's *The Avenue, Middelharnis* and Rubens's *Chapeau de paille*. On an annual purchase grant of £10,000 much could still be achieved, but the Treasury, still dominated by Gladstonian principles of thrift, cut this to £5,000 in 1889, and for many years this was to remain the basic grant, even after 1897, when the money was supposed to be shared with the Tate Gallery. The virtues of such an economy are hard to fathom in an international context. Prices of Old Master paintings had begun to rise steeply, and since 1880 serious competition had come from Wilhelm von Bode, who had embarked on a brilliant acquisition campaign for the Berlin Museums of which he was Director. Wealthy American collectors were soon to force an even more furious pace. The rapid increase in the number of important Old Master paintings exported from private collections in this country at the end of the century prompted a small group of art-loving patriots to form the National Art-Collections Fund in 1903. The object was to secure a fund raised mainly from small annual subscriptions with which to buy works of art for British public collections. A reserve fund was soon afterwards initiated by Edward VII. The National Art-Collections Fund was an extension of the earlier British Institution of London (1805), the Royal Association for the Promotion of the Fine Arts in Scotland (1834), and the Art Unions of London (1837) and Glasgow (1841), which had existed to encourage living artists and purchase their work. The initiative for the Fund came from MacColl, but he was soon supported by a committee which included Fry, Claude Phillips (the first Keeper of the Wallace Collection), and George Salting, with Lord Crawford as Chairman

[1] A calculation quoted by R. C. K. Ensor, op. cit. 135. Anthony Blunt and Margaret Whinney (eds.), *The Nation's Pictures: a Guide to the Chief National and Municipal Picture Galleries of England, Scotland and Wales* (1950), is still one of the best concise histories of the development of our major public collections.

and Robert Witt as one of the two Honorary Secretaries. The founders were also keenly aware of the benefits which the Société des Amis du Louvre (1897), the Kaiser Friedrich-Museums-Verein (1896), and similar foundations in Belgium and Holland conferred on the museums they were pledged to assist. Within two years of its creation, the Fund, against seemingly impossible odds, had raised £45,000 to secure for the nation the *Escurial* or *Rokeby Venus* by Velázquez, sold by the Morritt family to Agnew.[1] Government aid had not been forthcoming for this purchase, or for the Holbein *Christina, Duchess of Milan*, sold by the Duke of Norfolk in 1909 for £72,000, which the Fund, with the help of a last-minute anonymous donation of £40,000, again rescued for the National Gallery. The government had given only £10,000 towards this purchase. Even in 1890 when Holbein's *The Ambassadors* was bought from the Earl of Radnor for a reputed £35,000, the bulk of the money had been subscribed by three private benefactors. In 1911 the National Gallery, assisted by a contribution of £10,000 from the Fund, had to find £40,000 to buy the Mabuse *Adoration of the Kings* from the Dowager Countess of Carlisle, whose family had owned it since 1797, when it was bought for £525. Fry, in his evidence to the Curzon Committee, expressed his disapproval of this acquisition. Again, in 1916 the Fund found half the purchase price of £9,000 for the majestic Masaccio *Madonna and Child*. But the Fund and the National Gallery were powerless to stop the export in 1911 of one of Rembrandt's finest landscapes, *The Mill*, sold by Lord Lansdowne to P. A. B. Widener for a record £103,300. Within the space of a few years over fifty Rembrandts had left British private collections, but on the credit side, during Kenneth Clark's Directorship, the Gallery bought *Saskia as Flora* from the Duke of Buccleuch in 1938 (£28,000) and *Margaretha Tripp* from Lord Crawford in 1940 for £20,000, with the help of the National Art-Collections Fund.

Magnificent though these achievements by the Fund were, they only emphasized the seriousness of the losses from our private

[1] In 1813 J. B. S. Morritt had bought this picture for about £1,000. In March 1914 the picture was attacked by Suffragettes, who in May that year also seriously damaged five Bellinis.

collections, and sharpened criticism of the Trustees of the National Gallery for their apparent lack of a policy to combat them. This was one of the central problems discussed by the Curzon Committee and its recommendations were the result of a most thorough and wide-ranging inquiry over many aspects of the national collections, including the crucial ones of finance and government fiscal policy as it affected our national museums.[1] The Report contains a wealth of statistical information, and among the many appendices is a long list of masterpieces sold from British collections over the past twenty years or so to foreign buyers. It is an instructive comment on the great wealth of private collections in this country at that time. The most important of the Report's recommendations were: that there should be an increase in the annual purchase grant of the National Gallery from £5,000 to at least £25,000; that such an increase should not preclude the Trustees from applying for extraordinary Treasury Grants if circumstances warranted; that the proceeds of all death duties paid on works of art be separately kept and recorded and added to the purchasing funds of the national museums and galleries. The recommendations for the Tate Gallery have already been discussed, but the Curzon Committee also advanced arguments for rationalizing the collecting policies pursued in respect of British art, especially water-colours, by the British Museum, the Victoria and Albert Museum, and the Tate Gallery. The Committee set its face against the imposition of an export duty on pictures or works of art, and was also against legislation to restrict their export, contending that the practical difficulties of enforcement were too great.[2] It relied instead on adequate purchase funds and the advantages of private negotiation for first refusal with owners of pictures of outstanding national importance, and, to secure the goodwill of those

[1] *Report of the Committee of the Trustees of the National Gallery appointed by the Trustees to enquire into the Retention of Important Pictures in this Country and other matters connected with the National Art Collections : Report and Appendices : Minutes of Evidence* (1915). The Committee members were Lord Curzon, Sir Edgar Vincent, R. H. Benson, and Sir Charles Holroyd.

[2] The Reviewing Committee on the Export of Works of Art was not set up until 1952, in the wake of legislation to contain the continuing losses abroad of national treasures.

owners, recommended the government to consider granting suitable concessions, such as the exemption from or remission of estate duty, in return for private sales on favourable terms to the national collections.

To put the acquisition of these masterpieces in perspective, it should be remembered that in 1874 the National Gallery had bought some dozen pictures at the Alexander Barker sale for £10,000, among which were at least five major works: Piero della Francesca's *Nativity* (£2,415), Botticelli's *Mars and Venus* (£1,050), Pinturicchio's fresco *The Return of Ulysses* (£2,152), the Crivelli *Immaculate Conception* altar-piece (£577. 10s.) and Signorelli's *The Triumph of Chastity* (£840).[1] At the Hamilton Palace Sale in 1882 the Gallery acquired fourteen pictures, including a full-length Velázquez of Philip IV for £6,300 and two grisaille panels by Mantegna for £1,785.[2] (Twelve years later the National Gallery bought Lord Northbrook's haunting *Agony in the Garden*, by Mantegna, for £1,500.) From the riches of the Miles Sale in 1884, which brought the Altieri Claudes back on the market, the National Gallery only bought two Hogarths, *The Shrimp Girl* and *Polly Peachum* for just over £1,100. Much bigger game was being stalked from the Duke of Marlborough's collection, and negotiations between the Duke, the National Gallery Trustees, and the Treasury during 1884–5 resulted in the nation's acquiring Raphael's *Ansidei Madonna* for what was then a record price of £70,000 and the Van Dyck equestrian portrait of Charles I for £17,500.[3] The

[1] The discussion on collecting and sale-room prices has been based in part on Gerald Reitlinger's pioneering study, *The Economics of Taste: the Rise and Fall of Picture Prices 1760–1960* (1961), 127 ff. Disraeli, then First Lord of the Treasury, accompanied the Director of the National Gallery, Sir Frederick Burton, to the sale at Christie's. Reitlinger's book must, however, be used with some caution (see, for example, Denys Sutton's review, 'The Economics of the Art Market', *Burl. Mag.* CIV (Oct. 1962), 437–8).

[2] In 1936 the cleaning of the Philip IV caused the second of several violent and protracted controversies in the National Gallery's history about not only the policy adopted by the Trustees, but also the methods used by the conservators.

[3] The progress of the negotiations may be followed in the published government report: *Papers relating to the Proposed Purchase for the National Gallery of certain of the Blenheim Palace Pictures* (1885). Originally, the Duke had offered eleven pictures for 400,000 guineas.

Charles I, incidentally, had been one of the pictures sold from the Royal Collection during the Commonwealth. The Gallery's annual grant was stopped for the next two years after this large expenditure. A few earlier Italian pictures were still being bought at modest prices, and it is a comment on the decline in interest in this field since Eastlake's day that so fine a 'gold background' picture as the large Lorenzo Monaco *Coronation of the Virgin* altar-piece could be bought in Florence for £2,739 as late as 1902. Quattrocento pictures from the collection of William Graham, sometime Trustee of the National Gallery and a patron of Rossetti and Burne-Jones, went quite cheaply at his executors' sale in 1886.

The vagaries of fashion and taste are notoriously difficult to explain satisfactorily, although Gerald Reitlinger has analysed the economic indicators for us. The role of dealers, speculators, and collectors, and the growing importance of national museums and galleries during the later nineteenth century, are all factors in the picture market which must be considered; so, too, must the general economic health of the competing nations at any one time. Distinct from but related to the older genus of connoisseur is the newly emerging race of art-historian curators, one of the first and most distinguished of whom was Eastlake. Members of this new profession, by helping to systematize knowledge and exploring hitherto neglected or unregarded artists and schools, act as scholarly propagandists and trend-setters, sometimes *malgré eux*. Allowance must be made, too, for the irrational and subjective emotions which prompt, let us say, two multimillionaires to vie with each other over the acquisition of a bauble. The development of our national collections must be seen against this background.

One interesting—some might now say depressing—aspect of English patronage and collecting from the 1860s to the turn of the century was the great financial success enjoyed by certain living painters, mostly Royal Academicians, in relation to the London sale-room prices obtained at that time for works by some of the greatest European old masters. Quite disproportionate sums were paid for paintings by Landseer, Frith, Millais, Edwin Long, Alma-Tadema, and Leighton, whilst what are now regarded as incomparable masterpieces by Jan Van Eyck, Titian, Veronese, Poussin,

and Rubens went for trifling sums. Raphael, almost alone among the High Renaissance artists, was consistently highly prized in the nineteenth century: as evidence of this the price of the *Ansidei Madonna* may be seen as a peak on a constantly rising graph. The inference must be that the new class of patron and collector favoured certain forms of contemporary art because these appealed to them and required no great knowledge of the art of the past for enjoyment. A few examples of this disparity in values must suffice to show the general pattern. In 1872 Sir Francis Cook bought Van Eyck's *The Three Marys at the Sepulchre* for £336 at the Middleton Sale, a picture which his descendant sold in 1940 to D. G. van Beuningen for £225,000. Titian's *Man in a Red Cap* went through Christie's in 1872 for only £94. 10s. to be sold by Sir Hugh Lane to Henry Frick in 1915 for £50,000; although the Earl of Dudley's *Holy Family* was bought by Ludwig Mond in 1892 for the more respectable sum of £2,520, and entered the National Gallery as one of the Mond Bequest pictures in 1923. The Leonardo *Virgin of the Rocks* was bought by the National Gallery in 1879 for £9,000. Compare these prices with those paid for Landseer's *Monarch of the Glen*, sold by Lord Cheylesmore for £7,245 in 1892, and resold by Agnew that same year for £8,000. Even in 1916, Sir Thomas Dewar, the distillery magnate, paid £5,250 for it, whereas *The Otter Hunt*, which in 1877 had been auctioned from Baron Albert Grant's collection for £5,932, only realized £1,260 at Christie's in 1913. Landseer's *Chevy* (137 × 71 cm., not to be confused with *Chevy Chase*), which was sold at Christie's for £5,985, had sunk to £1,050 when auctioned in their rooms from Sir Joseph Robinson's famous collection in 1923.[1] The same artist's *Chevy Chase*, bought from him by the Duke of Bedford in 1826, was sold from the Bedford collection in 1951 for a mere 150 guineas, and acquired by the National Art-Collections Fund for presentation to Birmingham Museum and Art Gallery. One of the highest fees ever paid to a living English painter, at least until recently, was the £10,500 that William Agnew paid

[1] For accounts of Sir Joseph Robinson and his collection see E. K. Waterhouse, *The Robinson Collection*, R.A. (1958) and P. Cannon-Brookes, *Twenty Masterpieces from the Natale Labia Collection*, Wildenstein & Co. (1978).

to Holman Hunt in 1874 for his not very prepossessing *The Shadow of the Cross* (Manchester City Art Gallery) plus all engraving rights and an elaborate preliminary oil study. Since the painting took Hunt five years to complete, the annual remuneration was not high in comparison with the £25,000 to £40,000 a year earned by Millais in the 1870s and 1880s. But the print market for popular favourites was to continue to enhance their painters' earnings for a few more years, until supplanted by the chromo-lithograph, which could be reproduced more cheaply and in even greater numbers. The most idiosyncratic 'success' story, in financial terms, was Edwin Long's sale of his large *The Babylonian Marriage Market* from the Academy of 1875 to Edward Hermon, M.P., for £7,350. Seven years later it achieved a record sale-room price for a living English painter of £6,615 when it was bought at Christie's by the patent-medicine tycoon, Thomas Holloway, eventually to adorn the women's college of higher education which bears his name. In addition to work by Luke Fildes, Hull, MacWhirter, and many other Victorians, Holloway also bought a fine Dedham landscape by Constable for £1,250 and Gainsborough's grand *Peasants Going to Market* of c. 1770 for £2,835 in 1883.

As to the earlier generation of major British painters, Constable and Turner prices remained firm if not spectacular to the end of the century, but were overshadowed by the popularity of the Barbizon School and later the Impressionists. At the important Joseph Gillott sale of 1872, Constable's *Weymouth Bay* was sold for £735 (to be given in 1873 to the Louvre by John Wilson), Turner's *Walton Bridges* (acquired by the National Gallery of Victoria, Melbourne, for £3,675 in 1917) fetched £5,250, and the *Kilgarran Castle* was bought by the Metropolitan Museum, New York, for £2,835. Turner's water-colours were even more highly prized: *Bamborough Castle* was bought by the Earl of Dudley for £3,307. 10s., and the *Heidelberg* and *Ehrenbreitstein* water-colours each fetched £2,782. 10s. Three years later Lord Dudley bought from Agnew for £8,085 the *Grand Canal and Rialto* (a mark-up of £735 on the sale-room price), and in 1885 Cornelius Vanderbilt was said to have paid the Dudley heirs £20,000 for it. Not until Frick purchased *Mortlake Terrace* (R.A. 1826) for about £30,800 in 1913

was the peak of the American market for Turner reached, while in 1927 a sale-room record price of £30,450 was achieved by *Venice, the Dogana and Salute*, sold at Christie's from James Ross's collection. Constable's *Stratford Mill: The Young Waltonians*, which in 1895 fetched £8,925 at the Charles Frederick Huth sale, went for £43,050 in 1946 at Christie's, but in 1935 the National Gallery was able to buy an important work like the full-scale oil sketch for *Hadleigh Castle* from Percy Moore Turner for a modest £10,000.

Yet there was one class of British painting which did reach a quite extraordinary level of popularity among American millionaires. This was the grand full-length portrait or portrait group of which Gainsborough, Reynolds, and Romney were the pre-eminent exponents—although major works by Hoppner, Lawrence, and Raeburn were also much sought after, in a market created by Samson Wertheimer in the 1890s. This market was well cultivated by Joseph Duveen Junior in his boom years as a dealer, only to be curtailed during the general economic slump of the early 1930s. There is no simple explanation for the revival of interest in the eighteenth century during the latter part of the nineteenth century. The collecting activities of John Bowes and of his French-born wife, Josephine, fall mainly in the period of their residence in France, 1847–74, but the design and construction of the Bowes Museum at Barnard Castle in the grandest French Second Empire style took from 1869 to the year of its opening in 1892. In addition to magnificent collections of French and English decorative art, the Boweses assembled some superlative examples of French, Spanish, and Italian painting, with particular but by no means exclusive emphasis on the eighteenth-century masters.[1] It is significant that Baron Ferdinand de Rothschild, like other members of the family, greatly admired the opulence of French mid-eighteenth-century decorative art and painting. Although born in Paris, he was educated in Vienna, and in 1860, at the age of twenty-one, settled permanently in England. The main part of Baron

[1] Eric Young, *Catalogue of the Spanish and Italian Pictures, Bowes Museum*, County Council of Durham (1970), for evidence of the richness of these collections. The architect of the Bowes Museum was the Frenchman J.-A.-F.-A. Pellechet.

Ferdinand's French Renaissance château, Waddesdon Manor, was completed by H.-A.-G.-W. Destailleur between 1874 and 1880, and owes much to Chambord and Blois, with, as Pevsner observes, 'more than a dash of Louis XIII in the mixture'. The house is filled with *boiseries* from French town houses and villas, which provide a magnificent setting for the furniture and *objets d'art*.[1] The Rothschild's chief rival in this field had been the Marquess of Hertford, who also lived most of his life in Paris. There he amassed his collections from 1842 until his death in 1870, when they passed to his natural son, Sir Richard Wallace. In this context, too, the choice collection of predominantly French eighteenth-century painting, furniture, porcelain, and *objets d'art* formed by the prosperous military tailor, John Jones, has a special significance. Of obscure origins, Jones belonged to the newly emerging class of self-made men, but he showed singular refinement of taste and his memorial is the Jones Bequest to the Victoria and Albert Museum of 1882.[2] It has been suggested by Reitlinger that the buying of English portraits had a snobbish reason, whilst French art was bought for its decorative qualities, and the twin demands helped stimulate the market for both genres. But ancestor-worship could hardly have persuaded hard-headed men of business such as Frick and Henry Huntington to bid against each other: it was the obligations of prestige, not nobility, that spurred them on. As we shall see, the results were startling.

At first, in the early 1870s, Gainsborough landscapes fetched more than his portraits, but the trend was reversed in 1873 when Colonel Townley sold *The Misses Ramus* for £6,615, while, in 1875, *Cornard Wood*, admittedly an early landscape, was bought by the National Gallery for £1,207. 10s. A year later, Agnew successfully bid against the Earl of Dudley at Christie's for the Wynn Ellis *Duchess of Devonshire* at a price of £10,605.[3] The next

[1] See *Apollo* CV (June 1977), where the founder of Waddesdon, aspects of his collections, and the building which houses them are discussed in an editorial and sixteen articles.

[2] Denys Sutton, Peter Thornton, and others in a special number devoted to the Jones Collection, *Apollo* XCV (Mar. 1972), 156–211.

[3] This notorious picture was soon afterwards bought by Junius Spencer Morgan, only to be stolen before it could be delivered to its new owner. It reappeared in

landmark was Samson Wertheimer's bid of £11,150, in 1894, for a large Reynolds group of *Mrs. Delmé and her Children*, on behalf of James Pierpont Morgan, Senior. It would be tedious to recount, bid by bid so to speak, the rapid inflation of this market, but a few once-famous transactions will set the scene well enough. Romney's large group of the *Spencer Sisters, Allegory of Music and Painting* was bought by Wertheimer in 1896 for £11,025; but in 1914 Agnew bought privately, for Henry Huntington, Romney's *Penelope Lee Acton* for £45,000, a price only exceeded by Andrew Mellon's purchase of the same artist's *Mrs. Davenport* in 1926 for about £70,000. These were indeed the golden years for the English eighteenth-century grand manner, and the Duke of Westminster's sale to Duveen in 1921 of two famous Gainsboroughs, *Jonathan Buttall* ('*The Blue Boy*') and *The Cottage Door*, as well as Reynolds's *Mrs. Siddons, The Tragic Muse*, are a high-water mark of Duveen's activities in this field. He sold all three to Henry Huntington: *Jonathan Buttall* for £148,000 (the price he had paid the Duke of Westminster for both Gainsboroughs); the Gainsborough landscape and the Reynolds *Mrs. Siddons* for £73,500 each. These were sums well above the Colonna and the smaller Panshanger Raphaels sold to Pierpont Morgan and P. A. B. Widener in 1901 and 1913 at £100,000 and £116,500 respectively. Duveen's later dealings with Andrew Mellon may well have involved six-figure sums for the Gainsborough portrait of *Mrs. Sheridan* and the original *Duchess of Devonshire* from Althorp. It is some consolation that with profits of this order Duveen was enabled—and perhaps felt some moral obligation—to endow the Tate Gallery so generously.

What was the fate of living artists against this background of high finance dealing, and at a time long before the Council for the Encouragement of Music and the Arts (C.E.M.A.) and its successor, the Arts Council of Great Britain, were born? We have seen how some Academicians fared, and the contents of Sargent's studio, some 160 pictures and studies, were sold after his death in 1925 for £146,000. Whistler had had his times of acute financial

1901. An account is given by Geoffrey Agnew, *Agnew's 1817–1967* (1967), 77–86, of this picture's chequered career.

stress, especially after quarrelling with his most generous patron, F. R. Leyland, in 1877, but he made a livelihood from the sale of his etchings and lithographs, as well as from portrait painting in the 1880s and 1890s. Sickert and Steer never attained the Academicians' degree of wealth. Sickert was quite incapable of managing his affairs, and would either sell batches of pictures for ridiculously low sums, or refuse to allow collectors to see his work. His relationship with dealers was equally capricious until the Leicester Galleries took him under its wing in his later years.[1] One patron who bought Sickerts between 1910 and 1926 was Lord Henry Cavendish Bentinck—usually direct from the artist or through whichever dealer he was exhibiting with at the time.[2] Steer's patrons included Sir Augustus Daniel, who was one of the first to buy his work, Sir Cyril Butler (from 1897), and George Healing. Another collector who bought actively was J. L. Behrend, especially work by Stanley Spencer, whom he had supported since 1914; while Hugh Blaker, Michael Sadler, and Hugh Walpole had all begun collecting work by young contemporary artists before the First World War.[3] But the man who most consistently supported contemporary painters was the senior civil servant Edward Marsh, who, by a quirk of history, had inherited an allowance which enabled him to follow his other career as a collector. Sickert, Stanley Spencer, Grant, Gertler, Matthew Smith, and John and Paul Nash are only a few of the well-known artists whose work he bought.[4] The list is also significant for its omissions. No work by Wyndham Lewis, Nevinson, or Epstein, and none by the new generation led by Moore and Nicholson. Clearly, Marsh preferred the *belle peinture* tradition and had no

[1] Marjorie Lilly, *Sickert: the Painter and his Circle* (1971), 29–39.

[2] *Tate Gallery Modern British School Catalogue*, II (1964), nos. 5086–96. Henry Cavendish Bentinck also bought work by Spencer Gore, Henry Lamb, and Augustus John.

[3] The exhibitions of work from these collections give a useful survey of the range of each of these collectors' activities: *The Hugh Blaker Collection*, Platt Hall, Rusholme, Manchester (May–June 1929); *Hugh Walpole's Collection*, French Gallery (May–June 1937); *Selected Paintings, Drawings and Sculpture from the collection of the late Sir Michael Sadler*, Leicester Galleries (Jan.–Feb. 1944).

[4] Edward Marsh, *A Number of People* (1939) and *The Collection of the late Sir Edward Marsh*, Leicester Galleries (May 1953) and Tate Gallery (Nov.–Dec. 1955).

sympathy for abstract or violently expressionist art. He shared this taste with the painter Edward Le Bas, whose own large collection of modern British and foreign artists' work was formed with rare judgement and consistency. Le Bas's taste was more catholic than Marsh's, and, although strong on Camden Town painters, ranged widely enough to include Vuillard, Matisse, Klee, Léger, and Picasso.[1] Of the dealers' galleries prepared to sponsor the young and promising, mention must be made of the Goupil Gallery and the Carfax Gallery, which pursued an adventurous policy before and after the First World War, and the Leicester Galleries, directed with great perception by Oliver Brown in unpretentious surroundings in a small gallery off Leicester Square. Cézanne, Van Gogh, Gauguin, Pissarro, Picasso, and Matisse were all given their first 'one-man' shows at the Leicester Galleries,[2] and, for British artists especially, a series of exhibitions, 'Artists of Fame and of Promise', were devised in which, as the title suggests, the established were mixed with the new hopefuls on equal terms. Arthur Tooth & Sons also played an important role in promoting new artists, under the direction of Dudley Tooth. Stanley Spencer and Matthew Smith were two of the Tooth stable of painters. The boom in modern etchings and engravings is another feature of the period 1900–30, brought to a jarring halt by the depression of 1929–30. Besides major talents in this field like Augustus John, Bone, Cameron, Strang, Francis Dodd, and Henry Rushbury, many minor figures were treated to *catalogues raisonnés* by Harold Wright of the British Museum Print Room. In Paris, Stanley William Hayter gave a fresh impetus to printmaking and explored new techniques at his Atelier 17, which he founded in 1927. This was to become an important training ground for artists of many nationalities.

The next generation of painters looked to Dorothy Warren, Freddy Mayor, Rex Nan Kivell (of the Redfern Gallery), and Lucy Wertheim among the dealers; and among collectors, Kenneth Clark, Colin Anderson, W. A. Evill, and Jack Pritchard. The list cannot be exhaustive, but Clark and Anderson were undoubtedly

[1] *A Painter's Collection: an exhibition . . . from the collection of Edward Le Bas, R.A.*, Royal Academy of Arts (1963).

[2] Early, pre-Cubist, work by Picasso had been shown at the Stafford Gallery (April 1912), see p. 201.

the mainstay of the Euston Road painters, and of Moore, Piper, and Sutherland. At one stage, Clark made a regular allowance to four or five painters, in strict secrecy, and began collecting contemporary painting in 1928, when he bought his first Moore drawing from the Warren Gallery exhibition. A friendship followed, and Clark bought some thirty drawings and a half a dozen pieces of sculpture over the next few years.[1] He also bought in 1930 the first Pasmore ever sold in a public exhibition, the first of many he was to own. He recalls seeing his first Graham Sutherland in 1933, and was so impressed that he bought all the work the artist then had for sale. They were, he said, such a welcome contrast to the austere mood of the Euston Road Group. Early collages and Welsh landscapes by Piper also appealed to him. In the mid-1940s he gave the Contemporary Art Society one hundred pictures for distribution to provincial museums: among them were ten Pasmores, a dozen Sutherlands, three Ben Nicholsons, and many Euston Road pictures. As chairman of the War Artists' Advisory Committee in 1939 he was able to exert considerable patronage. 'We employed every artist whom we thought had any merit, not because we supposed that we would get records of the war more truthful or striking than those supplied by photography, but because it seemed a good way of preventing artists being killed.'[2] Ten thousand works thus accumulated fall outside the scope of this volume.

Colin Anderson began collecting in 1932, the year of his marriage, and did so to embellish his home—like a bower-bird, as he put it.[3] It was also a spontaneous response to works of art, and he bought direct from the artist wherever possible. His tastes, like those of any collector, changed and developed over the years, but

[1] In a letter to the author, 4 Feb. 1975, Lord Clark amplified the accounts given in his autobiography, *Another Part of the Wood*, 192, 251–7, and in the interview published in the *Sunday Times Magazine* (6 Oct. 1974), 33–41. In passing, it may be noted that he and Lady Clark also bought Cézanne, Renoir, Seurat, Matisse, and Bonnard during the early 1930s.

[2] Letter, 4 Feb. 1975. The W.A.A. Committee consisted of Clark, Muirhead Bone, Randolph Schwabe, Percy Jowett, and Walter Russell.

[3] Letter to the author, 19 Nov. 1974. *The Private Collector: an Exhibition of Pictures and Sculptures Selected from the Members of the Contemporary Art Society's Own Collections*, Tate Gallery (Mar.–Apr. 1950), gives an interesting insight into what had been collected and by whom.

up to 1940 he considered the paintings, drawings, and sculpture by Sutherland and Moore to be among his most satisfying acquisitions. However, his taste ranged widely and included artists as different from each other as Richards, Bacon, Piper, Colquhoun, MacBryde, and Coldstream. Edward James was another young collector whose tastes radically changed in 1932 following his marriage the previous year to the dancer and ballerina, Tilly Losch. But it was his first experience of the work of Salvador Dali that led to his keen interest in the Surrealists, particularly those who specialized in the minutely exact representation of irrational images. About 1935–6, James offered Dali a handsome retainer in exchange for his total output up to the outbreak of war in 1939, and he now owns over one hundred works by Dali. He has also formed a considerable collection of paintings by Magritte, from whom he commissioned three pictures for the dining-room of his London house at 35 Wimpole Street in 1937. Among other Surrealist artists whose work he has collected are Ernst, de Chirico, Pavel Tchelitchew, and Paul Delvaux.[1] Roland Penrose, too, usually bought from the artist, but in two instances he acquired ready-made collections on favourable terms. The first was René Gaffé's collection of some thirty paintings by Picasso, Miró, de Chirico, and others, soon after its showing at the Zwemmer Gallery in 1937; the other was Paul Éluard's in 1939.[2] Éluard's collection contained superlative work by Ernst, Dali, Magritte, and Klee, and some interesting ethnographic pieces. Penrose's close involvement with the Surrealists has already been discussed, but in his early years as a painter in Paris he had limited means, and only began collecting seriously on his return to England in 1935. He recalls one acquisition with particular affection— Picasso's *Woman Weeping*, bought from the artist before the paint was thoroughly dry, in 1937.

The role of the art historian, as distinct from such connoisseur-historians as Iolo Williams or Paul Oppé, has been mentioned as a factor in the collecting of Old Masters. But it was not until Sep-

[1] Martin Battersby, *The Decorative Thirties* (1969), 137, 149, 155–7; L. M. Bickerton, 'The Edward James Collection of Surrealist Paintings', in *The Edward James Collection: Dali, Magritte and other Surrealists*, Scottish National Gallery of Modern Art, Edinburgh (Aug.–Sept. 1976), 1–2. [2] Letter to the author, 24 Oct. 1974.

tember 1929 that Samuel Courtauld, urged on by Lord Lee of Fare-
ham, offered to endow a department of the University of London
where the history of art could be studied as a fully-fledged academic
discipline. His offer was accepted in the following year, and in 1932
he made over his house at 20 Portman Square for the use of the
new Institute.[1] Courtauld was probably most in sympathy with
the idea of fostering humanist scholarship and a deeper appreciation
of the fine arts, and saw the Courtauld Institute of Art as a centre
for this. Across the Square at No. 32, Robert Witt housed his
collection of Old Master drawings (which he had begun to collect
in the early 1920s) and an incomparable photographic archive he
had started by 1902, both destined for the Courtauld Institute.
Although art history had for long been an established academic
discipline in Europe, first at the University of Berlin in 1844 when
G. F. Waagen was appointed to the new chair of art history, then
in 1852 at Vienna where Rudolf von Eitelberger von Edelberg
became Professor, in this country the subject was not so studied
at our universities. The Slade Professorships at Oxford and Cam-
bridge provided a historical approach distinct from the practical,
art-school training carried out by the Slade Professor at London
University. All three Slade chairs had been founded in 1870
under the will of Felix Slade, but at Oxford and Cambridge, apart
from Ruskin and Fry, the earlier incumbents were to do little to
advance and sustain the study of art history. The Slade Professor-
ships were valuable adjuncts to the older universities rather than
keystones of specialist departments. The Watson Gordon Chair
of Fine Art at Edinburgh University, established in 1872 but not
filled until 1880, is arguably the first full-time chair of art history
in a British university, and the Deed of Foundation specifically
states that the Watson Gordon Professor 'should be bound to give
a course of instruction by lectures during the University session
on the History and Theory of the Fine Arts including Painting,
Sculpture and Architecture and other branches of art therewith

[1] Peter Lasko, *The Courtauld Institute of Art and Art History in Britain* (a talk
given to the Friends of the Courtauld Institute, 3 Mar. 1975), recounts the stages
leading to the foundation of the Courtauld Institute, at which the first students
began their studies in October 1932.

connected'.[1] Gerald Baldwin Brown, the first Watson Gordon Professor, by concentrating on the surviving material evidence, was closer to the archaeologist in his attitude to art history.

Generally speaking, the fact that distinguished French, German, and Austrian scholars, in particular, had already established rigorous standards of art-historical scholarship and methodical analysis with a formidable array of published work as evidence was either not known to, or dismissed by, some senior British dons who questioned the academic respectability of art history. Yet there were eminent British-born art historians, of whom Fry, MacColl, Charles Bell, T. S. R. Boase, W. G. Constable, T. D. Kendrick, Eric Mac-Lagan, A. E. Popham, and David Talbot Rice formed the vanguard of what was to become a considerable army. Heavy reinforcements, to pursue the military metaphor, were soon at hand. The famous Bibliothek Warburg, founded by Aby Warburg of Hamburg as Die Kulturwissenschaftliche Bibliothek Warburg, had become a target for the Nazis in 1933, and its Director, Fritz Saxl, looked to England for help. Again, Lord Lee took swift action, brought the Library to London, and eventually persuaded the University of London to adopt it as the Warburg Institute.[2] The study of *Das Nachleben der Antike*—for which there is no adequate English translation: 'the history of the classical tradition' does not convey the full meaning of the German original—has been immeasurably enriched by the learning of the Institute's staff. A publication by two of its members of particular significance for this country was Fritz Saxl and Rudolf Wittkower's *British Art and the Mediterranean* (1948). Scholars of this calibre, by their presence and work in England at a critical time, not only quickly dispelled any lingering doubts about the academic credentials of art history but also set it in the context of a much wider humanist study.

[1] Giles Robertson, *Artist and Art Historian: an inaugural lecture*, Edinburgh (privately printed 1972), 8–13, 27–30. I am indebted to Professor Robertson, the fourth holder of the Watson Gordon Chair, for drawing my attention to this account of its foundation and subsequent development.

[2] Kenneth Clark, op. cit. 207–8. I must also thank Professor Sir Ernst Gombrich for information about the German and Austrian antecedents of the study of art history, and for his comments about Warburg's intentions in founding the Bibliothek Warburg.

BIBLIOGRAPHY

THERE has been a rapid increase in the amount of published research on English art, particularly for the period since 1800, during the past fifteen years or so. This select bibliography is intended only as a guide to the most important sources for the study of English art 1870–1940. References to the literature on individual artists and specific topics are given in footnotes at appropriate places in the main text, although certain key general histories are also given below in that section of the bibliography.

It would be impracticable to list separately all the periodicals consulted and cited in the footnotes, but the *Architectural Review* and the *Studio Yearbooks of Decorative Art* are of particular importance for their subjects in this period.

The reader is referred to subject bibliographies contained in standard works wherever appropriate.

Unless otherwise stated, the place of publication is London.

BIBLIOGRAPHIES AND DICTIONARIES

BÉNÉZIT, E. *Dictionnaire des peintres, sculpteurs, dessinateurs et graveurs*, 10 vols. (new edn., Paris, 1976).

Courtauld Institute of Art, University of London, *Annual Bibliography of the History of British Art*, Cambridge, I, 1934 (1936) to VI, 1946–8 (2 parts, 1956). Useful for secondary literature on 19th- and 20th-century architecture, painting, sculpture, graphic and decorative arts, but inevitably reflects the greater interest in earlier periods at the time of publication

JOHNSON, J., and GREUTZNER, A. *The Dictionary of British Artists 1880–1940* (1976).

PEVSNER, N., FLEMING, J., and HONOUR, H. *A Dictionary of Architecture* (1972).

THIEME, U., and BECKER, F. (eds.). *Allgemeines Lexikon der bildenden Künstler*, 37 vols., Leipzig (1907–50). A new edition is in preparation.

VOLLMER, H. *Allgemeines Lexikon der bildenden Künstler des XX. Jahrhunderts*, 5 vols. and suppl., Leipzig (1953–62). The entries devoted to British artists need to be supplemented by reference to the Tate Gallery catalogues and reports.

WATERS, GRANT M. *Dictionary of British Artists working 1900–1950*, 2 vols., Eastbourne (1976).

CATALOGUES

CHAMOT, MARY, FARR, DENNIS, and BUTLIN, MARTIN. *Tate Gallery Catalogues: the Modern British Paintings, Drawings and Sculpture*, 2 vols. (1964). A most important source for biographical and other often previously unpublished information about artists born in or after 1850, and their work, represented in the Tate Gallery collections, with comprehensive bibliographies listing literature published up to the early part of 1964. It must also be supplemented by reference to the *Tate Gallery Annual Reports* (1964–7) and the *Tate Gallery Biennial Reports* (1968–70, 1970–2, etc.). Interim annual catalogues of new acquisitions have been published by the Tate Gallery since 1969. Only the principal monographs and 'one-man' exhibitions which have appeared since the 1964 *Tate Gallery Modern British Catalogue* are listed below. There are, as yet, few comparable modern *catalogues raisonnés* for the permanent collections in our major provincial museums and galleries.

COOPER, DOUGLAS. *The Courtauld Collection* (1954), with a list of corrigenda and supplementary information published by Cooper in *Burl. Mag.* XCVI (1954), 121. The Introduction contains the first detailed scholarly account of the impact of Impressionism on British artists and collectors.

DAVIES, MARTIN. *National Gallery Catalogues: the British School* (1946) for information about works by J. McN. Whistler subsequently transferred to the Tate Gallery before the second revised edition was published in 1959.

RITCHIE, ANDREW CARNDUFF. *Masters of British Painting, 1800–1950*. Museum of Modern Art, New York (1956).

Royal Academy of Arts: Bicentenary Exhibition 1768–1968, 2 vols. Royal Academy of Arts (1968).

SUTTON, DENYS. *British Art 1890–1928*. The Columbus Gallery of Fine Arts, Columbus, Ohio (1974).

Ten Decades: a Review of British Taste, 1851–1951, Institute of Contemporary Arts and Arts Council of Great Britain (1951).

The series of *Decade* touring exhibitions are also valuable. The first of these, *British Art and the Modern Movement 1930–40*, was organized by Tom Cross for the Welsh Arts Council at the National Museum of Wales (1962); to be followed by four organized by Alan Bowness and various collaborators for the Arts Council of Great Britain: *Decade 1910–20* (1965), *Decade 1890–1900* (1967), *Decade 1920–30* (1970), and *Painting, Sculpture and Drawing in Britain 1940–49* (1972–3).

For ease of reference, the principal thematic exhibitions organized since 1950 are listed under the section devoted to Movements of Art and Artistic Theory, and one-man retrospective or commemorative exhibitions appear under Monographs and Other Works of Reference.

GUIDES AND SURVEYS

Sir Nikolaus Pevsner's magnificent series, *The Buildings of England*, 46 vols., Harmondsworth (1951–74), of which he has written many volumes himself and edited all of them, is invaluable, especially as he and his collaborators discuss many twentieth-century buildings, although there are some omissions. Andor Gomme and David Walker's *Architecture of Glasgow* (1968) is the first major survey of the city and, less ambitious but useful, are: J. Quentin Hughes, *Liverpool* (1969), Derek Lindstrum, *Historic Architecture of Leeds* (1969), Ian Nairn, *Modern Buildings in London* (1964), and Dennis Sharp (ed.), *Manchester* (1969).

GENERAL HISTORIES

FERRIDAY, PETER (ed.). *Victorian Architecture* (1963).

GERTZ, ULRICH. *Plastik der Gegenwart*, Berlin (1953, translated as *Contemporary Plastic Art*, 1955).

HAFTMANN, WERNER. *Painting in the Twentieth Century*, 2 vols. (1960, also revised paperback edns.).

HAMILTON, GEORGE HEARD. *Painting and Sculpture in Europe 1880–1940*, Harmondsworth (1967, revised paperback edn. 1977).

HARDIE, WILLIAM. *Scottish Painting 1837–1939* (1976).

HITCHCOCK, HENRY-RUSSELL. *Architecture Nineteenth and Twentieth Centuries*, Harmondsworth (1958, 3rd edn. 1969, revised paperback edn. 1977).

HUBBARD, HESKETH. *A Hundred Years of British Painting* (1974).

IRWIN, DAVID and FRANCINA. *Scottish Painters at Home and Abroad 1700–1900* (1975).

KIDSON, PETER, MURRAY, PETER, and THOMPSON, PAUL. *A History of English Architecture*, Harmondsworth (1965).

MARYON, HERBERT. *Modern Sculpture* (1933).

MUTHESIUS, HERMANN. *Die englische Baukunst der Gegenwart. Beispiele neuer englischer Profanbauten*, 2 vols., Leipzig and Berlin (1900).

—— *Die neuere kirchliche Baukunst in England*, Berlin (1900).

—— *Das englische Haus*, 3 vols., Berlin (1904–5).

PEVSNER, NIKOLAUS. *An Outline of European Architecture*, Harmondsworth (1942, 7th revised edn. 1968–70, reprinted 1973).

PIPER, DAVID (ed.). *The Genius of British Painting* (1974).

READ, HERBERT. *The Art of Sculpture* (1956).

RICHARDS, J. M. *An Introduction to Modern Architecture*, Harmondsworth (1940, reprinted with revisions 1970).

RUSSELL, JOHN. *From Sickert to 1948. The Achievement of the Contemporary Art Society* (1948).

SERVICE, ALASTAIR (ed.). *Edwardian Architecture and its Origins* (1975). Includes new material, as well as reprinting earlier articles from the *Architectural Review* and elsewhere.

WHITTICK, ARNOLD. *European Architecture in the Twentieth Century* (1974).

Almost all the above contain good bibliographies. The *Pelican History of Art* volumes by Hamilton and Hitchcock, and Haftmann's two-volume history are essential reading, as the authors discuss British art and architecture in an international context. Ferriday, Muthesius, and Service are also key works for architecture.

MOVEMENTS OF ART AND ARTISTIC THEORY

Abstract Art in England 1913–1915, d'Offay Couper Gallery (1969), with introd. by Anthony d'Offay.

Art in Britain 1930–40 centred around Axis, Circle, Unit One, Marlborough Fine Art Ltd. (1965).

Art Nouveau in Britain, Arts Council (1965).

Art Nouveau in England und Schottland, Karl-Ernst-Osthaus-Museum, Hagen (1968).

The Arts and Crafts Movement. Artists, Craftsmen & Designers 1890–1930, Fine Art Society (1973).

ASLIN, ELIZABETH. *The Aesthetic Movement: prelude to Art Nouveau* (1969).

BANHAM, REYNER. *Theory and Design in the First Machine Age* (1960).

BATTERSBY, MARTIN. *The Decorative Twenties* (1971).

—— *The Decorative Thirties* (1969).

Birmingham Gold & Silver 1773–1973. An exhibition to celebrate the Bicentenary of the Assay Office, Birmingham Museum and Art Gallery (1973).

British Sources of Art Nouveau: an exhibition of 19th & 20th century British textiles and wallpapers, Whitworth Art Gallery, Manchester (1969).

BYWATER, WILLIAM G., JR. *Clive Bell's Eye*, Wayne State University Press, Detroit (1975).

CORK, RICHARD. *Vorticism and Abstract Art in the First Machine Age*: I. *Origins and Development* (1975), II. *Synthesis and Decline* (1976).

—— *Vorticism and its allies*, Arts Council (1974).

ELSEN, ALBERT E. *Origins of Modern Sculpture: Pioneers and Premises* (1974). Developed from the Arts Council exhibition, *Pioneers of Modern Sculpture* (1973).

English Influences on Vincent Van Gogh, Arts Council and University of Nottingham (1974–5). Useful survey of popular graphic illustration in the early 1870s.

FISHMAN, SOLOMON. *The Interpretation of Art*, University of California Press (1963). Perceptive essays on the aesthetic ideas of Ruskin, Pater, Clive Bell, Roger Fry, and Herbert Read.

GASCOYGNE, DAVID. *A Short Survey of Surrealism* (1970, reprint of *What is Surrealism?* 1935).

GIROUARD, MARK. *Sweetness and Light. The 'Queen Anne' Movement 1860–1900*. Oxford University Press (1977).

HILLIER, BEVIS. *The World of Art Deco* (1971, reprinted 1974). First published as exhibition catalogue for the Minneapolis Institute of Arts.

HITCHCOCK, HENRY-RUSSELL. *Modern Architecture in England*, Museum of Modern Art, New York (1937, reprinted 1969).

The Impressionists in London. Arts Council (1973), with introd. by Alan Bowness.

LETHABY, W. R. *Architecture, Mysticism and Myth* (1892, reprinted 1974) with introd. and bibliog. by G. Rubens.

Liberty's 1875–1975. An exhibition to mark the firm's centenary, V. & A. (1975).

LIPKE, WILLIAM C. 'A History and Analysis of Vorticism', Ph.D. Dissertation, Ann Arbor University, Michigan (1966).

LUMSDEN, IAN G. *Bloomsbury Painters and their Circle*, Beaverbrook Art Gallery, Fredericton, New Brunswick (1976–7).

MACCARTHY, FIONA. *All Things Bright and Beautiful* (1972, reprinted as *A History of British Design 1830–1970*, 1979).

Catalogue of A. H. Mackmurdo and the Century Guild Collection, William Morris Gallery, Walthamstow (1967).

MACLEOD, ROBERT. *Style and Society: architectural ideology in Britain 1835–1914* (1971).

MADSEN, STEPHAN TSCHUDI. *Sources of Art Nouveau*, Oslo (1956).

MARTIN, MARIANNE W. *Futurist Art and Theory 1909–1915*, Oxford University Press (1968).

MICHEL, WALTER, and FOX, C. J. (eds.). *Wyndham Lewis on Art* (1971).

NAYLOR, GILLIAN. *The Arts and Crafts Movement. A study of its sources, ideals and influence on design theory* (1971).

'From today painting is dead.' The beginning of photography, V. & A. (1972).

PEVSNER, NIKOLAUS. *Pioneers of the Modern Movement. From William Morris to Walter Gropius* (1936, reprinted with revisions by Museum of Modern Art, N.Y., as *Pioneers of Modern Design* 1949, and by Pelican Books 1960).

—— *An Enquiry into Industrial Art in England*, Cambridge University Press (1937).

—— and RICHARDS, J. M. (eds.). *The Anti-Rationalists* (1973, reprinted as paperback 1976).

PHYSICK, JOHN, and DARBY, MICHAEL. *'Marble Halls.' Drawings and Models for Victorian Secular Buildings*, V. & A. (1973).

READ, HERBERT. *Art Now. An Introduction to the Theory of Modern Painting and Sculpture* (1933, 3rd edn. 1958, revised 1960).

—— *Art and Industry. The Principles of Industrial Design* (1934, 5th edn. 1966).

The Real Thing. An Anthology of British Photographs 1840–1950, Arts Council (1975–6).

REWALD, JOHN. *The History of Impressionism*, New York (1946, 4th rev. edn. 1973).

—— *Post-Impressionism: from Van Gogh to Gauguin*, New York (1956).

SCHARF, AARON. *Art and Photography* (1968, rev. edn. 1974).

SCHMUTZLER, ROBERT. *Art Nouveau* (1964).

SELZ, PETER, and CONSTANTINE, MILDRED (eds.). *Art Nouveau. Art and Design at the Turn of the Century*, New York (1959, reprinted 1972).

SHONE, RICHARD. *Bloomsbury Portraits. Vanessa Bell, Duncan Grant & their Circle* (1976).

Les Sources du XXe siècle: les arts en Europe de 1884 à 1914, Council of Europe, Paris (1960).

SPENCER, ROBIN. *The Aesthetic Movement: theory and practice* (1972).

The Sacred and Profane in Symbolist Art, Art Gallery of Ontario, Toronto (1969), with contributions by Mario Amaya, Luigi Carluccio, and Simon Watson Taylor.

Le Symbolisme en Europe, Rotterdam, Brussels, Baden-Baden, and Paris (1975–6), with contributions by Hans Hofstätter, Franco Russoli, and Geneviève Lacambre. Detailed bibliography and chronological list of exhibitions.

From Realism to Symbolism: Whistler and his World, Wildenstein Inc., New York (organized by Department of Art History & Archaeology, Columbia University, N.Y.C., in collaboration with Philadelphia Museum of Art, 1971).

Victorian Church Art, V. & A. (1971).

Victorian and Edwardian Decorative Arts, V. & A. (1952).

Victorian and Edwardian Decorative Art. The Handley-Read Collection, Royal Academy of Arts in collaboration with V. & A. (1972). This and the two foregoing exhibitions contain much new research on many aspects of the decorative arts in Britain between 1837 and 1930.

CONTEMPORARY SOURCES

Much of the period under review is still within living memory of many of the people who took an active part in the art and architecture of this country, or of their friends and relatives. Wherever possible these primary sources have been tapped, and acknowledgements made at the appropriate place in the main text or in accompanying footnotes. In addition to this archive material in the author's possession, there is a considerable amount of first-hand information in the archives of the Tate Gallery, much of it published in the *Modern British School Catalogue* of 1964 and in its Annual and, latterly, Biennial Reports. Other source material, such as the records of British commercial galleries and art societies which are now defunct, as well as

artists' letters, press cuttings, unpublished memoirs, and related matter, has been consistently collected since 1953 (see *The Tate Gallery Review 1953–1963* (1963), 17–18, for a representative list of some of the more important earlier additions to the archive). The Paul Nash Trustees have deposited material at the National Art Library, Victoria and Albert Museum, and at the Tate Gallery; Miss Felicity Ashbee has also deposited the typescript Memoirs of her father, C. R. Ashbee, with the Victoria and Albert Museum. Another important set of personal papers (in no fewer than five tea-chests) belonging to D. S. MacColl was given by his son, the late René MacColl, to Glasgow University in 1968, and, apart from some Wilson Steer material published by Dr. Bruce Laughton, has still to be made fully accessible to scholars. For architecture, the Drawings Collection of the Royal Institute of British Architects contains much primary material of all periods, including, for example, personal papers and photographs belonging to C. F. A. Voysey, donated by his son. Many museums, galleries, and public libraries outside London also have valuable archives relating to their collections or to the history of artists and architects who worked in the locality.

Of the published material available at the Victoria and Albert Museum and at the Tate Gallery, contemporary British and foreign periodicals and exhibition catalogues form the two basic sources for the historian. It would be otiose to attempt to list all the relevant periodicals, but the *Art Journal* (until 1912), the *Magazine of Art* (1878–1904), the *Studio* (1893– : from June 1964 *Studio International*), the *Architectural Review* (1896–), the *Builder* (1843–1966), the *Architect* (1869–1926): subsequently the *Architect and Building News* (1926–), and the *Journal of the Royal Institute of British Architects* (3rd series 1893–) are the principal journals. Artists' and art critics' autobiographies, published lectures, and contemporary or near contemporary monographs often contain information and opinions not readily available elsewhere, but these often need to be viewed with a certain critical perspective. No less important are artists' manifestos, of which the two volumes of *BLAST* (1914 and 1915) are among the first and most significant English examples of this twentieth-century phenomenon, to be followed by *Unit One* (1934) and *Circle* (1937, reprinted 1971).

MONOGRAPHS AND OTHER WORKS OF REFERENCE

For those artists whose earlier careers are also discussed in Boase, O.H.E.A. X (1959), readers are referred to the bibliographical notes in that volume, but a selection of the more important recent publications is given below.

ALISON, FILIPPO. *Charles Rennie Mackintosh as a Designer of Chairs*, Milan–London (1974).

Sir Lawrence Alma-Tadema, Sheffield (1976).

ARCANGELI, FRANCESCO. *Graham Sutherland*, Milan (1973) and New York (1975).

ARGAN, G. C. *Henry Moore*, Milan (1971).

John Armstrong 1893–1973, Arts Council and Royal Academy (1975).

ASLIN, ELIZABETH. *Nineteenth Century English Furniture* (1962).

BARON, WENDY. *Sickert* (1973).

BEHRMAN, S. N. *Duveen*, New York (1952).

BEVAN, R. A. *Robert Bevan, a memoir by his son* (1965).

BLUNT, WILFRID. *'England's Michelangelo'. A biography of George Frederic Watts* (1975).

BOWNESS, ALAN (ed.), and ROSENTHAL, T. G. *Ivon Hitchens* (1973).

Catalogue of the Works of Sir Frank Brangwyn R.A. 1867–1956, William Morris Gallery, Walthamstow (1974).

BROCKMAN, H. A. N. *The British Architect in Industry 1841–1940* (1974).

BROPHY, BRIGID. *Portrait of Aubrey Beardsley: 'Black and White'* (1968).

—— *Beardsley and his World* (1976).

BRYSON, JOHN, and TROXELL, JANET CAMP (eds.). *Dante Gabriel Rossetti and Jane Morris. Their Correspondence* (1975).

Burne-Jones—The Paintings, Graphic and Decorative Work of Sir Edward Burne-Jones 1833–98. Introd. and notes by John Christian. Arts Council (1975).

CARRINGTON, NOEL (ed.). *Mark Gertler. Selected Letters* (1965).

CECIL, DAVID. *Visionary and Dreamer: two poetic painters, Samuel Palmer and Edward Burne-Jones* (1969).

CLARK, FIONA. *William Morris. Wallpapers and Chintzes* (1973).

CLARK, KENNETH. *Henry Moore Drawings* (1974).

CLARKE, B. F. L. *Church Builders of the Nineteenth Century* (1938).

—— *Parish Churches of London* (1966).

COLLIS, LOUISE. *A Private View of Stanley Spencer* (1972).

COLVIN, HOWARD, and HARRIS, JOHN (eds.). *The Country Seat. Studies in the history of the British country house*. Presented to Sir John Summerson on his 65th birthday (1970).

CORNFORTH, JOHN. *Country Houses in Britain: can they survive? An independent report* (1974).

CRAMER, GÉRALD; GRANT, ALISTAIR, and MITCHINSON, DAVID. *Henry Moore. Catalogue of Graphic Work* I: *1931–72*, Geneva (1973), II: *1973–5 and addenda to Volume I*, Geneva (1976).

DANNATT, TREVOR. *Modern Architecture in Britain* (1959).

DAVIS, FRANK. *Victorian Patrons of the Arts* (1963).

Frank Dobson C.B.E., R.A., 1886–1963. Memorial Exhibition, Arts Council (1966).

EASTON, MALCOLM. *Aubrey and the Dying Lady* (1972).

—— and HOLROYD, MICHAEL. *The Art of Augustus John* (1974).

EATES, MARGOT. *Paul Nash 1889–1946: the Master of the Image* (1973).

ENGEN, RODNEY K. *Walter Crane as a Book Illustrator* (1975).

FAWCETT, JANE (ed.). *The Future of the Past: attitudes to conservation 1174–1974* (1976).

J. D. Fergusson 1874–1961, Fine Art Society (1974).

FILDES, L. C. *Luke Fildes, R.A.—A Victorian Painter* (1968).

FITZGERALD, PENELOPE. *Edward Burne-Jones: a biography* (1975).

FREY, G. *The Modern Chair: 1850 to today* (1970).

Vision and Design. The life, work and influence of Roger Fry 1866–1934, Arts Council and University of Nottingham (1966).

GAUNT, WILLIAM, and CLAYTON-STAMM, M. D. E. *William de Morgan* (1971).

GEBHARD, DAVID. *Charles F. A. Voysey, architect. Writings by Voysey and a chronological list of his writings*, Los Angeles (1975).

GERE, CHARLOTTE. *Victorian Jewellery Design* (1972).

—— *European and American Jewellery 1830–1914* (1974).

Ernest Gimson, Leicester Museums and Art Gallery (1969).

GIROUARD, MARK. *The Victorian Country House* (1971, rev. edn. 1979).

GOULD, CECIL. *Failure and Success. 150 Years of the National Gallery 1824–1974* (1974).

HALL, DONALD. *Henry Moore. The Life and Work of a Great Sculptor* (1966).

HARLING, ROBERT. *The Letter Forms and Type Designs of Eric Gill* (1976).

HARRISON, MARTIN, and WATERS, BILL. *Burne-Jones* (1973).

HART-DAVIS, RUPERT. *A Catalogue of the Caricatures of Max Beerbohm* (1972).

HASLAM, MALCOLM. *English Art Pottery 1865–1915* (1975).

HAYES, C. (introd.). *Scrapbook Drawings of Stanley Spencer* (1964).

HENDRICKS, GORDON. *Eadweard Muybridge: the father of the motion picture* (1975).

Barbara Hepworth. Introd. by Ronald Alley. Tate Gallery (1968).

Barbara Hepworth. A Pictorial Autobiography (1970).

HERMANN, FRANK (introd. and annotations). *The English as Collectors. A documentary chrestomathy* (1972).

HOLROYD, MICHAEL. *Augustus John. A Biography*: I. *The Years of Innocence* (1974), II. *The Years of Experience* (1975).

JAMES, PHILIP (ed.). *Henry Moore on Sculpture* (1966).

JOHN, AUGUSTUS. *Autobiography* (with an introd. by Michael Holroyd, 1975).

Augustus John. With notes and introd. by Malcolm Easton and Romilly John. National Portrait Gallery (1975).

Gwen John 1876–1939. With introd. by Mary Taubman. Anthony d'Offay (1976).

JOHNSON, FRIDOLF (introd.). *William Morris. Ornamentation and illustrations from the Kelmscott Chaucer*, New York (1973).

KITCHEN, PADDY. *A Most Unsettling Person. An Introduction to the Ideas and Life of Patrick Geddes* (1975).

KORNWOLF, JAMES D. *M. H. Baillie Scott and the Arts and Crafts Movement. Pioneers of modern design*, Baltimore and London (1972).

LAGO, MARY M., and BECKSON, KARL (eds.). *Max and Will: Max Beerbohm and William Rothenstein, their friendship and letters 1893–1945* (1975).

LAMBERT, SUSAN. *Paul Nash as Designer* (1975).

LAUGHTON, BRUCE. *Philip Wilson Steer 1860–1942*, Oxford (1971).

LEDER, CAROLYN. *Stanley Spencer: the Astor Collection* (1976).

LEMIRE, EUGENE D. (ed.). *The Unpublished Lectures of William Morris*, Detroit (1969).

LEVY, MERVYN. *Whistler's Lithographs. An illustrated catalogue raisonné*. With an essay by Allen Staley, 'Whistler the printmaker' (1975).

LILLY, MARJORIE. *Sickert. The Painter and his Circle* (1971).

LIPKE, WILLIAM C. *David Bomberg* (1967).

L. S. Lowry. Retrospective Exhibition, Arts Council at the Tate Gallery (1966).

L. S. Lowry, R.A. 1887–1976. Memorial Exhibition, Royal Academy (1976).

MAAS, HENRY, DUNCAN, J. L., and GOOD, W. G. *The Letters of Aubrey Beardsley*, New York (1970).

MAAS, JEREMY. *Victorian Painters* (1969).

MACLEOD, ROBERT. *Charles Rennie Mackintosh* (1968, 2nd edn. 1983).

McMULLEN, ROY. *Victorian Outsider. A biography of J. A. McN. Whistler* (1973).

An Honest Patron: a tribute to Sir Edward Marsh, Walker Art Gallery, Liverpool (1976).

MELVIN, ANDREW (ed.). *William Morris Wallpapers and Designs* (1971).

MICHEL, WALTER (with introd. by KENNER, HUGH). *Wyndham Lewis. Paintings and drawings* (1971).

Minton 1798–1910. Introd. and notes by Elizabeth Aslin and Paul Atterbury, V. & A. (1976).

MITCHINSON, DAVID. *Henry Moore: unpublished drawings*, Turin (1971).

Albert Moore and his Contemporaries. Introd. and notes by Richard Green, Laing Art Gallery, Newcastle upon Tyne (1972).

Henry Moore. Introd. and notes by David Sylvester, Arts Council at the Tate Gallery (1968).

MORRIS, MARGARET. *The Art of J. D. Fergusson. A biased biography*, Glasgow (1974).

—— (introd.). *Café Drawings in Edwardian Paris. From the sketchbooks of J. D. Fergusson*, Glasgow and London (1974).

Paul Nash. Paintings and Watercolours. Introd. by Andrew Causey and Margot Eates, Tate Gallery (1975).

NASH, PAUL (ed. NASH, MARGARET). *Fertile Image*, with introd. by James Laver and preface to the new edn. by Andrew Causey (2nd edn. 1975).

NEEDHAM, PAUL, DUNLOP, JOSEPH, and DREYFUS, JOHN. *William Morris and the Art of the Book*, New York and Oxford (1976). Based on the exhibition held at the Pierpont Morgan Library, New York.

Ben Nicholson. Notes by Charles Harrison, Tate Gallery (1969).

NICOLL, JOHN. *Dante Gabriel Rossetti* (1975).

ORMOND, RICHARD. *John Singer Sargent. Paintings, drawings, watercolours* (1970).

—— *Leighton's Frescoes in the Victoria and Albert Museum* (1975).

—— and LÉONÉE. *Lord Leighton* (1975).

Victor Pasmore. Retrospective Exhibition 1925–65. Introd. by Ronald Alley, Tate Gallery (1965).

PHYSICK, JOHN. *The Wellington Monument [Alfred Stevens]* (1971).

PRIDEAUX, TOM. *The World of Whistler 1834–1903*, New York (1970) and London (1974).

PYLE, HILARY. *Jack B. Yeats: a biography* (1970).

READE, BRIAN. *Aubrey Beardsley* (1967).

REITLINGER, GERALD. *The Economics of Taste*: I. *The Rise and Fall of Picture Prices 1760–1960* (1960); II. *The Rise and Fall of Objets d'Art Prices since 1750* (1963); and III. *The Art Market in the 1960s* (1970).

REWALD, JOHN (ed.). *Camille Pissarro. Letters to his son Lucien.* Revised and enlarged edition (1972).

William Roberts A.R.A. Retrospective Exhibition. Introd. by Ronald Alley, Arts Council at the Tate Gallery (1965).

Claude Rogers. Paintings and Drawings 1927–1973. Introd. by Andrew Forge, University of Reading (1973).

ROSE, MURIEL. *Artist-Potters in England* (1955, 2nd edn. 1970).

ROSENTHAL, T. G. *Jack Yeats* (1963).

Dante Gabriel Rossetti. Poet and Painter. Introd. by John Gere, Royal Academy and Birmingham City Museum and Art Gallery (1973).

ROTHENSTEIN, JOHN. *Modern English Painters*, 3 vols. (1952, 1956, and 1974; collected edn. 1976).

—— *British Art since 1900* (1962).

—— *Autobiography*: I. *Summer's Lease* (1965); II. *Brave Day, Hideous Night* (1966); III. *Time's Thievish Progress* (1970).

Sir William Rothenstein 1872–1945: a centenary exhibition, Bradford (1972).

SAINT, ANDREW. *Richard Norman Shaw* (1976).

SANESI, ROBERTO. *The Graphic Work of Ceri Richards. An œuvre catalogue, biographical note and bibliography*, Milan (1973).

—— *Ceri Richards: Rilievi, disegni e dipinti, 1931–1940*, Pollenza–Macerata (1976).

SEWTER, A. C. *The Stained Glass of William Morris and his Circle*, 2 vols. (vol. II is 'A Catalogue'), New Haven and London (1974 and 1975).

SKEAPING, JOHN. *Drawn from Life: an Autobiography* (1977).

SPEAIGHT, ROBERT. *The Life of Eric Gill* (1966).

SPENCER, ISOBEL. *Walter Crane* (1975).

Stanley Spencer 1891–1959. Introd. by Duncan Robinson and other contributors, Arts Council (1976).

SURTEES, VIRGINIA. *The Paintings and Drawings of Dante Gabriel Rossetti (1828–1882). A catalogue raisonné*, 2 vols., Oxford University Press (1971).

The Etchings of Graham Sutherland from 1923 to 1931, P. & D. Colnaghi & Co. Ltd. (1975).

SUTTON, DENYS (ed. and introd.). *Letters of Roger Fry*, 2 vols. (1972).

—— *Nocturne: the Art of James McNeill Whistler* (1963).

—— *James McNeill Whistler* (1966).

—— *Walter Sickert: a biography* (1976).

SYLVESTER, DAVID. *Interviews with Francis Bacon* (1975).

THOMAS, E. LLOYD. *Victorian Art Pottery* (1974).

Victoria & Albert Museum Bulletin (1965–9) and *Yearbook* (1969–).

Edward Wadsworth 1889–1949. Paintings, drawings and prints, P. & D. Colnaghi & Co. Ltd. (1974).

Walker Art Gallery, Liverpool, *Annual Report and Bulletin*, I– (1969–).

WAUGH, EVELYN. *Rossetti: his life and works*, new edition with introd. by John Bryson (1975).

WEINTRAUB, STANLEY. *Whistler. A biography* (1974).

WHITE, COLIN. *Edmund Dulac* (1976).

WILKINSON, A. G. (introd.). *The Drawings of Henry Moore* (1971).

—— *The Drawings of Henry Moore*. The Tate Gallery in collaboration with the Art Gallery of Ontario (1977–8).

WOODESON, JOHN. *Mark Gertler. Biography of a painter 1891–1939* (1972).

YOUNG, ANDREW McLAREN. *Charles Rennie Mackintosh (1868–1928): architecture, design and painting*, Scottish Arts Council and Edinburgh Festival Society (1968).

—— *James McNeill Whistler*, Arts Council and English-Speaking Union of the United States (1960).

ADDENDA

English art of the period covered by this book continues to be most actively studied, and there follows a list of the more significant publications on the subject which have appeared between 1978 and January 1984.

ALLEY, RONALD. *Graham Sutherland*, Tate Gallery (1982).

ANSCOMBE, ISABELLE. *Omega and After. Bloomsbury and the Decorative Arts* (1981).

—— and GERE, CHARLOTTE. *Arts and Crafts in Britain and America* (1978).

ARNOLD, BRUCE. *Orpen. Mirror to an Age* (1981).

C. R. Ashbee and the Guild of Handicraft, Cheltenham Art Gallery (1981).

BARMAN, CHRISTIAN. *The Man Who Built London Transport* (1979).

BARON, WENDY. *The Camden Town Group* (1979).
BEATTIE, SUSAN. *The New Sculpture*, New Haven and London (1983).
BERTHOUD, ROGER. *Graham Sutherland. A Biography* (1982).
British Art and Design 1900–1960. Introd. by Carol Hogben, V. & A. (1983).
CANTACUZINO, SHERBAN. *Wells Coates: a Monograph* (1978).
CARLINE, RICHARD. *Stanley Spencer at War* (1978).
CAUSEY, ANDREW. *Paul Nash*, Oxford University Press (1980).
Circle. Constructive Art in Britain 1934–40, Kettle's Yard, Cambridge (1982).
COLLINS, JUDITH. *The Omega Workshop* (1984).
CORK, RICHARD. *Henri Gaudier and Ezra Pound. A Friendship*, Anthony d'Offay (1982).
CROOK, J. MORDAUNT. *William Burges and the High Victorian Dream* (1981).
—— (ed.). *The Strange Genius of William Burges 'art-architect' 1827–1881*, National Museum of Wales and V. & A. (1981).
DARRACOTT, JOSEPH. *The World of Charles Ricketts* (1980).
Frank Dobson 1886–1963. True and Pure Sculpture, Kettle's Yard, Cambridge (1981)
Christopher Dresser. Ein viktorianischer Designer 1834–1904, Kunstgewerbemuseum, Köln (1981).
FAIRCLOUGH, OLIVER, and LEARY, EMMELINE. *Textiles by William Morris & Co. 1861–1940*, Birmingham City Museums and Art Gallery (1981).
FALKENHEIM, JACQUELINE V. *Roger Fry and the Beginnings of Formalist Art Criticism*, U.M.I. Research Press, Ann Arbor, Michigan (1980).
FRY, ROGER (ed. BULLEN, J. B.). *Vision and Design*, Oxford University Press (1981).
Arthur and Georgie Gaskin, Birmingham City Museums and Art Gallery and Fine Art Society, London (1982).
Mark Gertler—the Early and the Late Years. Introd. by Noel Carrington, Frances Spalding, Luke Gertler, Richard Shone, and others, Ben Uri Art Gallery (1982).
Harold Gilman 1876–1919. Introd. by Andrew Causey and Richard Thomson, Arts Council (1981).
GIROUARD, MARK. *Alfred Waterhouse and the Natural History Museum*, New Haven and London (1980).
GRADIDGE, RODERICK. *Dream Houses. The Edwardian Ideal* (1980).
—— *Edwin Lutyens Architect Laureate* (1981).
GRAY, NICOLETE. *The Painted Inscriptions of David Jones* (1981).
GREEVES, T. AFFLECK. *Bedford Park, the First Garden Suburb. A Pictorial Survey (c. 1975)*.
HARRIES, MERION and SUSIE. *The War Artists* (1983).

HARRISON, CHARLES. English Art and Modernism 1900–1939 (1981).

HAYES, JOHN. *The Art of Graham Sutherland*, Oxford (1980).

IRVING, ROBERT GRANT. *Indian Summer. Lutyens, Baker and Imperial Delhi*, New Haven and London (1981).

David Jones. Introd. by Paul Hills, Tate Gallery (1981).

KELVIN, NORMAN (ed.). *The Collected Letters of William Morris*, I, Princeton (1982).

Landscape in Britain 1850–1950. Introd. by Frances Spalding, Ian Jeffrey, and Donald Davie, Arts Council (1983).

LEWISON, JEREMY. *Ben Nicholson: the Years of Experiment 1919–1939*, Kettle's Yard, Cambridge (1983).

Lutyens. The Work of the English Architect Sir Edwin Lutyens 1869–1944. Introd. by Mary Lutyens and other contributors, Arts Council (1981).

LYNTON, NORBERT. *The Story of Modern Art*, Oxford (1980).

MACCARTHY, FIONA. *The Simple Life. C. R. Ashbee in the Cotswolds* (1981).

—— *British Design since 1880* (1982).

MCCONKEY, KENNETH. *Sir George Clausen, R.A. 1852–1944*, Bradford Art Galleries and Museums and Tyne and Wear County Council Museums (1980).

MCCORMICK, E. H. *Portrait of Frances Hodgkins*, Auckland University Press and Oxford University Press (1981).

Henry Moore Sculpture, with Comments by the Artist. Introd. by Franco Russoli, ed. by David Mitchinson (1981).

MORRIS, LYNDA, and RADFORD, ROBERT. *The Story of the A.I.A. Artists International Association 1933–1953*, Museum of Modern Art, Oxford (1983).

MUTHESIUS, HERMANN. *The English House*. Ed. with introd. by Dennis Sharp, preface by Julian Poesner, trans. by Janet Seligman (1979).

NAIRNE, SANDY, and SEROTA, NICHOLAS (eds.). *British Sculpture in the Twentieth Century*, Whitechapel Art Gallery (1981).

Algernon Newton, R.A. 1880–1968. Ed. by Nicholas Usherwood, Sheffield City Art Galleries (1980).

The Omega Workshops 1913–1919. Decorative Arts of Bloomsbury. Introd. by Fiona MacCarthy, Crafts Council (1984).

John Piper. Introd. by John Russell and other contributors. Catalogue by David Fraser Jenkins, Tate Gallery (1983).

PLUNZ, RICHARD A. (ed.). *Serge Chermayeff. Design and the Public Good. Selected Writings of Serge Chermayeff 1930–80*, Cambridge, Mass. (1982).

Post-Impressionism. Cross-Currents in European Painting. Introd. by Alan Bowness and others, Royal Academy of Arts (1979–80).

RATCLIFF, CARTER. *John Singer Sargent*, Oxford Unversity Press (1983).

READ, BENEDICT. *Victorian Sculpture*, New Haven and London (1982).

Ceri Richards. Introd. by Bryan Robertson, Tate Gallery (1981).

RICHARDSON, MARGARET. *Architects of the Arts and Crafts Movement*, R.I.B.A. Drawing Series (1983).

ROBINSON, DUNCAN. *William Morris, Edward Burne-Jones and the Kelmscott Chaucer* (1981).

ROTHENSTEIN, JOHN (ed.). *Stanley Spencer. The Man: Correspondence and Reminiscences* (1979).

John Singer Sargent and the Edwardian Age. Introd. by J. Lomax and R. Ormonde, Leeds City Art Galleries (1979).

SERVICE, ALASTAIR. *Edwardian Interiors. Inside the homes of the poor, the average and the wealthy* (1982).

SHARP, DENNIS. *Sources of Modern Architecture. A Critical Bibliography* (1981).

Late Sickert. Paintings 1927 to 1942. Introd. by Richard Morphet and Helen Lessore, Arts Council (1981).

Matthew Smith. Introd. by Alice Keene, John Russell, and others, Barbican Art Gallery (1983).

Joseph Southall, 1861–1944. Artist-Craftsman. Introd. by George Breeze, Birmingham City Museums and Art Gallery (1980).

SPALDING, FRANCES. *Roger Fry. Art and Life* (1980).

—— *Vanessa Bell* (1983).

STAMP, GAVIN, and AMERY, COLIN. *Victorian Buildings of London 1837–1887. An Illustrated Guide* (1980).

William Strang, R.A. 1859–1921. Painter-etcher, Graves Art Gallery, Sheffield (1980).

TAYLOR, HILARY. *James McNeill Whistler* (1978).

Thirties. British Art and Design before the War. Introd. by A. J. P. Taylor, William Feaver, and others, Arts Council (1979).

Alfred Waterhouse 1830–1905. R.I.B.A. Heinz Gallery (1983).

WEST, ANTHONY. *John Piper* (1979).

WILKINSON, ALAN G. *The Moore Collection in the Art Gallery of Ontario*, Ontario (1979).

YORKE, MALCOLM. *Eric Gill. Man of Flesh and Spirit* (1981).

INDEX

References in **bold** type are to plates

INDEX 409

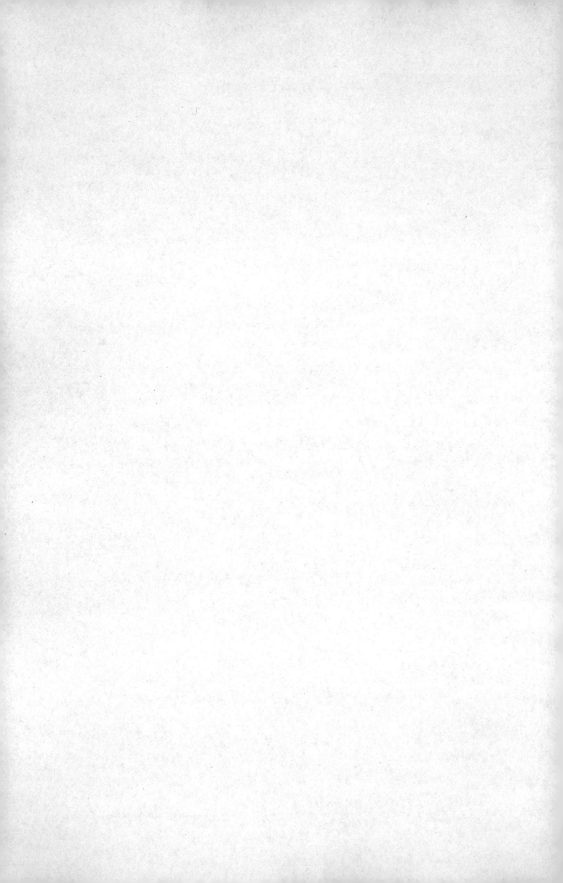

PLATE 1

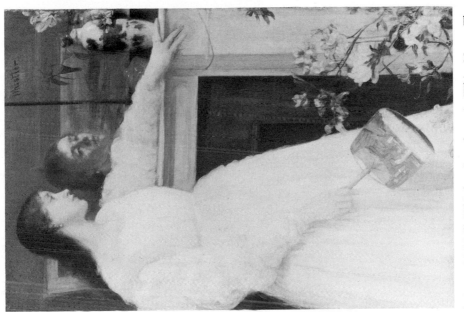

b. James McNeill Whistler: Symphony in White No. 2: The Little White Girl. 1864. R.A. 1865. [Canvas: signed 'Whistler': 76 × 51]

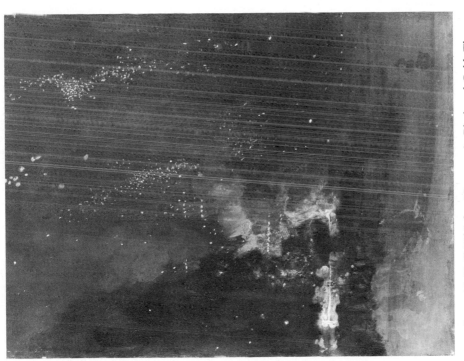

a. James McNeill Whistler: Nocturne in Black and Gold: The Falling Rocket. c. 1874. [Panel: 60·25 × 45·75]

PLATE 2

b. James McNeill Whistler: Arrangement in Grey and Black, No. 2: Thomas Carlyle. 1872–3. [Canvas: signed with butterfly: 171 × 143·5]

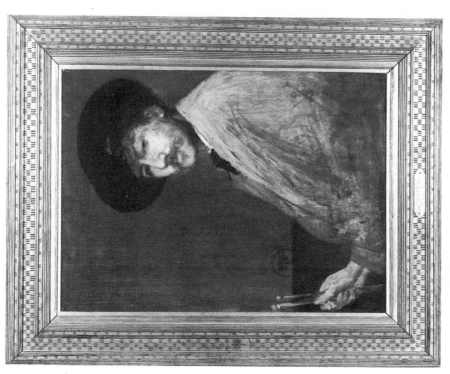

a. James McNeill Whistler: Arrangement in Grey: Self-portrait. *c.* 1871–3. [Canvas: signed with butterfly: 75 × 53·5] [The frame, decorated by the artist, is also signed.]

PLATE 3

a. James McNeill Whistler: Nocturne in Blue and Gold: Old Battersea Bridge. c. 1872–5. [Canvas: 56·75 × 50]

b. James McNeill Whistler: The Embroidered Curtain. 1889. [Etching: 23·9 × 16: K. 410.V]

PLATE 4

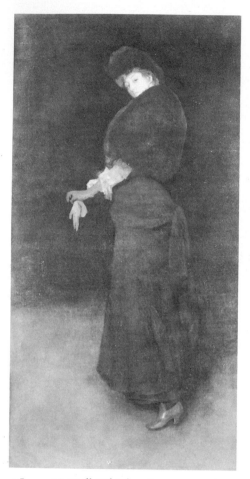 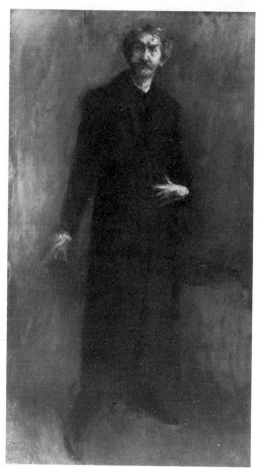

a. James McNeill Whistler: Arrangement in Black: Lady in the Yellow Buskin, Lady Archibald Campbell. *c.* 1883. [Canvas: 218·50 × 110·5]

b. James McNeill Whistler: Gold and Brown: Self-portrait. 1898. [Canvas: 95·8 × 51·5]

PLATE 5

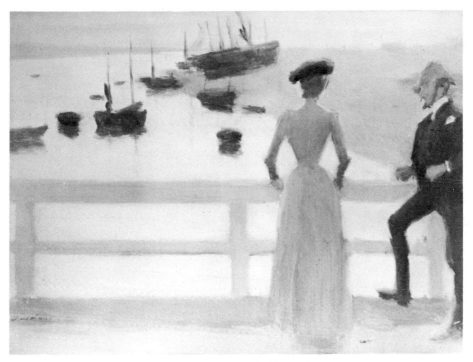

a. Philip Wilson Steer: The Bridge. *c.* 1887. [Canvas: signed 'P. W. Steer': 51×40·5]

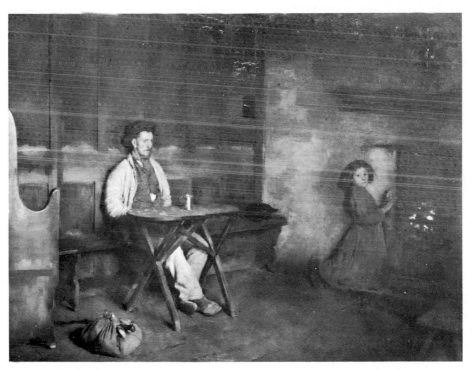

b. Fred Brown: Hard Times. 1886. [Canvas: signed and dated: 72×92·3]

PLATE 6

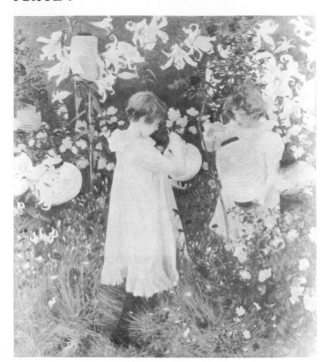

a. John Singer Sargent: Carnation, Lily, Lily, Rose. 1885–6. [Canvas: signed 'John S. Sargent': 174×154]

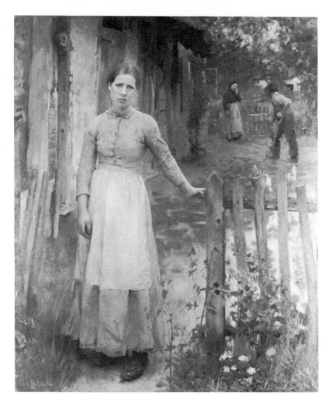

b. George Clausen: Girl at the Gate. 1889. [Canvas: signed 'G. Clausen 1889': 171·5×153·75]

PLATE 7

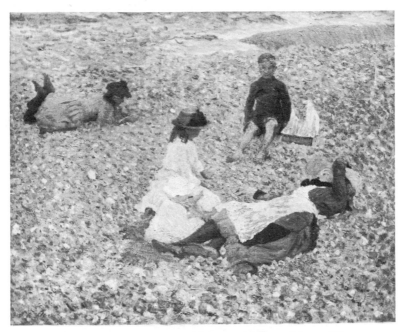

a. Philip Wilson Steer: Knucklebones, Walberswick. *c.* 1888–9.
[Canvas: 76 × 51]

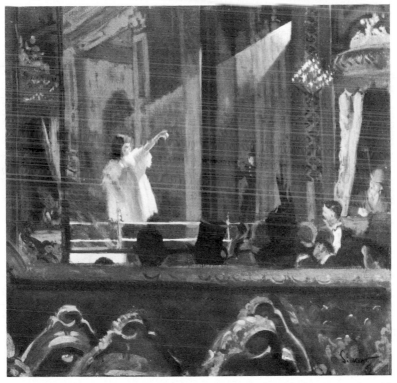

b. Walter Richard Sickert: Joe Haynes and little Dot Hetherington at the Old
Bedford Music Hall. *c.* 1888–9. [Canvas: signed 'Sickert': 61 × 61]

PLATE 8

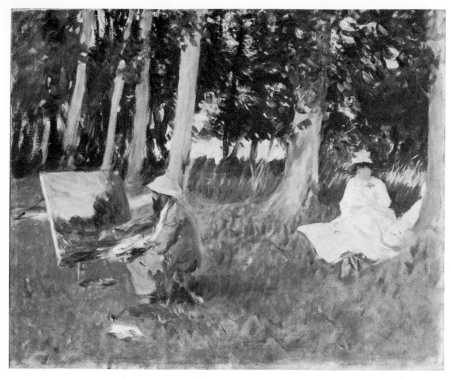

a. John Singer Sargent: Claude Monet painting at the edge of a wood. 1888.
[Canvas: 54×65]

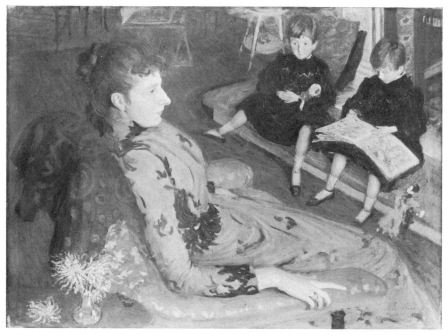

b. Philip Wilson Steer: Mrs. Cyprian Williams and her two little girls. 1891.
[Canvas: signed 'P. W. Steer': 76×102]

PLATE 9

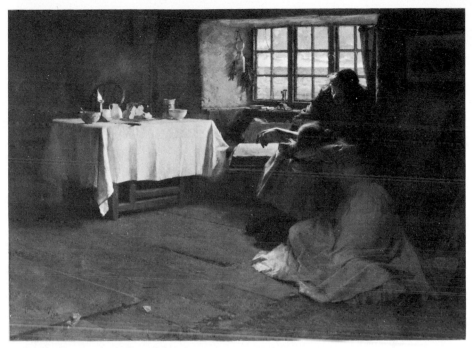

a. Frank Bramley: A Hopeless Dawn. 1888. [Canvas: signed 'Frank Bramley. 88': 122·5 × 168]

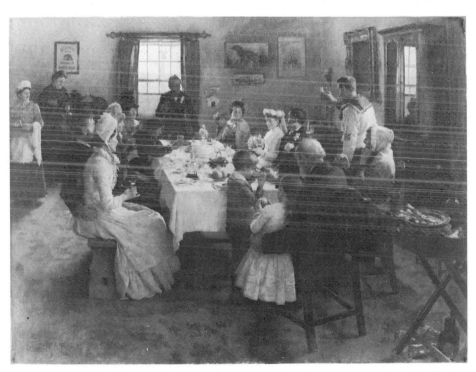

b. Stanhope Forbes: The Health of the Bride. 1889. [Canvas: signed 'Stanhope A. Forbes. 1889': 152 × 202]

PLATE 10

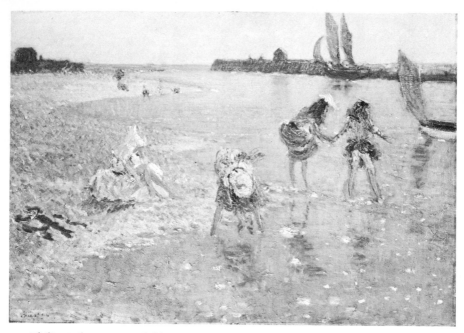

a. Philip Wilson Steer: Children Paddling. *c.* 1889–94. [Canvas: signed and dated 1894: 63·5×91·5]

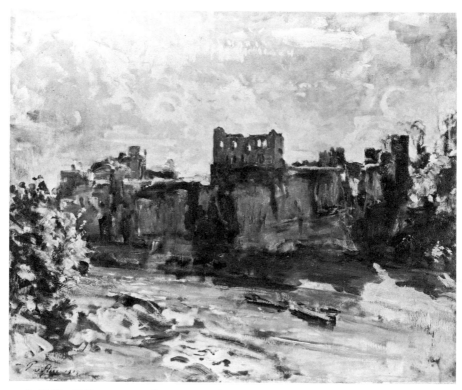

b. Philip Wilson Steer: Chepstow Castle. 1905. [Canvas: signed 'P. W. Steer 1905': 76·5×91·75]

PLATE 11

a. Walter Richard Sickert: St. Mark's Venice: Pax Tibi Marce Evangelista Meus. 1896–7.
[Canvas: signed 'Sickert': 91 × 120]

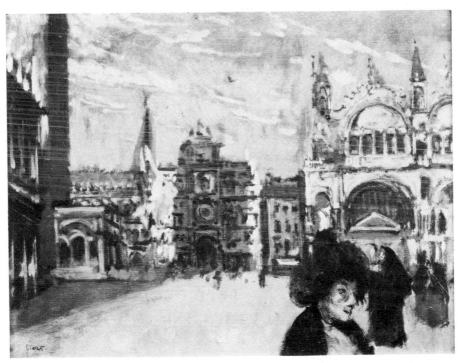

b. Walter Richard Sickert: Piazza San Marco. *c*. 1906. [Canvas: 40·5 × 51]

PLATE 12

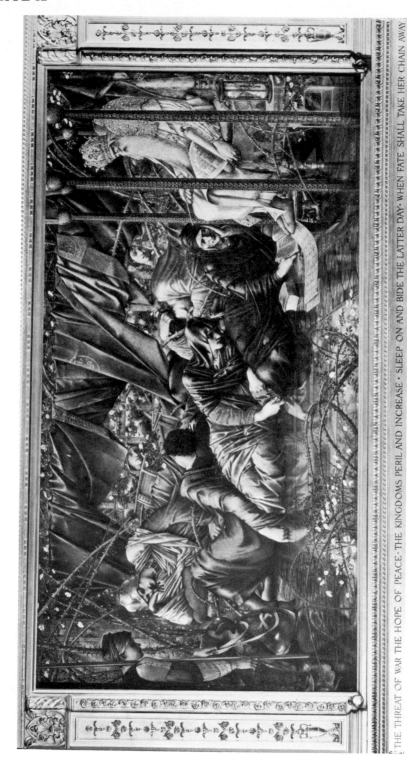

Edward Burne-Jones: Legend of the Briar Rose: The Council Chamber: The Threat of War the Hope of Peace. 1871–90. [Canvas: 122 × 239]

THE THREAT OF WAR THE HOPE OF PEACE·THE KINGDOMS PERIL AND INCREASE·SLEEP ON AND BIDE THE LATTER DAY·WHEN FATE SHALL TAKE HER CHAIN AWAY

PLATE 13

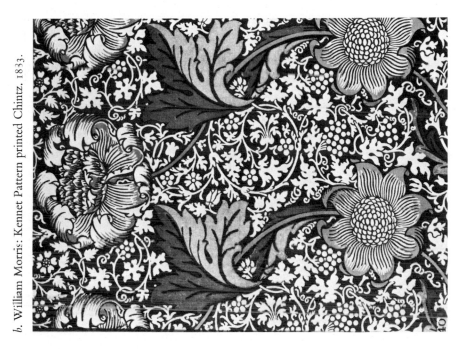

b. William Morris: Kennet Pattern printed Chintz. 1883.

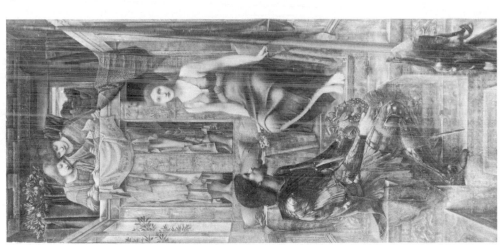

a. Edward Burne-Jones: King Cophetua and the Beggar Maid. 1884.
[Canvas: signed 'E. B. J. 1884': 293·5 × 136]

PLATE 14

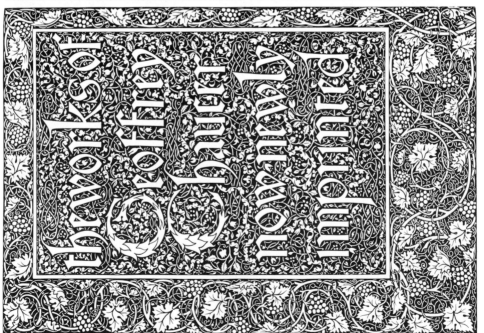

William Morris and Edward Burne-Jones: The Kelmscott Chaucer. 1892–6.

PLATE 15

a. John Everett Millais: An Idyll, 1745. R.A. 1884. [Canvas: signed 'JM 1884': 137×188]

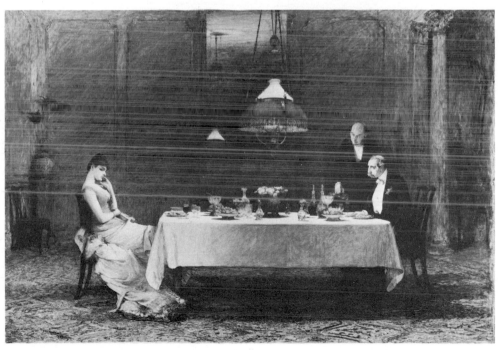

b. William Quiller Orchardson: Mariage de Convenance. 1883. R.A. 1884. [Canvas: signed 'W. Q. Orchardson 1883': 104·75×154·25]

PLATE 16

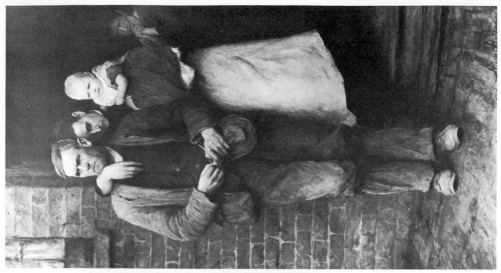

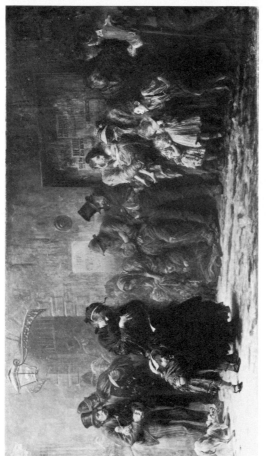

a. Luke Fildes: Applicants for Admission to a Casual Ward. R.A. 1874.
[Canvas: signed 'Luke Fildes 1874': 142 × 247·5]

b. Hubert von Herkomer: On Strike. R.A. 1891.
[Diploma Work. Canvas: signed 'Hubert Herkomer 91':
228 × 126·5]

PLATE 17

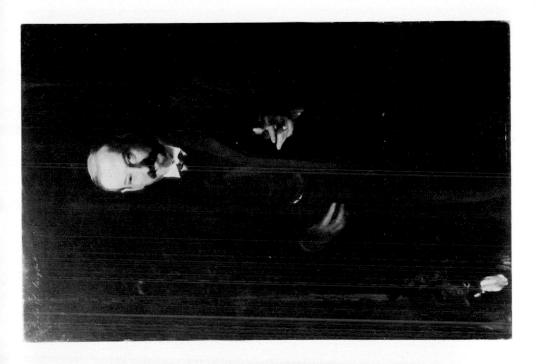

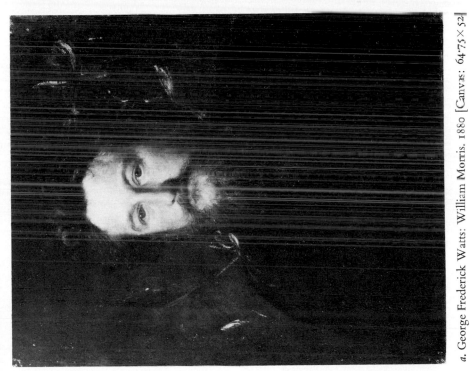

a. George Frederick Watts: William Morris. 1880 [Canvas: 64·75 × 52]

b. John Singer Sargent: Asher Wertheimer. 1898.
[Canvas: signed 'John S. Sargent 1898': 147·5 × 98]

PLATE 18

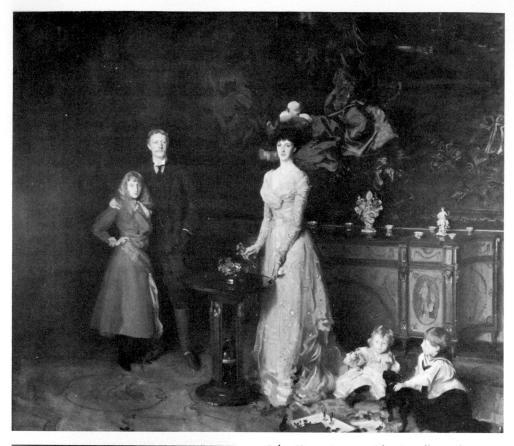

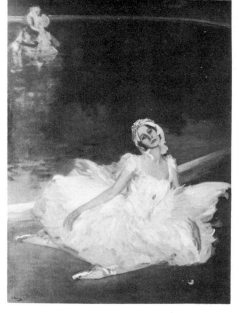

a. John Singer Sargent: The Sitwell Family. 1900. R.A. 1901. [Canvas: signed 'John S. Sargent': 170×193]

b. John Lavery: La Mort du Cygne: Anna Pavlova. 1911. R.A. 1912. [Canvas: signed 'J. Lavery' and dated '1911' on reverse: 198×146·5]

PLATE 19

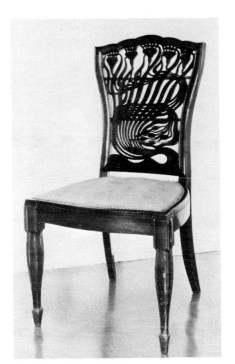

a. Arthur Mackmurdo: Chair. 1881.
[Inscribed 'CG' (Century Guild):
97 × 48·25 × 51]

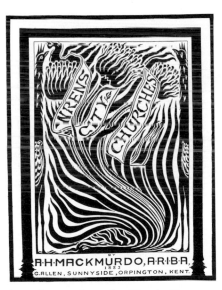

b. Arthur Mackmurdo: Wren's City
Churches. 1883.

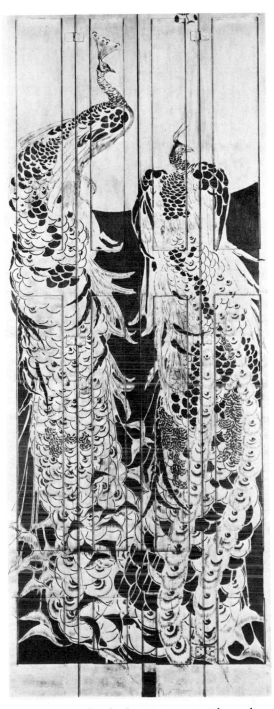

c. James McNeill Whistler: Harmony in Blue and
Gold: The Peacock Room. 1876–7. [Detail of Centre
Shutter]

PLATE 20

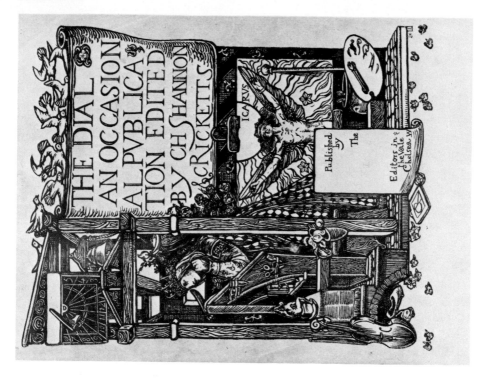

b. Charles Ricketts: The Dial, II. 1889.

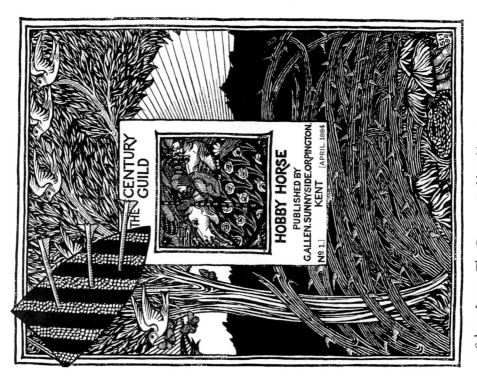

a. Selwyn Image: The Century Guild Hobby Horse, I. April 1884.

PLATE 21

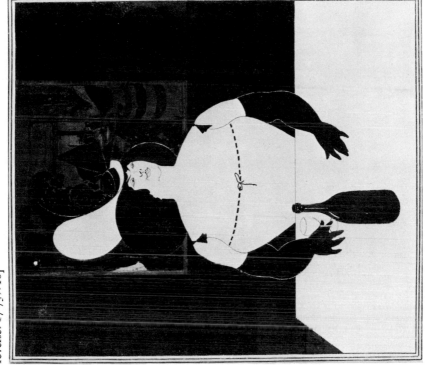

a. Aubrey Beardsley: Salomé: J'ai Baisé ta Bouche Iokanaan—J'ai Baisé ta Bouche. 1893. [Pen Drawing: 27·75 × 14·75]

b. Aubrey Beardsley: The Fat Woman. 1894. [Indian ink: inscribed on reverse: 17·75 × 16]

PLATE 22

a. Aubrey Beardsley: A Comedy of Sighs and the Land of Heart's Desire. 29 March 1894.
[Three-colour lithograph poster: 76×51]
b. Fred Walker: The Woman in White. 1871.
[Black and white gouache on buff paper: 216×127·5]

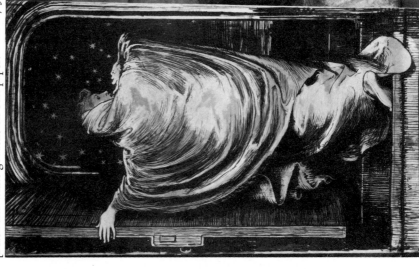

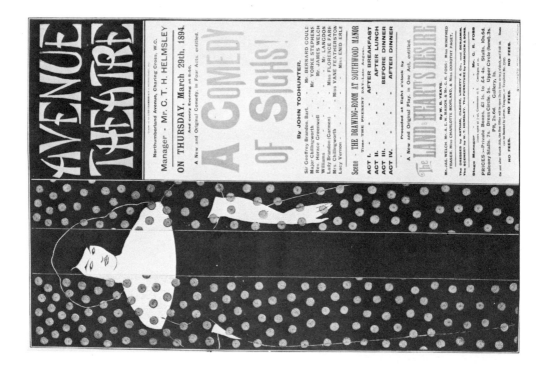

PLATE 23

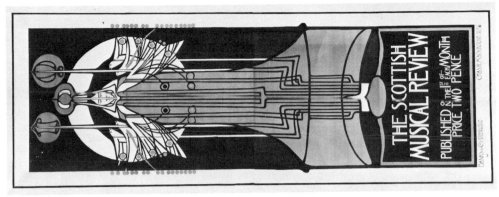

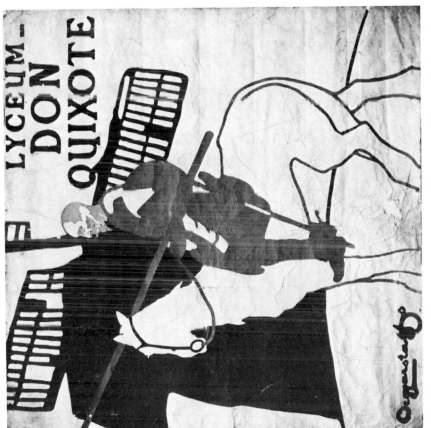

a. 'J. & W. Beggarstaff' (William Nicholson and James Pryde): Don Quixote. 1895.
[Black and brown paper collage on white: 19.5 × 196.25]

b. Charles Rennie Mackintosh: The Scottish Musical Review. 1896.
[Four-colour lithograph poster: 246.5 × 101.5]

PLATE 24

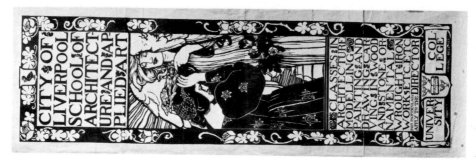

b. Robert Anning Bell: City of Liverpool School of Architecture and Applied Art. 1894–5. [Sepia lithograph: 240 × 81·25]

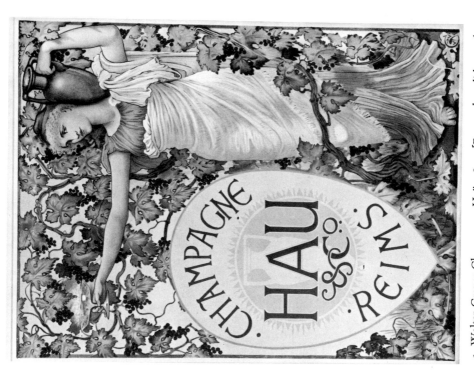

a. Walter Crane: Champagne Haü. 1894. [Four-colour lithograph poster: signed 'WC': 73 × 54·5]

PLATE 25

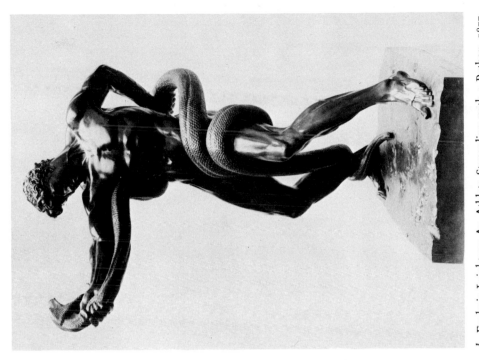

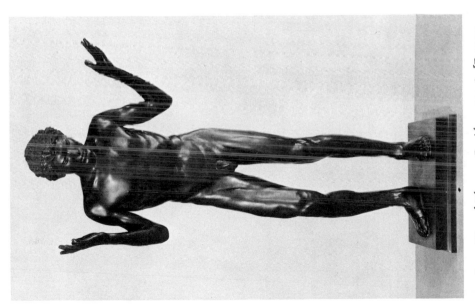

b. Frederic Leighton: An Athlete Struggling with a Python. 1877. [Bronze: signed 'F. Leighton 1877'; Height: 190·5]

a. James Havard Thomas: Lycidas. 1902–8. [Bronze: signed 'I. Havard Thomas Sc. MCMIII–VIII' 161 × 83 × 52]

PLATE 26

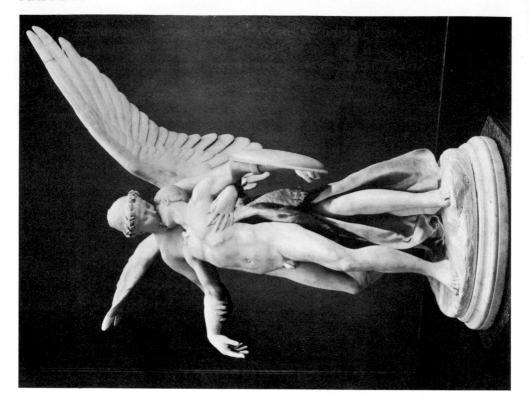

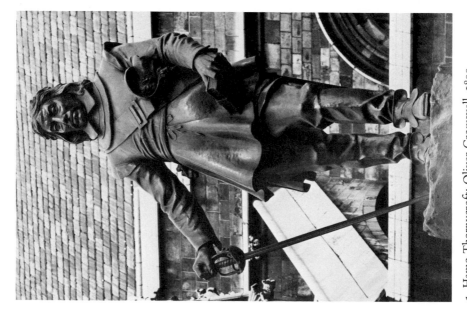

a. Hamo Thornycroft: Oliver Cromwell. 1899.

b. Alfred Gilbert: The Kiss of Victory. R.A. 1882. [Marble: Height: Sculpture 128·25, plinth 20·25, pedestal 78·75]

PLATE 27

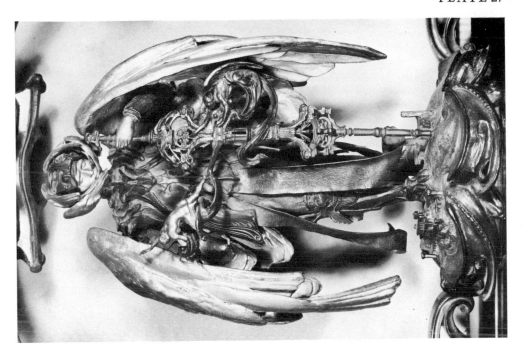

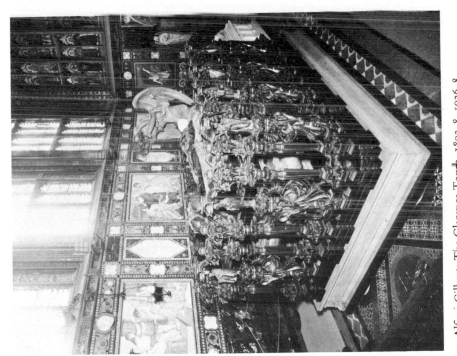

a. Alfred Gilbert: The Clarence Tomb. 1892–8, 1926–8.

b. Alfred Gilbert: The Clarence Tomb. Figure of St. Michael.

PLATE 28

Alfred Gilbert: Shaftesbury Memorial Fountain: 'Eros': Detail. 1887–93.

PLATE 29

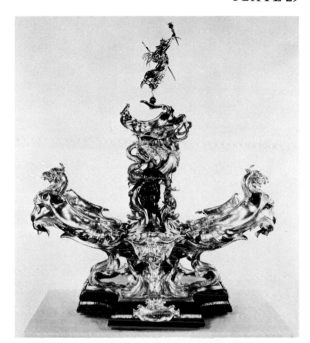

a. Alfred Gilbert: Epergne. 1887–90. Presented to Queen Victoria on her Jubilee by Officers of the Army. [Various metals, gilt, with mother of pearl and crystal: Height: 87]

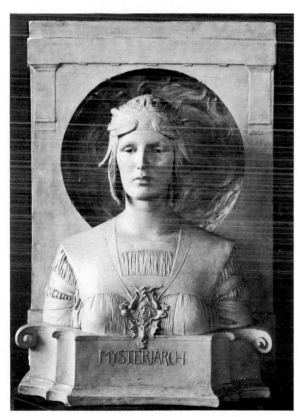

b. George Frampton: Mysteriarch. 1892. R.A. 1893. [Plaster bust and polychrome: signed 'Mysteriarch, Geo Frampton 1892': Height: 91·5]

PLATE 30

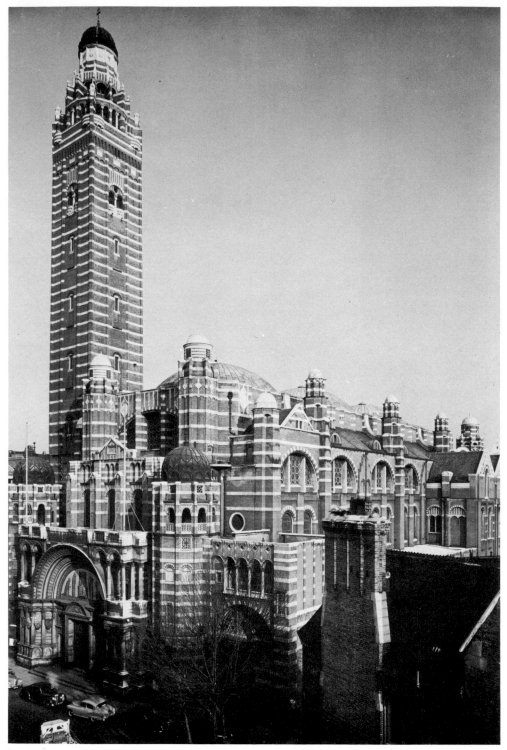

John Francis Bentley: Westminster Cathedral, London, from the south-west. 1895–1903.

PLATE 31

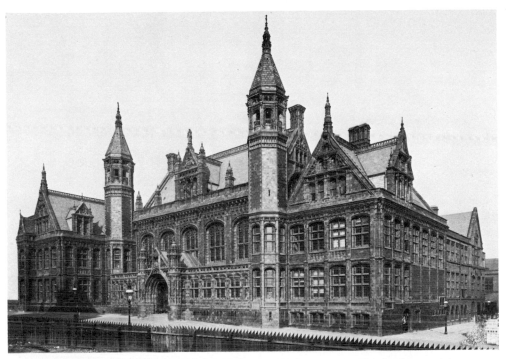

a. Aston Webb and Edward Ingress Bell: Victoria Law Courts, Birmingham. 1886–91.

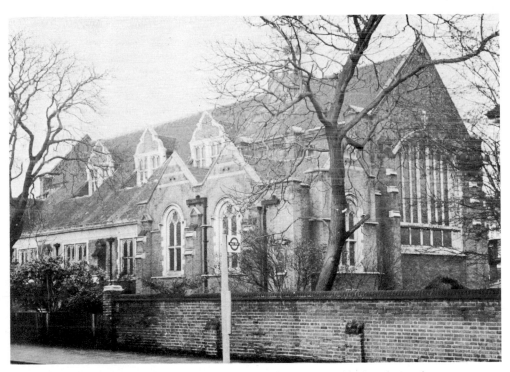

b. Richard Norman Shaw: St. Michael and All Angels, Bedford Park, London. 1878.

PLATE 32

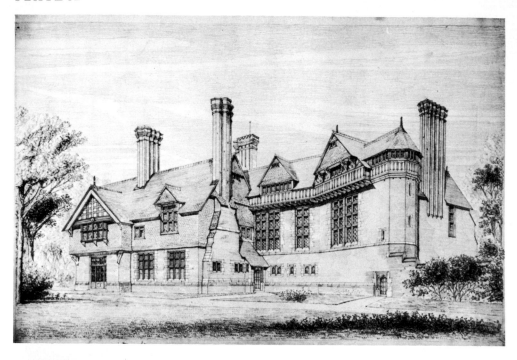

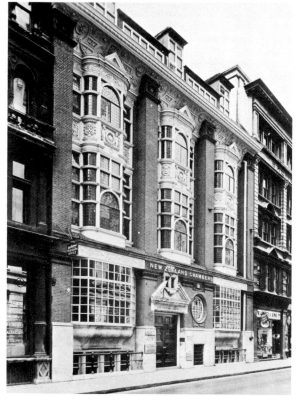

a. Richard Norman Shaw: Grims Dyke, Harrow Weald, Middlesex. 1870–2. Perspective drawing by W. R. Lethaby.

b. Richard Norman Shaw: New Zealand Chambers, Leadenhall Street, London. 1872–4. Destroyed in 1939–45 War.

PLATE 33

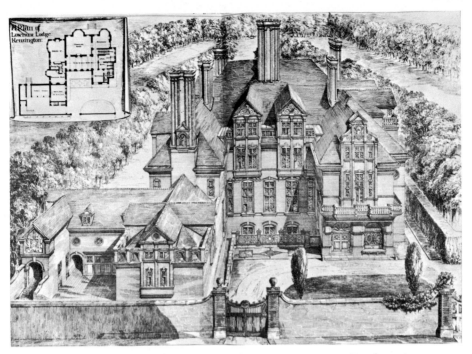

a. Richard Norman Shaw: Lowther Lodge, Kensington Gore, London. 1873–5.
Perspective drawing from *The Building News*, XXVIII (25 June 1875)

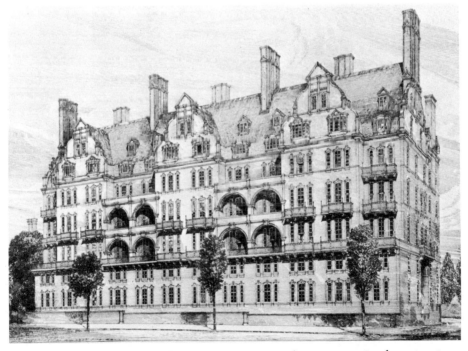

b. Richard Norman Shaw: Albert Hall Mansions, South Kensington, London. 1879–81.
Perspective drawing by W. R. Lethaby.

PLATE 34

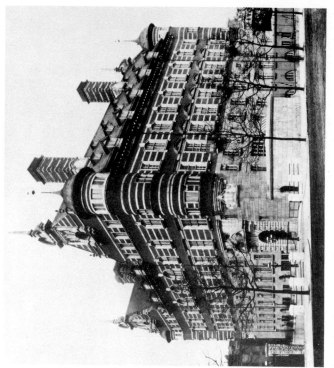

b. Richard Norman Shaw: New Scotland Yard, Victoria Embankment, Westminster. 1887–90. Before additions of 1901–7.

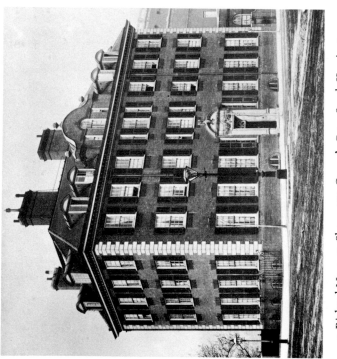

a. Richard Norman Shaw: 170 Queen's Gate, South Kensington, London. 1888.

PLATE 35

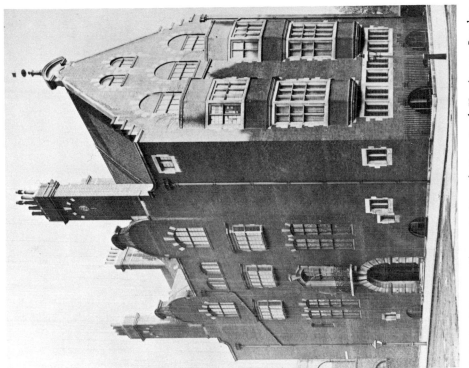

b. Richard Norman Shaw: 185 Queen's Gate, South Kensington, London. 1890. (Now demolished)

a. Richard Norman Shaw: Swan House, 17 Chelsea Embankment, London. 1875-7.

PLATE 36

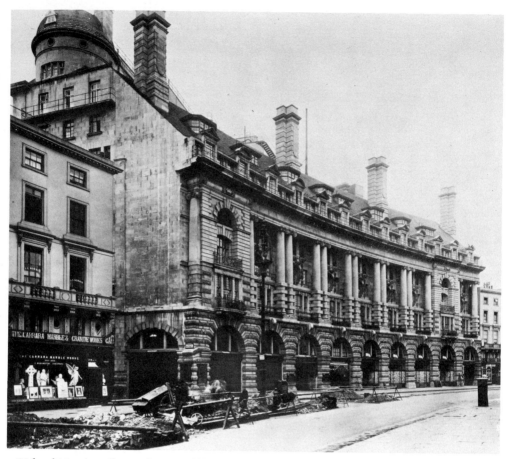

Richard Norman Shaw: The Piccadilly Hotel, Piccadilly, London. 1905–8. Regent Street façade.

PLATE 37

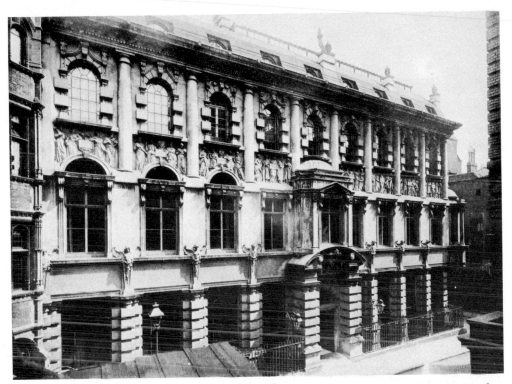

a. John Belcher and Arthur Beresford Pite: Institute of Chartered Accountants, Moorgate, London. 1888–93.

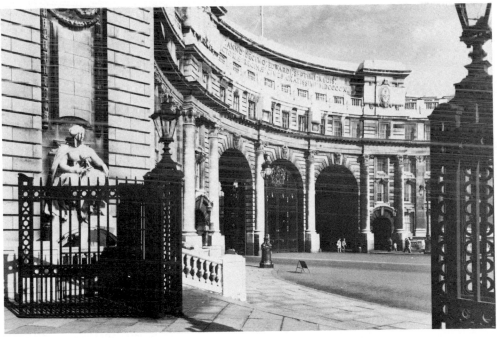

b. Aston Webb: Admiralty Arch, The Mall, Westminster. 1906–11.

PLATE 38

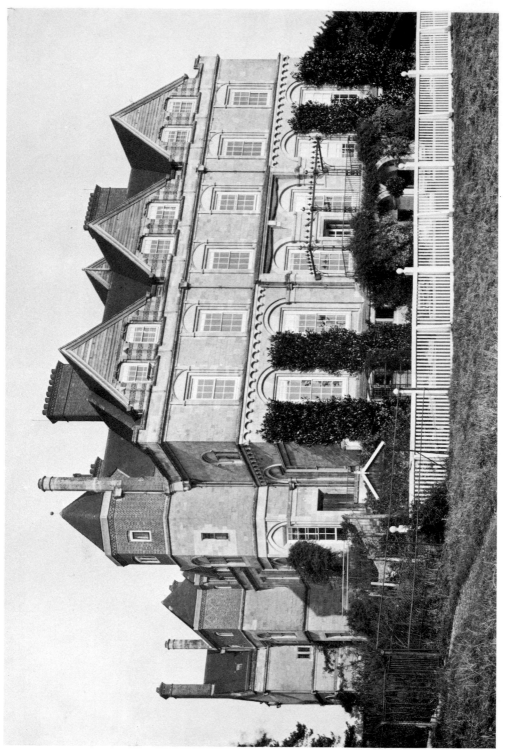

Philip Webb: Clouds, East Knoyle, Salisbury, Wiltshire: View from south-west. 1881–6.

PLATE 39

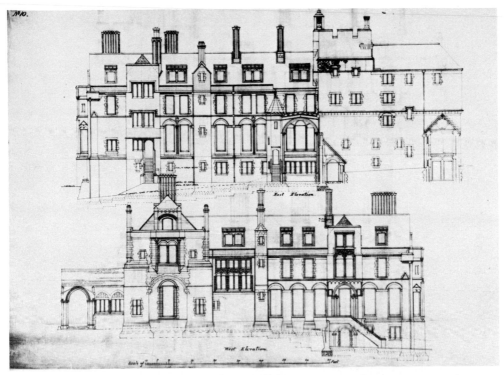

a. Philip Webb: Clouds, East Knoyle, Salisbury, Wiltshire. 1876 design for East and West elevations.

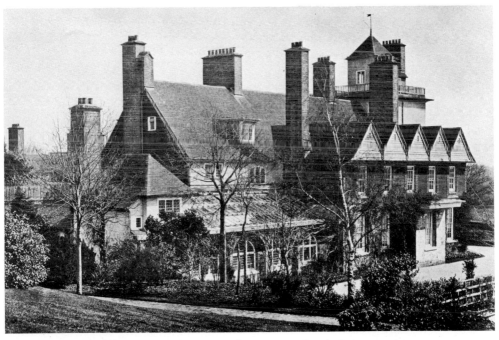

b. Philip Webb: Standen, Saint Hill, near East Grinstead, Sussex. 1891–4.

PLATE 40

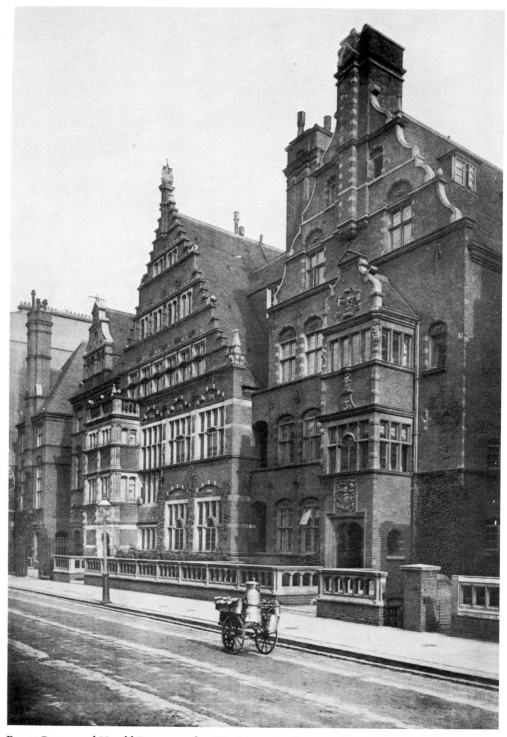

Ernest George and Harold Peto: 39 and 41 Harrington Gardens, South Kensington, London. 1882 and 1883.

PLATE 41

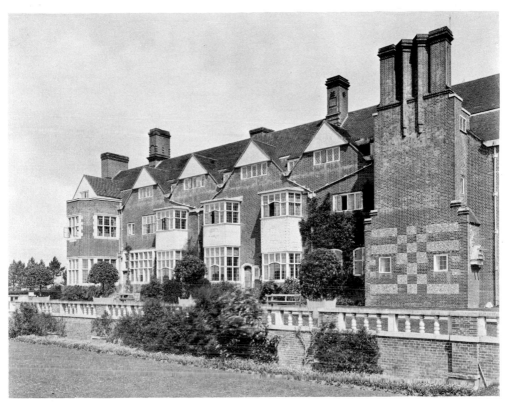

a. William Richard Lethaby: Avon Tyrell, near Christchurch, Hampshire: Garden Façade. 1891–2.

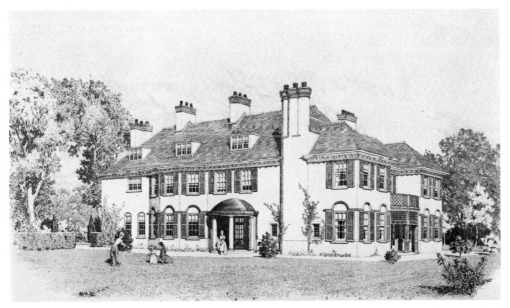

b. Ernest Newton: Steep Hill, Jersey: 1899–1900. Perspective drawing of garden façade by Crawford.

PLATE 42

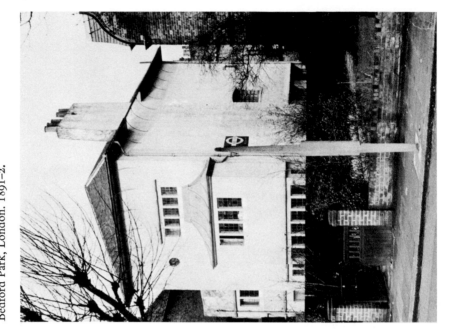

a. William Richard Lethaby and J. L. Ball: Eagle Insurance Buildings, Colmore Row, Birmingham. 1898–1900.

b. C. F. A. Voysey: The Forster House, 14 South Parade, Bedford Park, London. 1891–2.

PLATE 43

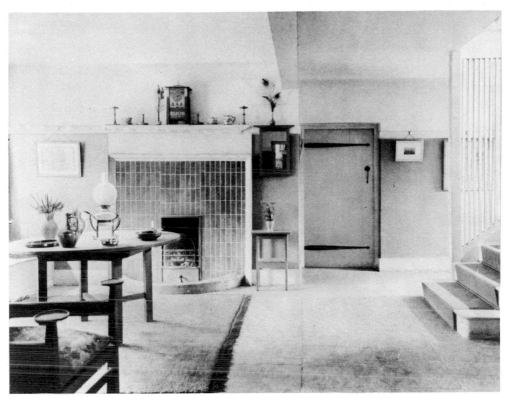

a. C. F. A. Voysey: The Orchard, Chorley Wood, Hertfordshire: Main living room. 1899.

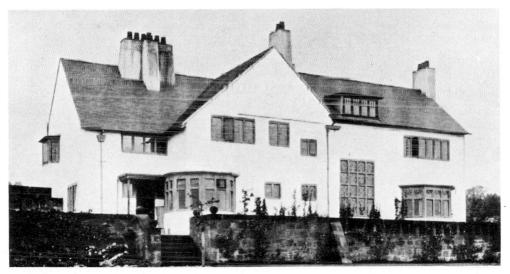

b. M. H. Baillie Scott: The White House, Helensburgh, near Glasgow. 1900. From M. H. Baillie Scott, *Houses and Gardens*, 1906.

PLATE 44

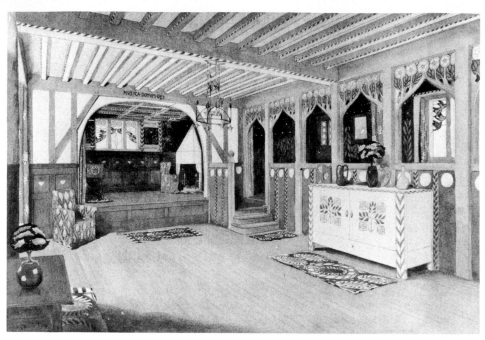

a. M. H. Baillie Scott: House for an Art Lover: Music Room. 1901. Meister der Innenkunst I: Baillie Scott, London, Haus eines Kunstfreundes 1901.

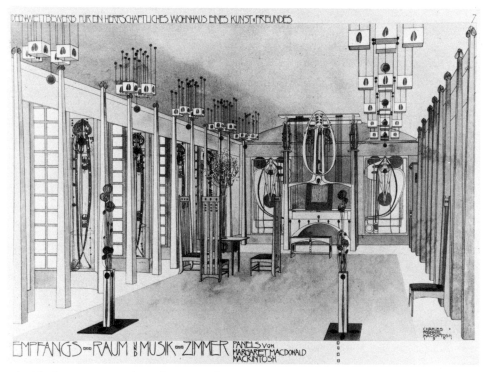

b. Charles Rennie Mackintosh: House for an Art Lover: Music Room. 1901. Meister der Innenkunst II: Charles Rennie Mackintosh, Glasgow. Haus eines Kunstfreundes 1902.

PLATE 45

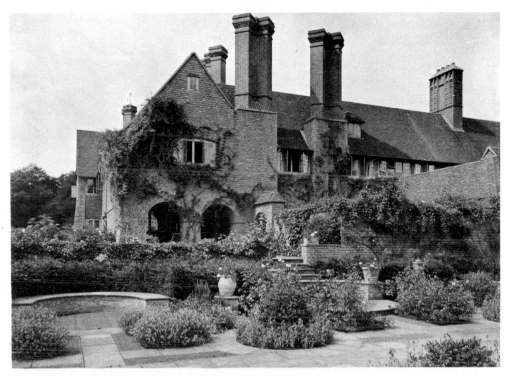

a. Edwin Landseer Lutyens: Orchards, Godalming, Surrey. 1899–1901.

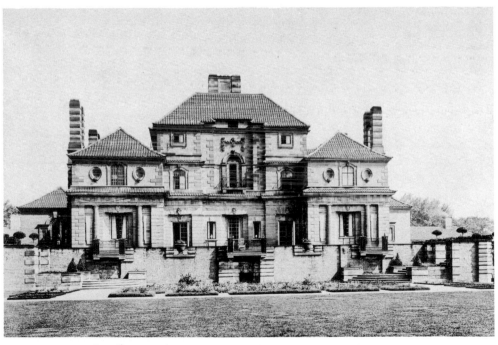

b. Edwin Landseer Lutyens: Heathcote, Ilkley, Yorkshire. 1906.

PLATE 46

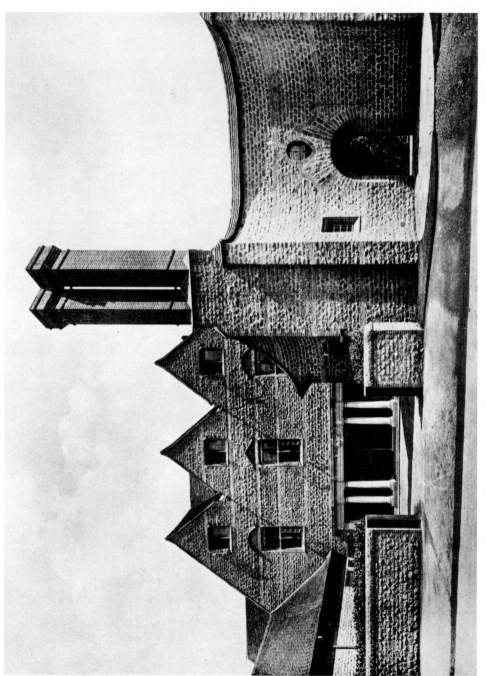

Edwin Landseer Lutyens: Tigbourne Court, Witley, near Godalming, Surrey. 1899.

PLATE 47

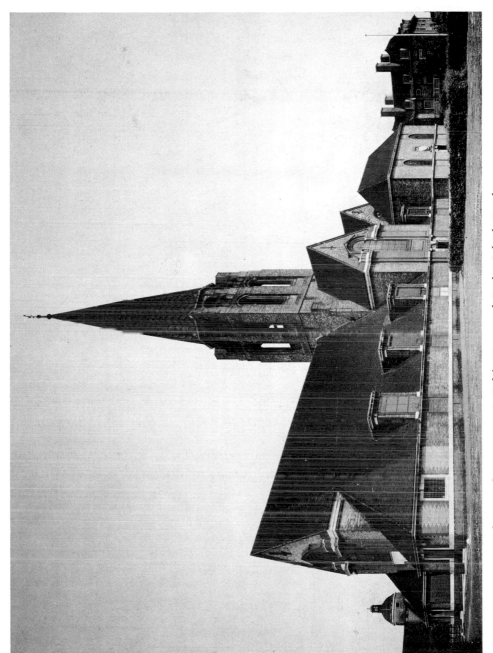

Edwin Landseer Lutyens: St. Jude's, Hampstead Garden Suburb, London. 1910–33.

PLATE 48

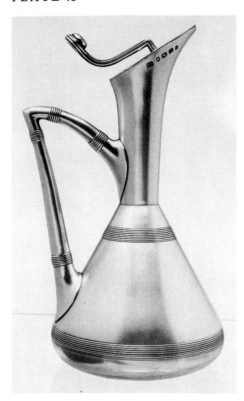

a. Christopher Dresser and Frederick Elkington: Claret Jug. 1885. [Maker's Mark FE: Designed by Dresser: Height: 24·5]

b. C. F. A. Voysey: 'The Snake' wallpaper design. *c.* 1889.

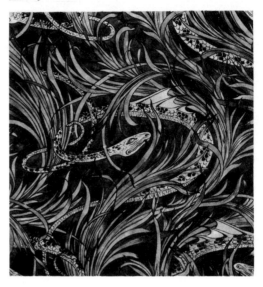

c. Edward William Godwin: The White House, 35 Tite Street, Chelsea, London. September 1877, the original unmodified design. [Pen and ink and watercolour, heightened with Chinese white: inscribed and dated: 38·75×56]

PLATE 49

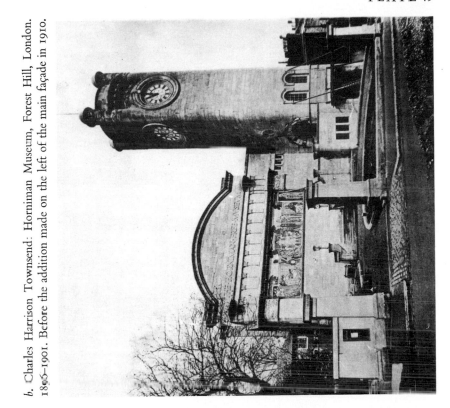

a. Charles Harrison Townsend: Whitechapel Art Gallery, London. 1896–1901.

b. Charles Harrison Townsend: Horniman Museum, Forest Hill, London. 1896–1901. Before the addition made on the left of the main façade in 1910.

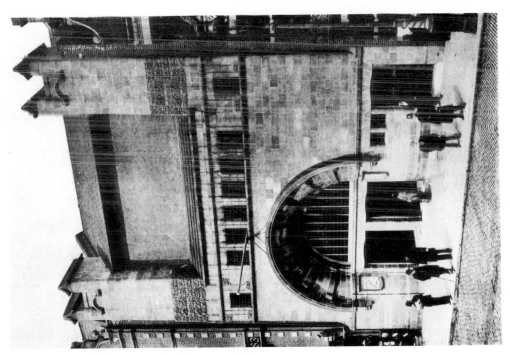

PLATE 50

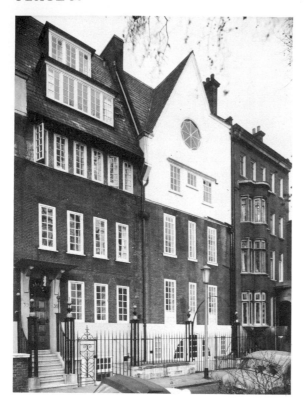

a. C. R. Ashbee: 39, 38, and 37 ('Magpie & Stump') Cheyne Walk, Chelsea, London. 39 and 38 1904, 37 1894.

b. A. Dunbar Smith and Cecil Brewer: Mary Ward Settlement, Tavistock Place, Holborn, London. 1897–8.

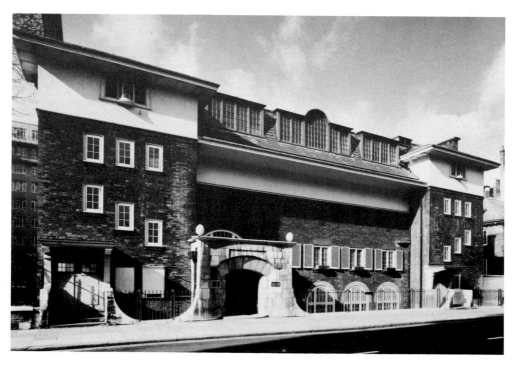

PLATE 51

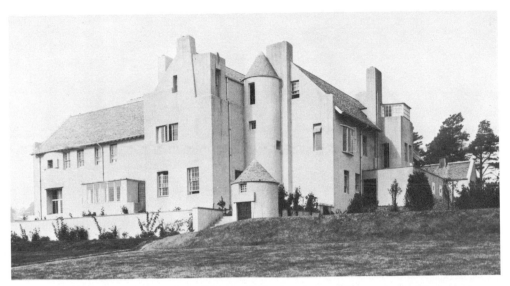

a. Charles Rennie Mackintosh: Hill House, Helensburgh, near Glasgow: exterior. 1902–4.

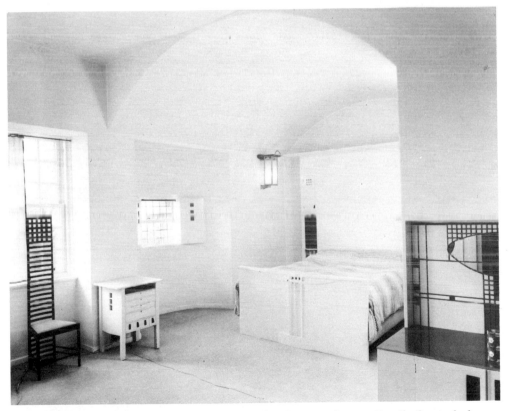

b. Charles Rennie Mackintosh: Hill House, Helensburgh, near Glasgow: Detail of main bedroom. 1902–4.

PLATE 52

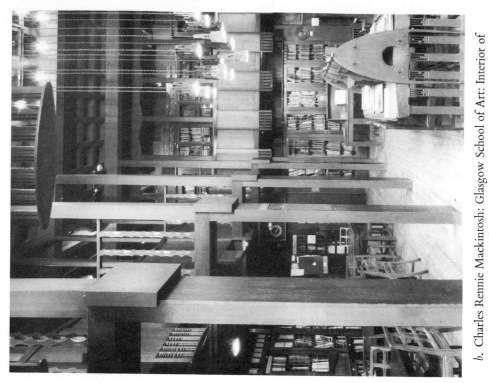

b. Charles Rennie Mackintosh: Glasgow School of Art: Interior of Library. 1907–10.

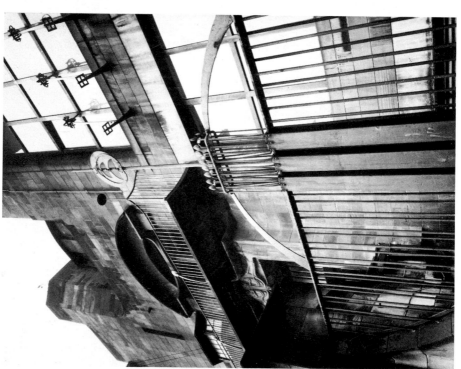

a. Charles Rennie Mackintosh: Glasgow School of Art: Detail of Railings.

PLATE 53

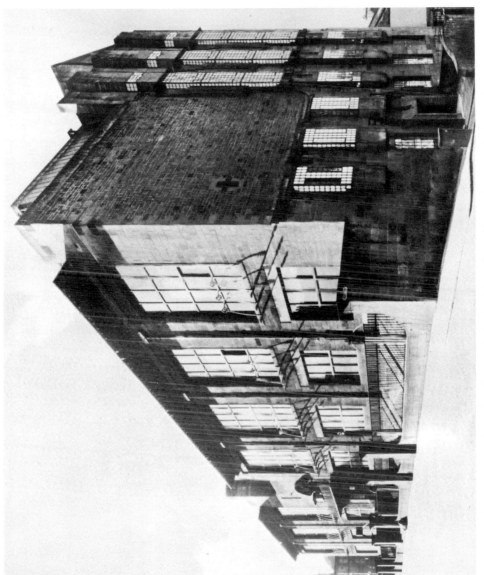

Charles Rennie Mackintosh: Glasgow School of Art: from the north-west: 1896-9 and 1907-10.

PLATE 54

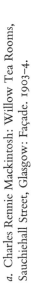

a. Charles Rennie Mackintosh: Willow Tea Rooms, Sauchiehall Street, Glasgow: Façade. 1903–4.

b. Charles Rennie Mackintosh: Willow Tea Rooms, Sauchiehall Street, Glasgow: Room De Luxe. 1903–4.

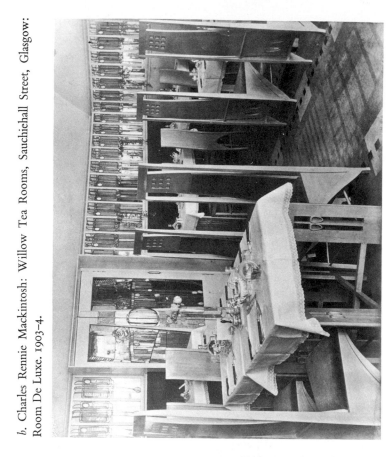

PLATE 55

Charles Rennie Mackintosh: 78 Derngate, Northampton: Guest Bedroom. 1916.

PLATE 56

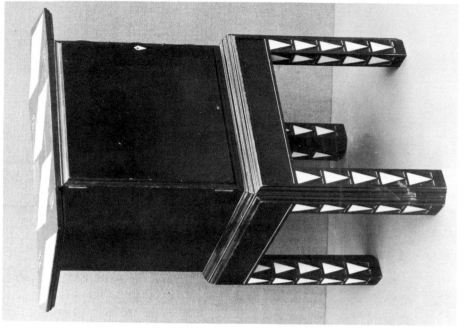

b. Charles Rennie Mackintosh: 78 Derngate, Northampton:
Smoker's Cabinet. c. 1916. [Ebonized wood inlaid with yellow
Erinoid (plastic): 59 × 33 × 58·5]

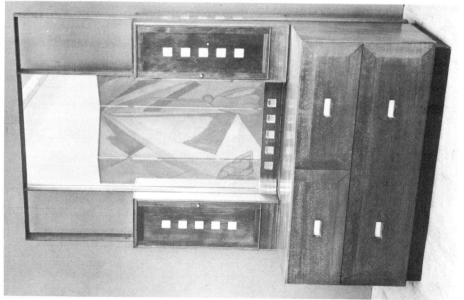

a. Charles Rennie Mackintosh: 78 Derngate, Northampton:
Dressing table. 1916–17. [Mahogany inlaid with mother of
pearl and aluminium: 172·75 × 116·75 × 51]

PLATE 57

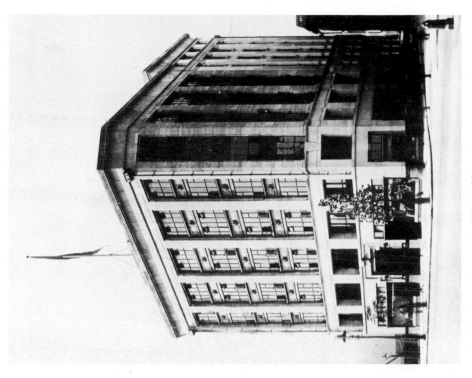

b. John James Burnet: Kodak Building, Kingsway, London. 1911.

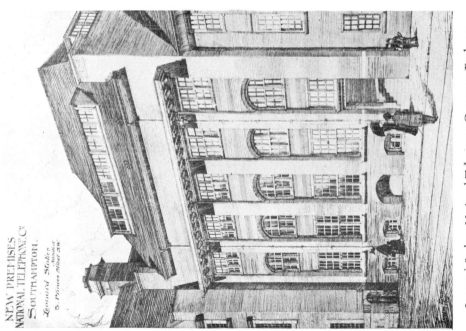

a. Leonard Stokes: National Telephone Company Exchange, Ogle Road, Southampton. 1900.

PLATE 58

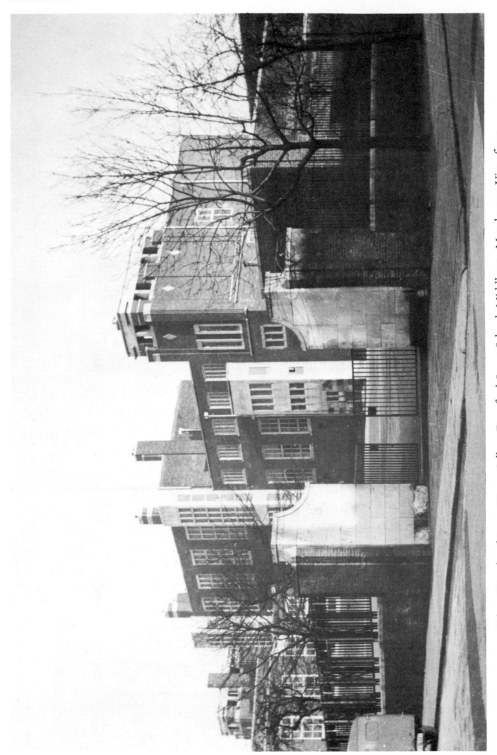

Edgar Wood and James Henry Sellers: Durnford Street School, Middleton, Manchester: View from street. 1908–10.

PLATE 59

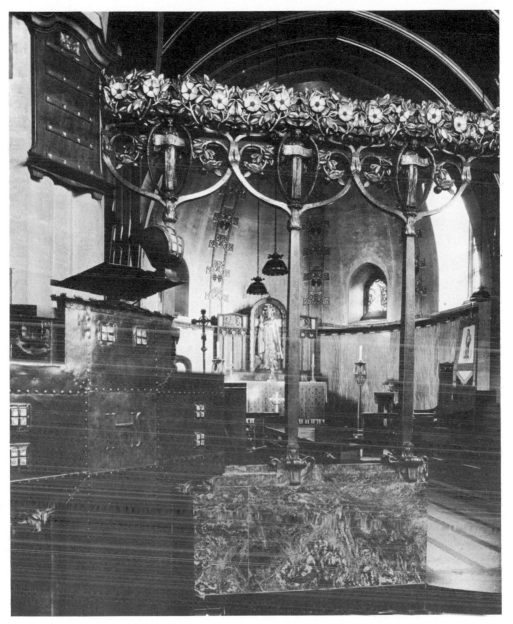

William Reynolds-Stephens: St. Mary the Virgin, Great Warley, Essex: Chancel screen, pulpit, and sanctuary. 1902–4.

PLATE 60

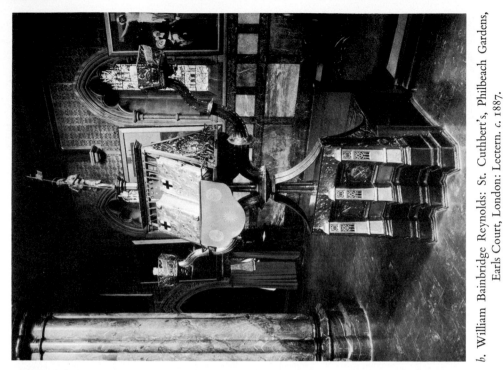

b. William Bainbridge Reynolds: St. Cuthbert's, Philbeach Gardens, Earls Court, London: Lectern. *c.* 1887.

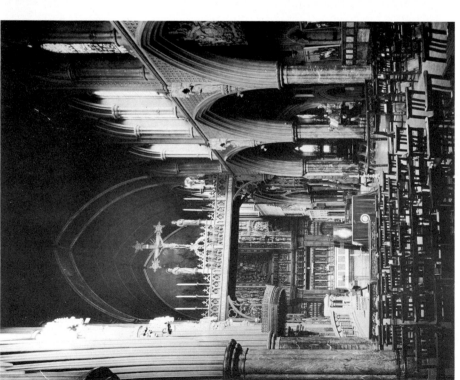

a. Hugh Roumieu Gough: St. Cuthbert's, Philbeach Gardens, Earls Court, London: Nave and high altar. 1884–7.

PLATE 61

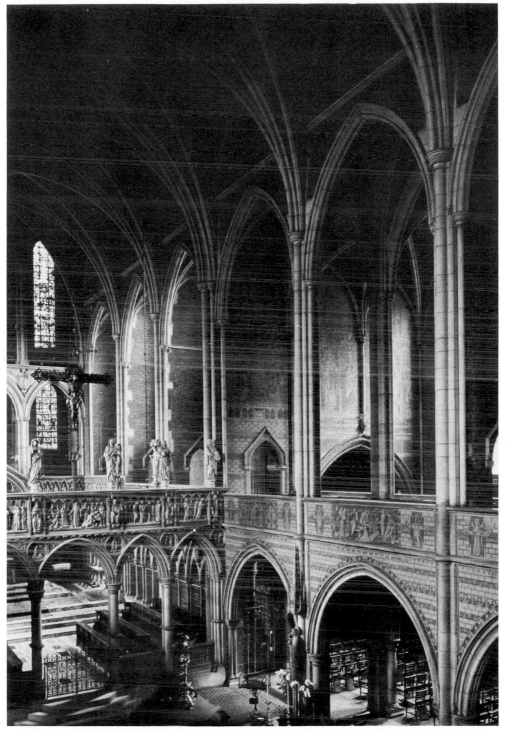

John Loughborough Pearson: St. Augustine's, Kilburn, London: Nave and south transept. 1871–80.

PLATE 62

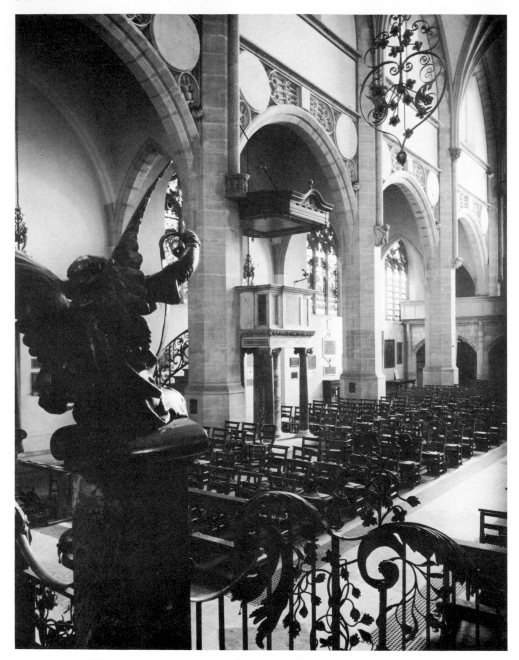

John Dando Sedding and Henry Wilson: Holy Trinity, Sloane Street, London: Nave and south aisle.
1888–90.

PLATE 63

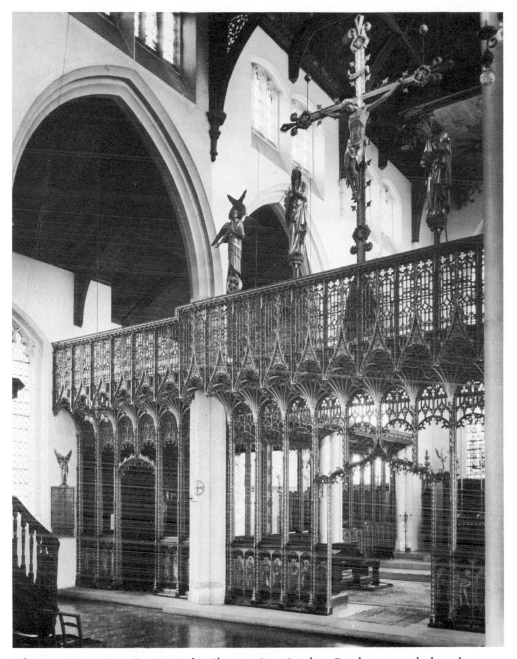

John Ninian Comper: St. Cyprian's, Clarence Gate, London: Rood screen and chancel. 1901–3:
Screen. 1924.

PLATE 64

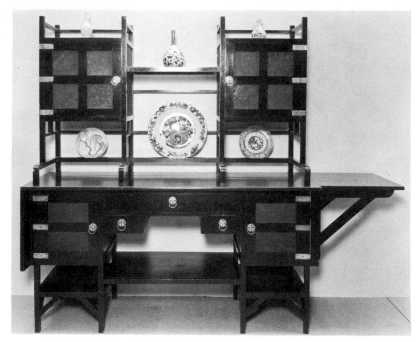

Edward William Godwin and William Watt: Sideboard. *c.* 1867. [Ebonized wood, silver-plated fittings and inset panels of Japanese leather paper: 180·25 × 259 × 56]

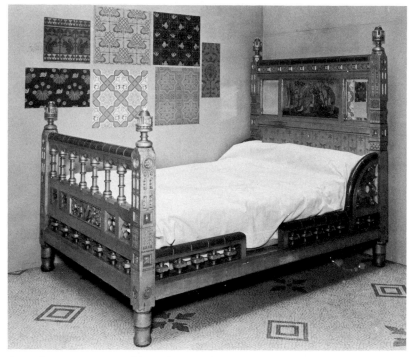

b. William Burges: Double Bed. 1889. [Gilded wood with carved and painted decoration, crystals, vellum and textile fragments under glass: signed and dated: Length: 233·5, Width: 160, Height: 165]

PLATE 65

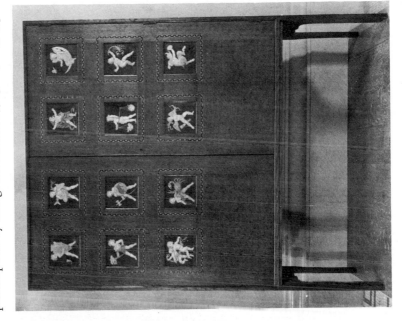

a. Thomas E. Collcutt and Collinson and Lock: Cabinet. 1871. [Ebonized wood, painted panels by Woolridge and incised designs: 236·25 × 145 × 58·5]

b. Lewis F. Day: Oak Cabinet with Signs of the Zodiac. 1888. [Oak, inlaid with ebony and satinwood, twelve grisaille painted panels by George McCulloch: 175·25 × 132 × 45·75]

PLATE 66

a. C. R. Ashbee and Guild of Handicraft: Oak Cabinet. 1889. [Oak with red and gilt painted floral decorations: Inscribed with quotations from William Blake's 'Auguries of Innocence': 193×167·5×45·75]

b. M. H. Baillie Scott and J. P. White: Clock. *c.* 1900. [Mahogany and inlays of coloured wood: Inscribed 'Festina Lente': 45·75×30·5×17·75]

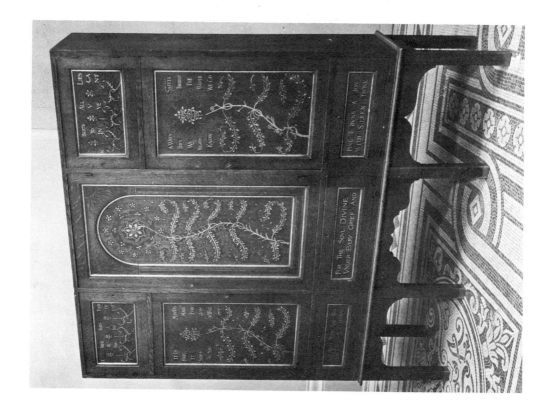

PLATE 67

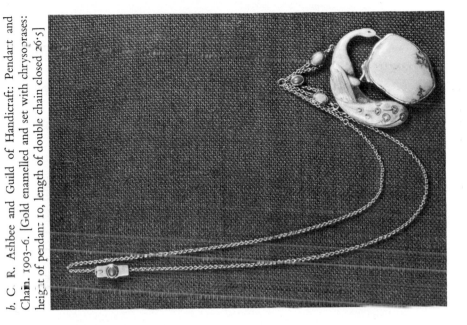

a. C. R. Ashbee: The Painter-Stainers' Cup. 1900. Maker's mark of C. R. Ashbee, but executed by W. Poyser. Inscribed around bowl 'The Gift of Harris Heal Master 1892 1893' and on cover 'Amor et Obedientia'. [Height: 44·75]

b. C. R. Ashbee and Guild of Handicraft: Pendant and Chain. 1903–6. [Gold enamelled and set with chrysoprases: height of pendant 10, length of double chain closed 26·5]

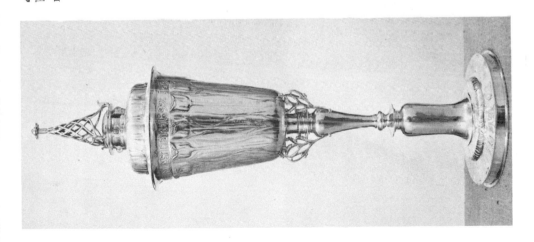

PLATE 68

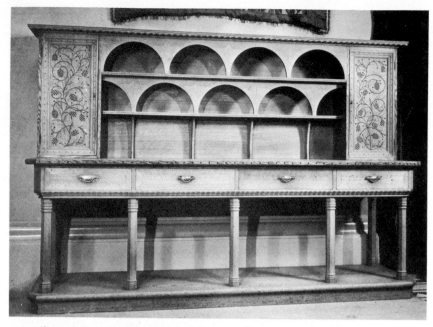

a. William Richard Lethaby: Sideboard. *c.* 1900. [Oak with inlays of ebony, sycamore, and bleached mahogany: 175·25 × 256·5 × 58·5]

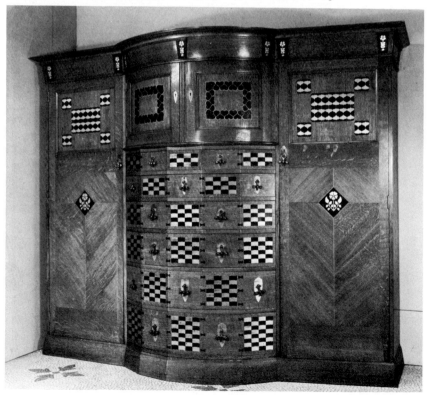

b. Ambrose Heal: Wardrobe. 1900. [Oak inlaid with pewter and ebony: 185·5 × 216 × 71]

PLATE 69

a. Ernest Gimson: Clergy
Stalls: St. Andrew's Chapel,
Westminster Cathedral. *c.*
1912. [Brown ebony inlaid
with bone]

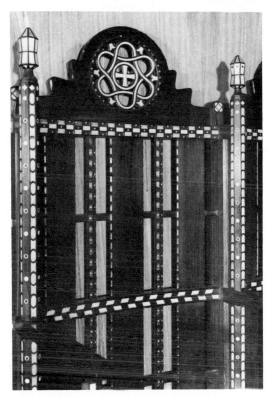

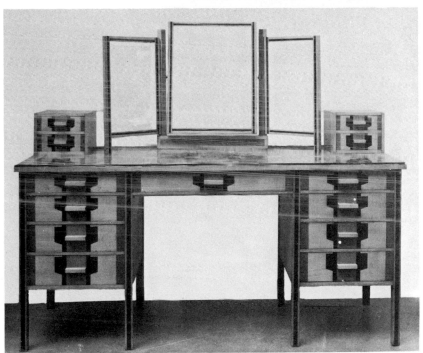

b. Omega Workshops and J. Kallenborn & Sons Ltd.: Dressing Table. 1919. [Holly, inlaid
with veneers of ebony, walnut, and sycamore: Base: 92 × 107·25 × 53·5. Mirrors: max.
height: 60·25]

PLATE 70

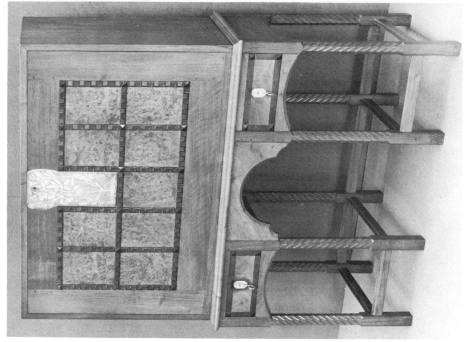

b. Gordon Russell: Writing Desk. 1927. [Walnut with burr elm panels, mulberry and bog oak, with chased silver lock plate: dated: 137×106·75×45·75]

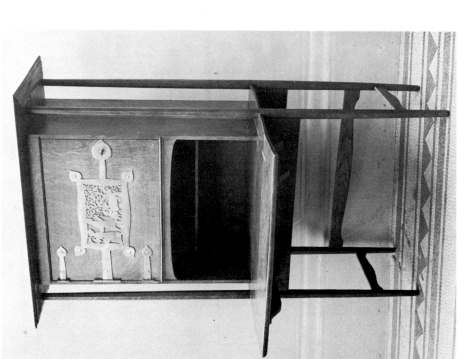

a. C. F. A. Voysey and W. H. Tingey: Writing Desk. 1896. [Unstained oak with beaten copper hinges and pierced decorative panel: 167·5×86·25×84]

PLATE 71

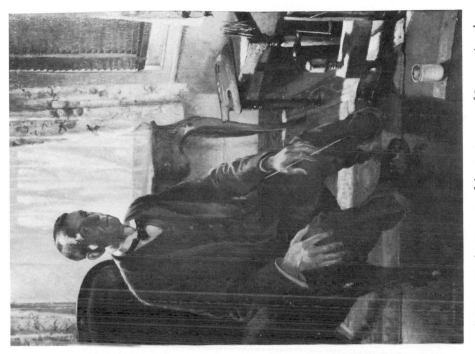

b. Henry Tonks: Portrait of the Artist. 1909. [Canvas: signed
'Henry Tonks 1909': 81 × 59·5]

a. William Rothenstein: The Doll's House. 1899.
[Canvas: 89 × 61]

PLATE 72

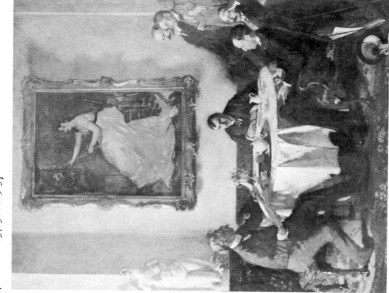

a. Max Beerbohm: The Edwardyssey: Edwardysseus smiles his well-known hanoverian side-long smile, and is instantly recognised by the faithful Eumaeus-Knollys, by George-Telemachus, and by Jacko-Argus. 1903. [Pencil and wash: 31·75 × 19·75]

b. William Orpen: Hommage à Manet. 1909. [Canvas: 157·5 × 129·5]

PLATE 73

b. Gerald Kelly: The Jester (W. Somerset Maugham). 1911.
[Canvas: 101·5×76]

a. Henry Lamb: Portrait of Lytton Strachey. 1914.
[Canvas: 244·5×78·5]

PLATE 74

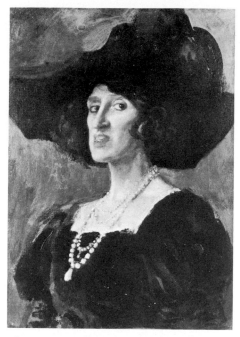

a. Walter Richard Sickert: Harold Gilman. *c.* 1912. [Canvas: 61 × 45·75]

b. Augustus John: Lady Ottoline Morrell. *c.* 1919. [Canvas: 66 × 48·25]

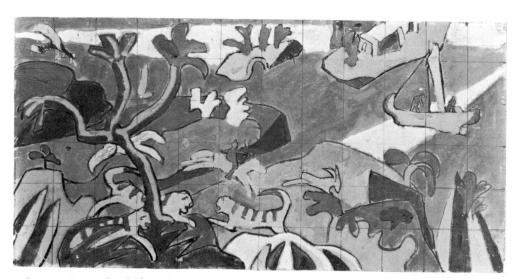

c. Spencer Gore: Sketch for a mural decoration for 'The Cave of the Golden Calf'. 1912. [Paper mounted on card: inscribed and dated on reverse, not in artist's hand: 30·5 × 60·5]

PLATE 75

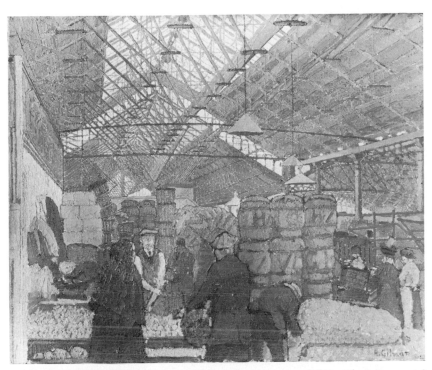

a. Harold Gilman: Leeds Market. *c.* 1913. [Canvas: signed 'H. Gilman': 51×61]

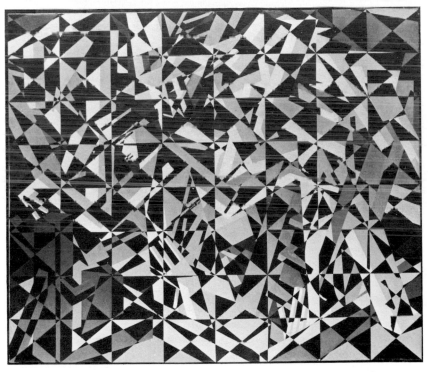

b. David Bomberg: In the Hold. 1913–14. [Canvas: 198×256·5]

PLATE 76

b. Vanessa Bell: Bathers in a Landscape (four-leaf folding screen). 1913-14.
[Canvas: 179×208·25 over all: each leaf: 52 wide]

a. Wyndham Lewis: The Crowd (Revolution). 1915. [Canvas: 198×152·5]

PLATE 77

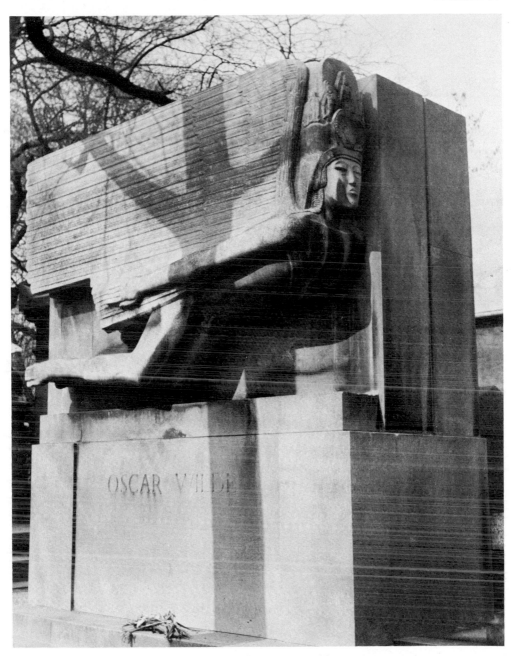

Jacob Epstein: Tomb to Oscar Wilde. 1912.

PLATE 78

a. Jacob Epstein: Mrs. Mary McEvoy. *c.* 1910. [Bronze: 42 × 39 × 23]

b. Jacob Epstein: Marble Doves. *c.* 1913. [Parian marble: 64·75 × 80 × 34·25]

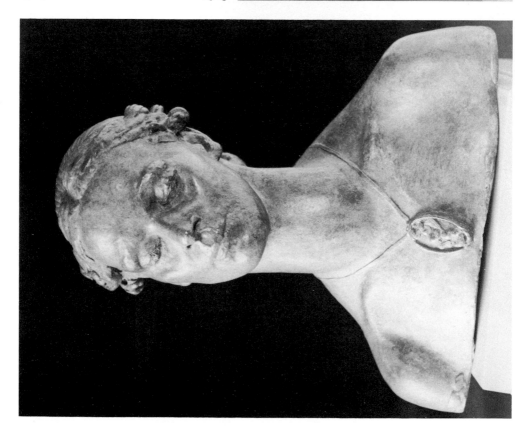

PLATE 79

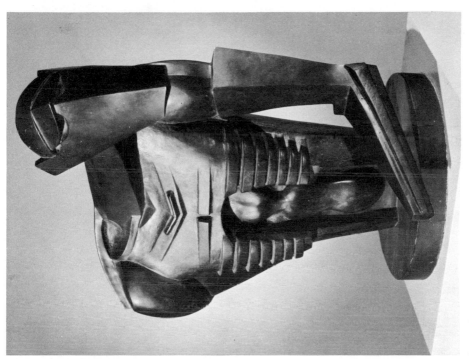

b. Jacob Epstein: Torso in Metal from 'The Rock Drill'. 1913–16. [Bronze: 70·5 × 58·5 × 44·5]

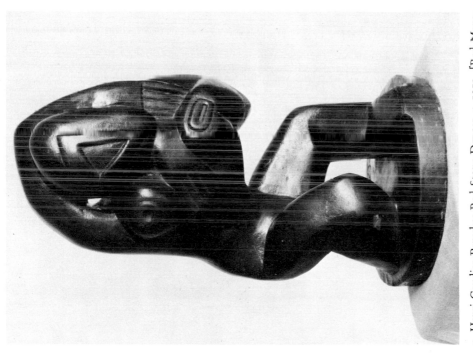

a. Henri Gaudier-Brzeska: Red Stone Dancer. c. 1913. [Red Mansfield stone: signed 'HGB': ·3 × 23 × 23]

PLATE 80

ABCDEFGHIJKLMNOPQRSTUVWXYZ
abcdefghijklmnopqrstuvwxyz

a. Edward Johnston: Sans serif typeface. 1916–31.

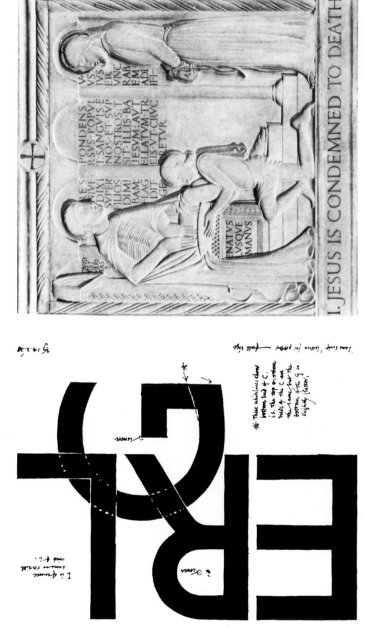

b. Eric Gill: Preliminary drawing for 'Gill Sans' typeface. 1928. [Pen and ink: signed and dated 14 February 1928: 26·5 × 21]

c. Eric Gill: Station of the Cross I: Jesus is condemned to death. 1913–15.

PLATE 81

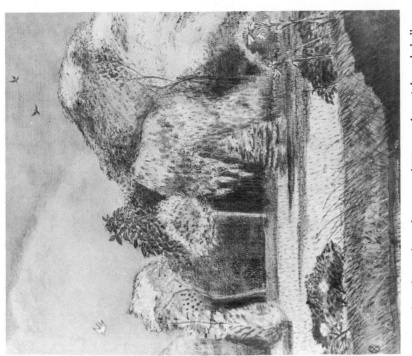

b. Paul Nash: Bird Garden. 1911. [Water-colour, ink, and chalk: signed and dated 'August 1911': 38·75 × 33·5]

a. John Duncan Fergusson: Blue Beads, Paris. 1910. [Board: signed 'Paris 1910' J. D. Fergusson': 50 × 45·75]

PLATE 82

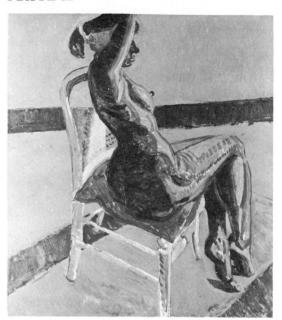

a. Matthew Smith: Nude, Fitzroy Street, No. 1. 1916. [Canvas: signed 'MS': 86 × 76]

b. Matthew Smith: A Winding Road: Cornish Landscape. 1920. [Canvas: 53·25 × 64·75]

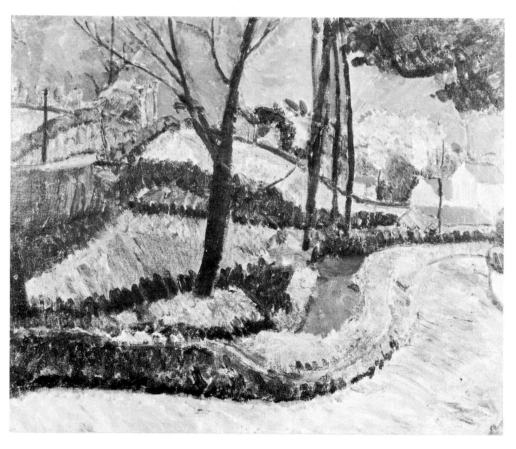

PLATE 83

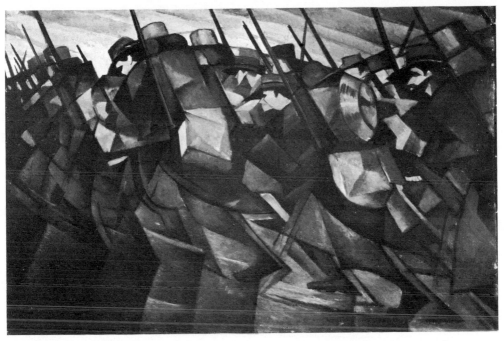

a. C. R. W. Nevinson: Returning to the Trenches. 1914–15. [Canvas: 51 × 76]

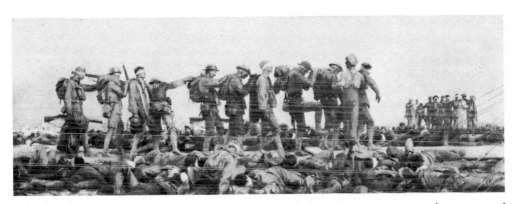

b. John Singer Sargent: Gassed. 1918. [Canvas: signed 'John S. Sargent Aug. 1918': 228·5 × 610]

PLATE 84

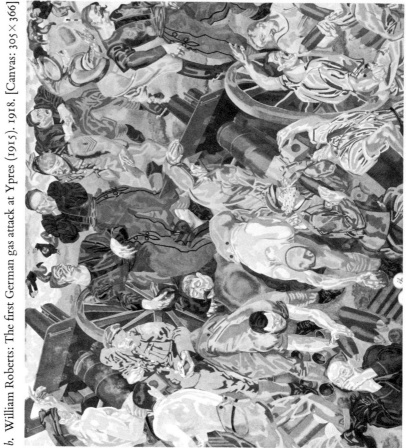

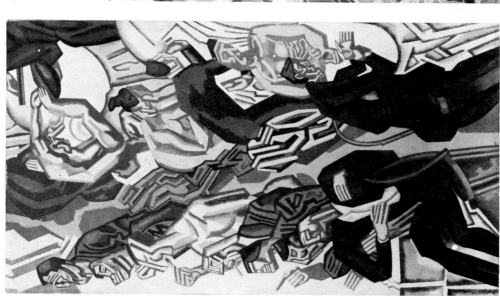

a. William Roberts: The Diners. 1919. [Canvas: 152·5 × 83·25]

b. William Roberts: The first German gas attack at Ypres (1915). 1918. [Canvas: 305 × 366]

PLATE 85

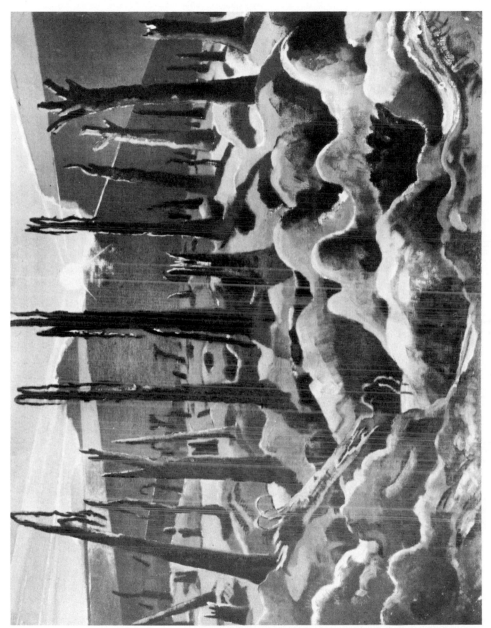

Paul Nash: We are making a New World. 1918. [Canvas: 71×91·5]

PLATE 86

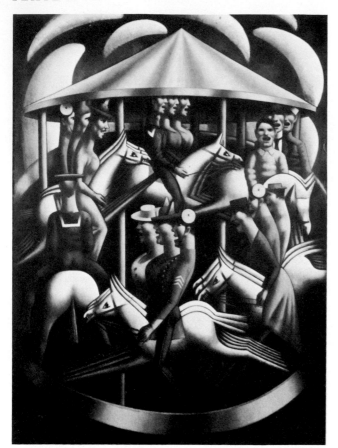

a. Mark Gertler: The Merry-go-round 1916. [Canvas: 193 × 142]

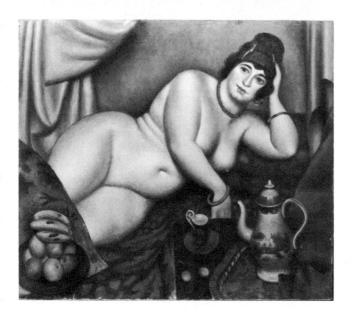

b. Mark Gertler: The Queen of Sheba. 1922. [Canvas: signed 'Mark Gertler 1922': 94 × 107·25]

PLATE 87

a. Duncan Grant: South of France. 1921–2. [Canvas: signed 'D. Grant/22':
64·75 × 80·75]

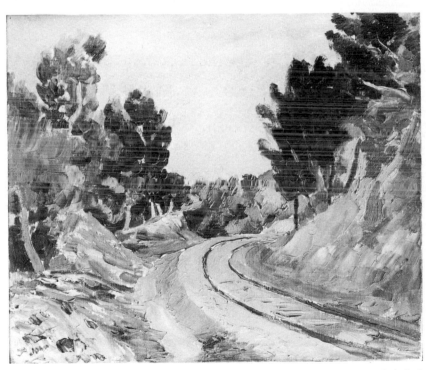

b. Augustus John: The Little Railway, Martigues. 1928. [Canvas: signed 'John'
47 × 54·5]

PLATE 88

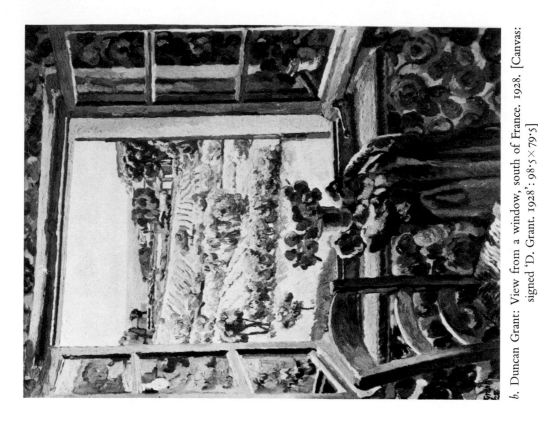

b. Duncan Grant: View from a window, south of France. 1928. [Canvas: signed 'D. Grant. 1928': 98·5×79·5]

a. Matthew Smith: Woman with a Fan. 1925. [Canvas: signed 'MS': 152·5×100·25]

PLATE 89

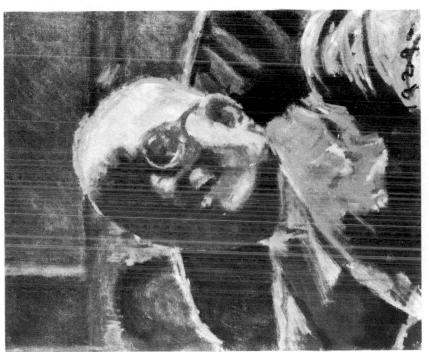

a. Walter Richard Sickert: Hugh Walpole. 1929. [Canvas: signed 'Sickert 1929': 76×63·5]

b. Walter Richard Sickert: The Raising of Lazarus. *c.* 1929–32. [Canvas: 244×91·5]

PLATE 90

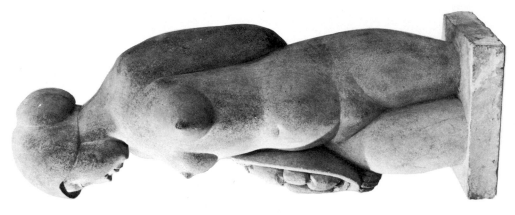

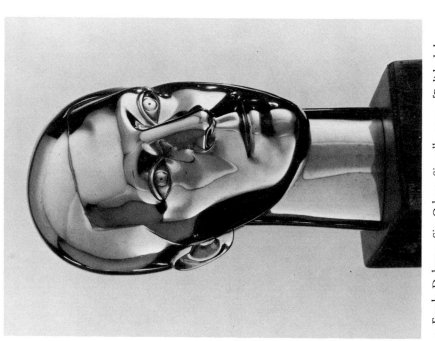

a. Frank Dobson: Sir Osbert Sitwell. 1923. [Polished brass: 32×18×23]

b. Frank Dobson: Cornucopia. 1925–7. [Ham Hill stone: Height: 152·5]

PLATE 91

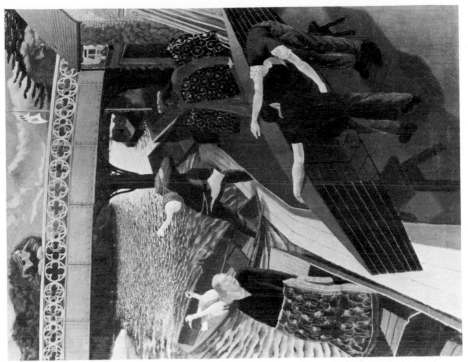

b. Stanley Spencer: Swan upping at Cookham. 1914–19. [Canvas: signed 'S. Spencer 1915 1919': 148×115·5]

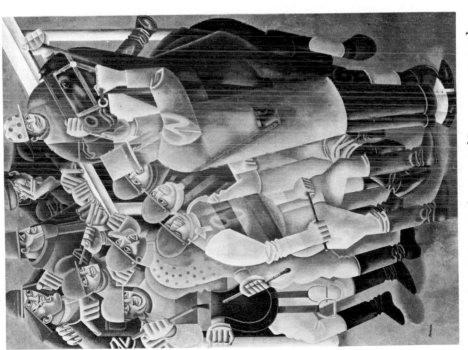

a. William Roberts: Jockeys. 1928. [Canvas: 122·5×92·25]

PLATE 92

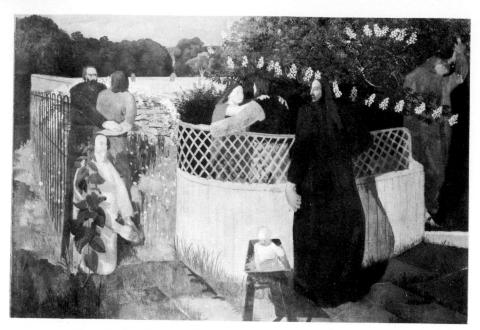

a. Stanley Spencer: The Nativity. 1912. [Canvas: 103 × 152·5]

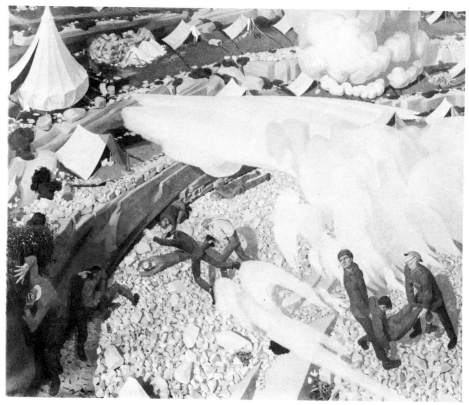

b. Henry Lamb: Irish troops surprised by a Turkish bombardment in the Judaean hills. 1919.
[Canvas: 183 × 218·5]

PLATE 93

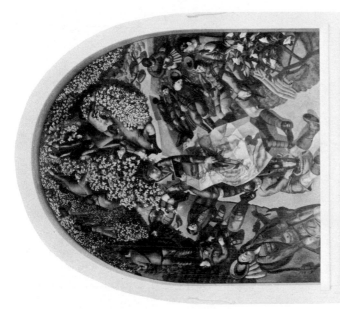

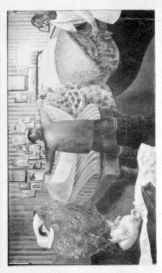

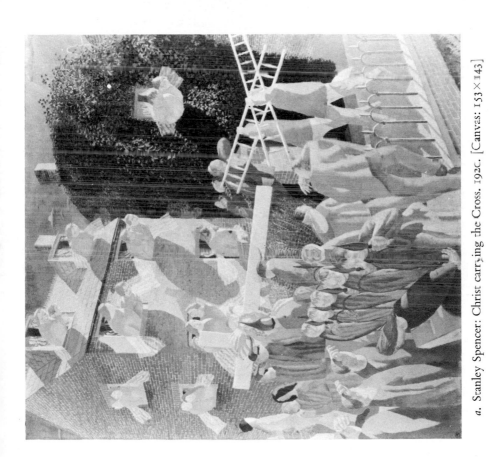

a. Stanley Spencer: Christ carrying the Cross. 1920. [Canvas: 153×143]

b. Stanley Spencer: Map-reading and making beds. 1927–33.

PLATE 94

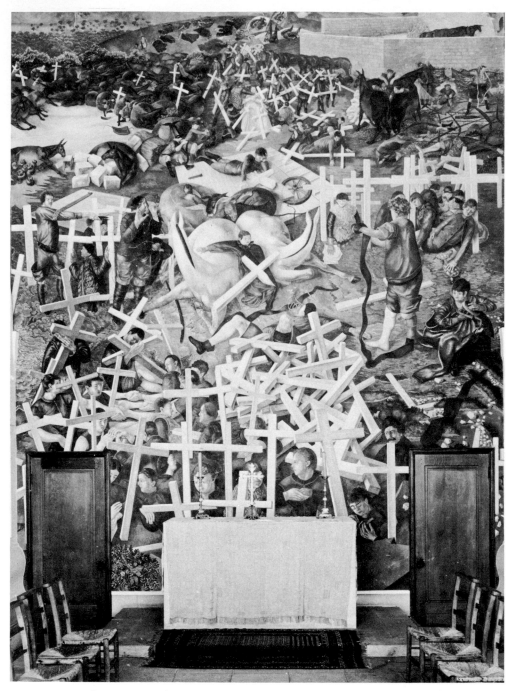

Stanley Spencer: The Resurrection of Soldiers. 1928–9. [Canvas: 640×556]

PLATE 95

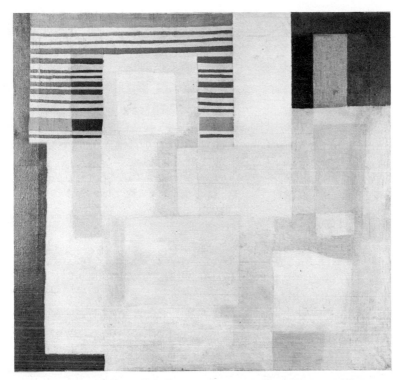

a. Ben Nicholson: Painting (Trout). 1924. [Canvas: 56×58·5]

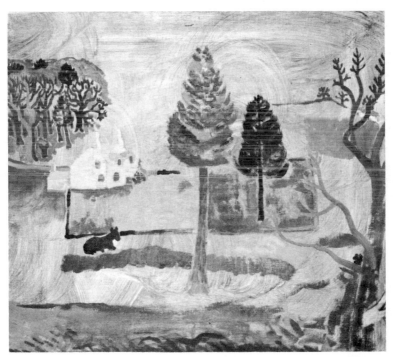

b. Ben Nicholson: Walton Wood Cottage No. 1. 1928. [Canvas: signed and dated: 56×61]

PLATE 96

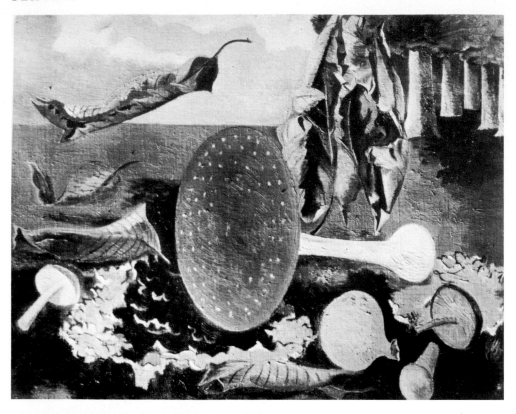

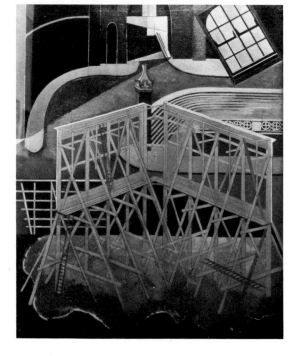

a. Paul Nash: Swan Song. 1928. [Canvas: signed 'PN': 42 × 52]

b. Paul Nash: Northern Adventure. 1929. [Canvas: signed 'Paul Nash': 91·5 × 72·5]

PLATE 97

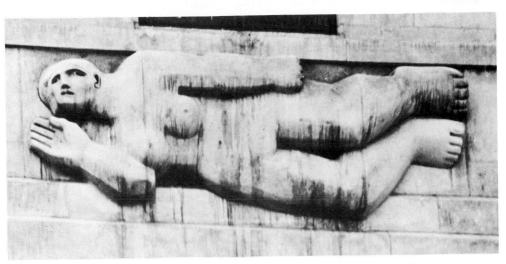

a. Henry Moore: West Wind. 1929. [Length: approximately 244]

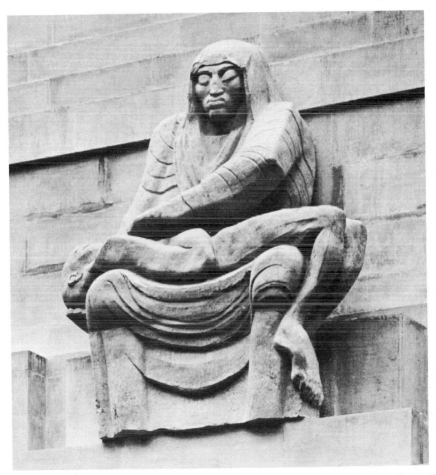

b. Jacob Epstein: Night. 1929. [Over-all width, excluding base, approximately 198]

PLATE 98

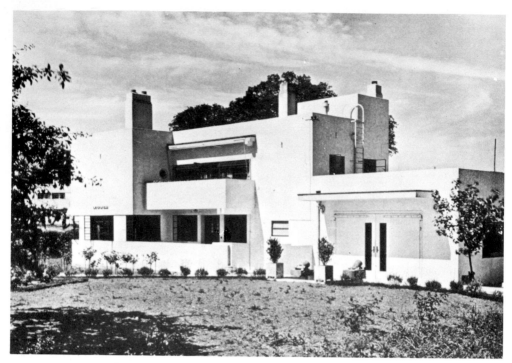

a. Thomas S. Tait: Le Chateau, Silver End, Braintree, Essex. 1926.

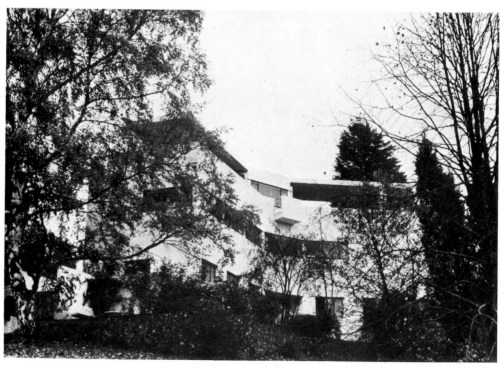

b. Amyas Connell: High and Over, Amersham, Buckinghamshire. 1929.

PLATE 99

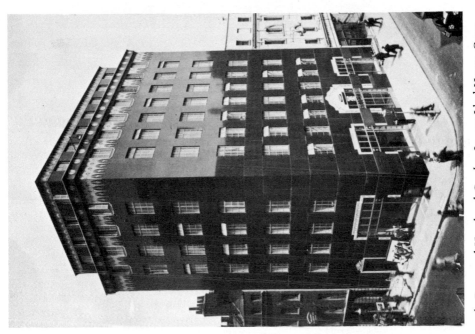

b. Raymond Hood and Gordon Jeeves: Ideal House, Great Marlborough Street, Westminster, London. 1928.

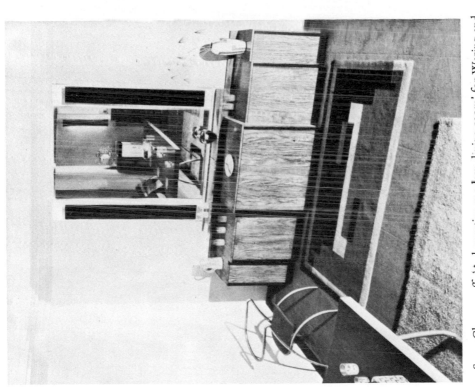

a. Serge Chermayeff: 'A decorative modern dining-room' for Waring and Gillow. c. 1930. From Decorative Art 1930: Year-book of 'The Studic'.

PLATE 100

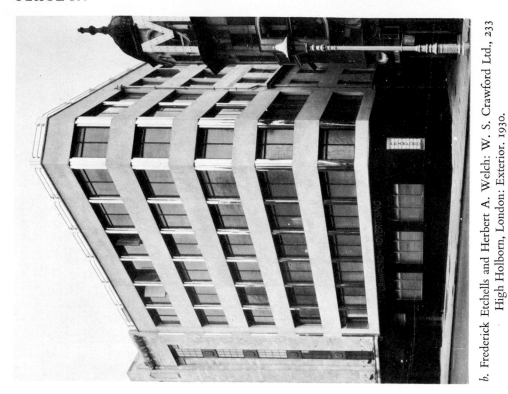

b. Frederick Etchells and Herbert A. Welch: W. S. Crawford Ltd., 233 High Holborn, London: Exterior. 1930.

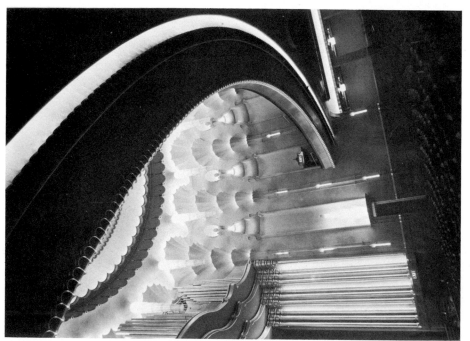

a. Trent and Lewis: New Victoria Cinema, Vauxhall Bridge Road, London: Interior. 1929.

PLATE 101

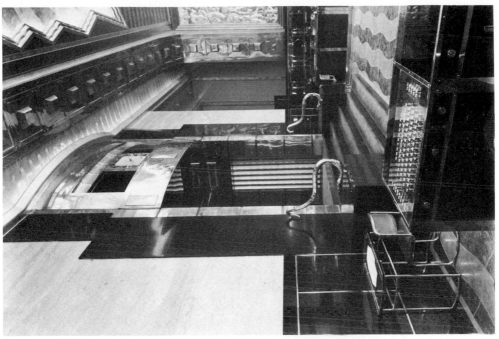

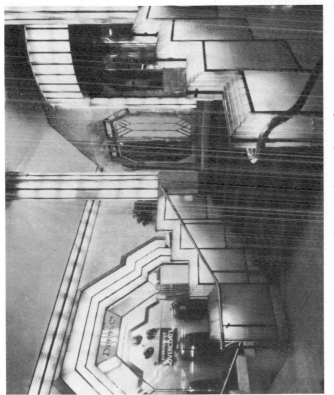

a. Oliver P. Bernard: Strand Palace Hotel, Strand, London: Foyer. 1930.

b. Robert Atkinson: Daily Express Office, Fleet Street, London: Entrance Hall. 1931.

PLATE 102

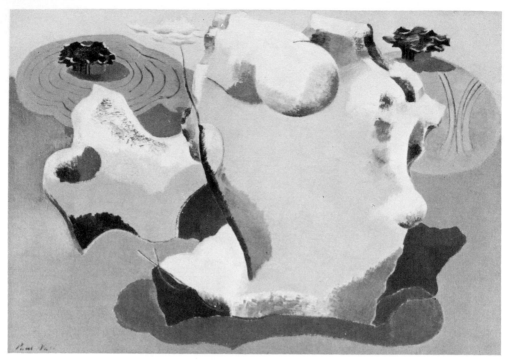

a. Paul Nash: Landscape of the Megaliths. 1934. [Canvas: signed: 59·75 × 72·5]

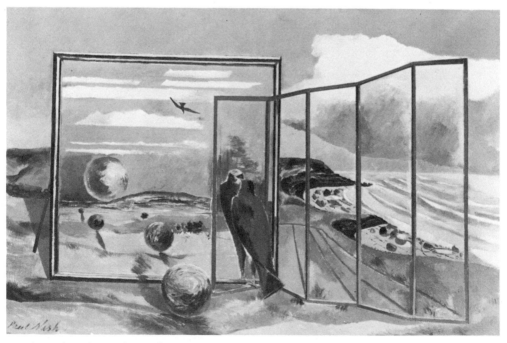

b. Paul Nash: Landscape from a Dream. 1936–8. [Canvas: signed: 'Paul Nash': 68 × 101·5]

PLATE 103

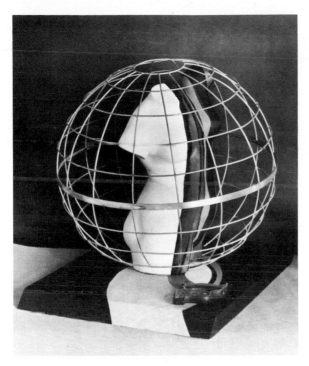

a. Roland Penrose: Captain Cook's Last Voyage. 1936. [Painted plaster, wood and wire: 68·5 × 66 × 86·25] ·

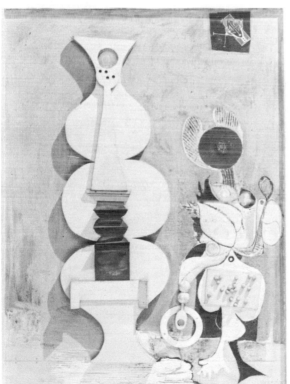

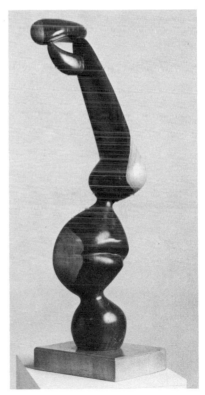

b. Ceri Richards: Two Females. 1937–8. [Painted wooden relief construction with brass strip and ornaments: signed and dated on front and reverse: 160 × 117 × 9]

c. F. E. McWilliam: Profile. 1939–40. [Lignum vitae: 62 × 17·75, on wooden base 20·25 × 14 × 3·75]

PLATE 104

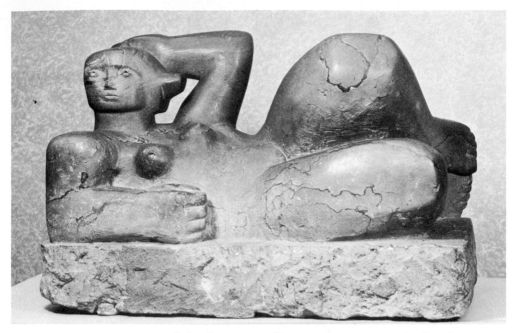

a. Henry Moore: Reclining figure. 1929. [Brown Hornton stone: Length: 84]

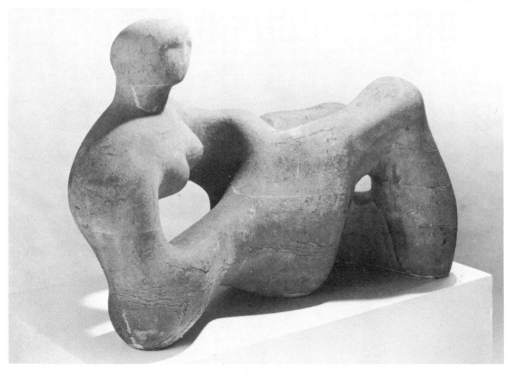

b. Henry Moore: Recumbent figure. 1938. [Green Hornton stone: 89×132·75×73·75]

PLATE 105

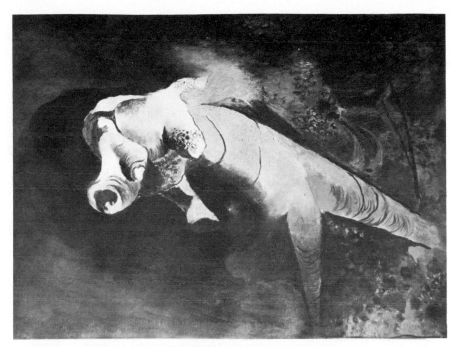

a. Graham Sutherland: Green tree form: Interior of woods. 1940. [Canvas: 79 × 107·5]

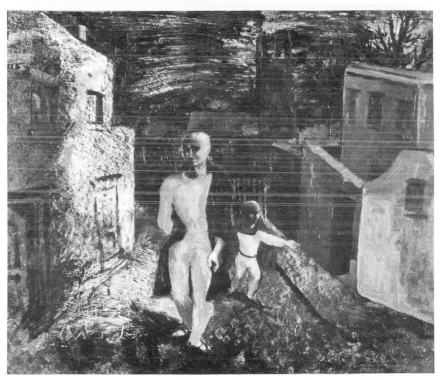

b. Christopher Wood: The Yellow Man. 1930. [Board: 51 × 76]

PLATE 106

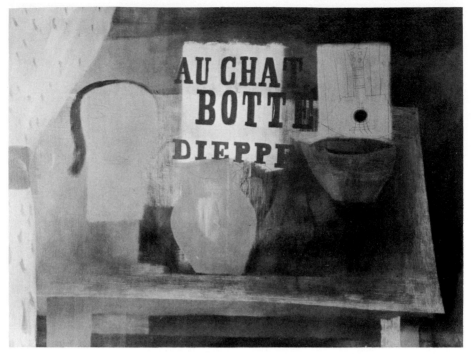

a. Ben Nicholson: Au Chat Botté. 1932. [Canvas: 93·5 × 123]

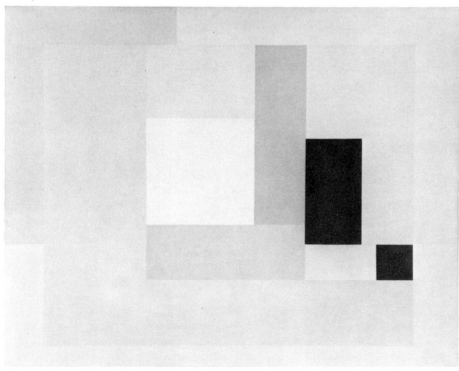

b. Ben Nicholson: Painting. 1937. [Canvas: Inscribed on verso 'Ben Nicholson June 1937':
159·5 × 201]

PLATE 107

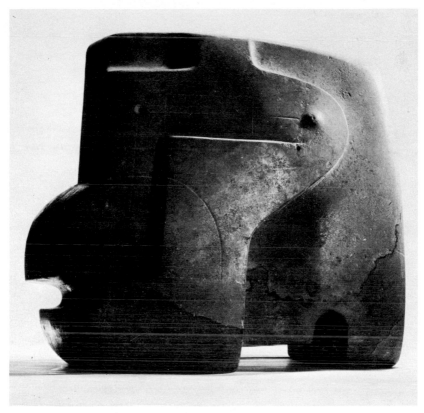

a. Henry Moore: Square form. 1936. [Green Hornton stone: Length: 40·5]

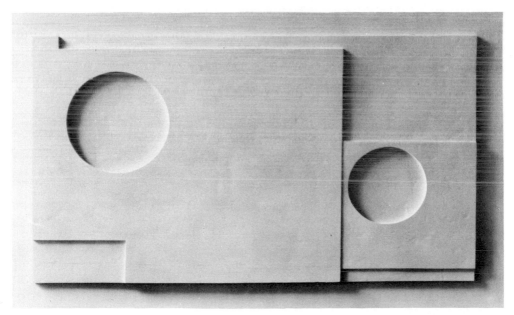

b. Ben Nicholson: White relief. 1935. [Carved out of mahogany mounted on plywood and painted white: Inscribed 'Ben Nicholson 1935' on reverse: 101·5 × 166·5]

PLATE 108

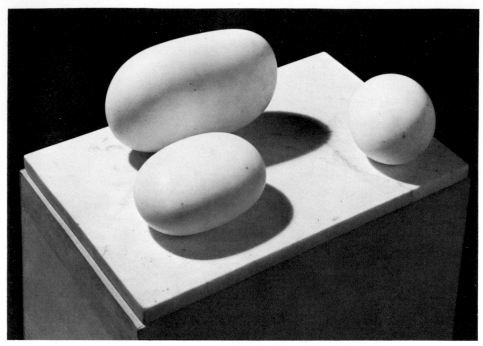

a. Barbara Hepworth: Three forms. 1935. [Serravezza marble: Height of largest form 25·5; all three on a marble base 2·25×53·25×34·25]

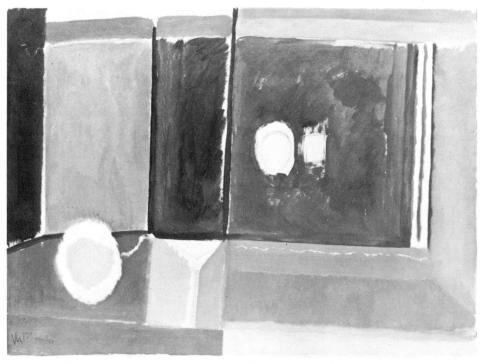

b. Ivon Hitchens: Coronation. 1937. [Canvas: signed 'Hitchens': 90×122]

PLATE 109

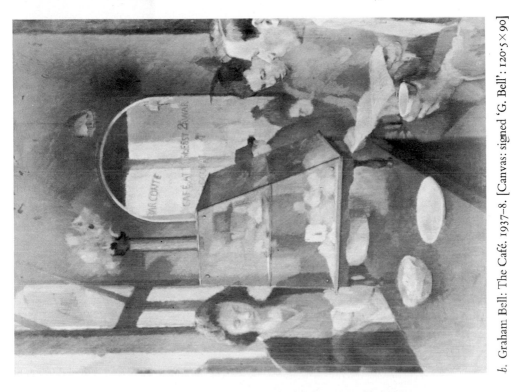

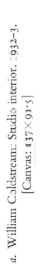

b. Graham Bell: The Café. 1937–8. [Canvas: signed 'G. Bell': 120·5 × 90]

a. William Coldstream: Studio interior. 1932–3.
[Canvas: 137 × 91·5]

PLATE 110

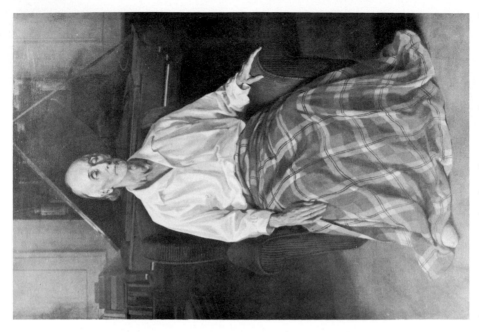

b, James Gunn: Frederick Delius. 1930. [Canvas: 183 × 122]

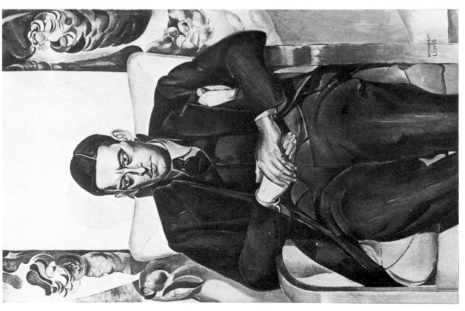

a, Wyndham Lewis: Portrait of T. S. Eliot. 1938. [Canvas: signed 'Wyndham Lewis': 132 × 85]

PLATE 111

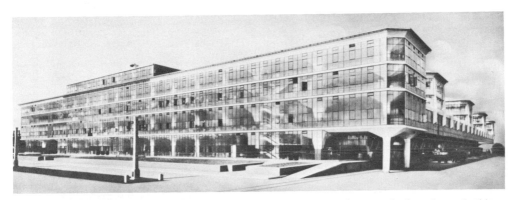

a. E. Owen Williams: Boots Pure Drug Company, Beeston, Nottingham: Packed goods wet building. 1930–2.

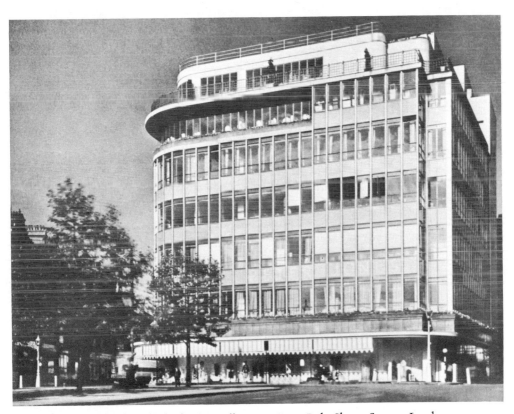

b. William Crabtree and Charles H. Reilly: Peter Jones Ltd., Sloane Square, London. 1933–9.

PLATE 112

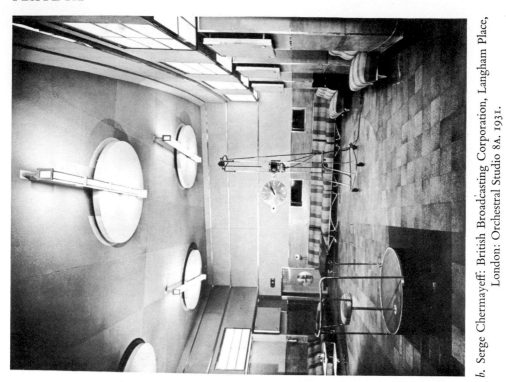

b. Serge Chermayeff: British Broadcasting Corporation, Langham Place, London: Orchestral Studio 8A. 1931.

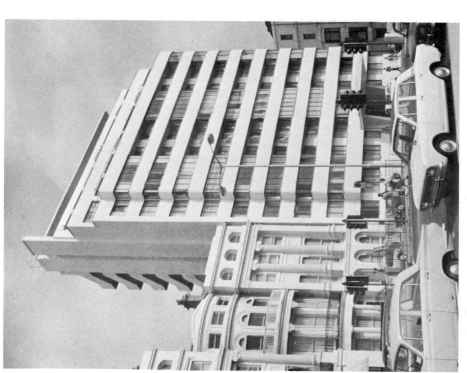

a. Wells Coates: Embassy Court, Brighton, Sussex. 1934–5.

PLATE 113

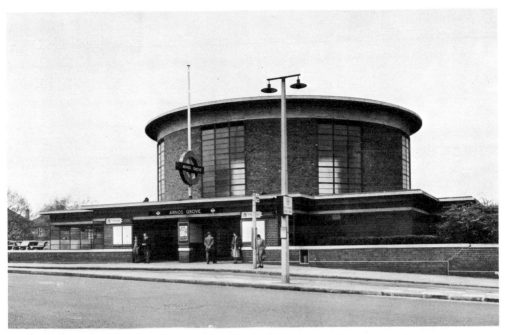

a. Adams, Holden and Pearson: Arnos Grove Underground Station, Middlesex. 1932.

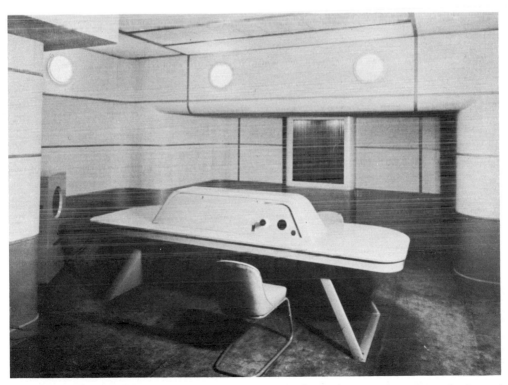

b. Wells Coates: British Broadcasting Corporation, Langham Place, London: Dramatic Control Room No. 1. 1931.

PLATE 114

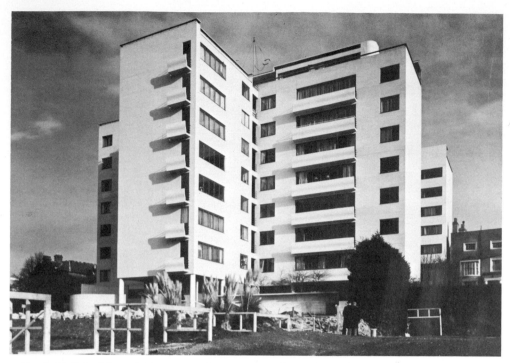

a. Berthold Lubetkin and Tecton: Highpoint I, North Road, Highgate Village, London. 1933–5.

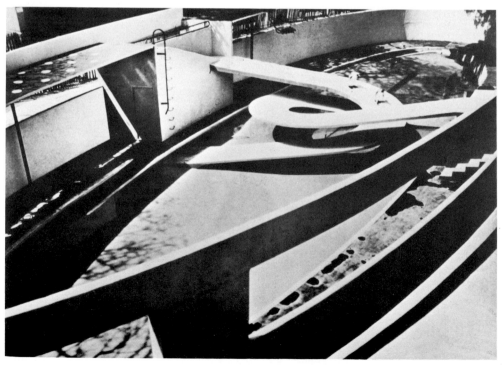

b. Berthold Lubetkin and Tecton: London Zoo, Regent's Park, London: Penguin Pool. 1934.

PLATE 118

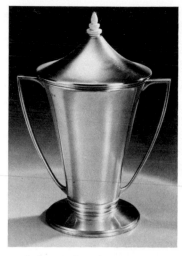

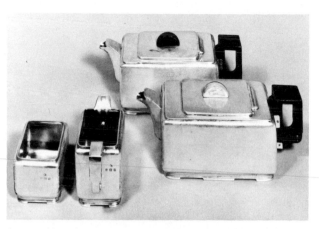

a. Arthur Edward Harvey: Cup and Cover. 1933. [Maker's mark of Hukin and Heath, Birmingham: Silver and ivory: Height: 25·5]

b. Harold Stabler: Tea Service. 1936. [Maker's mark of Adie Brothers Ltd., Birmingham: Silver, wood, and ivory]

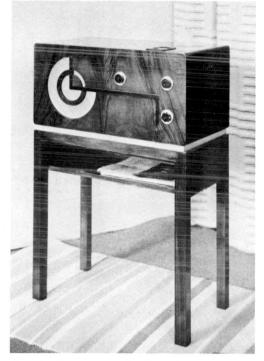

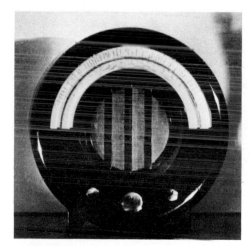

c. Wells Coates: Radio Cabinet. 1934. [Designed for Eric K. Cole & Co. (Ecko): Bakelite: diameter approx. 40·5]

d. Richard Drew Russell and Gordon Russell Limited: Radio Cabinet. 1932. [Designed for Murphy Radio Limited: Black walnut haldu plinth to cabinet, grey and blue check silk over loudspeaker opening: over-all height approx. 91·5]

PLATE 117

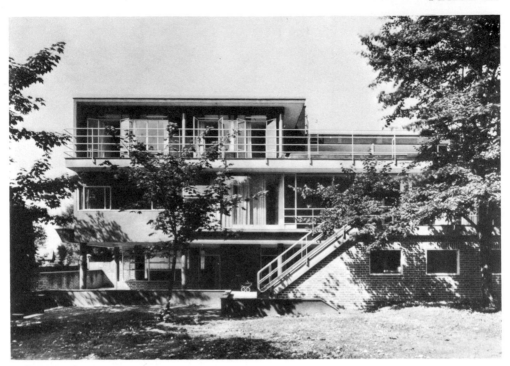

a. Connell, Ward and Lucas: 66 Frognal, Hampstead, London: Garden façade. 1937–8.

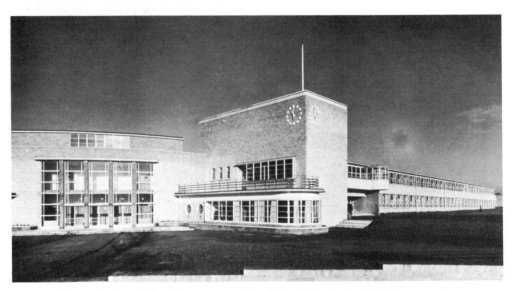

b. Marshall and Tweedy: Luton Modern School, Luton, Bedfordshire. 1936–8.

PLATE 116

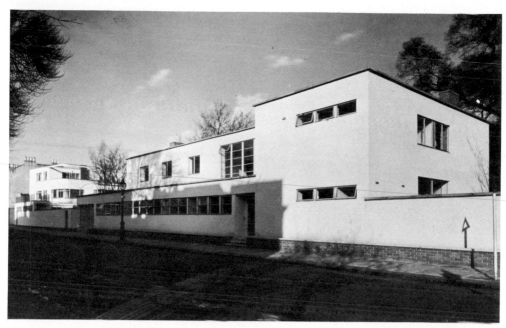

a. Erich Mendelsohn and Serge Chermayeff: 64 Old Church Street, Chelsea, London. 1936. In background: Gropius and Fry's, 66 Old Church Street.

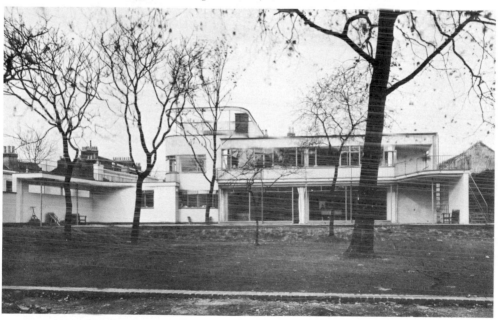

b. Walter Gropius and E. Maxwell Fry: 66 Old Church Street, Chelsea, London: Garden elevation. 1936.

PLATE 115

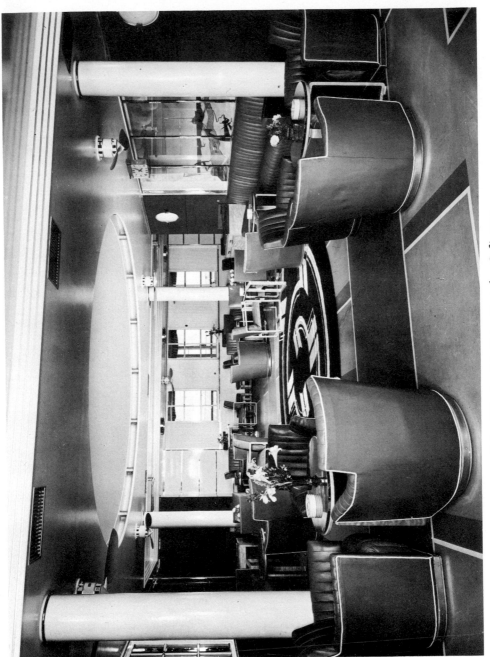

Brian O'Rorke: S.S. *Orion*: First class Café. 1935.

PLATE 119

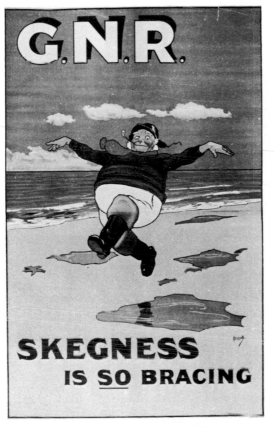

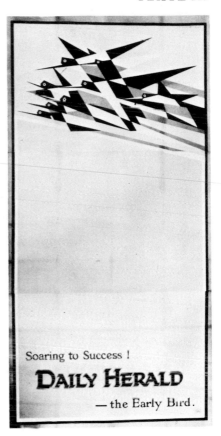

a. John Hassall: 'Skegness is *so* bracing'. Poster for Great Northern Railway. 1909.

b. Edward McKnight Kauffer: Early Bird: Poster for *The Daily Herald*. 1919.

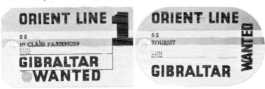

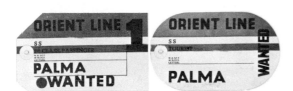

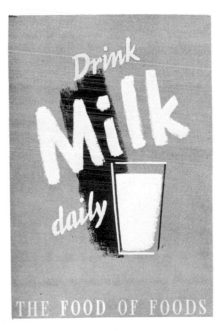

c. Edward McKnight Kauffer: Luggage Labels for the Orient Line. 1936.

d. Ashley Havinden: Drink Milk Daily: Poster. 1936.

PLATE 120

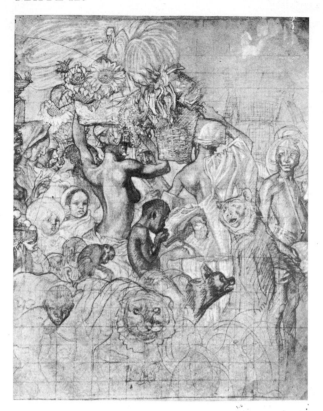

a. Frank Brangwyn: The British Empire Panels: Study of group of figures with baskets and lions. *c.* 1926–30. [Red and black chalk, heightened with white on buff paper: 58·5 × 58·5]

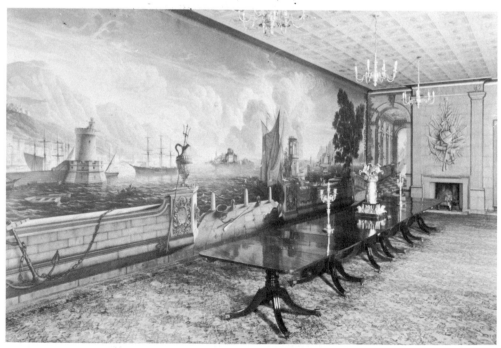

b. Rex Whistler: Dining room, Plas Newydd, Anglesey. 1937.